6 Double-click the top layer (named '**Information**') in the **Timeline** to make the text editable and then type your name to replace the existing text (Fig. 1.4d).

The right half of this panel is more akin to what you would find in a video-editing application. Think of this as a Timeruler, measuring time in a visual, sequential way from left to right. This is where you can move through time and see a global, sequential view of your whole comp from beginning to end.

The vertical red line with the blue handle is the 'Current Time Indicator,' You can move through time by clicking on the blue handle, and dragging it backward and forward along the Timeline (this is known as 'scrubbing') or by clicking on the time ruler at specific points in time. We will refer to Current Time Indicator from now on as the 'Timemarker'.

Fig. 1.4d

7 Scrub the Timemarker back to the beginning of the Timeline.

The Time Controls panel

The Time Controls panel provides you with all the buttons required to playback and navigate your compositions (**Time Controls.tif**).

8 Click on the **Play** button to see your animation play back.

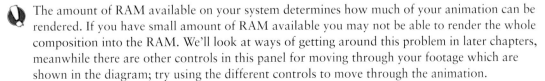

A. First Frame
B. Frame Reverse
C. Play
D. Frame Advance
E. Last Frame
F. Audio
G. Loop
H. RAM preview

This button activates a standard preview which plays your composition from the Timemarker to the end of the composition. It can also be activated by hitting the spacebar on your keyboard. Standard previews are not guaranteed to play back in real time and are only useful when working on fairly simple compositions. For more processor-intensive work it is usually better to preview using a RAM Preview.

RAM Preview

Notice that a green line extends across the Timeline as the animation is playing. As After Effects renders the frames they are stored in RAM for preview purposes, this line represents the frames that have already been rendered.

9 Click on the **RAM Preview** button to see After Effects play back as many of these frames as possible in real time.

The amount of RAM available on your system determines how much of your animation can be rendered. If you have small amount of RAM available you may not be able to render the whole composition into the RAM. We'll look at ways of getting around this problem in later chapters, meanwhile there are other controls in this panel for moving through your footage which are shown in the diagram; try using the different controls to move through the animation.

Templates are a great addition to After Effects, but often you will want to use your own ideas and source files. Let's take a look at how you can build a project like this from scratch; the first thing we need to do is import our source files.

Importing files

You can have only one project open at a time, but into this project you can import as many files as your system can possibly handle; you can even import one project into another! You can also import Photoshop, Illustrator, and Premiere files as ready-made compositions, retaining the ability to edit the files' individual layers in After Effects.

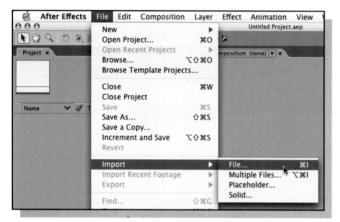

Fig. 1.5

It is important to understand that the files listed in the Project panel are only references, or pointers, to your source files which are left stored in their original locations on your hard disks. When you want to archive a finished After Effects project or share it with a colleague you must ensure that you also retain the original source files. This can be done easily using the After Effects Collect Files feature, which we will take a look at later.

In After Effects there are several different ways of executing commands. Throughout the book I will show you lots of different options, you will then be free to choose your preferred method. Let's import some files into our project (Fig. 1.5).

10 Go to **File > New > Project** to open a brand new, empty project.

11 Go back to the File menu and choose **Import > File** ⌘ *I* *ctrl* *I*.

Keyboard shortcuts are listed next to many commands in the menus. There is also a list of other keyboard shortcuts (which are not included in the menus) in the Online Help menu within After Effects. You can access this by going to **Help > Keyboard Shortcuts**.

Importing movies

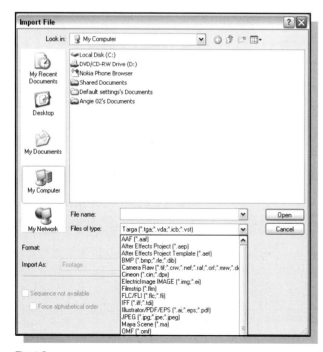

Fig. 1.6

The first file we'll import is a movie file. This particular one is a QuickTime movie, but After Effects supports many other movie formats including: AVI, MPEG, Windows WMV, and OMF (Fig. 1.6) (screen shot of file of type pop up menu).

12 In the Import File dialog box, navigate to your desktop and go to **Training folder > Source movies > Artbeats**.

13 In the Import File dialog, double-click on the file named **Backgrnd.mov** to import it into your project. This is a piece of royalty-free footage from the **Liquid Ambience** collection courtesy of **Artbeats Inc** (Ref. No: LA133.mov) (Fig. 1.7).

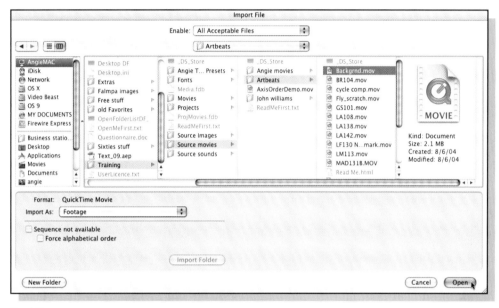

Fig. 1.7

You should now see a reference to this file in your Project panel. Notice that under the Type Column in the Project panel, it tells you that the format of the file you have imported. This file is a QuickTime Movie, in the Name column you will see a QuickTime icon to remind you of this.

When a file is selected in the Project panel you will see a thumbnail of the file at the top of the Project panel. To the right of the thumbnail is a description of its dimensions, pixel aspect ratio, duration, frame rate, color depth, and format (Fig. 1.8).

Fig. 1.8

 Experienced users may be interested to know that these thumbnail displays can be disabled by going to **Preferences > Display > Disable Thumbnails in Project panel**. Although these thumbnails can be useful reminders of the contents of source files, they can slow After Effects down when selecting compositions or high-resolution files as After Effects has to render the thumbnail in order to display it.

After Effects renders each thumbnail so when you select a composition or movie icon, the first frame is rendered as the thumbnail. This can really slow you down, particularly if you select a complex composition containing nested precomps.

> You can change the frame used as your comp thumbnail by moving through the Timeline to the frame you wish to use and then making the Comp panel or Timeline active and go to **Composition > Set Poster Time.**

14 Double-click the **Backgrnd.mov** file in the **Project** panel to open it up in the default Movie Player in its original state (Fig. 1.9).

Fig. 1.9

15 Play a continuous loop of the movie by hitting the **Play** button at the bottom of the player window, and then close the player window when you have finished viewing the movie.

Importing Photoshop files

After Effects allows you to import virtually any image file that you can think of: Tiffs, Targas, Picts, the list is endless. Probably the most versatile of the image formats supported are PSD files. This format retains information about layers, transparency, blending modes, and layer styles when you bring the file into After Effects.

16 Hit ⌘ **I** *ctrl* **I** to execute the **Import File** command, the **Import File** dialog box will appear again.

17 From **Training > Source Images > Angie Images**, open the file named **RMS_logo.psd**; another dialog box with various options will now appear.

18 Click on the menus to look at the options available. When importing Photoshop or Illustrator files into After Effects you have several choices available to you. In the Import Kind menu, choose **Footage** (Fig. 1.10).

With this choice two options will appear in the **Layer Options** section:

- The first option is to select **Merged Layers**. This will merge the layers inside After Effects into one single layer.
- The second option allows you to **Choose Layer** from the Photoshop or Illustrator file. We'll use this method of importing files later.

Fig. 1.10

19 In the **Layer Options** section, click on the **Merged Layers** radio button and then click **OK**. You will now see that the Photoshop file has also appeared in the Project panel. If you have Photoshop installed on your computer this is represented by the Photoshop icon in the Name column. At the top of the Project panel you can see a thumbnail of the image along with information about its dimensions, pixel aspect ratio, and color depth.

 Alternatively you can set the **Import Kind** menu to **Composition**. This will retain the layers from the original file, allowing you to edit and manipulate them in After Effects. We will look at this option later, when working with multi-layered Illustrator files.

Context-sensitive menus

After Effects sports context-sensitive menus, these are menus that contain unique commands for the item that you click on, for example, the Comp panel menu contains different items than those from the Project panel's context-menu (Fig. 1.11).

If you are using a Windows computer for your After Effects work you can access these menus by using the right mouse button when clicking virtually anywhere within the After Effects user interface.

If you are using an Apple Macintosh and you do not have a two- or three-button mouse, you can access the same menus by *ctrl* – clicking on the same areas.

Options in these context-sensitive menus will change depending upon where in the interface you click. From this point on, when I want you to access these menus, I will use the term, Context-click. When you see this instruction, right mouse click if you have a multi-button mouse; if you are

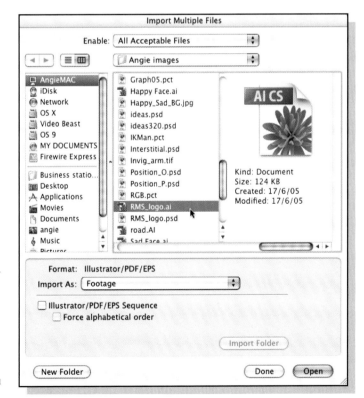

Fig. 1.11

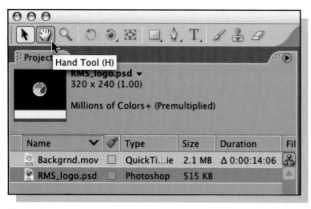

Fig. 1.12

a Mac user without a multi-button mouse you can *ctrl* – click on the same area.

Tool Tips
As well as menus, After Effects also has context-sensitive Tool Tips. When you hold the mouse over many of the interface elements (such as tools, menus, switches, and buttons) a yellow, context-sensitive Tool Tip will pop up telling you its function. These Tool Tips are very useful for new users, but once you are comfortable with the application the Tool Tips can be turned off in Preferences > General (Fig. 1.12).

Importing Illustrator files

20 **Context-click** in the space underneath your footage items in the Project panel to bring up the Project panel's context-sensitive menu. From the menu, go to **Import > Multiple Files** ⌘⌥*I* *ctrl* *alt* *I*. There are two ways of using this feature. You can either select all the files you wish to import by *Shift* -clicking them or you can double-click the files one after another to bring them into your project (Fig. 1.11).

> The Multiple Files command is useful when the multiple items that you want to import are in different folders on your hard disk or are individual layers from a multi-layered file. You can also import multiple files by hitting ⌘*I* *ctrl*, Shift-clicking them in the **Import File** dialog and then clicking the Open button.

21 Select the file named **RMS_logo.ai** from the '**Angie Images**' folder and double-click it to import it into your project. You will see the same dialog box as before.

22 Click on the **Choose Layer** button and then choose the '**Island Music**' layer from the drop down menu and then hit the **OK** button (Fig. 1.13).

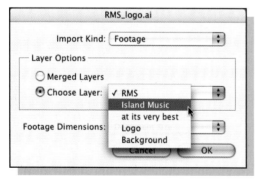

Fig. 1.13

23 You should now be back at the **Import Multiple Files** dialog box, double-click the RMS_logo.ai layer again but this time, from the **Choose Layer** drop down menu, select the '**at its very best**' layer and click **OK**.

Importing audio files

24 Once again you will be faced with the **Import Multiple Files** dialog box. This time double-click the file named **01_music.aif**, from **Source Sounds > Crank City folder to open it**, and then hit the **Done** button to close the dialog box.

25 To save your project go to **File > Save As**, and then navigate to the desktop. Create a new folder called **CAE Work in progress** on your desktop. Inside this folder, create a sub-folder named **Basics** and save the project into the **Basics** folder as **RMS_logo.aep**.

 To import an item directly into a folder within the Project panel, make sure the folder is selected in before you hit ⌘ I ctrl I .

Customizing the workspace

After Effects 7 uses a revolutionary new screen layout system that automatically resizes the application and panels to maximize the available screen space. This system also allows you to save your own customized screen layouts and in doing so removes many of the problems associated with applications that use individual palettes and panels. It can take a bit of getting used to, but the new system really does make the headache of screen management a thing of the past. If you utilize these custom screen layouts correctly, and save new configurations for each new layout you devise, you should never have to resize or reposition a panel or palette again.

The main window is the application window. Panels are arranged within the application window, this is known as a workspace. A workspace can contain groups of panels, known as frames, as well as single panels. As you make changes to a workspace, After Effects remembers those changes, saving them within the project.

1 If you do not have a project open, open **RMS_logo_01.aep** from **Training > Projects > Chapter 01**.

Changing the interface brightness

I find that the default After Effects interface is a little too bright for my liking, it can be quite tiring on the eyes to look at. After Effects allows you to adjust the brightness of the interface to suit your own requirements.

2 To change the interface brightness on the Mac go to **After Effects > Preferences > User Interface Colors**. On Windows go to **Edit > Preferences > User Interface Colors**.

3 Drag the **User Interface Brightness** slider all the way to the left to darken the interface as far as it will go. Click OK when you are happy (Fig. 1.14).

Fig. 1.14

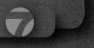

Working with panels and frames

There are various ways of adjusting the new interface to suit your requirements. The interface now consists of tabbed panels which are docked into the workspace. In previous versions of After Effects, windows would only open up if a project was open. With the new interface all the main panels are displayed, even when a project is not open. Panels can be moved and rearranged in various ways. When you dock one panel with another, the two panels are contained in a frame.

Resizing panels

4 To resize a panel horizontally or vertically hold the cursor over the edge till you see the resize icon (**double-headed arrow**) and then drag. The adjoining panels will resize dynamically to fit the screen layout (Fig. 1.15).

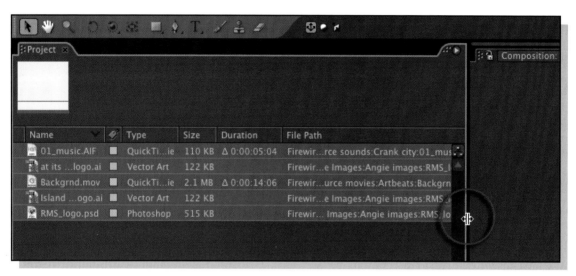

Fig. 1.15

Fig. 1.16

5 To resize panels diagonally, hold the cursor over the corner of a panel till you see the resize icon (quadruple-headed arrow) and drag (Fig .1.16).

You will now have five items in your Project panel, by default these items are sorted in alpha-numeric order. You can sort the footage by the information in a particular column, such as the **Type** or **Size**, by clicking on a **column name** in the **Project** panel.

6 If necessary, widen the Project panel and then click on the **Type** column name to change the order in which the items are displayed. Notice that the items all have colored labels: Lavender for stills, Aqua for video, and Sea Foam for audio files (Fig. 1.17).

Fig. 1.17

You can reposition the **Project** panel's columns by clicking and **dragging** their **names**. Timeline columns can be moved like this too but only when you have a composition open.

7 **Resize** the columns horizontally by hovering over the line between two columns and dragging when your cursor appears as a double-sided arrow. Try this before moving on to the next step (Fig. 1.18).

Fig. 1.18

Clicking an item's **color chip** allows you to define a new label color for the file. The colors used for labels can be changed by going to **Preferences > Label Colors**. The default label colors can also be changed in the **Preferences > Label Defaults** (Fig. 1.19).

Fig. 1.19

8 Click on the **Size** Column to reorder the footage items by their file size.

9 **Context-click** on any of the column names to bring up a context-sensitive menu that lists all available columns, choose **Columns > Comment** from the list; this will create a new column with the name **Comment** to the right of all the other columns (Fig. 1.20).

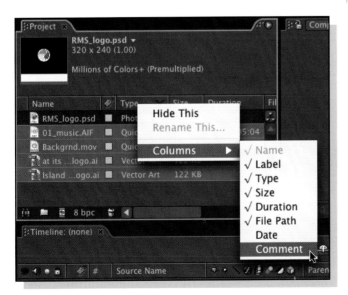

Fig. 1.20

Fig. 1.21

Fig. 1.22

Moving and docking panels

Panels can be moved and redocked to new locations within the screen layout by clicking and dragging on the tab located on left-hand side of each panel. Each tab contains the name of the panel; a close button and a grab-able Tab Handle. The Tab Handle has the appearance of raised dots to show you where it should be grabbed.

Once you have dragged the panel out from its original location you can reposition it over the edge or center of a targeted destination panel before releasing it. Hotspots will light up to indicate where the panel will be placed when the mouse is released.

10 Click on the **Project** panel tab and drag it down onto the **Timeline** panel but make sure not to let go of the mouse button before the next step.

11 Hover over the center of the **Timeline** panel till you see a blue highlighted box in the middle of the panel, then release the mouse button to dock the **Project** panel in with the **Timeline**. You will now see the **Project** panel stretched across the screen so that you can see all of the open columns (Fig. 1.21).

Dragging a panel over the center of the target panel will highlight the center of the underlying target panel. When dropped, the moved panel will appear as a new tab within the target panel (this also happens if you drag the panel over the tab of the target panel.)

If the dragged panel is held over the edge of the target panel, the edge will light up and it will be placed against the highlighted edge as a completely new panel, all other panels will resize intelligently to accommodate the new layout.

12 Drag the **Project** panel from the **Timeline** and hold it over the left, inside edge of the **Composition viewer** panel. Drop it into place when you see the edge highlighted blue (Fig. 1.22). You will then see the panel docked alongside the Composition viewer.

If you drag a panel to the very edge of the screen, the whole edge of the screen will light up. This is known as the 'edge drop zone'. Dropping a panel here forces the panel to fill the width or height of the entire application window (just as the Timeline does) placing it alongside existing panels and resizing them accordingly.

13 Click on the handle on the left edge of the **Composition viewer** panel's tab and drag it over the far left edge of the main application window. Drop it into place when you see a green highlight against the edge of the main application window (Fig. 1.23). The Composition viewer panel will fit itself in at the edge of the main application window and will resize all other windows to fit (Fig. 1.24).

Closing panels
14 There are a couple of ways to close panels; please choose one of the following to close the **Composition viewer** panel:

You can choose the **panel name** from the **Window** menu at the top of the application; this will toggle the panel either open or closed, depending on its current state.

Click on the little **x** button on the right side of the panel's tab. (If you have several tabs open in the same frame it may be hard to find the little **x** button. If this is the case, use the scroll bar at the top of the panel to scroll through open tabs.)

Resetting your workspace
We are currently working in the Standard workspace. When you make changes to the current workspace the changes are remembered. If you want to go back to the default Standard workspace, you can reset it.

Fig. 1.23

Fig. 1.24

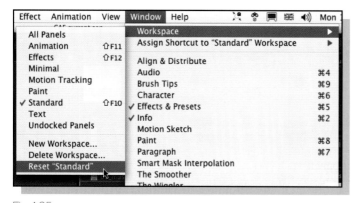

Fig. 1.25

Fig. 1.26

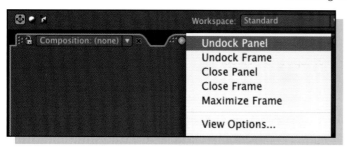

Fig. 1.27

Fig. 1.28

15 Reinstate the original Workspace by choosing **Window > Workspace > Reset 'Standard'** (Fig. 1.25).

16 Click on the **Discard Changes** button in the dialog that appears (Fig. 1.26).

Floating windows

You can also undock a docked panel to convert it to a floating window. These are windows which float above the other panels and can be moved around without affecting the positions and sizes of the underlying panels. Each floating window can consist of one or several docked panels. There are several ways to make a panel float above the other panels.

17 Hold down the ⌘ *ctrl* key while you click and drag the **Composition viewer** panel tab out to make it a floating window.

You can also make a panel a floating window by dragging it outside the main application window; this is particularly useful if you are working with multiple monitors.

Once you have created a floating window you can group other panels within it in the same way as you group the panels in the main screen layout (using the techniques mentioned in Steps 1 to 3).

Each panel also has a fly-out menu at its top-right which can be used to make your panel float. This menu allows you to choose whether to float a single panel or a whole frame; the menu item to do this is either **Undock panel** or **Undock Frame** (Fig. 1.27).

Frames

The frame's fly-out menu in its upper right corner allows you to choose whether to undock a single panel from within the frame or the whole frame, including all panels contained within.

18 Click on the **Composition** tab's panel handle and drag the **Composition viewer panel** onto the Project panel till you see the top of the Project panel highlighted in blue. You will now see two tabs within the frame, the project panel tab, and the Composition panel tab (Fig. 1.28).

 A frame of multiple panels has its own draggable handle which enables you to drag the entire frame and all of its panels to another frame/panel. A **frame's** draggable **handle** is located in the **upper right** corner to the **left** of the fly-out menu (Fig. 1.29).

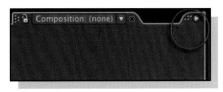

Fig. 1.29

In contrast, the draggable area to the **left** of a **panel's name** only moves the **panel**, not the entire frame of panels.

All panel menus contain the five following items (Fig. 1.29b):

Undock panel will make the active panel a floating window, **Undock Frame** will make the whole frame (including all panels within it) a floating window, **Close panel** will close the active panel, **Close Frame** will close whole frame (including all panels within it). **Maximize Frame** will maximize the frame (and all panels within) to the size of the Application panel. This menu command will change to **Restore Frame** when a frame is maximized.

The main panel menus will also contain items that are specific to that particular panel; we will take a look at these later.

19 Using the techniques listed above, take a minute or two to resize and reposition your panels so that they make the best use of the space available to you on screen. Make sure to have a good play with the panels, dragging them around, resizing them. Don't worry if you get into a bit of a mess with them, as you'll learn next, you can reset the layout at any time.

20 To reset the workspace go to **Window** > **Workspace** > 'Reset Standard' and then click the **Discard Changes** button.

Fig. 1.29b

Viewer panels

Some of the panels are known as Viewer panels; these include the Composition, Layer, Effect Controls, and Footage panels. A Viewer panel is different from a regular panel; it can manage multiple items within a single panel. This means you no longer have to have a separate tab for each open composition, layer or footage item. Instead, each Viewer panel contains a drop down menu where you can switch between the open items.

This is a great space saver, but if you need to go back to using multiple viewer panels, you can also use this menu to lock panels and create new viewers. We'll take a look at these in more detail once we start working with multiple items.

After Effects comes with several task-based Workspace presets that you can customize to suit your own needs, but you can also add to these presets. Customized workspaces can be saved and then accessed from the **Window** > **Workspace menu** or from the **Workspace** menu in the **Tools** palette. You can create new workspaces for different tasks and quickly switch between them.

Once you have saved them, custom workspaces appear in the Workspace menu. If a project with a custom workspace is opened on another computer, After Effects will look for a workspace with the same name. If a match is found, it will use that workspace; if it doesn't find a match it will open the project using the current workspace.

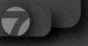

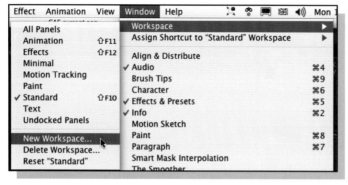

Fig. 1.30

21 Make some changes to your workspace and then save your current screen layout by going to **Window > Workspace > New Workspace** (Fig. 1.30).

22 Give it a name that means something to you and then click **OK** to save it.

After you've applied a custom workspace to After Effects, any changes that you make to the workspace's layout are saved to that workspace and remembered the next time you select that workspace.

23 Try making some changes to your workspace. Try closing some of the palettes to see how that affects your workspace. This can be done by going to **Window > < Name of palette >**.

24 Select the Standard workspace again by going to **Window > Workspace > Standard**.

25 Choose your new custom workspace again from the **Window > Workspace** menu. Notice that the changes you made earlier have been remembered. To remove any changes you've made to the saved workspace you must reset the workspace.

26 Reset your screen layout by going to **Window > Workspace > Reset < Name of Workspace >** and then choosing **Discard changes**.

Keyboard shortcuts

There are Keyboard shortcuts that can be assigned to workspaces to enable you to quickly jump between them. The defaults are **Shift F10** for 'Standard', **Shift /** for 'Animation', and **Shift F12** for 'Effects'.

27 Hit **Shift F10** to jump back to the default **Standard** workspace.

Deleting workspaces

You can also delete unwanted workspaces.

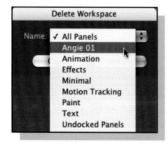

Fig. 1.31

28 Go to **Window > Workspace > Delete Workspace**; then choosing your new Workspace name from the drop down menu that appears and then click **Delete** (Fig. 1.31).

Assigning new shortcuts

To assign a new shortcut you must first select the workspace that you wish to assign the shortcut to.

29 Go to **Window > Workspace > Undocked panels** to change to a new workspace.

30 To assign a new shortcut to this workspace go to **Window > Assign Shortcut to 'Undocked panels' Workspace**, and choose **Shift + F11 (Replace 'Animation')** (Fig. 1.32).

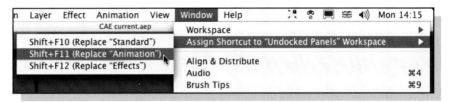

Fig. 1.32

There are three shortcuts for toggling workspaces, this method allows you to change the shortcuts so that they control the workspaces that you use most often.

31 Go to **File > Save** As and, in the Save As dialog box, navigate to your **CAE Work in progress** folder on the desktop and save the project into the **Basics** folder as **RMS_logo_02.aep**.

Recap

Now you should be feeling pretty confident about finding your way around the After Effects interface and importing source files into an After Effects project; so far we have covered the basics regarding the After Effects user interface. You learned how to use templates and navigate your files using Adobe Bridge. You should now feel comfortable with navigating the workspace and using the Time controls panel to preview and navigate your compositions.

We looked at ways of importing files including movies, Photoshop files, Illustrator files, and Audio files. You also learnt how to customize the workspace to suit your own preferred ways of working by moving and resizing the panels and frames that form the After Effects interface.

Inspiration – Jerry Ibbotson

At the end of each chapter I intend to include tips and tricks from industry professionals to provide you with inspiration and the incentive to complete all the tutorials within the book. Below are the questions and responses that I got when talking to colleague and friend, Jerry Ibbotson of Medial Mill in the UK.

http://mediamill.co.uk/

Q How did your life lead you to the career/job you are now doing?
A I used to be a BBC radio journalist and was always interested in the creative use of sound to tell a story. When I left the BBC in 200 I went freelance and while producing a documentary on the games industry met some developers who need help with audio, Five + years later Media Mill is a 'proper' business producing sound for games, animation, video, etc.

Q What drives you to be creative?
A I have a low boredom threshold and want to do a job that keeps me interested. I also have a fairly healthy ego and want to do things better and better each time. Getting good feedback and reviews (for games) is quite a buzz.

Q What would you be doing if not your current job?
A Probably still in radio. I never stopped enjoying it. I would hopefully still be reporting or producing radio news. Either that or I would have moved into television news.

Q Do you have any hobbies/interests and if so, how do you find time for them?

A I do dabble in photography but seldom have the time to really enjoy it (there are three very demanding females in my life: my two daughters and their good friend Barbie). I am also a keen writer and recently completed a creative writing course but the amount of time I spend writing has dwindled recently due to work, family, laziness, etc.

Q Can you draw?

A Nope

Q What inspires you?

A Seeing or hearing a finished piece of work and knowing I did my best. Also knowing that it has some kind of effect on other people: that they enjoy it and think it's good. In terms of coming up with ideas, inspiration often happens in unlikely ways. If I am out with my family at the weekend I can suddenly think of a new way to do something or imagine how something should sound. It just pops into the Ibbotson head!

Q Is your creative pursuit a struggle? If so, in what way?

A Sometimes it can be hard work. We work with very demanding customers and at times it can be very stressful! At other times it can be hard to come up with idea but after a nice cup of tea and a biscuit we tend to find our mojo.

Q Please can you share with us some things that have inspired you. For example, film, song, website, book, musician, writer, actor, quote, place, etc.

A When I first wanted to be a journalist I saw a film with Spencer Tracy and Katherine Hepburn, where they both played reporters. At one point she asks him why he does his job. She says 'Isn't it to see things other people don't and then tell them about it?' That inspired me and helped me get on a journalism postgraduate course (I put in on my application form).

More recently I have found bits of music that have inspired me. I love the folk singer Kate Rusby and just the sound of her voice can fill my head with ideas. My two little girls also inspire me because on really dull days they give me a reason to get out of bed.

Q What would you like to learn more about?

A Generally how to use After Effects so I can talk the same language as my customers in the video/animation fields!

Chapter 02 **Basics**

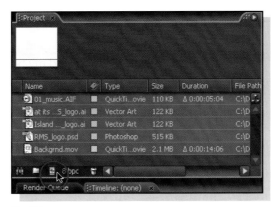

Fig. 2.1

Synopsis

This chapter will cover the basic fundamental principles of how to work successfully in After Effects. Topics will include; basic compositing; composition and project settings; understanding the After Effects interface; adding footage to your compositions; editing footage in the Timeline; working with the five transform properties; importing files as compositions; basic animation; methods for navigating through time; working with Keyframe Assistants; replacing footage in the Timeline; applying effects to your layers; rendering your finished work as movies; and archiving your projects.

Basic compositing

You should now feel comfortable with the new After Effects interface and be ready to start putting together a composition from your elements.

1 If you do not have a project open, open **RMS_logo_02.aep** from **Training > Projects > 03 Basics**.

You now have five items in your project. In order to put these items together to create a new piece of footage you need to create what's known as a *composition*. Think of the composition as the place where you *compose* all of the separate elements which go together to make up your final *composite* image. This panel is very similar to the main window in Photoshop; you can layer images on top of each other, apply blending modes, adjust color settings, and apply effects, just as you can in Photoshop. The main difference here is that all of this can be done over time adding movement to your composites and bringing them to life!

Within each project you can have several compositions; each composition can contain several layers. You can also put compositions inside other compositions; this process is called Nesting and we will look at that a bit later, but first, let's look at one of the ways we can create these compositions. There are several methods for creating compositions.

2 Look at the bottom of the **Project** panel, you will see a row of several buttons there. Click on the **New Composition button**. The **Composition Settings** dialog box will appear (Fig. 2.1).

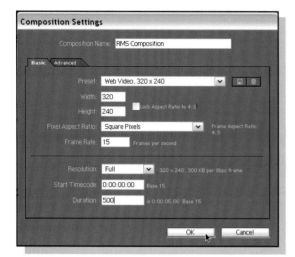

Fig. 2.2

Composition settings

You will now see the **Basic** tab of the **Composition Settings** dialog box.

3 In the **Composition Settings** dialog box, type **RMS Composition** in the **Composition Name** field and leave the dialog box open for the next step (Fig. 2.2).

It is important to get into the habit of naming your compositions carefully. When you become more confident with After Effects and are working with complicated, multi-layered, nested compositions, sensible and logical naming conventions can save you a lot of time, not to mention your sanity!

 Always remember, when using numbers in your naming convention, use zeros to proceed the numbers (e.g. 001, 002, 003, etc.). This will ensure that your files will be displayed in the correct alphanumeric order on your computer.

You can type in custom frame sizes or select a pre-defined frame size from the **Preset** menu. Unlike some of the proprietary broadcast systems, After Effects is resolution independent, meaning that it is not restricted to producing output of pre-set sizes. For example, you can produce something for a television broadcast and then, using the same software, output a copy for the web. You can also type in your own custom sizes and even output huge movies for Imax cinemas.

It may surprise you to learn that many designers use After Effects for preparing files for print. There are several reasons for this. For example, you can work with multiple layers that contain large-sized files without burdening your system. You see, After Effects only references the source files you're using (until you decide to render a frame or the entire movie), unlike Photoshop which has to constantly update the file.

The Composition Settings (and Project Settings) can be changed at any time. However, it is usually preferable to create your original composition at the largest size needed for output. For example, if you are creating a movie for Film, TV and the Web, you should create the original composition at Film resolution and then scale it down for the other output formats. Sizing down comps is not a problem but if you stretch a small comp up to a higher resolution output you can run into image quality problems.

4 Look in the **Preset** drop-down menu. You can see that there are pre-set choices for various outputs from **Web Video 320 × 240** (ideal for Web streaming) through to **NTSC** and **PAL** settings for TV and video. There are also settings for **Widescreen** and **HDTV** (high-definition television), as well as **Cineon** and **Film Academy** resolutions for working on feature films.

Notice that there are buttons for saving custom Presets and deleting Presets next to the drop-down menu, we'll take a look at these later.

5 Choose **Web Video 320 × 240** from the **Preset** menu.

The Preset determines the *Width* and *Height* of your comp (this is also referred to as the **Frame Aspect Ratio** which in this case is **320 × 240**), **Pixel Aspect Ratio** (currently set to **Square Pixels**), and the **Frame Rate** (currently **15 frames per second**). This setting is commonly used for CD ROM movies or for Web-streaming movies.

When typing timecode into any of After Effects' dialog boxes there's no need to type full stops, commas, or colons to separate the hours, minutes, seconds, and frames; After Effects will convert the number into seconds and frames for you. For example, if I were to type in 124, After Effects would convert this to; 00: 00: 01: 24 (1 second and 24 frames).

6 To easily change the **duration** of your composition, make sure that all of the text is highlighted in the **duration** field and type in **500**, this will change the **Duration** to **5 seconds and 0 frames**. To the side of the Duration dialog box is a display verifying the new timecode calculated.

However, if you type in a number where the last two digits are higher than the frame rate, After Effects will convert this number to seconds. For example if my frame rate is 25 and I type in 150 for my duration, then After Effects will convert this number to 00:00:03:00 (3 seconds). The number '1' is converted to 1 second; and the '50' is converted to 2 seconds (2 × 25 frames); then both are added together.

7 Click **OK** to leave this dialog box. A new icon has appeared in the Project panel named **RMS Composition**. All Compositions appear in the Project panel along with the associated source files (Fig. 2.3).

 Notice the icon that represents Compositions is different from icons representing other files and folders in the Project panel.

Project Settings

As well as having settings for each individual composition, After Effects also has global Project Settings which affect every composition within your current project.

8 Go to **File > Project Settings** ⌘ *alt* *Shift* **K** *ctrl* *alt* *Shift* **K**. You will see the Project Settings dialog box where you change the timecode base and the color depth that After Effects uses for each project (Fig. 2.4).

After Effects defaults to using the same Timecode base as your current Composition but can be customized to suit your own needs. You can find out more about Timecode issues in the **Import**

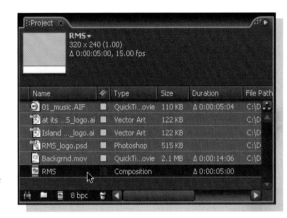

Fig. 2.3

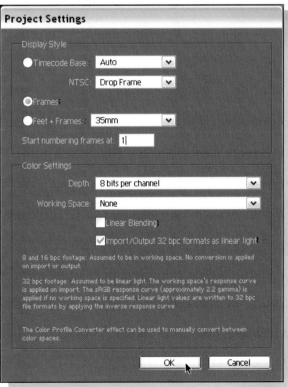

Fig. 2.4

chapter (Chapter 03), but in the following step we will change the settings so we are working in frames. It is largely a personal choice as to how you like your time displayed. People from editing backgrounds tend to prefer to measure time with timecode. Animators tend to prefer to measure time in frames.

9 Change the **Display Style** to **frames** and type the number 1 into the **Start Numbering frames** at box and click **OK**.

> I prefer to start numbering my frames from 1, I've never been able to get my head round remembering that there's a frame 0!

The **Project Settings** dialog box is also where you can choose the **Color Depth** and **Color Space** you wish to work in. The Professional version of After Effects has 32-bit-per-channel color support; 32-bit images use more colors than 8-bit or 16-bit images and can produce much higher quality output for film and HDTV.

10 Go to **File** > **Save As** to save a new version of your project, name it **RMS_logo_03a.aep** and save it into your **Work In Progress** folder.

Adding footage to your comp

When you create a new composition by clicking the New Composition button at the bottom of the Project panel or by choosing **Composition** > **New Composition** ⌘ N *ctrl* N, the resulting comp is totally empty. To include a footage file in this comp, you first have to place it in there. There are several methods for doing this.

11 If you do not have a project open from the previous step, open **RMS_logo_03.aep** from **Training** > **Projects** > **02_Basics**.

12 In the **Project panel**, double-click the **RMS Composition** icon to open up its Comp viewer and Timeline if they are not already visible.

13 Click once to select the file named **RMS_logo.psd** and then keep holding down the mouse button as you click and drag the icon over to the **Composition viewer** panel (Fig. 2.5).

Fig. 2.5

As you drag the file onto the Comp panel you'll see a bounding box with an **X** through it that represents your file. As you move the file over the center of the Comp panel you will feel it snap to the center of the composition, allow this to happen and then release the mouse to drop the file into your new comp.

This is a PSD file of a company logo for an imaginary record company called RMS, we will animate the logo. As a Motion Graphics artist starting out on your new career, this is fairly typical of the jobs that you will be expected to do. Although these small corporate companies don't often pay high rates for this type of work, there is a lot of it available and they tend to allow a little more creative flexibility than the big-budget jobs which may be very strictly storyboarded before you even see them.

These jobs are ideal for somebody who's just starting out as they give you good opportunities to practice with the software and try out your new ideas. We'll imagine that this is a small company with a low budget. They want a short snappy logo animation to be used both in presentations and for their Web site. You have a budget which will allow you less than one day to work on it so you can't afford to do anything particularly fancy!

14 You should now see the **RMS_logo.psd** layer in the center of the Comp panel. If you look at the Timeline you will also see a pink strip representing the layer's duration. You can see that the footage stretches along the Time Ruler from frame 1 to frame 75; it fills the length of the Timeline (Fig. 2.6).

Fig. 2.6

The duration of the image file is not defined by the file itself. After Effects automatically assigns any still images to be the same duration as the composition they are placed in. The duration can be altered by trimming the layer which we'll look at later.

Using audio as a guide

When animating titles I find it easier to have a soundtrack to work to, this is much easier than creating my animation and then trying to match up a sound track to go with it later. Audio is a very important part of any animation. Good audio can make the difference between an acceptable piece of work and a brilliant piece of work.

15 Go back to the **Project panel** and select the file named **01_Music.aif**.

16 **Drag** the audio file icon down to the **Timeline** and drop it below the **RMS_logo.psd** layer. As you drag, you will see a black, horizontal line telling you where in the layer stack the file will be placed. Place it underneath the **RMS_logo.psd** layer (Fig. 2.7).

Fig. 2.7

The new piece of **Audio** footage is labeled **Sea Foam** blue, this is because it is a sound file and sound files are, by default, labeled with this color, **Stills** are labeled **Lavender**, **Video** files are labeled **Aqua**, etc. This makes it easy to differentiate between different footage types.

17 Make sure that you have audio output from your machine and then hit the Period (or Full Stop) key on the number pad of your keyboard to preview the audio of your composition.

18 Hit the **Spacebar** when you have finished previewing to stop playback of the audio (otherwise it will loop continuously).

19 Select the **01_music.AIF** layer and Click on the disclosure triangle next to the colored layer label in the Timeline to display the layer properties. Then click on the disclosure triangle next to the word, **Audio** to display up the **Audio Levels**.

Disclosure triangle is the official name for these little things but you'll find that most After Effects users refer to them as Twirlies so from now on I will refer to the disclosure triangle as the **Twirly**.

This is where you can set keyframes to animate the levels of the audio (e.g. for fading the volume up or down).

20 Under the levels you will see the word **Waveform**, click the Twirly next to this to display a visual waveform of the Audio Levels. You may need to resize your Timeline (Fig. 2.8).

Fig. 2.8

The Audio Levels currently start at the beginning of the composition; this is not usually a good practice to adhere to. Whenever creating compositions, it is a good idea to leave breathing space at each end of your composition for editing purposes, in the same way that you would shoot extra footage at either end when working with video or film cameras. The extra footage will be essential for the editor of the finished program to create transitions into and/or out of the piece. I often leave as many as 2 or 3 seconds at either end of my animations just to be on the safe side.

Fig. 2.9

You will also see **Current Time** displays in both the Composition viewer and the Timeline panel. Notice these displays updating each time you move the CTI Timemarker (Figs. 2.9 and 2.10).

21 Click on the blue **Timemarker handle** at the top of the Timemarker and drag it until the **Current Time** Display in the top left of the Timeline reads 15, this will now be the current time of your composition.

22 Hit the . key on your number pad again to play the audio from the point in time of the CTI. Notice that the audio loops itself from the position of the Timemarker to the end of the composition. Hit the **Spacebar** to stop playback at any time.

Editing footage

Once footage has been brought into your composition it can be moved, trimmed, and altered in the Timeline. The After Effects Timeline is object based as opposed to layer based, this means that changes made to a single property are not destructive to other properties on the same layer, and they can be changed at any time without affecting the other properties. Photoshop is a layer-based system which means that each change you make to the file is rendered at the time of application (with the exception of Adjustment layers). This is what makes After Effects so creatively flexible, you never have to be afraid to make changes because everything is non-destructive. We'll now move the audio so that it comes in at the 15-frame (1 second) mark where we left our CTI.

Fig. 2.10a

Fig. 2.10b

Fig. 2.11

23 To move the footage in time simply **click and drag** the colored duration bar of the audio layer to the right. Hold down the **Shift** key after you start to drag to make the In point of the layer snap to the **Timemarker**. Let go when you feel this happen. The audio will now start from the 1-second mark; this is the point at which we will begin our animation (Fig. 2.11).

Make sure that you don't accidentally click on the gray Trim handles at either end of the colored duration bar. Doing this will trim the layer instead of moving it.

24 Hit the **Home key** on the keyboard to move back to the beginning of the **Timeline** and then **Preview** the audio again to hear the changes.

OK, now let's take a look at the properties of the Photoshop file's layer.

25 Select the **RMS_logo.psd** layer in the **Timeline** to make it active and then click the Twirly next to the layer label in the Timeline to display the layers' properties. Inside, underneath the Layer Name you will see a property group named **Transform**.

Working with layers

Compositing is the term used for the process of combining multiple layers to create one composite image; sort of like a collage. As soon as you place one layer upon another, you have created a composite image.

Five basic properties

Each layer has five basic properties that you can animate over time; Anchor Point; Position; Scale; Rotation and Opacity. All these can all be animated over time by using keyframes.

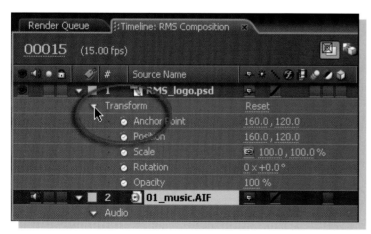

Fig. 2.12

26 Click on the Twirly next to the word **Transform** to display the five basic animatable properties of the layer (Fig. 2.12).

27 Go up to the **Project** panel and select the file named **Island Music/Logo**.

28 Hold down the **⌘** **ctrl** key as you select **at its very best/Logo**. You should now have both files selected.

Holding down the ⌘ ctrl modifier key allows you to select non-contiguous items. In other words, it allows you to select multiple files without selecting all the files in between (which would happen if you used the *Shift* key instead).

29 Hit ⌘ / ctrl / (Forward Slash key) to bring the files into your composition or go to **File > Add Footage to Comp**. Switch **off** the **Transparency Grid** so that you can see the new layers composited against the default black background (Fig. 2.13).

This shortcut for bringing footage into your composition is a very useful one that you will use often. When using this shortcut, footage is centered in the Composition viewer panel and the layers are placed at the top of the existing layers. The In Point of the layers will line up with the beginning of your comp.

Keeping things tidy

When working on complex projects it helps to set up a folder structure in the Project panel to keep our source files stored in a logical manner.

30 Create a new folder in the Project panel by clicking on the **New Folder** button at the bottom of the Project panel. As soon as the folder appears, type in **Footage** for the folder name (Fig. 2.14).

If you accidentally de-select the folder before re-naming it you can re-select it and then hit the **Return** key on your keyboard to activate the name for re-naming.

31 Select **all** of the **footage** files in the **Project** panel (but not the comp icon) and then drag them into the new **Footage** folder.

32 Go to **File > Save As** to save a new version of your project, name it RMS_logo_04a.aep and save it into your **Work In Progress** folder.

Importing files as comps

Fig. 2.13

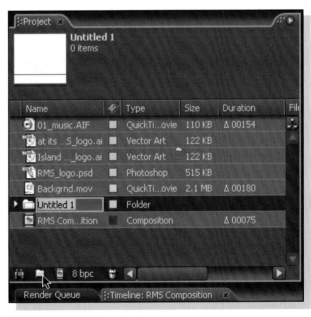

Fig. 2.14

In the Importing files section of the Interface chapter (Chapter 01) you learnt how you can import layers individually from a multi-layered file. In this chapter we've looked at ways of compositing these layers together into a new composition. But did you know that you can also import multi-layered Photoshop and Illustrator files as ready-made

compositions, maintaining layers, positioning, transparency, blending modes and certain styles and effects?

33 If you do not have a project open, open **RMS_logo_04.aep** from **Training > Projects > 02_Basics**.

34 In the **Project** window select the **Footage** folder and then hit ⌘ I ctrl I to open the **Import File** dialog and then **double-click** the file named, **Logo from Training > Source Images > Angie Images** to import it into the selected folder.

35 This time, in the **Import** dialog box, choose **As Composition** in the **Import Kind** menu and **Layer size** in the **Footage Dimensions** menu (Fig. 2.15).

36 You will notice that the **Footage** folder in the **Project** panel has opened to reveal two new items, a **folder** and a **comp** icon (Fig. 2.16).

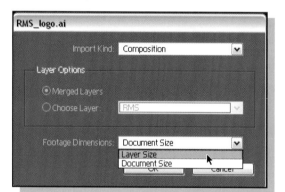

Fig. 2.15

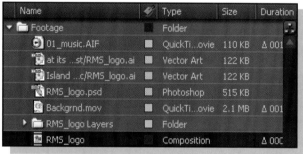

Fig. 2.16

Fig. 2.17a

37 Open the **RMS_logo Layers** *folder* (by clicking on the Twirly next to its name) to see all the layers from the original Illustrator file within.

38 Double-click on the **RMS_logo** *comp icon* to open up the ready-made composition. Notice that AE maintains the position and layer order originally determined in Illustrator (Fig. 2.17a).

39 Go to **File > Save** As to save a new version of your project, name it **RMS_logo_05a.aep** and save it into your **Work In Progress** folder.

Basic animation

Now we'll animate the Position properties of these layers over time to make them appear from outside the composition. In many cases it is quicker and easier to animate from the end point of your animation. This is one of those cases because the text is already in the place where we

want it to finish; we can simply set a keyframe to hold it in that position and then move to the start point and make our changes.

Keyframes

The term **Keyframe** comes from traditional animation. Imagine Walt Disney wants to create a simple animation of a ball bouncing on the floor. He would make three drawings: the ball at its starting point, the ball as it hits the floor, and the ball at its end point, all points where major changes occur in the animation. These would be the most important, or key, moments of the animation, hence the term **Keyframes**. He would then hand these keyframes to his assistant animator (tweener) who would then fill in all the frames in-between the keyframes, hence the term tweening (Fig. 2.17b).

When you are using After Effects you are Walt Disney, setting the most important parts, or keyframes of the animation (the white balls in the diagram). These are usually where major changes occur. After Effects is your assistant animator or 'tweener', filling in (or interpolating) all the frames between (the blue balls in the diagram).

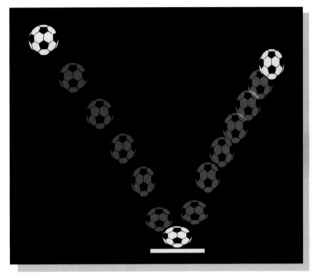

Fig. 2.17b

1 Open **RMS_logo_5.aep** from **Training > Projects > 02_Basics**. Here, I have added the music file to the comp which we created in the last few steps.

2 In the Timeline, display the **Logo** layers' properties by clicking on the Twirly next to the Layer Name. Then click on the Twirly next to the word **Transform** to display the group of properties.

Keyframing properties

3 Make sure that the Timemarker is parked at frame 15 and then click on the little **Stopwatch** next to the **Rotation** property in the **Timeline** (Fig. 2.18).

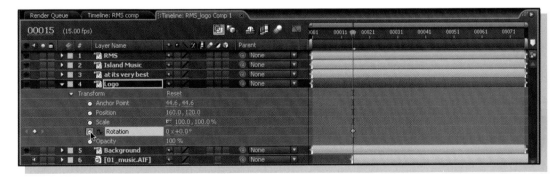

Fig. 2.18

By clicking on the Stopwatch you are telling After Effects that you wish to start recording animation of the active property. As you do this, three things will happen.

- A little yellow diamond-shaped icon will appear in the Timeline at the position of the Timemarker ; this is a default, linear keyframe. This tells After Effects to lock the value of the specified property at the current value, and at the current time. Think of it like tying a knot in the value to prevent it from changing at this point in time.
- The Stopwatch icon will have changed and a little Graph button will have appeared at its side. This allows you to add this property to the Graph Editor (don't worry about the Graph Editor for now; we'll look at it in more detail in the Animation chapter (Chapter 04)).
- A keyframe indicator button appears in the A/V Features column at the far left of the Timeline; this is there to tell you that the Timemarker is currently parked over a keyframe for that property – we'll also look at this later.

4 Click on the **Rotation** Stopwatch again to cancel the animation process and remove the keyframe.

 Clicking on the Stopwatch again will remove the keyframe and tell After Effects to stop animating that property. Try toggling the Stopwatch on and off, noticing all the things that change when a keyframe is added. Make sure that you finish with the Stopwatch switched on.

When working in After Effects you start by setting the first keyframe for a property manually; once you have done this, changes you make to the property will automatically generate new keyframes. These keyframes are created whenever changes occur to the property, After Effects will interpolate the values between the keyframes for you.

Navigating through time

Besides dragging it, another way to move the Timemarker is to click on any part of the gray Time Ruler at the top of the Timeline; the Timemarker will then jump to that point in time.

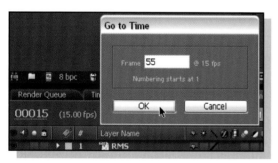

Fig. 2.19

5 Click on the **Rotation** Stopwatch again to signify that you wish to animate the property, this will also create a new keyframe at the Timemarker.

6 Click on the **Current Time** Display; the **Go To Time** dialog box will appear allowing you to enter a new Current Time. Type in **55** and then click **OK**. The Timemarker should jump to this new point in time (Fig. 2.19).

You can also hit ⌘ G ctrl G to bring up the Go To Time dialog box.

There are several ways of adjusting values of properties in After Effects. We will start by adjusting the value display numerically. Each property has a display showing the value of that property. If the property is animated then it will show the value of the property at the current time.

Before proceeding with the next step, notice that there are two values for the Rotation property in the Switches column; the first value specifies the number of **revolutions,** the second specifies the **angle** value.

7 With your mouse click once on the first **Rotation** value (which currently reads 0). Doing this highlights the text and makes it active so that you can enter a new value. Type in **18** and hit **Enter** on the number pad to change the value to **18** Complete **revolutions** (Fig. 2.20).

Notice that a new keyframe has automatically been created at the point in time where you changed the Rotation value. The new keyframe is tinted yellow to indicate that it is an active (or selected) keyframe. The property name is also highlighted showing that it is currently selected and is therefore the active property.

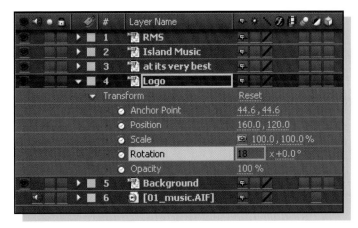

Fig. 2.20

8 Move the Timemarker back to the beginning of the Timeline by hitting the **Home** key on your keyboard and then hit the **Spacebar** to preview your animation. Notice that After Effects has worked out all the frames in-between the two keyframes for you.

Hitting the Spacebar will preview the action without the audio. After Effects will play back the frames from your hard disk as fast as it can, sometimes this will be faster than real time, sometimes slower, depending on your machine specifications and on the complexity of your project.

 If you have the Info panel displayed while previewing your comp it will tell you the speed that your comp is playing back at and whether or not it is playing in real time (Fig. 2.21).

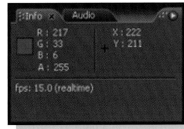

Fig. 2.21

Layer switches

Each layer has its very own set of switches that are used to switch on and off various features associated with the layers. Look to the right of the Source Name/Layer Name column (in the left side of the Timeline) and you should see the Switches column.

There are buttons at the bottom-left of the Timeline that can be used to switch the Switches and Modes columns on and off (Fig. 2.22).

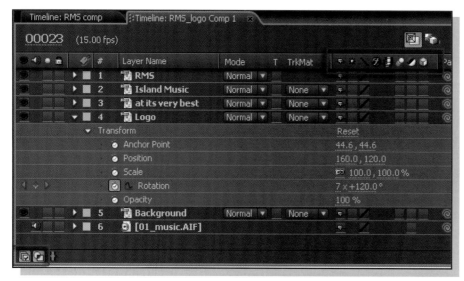

Fig. 2.22

9 Make sure that you can see the **Layer Switches** column; it is the column with various little icons running along the top of it. You can use the **F4** key to toggle between these columns.

We will now add an automated Motion Blur to the logo to make its rotation look more realistic. After Effect's Motion Blur is an intelligent Motion Blur, it looks at the speed and direction your layer is moving and blurs it accordingly.

Each layer has its own Motion Blur switch. You may not want Motion Blur applied to every layer within your comp; these switches allow you to apply it selectively by simply checking the layers that you want Motion Blur applied to.

There is also a global Enable Motion Blur switch for the composition, allowing you to toggle Motion Blur on and off for the any layers that have their own Motion Blur switch on. Switching this off will turn off Motion Blur for the comp in order to speed up previewing, it can then be re-enabled when rendering your composition.

The icons that you see at the top of the Switches column are there to identify the switches below. Clicking on these will not change anything. In order to activate a switch you must click inside the checkbox underneath the switch icons for each layer you wish to activate.

10 Hold the mouse cursor over the switch icons to see the name of the switches pop up.

11 Go to the empty checkbox underneath the **Logo** layer's **Motion Blur** switch and click in the checkbox, this will activate Motion Blur for this layer (Fig. 2.23).

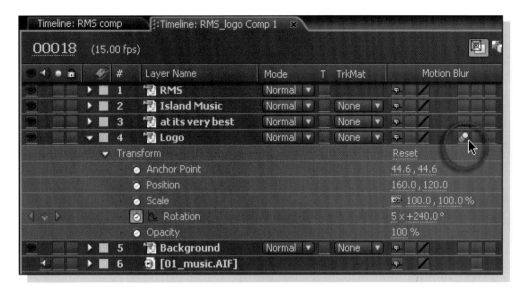

Fig. 2.23

As well as activating Motion Blur for the layer, we also have to enable it for the composition, doing this will enable it for all layers that have their own Motion Blur switch on.

12 At the top and to the right of the Switches column you will see several large buttons, click the button with the large (Screen shot!) on; this is the **Enable Motion Blur** button (Fig. 2.24).

Fig. 2.24

Applying Motion Blur to your layers will increase render times and therefore can slow down your workflow considerably. This button allows you to toggle it on when you need to see the results, and off when you wish to speed up your previews. With both of these switches activated you will have a nice, realistic Motion Blur applied to your animation.

13 Preview once again by hitting the **Spacebar**. As if by magic, we can see the rotational blur on our layer.

RAM Previewing

If you want to preview your animation in real time, along with the audio, After Effects allows you to do this by giving you a RAM Preview option. When you use the RAM Preview option After Effects renders the frames into RAM which is a much faster memory than hard disk memory. You can then view your rendered composition at the same frame rate as your composition (or as fast as your system will allow) complete with audio. The number of frames that you can load into RAM depends on the amount of RAM that you have on your system and on your After Effects preference settings.

All Previewing can be done using the Time Controls panel. Personally I prefer to use keyboard shortcuts as they are a lot quicker but let's first take a look at the Time Controls panel to see what our options for previewing are.

Purging RAM

First of all, let's get rid of any frames that are currently stored in the RAM cache so that you can see how the caching works.

14 Go to **Edit > Purge > Image Caches**. This will delete any image file that has been rendered to RAM.

As we saw earlier, when the frames are being rendered into RAM, a green line runs across the Time Ruler in the Timeline showing you the progress. You can also see the progress in the Info panel, where it tells you how many frames are loaded out of the total number requested. During playback the same display will tell you how many frames are playing, and at what speed they are playing.

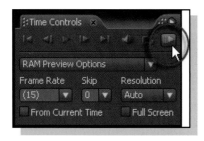

Fig. 2.25

15 In the **Time Controls** panel hit the **RAM Preview** button and watch as the frames are rendered and the green line extends across the Timeline, indicating which frames have been rendered into RAM. As soon as the green line is complete After Effects should play back your animation in real time, depending on your system's performance (Fig. 2.25).

16 Hit any key on the keyboard to stop playback.

The nice thing about using the RAM Preview button is that it will attempt to play back all animation, along with the audio in real time (whether or not it plays back in real time is dependent on your system configuration). The regular preview (which we activated by hitting the Spacebar) will not playback audio and will not attempt to play in real time.

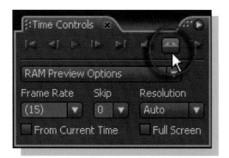

Fig. 2.26

In the Time Controls panel you'll see several buttons which all do different things. The Audio button will toggle audio on and off for your previews. Next to the Audio button, in the Time Controls panel, you'll see the Loop button. The default setting for the RAM Preview is for it to loop continuously till you either hit a key or click anywhere within the After Effects interface.

17 Click once on the **Loop** button to change it to **Palindrome** mode and then hit the **RAM Preview** button to preview. The movie will now play continuously forward and backward till you stop it. Click anywhere on the screen or hit the Spacebar to stop playback (Fig. 2.26).

18 Click once more on the **Loop** button to change the mode to **Standard** and then hit the **RAM Preview** button. The movie will now play continuously forward and stop when it reaches the end of the composition (Fig. 2.27).

19 Click on the **Loop** button once more to return to **Loop** mode (Fig. 2.28).

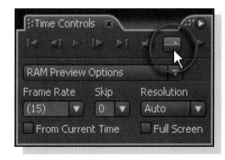

Fig. 2.27

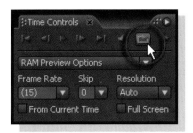

Fig. 2.28

My preferred way of activating a real time RAM Preview of my composition is to use keyboard shortcuts.

20 Make sure that either the **Composition viewer** panel or **Timeline** are active and then hit the 0 key on the number pad of your keyboard to start the process. This does the same as clicking the RAM Preview button in the Time Controls panel. After Effects will load all the frames into RAM and then play the result back to you in real time.

21 Go to **File > Save** As to save a new version of your project, name it **RMS_logo_06a.aep** and save it into your **Work In Progress** folder.

Animating multiple properties

OK, so you have now created a basic animation simply by animating one property of a single layer. In each layer, every property has its own keyframes; this defines an object-based animation system. In layer-based animation there is just one keyframe per layer which controls all properties for that layer. In order to animate a second property using layer-based animation, you would have to go back and adjust the existing keyframes. This is not the case with After Effects; here, each property's keyframes behave independently from each other and can be adjusted, moved, copied, and pasted without affecting the other properties. The downside to this is that you will need to set an initial keyframe for each property that you wish to animate but the benefits of this type of animation system far outweigh the pitfalls as you'll soon discover.

At the moment we are animating our layers in a two dimensional (2D) environment. It is possible to work in three dimensions (3D) within After Effects and we will look at that later but let's master the 2D aspects first. There are ways of faking 3D in a 2D environment and After Effects is king of the fakirs! Often it is easier and quicker to fake a 3D effect than to do it for real in a 3D environment; it can often be quicker to render this way too. You will now animate the Scale property of the same layer to give the effect of depth in your animation.

1 If you do not have a project open, open **RMS_logo_06.aep** from **Training > Projects > 02_Basics**.

2 Open the Twirly next to the **Logo** Layer Name and then the Twirly next the **Transform** Property group name to make sure that you can see the layer properties listed in the Timeline.

The j (forward) and k (back) keys on your keyboard can be used to jump to the points in time of visible keyframes and layer markers. You can remember these shortcuts more easily by thinking of the first letters of the words; **Jump Keyframes**.

3 Use these shortcuts to jump to the point in time of the first visible keyframe for the **Rotation** value.

4 Click the Stopwatch next to the **Scale** property name to set a keyframe for Scale (Fig. 2.29).

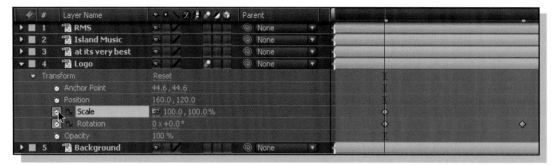

Fig. 2.29

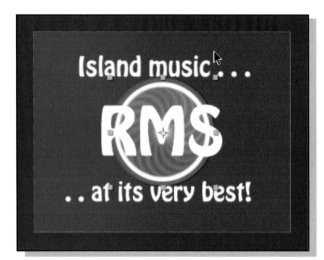

Fig. 2.30

5 Make sure that the **Logo** layer is selected in the **Timeline**. In the **Comp** panel you will see a bounding box around it with eight handles and an anchor point. You can use this bounding box to interactively move, scale and rotate your layer directly in the Comp panel.

6 In the Comp panel, click and drag the top/right corner handle of the layer toward the center of the comp. After you start to drag, hold down the **Shift** key to constrain the aspect ratio so that it scales equally horizontally and vertically. Notice the blue Scale value changing in the Timeline. Stop once you have had a bit of practice with this technique (Fig. 2.30).

Make sure to hold down **Shift** after you start to drag. Holding it down before you click will de-select the layer.

This method of scaling is fine if you want to roughly scale something but if you want to scale something by a precise value its much easier just to type the new value. The Scale property has two values, one for the X Scale value (Horizontal) and the other for the Y Scale value (Vertical).

7 **Reset** the Scale value to **100%** by context-clicking on it and choosing **Reset** from the menu. This will reset the value back to its default value (Fig. 2.31).

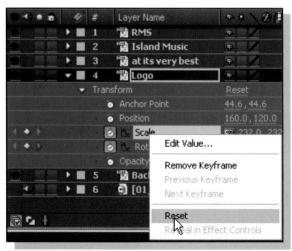

Fig. 2.31

We want the Scale animation to begin at 0% and end at 100%. We can easily change the location of the keyframe by picking it up and dragging it along the Timeline.

8 Click and drag the keyframe to frame **55**.

You can use the Info panel as a guide when adjusting most things in After Effects. In this case it will update to tell you the current time when dragging the keyframe.

9 With the Timemarker still at frame **15**, change either of the two **X** and **Y Scale** values in the Timeline to **0%** and then hit **Enter**. A new keyframe will automatically be created for you (Fig. 2.32).

Both the X and Y values will change because the lock aspect ratio button is switched on. The logo layer will now disappear from view because it has been scaled down to 0%.

10 RAM Preview your animation by hitting the **O** key. The layer now scales from 0% to 100% while rotating, making it appear to spin onto the screen from afar.

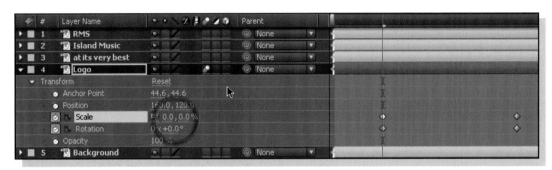

Fig. 2.32

Editing keyframes

There are several ways of adding, moving, and adjusting keyframes once they have been created. Each method is useful for different reasons and in different situations so it's important that you understand the differences.

11 Move to the **next visible keyframe** by clicking the little highlighted arrowhead next to the keyframe button for **Rotation** in the A/V Features column on the left side of the Timeline (Fig. 2.33).

These arrows do the same as the **J** and **K** keys, allowing you to quickly jump between visible keyframes (these only become active when keyframes are visible in the Timeline).

 Notice that as you move to the next visible keyframe a highlighted arrowhead appears next to the **Scale** keyframe button allowing you to jump back to the previous keyframe.

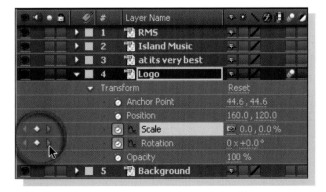

Fig. 2.33

Adding/removing single keyframes

You can add/remove single keyframes by using the keyframe button in the A/V Features column.

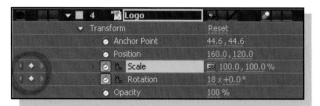

Fig. 2.34

12 Make sure the **Timemarker** is parked exactly on the **second scale keyframe** by checking that the **Keyframe button** is highlighted yellow in the **A/V Features** column (Fig. 2.34).

13 Click on the highlighted **Keyframe** button; this will switch off only the keyframe at the current time and change the value back to **0** at the current time.

14 Click on the **keyframe** button again, this will add a new keyframe at the current time. Notice that the keyframe is created with whatever the current value is (in this case, **0%**).

15 Move to frame 35 and notice that the current value is **0%**. At the moment we are animating between two keyframes but because each has a value of 0%, therefore nothing is changing.

Editing single keyframes
Keyframe values and units of measurements can be edited by double-clicking on a keyframe.

16 Double-click on the second **Scale** keyframe to open up the **Scale** value box. The Timemarker doesn't need to be at a keyframe in order to change its value. This box not only allows you to change the value but also the units of measurement and the aspect ratio.

17 Change the **Scale** value to **100% Width** and **100% Height**. With the **Timemarker** still at frame **35** the current **Scale** value should now read 50% (Fig. 2.35).

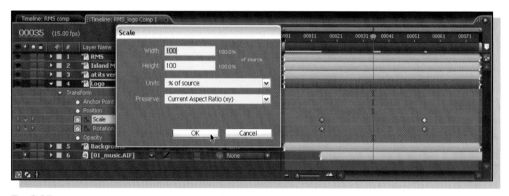

Fig. 2.35

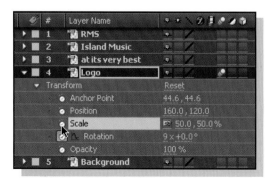

Fig. 2.36

Adding/removing all keyframes
All keyframes for a property can be added/removed by clicking on the property Stopwatch.

18 Click on the **Stopwatch** for the **Scale** value to remove all keyframes for the **Scale** property, doing this will remove all the keyframes while keeping the Scale value at the current value (in this case **50%**) (Fig. 2.36).

19 Go to **Edit > Undo** or hit ⌘ Z ctrl Z and then move the **Timemarker** to frame **20**; the current **Scale** value should read **12.5%**.

20 Click on the **Scale** Stopwatch again to remove the keyframes; this time the value will remain at **12.5%**.

Removing the keyframes in this way is permanent, the only way to re-instate them is to undo the operation.

21 **Undo** the last step so that your keyframes appear again.

Selecting property keyframes

All keyframes for a property can be easily selected by clicking on the name of the property.

22 To **select all** the keyframes for the **Scale** property, click on the **property name** (in this case the word '**Scale**') (Fig. 2.37).

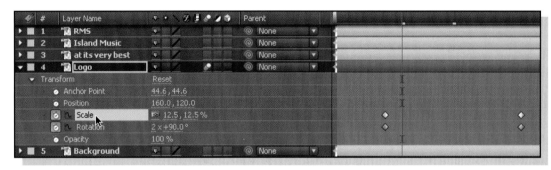

Fig. 2.37

23 Hit the **Delete** key to remove the keyframes but notice the difference, this time the value returns to **0%** which was the value of the first keyframe).

24 **Undo** the last step so that your keyframes appear again.

25 Hi the **Home** key on the keyboard to go back to the beginning of the composition.

Opening up individual properties

You can imagine that if I have to open up all of my layers to get to their individual properties, I will very soon run out of screen space. Luckily, After Effects provides you with keyboard shortcuts which allow you to display only the properties you want to see in the Timeline, keeping your screen neater and more manageable.

These property keyboard shortcuts are so easy to remember because they use single letters to represent the properties. If you wanted to bring up Scale you would have hit the **S** key. For Rotation – the **R** key. Anchor point – the **A** key. The only one that is not immediately obvious is the **T** key for Opacity but if you think of Transparency or OpaciTEE it is quite easy to remember! You can also use the acronym STRAP to remember the five shortcut letters. There are also modifier keys that can be used to simultaneously set keyframes for the selected properties.

26 Select the **Island Music** layer and then hold down the ⌘ ctrl key and click the **At It's Best** layer to select both of the layers.

27 Hit the **P** key on the keyboard to display both selected layer's **Position** properties in the Timeline. Click either of their Stopwatches to set keyframes for both of the selected **Position** properties.

28 Hit ⌘ **G** ctrl **G** to bring up the **Go To Time** dialog box, type in **30** and then click **OK** (or hit **Enter** on the keyboard) to move the Timemarker to your new position, 2 seconds into the animation. This is the point where our text layers will come to rest.

29 Drag the selected new keyframes toward` the **Timemarker**, holding down the **Shift** key after you begin to drag, you will feel it snap to the Timemarker (Fig. 2.38).

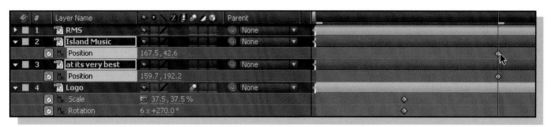

Fig. 2.38

30 Close up both layer properties by hitting the **P** key again.

31 Close the other two open layers by clicking on the little Twirlies next to the Layer Names. There is also a very useful keyboard shortcut to bring up all keyframed properties for selected layers.

32 Hit ⌘ **A** ctrl **A** to select all layers and then hit the **U** key on the keyboard. This will open any keyframed properties for the selected layers.

The **U** key (also known as the Uber key) will bring up only the properties that have been keyframed for any layers which are selected, this is very useful when working with complex animated compositions and particularly when working with multiple effects. The same key can be used to close any open layers.

33 Go to the beginning of the composition by hitting the **Home** key on the keyboard.

As well as being able to adjust values by entering them numerically, After Effects allows you to interactively change the values for a layer directly in the Composition viewer panel.

34 De-select all of the layers either by clicking in the empty, gray space at the bottom of the Timeline or by hitting the **F2** key.

> If you are using the **Mac OSX** operating system and you are using **Expose**, then hitting the **F** keys may activate Expose. You may want to change your Expose settings so that you can use the **F** keys as After Effects shortcuts.

35 In the bottom-left of the **Composition viewer** panel, change the **Magnification** drop-down menu to **50%**, so that you can see space at either side of the screen (Fig. 2.39).

Fig. 2.39

36 Select the **Island Music** layer in the Timeline. In the **Comp** panel, you will see a bounding box appears around your layer with eight selection handles and a center point, representing the edges, corners, and anchor point of your layer.

At this stage you want to avoid clicking on any of the handles or anchor point, we'll use these later to Scale and rotate our layers.

37 In the **Composition viewer** panel, click on the layer anywhere within the bounding box, avoiding clicking on the Anchor point in the center of the layer.

38 Drag the layer off the screen to the right. After you start to drag, hold down the *Shift* key to constrain the movement to a horizontal move (Fig. 2.40).

Fig. 2.40

You must make sure that you hold down the *Shift* key after you have started to drag the layer otherwise you will accidentally de-select it.

39 The screen shot will help you with positioning your layer. If you make a mistake, don't worry, simply go to **Edit > Undo** or hit ⌘ *Z* *ctrl* *Z* and then try again.

40 Now select the '**at its very**' best layer in the **Timeline**. Click on the layer in the **Composition viewer** panel and drag it downward, off the screen to the bottom. Again, hold down S after you start to drag the layer to constrain the movement, this time to a vertical move. Notice that holding down shift as you drag will constrain it either Horizontally or Vertically, depending on the direction you drag it (Fig. 2.41).

41 Change the **Magnification** back to **100%**.

Fig. 2.41

42 Hit the **Home** key to move the **Timemarker** back to the beginning and then hit the **0** key to build a **RAM Preview** of your animation so far.

43 Go to **File > Save As** to save a new version of your project, name it **RMS_logo_07a.aep** and save it into your **Work In Progress** folder.

There are a few changes to be made to the animation to make it work. At the moment both layers of text come into the screen at the same time, making it quite difficult to read. We will adjust the existing keyframes to improve the timing of the animation.

Fine tuning animation

1 If you do not have a project open, open **RMS_logo_07.aep** from **Training > Projects > 02_Basics**.

2 **Move** to frame **45** by using any of the methods that you learned in the previous lesson.

3 If you can't already see the keyframes for your layers hit **⌘A** **ctrl A** to select all layers and then hit the **U** key on the keyboard to show keyframes for all selected layers.

4 Select the **at its very best** layer and then click on the second **Position** keyframe by clicking once on it, the keyframe will be highlighted yellow when it is selected (Fig. 2.42).

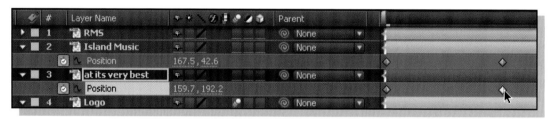

Fig. 2.42

5 Drag the keyframe over to the **Timemarker** ; hold down the **Shift** key as you drag to snap the keyframe to the Timemarker at frame **45**.

6 **RAM Preview** your composition and notice that the end point **at its very best** layer animation comes in later and fits much better with the music. The start points of the animation still need some work as they come in too soon.

7 Make sure that you can see the **Info** panel before taking the next step (**Panel> Info ⌘2 ctrl 2**).

The **Info** panel can provide you with valuable information regarding your actions in After Effects. We will use it here to tell us the current time position of our keyframe as we are dragging it. This saves us from having to move the Timemarker before dragging.

8 Drag a selection marquee around the first keyframes for both the **Island Music and at its very best** layers, alternatively you can **Shift**-select them.

9 With **both keyframes selected**, click and drag the first of the two keyframes, meanwhile, watch the **Info** panel until the keyframe time value reads 15 (Fig. 2.43).

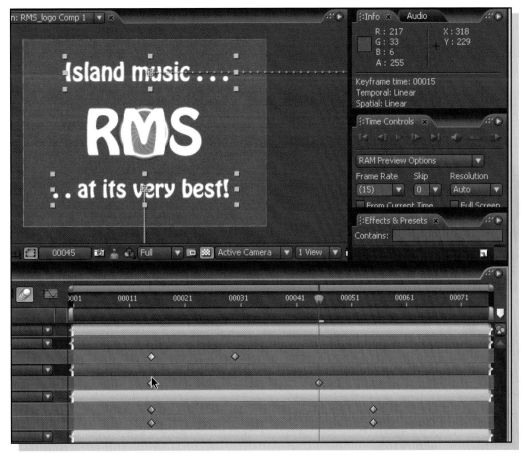

Fig. 2.43

10 **RAM Preview** the animation and notice that the text now appears in time with the music, making the animation immediately more dynamic.

Basic keyframe interpolation

At the moment the temporal (time-based) interpolation between the keyframes is linear, which means that the speed at which the layer moves is constant and even. Very few things in real life move at a constant speed, most things gradually accelerate or decelerate; they vary their speed as they move through time and space.

There are exceptions to this rule. Imagine a car traveling at a constant speed of say twenty miles per hour. Suddenly the car crashes into a wall. Up to the point at which the car is stopped by the wall, it is moving linearly through time. In other words, it moves at a constant speed till the wall abruptly stops it. It is described as linear movement because it is like drawing a straight line between one point and another.

If the car then reverses away from the wall then this is no longer a linear move through time and space, because the car starts off slowly and gradually accelerates, this would be a curved interpolation between the two points. It may still travel between the same two points within the same space of time but it may start off slowly and then become much faster, rather than traveling at a constant speed.

In our example the animation would look smoother if we gradually slowed the text down as it approached its end point. You can do this manually in After Effects but you can also use pre-built Keyframe Assistants, which will automate the process for you.

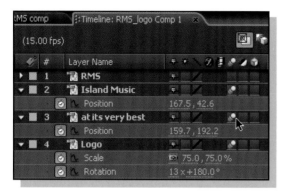

Fig. 2.44

11 Click on the **Motion Blur** checkboxes (in the Timeline's Switches column) for the **Island Music** and **at its very best** layers (Fig. 2.44).

12 **Preview** the animation and notice that the Motion Blur may be slowing the previewing down a little.

Quality settings

After Effects is currently using *Best Quality* as its default display setting; this setting uses anti-aliasing to smooth the edges of your graphics and uses sub-pixel positioning to place elements on screen. In other words, any spatial values will be worked out at tiny fractions of pixels. Previewing in this mode will increase rendering time and therefore slow down the display of your animation.

If things are getting unbearably slow but you still want to see Motion Blur being rendered you can choose to see your renders in draft quality, this will not use any anti-aliasing and it will position objects to the nearest pixel, rather than to a fraction of a pixel. The Quality switches of each layer can be set individually so you can have one layer previewing in Draft mode and another in Best, all within the same composition.

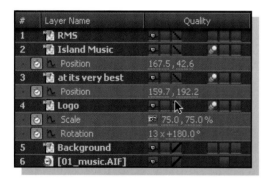

Fig. 2.45

13 To switch your layers onto **Draft** Quality mode simply click and drag across the **Quality Switches** for all the layers in the **Switches** column. The switch will currently be represented by a continuous diagonal line. As you click on the switches, the dotted lines change direction and become dotted lines. All switches are now 'drag-switchable' and can be switched on or off in this way (Fig. 2.45).

14 **RAM Preview** the animation in **Draft** quality to see how much faster the playback is.

This mode is fine for rough work but if you want more precision in your motion paths, or want to see what your final output will actually look like you need to make sure that you look at your layers in Best Quality mode. It may take longer to load into RAM, however, it will play back in real time as it does in Draft mode.

15 Change all the **Quality** switches back to **Best Quality** in one action by clicking the mouse on the first switch and dragging it down across the others.

16 Using any of the methods you have learnt make sure the **Timemarker** is at frame **45**. Let's animate some more properties.

To make a movement in an animation more dynamic it's a good idea to do what's known in traditional animation as 'go past the pose'. This is a well-known trick used by animators to

exaggerate movement. The idea is to push the value slightly above our desired end point, just for a split-second, before finally resting at the end point of the animation. We'll add a little 'scale bounce' to the animation to give it a bit more life.

To show more than one property for a layer without having to display all of the layers' properties, you can hold down the **Shift** key while hitting the property shortcuts, this will add them to the visible properties already displayed in the Timeline.

17 Make sure that the **at its very best** is the only layer selected in the **Timeline** and then hit **Shift** **⌥** **S** **Shift** **alt** **S**. Holding down **Shift** while hitting the **S** key will add the **Scale** property to the **Position** property, which is already visible. Holding down the **⌥** **alt** key will also set a keyframe for Scale at the current time.

18 Turn off **Motion Blur** for the composition by clicking the **Enable Motion Blur** button at the top of the Timeline.

This switch can be activated again when you render the movie, it is not necessary for us to see the blur for now and it will speed up our workflow if we switch this off.

19 Move three frames ahead by hitting the **Page Down** arrow key on your keyboard three times. Alternatively, use the **next frame** button on the **Time Controls panel** to do the same job.

20 Change the **Scale** property value to **170%** by clicking the Scale's value in the Switches column, entering 170 and then hitting the Enter key on the number pad of your keyboard. The layer will Scale beyond the edges of your comp.

21 Move ahead by another two frames by hitting the Page Down arrow key twice.

Copying/pasting keyframes

As well as being able to drag keyframes around in the Timeline, you can copy and paste them.

22 Select the first **Scale** keyframe and then go to **Edit > Copy** or hit **⌘ C** **ctrl C** to copy the keyframe information to the clipboard.

23 Hit **⌘ V** **ctrl V** or got to **Edit > Paste** to paste the keyframe and its value at the position of the Timemarker (Fig. 2.46).

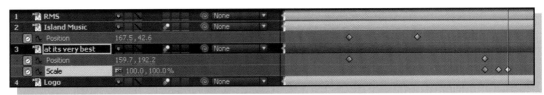

Fig. 2.46

24 Jump back to the previous keyframe by hitting the **J** key on the keyboard. Look at the text and notice that the edges are quite fuzzy when the layer is pushed past **100%** (Fig. 2.47).

Fig. 2.47

Continuous rasterization

This layer is an Illustrator file and they can be stretched to any size within After Effects without losing quality. In order to do this you need to activate what is called Continuous Rasterization. There is an explanation of this process later in this book so for now I'll just show you how to apply it. I don't want to fill your head with too much too soon!

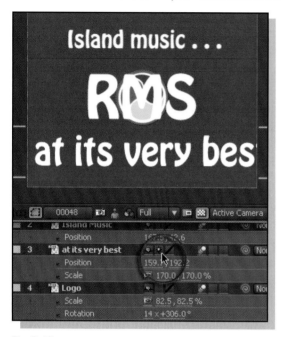

Fig. 2.48

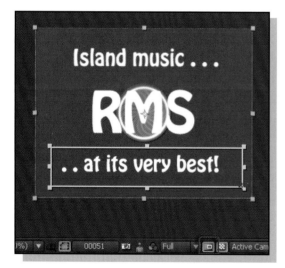

Fig. 2.49

25 Still watching the text in the **Composition Viewer** panel, click on the **Continuously Rasterize** switch for **at its best** layer. Notice that the text is now much clearer (Fig. 2.48).

26 Enable Motion Blur again by clicking on the **Enable Motion Blur** button at the top of the Timeline and then **RAM Preview**.

Wireframe preview

This is a quick way of seeing a real time preview of the animation without having to wait for a RAM Preview to build. It will only preview the layers which are selected in the Timeline, showing them as wireframe outlines, enough to get an idea about the movement of your animation.

27 Select all layers and then go to **Composition > Preview > Wireframe Preview**.

Region of interest

After Effects also provides you with a Region of Interest button which allows you to specify an area of the comp to preview, ignoring the remaining pixels. Obviously, the more pixels After Effects has to calculate, the slower the preview will be.

28 Click on the **Region of Interest** button at the bottom of the **Comp** panel (Fig. 2.49).

29 In the **Comp** panel, click and drag a box over the bottom third of the screen, just as if you were dragging a marquee selection. A box appears with handles on it. You can click and drag any of these handles to adjust the size and shape of the Region of Interest box after you have drawn it (Fig. 2.50).

Fig. 2.50

30 **RAM Preview** now and you'll see that only the pixels within the **Region of Interest** are previewed.

Keyframe Assistants

Notice that the scale bounce of the **at its very best** layer is very abrupt, I'd like the movement to be a bit softer as it bounces up and down in scale. At the moment the scale is moving linearly, we'll ease the motion using some Keyframe Assistants.

31 Move the **Timemarker** to frame 48, so that it is sitting over the middle keyframe of the three **Scale** keyframes on **at its very best** layer.

32 Select the middle **Scale** and then click on the **Show Graph** button at the top of the Timeline (screen shot) to display the layers value graph. Here you can see a visual display of the animation in graph form (Fig. 2.51).

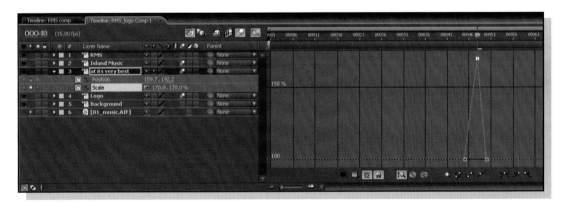

Fig. 2.51

33 Drag the **Zoom In/Zoom Out** slider, at the bottom of the **Timeline** all the way to the right to zoom in on the keyframes. Notice that there is a straight red line drawn between each of the yellow keyframes, this represents a linear move.

34 Click on the middle **Scale** keyframe to select it and then click on the **Easy Ease** button at the bottom of the **Timeline** panel to ease the velocity on the way into and out of the keyframe, this will soften the move (**F9** is the keyboard shortcut for Easy Ease) (Fig. 2.52).

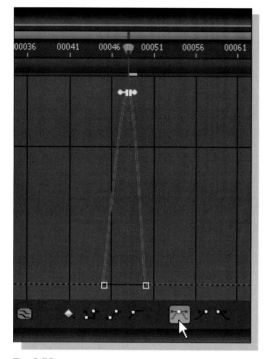

Fig. 2.52

You can access **Easy Ease** at any time, you do not have to be in the **Graph Editor** mode in order to apply it; simply select the keyframe in the Timeline and apply it. I only switched to Graph Editor mode so that you can see what's happening to the graph as you change the keyframe type.

35 Notice that the value graph has now changed to a nice, smooth curve as it goes through the middle keyframe. After comparing the graphs, drag the **Zoom in/Zoom out** slider back to the left so that you can see the whole Timeline.

36 Switch off the **Show Graph** button and notice that the keyframe shape has changed in the Timeline, telling us that this is no longer a **linear** keyframe but a **Bezier** keyframe, this will slow down the rate of change coming into and going out from the middle keyframe resulting in a much smoother animation (Fig. 2.53).

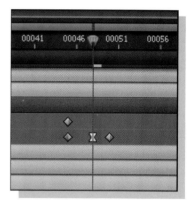

Fig. 2.53

You will learn more about the different keyframe types in Chapter 04 Animation.

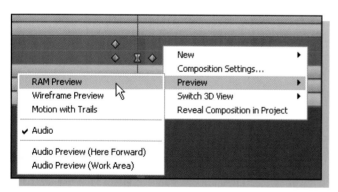

Fig. 2.54

37 Context-click on the gray area between the keyframes and choose **Preview > RAM Preview** from the menu to preview the animation (Fig. 2.54).

38 To switch off the **Region of Interest**, click on the **ROI** button again in the Comp panel.

You can reset the **Region of Interest** to the size of the comp by ⎇-clicking *alt*-clicking on the **Region of Interest** button in the **comp** viewer.

39 Hit the **Home** key to send the Timemarker back to the beginning of your composition.

40 Hit ⌘A *ctrl*A to select all of the layers in your composition and then close all of the layers by clicking the Twirly next to any of the layers names, this will close all selected layers.

41 Go to **File > Save As** to save a new version of your project, name it **RMS_logo_08a.aep** and save it into your **Work In Progress** folder.

Replacing layers

1 If you do not have a project open, open **RMS_logo_08.aep** from **Training > Projects > 02_Basics**.

Fig. 2.55

2 In the **Timeline**, select the **Background** layer and then click on the **Layer Name** column heading to toggle it to display the **Source Name**. You should now see the listed name as **Background/RMS_Logo.ai** (Fig. 2.55).

 Files can be renamed in the Timeline, the **Source Name** view allows you to override this to see the original name of the source file you are using.

3 Select the layer in the Timeline and then hold down the ⌥ *alt* key as you drag the **Backgrnd.mov** from the **Project** panel and then drag it onto the selected **Background/Logo** layer in the **Timeline** to replace it (Fig. 2.56).

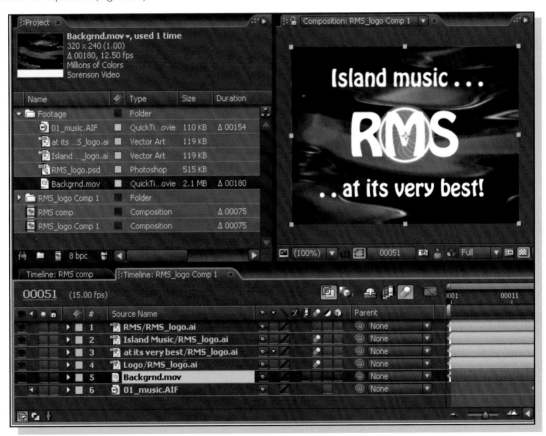

Fig. 2.56

4 At the left edge of the **Timeline** is the **A/V Features** column containing the **Video** switches. They look like little eyeballs and are similar to the ones in the Photoshop layers panel.

5 Move the **Timemarker** to frame **50** and then click on them one by one, starting from the top layer to switch off the visibility of the layers in the Comp panel. Leave the Background layer's visibility on.

When working in 2D, the stacking order in the Timeline determines the Position of the layer in the Comp panel. Just like the Photoshop layers panel, the top most layer in the Timeline will be the front-most layer in the Comp and the bottom-most layer in the Timeline will be the back most layer in the comp. All other layers in between will be composited in the order they appear in the Timeline.

At the moment the background is too literal, I don't want it to look like water, I simply want an abstract, moving background texture. We'll start by changing the color to match the Logo.

Applying effects

I'm sure most of the readers of this book will have all used Photoshop, or another image manipulation application for adding effects and filters to images. After Effects allows you to do this too but the main difference here is that it allows you animate the effects and filters over time! Just imagine being able to adjust settings for your effects so that they happen gradually, animating color changes, distortions, and transitions. Well you can do all this easily in After Effects – the possibilities are endless!

Fig. 2.57

6 Below the **Time Controls** panel sits the **Effects & Presets** panel. If you cannot see the Effects & Presets tab, go to **Window > Effects & Presets** to bring it up. Here you can view and search all the effects installed in After Effects. There are various different ways of viewing them.

7 Click on the wing menu and choose **Categories** from the list to view the effects in their categories, as they are displayed in the Effects menu in the main application (Fig. 2.57).

8 Open the **Color Correction** category by clicking on the Twirly next to its name.

9 Drag the **Change to Color** effect from the Effects & Presets panel and drop it onto the **Backgrnd.mov** layer in the Timeline. As you do this you will see the Effect Controls panel appear in the same frame as the Project panel, situated next to the Comp Viewer panel (Fig. 2.58).

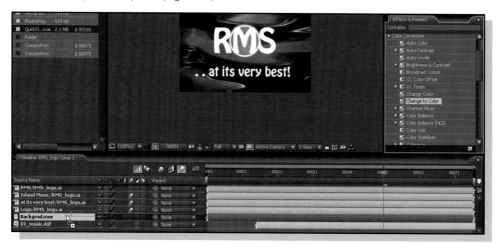

Fig. 2.58

An **X** appears over the layer as you drag it, this is very useful as it helps you to avoid selecting the wrong layer when you have more than one layer showing.

The Change to Color effect will do exactly what its name implies; it will change a specified color in the layer to another color. We're going to use this for a very simple color change but you can use this effect to achieve very striking results.

Adjusting effect properties

Look at all the properties that are available In the Effect Controls panel. All the properties with Stopwatch icons next to their names can be animated over time, and this is only one single effect! Just imagine what you'll be able to do with multiple effects! We'll start by simply adjusting the effect properties; you'll get a chance to animate the effect properties in the Effects chapter (Chapter 07).

10 In the **Effect Controls panel**, there are two white swatches, one is labeled **From**, and the other is labeled **To**. Click on the little eyedropper icon next to the **From** swatch.

11 Move the cursor over the **Comp** panel, the cursor icon will change to an **eyedropper** icon as you do so.

12 Click on the **blue** color on the **Backgrnd.mov** and you'll see that the exact color you clicked on is sampled and applied to the swatch in the **Effect Controls** panel; the footage will now appear pinkish in the Comp panel, After Effects uses the default color of red but we can change this to any color we want (Fig. 2.59).

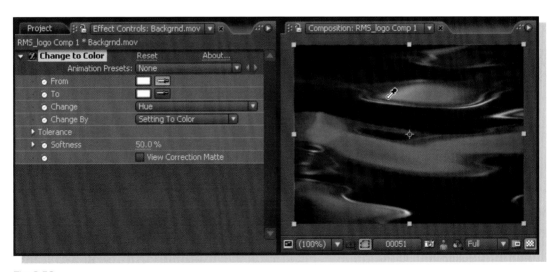

Fig. 2.59

13 Move to **frame 61** and then switch all the other layer's video switches back on so that you can see them displayed in the Comp panel and then.

Fig. 2.60

14 Click on the **To** eyedropper in the **Effect Controls** panel and then move the cursor onto the **Green** part of the logo. As soon as you do this, the **To** swatch will change to that color and the blue hues will change to a green hue that matches the logo (Fig. 2.60).

15 Open the **Tolerance** section by clicking on the Twirly and change the **Hue** setting by clicking once on the blue value to select it and then typing in **50**. This will ensure that all shades of blue are selected.

Combining multiple effects

You can apply multiple effects to each layer in your composition. You must remember though that the general rule is the more effects you apply, the slower your rendering time will become. Some effects will take longer to render than others and adjusting their settings can also affect their render speed. So you need to experiment with different effect combinations to get a feel for how they work. You can also apply effects to your layer from the main Effect menu.

16 With the **Backgrnd.mov** layer still selected go to **Effect** > **Noise & Grain** > **Median** (Fig. 2.61).

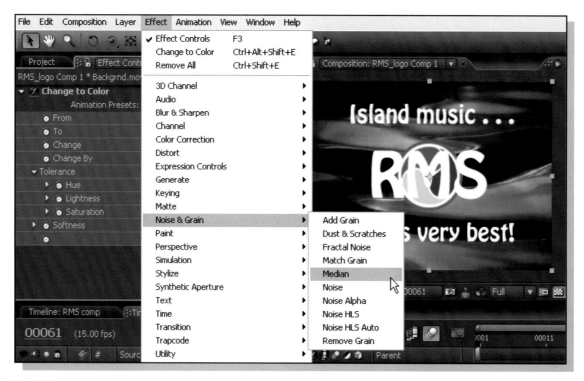

Fig. 2.61

17 In the **Effect Controls** panel notice that the **Median** effect is now listed underneath the **Change to Color** effect. Effects are rendered in the order that they appear in the Effect Controls panel. Usually, they will be listed in the order that they were applied but you can change the order afterward too. We'll look at this in the Effects chapter (Chapter 07).

18 Hide the **properties** of the **Change to Color** effect by clicking on the Twirly next to its name in the **Effect Controls** panel.

The Median effect works out the median (or average) color within a specified radius then applies this average value to all pixels within the radius. You adjust the range by adjusting the Radius slider in the Effect Controls panel. A setting of 1 will work within a range of 1 pixel from the center pixel. A radius of 10 will work out the average color of pixels within a radius of 10 pixels from the center point.

After Effects gives you several ways to adjust property values. As you've already seen you can adjust values by clicking on them and editing them, you can also adjust Effect values by using various sliders and dials.

19 Click on the Twirly next the **Radius** property to open it up. Inside you'll see s slider. Notice that the slider in the **Effect Controls** panel only allows a maximum radius of **10** (Fig. 2.62).

Fig. 2.62

20 Drag the slider all the way up to **10**. The effect looks good but I want a higher value so that the image is even more abstracted. If you need a higher setting than the slider allows you can change the slider's minimum and maximum range yourself, I'll show you how.

21 **Context-click** on the **radius** value and choose **Edit Value** from the drop-down menu, this brings up the **Slider Control** box. Change the **Maximum** Value to **35** and then click **OK** to leave the dialog box. Context-clicking on a value will bring up a dialog box where you can find more features to control how a value is adjusted (Fig. 2.63).

22 Using the slider in the **Effect Controls** panel, change the **radius** value to **30**.

Fig. 2.63

The Median effect has softened the background movie to give an effect of movement without the footage being easily recognizable as water. This effect can also be used to get rid of the artifacts from badly compressed footage; at a very low setting it can get rid of visual edge noise without having to blur the image.

23 Hit the **Home** key to return to the beginning of your composition and then hit the **RAM Preview** button or the **0** key on the number pad to preview your movie.

24 Go to **File > Save As** to save a new version of your project, name it **RMS_logo_09a.aep** and save it into your **Work In Progress** folder.

Rendering movies

OK, you are now ready to render your movie to the hard disk. At the moment references to your source files and information about all the changes you made to them are stored inside the After Effects project as a composition. In order to use your new composition in other applications you must render it out as a new file on your hard disk.

1 If you do not have a project open, open **RMS_Logo_09.aep** from **Training>Projects > 02_Basics**.

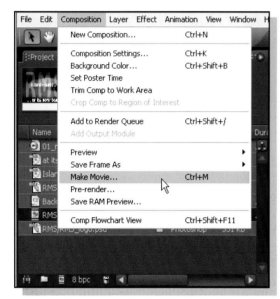

Fig. 2.64

2 Make sure that either the **Composition** tab or **Timeline** are active, then hit ⌘ **M** *ctrl* **M** or go to **Composition > Make Movie**. The **Output Movie To** dialog box will appear. As a default, After Effects will name the movie after your composition, if you want to change the name of your movie then this would be the time to do it, for now leave it as it is (Fig. 2.64).

3 Using the **Output Movie To** dialog box, navigate to the Desktop of your computer and open your Basics folder, in your **Work In Progress** folder.

4 Click the **Save** button or hit the **Return** key on your keyboard to choose to save your movie into the open folder.

You will now see the **Render Queue** panel in the same frame as the Timeline panel. This is where you specify the **Render Settings** and **Output Module** settings for your movies (Fig. 2.65).

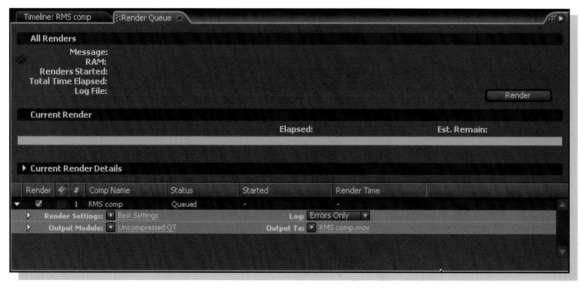

Fig. 2.65

5 Notice the **Render Settings** option in the **Render Queue** panel, next to the drop-down menu icon (it's currently set to '**Best Settings**'). You may need to adjust the size of the Render Queue panel in order to see these settings.

This setting will override the Quality, Resolution, and Motion Blur settings that we set up in the comp, that is, Motion Blur will be applied to all layers whose Motion Blur switch is checked in the Timeline, and all layers will be rendered in Best Quality no matter what the quality switches are set to in the Timeline.

6 Click the drop-down menu icon next to **Render Settings**; notice the choices available to you. These are pre-determined settings, which have been saved as templates for you. You can also make up your own templates with your own preferred settings (Fig. 2.66).

 Be aware that, if you had chosen Current Settings you would render the movie out exactly as it appeared in the Comp panel.

7 Choose **Custom** from the drop-down menu and the **Render Settings** panel will appear (Fig. 2.67).

This panel may look complicated to you but don't worry, by the time you finish this book you'll know it pretty well. In the top left corner is the Quality drop-down menu,

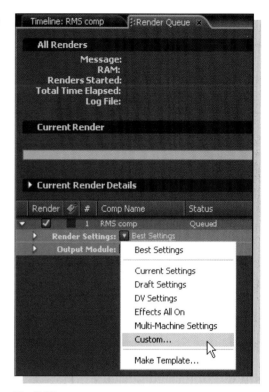

Fig. 2.66

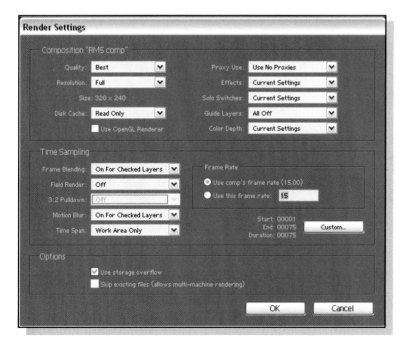

Fig. 2.67

this is where you can override the quality settings in your composition. With this set to Best, all layers will render at Best Quality regardless of the switch settings in the original composition.

8 Move down to the **Time Sampling** section and to the **Motion Blur** menu, which is now set to **On for Checked Layers**, this will turn Motion Blur on for all the layers whose Motion Blur switch we turned on in the Timeline. This will override the current state of the Enable Motion Blur switch in the composition.

We will leave some of the other menus in here till later, I don't want to bombard you with too much to learn for now but don't worry we'll be back here again, don't worry!

9 Click the **OK** button or hit the **Return** key on the keyboard to return to the **Render Queue** panel.

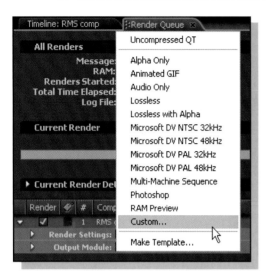

Fig. 2.68

10 Click on the **Output Module** drop-down menu and look at the templates available for you to use in there. This is where you determine the format of your output file, which channels are output, color depth, codec's used. You can also choose to output audio here as well as crop or stretch your movie file (Fig. 2.68).

11 Choose **Custom** from the drop-down menu and the **Output Module Settings** dialog will appear (Fig. 2.69).

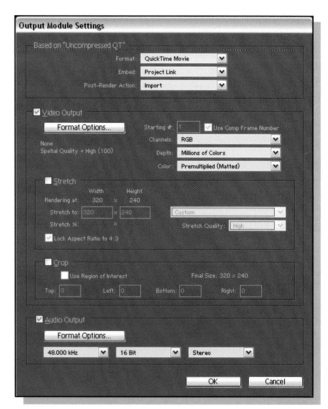

12 Click on the drop-down menu named **Format**, it will probably read **Quick Time movie** if you are on a **Mac** or **Video for Windows** if you are on **Windows**. Notice the huge choice of formats that can be output from After Effects. The format is also sometimes known as the architecture of your file. Leave these settings at the default.

As well as being able to output incredibly versatile QuickTime movies and AVI movies which can be read by most computer applications, you can output to various kinds of image sequence (e.g. Pict, Targa, Tiff, SGI) for outputting to proprietary systems such as Quantel's excellent post production and editing systems.

Fig. 2.69

You can even choose to output Cineon sequences for feature film production. At the other end of the spectrum, you can choose to output animated Gifs for inclusion in your Web page designs. In addition to the comprehensive list of output formats available here, there are plug-ins available to allow you to output to other formats not listed here. After Effects even gives you the option to output your movies in Macromedia Flash's SWF format; although this has to be done via the File>Export menu.

13 In the **Post Render Action** menu, choose **Import**. With this selected, After Effects will import a reference to the finished movie into your current project so that you can view the finished movie without leaving the application (Fig. 2.70).

14 In the **Video Output** section, click on the **Format Options** button to bring up the **Compression Settings** dialog box; this is where you can choose the codec (compressor) to use for your movie.

Fig. 2.70

A codec compresses your footage so that the computer bandwidth can cope with the information and decompresses so that it can be played back on screen. Depending on the hardware setup you have you will use different codec to optimize your footage. You can find out more about codecs and compression options in the final Output chapter (Chapter 12).

15 In the **Video Compression** dialog box, click and hold the **Compressor** pop-up menu. There you will see a list of available codec for you to choose from (Fig. 2.71).

The list of codec available include the ones that were installed during the installation of QuickTime or Video For Windows. If you have a third-party video card installed on your system you may have some extra codec showing in this list. Most video cards come with their own codec that are installed when you install the driver for your video card. Once installed, the codec will be included in the default list of codec available to you in the After Effects Compressor Settings panel.

Fig. 2.71

You can also install other codec onto your system; the new codec will then appear in this list the next time you restart your machine. An example of when this can be useful is when preparing footage to be used on an Avid system. You can download the Avid codec from the Avid Web site and drop it into your system. You can then render directly out from After Effects, using the Avid codec. This movie will then be easily imported into the Avid system in its native format.

16 Leave the codec at its default setting. Click **OK** to leave the **Compression settings** panel.

17 Go to the **Audio Output** section at the bottom of the Output Module settings dialog and check the checkbox to activate it.

18 Change the settings to **22.050 kHz, 8 Bit**, and **Mono** and then click **OK** to leave the **Output Module Settings** dialog box (Fig. 2.72).

Fig. 2.72

19 Before hitting the **Render** button, put the **Caps Lock** key down (on your keyboard). When you have Caps Lock down, After Effects locks the preview in the Composition viewer panel and stops it from refreshing on every frame. Doing this will speed up your render time.

20 Click the little Twirly next to **Current Render Details**. When you start to render, this will show you details of the estimated final file size, free disk space available, etc. It will also tell you how long each frame is taking to render each effect or transformation, this is very useful for learning which effects and processes are processor and memory intensive. Be aware, however, that this will slightly increase your render time so don't keep this open for longer renders.

21 Hit the **Render** button and watch the frames crunch away! Notice (if you have time to!) in the Render details, that the Median effect seems to be taking longer than anything else to process (Fig. 2.73).

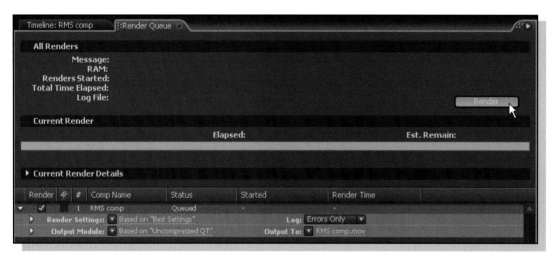

Fig. 2.73

22 When the movie has finished rendering you will hear the much loved After Effects prrring!! render alarm sound. This tells you that your movie is ready.

23 Close the **Render Queue** panel and go to the **Project** panel. There you will find the movie that has just been rendered (RMS Logo movie). Double-click the file to open it up in your video player and hit the Spacebar, on your keyboard to start playback, hit it again to pause the playback.

24 Go to **File > Save As** to save a new version of your project, name it **RMS_logo_10a.aep** and save it into your **Work In Progress** folder.

Archiving projects

Quite often, once you have rendered a movie, you may want to back up the project and source files into one single location. The collect files feature allows you to do this very easily and will retain all links between the project and the footage items. If you attempt to move your project any other way you may run into difficulties when links to source files are broken so here's the correct way to do it!

1 If you do not have a project open, open **RMS_Logo_10.aep** from **Training > Projects > 02_Basics**.

2 Go to **File > Collect Files**. This will open up the **Collect Files** dialog box. There are various options in here for choosing which items you wish to be collected. You'll also notice a display at the bottom corner of this panel which tells you how many files are to be collected, and exactly how big the file sizes are likely to be once collected (Fig. 2.74).

3 Keep the default settings and then hit the **Collect** button. You will be prompted for a location to save these files to. Locate your **Work In Progress > Basics** folder on the **Desktop** and save the new folder into it. Click **Save** and After Effects will make copies of all necessary files and move them to the single location of your choosing (Fig. 2.75).

Recap

Congratulations, you have completed the first two chapters of this book! You have learned how to create a composition within an After Effects project; import files into the project; add the footage files to your composition; apply effects to the layers; animate the properties of the layers; and output the finished animation as a movie. You have also learned a little bit about Codec, Keyframes, and the different file formats you can use within After Effects as well as the fundamental workings of the software.

Fig. 2.74

Fig. 2.75

Now that you've learned enough to get you up and running, you can start to play with what you've learned. On the DVD there is more footage available for you to use in the Source Movies, Source Sounds, and Source Images folders, within the Training folder. These folders contain all the other footage used in the book's tutorials. These also contain conditions of use documents which you must read carefully. Remember that you can also use your own footage, sounds, or images too. Don't try to work directly with the files on the DVD, make sure they are copied to your hard drive before using them within After Effects. Using them from the DVD can impair performance.

Workflow

You may find it difficult to come up with ideas, if so, before continuing with the next chapter I recommend that you now open the Workflow.pdf document in the Extras folder on the DVD, this document is for you to read and it gives you information about how to get started with your projects, decipher a brief, and create a storyboard. Please make sure that you read it thoroughly before continuing with the next chapter.

This document is an extra document designed primarily for those who may not have the experience of working on a real life project, or for those who find it difficult to create something from scratch. It provides you with a brief to design a stand-alone movie which will give you a sense of purpose while continuing throughout the rest of the book. I hope that some of these suggestions will help your creative flow.

Inspiration – Steve Caplin

When I began writing this book, I decided that I wanted it to be a book which would inspire creative thoughts as well as teaching software techniques. During the process of writing I have chatted a lot to other creative people to ask them how they deal with the demands of their work and how they keep coming up with new ideas. I've decided to share a few of these tips and tricks with you. They come from some of the best creative people I know, in fields ranging from Web and new media design to more traditional skills such as ceramic design and performance art. I also asked them how they go about combating creative blocks.

These tips have been interspersed throughout the book. The following two suggestions are from Steve Caplin, a very talented graphic designer and author friend of mine. Steve has a very

Caplin01

successful book published called 'How to Cheat in Photoshop'. You can find out more about this book and view his online portfolio at:

http://www.stevecaplin.com

Q How did your life lead you to the career/job you are now doing?

A Entirely by accident, as is so often the case. When I left university with a degree in Philosophy I got a job playing the piano in a wine bar. The manager of the wine bar left to start a listings magazine, and I started it with him… he dropped out after just four issues, and I kept the thing going for years, then turned it into a free newspaper. Kept editing magazines for several years, and started a satirical magazine using desktop publishing in 1987. When I closed that down two years later I had all this computer equipment left over, and started experimenting. Met the editor of Punch one day, and showed him what I'd been toying around with. He commissioned an illustration, then a regular weekly strip – and then the Guardian phoned up and said they wanted one too. Then the phone just kept ringing!

Q What drives you to be creative?

A Getting an idea is like getting a cold. It keeps you awake at night for a couple of weeks, and the only way to get it out of your system is to blow it out onto paper! It's a necessity, rather than just an urge.

Caplin02

Q What would you be doing if not your current job?

A Moaning about how awful my day job is, I suppose, and spending my weekends and evenings doing the stuff I do now.

Q Do you have any hobbies/interests and if so, how do you find time for them?

A Main hobbies are music and woodwork. Each weekend I build something that didn't exist before. Could be a large project – I've built a 16-foot camera obscura, and a full size bar billiards table – or even something small like a turned bowl or candlestick. Don't really mind what it is, as long as I'm making something. How do I find the time? By never, ever, turning the computer on at weekends!

Q Can you draw?

A You mean, with a pencil? Not really. I was never very attracted to it. I used to make complex montages from polystyrene, toy soldiers and bits of household junk, though – before I found I could have more fun doing the same thing in Photoshop.

Q What inspires you?

A Most of my work is commissioned for newspapers and magazines, so what inspires me there is the deadline and trying to interpret a brief in an innovative way. My 'personal' work is just … I don't know, you get an idea, there's no way of telling where it comes from!

Q Is your creative pursuit a struggle? If so, in what way?

A A struggle? Only when I'm trying to meet a very tight deadline. Otherwise, it's pure joy.

Q Please can you share with us some things that have inspired you. For example film, song, Web site, book, musician, writer, actor, quote, place, etc.

A Tricky one. I'm inspired by Chopin and Tom Waits, by Holbein and the Chapman Brothers – but there's really no direct link to my work. Unless you count Terry Gilliam, of course!

Q What is your most over-used AE feature/filter?

A That old KPT plug-in that lets you split a layer in the middle. Great for making people talk!

Q What would you like to learn more about?

A One of these days, I really must get around to learning Flash.

Q Any other tips for the readers?

A If you're on a tight deadline, I find the adrenaline rush usually does the trick on its own. It may be the increased oxygen, but outdoor thinking always proves profitable. If possible, think in your own garden – if you hang around parks gazing blankly into space you're likely to be arrested. And think obliquely. Often the most obvious idea isn't the one that will work best in practice, and presenting ideas visually is a different matter to explaining concepts verbally. Start by exploring common metaphors and see where they take you.

OK, so you've learned the basics about how After Effects works, you should now feel comfortable enough to begin thinking about the more creative side of things. You may have some ideas from the practice session that you've just completed but how can you formulate these ideas into a cohesive working project? Well, I think that's enough rabbiting from me, time for you to roll up your sleeves and get in there – Happy keyframing!

Chapter 03 Import

Although you can create Footage from nothing in After Effects, you'll find that most of the time you want to work with imported footage. This footage could be imported via an editing application such as Premiere Pro or Final Cut Pro. It could be a photograph ingested from a camera. It could be stock photography, clip-art, or stock footage bought online, or it could be images that you've drawn in Illustrator or scanned into Photoshop.

Synopsis

In this chapter you'll learn all about the issues associated with importing footage into After Effects. We'll talk about the cross-supported features when importing Photoshop, Premiere Pro, and Illustrator compositions. We'll also take a brief look at how to use Adobe Bridge as the 'asset-management hub' and 'batch-processing center' of all your productions; see how templates can ease your workflow and discover how to build up libraries of effects and settings with Animation Presets. We'll take our first look at how to take advantage of After Effects amazing Textacy text engine when importing editable text from Photoshop or Illustrator. Nested compositions will be discussed as will importing paths (or masks) from other applications.

We'll also take a look at some of the file types you can import into After Effects including: image sequences, audio files, folders, and data from editing applications. Finally, we'll look at how to avoid and fix potential problems such as fixing broken links and replacing footage in your compositions. It will also draw your attention to some important issues which you need to be aware of when designing for television and video, particularly in After Effects.

Importing Photoshop compositions

We're going to start by working on an image created in Photoshop. The tutorial also explains a little bit about layers, channels, and blending modes to help you understand how they work. As you learned in Chapter 02 – Basics, After Effects works with projects and compositions. Do you remember, in the Basics chapter (Chapter 02), importing a layered source image from Illustrator as a ready-made composition? Well you can also do this with Photoshop files.

Layers

1 Open After Effects. As soon as you open the application a new project will be created for you named **Untitled Project.aep**. If you have the wrong project open, just go to **File > New > New Project** to open a new one.

2 Double-click in the empty **Project** panel, or hit ⌘ I ctrl I to open up the **Import File** dialog box.

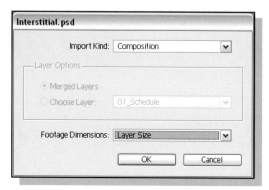

Fig. 3.1

3 Go to **Training** > **Source Images** > **Angie Images** and then double-click once on the file named, **Interstitial.psd** to open it. This will bring up the **Import Options** dialog since the file contains multiple layers (Fig. 3.1).

4 Click on the **Import Kind** drop down menu and choose **Composition**. This will tell After Effects to bring in the Photoshop file as a ready-made composition with any layers, adjustment layers, masks, guides, blending modes, and other features intact.

5 Make sure the **Footage Dimensions** menu reads **Layer Size** and then click **OK** to leave the dialog box.

With the **Layer Size** option selected the layer dimensions will be determined by the pixels of the layer, that is, the layer handles will be around the physical edge of the individual layers rather than placed at the edge of the comp. This makes the layers quicker to render and places the layer's anchor point in the center of each layer.

The other option is **Document Size**. With this option selected the layer dimensions will be determined by the dimensions of the whole document. This can be useful to leave the room for some third-party plug-ins to extend their effects (e.g. some blurs cannot render outside the bounding box of a layer).

Look in the Project panel and see that two things have appeared, a folder and a composition. The folder is named as **Interstitial Layers** and contains all of the individual layers from the Photoshop file. The other item is a ready-made After Effects composition, named as **Interstitial** which contains all the layers arranged in the same order as they were in Photoshop.

6 In the project panel, click the Twirly next to the **Interstitial Layers** folder this will open it up and display the contents within. Notice that there are several Photoshop layer icons and After Effects Composition icons within this folder. These are all taken from a multi-layered file, created in Photoshop (Fig. 3.2).

Fig. 3.2

Fig. 3.3

7 In the **Project** panel, widen the **Name** column if necessary, so that you can see the filenames clearly and then double-click the **01_Schedule/Interstitial.psd** layer to open its Footage panel in the same frame as the **Compositi.on viewer** panel (Fig. 3.3).

8 Notice that the layer is smaller than the Composition, it is trimmed to the size that the layer was created in Photoshop, the edge of the layer is at the very edge of the text. This is because we selected the **Layer Size** option in the **Import File** dialog.

Channels

At the bottom of the Footage panel resides the **Show Channel** pop up menu. This is to control the display of the channels within the image: **red, green, blue**, and **alpha**. These options allow you to see the individual channels which are combined to make up your full color image, similar to using the Channels palette in Photoshop. It is very important that you understand channels and how to use them. You will find that you will have more precise control over color correction, matte manipulation, and effect controls if you have a good, basic understanding of channels. So after finishing this chapter there is a more detailed section on channels in the Compositing chapter (Chapter 05) should you want to explore further.

Fig. 3.4

1 Open Interstitial.aep from Training > Projects > 04_Import.

2 Double-click the **05_Running/Interstitial.psd** layer in the **Project** panel and notice that it replaces the previous layer displayed in the Footage panel (Fig. 3.4).

Fig. 3.5

Fig. 3.6

3 In the **Footage** panel, click on the **Show Channel** menu. One-at-a-time choose the **red, green,** and **blue** channels from the menu to display, individually, each of the three, separate color channels. These images show the distribution of each color in the image (Fig. 3.5).

When you display a single channel using this menu, white represents 100% of the color, black represents 0% of the color, and gray areas in between show percentages of the color based upon their gray value.

4 Click on the **Show Channel** menu again but this time, select the **alpha** channel. You will see a gradient going from gray to white. This is a Layer Mask that was created in Photoshop, it is imported into After Effects as an alpha channel, and embedded in the forth channel of the 32 bit layer (Fig. 3.6).

5 Choose **RGB** from the **Show Channel** menu to see the complete, composite image again.

After Effects retains all of the information about transparency for each layer that you set up in Photoshop and keeps all of that information for you in a separate alpha channel.

6 Toggle on the **Transparency Grid** button to see how the alpha channel affects the layer that it's attached to. The transparent areas should now partially reveal the checkerboard background behind (Fig. 3.7).

7 Close the **Footage** panel by clicking on the little close button

in the top-right corner of the Footage panel tab.

File information

8 Go back to the **Project** panel and click on each layer to see a preview of it in the **thumbnail** at the top of the project panel. Notice that, as you click on each image, you can see information about its dimensions and color depth displayed in the Project panel, next to the thumbnail. It also mentions the type of Alpha channel in parentheses (in this case 'Straight') (Fig. 3.8).

Fig. 3.7

9 Click on the **02_Logo/Interstitial.psd layer** to select it and then click the Twirly, next to the highlighted name at the top of the **Project** panel. A drop down menu will open showing you all the places where this file is used within the project, this is very useful for keeping track of items and finding out whether or not a footage item is being used in your project (Fig. 3.9).

 You can choose a listed comp from this menu to quickly open the comp rather than locating the comp in the Project panel's list.

Ready-made comps

1 In the **Project** panel, close the **Interstitial Layers** folder and then double-click on the **Interstitial** composition icon, this will open up ready-made composition which contains all of the layers you have just finished looking at (Fig. 3.10).

Fig. 3.8

Fig. 3.9

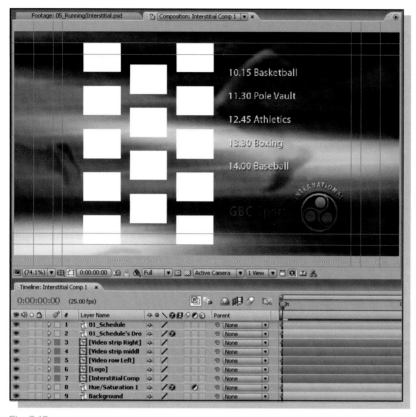

Fig. 3.10

There is no need to create a new comp to put the layers into, After Effects does all that for you when importing a file as a composition. The layers and nested comps are still there, in the layer source folder if you want to use them individually, but After Effects has put them together for you, retaining all of the information about position, transparency, effects, etc.

In the Timeline, After Effects has placed all the layers from Photoshop in the same order that they appeared in the Photoshop Layers palette. The front most layers in the Composition panel is the topmost layer in the Timeline.

Fig. 3.11

Blending modes

Each layer has the same Blending modes available as are available in Photoshop, in fact there are a couple of additional modes provided in After Effects specifically for moving footage. The Blending mode settings imported with the Photoshop file remain live and can be adjusted in After Effects the same way as they were in Photoshop. These modes are sometimes referred to as Layer Modes or Transfer Modes.

Adjustment layers

1 Look at the **Switches** column in the Timeline. Notice the switches for layer 8, the **Hue/Saturation** layer 1. Notice that there is a circular icon (half white, half black) (Fig. 3.11).

This is the Adjustment Layer switch. Any layer in After Effects can be made into an adjustment layer by turning on this switch (with the exception of audio files of course!). Adjustment layers can be created inside After Effects but can also be imported directly from photoshop. You'll learn more about Adjustment Layers in

the Effects chapter (Chapter 07) but basically, they host effects which are applied to all layers of footage below them in the Timeline.

2 Select the **Hue/Saturation** 1 adjustment layer and then hit the e key on the keyboard. All effects in the layer will open up in the timeline with a Twirly next to them. This adjustment layer was set up in Photoshop (Fig. 3.12 – detail).

3 Open the Twirly next to the effect name to see how the **Hue/Saturation** effect controls have also remained live during their journey here from Photoshop.

Layer styles and layer effects

As well as importing Image controls, Layer Masks, and Adjustment Layers from Photoshop, After Effects will also import some Layer Styles and Layer Effects if they were applied to your layers in Photoshop. These include: Drop Shadow, Inner Shadow, Outer Glow, Inner Glow, Bevel & Emboss, and Color Fill.

Although this link between applications is undoubtedly useful, the way that they are translated into layers and effects within After Effects can lead to some confusion. The key to understanding how this works is to know the difference between Layer Effects and Layer Styles. In Photoshop Layer Styles allow you to apply live, editable Layer Effects to your layers. Each Layer Style can be made up from one, or several Layer Effects.

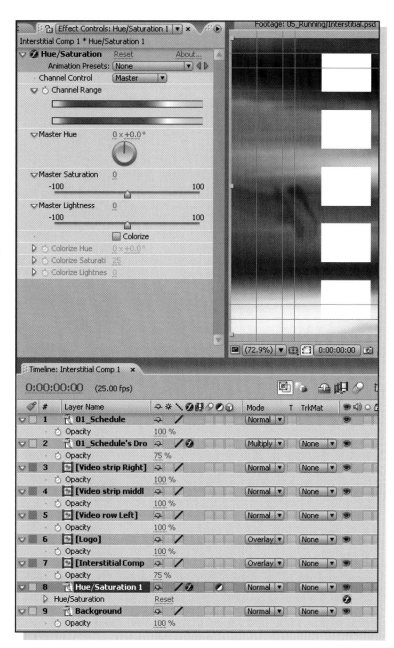

Fig. 3.12

Editable text

Text can be created directly within After Effects. It offers the same amount of typographic control as Photoshop or Illustrator. In the Text chapter (Chapter 08) we will look at all the weird and wonderful things you can do with After Effects text including animating individual characters along paths.

When you first import a **Text** layer from Photoshop or Illustrator the layer is rasterized as a bitmap image. You can edit this layer like any other layer by animating the properties and/or applying effects, but you cannot edit the text itself. However, if the layer is a true vector **Text** layer it can be even converted into editable text within After Effects, so that changes can be made to the content of the text and the character properties. These changes can even be animated over time.

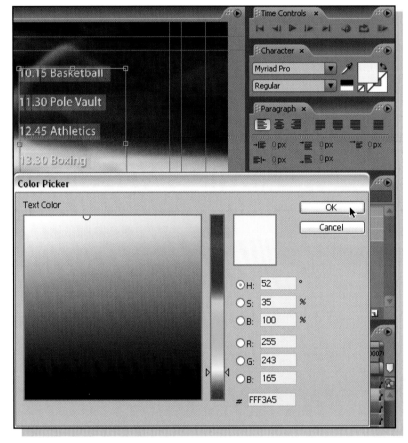

Fig. 3.13

1 Open **Interstitial_02.aep** from **Training > Projects > Chapter 03** and double-click the **interstitial** comp to open it if it's not already open.

2 Select the **01_Schedule** layer and then go to **Layer > Convert to Editable Text**.

3 Go to **Window > Workspace > Text**, this will open the **Character and Paragraph panels**.

Alternatively you can hit ⌘ 6 ctrl 6 or go to **Window > Character** to open up these panels.

4 Double-click the **01_Schedule** text layer. As you do this the text will become highlighted and a bounding box appears which represents the edges of the text paragraph box.

5 With the text selected, click on the **Fill Color** swatch, choose a pale yellow color and then click **OK** (Fig. 3.13).

Layer sets

Layer sets are used to group layers together in Photoshop and are imported into After Effects as nested compositions. In later chapters I will show you how to create your own nested compositions but for now we will look at how, when, and why Photoshop automatically nests compositions.

One golden rule when doing any sort of design work is to take regular breaks, even when you are working to a tight deadline. It is counter-productive to work for long hours without breaks, if you do, you'll become tired and your concentration and speed of thought will suffer. By taking a break you will refresh your senses. Go and take a break now, walk around, have a hot or cold drink and rest your eyes.

Importing Illustrator compositions

Illustrator files pretty much offer the same options as Photoshop files when imported as compositions. Like Photoshop files, you can import a multi-layered Illustrator file as a ready-made composition. The imported composition will retain all layers, adjustment layers, transparency information amongst other features.

You can choose to import your Illustrator files at the document size or at the Layer size, just as you can with Photoshop files. Text layers from Illustrator can also be converted to editable text in After Effects.

There are, however, a couple of differences to note.

Blending modes are only imported when they are applied to the whole layer in Illustrator. Blending modes that are applied to a single object within a layer are not supported. Having said that you can release the objects to layers in Illustrator in order to retain the blending modes in After Effects.

Guides are not imported when importing an Illustrator file.

If you are using an early version of Illustrator you may run into problems with the way gradients are translated in After Effects. If gradients look bad when imported the results can be improved by going to File > Interpret Footage dialog and clicking on the More Options button. This will open up the EPS options dialog where you can choose to make the antialiasing quality more accurate.

Effects applied in Illustrator cannot be adjusted within After Effects but you can choose Edit > Edit Original to open the file in Illustrator, adjust the effect there. When saved it will automatically update in After Effects.

Importing paths and masks

Paths can be brought into After Effects as Masks by copying and pasting the path information from Photoshop or Illustrator. Photoshop paths can be selected, copied, and then pasted into layers in After Effects as masks but to copy and paste path information from Illustrator, you will first need to check that your preferences in Illustrator will allow you to do so. This is done in Illustrator CS2 and CS by going to **Edit > Preferences > File Handling & Clipboard**, and making sure that the **AICB** checkbox and **Preserve Paths** radio button are both on.

 In the Animation and Effects chapters (Chapters 04 and 07) I will show you some tips and tricks using path information to control positional data and effect controls.

Converting merged footage to a layered comp

If you imported a Photoshop or Illustrator file as footage (instead of as a composition with layers), the layers appear merged together in After Effects. If you need access to the layers, you can convert the merged footage to a layered comp at any time without re-importing the file.

1 Go to **File > New > New Project** or hit ⌘ ⌥ **N** *ctrl alt* **N** to create a completely new project.

2 Go to **File > Import > File** or hit ⌘ **I** *ctrl* **I**

3 Go to **Training > Source Images > Angie images** and double-click the file named **Clock.ai** to import it into your new project. A dialog box will open allowing you to determine how the file should be imported.

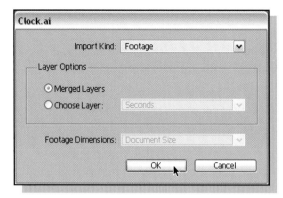

Fig. 3.14

4 In the **Import Kind** menu choose **Footage** and in the **Layer options** choose **Merged Layers** (Fig. 3.14).

5 In the **Project** panel, drag the **Clock.ai** layer onto the **New Composition** button at the bottom of the Project panel. Doing this will make a comp with exactly the same dimensions as the layer (Fig. 3.15).

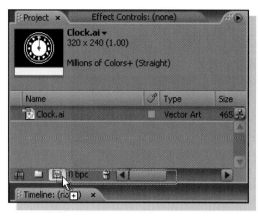

Fig. 3.15

6 Select the **Clock.ai** layer in the **Timeline** panel and then go to **Layer > Convert to Layered Comp**.

Notice that the layer icon in the Timeline has changed to a nested composition. In the Project panel a new Composition named **Clock 2** has also appeared as well as a folder that contains its layers (Fig. 3.16).

Fig. 3.16

7 Hold down the ⬚ *alt* key while you double-click the **Clock 2** comp layer in the Timeline to open up the nested comp. Notice that you now have access to all the original layers from your merged Illustrator file (Fig. 3.17).

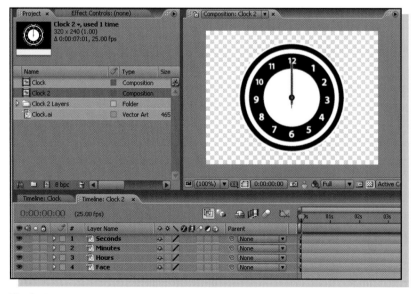

Fig. 3.17

Ok, now let's take a look at some other things you can do with your images during import.

Importing image sequences

A lot of software programs, particularly 3D programs, render out image sequences rather than QuickTime or AVI files. The rendered movie is saved into a folder as a series of still images that can be played back as a movie by any software that supports image sequences. Many of the

proprietary broadcast systems also work with image sequences so it's good to be aware of how to import them into your projects.

Image sequences can also be created from single image files, this can be a useful way of creating new footage cheaply and easily. In this example we'll import a series of images as a sequence and animate them for use as a fast-paced background with lots of interest and texture for some program titles that we'll work on in a later chapter.

The way in which image sequences are imported into After Effects is determined in the Import panel of the Preferences. In here, you can tell After Effects what frame rate Sequence Footage will be imported at.

1 Create a new project ⌘ ⌥ N ctrl alt N and then go to **Edit > Preferences > Import** to open the **Import Preferences** dialog box.

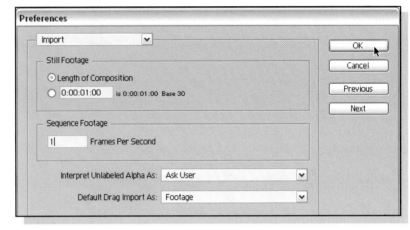

Fig. 3.18

2 Change the **Sequence Footage** setting to **1 frame per second** (Fig. 3.18).

Normally, you would import an image sequence at the same frame rate as your composition, but we want to have one image on screen for every second of our animation. With this setting, After Effects will use one image for every second of our comp.

3 Hit **OK** to leave the **Preferences** dialog box and then hit ⌘ I ctrl I to open the **Import File** dialog box.

4 Go to **Training > Source images > Angie Images** and open the **Graffiti Images** folder.

5 Select the first file in the folder and then make sure that the **JPEG Sequence** checkbox at the bottom of the **Import File** dialog box is checked (Fig. 3.19).

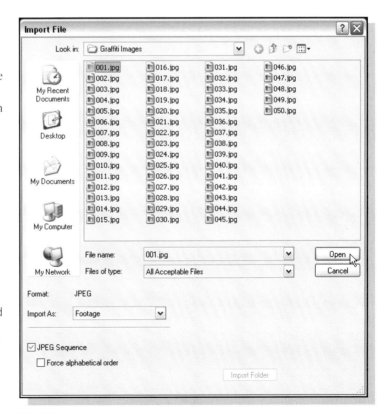

Fig. 3.19

This will tell After Effects to bring the footage in as an image sequence. After Effects will bring the files in using alphanumeric ordering, using the dimensions and bit depth of the first file you select.

6　Scroll down the list of JPEGs and you'll see that they have sequential numbers.

If the images in your folder are not numbered sequentially, you must force After Effects to import the files in the alphabetical order which they appear in the folder by clicking on the Force Alphabetical Order checkbox. Otherwise After Effects will leave blank frames between non-sequential files.

Fig. 3.20

Fig. 3.21

7　Click the **Open** button to import the sequence into your Project.

Although you've imported the entire sequence of images, the sequence appears as a single itemin the Project panel. After Effects treats it similarly to a movie file once in the Project panel (Fig. 3.20).

You can also import image sequences by dragging and dropping a folder of images directly into the Project panel. If you hold down the **alt** **⌥** key as you drag them, they will be imported as a folder containing individual files as opposed to importing it as a sequence file.

After Effects names the Image Sequence using the filenames of the first and last image within brackets [001-050].jpg.

8　Select the **[001-050].jpg** sequence in the **Project** panel and drag it onto the **New Comp** button at the bottom of the **Project** panel.

9　**RAM Preview** the Composition, notice that each image stays on screen for exactly 1 second (Fig. 3.21).

Importing audio files

Let's add some music to the animation. I always like to start with some good music to animate my images to.

10　Hit **⌘ I** **ctrl I** and import the file named, **Kid_sound.mov** from **Training > Source sounds > Groove Tunnel folder**.

This is a great piece of music for this purpose, it was composed and arranged by a very talented guy called Rod Spark of Groove Tunnel (http://www.groovetunnel.com).

Rod has a fully equipped studio where he produces very high-quality original music at very reasonable prices, thoroughly recommended! His details and more samples of his work are in the **CD > Free Stuff > Footage > Groove Tunnel** folder.

11 Make sure the **Timemarker** is at the **beginning** of the Timeline and then place the audio file into the Timeline (Fig. 3.22).

12 **RAM Preview** the result.

Notice that the images do not match up with the beats of the music. In the Animation and Expressions chapters (Chapters 04 and 11) I'll show you a couple of easy ways to make this happen.

Fig. 3.22

13 Go to **File > Save as** and, in the **Save as** dialog box, navigate to your **Work in Progress** folder on the desktop and save the project into the **Import** folder as **Graffiti01b.aep**. We will return to this project later to develop it further.

This technique for sequencing images is great for situations when you simply want a series of images to run with straight cuts in between. Obviously, you will not be able to place cross-fades in between the images as all the images are combined into one layer in your Comp, but it has the advantage of saving you from having to import lots of image files separately.

However, if you want more control over how your images are sequenced within the comp, you can choose to sequence them in the Timeline using the Sequence Layers Keyframe Assistant.

Sequencing layers

OK, so now we're going to start work on our news titles. If you haven't already read the Workflow.pdf from the DVD > Extras folder, go and read it now, it contains important information about the requirements of this project. Let's take a look at different ways of treating images

1 Go to **File > New > New Project** ⌘⌥N ctrl alt N. Then go to File > Import File ⌘I ctrl I.

Importing folders

To save you from having to select multiple items, After Effects allows you to import folders and all of their contents in one easy action.

2 In the **Import File** dialog box, go to **Training > Source images > Able Stock**. Click once on the folder named, **Seattle News Images** and then hit the **Import Folder** button at the bottom of the dialog to import the whole folder of images into your new project (Fig. 3.23).

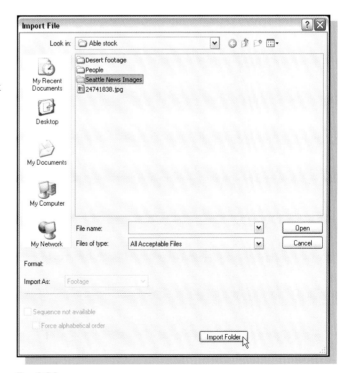

Fig. 3.23

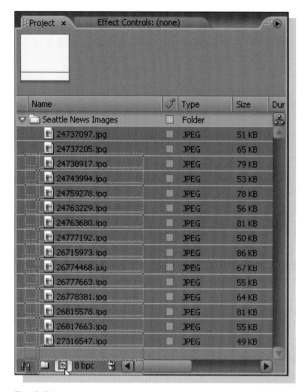

Fig. 3.24

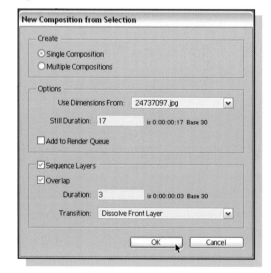

Fig. 3.25

3 In the **Project** panel, open the **Seattle News Images** folder so that you can see the contents of the folder. If you need to, make the Project panel bigger so that you can see all of the layers within it. Notice that After Effects brought in all the images as well as the folder which contained them.

4 Click on the top-most image and then hold down *Shift* and then click on the image at the bottom of the list, doing this will select all of the images in between.

Creating comps from selected layers

As we have already learnt, After Effects provides you with many options for making compositions. You can make a composition and then drag layers into it; you can create ready-made comps from Photoshop or Illustrator files. You can also automatically create comps by dragging layers onto the New Composition button in the Project panel.

5 With all the images selected, click and drag them onto the **New Composition** button at the bottom of the Project panel. The **New Composition from Selection** dialog box will now appear giving you several options as to how the images will be sequenced. There are several choices available to you here (Fig. 3.24).

6 In the **Create** section click on the **Single Composition** radio button to select it (Fig. 3.25).

In the **Create** section of the dialog box you can choose either; **Multiple Composition** to create a new composition for each layer selected or choose **Single Composition** to create one single comp containing all of the selected images. If you chose **Single Compositions** in the first section you will also be able to choose which layer to **Use Dimensions From** for the new composition. This will choose the first layer selected by default.

7 Leave the **Use Dimensions From** menu at the default first image. In the **Options** section you can also set the **Still Duration**.

8 Change the **Still Duration** to **17 Frames**.

Also in here is a checkbox which, when checked, will **Add to Render Queue** any new compositions created.

If you have chosen to make a single composition from the selected layers you will also have access to the final section where you can choose to place your layers into the new comp as a sequence (i.e. one after the other).

9 Click on the **Sequence Layers** checkbox. When you do this the **Overlap** checkbox will become active.

10 Click on the **Overlap** checkbox, this will give you access to the **Duration** and **Transition** menus. We'll use these to add a cross-fade, so that the images fade in and out.

11 Enter a value of **3** for the **Duration**, this will give us a cross-fade which lasts for 3 frames.

12 From the **Transition** drop down menu, choose **Dissolve Front Layer** and then click **OK** to leave the dialog.

To create a cross-fade in After Effects it is usual to only adjust the opacity of the top layer. If you adjust the opacity of both layers to 50%, you will get a combined opacity of 50% and will therefore be able to see the background color or transparency grid showing through, but this is not the effect that we want here.

You should now see all of your layers staggered in the Timeline. The comp's duration should be exactly correct for your sequence. Notice that the layers are staggered from the beginning to end of the Timeline in the order that you selected them in the Project panel (Fig. 3.26).

Fig. 3.26

You can also sequence layers that are already within a comp by selecting them and then going to **Animation > Keyframe Assistant > Sequence Layers**. The **Sequence Layers** Keyframe Assistant will give you exactly the same options as you have in the Overlap section of the **New Composition from Selection** box.

13 In the Timeline, drag the **Zoom In/Zoom Out** slider all the way to the left to maximize your workspace.

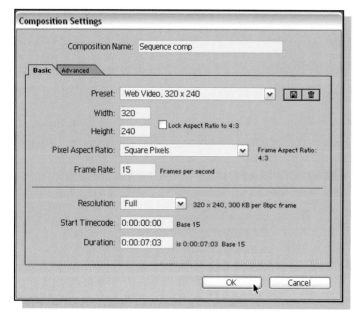

Fig. 3.27

When sequencing layers, the layers will be placed into the composition in the order in which they were selected in the Project panel, notice that the layer that we selected first has been placed first in the Timeline. The layers are numbered from 1 at the top of the Timeline to 16 at the bottom, they are also time-sequenced in the order that you selected them in the Project panel.

14 Close the **Seattle News Images** folder in the **Project** panel to keep things tidy.

15 Make the **Composition** panel active (by clicking on either the Timeline or the comp panel) and then hit ⌘ K ctrl K or go to **Composition > Composition Settings**. Change the Composition name to **Sequence Comp**, the frame rate to **15 fps** (Fig. 3.27).

16 Select all layers and then hit the **U** key to show all keyframes for selected layers. Notice that After Effects has staggered the layers and keyframed the opacity of the top layers in order to create the cross-fades, saving you a lot of work (Fig. 3.28).

Fig. 3.28

17 **RAM Preview** the resulting image sequence by hitting the **0** key on your number pad.

18 Move the **Timemarker** to the beginning of the Composition by hitting the **Home** key on your keyboard.

Note that the sequence will go in whichever order you select the footage. If you had selected the layers in a random order, they would have been staggered in that order. You can experiment with this at the end of this section.

19 Go to **File > Save as** and, in the **Save As** dialog box, navigate to your **Work In Progress** folder on the desktop and save the project into the **Import** folder as SeattleNews01b.aep.

Importing from editing applications

Although After Effects has some basic editing tools and can be used to edit short sequences, it is not really designed as a fully fledged editing program. I recommend that you use dedicated non-linear editing (NLE) software such as Adobe Premiere Pro or Apple's Final Cut Pro for capturing footage, putting your sequences together, and printing them back out to tape. Both products support both DV and analogue capture, and playback with device control and the editing tools provided in these programs will make these jobs a breeze.

I choose to use Final Cut Pro for most of my editing tasks in my own studio and also use Avid or Premiere Pro if in a Panels environment. As a freelancer I have to be flexible and be able to work on either platform.

When working between your NLE and After Effects you need to ensure that you lose as little as possible in terms of picture information and quality. Although it is possible to render sections from your edit as new movies to be enhanced within After Effects, it is far preferable to work with the original footage, avoiding re-rendering footage wherever possible. This can be done by importing your edit directly from the NLE into the After Effects Timeline.

Mac Only – importing from Final Cut Pro

Edits from Final Cut Pro can also be imported directly into After Effects as ready-made compositions. This can be done using a third-party product called Pro Import AE from Automatic Duck. This is an excellent product which aids integration by making timeline translations between the worlds most powerful NLE and compositing systems.

With **Pro Import AE** for **After Effects**, you can translate a sequence from an Avid or Final Cut Pro NLE, or a project from Apple's Motion. It will import all of your media and clips in one step. Effects, modes, and transformations are translated and recreated for you and your timeline becomes a composition in After Effects, ready for you to tweak and perfect.

You can find out more about this product and view some excellent online movies, demonstrating how the products work at; http://www.automaticduck.com/

Automatic Duck is one of those products that I just couldn't live without.

For those of you on the Mac, you will not be able to import the Premiere Pro project as detailed in the following steps 1b–5, so I have pre-saved a project that already has the original Premiere Pro project within it so that you can follow all the steps.

1a Go to **File > Open** and open **SeattleNews_Mac.aep** from **Training > Projects > 04_Import**.

PC only – importing Adobe Premiere Pro compositions

Out of the two editing applications I use most often, Premiere Pro has the edge in terms of integration with After Effects. You can import a Premiere Pro project directly into an After Effects project without third-party software, retaining all of the edit decisions you made as well as bringing

in markers and transition references. You can also copy and paste sections from Premiere Pro sequences directly into After Effects.

1b Open **SeattleNews.aep** from **Training > Projects > 04_Import**. This is a fresh copy of the project you saved in the **Sequencing Layers** section.

2 Hit ⌘ I ctrl I to go to the **Import File** dialog box. Select the file named **Edit07.prproj** from the **Training > Projects > 04_Import** and then click the **Open** button to import the Premiere Pro file as a ready-made After Effects Comp.

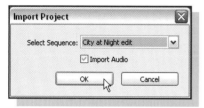

3 The **Import Project** dialog box will now appear. Look in the **Select Sequence** menu, this enables you to choose to open **All sequences** or a single sequence from the Premiere Pro project.

4 Click on this menu and choose to import the **City at Night Edit** sequence (Fig. 3.29).

5 Make sure that the Import **Audio checkbox** is checkmarked and then click **OK** to import the sequence into your project.

Fig. 3.29

- In the Project panel you should see several new items (Fig. 3.30).
- A folder named **Edit07.prproj**, within it are:
- A folder named **Bin 1** which is a **Placeholder** file named **Image Sequence** and an audio file, **Newssound.mov**.
- A composition named **City at Night Edit**.
- A folder named **Time-lapse Cityscapes** which contains six movie files represented by QuickTime icons.

Fixing broken links

If you followed the instructions for copying files onto your hard disk outlined in the **Before You Start** section of the **Introduction** you should not run into any problem but if you do, here's how to spot and fix broken links.

As I mentioned in the first chapter, when you import a file into After Effects it creates a **link** in the Project panel to the footage on your hard disk. If you are not careful you can break the link to the original file by moving, deleting, or renaming the original source file. If this

Fig. 3.30

happens the name of the file appears in italics in the Project panel and the icon is a placeholder represented by color bars. This can also happen if the selected file format is not supported on the system you are using.

You can easily re-link missing footage by double-clicking the icon in the project panel and then re-selecting the file from the hard disk. This should also re-link any other missing files within the same relative path. Alternatively you can use the following technique which also works if you want to replace any original file with a different one. You will only need to follow these steps if your

footage files have not come in as expected, if they are all as seen in the diagram then you can go directly to step number 8. However, there is no need to replace the image sequence placeholder as we will be replacing it in a later step, but just in case any other files need re-linking while working through the tutorials, here's how to re-link them.

6 Select the file in the **Project** panel, and got to **File** > **Replace Footage** > **File** ⌘ⓗ ctrlⓗ.

7 In the **Replace Footage File** dialog box, select the file that you want to replace the original with and then click **OK**.

Sometimes you can run into these kinds of problems when opening After Effects projects from different operating systems. To avoid these pitfalls make sure that you maintain the same filenames, folder names, and ensure that all of your source footage is on the same volume as your project file, using the same relative path.

Replacing Footage in the Timeline

If you use the Replace Footage File command it will replace the file in the Project panel. If the file has been used more than once in your project then it will be replaced in each place it has been used. There may be times when you only want to replace a single layer without affecting the file in the Project panel. This can be done by replacing a layer in the Timeline using a modifier key.

8 In the **Project** panel, open the **Edit07.prproj folder** and then select only the **City at Night edit** composition icon, double-click it to open up its own Timeline and Composition panel (Fig. 3.31).

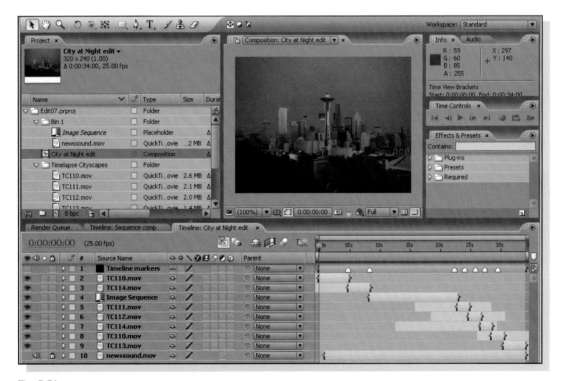

Fig. 3.31

Notice that the movies have been imported in the order in which they were edited together in Premiere Pro. All In- and Out-points are trimmed as they were in Premiere Pro, all markers, and labels are also imported. Premiere Pro now includes several After Effects filters. If you apply and set keyframes for these effects in Premiere Pro then they will be brought over live into After Effects too, where you can adjust them and use Keyframe Assistants on them just as you can with any other keyframes.

9 Select all of the layers in the Timeline **⌘ A** *ctrl A* and then double-hit the **U** key to see anything that has adjusted the layer's original state, for example any effects or transformations applied to the layer. This keyboard shortcut is extremely useful for figuring out what has been done to the edit.

This edit consists only of straight cuts but if I had used transitions in my edit, they would have also been represented here in After Effects by red transition marker layers. This serves as a very useful reminder of where the transitions occur, preventing me from adding too much interest to these sections. Notice also that there is an Placeholder file named **Image Sequence** marking where we want our image sequence to appear. The layer consists of standard color bars and was created within Premiere Pro. We'll use a keyboard shortcut to replace this placeholder with our pre-prepared footage.

Fig. 3.32

10 In the **Timeline**, close the layers again by hitting the **U** key once and then de-select the other layers and select only the **Image Sequence** placeholder on layer number **4**.

11 Go up to the **Project** panel, close the **Edit07.prproj** folder and then select the **Sequence Comp** that we worked on in the previous section.

12 Hold down the **⌥** *alt* key and then drag the Composition onto the **Image Sequence** layer that you wish to replace in the Timeline (Fig. 3.32).

13 **RAM Preview** your movie so far.

You can use this method to replace one layer with another layer from within the same project while retaining any of the original layer's keyframes, effects, and other modifications. In this instance we've replaced the layer with a comp.

When you drop one Composition into another the process is called Nesting. We will be looking at different methods of Nesting Compositions throughout the book, this is just one method.

Slide edit

Perhaps you'll have noticed that the views of Seattle at the start and end of the Composition are the wrong way round, the sunrise view should be at the beginning of the Composition, the night view should be at the end. I'll show you how we can change this using some of the editing tools I mentioned earlier.

14 Select the **TC110.mov** on layer number **8** and then move the Timemarker over the clip, so that you can see its contents displayed in the Composition panel.

This section of footage is cut from a time-lapse clip of Seattle, shot from morning, all the way through to night. This clip is taken from the **Artbeats Time-lapse Cityscapes** collection. There are more clips from Artbeats Inc. on the DVD in **Training > Source Movies** folder.

Time-lapse photography is very expensive and difficult to set, up but you can buy these clips at a very reasonable price from Artbeats. You can then use the clips as often as you like in your own work, it's a great way to source footage which would otherwise be difficult to shoot yourself.

Notice that in this section the sky is light, it is early in the morning. We want this clip to be dark so we need to choose a later section from the same piece of footage. You can see the ghosted sections of available footage to the left and right of the visible, trimmed section of the layer. This tells us that this clip has been trimmed and that there is surplus footage for us to play with. We need to slide the footage that's available along behind the existing edit points without moving the layer in time.

15 Place the cursor to the right of the layer's **Out**-point, the cursor will change to the **Slide** tool icon, which allows you to slide the surplus footage behind the edit points. Click and drag all the way to the left till you see a blue, evening sky on where it was once a pink, morning one (Fig. 3.33).

Fig. 3.33

At the beginning of our Composition we want the sky to be morning-pink. This time we'll use another method to adjust the TC110.mov clip on layer 2.

16 Move the **Timemarker** over the **TC110.mov** clip on **layer 2** and then double-click the layer name to open up in its **Layer** panel.

17 Click and drag the **Layer** panel onto the **Project** panel till the center of the Project panel is highlighted then release the mouse to dock the Layer panel in the same frame as the Project panel. We are doing this so that you can see both this and the **Composition** panel update simultaneously (Fig. 3.34).

Fig. 3.34

Fig. 3.35

The whole duration of the original footage is displayed in the Layer panel, notice the time ruler running along the bottom of the Layer panel. The trimmed section of the clip used in the timeline has a much shorter duration than the clip and is represented by the aqua-colored bar at the right side of the time ruler.

18 Move the Timemarker to the beginning of the Timeline in the Layer panel by clicking on it to make it active and then hitting the **Home** key.

19 Click on the **raised handle** in the middle of the colored bar. With this handle, you can drag the edit along the surplus footage. This will change the clips' **In-** and **Out**-points while maintaining the edited clip's duration and its position in the Timeline. Using the raised handle, drag the colored bar all the way to the left and watch the layer update in the Timeline. This has the same effect as using the Slide tool on the clip in the Timeline, it's just another method of doing the same job (Fig. 3.35).

20 In the Timeline notice that we now have a pink, daytime sky rather than the dark night sky.

21 Close the **Layer** panel when you are finished with it.

We will use the Sequence Layers Keyframe Assistant to add cross-fades in between all of the movie layers. This time we want to retain the order in which the layers appear in the edit. To do this, we have to select the layers in the same order that we want them to appear in the Timeline.

22 Click on the first **TC110.mov** layer (Layer number **2**). Now hold down the **Shift** key and click **TC113.mov** layer (number **9**) selecting all the layers in between.

23 With all of the layers now selected, go to **Animation > Keyframe Assistant > Sequence Layers**.

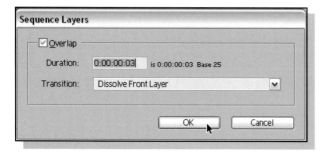

Fig. 3.36

24 Leave the settings on a **Duration** of **3** frames and choose to **Dissolve Front Layer** in the **Transition** options. Click **OK** to leave the dialog box. You may need to trim the last layer to extend it to fit the duration of the comp. Do this by clicking and dragging the layers Trim handle till it reaches the end of the Timeline (Fig. 3.36).

25 Close the layers and then **RAM Preview** your edit. The edits should now happen in time with the music. However, the edit has shortened as a result of the cross-dissolve, notice that the cross-dissolve uses frames from within your trimmed clip, rather than from the handles.

26 Go to **File** > **Save as** and, in the **Save as** dialog box, navigate to your **Work In Progress** folder on the desktop and save the project into the **Import** folder as **SeattleNews02.aep**.

Adobe Bridge

Adobe Bridge is a new cross-platform application that is installed as part of the Adobe Production Studio. It is also included as part of CS2 or separately with individual Adobe products such as: After Effects 7, Premiere Pro 2.0, Audition 2.0, Encore DVD 2.0, Photoshop CS2, Illustrator CS2, InDesign CS2, and GoLive CS2.

Bridge is a tool for organizing your assets, it allows you to browse files including movies, audio files, images, and PDFs. Files can be dragged from Adobe Bridge into your projects and compositions. It also provides a great interface for previewing files, batch processing, renaming, and even adding metadata file information, making it easier to catalog and search the files based upon user definable data. You can even create new folders; sort, manage, rename, move, and delete files in Adobe Bridge, making it a fantastic cross-platform alternative to the Panels Explorer or Macintosh finder. Adobe Bridge provides you with a consistent, user-friendly, and creative environment for file management.

1 Open Adobe Bridge by going to **File** > **Browse** ⌘ _Shift_ ⌥ _O_ _ctrl_ _Shift_ _alt_ _O_.

The bridge interface

The first panel you will see in the top-left corner of the Bridge workspace is the Favorites panel. This provides you with quick links to frequently used files and locations on your hard disk. For example the desktop, any hard drives mounted on your system, and your documents folder.

The Favorites panel can also contain links to web locations such as the Adobe Stock Photos. If you have an Internet connection you can click on Adobe Stock Photos in the Favorites panel to search a selection of leading stock libraries for royalty-free images and movies. You can even download low-resolution, complimentary versions of the images and try them out in your projects before deciding whether or not to buy them.

If you have Adobe Creative Suite 2 installed, you will also have a link to Version Cue in the Favorites panel.

Behind the Favorites tab is the Folders tab which shows a more traditional display based on the system folder hierarchy.

2 Click on the **Folders** tab to display the contents. You can use this to navigate through any mounted hard drives, removable media, or attached cameras and camcorders.

3 Use the folder display to navigate to your **Training folder** > **Images** > **Angie Images** > **Graffiti**. Select the **Graffiti images** folder to see thumbnails of the images contained within this folder.

4 Context-click on this folder and choose **Add to Favorites** from the context-sensitive menu. This will add the folder to your **Favorites** list, giving you easy access to it in the **Favorites** panel (Fig. 3.37).

5 Adjust the **Thumbnail Size** slider at the bottom of the Bridge workspace to scale the thumbnail images up or down.

6 Click the images one by one to see a Preview of the Images displayed in the Preview panel to the left of the workspace (Fig. 3.38).

7 Adjust the size of the **Preview** panel by placing the cursor over the dividing edge till you see a double-headed arrow. Click and drag the divider to the size you want.

Fig. 3.37

Fig. 3.38

8 Underneath the **Preview** panel is the **Metadata** panel which contains metadata information for the selected file such as date created, resolution, bit depth, etc. You can also add custom data to your images using Adobe Bridge. For instructions on how to do this choose **Help > Bridge Help**.

The Keywords panel helps you organize your images by allowing you to give them keywords to aid your memory.

9 Open the **Keywords** panel by clicking on the **Keywords** tab to bring it to the front.

10 Open the **Places** section and then context-click on the **Brighton** keyword and choose **Find** from the main Adobe Bridge menu. This will open up the **Find** dialog. Click **OK** without adjusting any settings to open all images with the associated keyword within the selected folder (Fig. 3.39).

11 Try clicking on the four **View** buttons at the bottom-right of the Bridge workspace to choose between **Thumbnails** view, **Filmstrip** view, **Details** view, and **Versions** and **Alternatives** view (Fig. 3.40).

Fig. 3.40

12 You can save workspaces just like you can in After Effects. Bridge comes with some preset Workspaces, you can add to these by going to **Workspace > Save Workspace**.

A whole book could be dedicated to Adobe Bridge, it is really fully featured and is capable of many more things than just file management. For example, did you know that you can import camera raw files from Bridge, edit them, and save them in a Photoshop-compatible format, without starting Photoshop. You can also use Bridge to browse for project templates or animation presets, we will look at some other options as we progress throughout the tutorials in the book.

Technical considerations

The following section is here to draw your attention to some important issues which you need to be aware of when designing for television and video, particularly in After Effects. I wasn't quite sure where to put this, but I reckoned that the Import chapter (Chapter 03) was the best place as these considerations are important when importing footage into After Effects.

Some subjects will be covered comprehensively, others are explained clearly in more detail elsewhere (e.g. on the Adobe technical database which can be accessed via the Adobe web site). When this is the case, I will direct you to the appropriate information.

Video formats

When designing for television, the first thing that you need to think about is what medium and format you will be outputting to. Usually, the medium you will be outputting the footage to is video

Fig. 3.39

tape, unfortunately there is not one, universal video format. In Europe, the video format used is PAL (Phase Alternating Line). In the USA, Canada, Mexico, and Japan, the video format used is NTSC (National Television Standards Committee). There is another format called SECAM (Sequence a memoir or Sequential Color And Memory), which is used in France but is generally being phased out of use in favor of PAL.

Each of these formats has different rules regarding frame rates, aspect ratios, color gamuts, and field orders, in the following paragraphs I will explain these differences to you and instruct you on the best ways to ensure that you are using the correct settings for your chosen format. We'll start by looking at frame rates.

Frame rates

The frame rate is the number of frames (or pictures) which are transmitted for every second of footage. When working in After Effects, the frame rate of your composition should be based upon whatever your final output will be. If you are outputting your final movie for the PAL video format you must use a frame rate of 25 fps; NTSC has a frame rate of 29.97 fps; the frame rate of film is 24 fps. Movies which are to be distributed on a digital medium such as CD-ROM or the web do not have a fixed frame rate but are usually played at between 8 and 15 fps.

You define the frame rate and duration of each composition in the Composition Settings dialog box, the frame rate is determined on a comp by comp basis which means that comps within the same project can have different frame rates. When working with time-based mediums (e.g. video, animation), you need a method for measuring and displaying the time, this is where the Time display styles come in.

Time display styles

The way that time is measured and displayed is determined in the Project settings, and you change the way that time is displayed on a project-by-project basis. There are three main time display styles: Timecode, Frames, or Feet and Frames.

Frames

With this method, the footage is measured by the number of frames it is made up from, no reference to time is used (e.g. hours, minutes, seconds). To work out the length of a comp in time units, you simply divide the number of frames by your chosen frame rate.

1 Open up the **Numbers.aep** from **Training > Projects > 05_Import** and **RAM preview** the **Numbers** comp. The numbers change on each second of the comp.

2 Go to **File > Project Settings** to see where the **Display Style** settings are defined. Notice that I have chosen to **Start Numbering Frames** at: **1**, which I find much easier to get my head around than the default of starting at frame **0**. Click **OK** to leave (Fig. 3.41).

3 Hit **⌘ K** **ctrl K** to open up the **Composition Settings** dialog box. Notice that this composition's **Duration** is **300 frames** and its **frame rate** is **30 fps**. By dividing the duration by the frame rate (300 divided by 30), we can work out that the composition is ten seconds long. Click **OK** to leave.

4 Drag the Time Marker through the comp and notice that the **frame** numbers (in the **Time Display** on the top-left of the Timeline) count up all the way from **1** to **300** and that the animation fills the length of the comp. When working in Frames, adjusting the Frame rate will affect the timing of your composition, which I will now demonstrate for you.

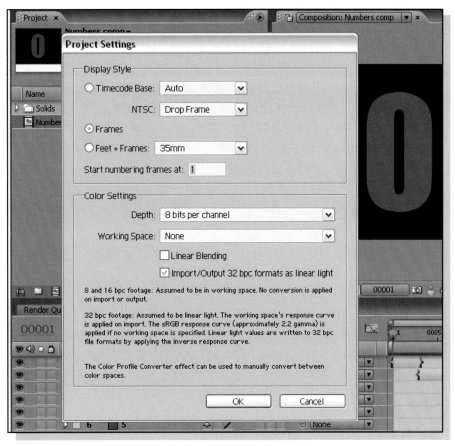

Fig. 3.41

5 Hit ⌘ K ctrl K again to reopen the **Composition Settings** dialog and change the frame rate to **15 fps**, which is half of the current frame rate.

6 At the bottom of the Timeline, drag the **Zoom In/Zoom Out** slider all the way to the left so that you can see the Whole length of your Timeline. Notice that the layers now only occupy half of the Timeline, in fact **150 frames** of it (**ten** seconds @ **15 fps**) (Fig. 3.42).

Fig. 3.42

7 **RAM preview** your animation and notice that the timing of the sequence is the same, the image changes on every second of playback, the only difference is that After Effects is using half as many frames per second for the animation, leaving another **150** frames unused at the end of the comp.

Many animators I know prefer to work in frames, particularly designers who work across different output mediums and formats but it's very important to be aware of the retiming issues.

In Europe this method of displaying time is pretty easy to work with as it is a piece of cake to divide by multiples of 25, in NTSC-land this may not be so easy to divide by 29.97. In the following section I'll explain how this irregular frame rate can be displayed as 30 frames per second.

8 Go to **Edit > Undo** ⌘Z *ctrl*Z to undo the steps till you are back to the original settings of **30 fps** before moving onto the next section.

Timecode

The following section covers topics relating to Timecodes. The whole section should be covered from beginning to end in order to get the full picture, even if you are from a PAL format country, you should still work through the NTSC section and vice versa.

Another method of measuring and displaying time in After Effects is to use Timecode. After Effects uses SMPTE timecodes which were originally developed as reference systems, encoded onto video tape, to enable accurate synching of video footage. They were devised by the Society of Motion Picture and Television Engineers, hence the name, SMPTE.

Think of timecodes as just units of measurement for time. Just as you would measure a room in meters and centimeters, you would measure the timing of your animations in hours, minutes, seconds, and frames.

Project Settings

Display Style
- ◉ Timecode Base: 30 fps
- NTSC: Drop Frame
- ○ Frames
- ○ Feet + Frames: 35mm

Start numbering frames at: 1

Color Settings
- Depth: 8 bits per channel
- Working Space: None
- ☐ Linear Blending
- ☑ Import/Output 32 bpc formats as linear light

8 and 16 bpc footage: Assumed to be in working space. No conversion is applied on import or output.

32 bpc footage: Assumed to be linear light. The working space's response curve is applied on import. The sRGB response curve (approximately 2.2 gamma) is applied if no working space is specified. Linear light values are written to 32 bpc file formats by applying the inverse response curve.

The Color Profile Converter effect can be used to manually convert between color spaces.

[OK] [Cancel]

Fig. 3.43

NTSC

1 Open up the **numbers.aep** from **Training > Projects > 05_Import** if it is not already open and then go to **File > Project Settings**.

2 Click on the **Timecode Base** radio button to start displaying time in Timecode and make sure that the drop down menu is set to **30 fps**. As I said earlier, **NTSC** actually runs at **29.97 fps**. After Effects supports this irregular playback speed, but allows you to measure time at 30 fps, making it simpler to calculate. Remember that the Timecode Base does not affect your actual frame rate, only the way the time is displayed (Fig. 3.43).

You'll notice that there is a drop down menu underneath the main Timecode Base menu which has two choices available in it, Drop Frame and Non-Drop Frame, what are these for? Well, these are for determining how After Effects counts the 30 frames per second. OK, so you know that the real frame rate of NTSC is 29.97 fps? This is the frame rate that you need to use when outputting for the NTSC format. If you are measuring and displaying your time at 30 fps, this will be very slightly faster than 29.97. Therefore, if you run

your movie at 29.97 fps but count the frames at 30 fps, eventually, the frame rate and the time display will drift apart. The longer the sequence, the more the two values drift apart. This very slight time drift will be acceptable on most short sequences, and shouldn't cause any problems. So on any sequence shorter than say half an hour you should be fine using Non-Drop Frame Timecode.

Remember that the time may slip on longer sequences and that you may need to be aware of this problem when working on projects which need to be very precise time wise. For these situations you are better to use the following solution. To compensate for this problem SMPTE developed what's known as Drop Frame Timecode. When you use this, a frame is dropped every so often to compensate for the time difference between frame rate and display time. This ensures that the measurement of time doesn't drift behind the real time of the footage, without this compensation you may find that your layers will move progressively out of sync the longer the sequence is.

3 Change the **NTSC** menu to **Non-Drop Frame Timecode** and then click **OK** to leave the **Project Settings** dialog box. Notice that the Timeline's time ruler is now marked with seconds instead of frame numbers (Fig. 3.44).

4 Press the **Home** key on your keyboard to move the Timemarker to the beginning of the Timeline and look at the **Time Display** at the top-left of the Timeline panel. It should look like this **0:00:00:00**.

The colons between the numbers separate them; they represent **Hours: Minutes: Seconds: Frames**. This is how Timecode measures time.

5 Drag the Timemarker along the Timeline and notice that the right-most two numbers in the Timecode display count in multiples of 30 (Fig. 3.45).

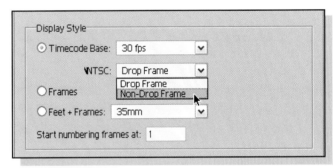

Fig. 3.44

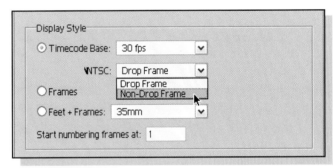

Fig. 3.45

The first section on the right of the display represents frames and each time this number reaches 30, the value jumps back down to 0; and the number in the next section to the left of this (which represents seconds) will increase by one second.

As I said earlier, Timecode works independently from the Frame Rate of your Composition. You can change the frame rate of your Composition at any time without affecting the Timecode Base.

6 Hit ⌘K ctrl K to open the **Composition Settings** dialog box and change the frame rate to 15 fps. Notice that the **Duration** value is now displayed as a Timecode, displaying **hours, minutes, seconds**, and **frames**.

7 Click **OK** to leave the dialog box and notice that nothing appears to have changed in the Timeline, this is because the duration is the same, only the amount of frames contained within that duration have changed. (For a more detailed explanation of this, see the **Frame Rate** page in the online help system.)

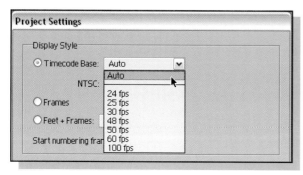

Fig. 3.46

8 **RAM preview** the comp and notice that the timing remains the same, with each new number appearing on each second of the comp. You'll notice, however, that the Timecode base remains at 30 fps Drop Frame Timecode because we selected it in the Project Settings.

9 Go to **File > Project Settings** and change the **Timecode Base** to **Auto** and then click **OK** (Fig. 3.46).

10 Drag the Timemarker along the timeline and notice that the seconds are still marked but notice that the frames count up in groups of 15 (Fig. 3.47).

PAL

Phew! OK, so you've seen how difficult it is to figure out NTSC. For those of you in PAL–land, you'll be relieved to know that things are a lot simpler where you are. PAL is always transmitted at 25 frames per second, with no need for any drop frame conversions whatsoever. Let's see how simple it really is.

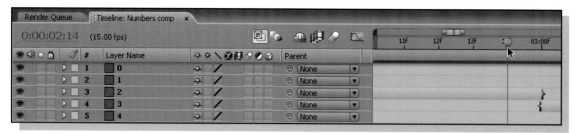

Fig. 3.47

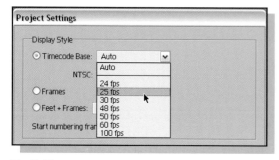

Fig. 3.48

1 Open up the **numbers.aep** from **Training > Projects > 05_Import**. Click **OK** if you see a warning message about the version used to create this project and then hit ⌘ Shift ⌥ K ctrl Shift alt K or go to **File > Project Settings**.

2 Change the **Timecode** menu to **25 fps** and notice that the **Drop Frame** option is grayed out and cannot be selected. Click **OK** to leave the dialog box (Fig. 3.48).

3 Drag the Timemarker along the Timeline, you'll see that the Timecode now counts upward in groups of 25 frames.

How simple life can be when using PAL! In fact it's so simple that there's a growing trend for people in the USA to use the PAL format. Partly due to its ease of use but also because the PAL frame rate (25 fps) is so close to the frame rate of film (24 fps). Not only does this mean that PAL has a more film-like quality but by working in PAL you can avoid 3:2 pulldown, which is another little NTSC problem which we'll discuss shortly.

Both the PAL and NTSC Timecodes are industry standard for TV production. Most designers who come from an editing background (or anyone else coming from a video background) will tend to use Timecode as it is the time measurement system that they have grown up with.

Feet and frames

There is another Display Style choice available in the Project Settings panel. If you are working with film, you can choose to display your time in Feet and Frames. This option allows you to choose between either 35 mm film (16 frames per foot) or 16 mm film (40 frames per foot) from the drop down menu. I do not recommend using this option unless you have experience with film and are familiar with other related issues. See the online help system for more information about working with film.

 ⌘-click ctrl-click the time display at the bottom of the Composition panel or at the top of the Timeline panel to cycle between the different Display Styles.

More about frame rates

Whenever possible you should avoid altering the frame rate of your original footage. If it is absolutely necessary, then try to keep the frame rate as a multiple of the original (e.g. change from 30 to 15 that is half the frame rate), this will ensure that the motion remains even and that frames do not have to be duplicated.

If you do have to alter the frame rate of your footage, there are a couple of options for you to try.

You can use the conform feature in the Interpret footage dialog box to redistribute the existing frames into a new frame rate. Doing this will not alter the existing frames but will affect the overall timing of the footage.

For example, conforming the frame rate from 15 to 30 fps will double the speed of your clip and make it half the duration in the Timeline. To change the frame rate of video and film footage see the online help system for details of how to do this.

You can also change the frame rate simply by dropping the movie into a new comp with a different frame rate. If you were to drop a 15 fps movie into a 30 fps comp, After Effects would repeat every frame to fill in the spaces, this will not affect the timing of your comp but After Effects will have to make up the intermediate missing frames. You can use Frame Blending on the footage to create unique intermediate frames to produce a smoother motion. See **Enhancing time-altered motion by blending frames** in the **After Effects Help** for further information on how to do this.

There is no right or wrong choice between displaying time as Timecode or as frames, just use whichever method you prefer and feel most comfortable with. If you are using Timecode, just make sure that you are using the correct Timecode for the video format you will be working with.

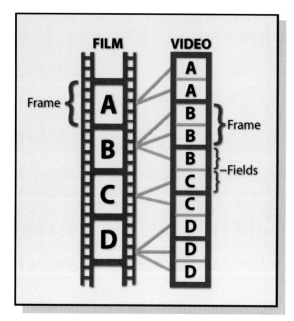

Fig. 3.49

3:2 Pulldown (Fig. 3.49)

When transferring footage from a film source to the NTSC format, there is quite a large difference in frame rates between the two formats. If you sped up the 24 fps film footage to fit NTSC's 29.97 frame rate, the speed change would be unacceptable. To compensate for this difference a process called 3:2 pulldown was developed to distribute the repeated frames as evenly as possible between the two formats. Every second film frame is made to consist of an extra video field. In other words, four film frames are converted into five TV frames by double-scanning a field on every second film frame. After Effects supports this process, allowing you to remove the pulldown on import and/or introduce it at the rendering stage.

The complete processes are outlined clearly in the online help system (see **About 3:2 and 24Pa pulldown**). The problem is not so great when transferring footage from film to the PAL video format. Because the difference in frame rates is so small (24 and 25 fps) the footage can usually be transferred without the need for pulldown, the footage is often just sped up to make up for the 1-frame difference. There is a PAL pulldown system that is used when the conversion between 24 and 25 fps causes problems. This pulldown system is not something that is supported by After Effects but in all my time I have never come across this problem.

Resolution issues

After Effects is Resolution independent, this means that you can create Compositions of any frame size up to a current possible limit of 30,000 × 30,000 pixels – RAM permitting. For example, you can use After Effects to design the opening title sequence for a movie and output it three times from the same After Effects project; once for the actual film title sequence, once for the accompanying television adverts for the movie, and another for streaming broadcast via the Internet.

This makes After Effects a very flexible system to use. Unlike most proprietary television systems, which are designed to use a fixed resolution of input and output, After Effects allows you to mix footage from various different sources into one Composition and output it to the format of your choice, or even multiple formats.

The one drawback about having such a flexible system at your disposal is that you have a lot of choices as far as input and output settings are concerned. This can create a lot of confusion and debate amongst users, but it is really quite simple to decide on the correct settings for you once you understand the way the system works.

If you're a freelancer it is always a good idea to check the specifications of the equipment before you start working. Unfortunately, there are very few reliable standards in broadcast. Each and every setup will be different and have different rules associated with it. As a freelancer myself, I have had to work on various different systems with various different input and output setups, because of this I have had to learn about some of the different options which I will now attempt to explain to you.

There are two main things to consider when determining the resolution of an image for viewing on a screen; the frame aspect ratio and the pixel aspect ratio.

Frame aspect ratio

The frame aspect ratio determines the shape of the screen which you will view the images on. Most televisions have either a 4:3 frame aspect ratio (4 units width, 3 units height). Or, in the case of widescreen televisions a 16:9 frame aspect ratio (16 units width, 9 units height).

Computer equipment can be setup to use different screen resolutions depending on the graphics display capabilities of each particular system. They tend to be 4:3 but there are also several 16:9 flat screen displays on the market.

After Effects is also capable of outputting film resolutions, for example the Cineon aspect ratio of 457:333. In fact After Effects can cope with any custom screen sizes up to 30,000 pixels square.

Pixel aspect ratio (Fig. 3.50)

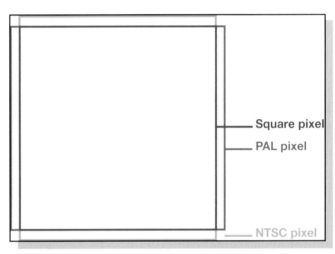

Pixels are what the images on screen are made up of. If you were to take a magnifying glass to the computer screen you would see that your images are made up of thousands of tiny little squares or cells which form a grid. The term Pixel is an abbreviation of Picture Cell. The pixel aspect ratio determines the dimensions of each individual pixel used to make up the complete picture on screen.

Computers display pictures using square pixels. Any original footage created in a 3D application, Illustration application, or an image manipulation application will usually consist of square pixels. D1 is a video format but the name D1 is commonly used

Square pixel

PAL pixel

NTSC pixel

Fig. 3.50

to describe the shape of pixel most commonly used to make up an image on a video monitor or television. These pixels are rectangular in shape. Just to complicate matters even more, the shape of the rectangle differs depending on whether you are using a PAL or NTSC system! (See also: **About pixel aspect ratio** in the After Effects Help system.)

PAL

PAL square pixels measure 1 unit by 1 unit and it takes 768 of these square pixels to make up the width and 576 to make up the height of a 4:3 PAL screen.

D1 or DV PAL pixels are the same 1.0 in height but are approximately 9% wider than the square pixels, they are rectangular in shape. Because they are wider, fewer of them are needed to fill the same frame width, only 720 are needed. The same 576 pixels are required to fill the height. In the case of PAL D1 pixels, the height remains the same while the width changes.

NTSC

NTSC uses fewer lines than PAL to display a picture so it uses less square pixels to fill the same 4:3 screen, it uses 720 to make up the width and 540 to make up the height of a 4:3 NTSC screen.

D1 or DV NTSC pixels are also rectangular, but are tall and thin as opposed to PAL's short and wide pixels. NTSC pixels are the same width, but are approximately 10% taller. It takes 720 pixels to fill the width, but only 486 to fill the height. In the case of NTSC, the width remains the same but the height changes.

Why is all this important? Well, you need to be aware of these aspect ratios when you are creating source materials for your movies otherwise the footage may become distorted when it's brought into your After Effects compositions.

1 Open the project named, **AspectRatios.aep** from the **Training > Projects > 05_Import** folder.

2 Hit ⌘ **I** *ctrl* **I** and import the file named **720.pct** from **Training > Images > Angie Images**, this file was created in an old version of Photoshop and measures 720 × 576 square pixels.

3 Select the file in the **Project** panel and notice the file information telling you that this file has **D1** pixels with a **1.07** aspect ratio, the standard for PAL 4:3. When you import a file that is 720 × 576, After Effects assumes that it has D1 pixels and treats it as such. When this happens to a square pixel file, the image will become distorted.

4 Open up the **Square pixel** comp, this has the correct dimensions for a PAL square pixel comp which are 768 × 576.

5 Drag the **768.pct** down onto the **Timeline**. It should drop into place looking absolutely correct (Fig. 3.51).

Fig. 3.51

6 Select the file named **720.pct** in the **Project** panel and drag it into the **comp** panel, allowing it to snap to the center of the comp. Notice that the file has been stretched horizontally in order for it to fill the screen, slightly distorting the circle (Fig. 3.52).

7 Context-click on the **720.pct** file in the **Project** panel and go to **Interpret Footage > Main**, this is where you can change the way that After Effects has interpreted various aspects of your file, for example, aspect ratio, alpha channel, and field order. Notice that After Effects has assumed that this file is made up from D1 pixels, which we know is not the case.

Fig. 3.52

8 Change the **Pixel Aspect Ratio** menu to the correct setting, **Square pixels** and then click **OK** (Fig. 3.53).

9 Click the **Solo** button for the **720.pct** layer and notice the edges of the layer don't quite extend to the edge of the comp. This is because there are only 720 square pixels in the image and this is a 768 square pixel comp (Fig. 3.54).

Any video footage that you bring into your comps should also be checked for correct interpretation in the Interpret footage dialog box. As long as the pixels are interpreted correctly, mixing footage with different aspect ratios should not cause you any major problems.

10 Switch off the **Solo** button for the **720** layer and notice that the **768.pct** fills the comp size perfectly, without distortion.

When creating footage in any software application that does not support non-square pixels, you should create your files at:

PAL: 768 × 576 square pixels.

NTSC: 720 × 540 square pixels.

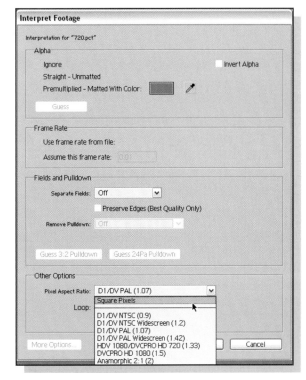

Fig. 3.53

Fig. 3.54

Any footage imported from a D1 video source with non-square pixels should be interpreted as:

PAL: 720 × 576 D1 pixels.

NTSC: 720 × 486 (or 720 × 480 NTSC DV) D1 pixels.

These files can then be imported into square pixel comps in After Effects of the following sizes:

PAL: 768 × 576 square pixels.

NTSC: 720 × 540 square pixels.

If you want to render out your movie for video output, simply drop the square pixel comp into a D1 comp of the following sizes:

PAL: 720 × 576.

NTSC: 720 × 486 (or 720 × 480 NTSC DV).

Anything that will be viewed on a computer monitor (e.g. CD; Web, etc.), then output your movie with square pixels.

Working in widescreen

You can find more about HD and widescreen issues on the **DVD > Extras** folder but if you are creating footage in Photoshop, Illustrator, or any other image creation software which will eventually be used for a widescreen broadcast, you need to use the square pixel measurement of the frame which is 1024 × 576 for PAL format or 864 × 486 for NTSC. HDTV (High Definition Television), can be either 1280 × 720 or 1920 × 1080.

If you are shooting footage or designing footage from scratch for inclusion in a widescreen broadcast, it is very important to stick within the 14:9 safe areas to ensure that your footage will be safe on all systems. You can download templates, plus the latest information regarding widescreen and HDTV formats from the BBC web site on (http://www.bbc.co.uk/delivery/).

Fields and interlacing

Each frame of footage shot using a video camera (with the exception of footage shot in progressive scan mode) actually consists of two separate fields. Think of these like two sets of venetian blinds slotted together to form one picture.

These fields are captured in sequence onto video tape and then combined together when you capture the footage into your computer to make up one interlaced frame.

The reason for interlacing video goes back to the days when television was in its early stages. When television were first invented, they used progressive scan screens (like your computer monitor).

A progressive scan screen scans the screen once from top to bottom for each frame. The problem with this is that the phosphors, used for displaying pictures on TV screens, would heat up to create the

picture, but by the time the picture had scanned down to the bottom of the screen, the phosphors at the top were already beginning to cool and were therefore losing their luminance. This phenomenon resulted in a downward, dark banding, as the phosphors cooled down.

The solution to this problem was to interlace the video that is split it into two separate fields. These fields of video are then played in such quick succession that the human eye reads it as one complete frame, this is why you see a very slight flickering on TV pictures.

The first problem which you must be aware of is that the order in which these fields occur is dependant on the video format you are using. Some formats capture the Upper field first, some the Lower field first. The general rules are that PAL uses Upper field first, PAL DV; NTSC and NTSC DV all use Lower field first.

There are a few exceptions to this rule. As you know by now, there are very few constants in the world of digital video, so it doesn't hurt to check the field order with the manufacturer of the equipment you are using and also to check the format on which the final movie will be shown. Once you have fixed your settings in After Effects, so that they match your hardware setup, you should not have to do it again unless you change your setup.

When shooting PAL 25 fps footage, the fields are captured at double the frame rate (i.e. 50 fields per second). Each field is captured sequentially at a different moment in time, After Effects will then put these back together as frames at 25 fps, the two fields will be mixed together to make up each frame shown on screen.

Because of this you may see a feathering effect where the two fields are different, this is especially noticeable where the subject (or the camera) is moving, the faster the movement, the more feathering occurs. The following diagrams show an interlaced frame and a close up of the feathering (Fig. 3.55).

This is what happens when two separate fields are combined (or interlaced) together. You can imagine that applying effects or transformations to this image would result in a pretty poor quality output.

Fig. 3.55

To overcome this problem, After Effects can de-interlace (or separate) the fields for you so that you can apply effects and transitions to individual fields rather than to the mixed frames, ensuring the highest quality possible on output. Pictured below are the two individual frames originated from the interlaced frame in the previous diagram.

Other applications can de-interlace your footage for you but many of them will use different methods to After Effects. Some will separate the fields, keep 25 fields, interpolating the spaces between the lines to create 25 full frames per second and then throw the other 25 fields away. After Effects keeps all the fields so that you are working with 50 full, interpolated fields per second. This yields higher quality and preserves the fields for output (Figs. 3.56 and 3.57).

Fig. 3.56

Fig. 3.57

Any footage rendered from After Effects or some of the most popular NLEs will include a label which tells After Effects the correct field order on import but if the file has no label. After Effects will treat the footage as if it is not interlaced, because of this reason, I always recommend that you become comfortable with the process of manually separating the fields yourself. It's very easy to do, I'll show you how in the following exercise. You can also alter the way that After Effects interprets files on import by customizing the Interpretation Rules.txt file. See **To specify interpretation rules** in the After Effects help system for instructions.

The Interpret footage dialog box is where you can tell After Effects the correct field order in which the original footage was shot. After Effects will then separate the fields accordingly. I'll show you how it works.

1 Open the project file, named, **Interlace.aep** from the **Training > Projects > 05_Import** folder (Fig. 3.58).

Notice in the timeline that there are two tabs, one for each Composition one is called Upper comp and contains a movie rendered with upper field first; the other is called Lower comp and contains a movie rendered with lower field first.

Fig. 3.58

Without any Interpretation by After Effects the movies each show both fields blended together. I'll now show you how you can tell After Effects to de-interlace the footage for you.

2 To ensure the fields are displayed correctly you must make sure that your comp viewer is set with a **Magnification of 100%** and is displaying at **Full resolution**.

3 Click on the **Upper Comp** Tab in the timeline and then, in the project panel, context-click on the **Upper.mov** and go to **Interpret Footage > Main** in the context-sensitive menu (Fig. 3.59).

4 In the **Fields and Pull Down** section, under **Separate Fields**, choose **Upper Field First** from the menu and then click **OK** (Fig. 3.60).

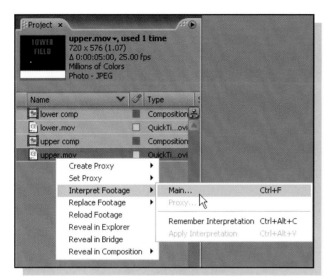

Fig. 3.59

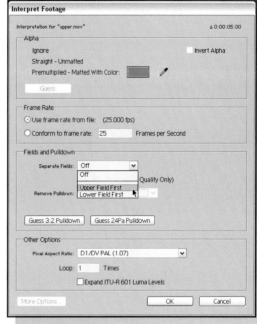

Fig. 3.60

5 **RAM preview** the movie. After Effects has now separated the fields. Because the upper field is first in this instance we will only see the upper field displayed on of each of the frames (Fig. 3.61).

6 Go to the **Project** panel, context-click on the **Upper.mov** again and go to **Interpret footage > Main**; choose **Lower Field First** and click **OK**.

7 **Ram preview** the comp again and notice that now only the lower field is displayed on each frame (Fig. 3.62).

When previewed, both interpretations seem to be correct. This is because we are only seeing one out of every two fields that exist in this movie. In order to see all of these fields we will need to increase the frame rate of the composition.

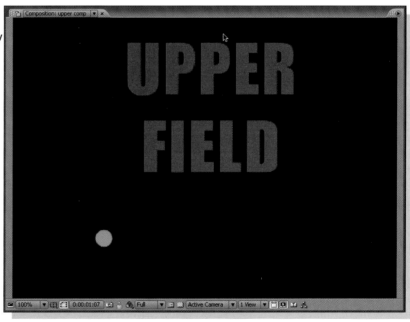

Fig. 3.61

Although After Effects separates the footage into its individual fields, it will still be displaying the footage in frames per second. To see all of the fields you must double your frame rate. It is sometimes necessary to do this for precise keyframing work such as Motion tracking and stabilizing, Complex masking, etc.

Fig. 3.62

8 Hit ⌘ **K** *ctrl* **K** to open the Composition Settings dialog box and change the **Frame Rate** to **50 fps** and then click **OK** to leave the dialog box (Fig. 3.63).

9 **RAM preview** the movie again and notice that the fields are being played back in the opposite order to the order in which they were originally created. This is particularly noticeable if you watch the movement of the green ball at the bottom of the screen. This is what happens when you incorrectly interpret the field order of a movie, the first field is shown after the second field, causing a stuttering effect.

10 Go back to the **project panel** and context-click on the **Upper.mov** again, go to **Interpret Footage > Main** and then change the **Separate Fields** menu back to **Upper Field First** and then click **OK**.

11 **RAM preview** movie again, it will now playback with the fields in the correct order. The green ball will move smoothly across the screen.

12 Hit ⌘ **K** *ctrl* **K** to go back to the **Composition Settings** dialog and change the **Frame Rate** to **25 fps**.

This process demonstrates how the fields work when de-interlaced by After Effects, but is a bit of a long-winded way of going about it! If you are ever unsure about the field order of a piece of footage, there is a very easy way to determine it without having to go through the process we have just completed.

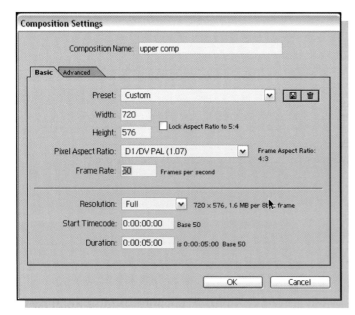

Fig. 3.63

13 ⌥ – double-click *alt* – double-click on the **Upper.mov** in the project panel. This will open the footage in the **Footage** panel, allowing you to see all the fields after the interpretation has been applied.

Once you have separated the fields and made any changes that you need to make to your footage, you can render your movie out to any format you choose.

Many software programs, including After Effects can also render your footage in fields as well as frames. If the footage originated with 50 fields per second, After Effects will re-instate those fields, producing interlaced footage. If the footage was originally progressive, After Effects interlaces the footage for you by splitting each frame into two new fields.

Footage which is going to be broadcast or printed back to videotape should generally be re-interlaced on the way back out of After Effects. It's vitally important to get the field order right both on import and render stages. Because the fields are captured and/or rendered at different moments in time, if interpreted or rendered wrongly, the footage will play a later moment in time before an earlier one, causing a stuttering, jerky movement.

It's important that you are aware of interlacing issues, even if you do not fully understand them. At least you should know enough by now to spot the incorrect interpretation of field order. This is particularly important if you are a freelancer like me. Each company will have a different setup and a unique way of approaching a job. It is vital that you are aware of the pitfalls you may encounter; interlacing errors are among the most common mistakes I've come across.

If you do recognize a problem, you can refer this book and the After Effects online help system to help you fix it. Search the After Effects Help Search page for **about interlaced and non-interlaced video** and **To determine the original field order**.

OK, so to recap on what you've learned about field order and interlacing, the things that can go cause problems are:

- *On input*: Incorrect or no interpretation of field order – check in the Interpret Footage dialog box that your footage is being de-interlaced and that it is being done using the correct field order.
- *On output*: No interlacing applied – check in the Render Settings panel that you have chosen to interlace your footage, do this from the Field Order menu.
- Incorrect render settings – check in the Render Settings > Field Order menu that you have chosen the correct field order for outputting to the format you will be transmitting the pictures on.

There are a couple of other things that can cause a jittery motion in your After Effects movies. If you have checked the interlacing and everything seems to be OK, it may be one of the following reasons.

- If you are moving text or any other similar graphics up or down the screen, you may get a jittery effect caused by the interlacing. To overcome this you should make sure that the speed at which it is moving is an even multiple of your field rate. For example, if you are working in PAL, the speed of the scroll should be a multiple of 50.
- You should generally avoid using very thin horizontal lines in your designs, as they tend to flicker between the fields if they are too thin. Always make sure that your horizontal lines are at least two pixels wide if not more.

Here are some great links to technical guides on the Adobe web site which will help you understand the potential problems. Simply go to the URL listed below and do a search for Fields or Interlacing (http://www.adobe.com/support/main.html).

Remember that you can specify to After Effects how you would like your footage interpreted by customizing the Interpretation Rules.txt file in your After Effects folder. Use the search feature in the After Effects Help system to find the document, named **To specify interpretation rules**.

Recap

So, in this chapter you've learned a fair bit about some of the import options and some other stuff associated with that. You now understand all the basic options available to you when importing files into After Effects, we'll expand on this knowledge as we progress throughout the book but for now let's recap on what you've learnt.

In the first few paragraphs you discovered a new way of importing Photoshop files as ready-made compositions to retain layers, blending modes, channels, adjustment layers, layer sets, styles, and layer effects. You also saw that vector text layers in Photoshop can be converted to editable text in After Effects and combined with animators to create intricate text animations. We also discussed how multi-layered Illustrator files are supported in similar ways but with some important differences including using Illustrator to export complex importing path shapes into After Effects as masks.

We imported many different file types and formats into After Effects including; image sequences, audio files, folders, Premiere Pro files, and Final cut Pro files. We then learnt to use various features in After Effects to customize the files for example, the Sequence Layer Keyframe Assistant, and the Layer window to do basic editing tasks. We also looked at some trouble-shooting tips and tricks for fixing broken links, and replacing footage within After Effects.

You were introduced to Adobe Bridge as your production center and asset-management hub, and we touched on some of the features that will really help you organize your workflow in order to become more productive.

By now you should also understand the basics involving the nesting of Compositions. You saw how After Effects can automatically create nested comps from an imported Photoshop composition; how to animate nested Compositions and when to Collapse Transformations for a nested Composition.

Finally we looked at some important technical considerations including: video formats, frame rates, time display styles, timecode, 3:2 pulldown, frame aspect ratio, pixel aspect ratio, Widescreen and HD issues, fields, and interlacing.

BillByrne01

Inspiration – Bill Byrne

Bill Byrne is a graduate from New York's School of Visual Arts Master Fine Arts in Photography and Related Media. His work focuses on the use of photographic montage to build a surrealistic, organic world. He makes digital prints and animated installations (**BillByrne01.tif**).

His images have been featured in the Digitalis series of exhibitions and has also recently been shown in Brooklyn's M3 Projects Gallery as part of the show New Maps of Hell. His image "The Flowering" was recently published in Wired magazine (October 2005 issue).

As well as making art, Bill is also a motion graphics designer and editor for television and film working with clients such as Tiffany & Co., ABC Sports, ESPN, Panasonic, Snickers, and RCA Records (**BillByrne02.tif**).

Film projects include the title sequence and special effects for the independent feature Red Doors (winner, best narrative feature, Tribeca Film Festival 2005). He has also directed and animated the video for All About House Plants for the DVD project, Addendum by the band One Ring Zero.

Bill is now a Professor of Motion Graphics and Digital Filmmaking at the Katharine Gibbs school in New York (**BillByrne03.tif**).

BillByrne02

Interview:

Q How did your life lead you to the career/job you are now doing?
A This all started for me when I was in grad school, I was making very morphic composited Photoshop-based artwork. My colleagues wanted my work to come to life, so I learned After Effects to create video installations. After school, I need to work so I started working on commercials. The rest is history.

Q What drives you to be creative?
A I love to try and make things that are new or unusual. My focus is pushing my artwork forward to the next plateau, so I am always looking for ways to inform my art. So when I take a profession motion graphics job, I use it as a way to improve my skills and figure out new arenas for the art.

Q What would you be doing if not your current job?
A Chef?

Q Do you have any hobbies/interests and if so, how do you find time for them?
A Like I hinted above I enjoy cooking but that's easy to find time for because I need to eat. My other hobbies like making music, I always make time for. I feel the process of making music informs my other work. I believe in going in every direction at once because every bit of inspiration feeds every other bit. A perfect example of this is my music video "All About House Plants". I don't think it would be the way it is if I had not been working on commercials and editing, the style of storytelling I used came from that work.

Q Can you draw?
A No, but I can make some sick paths with my Wacom tab, does that count?

Angie Yes, definitely!

Q What inspires you?
A There's so much. I find inspiration everywhere. Especially music, be it jazz, rock, classical, avant-garde, or electronic. Good commercials, print design, TV shows, movies, art. There is so much out there to be inspired by.

Q Is your creative pursuit a struggle? If so, in what way?
A It's not a struggle, it's an adventure. I think that I'd be bored if I were I dreamed to be right now. It's better to always be a work in progress, that's where new challenges and inspiration lie.

BillByrne03

Q Please can you share with us some things that have inspired you. For example, film, song, website, book, musician, writer, actor, quote, place, etc.
A The opening title sequence from the HBO show "Carnivale"; Gang Of Four's "Entertainment"; Roberto Matta's Paintings; Rube Goldberg's Illustrations; the music of Albert Ayler; the music of John Fahey; the TV show "Arrested Development"; Hewlett-Pakard's commercials.

Q What is your most over-used After Effects feature/filter?
A I have a deep love and sick obsession with Mesh Warp.

Q What would you like to learn more about?
A I would love to master expressions.

Q Please include examples of the work that you are most proud of and give a brief description and explain your feelings about them.
A The first link here is to my professional graphics reel. I'm particularly proud of the Tiffany logo and the movie title sequence from Red Doors (http://billbyrne.net/billreel06.mov).

Q Do you have any other tips for people venturing out on a creative career.
A Increment and save. Buy extra RAM. Don't give up. Be nice to people even when they are not nice to you. Call people back, right away. Right now means yesterday. Everything is an emergency. Coffee is not food. Sleep only when you absolutely have to.

Chapter 04 **Animation**

Synopsis

Before moving ahead with the projects it's important that you learn the rules of animation and how we can apply these rules to our work in After Effects. Time, along with motion are the two things that set motion graphic design apart from any other type of design.

In this chapter you'll also learn how to really control the timing of your animations using the Graph Editor. I'll teach you several time-stretching techniques using Time Remapping. You'll discover which Keyframe Assistants and Effects are the most useful and, most importantly, you'll learn how to apply tried and tested rules of animation to your After Effects projects.

This chapter will set you in good stead for recreating all the time-based trickery you may have seen on the big screen and on music videos including speed ramps, slow motion, video scrubbing, and time warping!

Animation rules – part 1

Traditional stop-frame animation is created by drawing a series of images which when played back sequentially will give the illusion of a moving image. Traditional animation started in the early 1900s. Originally it was only thought of as a novelty for entertaining children and adults until Walt Disney in the 1930s developed it into the magical art form it is today.

Traditional stop-frame animators have collectively had approximately 100 years to develop their skills and techniques. As with most forms of art and design, this has resulted in a well-respected set of rules which need to be understood in order to produce successful and compelling animation.

Computer animation is a much younger art form and has not yet developed as far as traditional animation. The tendency by many computer animators is to use the computer's immense capabilities to copy the physics of the real world. While this is a good practice if you are a visual effects artist, it is not so good for creating convincing animation.

When Disney created Snow White, the animators had real difficulty in developing the human characters, they tried tracing film frames but found that the movements were just too 'real' to be convincing for an animated film. They learned from this that pushing the possibilities of science and nature to extremes would result in more dynamic and appealing animation.

Don't get me wrong, I love what computers are capable of and have an immense amount of admiration for the creators of visual effects but I do think that animation is a different skill with different rules.

My philosophy is not to mimic the real world too much and to try to adapt the rules developed over the years by traditional animators. Here are some of the rules and tips for implementing them in your After Effects work. Let's start by looking at the two main types of animation.

Animation types

Straight ahead animation

This is where the animator draws a series of frames in sequence, one after the other till he or she reaches the end of the animation. This is a very difficult way to animate but is the most experimental approach, allowing the animator to make decisions and change ideas as he/she goes.

Pose to pose animation

This is when the animator first storyboards the animation and then draws the main poses in the animation (keyframes), planning the whole story before the animation stage. He/she then fills in all the in between drawings afterward. This is the most commonly used approach and one that most of the big animation studios use today. Everything is planned carefully before proceeding with the animation, formulas are followed and therefore the risks are minimal.

When working in After Effects I use a cross between these two techniques which I like to call 'straight to pose animation'! I find that a combination of the two techniques works best for me.

As you've already experienced, After Effects also uses keyframes to mark the key poses within your animation. You tell After Effects, 'I want this object to start at point A and end at point B'; After Effects will save you hours by working out all of the steps in between. But, unlike a human 'Tweener', After Effects doesn't know which path it should take from A to B, you must help After Effects determine the steps in between.

1 Open the project named **Animation01.aep** from **Training > Projects > 04_Animation**. 01_Road comp should be open and ready for previewing **(Fig. 4.1 – doesn't have to be readable)**.

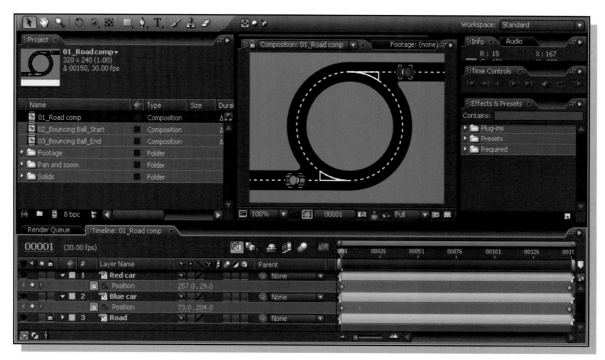

Fig. 4.1

In this composition there are two car layers, we want the cars to drive around the roundabout in opposite directions and leave on the opposite exit road.

2 Hit **0** on the number pad to **RAM Preview** the animation. Notice that the layers overlap as they cross the center of the layer.

In traditional animation I would draw the cars start point as my first keyframe and then draw the end point. I would then hand these drawings to my Tweener who would then draw the steps in between. When working in After Effects, you are the Key animator and After Effects is your Tweener. But After Effects will animate as the crow flies, in a straight line from point A to point B. In this example, the cars drive over the roundabout to get from exit to exit instead of going around the roundabout.

So that's our pose to pose animation, now what we must do is go in and adjust this to make it work, this is where the straight ahead bit comes in! In After Effects it's usually a good idea to control your motion paths using as few keyframes as possible. The easiest way to achieve this is to set the extremes and then go half-way between the extremes to make your adjustments.

3 Move to **frame 76** (which is the half way between our two keyframes) and select only the **Red Car** layer.

4 Drag the **Red Car** layer to the position that you would expect it to be at this point (Fig. 4.2).

This is where your observation of how things work in the real world is important. We take for granted the fact that we can judge the distance and speed of the cars to decide on their current position but reasoning is something that the computer cannot yet do.

5 Drag the **Blue Car** layer to the position you would now expect it to be in. Notice that the paths are now curved. This is because After Effects will, as a default, draw a curved Bezier path between keyframes.

6 **RAM Preview** the animation again to see the results of your changes.

Fig. 4.2

The cars are now moving more closely along the road but need to make more adjustments to the shape of the path so that it fits the road exactly. Before we adjust the path further, let's make sure that the cars are facing in the right direction.

Auto-orientation

You may have noticed that the cars remain facing in one direction as they move along the path, they don't turn as they move around the corners. After Effects provides a feature that makes layers change direction automatically as they follow the path, it's known as Auto-Orient.

7 **Select** both the **Red Car** layer **and** the **Blue Car** layer and then go to **Layer** > **Transform** > **Auto-Orient** ⌘ ⌥ O ctrl alt O.

Fig. 4.3

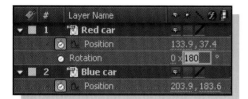

Fig. 4.4

8 In the **Auto-Orientation** dialog box, choose **Orient Along Path** and then click **OK** (Fig. 4.3).

9 **RAM Preview** the animation to see the results. You'll notice that the cars now align their direction with the path. The only trouble is that the red car is moving backward, but don't worry, it's very easy to correct this.

10 Select only the **Red Car** layer and then hit **Shift**+**R** to bring up the Rotation value alongside the Position value.

11 Highlight the **second value** for **Rotation** (which is the value in degrees), type in 180 and hit **Enter** to rotate the car 180 degrees. Doing this will not affect the Auto-Orientation of the layer (Fig. 4.4).

12 **RAM Preview** the animation again. All that's left to do now is to adjust the path a little to make the shape more precise.

Adjusting motion paths

I've seen many new users of After Effects try to control the shape of their paths by creating lots of keyframes. There is no need to create any more keyframes for this path, we can control the shape of the path using the existing keyframes and their Bezier handles. These handles work just like the ones that you use in Illustrator to draw your Vector shapes, or the ones you use in Photoshop for drawing paths.

1 Select the **Position** keyframes one by one in the **Timeline**, you will notice that, as you do, they also become selected in the **Composition** panel (Fig. 4.5).

Spatial keyframes

The Composition panel is where you can see the spatial positioning of your position keyframes (i.e. their position in space). The Timeline is where you can see their temporal position (i.e. their position in relation to time). It is very important that you understand this subtle but important difference, and that you do not attempt to

Fig. 4.5

adjust the timing of your animations by adjusting them in the Composition panel, this will only lead to confusion and frustration. Let's start by adjusting the keyframes spatially in the Comp panel.

When you view the selected keyframes in the Composition panel, you'll see that they have Bezier handles coming out from each side of the keyframe. These handles allow you to change the direction and amount of curve going into and coming out from the keyframe. One again we will use the rule of animating the extremes first, then making finer adjustments later to the in-between frames.

1 Move the Timemarker to **frame 76** and then click on the **first Position keyframe** for the **Red Car layer** to select it.

You can select keyframes either in the Composition panel or the Timeline, the appearance will change to indicate when a keyframe is selected. In the Comp panel, the keyframe will change from an empty square to a solid square. In the Timeline, the keyframe will become highlighted in yellow to show that it is selected.

You can still edit the Bezier properties of keyframes at other points in time even when the Timemarker is not parked over the keyframe that you wish to edit. For instance, in this example we're currently at frame 76 but are about to make changes to the first keyframe at frame **1**.

2 In the **Comp panel**, click on the handle coming out from the keyframe and drag it up and out to the left till the first half of the car's path lies along the road's dotted line and is in the same position as the one in the diagram. Notice that the shape of the curve changes (Fig. 4.6).

3 Do the same with the first **Blue Car** keyframe, this time, dragging it to the right and down until the first half of the Blue Car's motion path lies along the dotted line of the road (Fig 4.7).

Fig. 4.6

4 Repeat these steps with both layer's **Position** keyframes at the **frame 150** of the Timeline.

Now we have adjusted our extremes, all we need to do now is to adjust the middle keyframes to make the path exactly the right shape.

5 One-at-a-time, select the **middle** keyframes (at frame 76) for each of the two car layers and adjust the handles coming from the keyframes so that the path fits the road. If you don't get this right first time, simply undo your changes and start again till you feel more comfortable with the

Fig. 4.7

Fig. 4.8

process, we will be doing more of this in the following lessons (Fig. 4.8).

Dragging the handles up and down will change the angle of the curve while dragging the handles in and out from the keyframe will change the amount of curve. Notice that you can have a greater amount of curve on one side of the keyframe than the other. Each handle coming out of the keyframe can be adjusted independently to control the amount of curve by pulling it in toward or away from the keyframe.

6 **RAM Preview** the animation and notice that the cars are now following the road.

7 Go to **File** > **Save as** and, in the **Save as** dialog box, navigate to your **Work in Progress** > **04_Animation Chapter** folder on the desktop and save the project as **Animation02.aep**.

As you can see After Effects will do a good job at animating directly between two defined points, but that manual adjustment of the interpolation by you is often necessary. Let's take a closer look at how to control spatial keyframes.

Linear

This next tutorial is a bit of a classic, it's the good old bouncing ball animation. It's a bit of a cliché I know but I've yet to find a better way of illustrating some of the basic rules of animation.

1 If you do not have a project open, open **Animation01.aep** from **Training** > **Projects** > **04_Animation**.

Fig. 4.9

2 Open 02_**Bouncing Ball Start** comp and **RAM Preview** the animation of the ball bouncing along the bottom of the Comp panel. You'll notice that the bounce of the ball does not look real, there are several reasons for this which we will now look at (Fig. 4.9).

The first problem facing our animation is the shape of the path. The shape of the path that the ball follows is also known as the Arc. Some things in life follow a straight path, for example a ball dropped from above with no force applied

will drop in a straight line because gravity is the only force being applied to it and gravity will always pull in one direction – downward (Fig. 4.10).

The ball in our animation is being thrown in from the left so it has been given an additional force from the person who is throwing. This is a left to right directional force.

When these two forces are combined, this will produce a curved path because the two forces are acting against each other. The shape of the curve will depend on how strong the throw force is compared to the gravity force, which, under normal circumstances, remains constant (Fig. 4.11).

Auto Bezier

If we imagine our ball is being thrown quite gently, and that the gravity pulling down will be slightly stronger than the throw force, this will produce quite a steep curve. Our path is almost straight so let's start by adjusting the curve (or arc) of our path.

3 In the **Comp** panel, select the middle keyframe at **frame 15**.

Keyframes can be converted from Linear to Bezier (or visa versa) by using the Convert Point tool g from the tool panel. If the Selection tool **V** is active, holding down the **⌘** **ctrl** key will temporarily toggle on the Convert Point tool.

4 In the **Comp** panel, hold down the **⌘** **ctrl** key and then click once on the keyframe, this will change it into a default **Auto Bezier** keyframe. This is represented by the two dots at either side of the keyframe, these are the handles used to determine the curve going through the keyframe (Fig. 4.12).

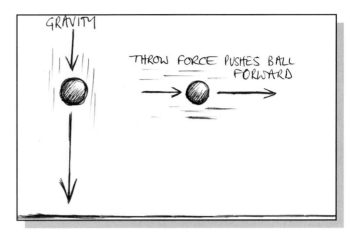

Fig. 4.10

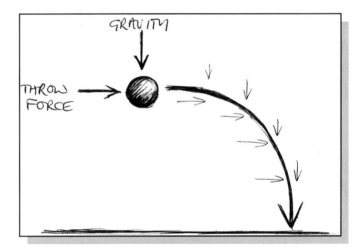

Fig. 4.11

Fig. 4.12

Auto Bezier keyframes are normally the default keyframe type. Their handles always maintain the same angle and distance as each other going into and out from the keyframe. This means that both the *amount* of curve and the *angle* of the curve are the same on either side of the keyframe.

 Look at the dots on the lines running between the keyframes, each dot represents one frame of your animation. When the dots are spaced further apart, we know that the layer is moving further on each frame and therefore is moving faster. When the dots are closer together we know the layer has less distance to travel and is moving slower.

Fig. 4.13

Continuous Bezier

5 In the **Comp** panel, still on the middle keyframe, click and drag on the right Bezier handle and drag to the right a little. Try to avoid moving it up or down as you do. A line will appear joining the handle to the keyframe – as soon as you adjust the angle of an **Auto Bezier** handle it is converted to a **Continuous Bezier** keyframe (Fig. 4.13).

6 Drag the opposite handle out till you have a nice, even curve like the one in the diagram (Fig. 4.14).

Fig. 4.14

You can adjust the amount of curve by pulling the handles *in toward* or *out from* the keyframe. This means that the curve maintains the same *angle* going *into* and *out from* the keyframe but the *amount* of curve can be different on either side of the keyframe.

With a Continuous Bezier keyframe, the handles going into and out of the curve always form one continuous straight line, meaning that the curve follows a continuous *angle* going through the keyframe, giving you a smooth and constant movement through the keyframe. However Continuous Bezier keyframes can have a different *amount* of curve, making them different from regular Bezier keyframes.

Now we need to create curves on the paths coming into the frame. To do this you need to adjust the curves coming out from the first and into the last keyframes.

7 ⌘ *ctrl*-click and drag on the first keyframe, pulling the handle to the right till the curve almost touches the curve between the second and third keyframes. ⌘ *ctrl*-clicking and dragging on a keyframe will convert it to a **Continuous Bezier** keyframe, allowing you to change the angle and amount of curve as you drag (Fig. 4.15).

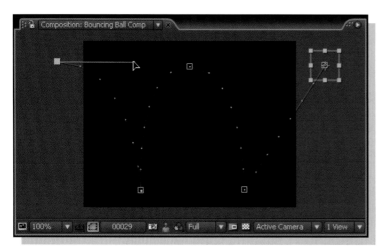

Fig. 4.15

Notice that the spacing between the dots on the path are becoming very slightly wider apart, meaning the layer is now moving faster. A curved line between two points is always longer than a straight line. Because we are making the layer travel further between the two points, it has to travel faster in order to get to the next keyframe in the same amount of time.

As soon as you alter an Auto Bezier keyframe it becomes a Continuous Bezier keyframe. You can see that the handles are now joined to the keyframe by a straight line which, like the Auto Bezier keyframe, will always maintain the same curve angle on either side of the keyframe. Whenever you adjust the angle on one side, the other will follow. The difference is that the amount of curve can be different on either side of the keyframe. Notice that this keyframe only has one handle because there is no motion path on the left side of the keyframe.

8 Repeat this process to drag the last keyframe handle to the left till you have nice curves on either side of the motion path (Fig. 4.16).

9 **Preview** your changes, the movement is slightly more natural but there is one more thing wrong about this spatial path, the ball bounces in and out of the animation at the same height.

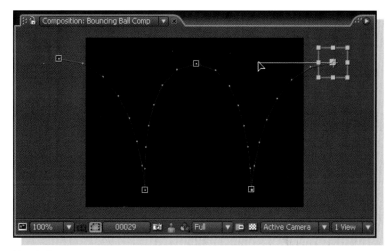

Damping force

When a ball bounces, the object that it bounces against (e.g. the ground) will absorb some of the energy from the ball, the result is that its bounce will be dampened each time it comes into contact with the ground. In other words, the path will gradually get smaller as the ball bounces. The softer the object that it bounces against, the higher the damping force, this means that it will come to a halt quicker after landing on a soft surface than on a hard surface. As an animator you have to try to imagine how the subject of your animation is going to react, depending on how it's affected by its surroundings. This basketball is being bounced onto a wooden basketball court which is fairly hard, therefore the floor will have a fairly low damping force and the ball will bounce quite well.

Fig. 4.16

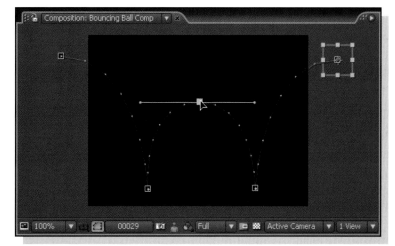

Fig. 4.17

10 In the **Comp** panel, select the **middle keyframe** and drag it down so that it is almost half-way down the Composition panel (Fig. 4.17).

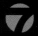
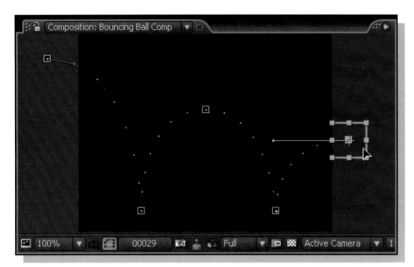

Fig. 4.18

11 Select the **last keyframe** and drag it down so that it is even lower (Fig 4.18).

We now have the shape of the path as we want it. It may not be an absolute scientifically accurate projection but it is good enough for our animation. If you want to create an absolutely accurate curve there are physics books listed on the resources page of my website that can help you work out the exact angles and curves. Go to: www.creativeaftereffects.com

12 Go to **File > Save as** and, in the **Save as** dialog box, navigate to your **Work in Progress > Chapter 04_Animation** folder on the desktop and save the project as **Animation03.aep**.

Temporal keyframes

The next problem with our bouncing ball is the timing. If you preview the animation you'll notice that the speed that the ball travels remains pretty much constant when it travels between the keyframes. This would not happen in the real world, objects accelerate as they fall and decelerate as they rise; this is because of the force of gravity acting on the mass of the object. The amount of acceleration/deceleration depends on the weight of the object.

1 If you do not have a project open, then open **Animation01.aep** from **Training > Projects > 04_Animation**.

2 Open **02_Bouncing Ball Start** comp from the **Project** panel. At the top of the **Timeline**, click on the **Graph Editor** button to display the property graph for your layer.

3 In the **Timeline** select the **Basketball.ai** layer and hit **P** to open its **Position** property. Select the **property name** to display its Speed graph (Fig. 4.19).

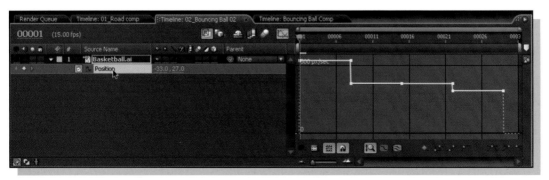

Fig. 4.19

The Graph Editor

After Effects 7 sports a brand new Graph Editor, which means that you can now view single properties or multiple properties simultaneously within the same graph. The graph you see before you is the Speed graph for the property value. Each property also has its own color-coded Value graph which displays the property's values as a graph.

 You may need to make the graph bigger at this point in order to view the entire graph for the Position property. Make the Timeline as tall as you can by dragging the line between it and the other panels, the Graph Editor will re-size automatically to fit the Timeline depth.

The Speed graph

This is the graph which is currently showing for the Position property. It shows the *rate of change* of the Position value over time. The minimum to maximum values, measured in pixels per second are listed down the left side of the graph.

A straight line between keyframes denotes an even speed. By looking at this graph we can tell that the ball is moving at a constant, steady rate between each set of keyframes. An absolutely straight line means an absolutely constant speed.

The height of the line determines how fast or slow the position value is changing. You can move the cursor over the white graph lines to see a Graph Tool tip telling you the speed between each set of keyframes.

4 Move the cursor over the white horizontal line that runs between the first two, white points on the graph line. Take a reading per second from the yellow **Graph Tool Tip** that pops up. It should read, approximately **538.34 pixels per second** (Fig. 4.20).

There is a straight line drawn between these two points which tells me that between the first keyframe and the second, the position of the ball is changing at an even rate of 538.34 pixels per second.

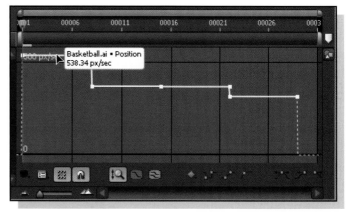

Fig. 4.20

It is inevitable that the spatial adjustment of keyframes in the Composition panel will result in a timing change, by altering the shape of the path, we also affect the distance that the ball has to travel between keyframes, a curved path will always take longer to travel than a straight path between the same two points. But attempting to adjust the timing of your animation by adjusting the spatial positioning of the keyframes in the Comp panel is not advisable. The Comp panel is specifically for adjusting spatial properties; the timing of your animation should all be controlled in the Timeline, the place where the true power and flexibility of After Effects lies. Always begin by getting your positioning correct in the Comp panel, then worry about the timing afterward, that's exactly what we are doing here.

Adjusting the Value graphs is probably one of the most challenging things you'll encounter when working in After Effects so don't be put off if you find it difficult to get your head round initially, we all did to start with! Just remember that practice makes perfect!

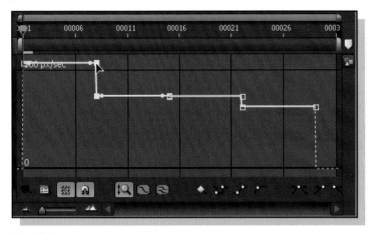

Fig. 4.21

In the following steps don't worry if your settings are not *exactly* the same as mine, there will be slight discrepancies depending on how close your motion path shape is, compared to mine.

5 Move the Timemarker to **frame 8** and notice that, at this point in time, the white line appears to have two little points on it which both look like keyframes, confusing eh?

6 Click on either of the two points to select it and notice that both points at **frame 8** become selected and highlighted yellow (Fig. 4.21).

These points are not actually keyframes but 'Speed graph points' that indicate the **Incoming Velocity** and **Outgoing Velocity** wherever a change of speed occurs. Frame 8 is the point where the speed changes suddenly so the graph line must display a point for controlling each velocity; one to control the speed *coming into the keyframe* and another for speed *going out from the keyframe*.

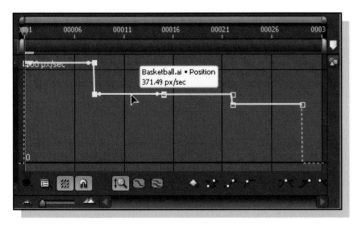

Fig .4.22

7 Move the cursor over the horizontal, white line running between **frames 8** and **15**. Again, the line is straight and horizontal denoting an even speed between the keyframes, the tool tip tells me that it is an even speed of approximately; **371.49 pixels per second** (Fig. 4.22).

This is slower than the speed between the first two keyframes. You can see that it's slower because the line running between the keyframes is lower in the graph, the lower the line, the slower the rate of change.

8 Repeat the last step, moving the cursor between **frames 15** and **22**.

From the appearance of the graph line it would seem that there is little or no difference in speed before and after the third keyframe at frame 15. But, if you look at the value here, you'll see a reading of **368.82**, meaning that the speed changes at this point, it's such a slight change that it is barely visible on the graph but it still needs to be fixed; it is important that the speed remains even as the ball is in mid-flight.

Roving keyframes

In situations like this where the *position* of your keyframe in the Composition panel is fine but the *timing* of the animation is wrong. As you've already learnt, you can adjust the timing of an animation by manually dragging keyframes closer together (to make the animation faster) or further apart (to make the animation slower).

In After Effects you can perform this process automatically, allowing After Effects to work out the correct position in time to give you an even speed on either side of a keyframe. This process is known as roving across time. Doing this will retain the position information associated with the keyframe in the Comp panel but will adjust the time at which the keyframe occurs within the animation automatically, After Effects calculates a smooth, even speed going into and out from the keyframe.

9 Make the **Timeline** as wide as you can so that it fills the width of your screen and if necessary, drag the **zoom slider** at the bottom to the left until you can see the entire position graph.

10 Move the **Timemarker** so that it's parked on the middle keyframe at **frame 15**.

11 Select the middle keyframe (at **frame 15**), then click on the **Edit Selected Keyframes** menu at the bottom of the Timeline and choose **Rove Across Time** (Fig. 4.23).

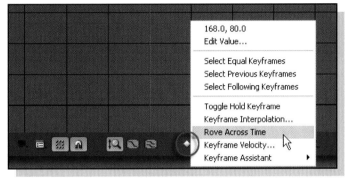

You can also access the same menu by context-clicking on the Keyframe in the Timeline.

This can also be done in the default Timeline view, it is not necessary to be in the Graph Editor to rove keyframes across time.

Fig. 4.23

There is a very subtle difference but you may also have noticed that the line running through the roving keyframe is immediately leveled, making it the same speed on either side. Also notice that in the Comp panel, the dots on the motion path are now evenly spaced between the second and fourth keyframes. All of this indicates that the layer is now moving at a constant speed between these two points.

12 If you missed any of this, simply **undo** and **redo** the last step to see the changes occur. The change may be too subtle for you to notice; try hovering the cursor over the white line again on either side of the keyframe and notice that the yellow popup displays the same value on either side of the roving keyframe (Fig. 4.24).

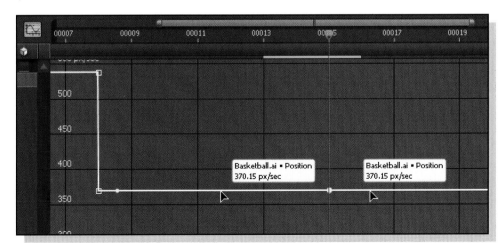

Fig. 4.24

When you make the keyframe a *roving keyframe* the spatial position remains the same in the Comp panel. While in the Timeline the keyframe jumps to a different point in time to ensure that the speed at either side of the keyframe remains constant.

13 **RAM Preview** your animation to see the results of your changes. Roving the keyframe has smoothed out the timing of your animation.

We'll work more with Roving keyframes later in this chapter, and we'll see how you can change the keyframes back to Locked keyframes.

Continuous Bezier

As you've discovered there are several different types of keyframes. You adjusted the positional curves of your motion path by changing the keyframe type and dragging their handles. You can do a similar thing with the temporal keyframes in the Timeline.

OK, so we determined that the ball should accelerate as it falls and decelerate as it rises. This will be an uneven speed and is represented by curved lines between the keyframes. Did you know that you can toggle between linear and Bezier keyframes in the same way that you can with keyframes in the Comp panel.

14 In the **Comp** panel, select the **first keyframe** by clicking once on it (this can also be done in the Timeline by clicking on the keyframe represented by a hollow yellow square), as you do, you'll notice the hollow yellow box is filled and a protruding yellow handle appears.

15 In the **Timeline**, drag the **yellow square** down till the value in the popup reads approximately **350 pixels per second**. Doing this has the effect of changing the speed coming out from the first keyframe, the ball will start more slowly and then accelerate to compensate. Try to avoid dragging the handle to the left or right (Fig. 4.25).

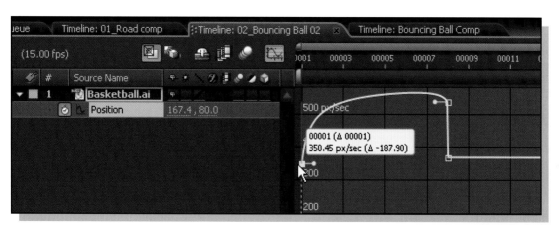

Fig. 4.25

Dragging the yellow square up or down will affect the value of the keyframe, as the value changes, the line joining the two keyframes will form a curve between the two differing values representing a new uneven speed.

16 Move the cursor along the curve, reading the tool tip's current values as you go, you'll notice that it increases in speed quite rapidly at the beginning, then levels out a bit in the middle before gradually decreasing in speed toward the end (Fig. 4.26).

17 **RAM Preview** the animation, it's an improvement, the ball looks more like it's dropping now, but to improve it the ball needs to have more acceleration, building gradually so that it is moving very fast when it approaches the second keyframe.

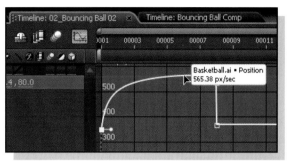

Fig. 4.26

We can change how the speed builds by adjusting the *influence* of the curve. The influence determines how quickly the acceleration or deceleration takes place. We've set the speed of the two keyframes at either side of the curve, now we can determine how it graduates from one speed to the next. At the moment it gets slightly faster in the middle of the two keyframes, we want it to get faster as it nears the second keyframe, where the ball will hit the ground.

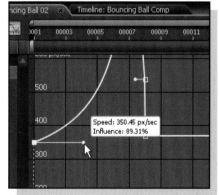

Fig. 4.27

18 Open the **Info** panel. As you adjust the handles of your keyframes notice that the Info panel will give you feedback on the **velocity** and **Influence** of your curve (Fig. 4.27).

When any part of your graph is selected, the **Info** panel displays the **Minimum** and **Maximum** values of the graph. It also displays the **value of the graph** at the **current frame**. This is extremely useful, particularly when working with expressions.

19 Still on the first keyframe, **click** and **drag** the little **yellow handle** to the right till it is about one-third of the way in between the two keyframes. The **Influence** reading in the pop-up that appears as you drag should be at about **90%** (Fig. 4.28).

Fig. 4.28

The graph will re-size itself automatically when you let go of the mouse. The graph shape will change so that it almost touches the top of the graph, just before the second keyframe.

20 Move to the second keyframe (**frame 8**) and click on the top-most point to make it active; then drag the handle that appears in toward the keyframe, till the **Influence** reading in the popup is **0.01%** and the top of the curve is cut off by the boundary of the graph. As soon as you release the mouse the graph will re-size to accommodate the altered graph (Fig. 4.29).

You may find that it is quite hard to control the velocity by dragging these handles, the only feedback you get is from the curve itself and from the Info panel. It's very easy to

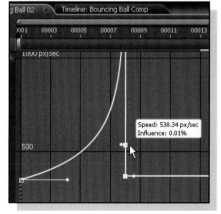

Fig. 4.29

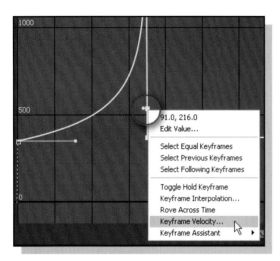

Fig. 4.30

Fig. 4.31

accidentally move the handle up or down while dragging. I'll show you an easier way to adjust the velocity settings.

21 Context-click on the point and choose **Keyframe Velocity** from the menu. This will open up the **Keyframe Velocity** dialog box where you can alter the values for speed and velocity (Fig. 4.30).

22 Change the **Incoming Velocity Speed** to **1000** and the **Incoming Velocity Influence** setting to **6**.

Doing this will adjust the curve, the first keyframe's Outgoing Velocity value has much more influence on the curve than the last one. The result will be that the ball will accelerate very quickly into the second keyframe. A ball will bounce faster coming out of a bounce than going into it so we need to adjust our Outgoing Velocity while we're in here.

23 Change the **Outgoing Velocity Speed** setting to **1300** and the **Outgoing Velocity Influence** to **16** and then click **OK** to leave the dialog box (Fig. 4.31).

Notice that your Speed graph has changed quite dramatically. You may have noticed that the shape of the graph is starting to look like a mirror image of the motion path in the Comp panel because, as the ball's motion drops, its speed increases.

24 **RAM Preview** your animation and notice how the ball appears to be heavier now, falling to the ground very suddenly.

OK, now we need to adjust the curves between the other keyframes. The Roved keyframe does not need any adjustment as it will now automatically rove to maintain the correct timing as we make adjustments to the graph.

25 Move to the fourth keyframe (at **frame 22**) and make the top-most point active by clicking once on it.

26 Drag the little **yellow handle** up and to the left till you have a nice smile-shaped curve (Fig. 4.32).

The top point of this curve should be slightly lower than the top point of the first curve as the ball will slow down a little after each bounce. The roved keyframe should sit on the apex of the curve.

With the **Snap** button activated at the bottom of the Timeline the handles will snap to the other keyframes on the graph.

27 To ensure you have the correct values, **context-click** on the keyframe to open the **Keyframe Velocity** dialog and enter a value of **860** for the **Incoming Speed** and **25** for the **Incoming Influence**. While in there, enter values of **930** for the **Outgoing Speed** and **30** for the **Outgoing Influence** and then click **OK**.

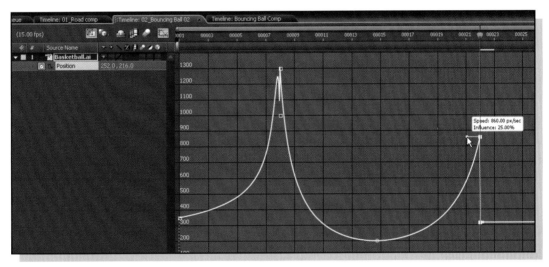

Fig. 4.32

28 Finally, select the **last keyframe** and drag the handle till you have another nice, smiley curve like the one in the diagram below (approximately; **Incoming Speed 280, Incoming Velocity 35**) (Fig. 4.33).

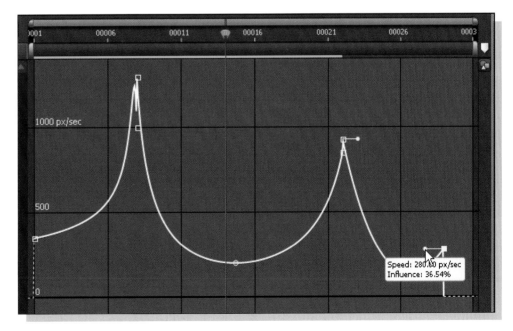

Fig. 4.33

29 **RAM Preview** your animation, the timing should be much more like a real bouncing ball now, the movement is slightly exaggerated for the purposes of this tutorial but you should now have a better idea of how you can use the graph to fine tune your animation timing.

Retiming animations

If you select multiple keyframes (when the Show Transform Box button is on) a Free-Transform box is placed around the selected keyframes allowing you to reposition, scale, rotate, and even shear the selected keyframes. This is the quickest and easiest way to retime your animations.

30 Select all the keyframes by double-clicking the **Position property name** in the Timeline. Doing this will place the Free-Transform box around your keyframes.

31 Place the cursor over the middle handle of the box on the right edge of the Free-Transform box and drag toward the left. Notice that the whole animation becomes squashed, this has the effect of speeding up the whole animation. Drag the handle till it sits on frame **21** (Fig. 4.34).

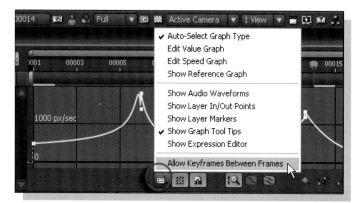

Fig. 4.34a

You can also speed up or slow down any group of keyframes in the regular Timeline view by ⎇ _alt_-dragging either the first or last keyframe in a selection; and you don't have to retime the whole animation, this technique will work on any selection of keyframes.

With the default settings, After Effects forces keyframes to be positioned on frames of your animation, however it also provides an option for you to place keyframes in between the frames.

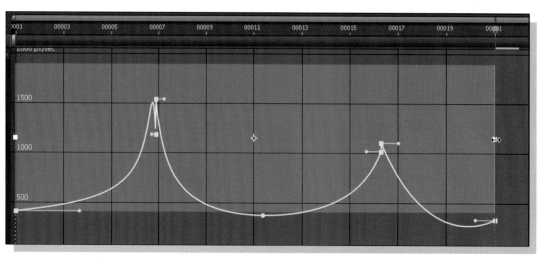

Fig. 4.34b

32 Click on the Choose Graph Type and **Options** button and select **Allow Keyframes between frames** from the list.

When using this technique it is possible to accidentally adjust keyframes so that they no longer sit exactly on a frame of your animation, this can produce strange results because After Effects does not render anything that happens in-between the frames.

If you want to see an example of this happening, use the technique from steps 28 and 29 to adjust the whole animation until the last keyframe sits on frame 22. Play back the animation and you'll see that the ball no longer touches the bottom edge of the Comp panel. Step through the frames (Page Up and Page Down keys) and you'll find that the keyframes are no longer sitting on frames of your animation.

33 Click outside the Free-Transform box to accept the changes and de-select the keyframes.

34 Remember that you can also adjust keyframes individually. To perfect the animation click and drag the second-last keyframe to **frame 14** and the last keyframe to the **frame 18**. The **Info** panel is useful here as it will display the time of the selected keyframe as you drag (Fig. 4.35).

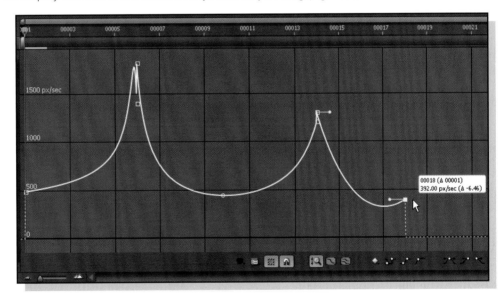

Fig. 4.35

35 Click on the **Choose Graph Type and Options** button and de-select **Allow Keyframes between frames**.

36 Go to **File > Save as** and, in the **Save as** dialog box, navigate to your **Work in Progress > 04_Animation** folder on the desktop and save the project as **Animation04.aep**.

OK, so to recap, the Timeline is where you adjust the layers movement through *time*. You can adjust the keyframes and/or the Speed graph to determine the *rate of change*. The keyframes in the Timeline are *temporal* keyframes.

The Comp panel is where you adjust the layers movement through *space*. You can adjust the keyframes and the curves between them to determine the layers *movement in space*. The keyframes you see in the Comp panel are *spatial* keyframes.

Value graph

Now that you understand the difference between temporal and spatial keyframes, allow me to throw a spanner (or wrench if you are from the USA) in the works! Every Transform property has a Value graph. This means that the position of your keyframes in the Comp panel can be adjusted by editing the graph.

Fig. 4.36

1 If you do not have a composition open, then open **Animation04.aep** from **Training > Projects > 04_Animation**. Open the **02_Bouncing Ball 02** comp from the **Project** panel.

2 Click on the **Position** property name in the Timeline to make the property's **Speed** graph visible.

3 Look at the buttons that appear at the bottom of the Timeline. These buttons allow you to customize the graphs to suit your needs.

4 Click on the **Choose Graph Type and Options** button and select **Edit Value graph** from the list. The **Speed** graph will disappear and the **Value** graph appears in its place (Fig. 4.36).

The *Red* line represents the *X*-value of position, the *Green* line represents the *Y*-value. The best way to learn about these property graphs is to get in there and play with them. But first, let's save our project.

5 Hit ⌘ Ⓢ *ctrl* Ⓢ to save your project before experimenting with the **Position** Value graph.

6 Experiment with the following:
- Drag a point on the **red** line upward or downward to adjust its **X-Position** value. Dragging downward will decrease the value and make the layer move in a negative direction; dragging upward will increase the value and make the layer move in a positive direction.
- Drag a point on the **green** line upward or downward to adjust its **Y-Position** value. Dragging downward will decrease the value and make the layer move in a negative direction; dragging upwards will increase the value and make the layer move in a positive direction.
- Drag a point left or right to move it along the Timeline, changing its position in time. Drag left to make it appear earlier, drag right to make it appear later.

7 Once you have experimented with this, go to **File > Revert** to revert back to the last saved state.

Let's use the Value graph on another property, the Scale property.

8 Make sure that the **Timemarker** is back at **frame 1** and then, with the layer selected in the Timeline, hit *Shift* Ⓢ *Shift* Ⓢ key to open up the **Scale** property alongside the Position property.

9 Click on the **Scale** stopwatch to set a keyframe doing this will also make the property active.

10 Click on the yellow **Scale** keyframe at **frame 1** and drag it down the graph till the value reads 20. Dragging the keyframe down the graph will decrease the **Value** of the keyframe (Fig. 4.37).

Fig. 4.37

11　Hold down the ⌘ *ctrl* key as you click on the red line at **frame 27** this will temporarily toggle the **Pen** tool on and create a new keyframe here (Fig. 4.38).

12　Drag the new **keyframe** in toward the beginning of the Timeline till it sits on frame **20**. Dragging the keyframe along the graph will change the **Time** of the keyframe.

13　**Drag** the **keyframe up** till the pop up displays a value of **25%**. Notice how easy it is to make slight adjustments to your values in this way (Fig. 4.39).

Fig. 4.38

As I said before, using these graphs is probably one of the more tricky things that you'll have to deal with when using After Effects but the more practice you get, the more you will start to understand the curves and how they relate to your animations. There are a couple of other changes that we can make to this animation to really make it look real. First of all, we'll use the Auto-Orientation feature to make the ball spin as it moves through the air.

14　Context-click the layer in the **Timeline** and go to **Transform > Auto-Orient**. Choose **Orient Along Path** and then click **OK** to leave the dialog box. When you preview this you'll perhaps notice that the rotation is not 100% accurate but it's enough to give the impression. If you want to have more control over the spin you could animate the rotation manually.

Fig. 4.39

15　Go to **File > Save as** and, in the **Save As** dialog, navigate to your **Work in Progress** folder on the desktop and save the project into the **04_Animation Chapter** folder as **Animation05.aep**.

Animation rules – part 2

Squash and stretch

One of the most important rules of animation is the squash and stretch rule. For an object to look convincing it must 'give' when external forces are applied to it. In this example the ball hitting the ground or being affected by gravity. As the ball hits the ground it will squash, but did you know that it will also stretch as it falls and rises? The only time the ball should look perfectly round is at the top of each arc, where resistance is at its least. Obviously a softer ball, for example a beach ball will squash and stretch a lot whereas a cannonball will hardly squash and stretch at all. You can use squash and stretch techniques to convey an object's density and mass.

We're going to cheat a bit here, to stretch and squash the ball properly we should use a warping tool such as the Professional version Bezier Warp effect to allow us to squash the ball into exactly the right shape. For this tutorial we'll just use Scale to reshape the ball. We won't get exactly the right shape but it will be close enough to demonstrate the principles of squash and stretch.

1 Open **Animation06.aep** from **Training > Projects > 04_Animation**. Close any other open projects. Make sure that you have the **02_Bouncing Ball 02** comp open.

2 With the Timemarker at the beginning of the Timeline, select the **Basketball.ai** layer and then hit the **S** key to open up the **Scale** property. Switch off the **Graph Editor** button so you can see the regular Timeline and keyframes (Fig. 4.40).

Let's start by resetting the Scale property so it remains at 25% throughout the animation.

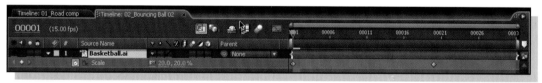

Fig. 4.40

3 Delete the first keyframe by clicking on it and then hitting the **Backspace** key.

4 Create a new keyframe at **frame 1** by clicking on the **Add or Remove Keyframe at Current Time** button. You should now have two Scale keyframes with the same value of 25% (Fig. 4.41).

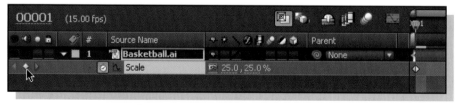

Fig. 4.41

It's very important when using the squash and stretch rule that the form of the object always appears to retain the same amount of volume to be believable. In other words, if you squash the object by 50% on the X-axis, you must also stretch it by 50% on the Y-axis. You can pretty much distort it as much as you like, as long as the object appears to contain the same amount of mass. In this case, the ball is currently 25% on each axis so we should change these values by the same amount.

Exaggeration

Another great animation rule is the rule of exaggeration. Exaggeration in animation terms is used to emphasize whatever key idea or feeling you wish to portray. For example, if you create an animation of a dog smoking a cigarette while dancing, you would exaggerate the action that was most relevant to the scene. If the animation's purpose was to illustrate the joys of dancing (perhaps the cigarette is simply there as a tool to suggest the dog is in a bar somewhere) the dancing would be exaggerated. If, however you wanted to focus on the fact that the dog was smoking (perhaps an anti-smoking advert) you would make him smoke in a very ostentatious way, with his feet making tiny little dancing movements. By exaggerating certain elements you can guide the viewer's eye and give exactly the message that you wish to give.

Taking our bouncing ball as an example, if we scale this ball by the correct amount the animation would probably look a little weak. Just as we exaggerated the amount of bounce in the timing exercise, we will also exaggerate the amount of squash and stretch. Good use of exaggeration can make an animation come to life, as long as all of the elements are exaggerated to a similar degree.

5 Move to **frame 6** and then, in the **Composition** panel, click on one of the layers corner handles and re-size the ball, so that it's squashed vertically and stretched horizontally. Use the Info panel as a guide to help you to scale it to **20%** on the **X**-axis and **30%** on the **Y**-axis, adding **5%** to the **X**-axis while removing **5%** from the **Y**-axis. A new key-frame will be created (Fig. 4.42).

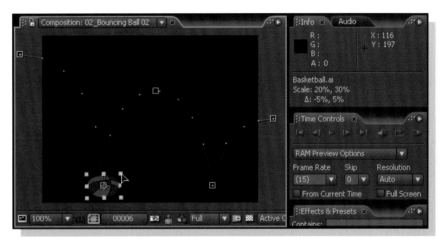

Fig. 4.42

If you look at the Scale values in the Timeline and the Info panel, you might be confused, you may have noticed that the values seem to be the wrong way around, the smaller X-value appears to be squashing the height of the ball while the bigger Y-value appears to be stretching the width, surely it should be the other way round? This is happening because we have the layer Auto-Orientated to the path, it is no longer at its default rotation.

You have a few options to solve this problem if this happens to you, you could:
● Remove the Auto-Orientation and animate Rotation manually.
● Reshape the ball in a nested comp before animating it.
● Adjust the values by eye like I have done here.

This is a bit of a cheat's workaround but, hey, we all have to cheat sometimes to get the job done!

6 So the **Scale** value in the **Timeline** should read approximately **20, 30**. If not, you can go to the **Timeline** and adjust the values till they are exactly right.

Fig. 4.43

Fig. 4.44

Make sure to uncheck the **Lock Aspect Ratio** box before adjusting the values. We have squashed the ball horizontally by five degrees and stretched it vertically by five degrees, ensuring that the volume remains the same (Fig. 4.43).

7 Move to **frame 14** and then select the **second keyframe**; hit ⌘C ctrl C followed by ⌘V ctrl V to copy and paste the keyframes values into the current frame.

8 Using the same technique, copy and paste the **first keyframe to frame 10**.

9 Move to **frame 4** and change the **Scale** value to **30, 20**. This is where the ball will be at its most stretched (Fig. 4.44).

10 Select the keyframe at **frame 4** and hit ⌘C ctrl C to copy it to the clipboard.

11 Move the Timemarker to **frame 8** and hit ⌘V ctrl V to paste the keyframe. Repeat this process to paste the keyframe at **frames 12 and 16**. These are the points on the path where the ball would be stretched.

12 Select the **first Scale** keyframe and then Shift click the **third, fifth, seventh,** and **ninth** so that every second keyframe is selected.

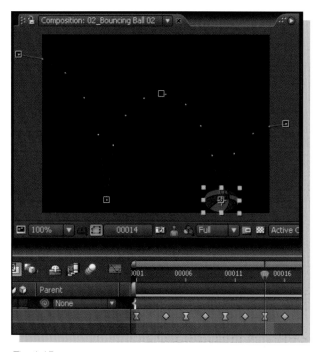

Fig. 4.45

13 Go to **Animation > Keyframe Assistant > Easy Ease**, this will have the effect of the Scale holding slightly at each extreme, giving us a more exaggerated look.

14 Finally, go to frames **6** and **14**, respectively and use the **Down** arrow key to nudge the position values so that the ball touches the bottom of the Comp panel as it bounces (Fig. 4.45).

15 Activate the **Motion Blur** switch for your layer and also enable **motion blur** for the comp by clicking the **Enable Motion Blur** button in the Timeline.

16 Hit ⌘K ctrl K to go to open the **Composition settings**, click on the **Advanced** tab and change the **Shutter Angle** setting to **20**, reducing this setting will reduce the amount of motion blur used in this comp (Fig. 4.46).

17 **RAM Preview** your composition.

18 Open up the finished
BouncingBall.mov from the **Project** panel
and preview it to compare your results with
mine. If yours are drastically different, you
may have missed some steps – just quickly
follow the steps again till you are feeling
confident.

19 Go to File > Save as and, in the
Save as dialog, navigate to your **Work in
Progress** folder on the desktop and save
the project into the **04_Animation** chapter
folder as **Animrule06.aep**.

Fig. 4.46

Panning and zooming

A fairly common job that you may be
asked to do as a motion graphic designer is
to animate a still image by panning and
zooming. Traditionally this would have
been done using a rostrum camera. The
image would be placed under a camera,
mounted upon a frame, the camera would either be moved closer to or further from the image to
pan in and out (or the zoom lens would be used to zoom in and out). The camera could also be
moved left, right, up, or down to pan around the image.

These days computers are used to do the same job and After Effects is ideal for this type of work.
There are a few tips and tricks that will be useful for you to be aware of before attempting this
yourself, it's not as straightforward as it first seems.

You would naturally assume that the best way to do it would be to animate the scale property to
zoom in and out, then the position property to pan around the image. Anyone who's tried this
technique will most probably have found it quite awkward.

Basic image panning

Imagine that animating the position property is like moving the image under the rostrum camera,
rather than moving the camera over the image, it's very hard to get a smooth move. It's much easier
to get a nice smooth pan if you move the camera. This is achieved in After Effects by animating the
Anchor Point rather than the Position value.

Anchor Point

After Effects rotates and scales a layer using its Anchor Point as a pivot, the anchor point's default
position is in the center of the layer. You can move the Anchor Point to adjust its position on the
layer and there are two ways of doing this; one is to move the Anchor Point using the Pan Behind
tool (we'll look at this technique in the hierarchal motion section of Chapter 06 – Grouping). The
other method is to move the Anchor Point in the Layer panel.

1 Open Animation07.aep from **Work in Progress > 04_Animation** folder. In the **Pan_and_Zoom**
folder in the Project panel, double-click the **01_Panning comp** to open it.

This comp contains a single Illustrator file which is an Edinburgh street-map. This street-map was
produced specially for this book by a company called Falmap who specialize in making maps for

both print and on-screen production, you can find out more about the company on their website at www.falmap.com.

2 Select **Layer 1** in the Timeline and then open the **Anchor Point** and **Scale** properties and set keyframes at **frame 1** for both of them by hitting **Shift** **⌥** **S** **Shift** **alt** **S** followed by **Shift** **⌥** **A** **Shift** **alt** **A**.

3 Double-click **Layer 1** in the **Timeline** to open up its **Layer** panel.

4 Position the **Layer panel** and the **Comp panel** side by side. The easiest way to do this is to dock the Layer panel into the same frame as the Project panel. You may need to readjust the edges of the panels so that you can see both panels, you may also want to close or reposition some panels in order to give you enough space to work with (Fig. 4.47).

Fig. 4.47

This image is huge, it's 3000 pixels square, so we can have some real fun panning and zooming round it! Your aim is to see the complete layer in the Layer panel so, if you need to, you can adjust the magnification so you can see all the way to the layers' edges, I've reduced my magnification in the Layer window to 25% in order to do this.

5 In the **Layer panel** you should see the **View menu** around the bottom middle, which currently reads **Masks**. Click on this menu and choose **Anchor Point Path**. This will allow you to see where your Anchor Point animation is taking you as the imaginary camera travels across the image (Fig. 4.48).

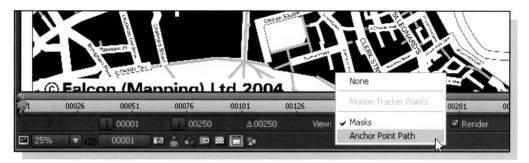

Fig. 4.48

6 With the **Layer panel** still active, hit the ● key on your keyboard to zoom in till you can see the Anchor Point of your image which currently sits on the letter **G** from the name **NORTH BRIDGE** in the center of the layer (Fig. 4.49).

Fig. 4.49

7 Click and drag the **Anchor Point** so that it sits in the middle of the junction between **NORTH BRIDGE** and **HIGH STREET**. You may need to zoom out using the **Comma** key on your keyboard to see the names of all the streets (Fig. 4.50).

Fig. 4.50

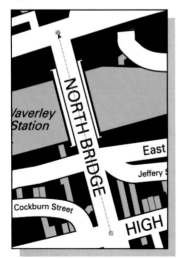

Fig. 4.51

As you do this **Layer 1** moves in the Composition panel, notice that the layer's Anchor Point remains exactly in the center of the Comp panel and the map area that's in view in the comp has shifted. We can use the Anchor Point as a kind of target, by moving it around the Layer panel onto the points that we want to be central in the Comp panel.

8 Go to the **Timeline** and move the **Timemarker** ahead by two seconds to **frame 51**.

9 Go back to the **Layer panel** and **click and drag** the **Anchor Point** to the junction between **NORTH BRIDGE** and **PRINCES STREET** (Fig. 4.51).

You should now see a dotted line between the two points, just as you do when animating Position in the Comp panel. This is the Anchor Point Path, this shows the points that will be central in the Comp panel. I find it extremely useful to see this path, it makes it very easy to spot any errors in the motion.

10 Click on the little **Always Preview This View** button situated in the bottom left corner of the **Comp panel** and then hit the **RAM Preview** button in the Time Controls panel to see what this looks like in the Comp panel. The 'camera' appears to pan over the image between the two points (Fig. 4.52).

11 Move ahead by another two seconds to **frame 101** and then, in the Layer panel, drag the **Anchor Point** to the next intersection to the left of the current one to create a third keyframe for the Anchor Point value.

12 Move ahead another two seconds to **frame 151**, this time scrub the **Anchor Point** values in the Timeline to move the Anchor Point to the junction between **MARKET STREET** and **COCKBURN STREET**.

 If you can't see the Anchor Point in the Layer panel select **Anchor Point Path** from the **View menu** at the bottom of the Layer panel.

Fig. 4.52

Fig. 4.53

Fig. 4.54

If you have followed all the instructions in this chapter the path should be a linear one because we set the preferences for the default spatial interpolation to be set to linear. This can be changed at any time.

13 Move ahead another two seconds to **frame 201** and then drag the **Anchor point** to the junction between **COCKBURN STREET** and **HIGH STREET**, notice that the path between the keyframes is a straight (or linear) one. But this path needs to be curved! Don't worry, it's just as easy to convert it back from linear to curved.

14 Hold down the **⌘** **ctrl** key and then **click and drag** downward to pull a Bezier handle out from the vertex, creating a curve. This will change the keyframe type to continuous Bezier (Fig. 4.53).

15 Hold down the **⌘** **ctrl** key and then **click and drag** a handle from final keyframe up slightly to finish off the curve.

16 Make any adjustments necessary to the path by adjusting the handles. Holding down the **⌘** **ctrl** key when you click on a handle will allow you to break the handles on either side of the keyframe so that they can be adjusted independently from each other (Fig. 4.54).

17 RAM Preview the Comp panel again to see the animation, the camera moves around the roads, following the Anchor Point Path. Notice that the speed is not constant, we moved the Timemarker at regular intervals of two seconds but because the spacing between the points is not regular the timing is uneven between the keyframes, we'll fix this by roving our keyframes across time.

18 Select the **second, third, and fourth keyframes**, and then go to **Animation > Keyframe Interpolation** and in the **Roving** section, choose **Rove Across Time**. This will reposition the keyframes in the Timeline to even out the speed and make it constant (Fig. 4.55).

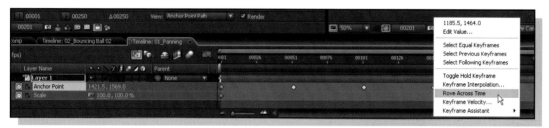

Fig. 4.55

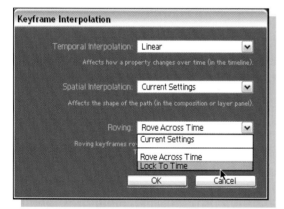

Fig. 4.56

19 RAM Preview the Comp panel again to see the animation, the camera moves around the roads at a constant speed.

We now want to ease the motion going through the keyframes to give the impression of a car, pausing at each junction before proceeding. The problem is that we cannot ease roved keyframes, in order to ease them we need to lock them again to their new times.

20 Select all the **Anchor Point keyframes** by clicking on the property name in the Timeline, then go to **Animation > Keyframe Interpolation** and in the **Roving** section, choose **Lock to Time** (Fig. 4.56).

21 Select **all** the **keyframes** and then hit **F9** to **Easy Ease** them all (if you are on the Mac, and have Expose on at its default settings you can use the **Animation > Keyframe Assistant > Easy Ease** menu item instead as F9 is used for Expose).

22 RAM Preview the Comp panel again to see the animation, now the motion slows down before approaching each corner.

Copying and pasting paths

The animation looks great but something is still missing, it's not really clear exactly what roads we want the viewers to focus on. Highlighting the route can often help to guide the viewer's eye. The good news is that we can use the path that we have just created to highlight the route by copying and pasting the path information into an effect property.

As we've seen, Position and Anchor Point Paths are very similar to the Bezier paths that you draw with the mask tools, the tools and modifiers used to adjust and control them are exactly the same. In fact the path information can be copied and pasted from one property to another; Position and

Anchor Point keyframes can be copied and pasted as Masks, and Mask keyframes can be pasted into Position or Anchor Point properties. These Bezier paths can also be copied and pasted into any Effect that contains a property with a spatial value such as particles, lens flare, lightning, etc.

Into Effect properties

1 If it's not already open, open **Animation07.aep** from **Work in Progress > 04_Animation**. And then, in the Project panel, open the **02_Write On comp** from the **Pan and Zoom** folder.

2 Switch to the **Effects** workspace by going to **Window > Workspace > Effects**. In the **Effects and Presets panel**, type the word **Write** into the Search field at the top of the panel, you should now see the **Write On** effect in the **Generate** category.

3 **Drag** the **Write On effect** onto **Layer 1** in the **Timeline**, the **Effect Controls** panel should appear.

The Write On effect will draw a line between points specified by the Brush Position property. These points can be animated by hand, one-by-one, or can be copied and pasted from existing path information.

4 With the layer selected, hit the **E** key on your keyboard to display the **Effect** property controls in the Timeline.

5 Hit **Shift A** to open up the **Anchor Point** property alongside the **Write On** effect in the Timeline, then click on the **Anchor Point property name** to select all keyframes for the property and then hit **⌘C** **ctrl C** to copy the keyframes to the clipboard (Fig. 4.57).

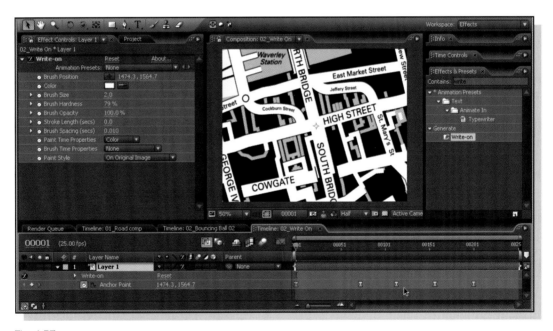

Fig. 4.57

6 Expand the Write On effect in the Timeline, and select the effect **Brush Position** property by clicking on the property name.

7 Hit **⌘V** **ctrl V** to paste the keyframe data into the **Brush Position** property. We need to make some changes to the other Write On properties before we preview it.

8 In the **Timeline**, change the **Color** to **Red** and the **Brush Size** to **20**.

9 **RAM Preview** the animation to see a red line illustrating the path (Fig. 4.58).

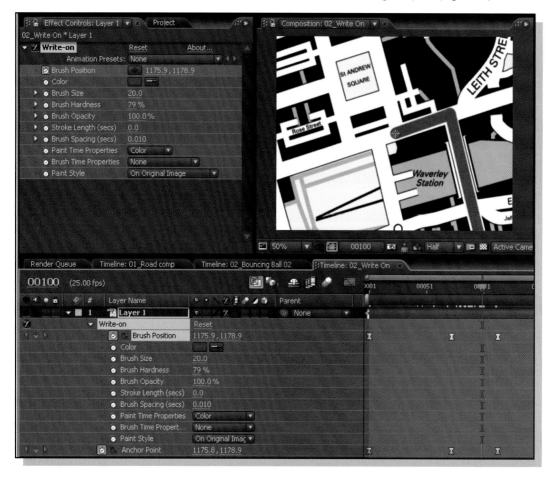

Fig. 4.58

Notice how the red line obscures the names of the streets on the map because it is opaque. The one thing that I would like to see added to this effect are Blending Modes so that the line could be blended with the image it is being drawn on. But the only way of using Blending Modes with this effect is to put the effect on a different layer and use the layer's Blending Mode. The new layer must be the same size as the existing one so the easiest way of creating it will be to duplicate the existing layer.

> Almost anything can be copied, pasted, or duplicated, including Masks, Effects, Keyframes, Values, Properties. So it's very important to make sure that you have the correct item selected before copying and pasting in After Effects as it's very easy to copy and paste the wrong thing.

10 **De-select everything** by hitting **F2** to and then **re-select** the Layer by **click**ing the **Layer name** in the **Timeline**.

11 Hit **⌘D** **ctrl D** to **duplicate** the selected layer.

12 **Switch off** the **Write On** effect on the **bottom layer** by clicking on its **Effect** switch in the Timeline (Fig. 4.59).

Fig. 4.59

13 Open up the **Write On effect controls** for the new top layer in the **Timeline** and change the effect's **Paint Style** menu to On **Transparent** (Fig. 4.60).

14 Change the **Blending Mode** of the **top layer** to **Darken** and then preview the animation again to see the text showing through the brushstroke as it is drawn along the path (Fig. 4.61).

15 To see how the layers are being composited, one-at-a-time, click on their **Solo** buttons. Notice that the bottom layer now displays the original map image, and the layer above only contains the red line. Make sure that you finish with both Solo switches turned off so that you can see both layers.

As well as being able to create path information within After Effects, remember you can also copy and paste path information from Photoshop or Illustrator. To copy and paste path information from Illustrator, you will first need to check that your preferences in Illustrator will allow you to do so. This is done in Illustrator CS2 by going to **Edit > Preferences > File Handling and Clipboard** and making sure that the **AICB** checkbox and **Preserve Paths** radio button are both checked.

2D zooming

When objects get closer to a camera they appear to get bigger. You can achieve a similar effect by animating the scale property of a layer. The problem here is that we now have two layers to animate, the solution is to somehow group the layers together. There are various ways of grouping layers that you will learn about in the

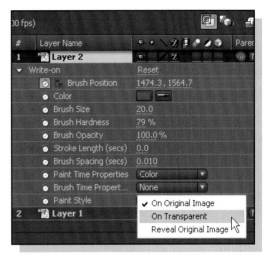

Fig. 4.60

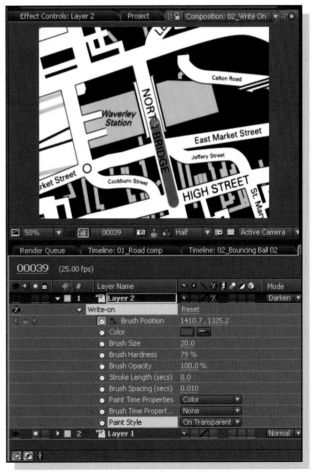

Fig. 4.61

Grouping chapter (Chapter 06), each one is useful but usually one will be preferable in a particular situation. In this situation Expressions are the best option.

Basic Expressions

Expressions are based on Java Script, they can be very complex and can do amazing things but you don't have to be a scripting genius to be able to use them, After Effects automates the process for you, making it really easy to get started. Expressions can do lots of wonderful things that you will learn about in Expressions chapter (Chapter11), but the most basic of uses is to quickly and easily link layer properties together.

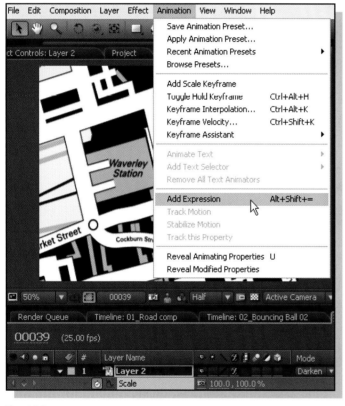

Fig. 4.62

Fig. 4.63

16 **Select both layers** and then hit the **S** key to open up the Scale properties for both layers.

17 **Click** on the **Scale property name** for **Layer 2** and then go to **Animation** > **Add Expression** (Fig. 4.62).

You will now see several new buttons appear underneath the Scale property values in the Switches column. The value of the property also changes to red (or pink), indicating that the value will now be determined by an expression.

18 Before doing anything else, **click and drag** the **Pickwhip** icon from **Layer 2** onto the **Scale property name** on **Layer 1**. The Scale property name will become highlighted in blue, when this happens, **release** the **Pickwhip** and then hit the **Enter** key on the **number pad** of your keyboard to activate the expression (Fig. 4.63).

Make sure to use the **Enter** key on the number pad and not the Return key on the main keyboard as this will not work for activating expressions but will instead add a carriage return to the expression.

Congratulations, you have created your first expression, After Effects automatically enters the code needed to link the properties together into the Expression text field. Not even a single letter of code had to be typed by your poor little creative fingers – great isn't it?

19 Move to **frame 1** so that the Timemarker is parked over the first keyframe and then scrub **Layer 1's Scale** value to see both Scale properties update simultaneously.

20 Scale **Layer 1** down to **30%** at **frame 1**. Notice that **Layer 2's Scale** value is always the same as **Layer 1's Scale** value.

21 Move to **frame 201** and then change the **Scale** value of **Layer 1** to **100%** (Fig. 4.64).

Fig. 4.64

22 **RAM Preview** the animation to see both layers scale up over time.

You may notice a problem with the zoom when you look at this animation. Even though we animated the Scale linearly, it appears to slow down as the animation progresses. Let me show you why this happens and we'll look at ways of fixing it.

Exponential Scale

The zoom on this text looks quite odd, it appears to slow down as the text gets larger. You may have come across this problem when trying to create convincing zooms. The Professional version of After Effects supplies you with an Exponential Scale keyframe assistant that can fix this problem. If you do not have the professional version, the same thing can be achieved by adjusting the Speed graphs in the Timeline.

1 Open **Animrule08.aep** from **Training > Projects > 04_Animation**. And then, in the **Project** panel, open the **04_Scale comp** from the **Pan and Zoom** folder.

2 **RAM Preview** the animation to see the word **Zoom!** Scale up from **0%** to **100%** over the space of **two seconds** (Fig. 4.65).

Fig. 4.65

3 Hit ⌘ **K** *ctrl* **K** to open the **Composition settings**. Change the frame rate to **5 fields per second (fps)** and then click **OK**.

Our comp's Duration is two seconds, giving it a frame rate of 5 fps will leave us with exactly 10 frames in the animation.

RAM Preview the comp. Because the comp is two seconds long, this means our zoom now happens faster but the even increments will make it easier for you to understand what is happening.

4 Select the **Zoom.psd** layer and hit the **S** key to display the **Scale** property in the Timeline.

5 Hit the **Home** key to jump the Timemarker to the beginning of your comp and then hit the **Page Down** key repeatedly to step through the animation frame-by-frame. Notice the Scale values as you go – they will rise linearly at even intervals 1**0%, 20%, 30%, 40%, 50%**, etc. (Fig. 4.66).

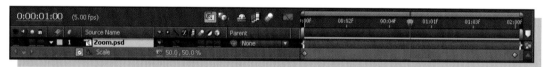

Fig. 4.66

With these default settings, After Effects scales linearly, in other words it scales at an even rate. If you think about the difference between 0% and 10% it seems like a very big change, compared to the difference between 90% and 100% which is quite a small change. This is why the scale change appears to slow down when increasing and speed up when decreasing.

When you zoom using a real camera the rate of change increases as you zoom. To simulate this phenomenon the scale must build exponentially. You can create an Exponential Scale by adjusting the graph as we did in the Position exercise but there's an even easier way to do this by using the Exponential Scale keyframe assistant. If you do not have the Professional version of After Effects you can try adjusting the graphs manually, using the following diagrams as a guide, alternatively you can skip ahead to the 'animating rotation' section.

6 Click on the **Graph Editor** button and then click once on the **Scale** property name so that you can see the **Scale Value graph**.

7 Select both of the Scale keyframes by clicking again on the **Scale** property name (Fig. 4.67).

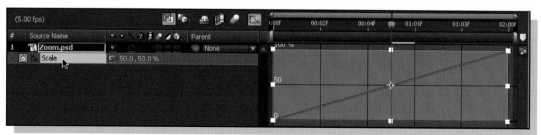

Fig. 4.67

In the Graph Editor, clicking the property name once displays the Value graph for the selected property, to select the property's keyframes, you have to click the property's name a second time. Notice that this also places the Free-Transform box around the selected keyframes.

8 Go to **Animation > Keyframe Assistant > Exponential Scale**. After Effects calculates a perfect Exponential Scale curve for you (Fig. 4.68).

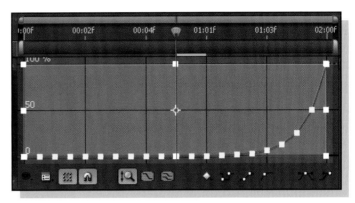

9 Step through the frames again by hitting the **Page Down** key and notice the difference in the graph. The Scale value changes from 0% to 1% over the space of the first second and then increases exponentially till it reaches 100% at the 2 second mark. The graph is no longer a straight line because the value is building exponentially as the animation progresses.

Fig. 4.68

10 Hit ⌘ 🄺 *ctrl* 🄺 to open the **Composition settings**. Change the frame rate back to **15 fps** and then click **OK**.

11 **RAM Preview** the animation and see the difference – a much more dynamic zoom.

The only problem with this keyframe assistant is that it creates loads of extra keyframes. Remember that we only need two or three keyframes to create this sort of curve. We can easily get rid of the non-essential keyframes by using the Smoother.

The Smoother

12 Select all the keyframes by clicking on the **Scale** property name, next to its stopwatch.

13 Go to **Window > The Smoother** to open up the Smoother panel. Enter a **Tolerance** value of **5** and then click Apply (Fig. 4.69).

Fig. 4.69

The Smoother removes all non-essential keyframes but has maintained the exponential curve. The higher the tolerance setting, the more keyframes will be removed, I simply used trial and error till I hit on the correct number in this situation. As you use this assistant more, and keep an eye on the results, you'll gain enough confidence to create your own exponential curves without the need for the assistant.

14 Double-click on the **03_2D Zooming** comp icon in the **Project** panel again to open its Comp panel and Timeline.

15 Make sure you can see **Layer 1**'s **Scale** property graph and make it bigger if necessary.

16 Select both **Scale** keyframes and go to **Keyframe Assistant > Exponential Scale** (Figs. 4.70 and 4.71).

17 **RAM Preview** the animation and make any adjustments you feel are necessary.

We've now covered most of the fundamental rules of animation but there are a few more principles which are worth considering.

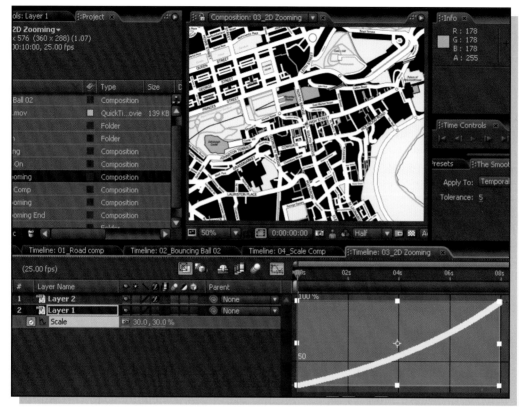

Fig. 4.70

Fig. 4.71

Animation rules – part 3

Staging (setting the scene)

You must remember that the viewer does not have the luxury of knowing what is about to happen in your animations so if something moves very quickly, they may not have time enough to realize what is going on, blink, and they'll miss it! This is why it is necessary to set the scene for them. Setting the scene (or staging the animation) involves attracting the viewer's attention and focusing it on a particular subject or area of the screen. It can also set up a mood or feeling that you want the

viewer to understand before the main action takes place. Examples of this would be having the subject move suddenly to attract attention or coloring/lighting your subject in such a way that it stands out from the rest of the scene.

Anticipation

Anticipation can also be used to direct the viewer's attention to part of the screen and is often intermingled with staging. However, there are differences which make it a rule unto itself. Some anticipation occurs naturally, for example, a mouse is about to hit a cat over the head with a mallet. Physically, the mouse would have to pull the mallet back before plunging it down, this is the anticipation moment. By exaggerating this moment you can let the viewer know what is about to happen in the scene. There are other anticipation tricks which do not always happen in nature but are useful in animation. For example, in the old Road Runner cartoons, when the coyote falls off the cliff, he hangs in the air for a second or two before plummeting to the ground. Without the pause, the viewer would not have time to register his very fast fall to earth.

Motivation

This is when one action clearly shows that another action is about to take place. When a car motor starts, the engine makes the car judder as it revs, ready to explode into action.

Secondary action

A secondary action is any type of action which results from the main action. This could be a character's tummy wobbling after they have jumped from a great height or a facial expression of agony after Tom has been hit on the toe by Jerry. One thing to be cautious of, is not to make the secondary action more prominent than the main action.

Overlap

Overlap is when one action overlaps another. If we look at nature again, very seldom does one action finish completely before another starts. Imagine at breakfast taking a bite of your toast and then having a sip of your tea. You may still be putting the toast back down on your plate with one hand while putting the cup to your lips with the other – these are overlapping actions. Your animation will look rigid and unnatural if you don't overlap the actions within it.

Follow through

Follow through is, again, something that occurs in nature but is often exaggerated in animation. Think of a golfer, taking a swing at a ball, the golf club doesn't stop suddenly when it comes into contact with the ball, it follows through the same path and then gradually settles back down to a halt. This is follow through. You'll also see follow through when you observe a cat flicking its tail. After the cat has flicked its tail a wave of action will follow through to the tip of its tail after the base of its tail has stopped moving.

- Balance is crucial for an animation to be convincing, you must draw your characters in poses which look real and sustainable. Balance will change according to the weight or mass of an object, heavy objects will generally take longer to pick up speed. They will also take longer to stop moving than light objects because more resistance is needed to fight against the heavier weight.
- A good understanding of rhythm will help you to work out the timing of your animations.

- A good knowledge of physics and math will certainly help you understand how things work. My advice, above everything else, is to get out there and observe how things move and react with their surroundings.
- Life-drawing classes are also a very good way of studying form and structure, your local art college will have evening classes you can enroll in.

Time-stretching footage

The following movie is not intended to be a serious piece of art; it's only supposed to be a bit of fun, light relief from the serious world of motion graphics! It's a pastiche of other music videos, you see I've always wanted to be a Rock star so I just couldn't let this opportunity go to waste!

1 Open **MacDonna.aep** from **Training > Projects > 04_Animation** and then in the **Project** panel, double-click the **MacDonna.mov** to view it.

Fig. Time FX 4.1

As you can see the movie contains lots of edits, time trickery, effects, and fast cuts, I put the rough edit together using Final Cut Pro and then imported this into After Effects using Automatic Duck (http://www.automaticduck.com). The project was created at PAL resolution but I have re-rendered parts of it at a smaller resolution for these tutorials.

2 Open the **01_Time Stretch** comp and preview this excerpt from the movie.

3 **RAM Preview** **0** the movie, I had to stand right in the middle of the road with traffic whizzing all around me to get this shot, it was a tad scary (Fig. Time FX 4.1)!

I knew that I wanted to speed this footage up so I shot about two or three minutes of it. I'll show you how to alter the timing, and how to apply some nice effects to bring it to life even more.

Fig. Time FX 4.2

4 With the **PrincesSt.mov** layer selected in the Timeline, go to **Layer > Time > Time Stretch**.

This is where you can alter the **Stretch Factor** or the **Duration** of a layer. This value cannot be animated.

5 Change the **Duration** Value to **60** frames (Fig. Time FX 4.2).

Notice that, as you adjust the **Duration** value, the **Stretch Factor** value also changes. You can enter a new timing for your layer by adjusting either of these values.

Below the Stretch settings are the **Hold in Place** settings, these allow you to determine which part of your layer will act as the

anchor. With the default Layer In-point selected, the In-point will remain anchored at the beginning of the comp while the rest of the layer adjusts itself around it.

6 Hit **OK** to leave the dialog box and then **RAM Preview 0** the changes so far. We are playing back two minutes of video footage over the space of four seconds (60 divided by 15).

7 You can also access the Time Stretch settings in the Timeline. Click on the **Expand or Collapse the In/Out/Duration/Stretch Panes** button at the bottom of the Timeline to open up the **Stretch** Panel (Fig. Time FX 4.3).

Fig. Time FX 4.3

It is possible to adjust the **In, Out, Duration**, and **Stretch** values by clicking on them directly in the Timeline and typing in new values.

8 Close the **Time Stretch** pane by clicking again on the **Expand or Collapse the In/Out/Duration/Stretch Panes** button.

OK, your comp will now be far too long for your footage so we will trim it down a bit using a handy shortcut.

9 With the layer selected, hit the **0** key on the keyboard to make the Timemarker jump to the **Out-point** of your layer.

10 Hit the **N** key on the keyboard to place the **Work Area End** marker to the position of the Timemarker (Fig. Time FX 4.4).

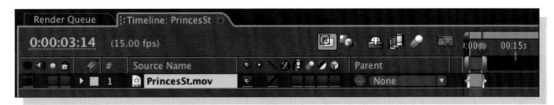

Fig. Time FX 4.4

After Effects will only preview or render the frames within this work area. The **B** key on the keyboard can be used to set the **Beginning Work Area** Marker. You can also click and drag these handles manually.

11 **RAM Preview 0** the comp again, notice that the RAM Preview **0** is only previewing the frames within the Work Area.

You can also trim the comp to fit your marked work area, this is an efficient way of trimming your comp without having to go to the comp settings window.

12 Context-click on the **Work Area** and choose **Trim Comp to Work Area** to quickly change the comps duration to fit the clip (Fig. Time FX 4.5), the same command can also be accessed in the Composition menu.

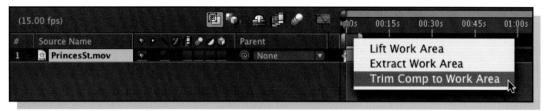

Fig. Time FX 4.5

Frame Blending 1 – frame mix

OK, so our clip is running nice and quickly now, but it looks a bit jumpy, kind of like a Keystone Cops movie. This is because speeding up the footage has removed a considerable amount of intermediate frames, causing people to jump suddenly in and out of shot and cars to appear stuttered in their motion. We can fix this by applying Frame Blending to the layer. There are two types of Frame Blending in After Effects 7, Frame Mix and Pixel Motion.

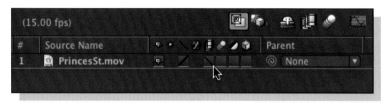

Fig. Time FX 4.6

13 In the **Switches** panel, click once on the checkbox under the **Frame Blending** switch icon to activate **Frame Mix** blending for the layer, this is represented by a dashed diagonal line in the checkbox (Fig. Time FX 4.6).

As well as activating the **Frame Blending Switch** for the layer, you must also **Enable Frame Blending** for the whole composition. Frame Blending is very processor intensive and can really slow down your workflow if it is left on while you are working. The **Enable Frame Blending** switch allows you to disable Frame Blending for the comp while still having the layer switches activated for the final render.

Fig. Time FX 4.7

14 Click on the **Enable Frame Blending** button at the top of the Timeline to enable Frame Blending (Fig. Time FX 4.7).

15 **RAM Preview 0** the movie and notice that the moving objects now appear to leave a trail or echo behind them as they move. It is a similar effect to using a slow shutter speed on a camera.

 You will only see the true results of Frame Blending on a layer if you preview the layer in best quality. Draft quality will not give you an accurate preview of the Frame Blending results.

When After Effects uses Frame Mix to blend the frames it compares each frame to the last and creates a blend in-between them. This is useful when speeding footage up, slowing footage down, and creating intermediate frames.

Slowing things down

1 Go back to the project window and create a new composition by dragging the **PrincesSt.mov** onto the **New Comp** icon.

2 Open up the **Time Stretch** panel in the **Timeline** by going to the wing menu and selecting **Column > Stretch** (Fig. Time FX 4.8).

3 In the **Stretch** column, enter a new Stretch Factor of **200%**. By stretching the movie we are effectively slowing it down.

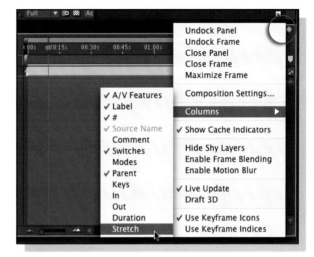

Fig. Time FX 4.8

4 RAM Preview **0** the movie, notice that it is now running slower but that it is not playing back very smoothly. This is because After Effects is having to repeat frames in order to stretch the movie.

5 Move to frame **15** and then use the **Page Down** key on your keyboard to step through the frames one by one. Notice that After Effects is repeating frames, this means that the movie will appear to have half the frame rate when played back.

6 Activate Frame Blending for the layer by **selecti**ng **the layer** and going to **Layer > Frame Blending > Frame mix**.

7 **Enable Frame Blending** for the comp and make sure that the layer **Quality switch** is set to **Best**.

8 Step through the frames again, see that After Effects has taken info from both frames and blended them to create intermediate frames.

9 RAM Preview **0** the footage to see how much smoother the playback now is.

10 Go to **File > Save As** and save the project into your **Work in Progress > Chapter 04_Animation** folder as **Frameblend.aep**.

Time remapping

Some of my favorite effects are time-based effects so I reckon that Time Remapping has to be one of my favorite features in After Effects, you can use it in so many great ways. Enabling Time Remapping for a layer reveals an extra, animatable property in the Timeline, and that property is time itself! Time Remapping allows you to vary the speed of your footage and animate the speed changes over time. You can stretch the timing of your layer backward or forward at any speed you desire (real time, slow motion, or ultra fast). You can also use it as a quick and easy way to create freeze-frames.

Fig. Time FX 4.9

There are also loads of groovy tricks you can do with Time Remapping, we'll start by having a look at a pre-built project which I'll use to demonstrate some of the basics of Time Remapping. We'll then apply what we've learnt to the projects we've been working on.

1 Go to **Training > Projects > 04_ Animation** and open the project named **T_remap.aep** (Fig. Time FX 4.9).

2 Make sure that the composition named **01_Dance comp** is open and **RAM Preview** **0** it.

This is one of the movies I'm going to be using for the music video project. It features a certain person prancing around like a lunatic. Yes, I'm afraid it's me!

Freeze-frames

The easiest thing to do with Time Remapping is to create freeze-frames. After Effects 7 has a menu item which will automate the process for you. All you need to do is position the Timemarker on the frame that you wish to freeze.

3 Move the Timemarker to frame **20**.

4 Select the **MeDanceAlpha.mov** layer in the Timeline and then go to **Layer > Time > Freeze-Frame**.

Notice that a new property has appeared in the Timeline called Time Remap. The property has one single keyframe at the position of the Timemarker. When applied, the Time Remap value will have the same value as the current time. Notice that when the Timemarker is at frame 20, the Time Remap value is also **20** (Fig. Time FX 4.10).

Fig. Time FX 4.10

Time remap value graph

The nicest thing about using Time Remapping to alter the speed of your footage (as opposed to simply changing the duration of a clip) is that you can vary the speed over time. You can also tweak the speed using the Value graph.

Auto-editing

1 Open **Graffiti.aep** from **Training >
Projects > 04_Animation**. In **Chapter 03,
Import** chapter, we imported a series of
images as a sequence, we also added a
music track to our composition
(Fig. Time FX 4.11).

2 **RAM Preview 0** the comp to remind
yourself of the current state of the Project.
We are going to use **Time Remapping** to
make the images change in time with the
music. This is a quick and easy way to line
up your edits in time with music.

3 Select the **Graffiti Images** layer and
go to **Layer > Time > Enable Time
Remapping ⌘⌥T** *ctrl alt T*.

4 Select the audio layer and then hit the
L key twice in quick succession to bring
up the audio waveform. Re-size the
Timeline if need be (Fig. Time FX 4.12).

Fig. Time FX 4.11

Fig. Time FX 4.12

I'm now going to show you two ways of matching your images in time with the music, one using the
Standard version of After Effects, the other using the Professional version. If you own the Professional
version it is still worth going through the first exercise as you may pick up on techniques that you
were previously unaware of.

Using layer markers

Some audio tracks can be so distinct that you can clearly see the beats of the music, if this was the
case here you could just draw in your keyframes, with the pen tool at each beat. Unfortunately this
audio track contains quite a few sounds, making it difficult to work out the beats visually. This is
where After Effects Layer Markers come in handy for marking key points in the audio.

Before continuing with the following steps you need to make sure that your preferences are
set to allow you to preview more than a few seconds of audio. To do this, go to either; **After**

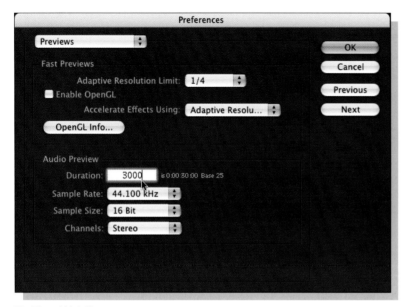

Fig. Time FX 4.13

Effects > **Preferences** >
Previews (Mac) or **Edit** >
Preferences > **Previews (Win)**
and change the **Audio Preview
Duration** to 0:0030:00 (Fig.
Time FX 4.13).

5 Select the **Graffiti Images**
layer and then make sure the
Timemarker is at the beginning
of your composition **(Home
key)**. Hit the ⬛ key on your
number pad to preview the
audio.

6 Listen carefully to the music
to determine where you want to
mark the beats. You don't want
to mark every beat, roughly one
beat per second
will be plenty. Only choose the
main beats as you can always go back and add more markers later. Listen to the music as many
times as you need to, till you feel that you know the music well enough to be able to lay down your
markers.

Markers can be set at any time, simply by selecting the layer you want to mark and then hitting
the ✱ key on the number pad. Using this method, you can even add markers while the audio is
being previewed. Markers can also be added to a layer by going to **Layer > Add Marker**.

7 With the Graffiti Images layer selected in the Timeline, hit the ⬛ key on your number pad to
begin previewing your audio and then hit the ✱ key on your number pad each time you want to add
a marker till you reach the end of the audio. There is a short delay before the audio starts so you
should have enough time to prepare for the first beat coming in.

☠ Make sure that you hit the ✱ key on the number pad, not the one on the main keyboard!

Don't worry if you make a few mistakes to begin with, it's only natural. If you do, simply undo the
last step and then try again. One undo step will undo all of the markers set during the last preview.
Just don't give up! Repeat the process till you get the hang of it. As with most things, it will become
easier the more you practice.

8 Once you've laid down some markers that you are happy with, double-click the layer to open up
its Layer window. Make sure that you can see both the Layer window and the Composition window
side by side (Fig. Time FX 4.14).

9 Once you have the layout exactly how you want it, go to **Window > Workspace > New
Workspace** and give your workspace a name. I've called mine **Layer window editing**.

Fig. Time FX 4.14

When Time Remapping is enabled you will see an extra **Source Time Ruler** in the Layer window, it's situated above the regular **Time Ruler** and has its own **Time-Remapping Thumb** (which looks like a mini-Current Timemarker). The Source Time Ruler's **Time-Remapping Thumb** can move independently from the regular Timemarker, Time Remap keyframes will be automatically set wherever there is a difference between the two markers.

10 With the **Layer** window active, use the **J** and **K** keys to jump between the Layer Markers till the Timemarker is on your first Layer Marker. You will notice that both the **Timemarker** and the **Time-Remapping Thumb** in the Layer Window move simultaneously with the Timemarker in the Timeline (Fig. Time FX 4.15).

11 In the **Layer** window drag the **Time-Remapping Thumb** to the right till you see a new image that appeals to you appear in the Layer window. Notice that a new keyframe appears at that point in the Timeline (Fig. Time FX 4.16).

Fig. Time FX 4.15

Fig Time FX 4.16

12 Hi the **K** key to jump to the next layer marker and then drag the **Time-Remapping Thumb** to the right till you see the next image that appeals to you.

13 Continue doing this at each marker till you reach the end. You can move backward or forward to find the image you want, you can also repeat the same image now and then if you wish. Just make sure that the image changes to a new one on each marker. If you move to a marker which already has an image you want, create a keyframe at that point by either clicking in the Keyframe checkbox in the Timeline or by slightly moving the Time-Remapping Marker to register a change in value (Fig. Time FX 4.17).

Fig. Time FX 4.17

14 RAM Preview **0** to see the results. The images flash up in time with the music very rapidly in a 'scratch video' style. This technique makes it look as though a lot of frame-by-frame editing has been involved. For a definition of the term 'Scratch video' and a description of scratch-video techniques go to http://artengine.ca/scratchvideo/intro.html

It is important to have a keyframe at each marker in order to make the images jump in time with the music, to do this we are going to do what's known as Toggle Hold the keyframes so that the changes only occur on the keyframes and no where else, let me explain.

15 Go to **File > Save As** and, in the Save as dialog box, navigate to **Work in Progress > Chapter 04_Animation** folder. Save the Project as **Graffiti01b.aep**. We will come back to this project later so make sure that you save it here.

Toggle held keyframes

When using default keyframes, After Effects interpolates between the keyframes in a linear way. For example, if I was to animate a color from black to white over two seconds, After Effects would go through all the gray tones from one keyframe to the next, showing a gradual change in color over time. Toggle holding a keyframe forces the property to hold on the specified value till another keyframe is met to change the value. In our example, the color would stay at black for two seconds and then suddenly change to white.

Toggle holding a keyframe is very useful in situations where you want a property to switch suddenly from one value to another as opposed to changing linearly (or gradually). For example, if you want to animate lights flashing on and off, or if you want to create some sort of sudden movement. There are a couple of situations where Toggle holding your keyframes can prevent some sticky situations, I'll give you an example.

1 Open the project named **Toggle_hold.aep** from **Training > Projects > 04_Animation** folder.

2 With the **1_Position Composition** open, **RAM Preview 0** the animation of the square moving from left to right across the bottom of the screen.

Imagine that we want to move the red square to the top of the screen, for it to hold for 20 frames and then for it to move to its final resting place at the right side of the screen. Let's look at the wrong approach to this first to show you what can happen.

3 Go to two frame **64** (about half-way between the two keyframes, this will ensure that the path remains pretty even on both sides) and move the square to the top, center of your composition, holding down **Shift** to constrain the movement to a vertical one (Fig. Time FX 4.18).

The next logical step would be to move this keyframe 10 frames back and then copy and paste another keyframe 10 frames (making a total of 20 frames around the center of the curve), so let's try that.

167

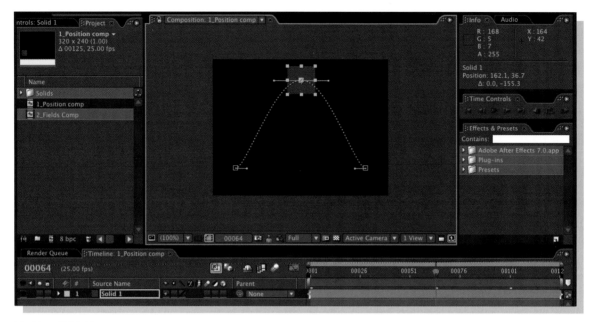

Fig. Time FX 4.18

4 Move the Timemarker to frame **54** which is 10 frames back from our current point by hitting **Shift**-**Page Up**.

5 Hit the **U** key to open up the keyframed properties in the Timeline, this will expose the **Position** keyframes (Fig. Time FX 4.19).

Fig. Time FX 4.19

6 In the Timeline, select the middle keyframe and drag it to the left till it meets the Timemarker (holding down the Shift key while dragging will snap it to the Marker).

7 Hit **Shift**-**Page Down** twice to move the Timemarker to frame **74** (20 frames ahead).

8 With the previous keyframe selected, hit **⌘ C** **ctrl C** or got to **Edit > Copy** to copy the keyframe followed by **⌘ V** **ctrl V** or go to **Edit > Paste** to paste the keyframe into the position of the Timemarker.

9 RAM Preview **0** the animation.

You will notice that, despite copying and pasting the same values for each keyframe, the object still moves when it is in between the two middle keyframes; it is not holding its position value constant between these two points. The reason for this is that we adjusted the curve after creating the final keyframe. If we had created the keyframes in the order in which they appear, we wouldn't have the same problem.

10 Take a look at this diagram (Fig. Time FX 4.20). I have zoomed in to the center keyframe with the magnifying tool and dragged the foremost keyframe up slightly so that you can see the curve in the path which causes this phenomenon.

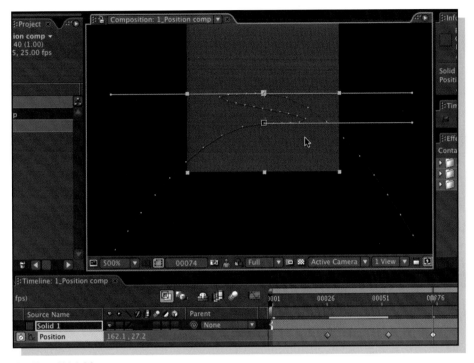

Fig. Time FX 4.20

11 To fix the problem, go to the **Timeline and** then **context-click** on the **second** keyframe, choose **Toggle Hold Keyframe** from the context-sensitive menu (Fig. Time FX 4.21).

12 RAM Preview **0** the sequence again and notice that we have cured the problem.

Using two non-toggle held keyframes to hold a property static can also lead to problems when rendering out to fields. Here's an example project to explain why.

Fig. Time FX 4.21

13 Open up **2_Fields Comp** and **RAM Preview 0** it. The blue square is jumping up and down between two points.

14 Select the blue **Solid 1** layer in the Timeline and hit the **U** key to open up all keyframes. Position keyframes which are set one frame apart are being used to prevent the square moving between the key points.

This looks fine at 25 frames per second but if you rendered this out using fields (50 fps), you'd see that there is a little hint of the square at the time between the two keyframes. I call this a 'ghost' field. I'll show you how it happens.

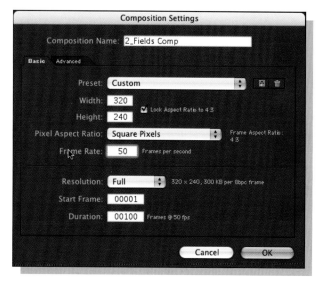

Fig. Time FX 4.22

15 Hit ⌘**K** *ctrl***K** to open the comp Settings dialog and then change the frame rate of the composition to **50 fps** (Fig. Time FX 4.22).

16 Move the Timemarker to frame **50** (between the first two keyframes) you will see that there is a single frame, in between the two keyframes, showing the intermediate position. This would be our 'ghost' frame which would appear when rendering out to fields.

17 Click the **Video** switch on for **Solid 2**; this layer is animated correctly, using Toggle Hold keyframes.

18 Select the green **Solid 2** layer and hit the **P** key to open up the **Position** keyframes for the layer (Fig. Time FX 4.23).

Fig. Time FX 4.23

19 **RAM Preview 0** the animation to see the blue 'ghost' square popping up between keyframes. This is the effect you would see if rendering out fields.

OK, Let's go back to our Graffiti Project.

1 Hit ⌘**O** *ctrl***O** or go to **File > Open Project**. Navigate to your **Work in Progress > Chapter 04_Animation** folder and open the project that you saved in the last section, **Graffiti01.aep**. If you did not save the file, there is a backup file in **Training > Projects > 08_Time FX > Graffiti01.aep**.

Fig. Time FX 4.24

2 Select the **[001-050].jpg** layer in the Timeline and then double-hit the **R R** key to display the **Time Remap** property. Select all of the **Time Remap** keyframes by clicking on the time Remap property name in the Timeline.

3 **Context-Click** on one of them and choose **Toggle Hold Keyframe** from the context-sensitive menu (Fig. Time FX 4.24).

4 **RAM Preview 0** the movie and notice that the cuts now happen in time with the music, with no linear changes in between.

24 Save the project to your Work in Progress > **Chapter 04_Animation** folder.

Make 'em dance!
Now let's use Time Remapping again to make me dance in time with some music.

1 Hit ⌘O `ctrl O` and then open the Project named **MacDonna02.aep** from **Training > Projects > 04_Animation**.

Here we have some footage of me showing off in front of my camera (it's a sad existence I know!) My plan was to composite this in front of the Princes Street footage so that it would look like I was dancing in the middle of the street.

The original footage was shot on DV, in order to fit all of the footage onto the accompanying DVD I have had to re-compress and re-size the movies. Because of this the keying is not as effective as if we had performed it on a full size, full quality original, but it will be good enough to demonstrate the following techniques.

2 Make sure that **01 Time Remap** Comp is active and **RAM Preview** *0* it. I have added some **Layer Markers** to the **MeDanceAlpha.mov** layer to mark the main beats of the music.

You may have noticed that I am not currently dancing in time with the music – almost but not quite! We'll use the Time-Remapping technique that we learnt earlier to make me dance perfectly in time with the music.

Fig. Time FX 4.25

3 Double-click the **MeDanceAlpha.mov** layer and make sure that you can see the Comp window and the Layer window at the same time. You can use the saved workspace that you saved earlier in this chapter (Fig. Time FX 4.25).

4 Select the **MeDance.mov** layer and then hit ⌘⌥T `ctrl alt T` to open the Time-Remapping property.

Notice that the *MeDance.mov* is longer than the length of the comp, in fact it is more than double the length of the comp at 126 frames. We will use this extra footage to speed up the dance and time it with the music.

5 Make the **Timeline** active and then hit the *K* key on the keyboard to jump to the **first** marker.

 If you change the frame rate of your comp or retime your animation by stretching out the keyframes some of your Layer markers may not sit exactly on the frames. I have retimed this animation so they're in between some frames; as a result, so when you hit *K* to move to the

Fig. Time FX 4.26

Fig. Time FX 4.27

next keyframe the Timemarker isn't right on the Layer marker, instead it is just to the left of or right of it, in this case it's not a problem.

The secret here is to look for the main moves of the dance. I move my hips from side to side so just look out for the frame before my hips begin to change direction.

6 Go to the **Layer** window and drag the **Time-Remapping Thumb** till you reach the next main move; I chose frame **14**. You can use the Source label in the Layer panel to identify the frame number that the thumb is on (Fig. Time FX 4.26).

7 Hit the **K** key again to jump to the **second** marker and move the **Time-Remapping Thumb** till you reach the point where the hips change direction again. I have it as frame **21**.

8 Repeat this process to change the Time Remap value at the **third** marker to **28**.

9 RAM Preview **0** the comp and notice that the music picks up energy after the third marker. The footage plays in triple time here to echo the increase in energy.

10 Move to the **fourth** marker and move the Time Remap Marker along till I have moved my hips backward and forward three times, I have this as frame **49** (Fig. Time FX 4.27).

11 Do this again at the **fifth** marker, with a value of **61**.

12 Change the Time Remap values at the **sixth** and **seventh** markers to **49** and **61**, respectively.

13 Finally, ignore the penultimate marker and go directly to the **last** marker and change the Time Remap value to 01.

14 RAM Preview **0** the comp, now I am dancing perfectly in time with the music but am looking a bit 'jerky', in more ways than one!

You cannot RAM Preview the time Ramapped layers in the Layer panel, so make sure you RAM Preview the Comp panel.

Frame Blending 2 – pixel motion

We can make the motion smoother by applying Frame Blending again. This time we'll use the second option, Pixel Motion to blend the frames to make the motion smoother. Pixel motion works by analyzing the pixels in intermediate frames and creating motion vectors from this information. This produces a much smoother result than frame mixing.

15 In the Switches panel, click **twice** on the checkbox under the **Frame Blending** Switch icon to activate **Pixel Motion** blending for the layer, this is represented by a continuous diagonal line in the checkbox (Fig. Time FX 4.28).

Fig. Time FX 4.28

As well as activating the **Frame Blending** Switch for the layer, you must also **Enable Frame Blending** for the whole composition. Frame Blending is very processor intensive and can really slow down your workflow if it is left on while you are working. The **Enable Frame Blending** Switch allows you to disable Frame Blending for the comp while still having the layer switches activated for the final render.

16 Click on the **Enable Frame Blending** button at the top of the Timeline to enable frame blending (Fig. Time FX 4.29).

Fig. Time FX 4.29

17 RAM Preview **0** the movie and notice that Pixel Motion Frame Blending does not produce the same 'trail' or 'echo' effect as the Frame Mix Frame Blending which has been used on the background footage. Notice that two different types of Frame Blanding can be used within the same composition.

 You will only see the true results of Frame blending on a layer if you preview the layer in best quality. Draft quality will not give you an accurate preview of the frame blending results.

Time effects

There are several other time-based effects in After Effects, we'll take a look at two of them here, Posterize time and Timewarp (Pro only).

Let's do the timewarp! (Pro only)

Timewarp is only available as part of the Professional version of After Effects and provides you with pin-point control of the playback speed of a layer. It works independently from Time Remapping and the Frame Blending in the Timeline. It allows you to animate the speed of your layer either using the traditional method of allowing you to specify frame values, and then working out the speed for you. Or you can use another method which is to set keyframes for the speed at which your footage needs to be played. This makes it much easier to have your footage playback at a certain percentage of the original speed.

Fig. Time FX 4.30

Fig. Time FX 4.31

Timewarp also includes other features to help you clean up your time-stretched footage including several interpolation methods, built in motion blur, smoothing options, and matte options.

1 If it is not already open, hit **⌘O** **ctrl O** and then open the Project named **MacDonna02.aep** from **Training > Projects > 04_Animation**.

2 In the **Project** panel, **double-click** the **03_Timewarp** comp to open it. This comp has the same footage of me dancing, this time we will use the **Timewarp** filter to do the retiming on the clip.

3 In the **Effects and Presets** panel **⌘5** **ctrl 5** type the word **Timew** into the **Contains** field at the top.

4 Drag the Timewarp effect from the **Effects and Presets** panel onto the **MeDanceAlpha.mov** layer in the **Timeline** (Fig. Time FX 4.30).

5 Go to **Window > Workspace > Effects** **Shift F12** to open up the Effects workspace. Hit **F3** to open up the Effect Controls panel if it is not visible.

6 Make sure that the **Timemarker** is at the beginning of the **Timeline** and then click on the stopwatch for the **Speed** property in the **Effect Controls** panel to set an initial keyframe (Fig. Time FX 4.31).

7 Change the **Speed** value to **0%** and then **RAM Preview** **0** the movie. With the Speed set at 0% the footage will not play.

8 Click on the **Timeline** to make it active and then **double-hit** the **U** key to open up any properties that have been adjusted from their default value. The Speed value should now be visible in the Timeline.

9 Move to **frame 11** and change the speed value to **200%** to set a new keyframe.

10 Click on the **Graph Editor** button at the top of the **Timeline** to show the Value graph for the speed value (Fig. Time FX 4.32).

Fig. Time FX 4.32

11 **RAM Preview** 🄾 to see the speed gradually build from 0% to 200% over the 11 frames.

12 Move the cursor to **frame 21** and ⌘ *ctrl* **Click** on the **dotted line** at **frame 21** to create a new keyframe with a value of 200%. This means that between these two keyframes, the movie will play at a constant speed of 200% (Fig. Time FX 4.33).

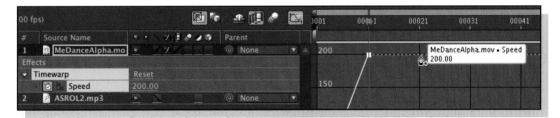

Fig. Time FX 4.33

13 Move the cursor to **frame 31 and** ⌘ *ctrl* **Click** again on the **dotted line** to create another new keyframe at **frame 31**.

14 Release the ⌘ *ctrl* key and then **click and drag** the new keyframe down till the speed is approximately **100**. As you drag a little yellow Info patch will appear next to the cursor to guide you. This tells you the current frame number, the current value, and also displays any differences in frame number and values (Fig. Time FX 4.34).

Fig. Time FX 4.34

175

Fig. Time FX 4.35

Fig. Time FX 4.36

Fig. Time FX 4.37

15 ⌘ *ctrl* – **click** on the path again at **frame 41** to add a new keyframe; then **release** the ⌘ *ctrl* key and then drag the keyframe up till its value is 200%. You should see a red snapping line appear as it snaps to the other keyframes at 200% (Fig. Time FX 4.35).

Easy ease button

After Effects provides you with buttons at the bottom of the Timeline for quick access to some of the most commonly used keyframe Assistants.

16 **Select all** keyframes by clicking on the **Speed** property name in the Timeline.

17 Click on the **Easy Ease** button at the bottom of the **Timeline** to easy ease the selected keyframes (Fig. Time FX 4.36).

18 In the **Effect Controls** panel click on the **Enable Motion Blur** checkbox. Motion Blur will slow down the rendering process considerably but will yield much smoother results (Fig. Time FX 4.37).

19 Change the **Shutter Control** menu to **Manual** and change the **Shutter Angle** value to **100** to reduce the amount of motion blur.

20 **RAM Preview** **0** to see the results of all your changes.

To find out more about this filter, and the others in this category you can visit the excellent Adobe After Effects online Help that is built into your application software.

21 Go to **Help > Effects Help** to open up the **Adobe Help Center** and go to the Effects section of Help.

22 Click on the **Time Effects Gallery** to open up example movies of all the Time effects (Fig. Time FX 4.38).

23 Click on the **hyperlinks** under each of the movies to open up explanations of each of the effects.

Fig. Time FX 4.38

Other time effects to find out about include the **Time Difference** effect, **Posterize Time**, and the **Time Displacement** effect (Pro only). Let's take a closer look at one of them.

Posterize time

1 If it is not already open, hit ⌘O ctrlO and then open the Project named **MacDonna02.aep** from **Training > Projects > 04_Animation FX**.

2 Open up the **04 Posterize Comp**. In this comp, the top layer has the Posterize Time effect applied to it but it is currently switched off.

This filter will lock the layer to a specified frame rate. By applying a setting of 2 fps, the movie will play back 2 out of 15 frames for each second of the comp. This filter overrides any effects or masks which are already applied to your layer so you must either apply it before you apply any other effects or apply it to a nested comp.

3 Select the top layer, **MeDancingAlpha.mov** and then hit **F3** to open up its **Effect Control** panel.

4 Click on the **Effect On/Off** switch to activate the effect. The default setting is 24 fps, the frame rate of film (Fig. Time FX 4.39).

5 **RAM Preview** *O* now and you will notice very little difference from the original movie.

Fig. Time FX 4.39

6 In the **Posterize Time Effect Controls** change the **frame rate** to 2.1.

7 **RAM Preview** *O* the movie to see the effect that you get from Posterizing the time of a layer.

We will take a look at some other time-based effects in the Effects chapter (Chapter 07). For now I'd like you to have a bit more practice with the things you've learnt in this chapter.

8 If you want to, you can **Save as** a copy of this project into your **Work in Progress** > **Chapter 04_Animation** folder as **MacDonna02b.aep**.

Recap

So you can see that time-based effects can be used in very effective ways, retiming edits, applying different 'looks' to your video or animation, you can improve dancing skills or simply adjust the timing at which events appear to happen, you can even make characters talk (we'll be looking at lip-synching techniques in the Expressions chapter – (Chapter 11)).

Go and take a break away from the computer for half an hour to clear your mind and to give your eyes a rest. Have a little think about whether you can incorporate any of these ideas into your chosen project. Write down any ideas you may have, sketch down any visual ideas. When you return from your break, start to experiment with your ideas to see if they'll work.

Joan Armatrading

Inspiration – Joan Armatrading

Singer/songwriter Joan Armatrading was awarded an MBE in 2001. She was nominated twice as Best female vocalist for the Brit awards and also nominated twice for the American Grammy Award of Best Female Vocalist. She received the Ivor Novello award for Outstanding Contemporary Song Collection in 1996. She wrote a tribute song for Nelson Mandela and sang it to him in a performance with the Kingdom Choir. Joan has received numerous platinum, gold, and silver albums and consistent enviable critical acclaim.

www.joanarmatrading.com

Q How did your life lead you to the career/job you are now doing

A I think I was born to make music that's the basic answer. How I started to write my own music was my mother buying a piano for the front room because she thought it was a goodpiece of furniture. I just started to make up my own turns as soon as it arrived. I'm self-taught on the piano and guitar.

Q What drives you to be creative

A See above answer. I think I was born to it. The drive basically has to do with creating without even knowing properly why I want to. Everything inspires. It could be something that I see, something that someone says or just a riff I doodle on the guitar.

Q What would you be doing if not your current job?

A I love what I do and I feel lucky to be doing something as a career that I love so much so the answer is I wouldn't want to be doing anything else.

Q Do you have any hobbies/interests and if so, how do you find time for them?
A I like to watch TV, when I can. I like to go for walks and if I ever get the time do nothing.

Q Can you draw?
A It depends. Sometimes it looks OK other times it looks like the cat drew it.

Q If so, do you still draw regularly?
A No I don't draw much.

Q What inspires you?
A Any and everything.

Q Is your creative pursuit a struggle? If so, in what way?
A No it's not a struggle. I tend to only get draw into any creative writing when the muse takes me. I don't really say it's 9 a.m. therefore I should go and try and write a song. I tend to just wait. So this means sometimes I don't write for months on end because nothing is inspiring me. At those times I just wait until something does.

Q Please can you share with us some things that have inspired you. For example,; film, song; web site; book; musician; writer; actor; quote; place etc.
A I wrote a song called Everyday Boy when I met someone who was dying of AIDS. He was a very genuine person and inspired me to write the song about him the instant we met.

Q What would you like to learn more about?
A All kind of things, more history, more about the Internet, more about playing the guitar, and more about creating the better song.

Q Do you have any other tips for people venturing out on a creative career?
A Especially in creative activities it's important to be honest with yourself. Be truthful about whether you really have the talent to do the thing you are tying to do at the standard you are aiming for. If you have the talent, then don't let anyone put you off trying to get to the height you are striving for.

Chapter 05 **Compositing**

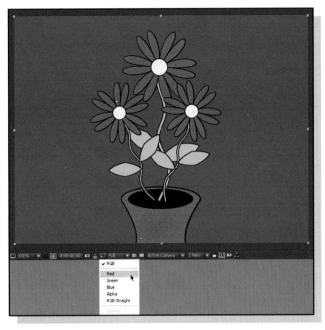

Fig. 5.1

Synopsis

Compositing is the process of layering images or movies together to create a new image or movie. There are several methods of compositing images together. In this chapter we'll explore many ways of combining images including the use of masks, blending modes, layer switches, and keying effects. We'll start by looking at channels which are fundamental in all types of compositing work; understanding how channels work will greatly enhance not only your After Effects skills but also your general understanding of how to successfully manipulate digital images.

Channels

When designing for television or any other screen-based medium, you usually work with RGB images. RGB images are made up from three, 8 bit, grayscale images, called channels. Each image is made up of a red channel, a green channel, and a blue channel. When these three grayscale channels are blended together they make up a full color image.

1 Open **Channels.aep** from **Training > Projects > 06_Compositing**.

Here you will see a simple composition containing a single image of flowers. In this RGB image there are very definite areas of red, green, and blue, we'll use this as an example to help you understand channels. It will be much easier to see the channels in this image as it only uses flat red, green, and blue (with a sprinkling of pure black for the outlines) (Fig. 5.1 RGB image).

Fig. 5.2

We can take a look at the three channels from our image of flowers to see how they compare with each other. In the following diagrams you can see the individual color channels that make up the image of the flowers. The areas that are white contain most of the color, the darker areas contain less of the color.

2 In the **Comp** panel, click on the **Show Channel** menu and choose **Red** from the list.

Each grayscale channel determines how much of each color will be used in the final image. Where there is white in the channel, the respective color will show at 100%. Where there is black, there will be none of the color. Where there is 50% gray, there will be 50% of the color and so forth. Notice that the Flowers and the Vase are pure white in the display, this is because they contain 100% pure red. The yellow centers of the flowers are also pure white. This is because pure yellow is made by combining 100% red and 100% green. The rest of the image is pure black as there is no red contained elsewhere (Fig. 5.2).

When you view a single channel in the Comp panel two things indicate this. The appearance of the Show Channel button changes to reflect whatever color channel you are viewing and a colored line runs horizontally across the top and bottom of the Comp panel to remind you that you are viewing a single channel. These lines will be the color of whatever channel you are viewing, either, red, green, or blue. When you view a full color RGB image there are no lines displayed. When you view only the Alpha channel the lines will be either white for a premultiplied alpha or yellow for a straight Alpha channel. If you are unfamiliar with Alpha channels, don't worry, we'll be looking at them in more detail a little later in this chapter.

3 In the **Comp** panel, click on the **Show Channel** menu and choose **Green** from the list **(the green channel)**.

The green channel, displays pure white on the stalks and leaves of the flowers as they are pure green. The yellow dots in the center of the flowers are also white as they contain a mix of 100% red and 100% green.

4 In the **Comp** panel, click on the **Show Channel** menu and choose **Blue** from the list **(the blue channel)**.

Compare this to the flowers in the blue channel. Everything in this image is black except for the background which was pure blue in the original image and is therefore pure white in the blue channel.

Here are three diagrams of the channels displayed in their own colors to help you understand what each channel is contributing to the image in terms of color (Fig. 5.3):

- The red channel – notice that the flowers contain a lot of red.
- The blue channel – hardly any blue in the flowers but lots in the blue background of course!
- The green channel – the leaves and the centers of the flowers contain most green.

RGB colors are also known as additive colors. Each channel ranges from 0 (black) to 255 (white). When all three channels are at 255 (maximum value), pure white will be the product; when all are at 0 (minimum value), you get black; the higher the values, the stronger the colors, hence the name additive colors.

Our RGB image of the flowers is a 24-bit image, what does this mean?

There are three channels: red, green, and blue:

$24 \div 3 = 8$ which gives us a total of 8 bits in each of the RGB channels.

A bit has two possible values; black or white:

2 to the power of 8 = 256 which means that each channel has 256 possible levels of gray.

These three channels are then combined to make one 24-bit image (2 to the power of 24), which gives us about 16.7 million possible colors in each RGB image.

In After Effects you can view the individual channels of an image by clicking on the channel display buttons in either the Composition or Layer panels.

It is important to understand the significance of channels and grayscale images because they are integral to the manipulation of images and movies in both Photoshop and After Effects. As well as being able to adjust an image by altering the channels, you can use grayscale information in a variety of creative ways.

Fig. 5.3

For example, in an RGB image, the red channel tends to contain the contrast information, the green contains most of the detail information, and the blue channel contains most of the noise. Therefore, if your image is noisy then blur only the blue channel or substitute the blue channel with a copy of the green to reduce the noise without losing the contrast and clarity of your image.

The Show Channels menu in the Comp panel is only for displaying the channels that make up your image. Any changes made to the image while viewing in this mode will affect the whole RGB image. In order to manipulate the channels of the images or movies in After Effects you must use the effects.

Channel effects

5 In the **Project** panel, double-click the **02_Channel blur** comp to open it.

This contains a clip from the Macdonna movie that was shot on DV and has since been re-compressed in order to fit onto the DVD, as a result the footage is full of artifacts making it really difficult to key. The object of this exercise is to remove the blue background so that we can replace it with a new one. We'll be looking at Keying in more detail later in this chapter, here we'll just take a look at some channel effects that can help you improve your footage before using keying effects. These techniques are particularly useful if you have the Standard version of After Effects and have no access to high-end keying tools.

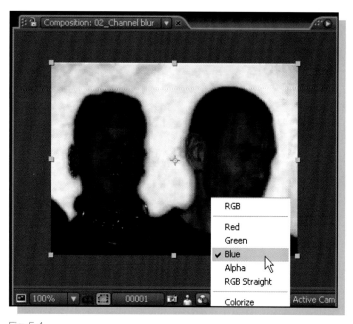

Fig. 5.4

6 Select the **Closeups.mov** layer in the **Timeline** and then hit **F3** to open up the **Effect Controls** panel.

7 In the **Composition** panel, click on the **Show Channel** menu and then, one-by-one select each of the color channels to see what they look like individually. Notice that the **Blue** channel contains more edge artifacts than the other layers. Finish with the Blue channel displayed (Fig. 5.4).

8 In the **Effect Controls** panel you'll notice that there are several effects applied to this layer but that all of them are switched off. Click on the **Effect switch** on the **Channel Blur** effect to switch the effect on. This effect is from the **Blur & Sharpen** group of effects, it allows you to blur the channels of your image individually (Fig. 5.5).

Notice, in the Comp panel, that the blue channel now looks quite blurred because the **Blue Blurriness** setting has a value of 8 (Fig. 5.6).

9 In the **Composition** panel, click on the **Show Channel** menu and then, one-by-one select the Red and Green channels to see what they look like individually. Notice that they are still un-blurred.

Fig. 5.5

10 Change the **Show Channel** menu to **RGB** to see the results of combining the blurred Blue channel with the other channels. The edges of the people are blurred without affecting the features too much (Fig. 5.7).

11 Switch on the **Color Range** effect to key out most of the blue background. This is a keying effect included in the Standard version of After Effects. It works by removing pixels based upon a user-defined range of colors; you'll learn how to use this effect later in the 'Keying' section of this chapter.

There is still a blue halo around the image but you can use other effects from the **Effects > Channel** menu to reduce this (Fig. 5.8).

Fig. 5.6

Fig. 5.7

Fig. 5.8

185

Mattes

We've learnt that all 24-bit RGB images are made up of three channels, which are essentially grayscale images. You will discover, as you progress through the tutorials in the book, that grayscale images are very important in digital compositing. They are used in all sorts of creative ways, one of them being the use of mattes. A matte is an image or movie, which is used to tell the compositing software of which areas in your image or movie should be transparent and which should be opaque. Black represents areas you wish to be transparent, white represents areas you wish to be opaque. It follows that 50% gray represents 50% opacity and all other shades of gray represent all the other percentages of opacity between 0% and 100%. This allows you to mix the images together into a composite image.

Many applications, including After Effects, allow you to import these mattes as separate layers, and to use the grayscale information to affect the transparency of the main layer. A lot of royalty-free footage comes with a separate matte which can be used in this way. You can also create mattes for footage yourself in Photoshop, Illustrator, or After Effects itself.

Any image can be used as a matte but with grayscale images it is easier to predict how the values are going to affect the transparency. Think of it as a way of selecting areas to be transparent without losing the original information in the RGB channels. These mattes are sometimes referred to as 'stencils' by people who use proprietary broadcast systems. You will learn how to use these mattes as stencils in the Track Matte section of the Text chapter (Chapter 08), for now we'll concentrate on the tools that can help you refine your mattes.

 For more information about mattes, see the 'About transparency' in the 'Masks, transparency, and keying' chapter of the After Effects online help system.

Minimax

The Minimax effect can be used to grow or shrink the matte for a specified channel.

12 Switch on the **Minimax** effect to trim the halo and open the effect to see the settings (Fig. 5.9).

Fig. 5.9

I have adjusted the **Operation** menu to **Minimum**, this setting will *shrink* the edges of the matte, *Maximum* would *grow* the edge of the matte.

A **Radius** value of **2** will *reduce* the edge by 2 pixels.

The **Channel** menu allows you to determine which channel is affected by the Operation, in this case the **Alpha** channel. We'll talk a little more about Alpha channels shortly.

Finally I've checked the **Don't Shrink Edges** checkbox so that the operation does not affect the edges of the layer.

Alpha channels

Another way of saving mattes is to embed them into the associated image file. You can save certain file types (such as picts)

as 32-bit images. These images contain a fourth grayscale channel called an Alpha channel. An Alpha channel is a matte which is embedded into a separate channel in your image. Like a separate matte, it contains information about which areas of an image you want to be transparent and which you want to be opaque. Alpha channels are convenient to use as they are embedded in your image and therefore don't need to be imported as a separate image.

Every layer in After Effects has an Alpha channel to determine areas of transparency and opacity, this happens automatically. Anything that affects the transparency of a layer will also affect the Alpha channel of the layer e.g. Masks, Keying, and any effects which alter the shape or transparency of your layer. You can view the alpha information by clicking on the **Show Channel** display button in the Composition panel or in the Layer panel, let's see how the keying has affected the Alpha channel of our layer.

13 In the **Comp** panel, click on the **Show Channels** menu and choose **Alpha** from the list (Fig. 5.10).

Fig. 5.10

Notice that the white areas are the opaque areas in the image, the black areas are the areas that have been removed by the color Range keying effect. Pixels that are completely opaque will be displayed as 100% white, transparent pixels will be displayed as 100% black, and semi-transparent pixels with 50% opacity will be represented by 50% gray.

Some of the proprietary film and broadcast systems do not support embedded Alpha channels, so if you are supplying footage to one of these systems you must export the Alpha channels as a separate matte. This can be done during rendering from After Effects by simply choosing **Composition > Add Output Module** to add more than one Output module to the current render. You can use the extra output module to export the matte as a separate file. There are detailed instructions on how to use the Render Settings and Output modules this way in the final chapter of this book.

To be absolutely sure that you are outputting exactly what is required you should always check with the individual companies about the limitations of the editing system you are outputting for.

14 In the **Effect Controls** panel, switch on the **Channel Blur 2** effect and then open the effect to see the settings. I've applied the channel Blur effect again but this time I have chosen to blur the Alpha channel of the image, notice how the edges of the Alpha are blurred.

15 In the Comp panel switch the **Show Channels** menu to **RGB** to see the results.

16 In the **Effect Controls** panel, switch on the **Shift Channels** effect and then open the effect to see the settings. I've applied this to remove the last traces of blue from the edges of the characters by switching the Blue channel for the Green channel (Fig. 5.11).

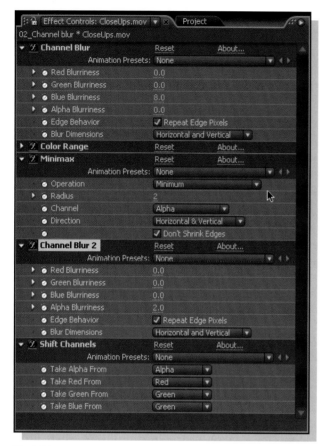

Fig. 5.11

17 Switch on the **Transparency Grid** to see the image composited against a checkerboard background (Fig. 5.12).

Just when you thought you knew everything there was to know about Alpha channels … I'm sorry to say it but there are two types of Alpha channels, straight and premultiplied.

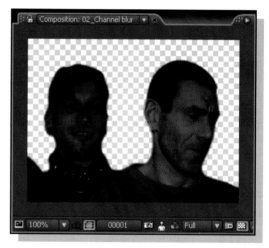

Fig. 5.12

Straight alpha

A straight Alpha channel has the transparency information only in the Alpha channel of the image. The other three channels of the image remain unchanged and are therefore 'unmatted' when saved from the application where they originated.

18 Open the **02_Straight comp** from the Project panel. This comp contains a simple pict file, created in Photoshop. The edges of the text have been feathered.

19 Select the **Alpha_Straight.pct** layer in the **Timeline** and then go to **Edit > Edit Original** ⌘ E ctrl E . This will open the image in Photoshop (or your system's default image-editing application).

When the image opens up in Photoshop it looks very different. In fact it looks like a solid layer of pure red. That's exactly what it is, in fact the only thing that determines the edges of the text is the Alpha channel.

20 In **Photoshop** go to the **Channels** panel and click on the fifth channel, named **Alpha 1**. This is the Alpha channel, when imported this tells After Effects which pixels to make transparent.

21 In the **Channels panel**, click on the **Load Channel as Selection** button. You will now see a selection outline around the letter's edges (Fig.5.13).

22 Click on the **RGB channel** again to see the full color image with the selection.

23 Go back to After Effects and notice that the edges of the letters are very clean, there are no stray pixels of any other colors.

Fig. 5.13

With a straight Alpha channel the anti-aliasing does not take place till the image is imported into After Effects. After Effects reads the alpha information and makes transparent any areas determined by the alpha channel. The edges of the straight matte are anti-aliased against transparent pixels in After Effects and can therefore be placed against any color of background without problems. Straight Alpha channels are usually the most versatile to use, as the Alpha channel has not been used to alter the RGB information, leaving it open to change.

Premultiplied alpha

In a premultiplied image, one, or all of the other RGB channels in the image were altered using the alpha information. The alpha information may have been used to make a selection and then this area may have been either deleted or filled with a color.

24 Open the **03_Premultiplied** comp form the Project panel. Notice that the edges of the text have a white halo around them (Fig. 5.14).

This image has been 'matted' before leaving the original application. The edges of premultiplied matte are anti-aliased against the

Fig. 5.14

background color. This makes them generally less flexible as the RGB information has been changed before the file is saved for export, making it more difficult to adapt the original without running into problems.

25 Select the **Alpha_Premult.pct** layer in the Timeline and then go to **Edit > Edit Original** ⌘ E / ctrl E (Fig. 5.15).

189

Fig. 5.15

Fig. 5.16

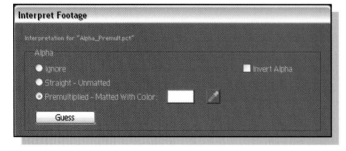

Fig. 5.17

In this image, the area selected by the Alpha channel has been filled with white pixels. When this happens, the edges separating the subject from the background are anti-aliased (or smoothed). In Photoshop, creating a soft, blended edge between the foreground and background color, this can create a halo effect if the alpha is not correctly interpreted when importing it into a compositing environment. After Effects can fix this problem by removing all traces of the specified color from the RGB image.

26 Go back to **After Effects** and notice how the image has been imported. After Effects has recognized the Alpha channel but has interpreted it wrongly as a **Straight** Alpha channel. You change the way that After Effects interprets the Alpha channel in the **Interpret Footage** dialog.

27 Go to the **Project** panel and open the **Source files** folder. There, context-click on the **Alpha_Premult.pct** image and go to **File > Interpret Footage > Main** ⌘ F ctrl F (Fig. 5.16).

28 In the **Alpha** section, choose **Premultiplied – Matted With Color**.

29 Next to this you will see a color swatch. Click on the color swatch and change the color to pure white (the color of the background in the original image) and then click **OK** to leave the Interpret Footage dialog (Fig.5.17).

All traces of white are removed from the anti-aliased edges, leaving us with a nice clean composite.

 This works fine in cases when the background has pretty even color, but in cases where the background is multicolored, this can create problems as After Effects can only remove a single color.

Many 3D animation applications can only use premultiplied Alpha channels, in these cases you must try to keep the background as evenly colored as possible to make it easy for After Effects to remove the color. The general rule that I use is to use straight alphas wherever possible.

Photoshop, After Effects, and Illustrator are some of the few applications to support Straight Alpha channels. After Effects will be able to tell what type of Alpha channel has been saved if the image was created in Photoshop or Illustrator as the images are tagged accordingly. If your image was created somewhere else you may have to tell After Effects which type of Alpha channel it is in the Interpret Footage dialog box.

There are several effects that are useful when working with Alpha channels, we have already looked at some of them and will look at more as we work with several of them, as we work our way through the book. As I cannot cover every effect in this book I have had to select what I consider to be the most useful to you for the tutorials within this book.

Remove color matting

The Remove color matting effect removes a specified color from the anti-aliased edges of your alpha but will do it as an effect in the Timeline rather than to the file in the Project panel. It removes the original background color from the edges, the color is determined by using an eyedropper tool or color swatch.

Luminescent premultiplied

Sometimes when rendering 3D animations with light glows or lens flares, interpreting the alpha as premultiplied will not be enough to remove the matted color and you may still see a dull edge to your image. If this ever happens to you, interpret the footage as having a straight alpha and apply the Luminescent Premultiplied Blending mode, it should clean up the edges nicely for you.

 For more information regarding Alpha channels, please refer to the 'About alpha channels and mattes' and 'About straight and premultiplied channels' in the 'Transparency overview' in the After Effects help system.

Masks

As well as importing ready-made mattes and Alpha channels into After Effects, you can create your own mattes inside After Effects by using masks.

Masks are user-defined shapes which mask out areas of your image. The term comes from traditional photography where a masking solution would be painted on to the negative to 'Mask out' the exposure of certain areas.

Masks can be drawn within After Effects, using Bezier drawing tools, which are very similar to those used in Photoshop and Illustrator for drawing paths. Masks can also be copied and pasted from any application that supports paths.

Note to copy and paste paths from Illustrator you must make sure to have the Illustrator preferences setup to do so. With the default Illustrator preferences don't preserve paths when copying and pasting. To fix this open Illustrator and then, on the Mac go to the Illustrator menu or on Windows, go to the Edit menu. Here choose **Preferences > File Handling & Clipboard**. Make sure that **AICB**

Fig. 5.18

(no transparency support) and **Preserve Paths** are both checked. Now you will be able to copy a file in Illustrator and then paste it into a layer in After Effects (Fig. 5.18).

Masks, like any other element in After Effects can be animated over time. They can also be stroked or filled with color and are also used to control some effects which we will look at in the Effects chapter (Chapter 07).

You can create an unlimited number of masks on each layer of your comp and you can combine these masks in different ways by using the Mask Modes. You can also feather, or soften, the edges of your masks.

Masks can be used to isolate part of your layer when no matte or Alpha channels exist. They can also be used to animate shapes over time or to control how effects are applied when combined with adjustment layers.

There is so much to learn relating to masks that I suggest that you follow this chapter up by going through the 'Masks, transparency, and keying' section of the After Effects online help system.

Seattle evening news

1 Open **SeattleNews01.aep** from **Training > Projects > 06_Compositing**.

2 RAM Preview the **Edit.prproj** Composition. The comp consists of several movie clips and stills edited in time with the music (Fig.5.19).

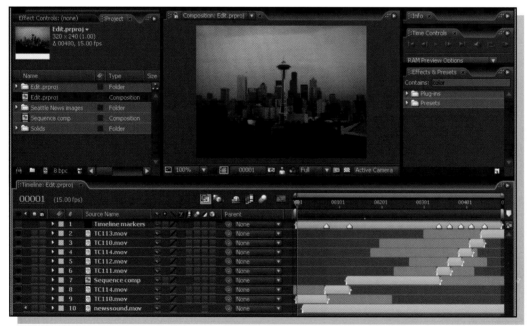

Fig. 5.19

The problem here is that the images are very disparate, the composition contains a mishmash of images which don't really look as though they belong together. A big part of the problem is the fact that all have been shot using different camera equipments, some clips are DV, some analog video, and others are stills shot with SLR cameras. Another big problem is with the color of the images. When an artist paints a picture, he/she will choose colors to build the picture with, he/she may do this by instinct, but there is still a decision-making process involved.

The trouble with our job is that we are often provided with a lot of source material that has been shot by other people. There's often a good chance that we are not involved in decisions about lighting, color schemes, etc. It is our job to pull these bits and pieces together into something more unified. There are several ways of doing this using colors and overlays to give all the individual bits of footage a common thread throughout.

We are going to use masks, layer modes, and later, expressions to create an effect layer to place over the Edit.preproj sequence, bringing all the clips together in a delicious design fusion! Let's start by building some new footage.

Solids

There is a popular misconception that you must have some source footage before you start working in After Effects, but this is not true. In After Effects you can create raw footage from scratch by using Solid layers, these are plain, colored layers which can then be animated and transformed by altering properties and applying masks and effects.

3 Create a new composition, name it **Masks Comp** and check that the composition size is **384 × 288**, slightly bigger than our Edit.preproj comp. Pixel Aspect Ratio should be set to **square pixels**. The **Frame Rate** should be **15 fps** and **Duration** should be **480 frames**.

4 To create a new solid, make sure that the Timemarker is at the beginning of your composition and then go to **Layer > New > Solid** or hit ⌘ Y ctrl Y to bring up the Solid Settings dialog box.

5 In the **Solid Settings** dialog box, type in **Gray Masks** for the Solid name, change the width and height to **300 pixels,** and then choose a **gray** of about **70% brightness** for the color (Fig.5.20).

> You can do this by eye if you feel confident but if you are unsure, simply enter values of 0% each for Hue and Saturation, and of 70% for the brightness value in the Color picker.

Idea! Solids are created and then saved into the Project panel in a folder named Solids, this means that you can set up animations using solids (which are quick to render) and then replace them with other movie or image files.

Solids are always rectangular or square but you can create Solids of virtually any shape by using masks. Masks alter the Alpha channel of your layer. The size and shape of a mask is defined using the Mask Tools

Fig. 5.20

in the tool panel. These include the Pen tool and the Rectangular Mask tool and the Elliptical Mask tool. You will be familiar with these tools if you have ever drawn paths in Illustrator or Photoshop.

Drawing masks

Masks are most commonly used to isolate (or *mask out*) parts of your image that you either want to be visible or transparent. You define the area by drawing a path around it using Bezier controls. This technique is called *Garbage Matting* and you can find out more about it later in the Keying section of this chapter.

As I said earlier, masks can also be used in conjunction with certain filters to create shapes, animations, and effects. In this example we will use the Mask modes in conjunction with the Layer modes to create our own custom effect.

There are several ways of drawing Masks, each has its own pros and cons. It is useful to be aware of all of the techniques available to you. I'll show you a few in this exercise and some more in later exercises. We will start by drawing some basic shapes.

In the Comp panel

The easiest method is to draw your masks directly into the Composition panel.

Fig. 5.21

6 Select the **Elliptical Mask** tool from the **Tools** panel. The Elliptical Mask tool is grouped with the Rectangular Mask tool and can be accessed by clicking and holding on the Rectangular tool till it reveals itself on the pull-out strip (Fig. 5.21).

A quicker way to access these tools is by using a keyboard shortcut. You can toggle between the Rectangle and Elliptical Mask tools by repeatedly hitting the **Q** key on your keyboard.

7 Once selected, double-click the **Elliptical** tool in the **Tools** panel, this will create a default Elliptical mask exactly the same size of your layer. With the **Gray mask** layer selected in the Timeline, hit the **M** key to display the **Mask Shape** properties.

Fig. 5.22

If your mask is not showing in the **Comp panel**, click on the **Composition** panel **wing menu** and choose **View Options** (Fig. 5.22). In here, make sure that the Masks checkbox is checked (Fig. 5.23).

Notice that a default oval-shaped mask has been created with exactly the same dimension as your layer. Notice that areas outside the mask are transparent, areas within the mask are solid.

8 Switch on the **Transparency Grid** button at the bottom of the Comp panel to see the transparent areas more clearly. Switch it off again before continuing with the next section.

In the Layer panel
Masks can also be drawn directly in the Layer panel.
There may be times, when working with complex
compositions, that drawing masks directly in the
Composition panel is impractical for the following
reasons. In these situations I find it much easier to draw
masks in the Layer panel:

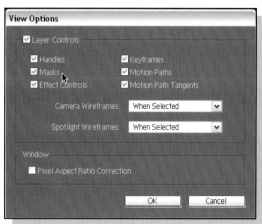

- When a layer's edge extends outside the edge of the
 composition window and is not visible, the Layer
 panel will show the whole layer.
- Effects and transformations will be rendered on to the
 layer when viewed in the Composition panel, often
 making it difficult to see exactly what you are doing.
 The Layer panel allows you to choose what is
 displayed in it via the View menu.

Fig. 5.23

- In After Effects masks are applied before Effects and
 Transformations so any masks you add to a layer will be applied to the layer in its original state.
 The Layer panel can show you the original file before any Effects and Transformations are applied.
- You don't have to wait for all the other layers in the Comp panel to refresh while drawing your mask.
- When one or more layers obscure the layer that you wish to edit in the Comp panel, the Layer
 panel shows it in isolation.

For these reasons I usually prefer to draw my masks in the Layer panel where I can see the complete,
original layer.

9 **Double-click** the **Gray masks** layer in the Timeline to open up its Layer panel (Fig. 5.24).

Fig. 5.24

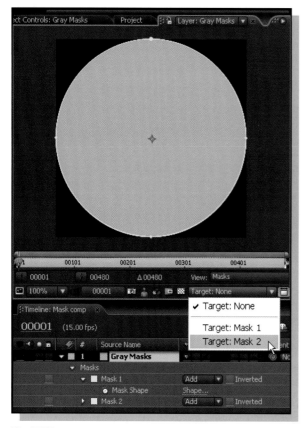

Fig. 5.25

I usually prefer to have my Layer panel alongside my Comp panel so that I can see them both update simultaneously. It also avoids any potential confusion between the two panels that can often arise when you are new to After Effects.

10 Click on the left Tab handle of the Layer panel and drag it onto the **Project** panel till the center of the Project panel is highlighted in blue, then release the mouse to dock the panel.

We are now going to create another new mask but before we do it's important to make sure that Mask 1 is de-selected.

11 Click the **Gray Mask** layer's name first to de-select **Mask 1** and then double-click the **Elliptical** Mask tool to create a new Elliptical Mask the same size as your layer.

> Double-clicking the Mask tools with an existing mask selected can lead to confusion as it does not create a new mask, it just edits the existing mask.

12 To prove that you have two masks, look in the **Target** menu at the bottom of the **Layer** panel, this is one place where you can select masks to make them active. There should be two masks listed in this menu (Fig. 5.25).

13 Select **Target: Mask 2** from the **Target** menu. If you do not have two masks undo your steps and start again, making sure that Mask 1 is de-selected; repetition is the best way to learn!

14 With **Mask 2** selected, hit ⌘ T ctrl T or go to **Layer > Mask > Free-Transform Points**. A bounding box will appear around your mask. This bounding box allows you to move, rotate, or reshape your mask using only one tool, the standard Selection Tool.

> The cursor changes as you move it over different parts of the bounding box. Hover outside the edge of the bounding box boundaries and the cursor will become the Rotate icon, clicking and dragging now would rotate the mask. Hover directly over the handles and the cursor will change to the Scale Tool.

15 Make sure that the Info panel is visible and then click on any of the corner handles when you see the Scale icon. Drag toward the center of the layer, and after you start dragging, hold down the ⌘ ctrl key and the Shift key simultaneously. The **Info** panel will show you information about the amount of scale you are using, stop dragging when the display reads about **68%** of the original scale (Fig. 5.26).

> In After Effects version 7 there appears to be a bug with the Info panel meaning that it does not update as you are adjusting the mask. This should be fixed in later revisions but meanwhile I'm afraid you will just have to use the trial and error approach if you are experiencing this bug.

This is a tricky maneuver so you may need to practice it a few times but it's definitely worth persevering with. Dragging toward the center of the layer will scale your layer down. Holding the

Fig. 5.26

⌘ *ctrl* key while dragging will force the mask to scale around its center point. Holding down the *Shift* key while dragging will constrain the scale, so that it scales equally on both the X- and Y-axes.

16 Hit the **Enter** key on the number pad of your keyboard to accept the changes you've made.

To create a third mask we'll copy and paste Mask 2 and then adjust it using the Mask controls in the Timeline.

17 Make sure that the **Mask Shape** properties are displayed in the Timeline (**M**).

As well as using the Target menu in the Layer panel to select your mask you can also select them by clicking on their names in the Timeline.

18 In the **Timeline**, try clicking on the **Mask Names** one at a time and watch as they are selected in both the **Layer** and **Composition** panels (Fig. 5.27).

A mask is made up from Vertices which are represented by the little points dividing the mask into segments. When a whole mask is selected the shape of all the vertices change from circular dots to solid squares. You may also have noticed that one of the vertices is bigger than the others, this is the first vertex drawn, we'll see why this is important later.

19 When you have finished make sure that you have **Mask 2** selected and then hit ⌘ **C** *ctrl* **C** or go to **Edit > Copy** to copy the selected mask to the clipboard.

Fig. 5.27

You can lock the existing masks to prevent you from accidentally replacing them with any new masks.

20 Click in the **Lock** checkboxes for each mask. These are situated underneath the padlock icon in the **Audio/Video Features** panel of the Timeline.

21 Hit ⌘ **V** ctrl **V** or go to **Edit** > **Paste** to paste the new **Mask 3** onto the layer.

22 De-select the layer and then re-select **Mask 3** by clicking on its name in the Timeline and then hit ⌘ **T** ctrl **T** to apply the Free-Transform bounding box to the mask.

The selection of Mask properties can be a little awkward and perhaps even a bit buggy. In my experience it's always best to make sure that the correct mask is selected by de-selecting and then re-selecting the item.

Fig. 5.28

23 Use the same technique as you used in **step 11** to scale the mask down by about **48%** and then hit the **Enter** key to accept your changes (Fig. 5.28).

Mask modes

In the Switches panel of the Timeline you'll notice that each mask has a Mask Mode drop down menu where you can choose different ways of combining the masks to make them interact with each other in different ways.

These modes work independently from Blending modes, it is important not to get the two menus confused. Mask modes can be applied individually to each mask. Each mode will have a different result depending on the content of both the layers it's applied to, and the layers above and below it in the Timeline. Any overlapping masks will have their opacities combined, creating the impression of one solid block.

The default mode is Add, which will add the contents of the mask to the Alpha channel, making any pixels outside the masked area transparent. The Mask modes, like Layer modes cannot be animated over time.

24 **Unlock** all masks and then make sure that they are de-selected by clicking the layer's name.

If you change the Mask mode with all masks selected, it will change the mode for all selected layers.

25 Using the **Mask Mode** drop down menu, change **Mask 2**'s mode to **Subtract** (Fig. 5.29).

This mode will have the effect of subtracting any pixels within the specified mask from the layer. You can see that Subtract mode does the opposite to Add mode by making the pixels within the mask transparent in the Alpha channel. By combining masks with different modes you can start to create new shapes which would be much more difficult to create with only one mask.

26 Create another new solid ⌘Y ctrl Y.
Name the new layer **White Masks**. Change the size
to **260 × 260 square pixels** and the color to **white**.

27 Go to the **Gray Masks** Layer panel. Select all
of the masks by hitting ⌘A ctrl A or dragging a
marquee selection around all of the masks.

28 Hit ⌘C ctrl C to copy them to the
clipboard.

29 In the **Timeline**, double-click the **White
Masks** layer to open up its **Layer** panel and then hit
⌘V ctrl V to paste the masks into the new layer.

30 Without leaving the **White Masks Layer** panel
hit ⌘A ctrl A to select all of the masks followed by
⌘T ctrl T to bring up the **Free-Transform** box.

In earlier versions of After Effects you may need to
click in the pasteboard area of the Layer panel before
hitting ⌘A ctrl A to make the Layer panel active.

As we discovered earlier, Free-Transform allows
you to perform different transformations on your
masks using one tool. You can use it on specified
points of a mask, on the whole mask or, as in this
case, on Multiple masks.

31 Move the cursor over one of the corner
handles, it will change again to a scaling tool. With
this tool active, click and drag the corner handle

Fig. 5.29

inward to re-size all of the masks. Hold down the ⌘ ctrl key while dragging to scale around the
center point, hold down **Shift** while dragging to maintain the correct aspect ratio (Fig. 5.30).

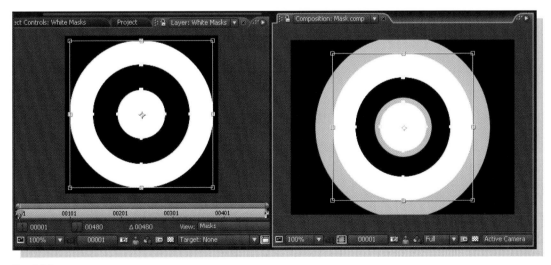

Fig. 5.30

You should re-size the masks till they fit snugly inside the Composition panel; about 82% of their original size should do it. You can watch the Composition panel update as you drag to get a real-time preview of the scaling. You can use the Info panel to get a precise reading, in percentage of how much you are scaling the selection by.

32 When you are happy with the result, either hit the **Enter** key on the number pad of your keyboard or double-click inside the bounding box to accept the changes.

33 In the **Timeline**, select the **White Masks** layer and hit the **M** key to open up the **Mask Shape** properties.

In some earlier versions of After Effects you needed to first de-select the masks and then change **Mask 2's** mode to subtract as previous versions did not retain the Mask mode when copying and pasting.

To make life easier when working with Multiple masks you can change the label color so that they are easier to distinguish. In my example I've chosen primary colors for the white layer (red, yellow, and blue) and secondary colors for the gray layer (green, orange, and purple). This way, it is easy to tell which mask belongs to each layer.

34 To change the mask's label color, simply click on the **Mask's colored label** in the **Timeline** and choose another color from the color picker. Do this for all of your masks. Change the **Gray Mask** layer masks to the primary colors; **red, yellow**, and **blue**; change the **White Masks** layers masks to **purple, orange**, and **green**, the secondary colors (Fig. 5.31).

Fig. 5.31

There is a **Cycle Mask Colors** preference in **Preferences > User Interface Colors** which will automatically cycle the colors of your masks to make it easier to distinguish them from each other. This works by using the **Label Colors**, which are also set in the preferences.

We'll now combine the layers together using Blending modes.

35 Click on the **Transfer Controls (Modes)** button at the bottom of the **Timeline** panel to open up the **Modes** column.

36 In the **Modes** column change both layer's modes to **Difference** and notice how the layers now react differently with each other. Your results may vary depending on the shade of gray that you chose for the **Gray Masks** layer (Fig. 5.32).

37 Go to **File > Save as** and, in the Save as dialog box, navigate to your **Work in Progress** folder on the desktop and save the project into the **06_Compositing** folder as **SeattleNews02b.aep**.

Nesting

1 Open SeattleNews02.aep from the Compositing folder, in **Training > Projects**.

We now have three separate compositions within this project; the Sequence comp and the **Edit.prproj** comp which we put together in Import chapter (Chapter 03) and the **Mask** comp, which we have just finished building.

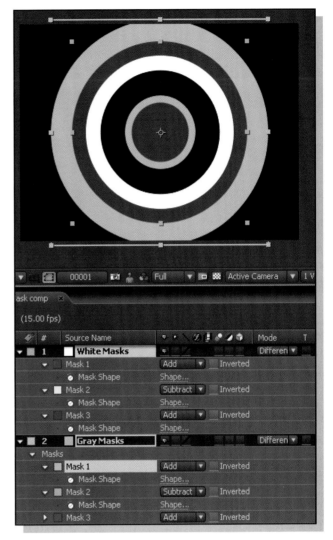

Fig. 5.32

When designing for Television, or in fact any medium, the composition of elements on the screen is very important. Good composition will draw the viewer's eye and keep their attention focused on what you want them to see.

In this case we are going to base the design around the center of the screen. This can sometimes have a tendency to make the screen appear quite small and the design become too dominating. Later in this book we will be animating the discs in and out from the center. This will bring the diagonals into play a little bit more than with a static image and will carry the viewer's eye around the screen.

So, by combining Masks, Layer Modes, and Effects we have created an interesting geometric image. We will now nest this image into our footage sequence to bring it all together. We can use it as an overlay and we can then apply color treatments to pull the whole thing together into a cohesive sequence.

Fig. 5.33

2 Open up your **Edit.prproj** Composition from the **Project** panel and make sure that the Timemarker is at the beginning of your Timeline.

3 Go to the **Project** panel and, instead of dragging the comp to the Timeline or Composition panel, drag the **Masks** Composition icon directly onto the **Edit.prproj** Composition icon in the **Project** panel, this will place it into the **Edit.prproj** composition as the top layer (Fig. 5.33).

Collapsing transformations

Usually when you nest one composition into another, Blending modes inside the nested composition are rendered as pixels before being brought into the main composition, therefore the Blending modes in the nested comp do not interact with the layers in the main composition. However we can bring these modes through to the main comp by **Collapsing Transformations** for the layer.

Under normal circumstances all Blending modes and transform properties will be calculated and applied in the comp that they were originally set in, the result is that these are rasterized and then rendered pixels are placed into the new comp as a single layer. Once this is done successive effects and transformations can be applied to this as they can be to any other layer.

If you collapse transformations for a nested composition After Effects will perform all the transform and Blending mode calculations for both the current layers, and the layers in the nested comp, in one single process. This can reduce rendering times and avoid degrading the image as all transformations are calculated and then applied only once.

There are many situations where collapsing transformations can be useful and these are mentioned throughout the book in appropriate places. To find out about collapsing transformations for the basic transform properties you can look in the **Precomposing** section of **Chapter 07 Grouping** and to see how it affects working with **effects** see **Chapter 09, 3D**.

You can also find a good general explanation of collapsing transformations by going to **Help > Compositions > Nesting > to collapse transformations in a nested composition.**

4 Click on the **Collapse Transformations/Continuously Rasterize** layer switch in the **Timeline**. Now you will see the Blending modes, which were applied to the layers in the Masks comp, applied to the underlying layers in the **Edit.prproj** comp (Fig.5.34).

Fig. 5.34

5 **RAM Preview** the composition along with its new layer.

The shapes composited on top of the footage are constant throughout the sequence, giving the piece a common theme throughout. The varying colors of the source footage are still a problem but don't worry, I'll show you ways of fixing this problem in Chapter 09 3D.

6 Go to **File** > **Save as** and, in the **Save as** dialog box, navigate to your **Work in Progress** folder on the desktop and save the project into the Nesting folder as **SeattleNews03b.aep**.

Editing nested comps

Our design problem here is that we need something to break up the circles and accentuate the diagonals. One way of doing this is to divide the screen into quarters. Normally, this would be too rigid a design but remember that the circles will be moving in and out, pulling the design together. This is an example of using two designs which on their own may be too strong but used together can produce something both simple yet visually exciting. We'll start by creating one more masked layer.

1 Open SeattleNews03b.aep from **Training** > **Projects** > **Compositing** folder.

2 Hold down the alt key as you double-click on the **Masks Comp** layer in the Timeline to open up the nested comp for editing the layers within.

You can also open up a nested comp by clicking on its icon in the **Project** panel.

3 Make sure that the Timemarker is back at the beginning of your composition and then create another white solid by hitting ⌘Y ctrl Y. Change the solid name to **Square Masks** and click the **Make Comp Size** button to make sure that the layer is exactly the same size as the composition. This time we will draw our masks directly in the Comp panel.

The option for viewing and editing masks in the composition can be toggled on and off in the **View Options** section, the **Composition** panel **wing menu**. This menu allows you to toggle on and off your display settings as well as allowing you to access to some of your Composition settings (Fig. 5.35 and 5.36).

4 Go to **View** > **Show Rulers** and then make sure that your **Info** panel is visible.

It is a good habit to get into using rulers, guides, and grids to set up your compositions, particularly if you are working with precise geometric shapes as we are about to do here. Guides can be dragged out from the rulers and positioned anywhere within the Composition panel.

Fig. 5.35

Fig. 5.36

Using rulers and guides

You can create custom guides by clicking on either ruler and dragging inward toward the comp away from the ruler. The **Info** panel can be used to track the positional values while you are dragging the guides.

5 Drag the horizontal guide from the top ruler, placing it at **144** pixels on the **Y**-axis, so that it crosses the center of the layer (Fig. 5.37).

Don't worry if you don't get it exactly right the first time, once the guide has been created, it can then be moved simply by clicking and dragging it. Be aware that you may need to unlock the guides before adjusting them by going to **View > Unlock Guides**.

Fig. 5.37

6 Drag a vertical guide from the left ruler and place it at **192** pixels on the **X**-axis. Your guides should meet at the center point of the layer (Fig. 5.38).

7 Once your guides are in place, with the Comp panel active, go to **View > Lock Guides** to prevent you from accidentally moving them.

8 Go to the **View** menu and make sure that the **Snap to Guides** Option is ticked. This will ensure that any new layers or masks will snap to the guides that you have just created.

Fig. 5.38

Fig. 5.39

9 Select the **Rectangular** Mask tool and draw a mask from just outside the top, left corner of the screen to the center point of the layer, you should feel the new mask snap to your guides (Fig. 5.39).

10 Repeat the last step again, this time drawing from the **center** to the **bottom, right** of the composition.

11 Change the Layer mode to **Difference** to divide the screen into quarters (Fig. 5.40).

Fig. 5.40

Your composition should now look like the one illustrated here. Difference Mode will subtract the value of the top layer's channel pixels from the bottom layer's channel pixels. This produces similar results to inverting the images color channels, producing an effect comparable to a photographic negative.

12 Click on the **Edit.prproj** tab in the Timeline to open up the main composition and notice that the changes you made to the nested comp have been updated in this composition.

13 Go to **File > Save as** and, in the **Save as** dialog box, navigate to your **Work in Progress** folder on the desktop and save the project into the Nesting folder as **SeattleNews04b.aep**.

The Pen tool

You can also draw freehand shapes as masks by using the Pen tool from the Tool panel. This can take a bit of practice and is possibly one of the most difficult things to master in After Effects. But investing time in learning how to control Bezier curves will pay dividends to your After Effects workflow as they control not only mask shapes but also motion paths. Learning how to control them will make you a much better and more confident After Effects expert!

Fig. 5.41

1 Open **Compositing. aep** from **Training > Projects > Compositing folder**.

2 Make sure that the **01a_Bezier practice** comp is open and that you can see its Composition panel and Timeline (Fig. 5.41).

Here we have a still frame taken from some footage that has been provided by Artbeats, my favorite royalty-free footage company. (Image Reference number: MN120 NTSC.mov.) You can find out more about Artbeats and search through their extensive footage at: http://www.artbeats.com

 To save a still frame for a movie or comp, move the Timemarker over the frame that you wish to save and then go to **Composition > Save Frame As** and choose either **Frame** (to save as a flat image file) or **Photoshop layers** to save a multi-layered frame for editing in Photoshop.

Drawing straight lines

Drawing straight lines is easy, simply click to determine the Vertices and After Effects will draw a straight line between the clicks. In this example I want to isolate the drums from the background so that I can composite some new footage behind. In order to do this I need to draw lines and curves using the Pen tool.

3 Select the **Pen** tool from the toolbar and make sure that the checkbox labeled **RotoBezier** in the **Toolbar** is *unchecked* (Fig. 5.42).

Fig. 5.42

4 Move the mouse cursor onto the image and keep an eye on the value in the **Info** panel as you do so. Move over to the right edge of the layer just above the right-most drum and then click when the **Y** value reads **180**, and a **first mask vertex** will appear (Fig. 5.43).

Fig. 5.43

5 Click once again on the **bottom-right** corner of the layer to create a second vertex, After Effects will draw a straight line between the two vertices (Fig. 5.44).

6 Click once more on the **bottom edge** of the layer, where the left-most drum cuts off the edge of the screen (Fig. 5.45).

Fig. 5.45

Fig. 5.44

Fig. 5.46

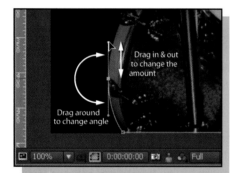

Fig. 5.47

Drawing curves

You can create Bezier curves by clicking and dragging when you draw your Vertices. This is a bit tricky but the more you practice, the more you'll get the hang of it.

7 Click and drag upward on the apex of the curve on the left edge of the lower-left drum. You want to drag the cursor across the edge of the curve, in the direction that you are drawing. Imagine you are dragging an elastic band, watch where the curve moves and notice what makes the changes (Fig. 5.46).

Dragging the handles around the vertex changes the angle of the curve (Fig. 5.47). Dragging the handle into and out from the vertex changes the amount of the curve.

8 Click once again where this drum meets the next drum to create a corner point and complete the curve (Fig. 5.48).

The aim here is to follow the line of the curve. Don't worry about the controls on the edge of the drums, we can add additional masks later to select these awkward areas.

9 Click and drag to the left on the apex of the curve on the bottom edge of the next drum to follow the curve on the bottom edge of the drum (Fig. 5.49).

Fig. 5.48

Fig. 5.49

Fig. 5.50

Fig. 5.51

10 Click and drag upward on the edge of the layer, where this drum is cut off by the edge of the comp to finish off the curve (Fig. 5.50).

Adjusting Bezier curves

You may have noticed that, up to this point, the handles have always remained parallel to each other on either side of the vertex, producing an even curve. You can break the handles so that a different angle can be achieved on either side of a vertex. This is useful where you may have a curve on one side of the vertex but a straight line on the other side like we have here.

11 Move the cursor over the left handle that you last created and notice that the cursor changes to the **Convert Vertex** tool.

12 Click and drag the handle to line it up with the edge of the comp. Notice that the other side of the curve is not affected by the adjustment (Fig. 5.51).

13 Click once on each of the **seven** points that mark the edge of the drum in the top-left corner, adjusting the handles as you did before if necessary (**illustrated in** Fig. 5.52).

Fig. 5.52

If you make a mistake, don't worry, just undo and try again till you get it right – remember, practice makes perfect!

14 Click and drag a curve around the rim of the top-left drum, on the edge where it meets the symbal (Fig. 5.53).

I've also taken the extra step of changing the **Mask Color** here by clicking on the little color swatch next to the Mask Name in the Timeline, this makes it stand out against the background a little better. You can do this at any time, even while you are in the middle of drawing your mask.

15 Click and drag the handle extending from the last vertex you drew so that the curve hugs the edge of the symbal (Fig. 5.54).

Fig. 5.53

Fig. 5.54

16 Click and drag the top edge of the curve going around the symbal. You should be able to define this curve with only three points. The aim to efficient masking is to define your shapes with as few points as possible (Fig. 5.55).

17 Click and drag on the right edge of the symbal, drag the handle downward till the curve looks correct.

18 Click once on the point where the symbal meets the percussion instrument. Notice that the curve is too steep and does not look correct (Fig. 5.56).

Fig. 5.55

Fig. 5.56

19 Move the cursor over the handle which extends from the last vertex you drew. Again, the cursor changes to the Convert Vertex tool. Adjust the handle by dragging it in toward the vertex till the curve is corrected, this will maintain the angle of the curve but will change the amount of curve (Fig. 5.57).

20 Click once at the edge of the percussion instrument and the right-most drum.

21 Finally click once on the first point you drew to close the mask. Notice that when you hover over the first mask created, the cursor changes to show you will be creating a closed mask shape (Fig. 5.58).

Fig. 5.57

You can also make adjustments to the Mask shape after it has been drawn. You have access to all the individual masking tools in the Toolbar but I prefer to access them all by using modifier keys. This way I can keep the Pen tool selected and toggle between the different tools as I need them. This takes a bit of getting used to, but is the best way to work efficiently with the mask drawing tools.

Fig. 5.58

To access the selection tool hold down the ⌘ *ctrl* key as you hover over a vertex. Remember that if all vertices are selected, then all of them will move if you click and drag them with the selection tool. To de-select vertices, hold down the ⌘ *ctrl* key and the S key as you click on a point.

22 Hold down the ⌘ *ctrl* key and the S key as you click on the last point you drew, this will de-select it.

23 Hold down the ⌥ *alt* key as you hover over the selected vertex to access the Convert Vertex tool again. Using the shortcuts, make any adjustments to the mask you deem necessary.

Adjusting mask properties

Masks have basic properties that can be animated over time, these are Mask Shape, Mask Feather, Mask Opacity, and Mask Expansion.

1 Open the **01b_Bezier end** comp to see the masks that I have drawn to compare them with yours. I've added an extra mask for the space in the center of the drums (Fig. 5.59).

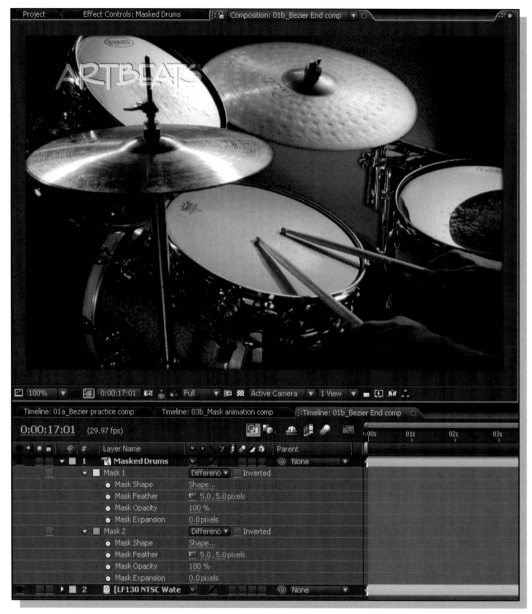

Fig. 5.59

2 To access the Mask properties, select the **Masked Drums** layer and then **double-hit** the **M** key on your keyboard. Or you can open each mask individually in the Timeline by clicking on the Twirly next to the Mask name.

3 Change the **Mask Feather** setting to **5%**, notice the edges of the mask are now softened.

4 Finish by making any adjustments to the settings that you wish. Scrubbing the **Mask expansion** value will move the feather inside or outside the mask edge.

The Mask Opacity value will adjust the Opacity of the pixels controlled by the mask.

5 Save the file into your **Work in Progress** folder as **Masks02.aep**.

As you've seen, Bezier masks give you a massive amount of precise control with shapes but they can be tricky to animate. Because of this, After Effects team have supplied us with some great features for assisting in the animation of masks.

RotoBezier masks

New to After Effects 6.0 was the option to draw RotoBezier masks. These are also made up from vertices but the vertices do not have handles, instead, each vertex has a tension setting to determine how much it curves. RotoBezier masks are generally easier to animate as the curves are worked out automatically. The downside to them is that it is a little bit more tricky to define precise shapes with them, you'll tend to need more vertices to get the shapes you want.

6 Open the **01b_RotoBezier practice** comp from the **Project** panel. We will trace the same image using **RotBezier** so that you can experience the differences between the two methods.

7 From the **Toolbar, select** the Pen tool **G** and this time, make sure that **RotoBezier** checkbox is ticked (Fig.5.60).

With RotoBezier, you do not have to click and drag to create curves, they are automatically created as soon as you have drawn at least three vertices. Using this method it is easier to draw the vertices first, then make adjustments afterwards.

Fig. 5.60

8 Create a new mask by clicking once on each main point that we clicked on the first time we drew the Bezier mask. Notice that curves are automatically created between the vertices. Don't worry that the shape is completely wrong, we will tidy it up in the next few steps (Fig. 5.61).

9 With the Pen tool still selected, hold down the

Fig. 5.61

key and the **Shift** key while you click on the last vertex that you drew to de-select it. The **⌘** **ctrl** key modifies the **Pen** tool to the Selection tool. The **Shift** key modifies this to allow you to **Add to Selection/Remove from Selection**.

Doing this will de-select the vertex, leaving all other vertices selected. If we now click on the vertex again it will select the vertex and de-select the others.

Fig. 5.62

10 Let go of the **Shift** key but still hold down the **⌘** **ctrl** key to re-select the vertex and adjust the position of it by clicking and dragging.

11 Let go of the **⌘** **ctrl** key and then hold down the **⌥** **alt** key to modify the **Pen** tool as you hover over the vertex. It will become the **Adjust Tension Pointer** which allows you to determine how curved the line is going through the vertex (Fig. 5.62).

12 Click and drag to the left and then right to adjust the tension of the vertex, notice the effect dragging has on the line traveling through the vertex. When you have finished experimenting, drag it all the way to the left to make the tension **100%** (you can see the **RotoBezier Tension** value in the Info panel as you drag).

13 Hold down the **⌥** **alt** key and single-click on the next vertex (at the bottom right of the screen), don't drag it this time. Doing this will set the vertex to a corner point with 100% tension. Do this to the next vertex also (Fig. 5.63).

Fig. 5.63

14 **⌥** **alt** click on the next point and then again to see it change from corner point to a smooth point with 33% tension. Clicking will convert from one state to another, finish with a corner point.

The following section is quite difficult because each side of the drum should be a corner point but we need to follow the curve in-between them. If we were using Bezier curves (Curves 1) two or three vertices would suffice for this curve, but with RotoBezier we need four vertices to get the correct shape.

Curves

15 Move the **Pen** tool over the path, on the segment between the next two vertices (without any modifier keys held down). The cursor will change to an **Add Vertex** tool (Fig. 5.64).

16 Click once on the path to add a new vertex.

17 ⌘ *ctrl* click and drag the new vertex to the left so that it touches the rim of the drum.

18 ⌥ *alt* click and drag on the new vertex to adjust the tension all the way to the right, making it 0% tension, a smooth point.

> You can also adjust the tension of a vertex by using the convert Vertex tool in the same way as we have done here.

19 ⌥ *alt* click on the vertex at the other corner where the drum meets the edge of the drum above it (Fig. 5.65).

20 Adjust the position of the vertices along this curved segment by ⌘ *ctrl* clicking and dragging them till the curve fits nicely along the edge of the drum. Remember that sometimes, in order to get a curve you must first set corner vertices at each side, then add a new smooth vertex in-between to create the curve.

21 Continue around the path using the various tools to adjust the path. Remember that you can use the tools directly from the Tool panel if you prefer if you don't like using modifier keys. However modifier keys (Fig. 5.66) are worth persevering with as they will speed you up tenfold!

Fig. 5.64

Fig. 5.65

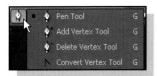

Fig. 5.66

22 Open the **01d_RotoBezier** End comp to see how many vertices I had to add to achieve the curves, and it's still not perfect by any means (Fig. 5.67).

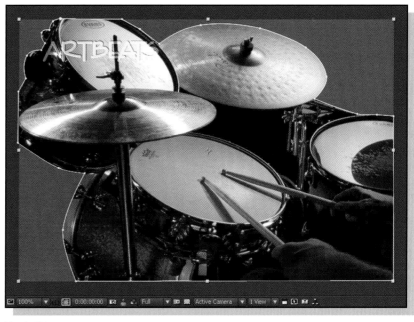

Fig. 5.67

So, to summarize, RotoBezier masks are great for drawing simple shapes and are great for animating as they automatically adjust curves between keyframes.

But shapes can be drawn more easily and accurately using Bezier masks but they are more difficult to animate as they have vertices and handles to deal with.

Experience using both of these types of mask drawing will increase your confidence in deciding which one is suitable for each job you encounter. Try practicing on different images; cars are good images to practice on as they have lots of lovely curves!

Auto-Trace

Auto-Trace is a godsend to anyone finding it a nightmare to successfully isolate an object from its background using traditional masking techniques.

While attending trade shows and seminars, many people have asked me how they can separate a person from a background using masks. Of course it is much easier to use a chroma-keying technique for this purpose, but what about those occasions when you just don't have that option? Perhaps somebody was shot against a moving background or a well-intentioned but naïve director asked for the subject to be shot against black, white or worse still, red!

Well, masking is the next best thing for isolating a subject, but it's a notoriously tricky process which involves a lot of time and patience. However the Auto-Trace feature combined with the Smart Mask Interpolation panel can remove some of the tedious path work and help you to achieve better results when masking the human form (or any other organic shape for that matter).

1 Open **02_Auto-Trace Start** comp and **RAM Preview** the composition. Here we have a dancer silhouetted on a black background. (Make sure that you have the Loop button switched on in the Time Controls panel.) (Fig. 5.68).

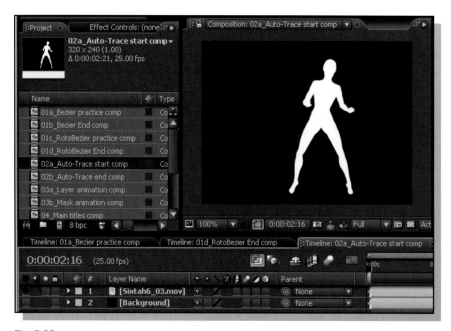

Fig. 5.68

Notice that the movie does not loop perfectly – there is a slight jump from the start frame to the last frame. My idea is to use this movie in the Sixties project that I mentioned in the Workflow.pdf (in the DVD > Extras folder) chapter. I want to create a group of dancers who will dance continuously throughout the title sequence therefore I need to loop the movement. I am going to use Smart Mask Interpolation to loop the dancer's body shape from the first frame to the last, creating a more fluid movement between the two.

2 Move the Timemarker to the beginning of the Timeline and select the **Sixtah6_03.mov** layer.

3 Go to **Layer > Auto-Trace** to open up the **Auto-Trace** panel (Fig. 5.69).

4 In the **Time span** section click on the **Current Frame** radio button, this will trace only the current frame. You can also set it to trace the whole Work-area if necessary.

5 In the **Options** section check that the settings are as follows: **Luminance** from the **Channel** menu, **Tolerance** to **1**, **Minimum Area 10** pixels, **Threshold 50%**, and **Corner Roundness** to **30%**.

6 Finally, click on the **Apply** to new layer checkbox and then click **OK** to trace the luminance values of the frame.

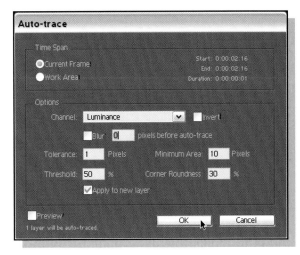

Fig. 5.69

A new layer will now appear at the top of the Timeline with a new mask applied to it.

7 With the new layer selected, hit the **M** key to open up the **Mask Shape** property (Fig. 5.70).

8 Solo the **Sixtah6_03.mov** layer by clicking on the **Solo** switch in the **A/V Features** column (Fig. 5.71).

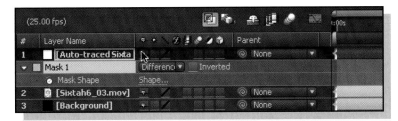

Fig. 5.70

Fig. 5.71

9 Move to the last frame of the **Sixtah6_03.mov** by selecting it in the Timeline and then hitting the **O** key to jump to its **Out** point (Fig. 5.72).

10 With the **Sixtah6_03.mov** layer selected, go to **Layer > Auto-Trace**. When the **Auto-Trace** box appears click **OK** to accept the same settings as before. (The Auto-Trace box will remember your previous settings.)

We now have two layers, one each for each mask shape we created. Now we must animate between the Mask Shapes on a single layer. To do this we will copy and paste the Mask from one layer to the other.

11 Switch off the **Solo** button on the **Sixtah6_03.mov** layer and then select **Layer number 1**, the one you have just created.

12 Hit the Home key to jump to the beginning of the Timeline and then **⌥ Shift M alt Shift M** to open up the **Mask Shape** property and simultaneously **create a keyframe** at the first frame.

We now need to copy and paste the mask shape from the other layer into this mask shape to animate between the two shapes.

Fig. 5.72

Fig. 5.73

13 Click on **Layer number 2** to make it active and then click on the property name that reads **Mask Shape** (Fig. 5.73).

14 Hit ⌘C ctrl C to copy the **Mask Shape** to the clipboard.

15 Click once on the Mask Shape property on **Layer number 1** and then double-click the layer name to open up the **Layer** panel.

16 Hit the **Home** key on the keyboard to jump to the beginning of the layer and then change the **Target** menu to **Target: Mask 1** (Fig. 5.74).

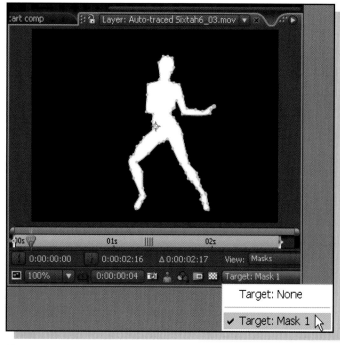

Fig. 5.74

17 Move to the **frame 5** and then Hit ⌘V ctrl V to paste the new mask into the **Mask Shape** property, creating a new keyframe. Hit Spacebar to preview the mask shapes animating.

18 In the **Timeline** Select **Layer number 2** and hit the **Delete** key to remove it, we don't need it anymore.

In order to create our loop we must line up the beginning of the new layer with the last frame of the movie layer.

19 Select the **Sixtah6_03.mov** layer and hit the **O** key to jump to its **out** point.

20 Select **Layer number 1** and then hit the **I** key to make it is **in** point jump to the Timemarker.

The Work-area
There may be times when previewing or rendering that you want to limit it to a shorter section of the Timeline, you can

do this by adjusting the Work-area. The Work-area defaults to the duration of the comp you are working in but can be adjusted to suit.

To change the Work-area you can drag the start and end Work-area markers in the Time Ruler to a new location in the Timeline (Fig. 5.75).

Fig. 5.75

You can also move the Work-area by clicking and dragging the center of the Work-area bar left or right (Fig. 5.76).

21 Drag the **Work-area markers** in so that they line up with the keyframes on layer number 1, **Auto-traced Sixtah6_03.mov** (Fig. 5.77).

22 **RAM Preview** the animation, notice that the RAM Preview plays only the frames within the Work-area.

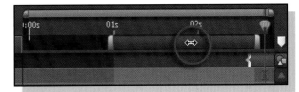

Fig. 5.76

You can expand the Work-area to the size of the composition by double-clicking the center of the Work-area bar.

23 **Extend** the **Work-area** to the full duration of the comp by double-clicking on the center part of it.

There are also several keyboard shortcuts for setting the Work-area

Set beginning of Work-area to current time – **B**.
Set end of Work-area to current time – **N**.
Set Work-area to the selected layers (or to the composition duration when no layers are selected) – **⌘ O B** **ctrl A B**.

Fig. 5.77

24 Make sure all **Solo** buttons are switched off so that you can see all layers and then **RAM Preview** the comp to see an improvement in the looping movie.

We now have an interpolated shape from the last frame back to the first frame but as you can see, it's not the best interpolation and looks very weird – this is where Smart Mask Interpolation can help!

Smart Mask Interpolation – pro only

Smart Mask Interpolation is only available in the Professional version. Standard version users who wish to follow this tutorial can download a 30-day tryout version of the After Effects professional version from the Adobe web site at www.adobe.com in order to try out this feature, otherwise skip this section and continue to the Blending modes section.

Animating masks in After Effects has always been a tricky business. Anyone who has attempted to isolate a moving object using masks will certify to that! But don't despair; help is at hand in the form of several masking improvements provided in the last few revisions of After Effects. One of the major new features added to version 5.5 was The *Smart Mask Interpolation* panel.

Many of us have encountered problems with the way mask shapes interpolate when they are animated; masks are not layers and therefore animate differently from layers. Unlike a layer, each

point on a mask will move to its new position by following the shortest path available (or 'as the crow flies'). Let's take a look at an example project that illustrates this phenomenon.

1 If you do not have it open already, open the **Compositing.aep** project from **Training > Projects > 06_Compositing**.

2 Open up the comp named **03a_Layer animation** comp. You should see a composition containing a small white layer measuring 50 pixels square (Fig. 5.78).

3 Hit the **0** key on the number pad to **RAM Preview** the animation.

Fig. 5.78

Fig. 5.79

In this example the movement is achieved by animating two individual properties, position, and rotation. The square rotates as it moves across the Comp panel. Let's have a go at achieving the same result using a masked shape.

4 In the **Project** panel, open the second example, **03b_Mask animation** comp. This comp contains a red layer that's the same size as the composition. This layer has a mask applied that is 50 pixels square.

5 Select the layer and hit the **M** key to open up the **Mask shape** property, notice that a keyframe has already set at the beginning of the layer (Fig. 5.79).

6 Move to the last frame of the Timeline by hitting the **End** key.

7 Make sure that the mask is selected (if not, click on its name in the Timeline) and then hit ⌘ T ctrl T to apply the Free-Transform tool.

8 Move the mask to the opposite corner of the screen by clicking and dragging inside the bounding box. You can nudge the Mask 1 pixel at a time by using the arrow keys on the keyboard (holding down **Shift** as you hit the arrow keys will move the mask in increments of 10 pixels) (Fig. 5.80).

9 Move the cursor over one of the corner handles of the bounding box. You will see it change to a **Rotation** tool icon.

Fig. 5.80

10 Click and drag on the corner handle to rotate the mask by **180 degrees** – so that the top-left corner replaces the bottom-right corner (Fig. 5.81).

 The **Info** panel should provide you with feedback on the Rotation of the mask but this is broken in version 7.0; hopefully this will be fixed in the next update to the software.

11 Scrub through the animation and notice that the points all merge toward the center at frame 75 which is approximately half way through the comp. This is because all of the points are following the quickest route from one position to the next. In other words, they are following linear vertex paths. Look at the following illustration to see how the paths are drawn between points (Fig. 5.82).

Fig. 5.81

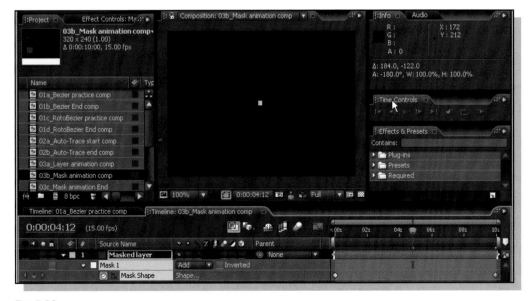

Fig. 5.82

Fig. 5.83

Because there is only one property to animate (Mask Shape) After Effects figures out the most direct way of getting from stage one to stage two. This is where the Smart Mask Interpolation tool comes in handy, giving you options to change how the mask shapes are interpolated.

12 Move the Timemarker to **0:00:04:12** and then select both keyframes by clicking on the **Mask Shape** property name in the Timeline. For Smart Mask Interpolation to work, both keyframes being interpolated must be selected.

13 Go to **Window > Smart Mask Interpolation** to open up the **Smart Mask Interpolation panel** (Fig. 5.83).

14 In the **Smart Mask Interpolation** panel, uncheck the box that reads **Use Linear Vertex Paths**. Doing this will prevent After Effects from mapping a straight line between the points.

15 Uncheck the **Add Mask Shape Vertices** checkbox.

This option is for adding vertices to complicated shapes to improve interpolation. In cases like this, where you have a relatively simple shape transforming into another very similar shape, adding vertices can sometimes produce unexpected results. I always recommend trying the assistant with this option turned off to begin with.

16 Click Apply and watch as After Effects interpolates between the mask shapes, creating a new mask shape for each frame of the animation (Fig. 5.84).

Fig. 5.84

17 Hit the **Spacebar** on your keyboard to preview the animation and the masks. Notice that the square now appears as if it is rotating correctly.

Interpolating complex shapes

Let's take another look at our animation of the dancer. We'll use the Smart Mask Interpolation panel to improve the interpolation between our existing mask shape.

18 If it's not already open, open the **Compositing.aep** project from **Training > Projects > 06_Compositing**.

19 Open up the comp named **02b_Auto-Trace end** comp and **RAM Preview** the animation to remind you what you have already done.

20 Select the **Dancer** layer and then hit the **U** key to open up all keyframed properties (Fig. 5.85).

Fig. 5.85

21 Move the Timemarker so that it sits half way between the two keyframes on the **Dancer** layer. You will notice that the mask shape is not as it should be at this point.

22 Select both **Mask Shape** keyframes by clicking on the **property name (Mask Shape)** on the **Dancer** layer.

23 Go to **Window > Smart Mask Interpolation** and, in the SMI panel, change the **Bending Resistance** to **80%**.

This setting determines whether the mask shape tends toward either bending or stretching to get to the next shape. With a high-bending resistance the shape will tend more toward stretching than bending. If you study how the figure should move between the two points you'll see that more stretching than bending is required. Often the best way to work out the required setting is by trial and error but studying the animation carefully helps.

24 Change the **Quality** setting to **80%**.

This setting determines how the vertices match up. With a setting of 0%, each vertex in the start shape will match exactly with its corresponding vertex in the end shape. With a setting of 100, each vertex can match up with any of the vertices in the end shape, usually producing slower, but better results.

25 Switch on the **Add Mask Shape Vertices** option and then change the **pixels between vertices** value to **5**.

This setting will ask the Smart Mask Interpolation to subdivide the vertices of the intermediate shapes into smaller sections (in this case the sections will be 5 pixels apart). This makes it easier to interpolate successfully between shapes. The original vector shapes are not affected, only the new mask shapes created by the Smart Mask Interpolation. Generally more vertices mean more accuracy but, again, trial and error is often the best way of determining the settings required.

26 Finally, change the **Matching Method** to **Polyline**.

27 Hit the **Apply** button to interpolate between the start and end shapes, notice that new mask shapes are created for every frame of the animation (Fig. 5.86).

28 Using the **J** and **K** keys, jump from frame to frame checking the results. See that the resulting shapes are much improved. Notice also that the start and end shapes have not had any vertices added, this has only happened to the shapes in-between.

29 **RAM Preview** the result to see that the movement is now more fluid.

Fig. 5.86

There are a few ways of working with masks in After Effects. We will work with them more in the following chapters where you will see them use to control effect properties, mask adjustment layers, and aid in keying footage. Another way to combine layers in interesting ways is by using Blending modes.

Blending modes

Remember in the Channels section we spoke about how an image is made up of three 8-bit, grayscale channels; each is made up of 256 shades of gray that are numbered between 0 and 255. Well, understanding this concept will help you understand how transfer modes work.

Transfer modes work by performing mathematics with the numeric color values of the channels. By adding, subtracting, multiplying, and dividing these values together, After Effects comes up with a composite image which is a blend between the two originals. Don't worry if you don't understand this concept immediately. By experimenting with the different modes and coming back to compare your results to what is written in the following paragraphs, you will eventually find that you can use the modes quite intuitively.

1 Open the **Compositing.aep** project from **Training > Projects > Compositing** if it's not already open (Fig. 5.87).

2 Double-click the **05_Blending modes** comp in the **Project** panel.

 Before moving ahead I want you to check your settings.

Fig. 5.87

3 In the **Timeline**, make sure that the **Live Update** button is activated so that you can see values changing as you scrub them. In the Composition viewer, click on the **Fast Previews** button and choose **Off** to switch off **Adaptive resolution** and **Open GL previews**. Open GL previews will not display Blending modes during interactions (Fig. 5.88).

This comp is made from a file named Blends.psd (which is in the Source files folder); which consists of five layers. Underneath the top four still image

Fig. 5.88

layers is a movie file from the **Artbeats** Liquid ambience collection (Reference number: **LA108.mov**), this is here to demonstrate how the Blending modes look used with moving footage. You will use this comp to look at the effect of the different modes.

In this comp there are three text layers, one is black in color, one is filled with a gradient, and the other is white. These have been placed over their opposite color to give us maximum contrast between the layers.

Fig. 5.89

4 Switch on the **Transparency Grid** button and then solo the **Black**, **White**, and **Gradient** layers, one at a time to see what is contained on each layer (Fig. 5.89).

5 Click on the **Transfer Controls** button at the bottom left of the Timeline to display the **Modes** column. Notice, in the **Modes** column, that all of the **Blending mode** menus are set to **Normal**.

Normal
This is the default transfer mode and involves no interaction between the layers, the result is that the top layer may obscure the underlying layers.

6 Switch off the **Solo** buttons so that you can see all layers again.

7 *Shift* select the top four layers and then change the **Blending mode** menu of one of them to **Dissolve**, all four layers should now be using the Dissolve Blending mode. Changing the Blending mode of any selected layer will change the mode for all of the selectedlayers.

Dissolve
Notice that the three text layers have now got 'speckly' edges, while the Background layer has remained unchanged. The Dissolve mode creates random transparent pixels, based on the transparency of the layer. The edges of the text are affected where anti-aliasing has occurred, creating semi-transparent pixels where the edge blends into the background. If the layer has no semi-transparent areas, you will not notice any difference, this is why the background layer has remained unchanged (Fig. 5.90).

8 Select only the layer named **Background** (Layer 5) and then hit the 🅣 key on the keyboard to bring up the **Opacity** value, and then scrub (drag to the left) the **Opacity** value for the **Background** layer to about **40%**.

As you bring down the opacity for the layer, rather than making all pixels reduce their transparency simultaneously, it will pick off pixels randomly to change from 100% opacity to 0%, creating a random dissolve effect. I must say, this is one of the Blending modes I've never used but I suppose

it may come in useful in some situations.

9 RAM Preview the effect, notice that the **LA138.mov** is moving in the background but the dissolved pixels remain static.

Dancing dissolve

This works the same way as dissolve except that the solid and transparent pixels animate randomly (you must still have an areas of transparency for it to work).

10 Select the top four layers again and then change the **Blending mode** to **Dancing Dissolve**.

11 RAM Preview the comp and notice that the effect is similar to Dissolve, the only difference is that the pixels are now animated.

This mode could be used for faking interference on a TV screen. Although I would personally prefer to use other techniques, the results are a bit too 'blocky' for my liking.

12 Change the **Opacity value** of the **Background** layer back to **100%** and notice that the effect has gone from that layer.

13 Change the **Background** layer mode back to **Normal**.

14 Select only the **top three** text layers and then change their **Blending mode** to **add**, notice that all of the black areas of text disappear into the background, only the white areas remain visible. The top word has disappeared since it's now all white (Fig. 5.91).

Fig. 5.90

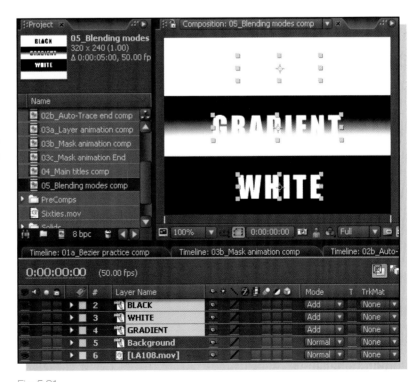

Fig. 5.91

Add

Add is probably the easiest Blending mode to understand. It adds the values from your layer to the value of the underlying layers, usually resulting in an image which is lighter than the original. Because the values are added together, they generally become higher, and therefore brighter.

Pure black is valued at 0, so adding areas of black will have no effect on underlying colors. Adding white to an underlying color will make that area pure white. If white is represented by 255, add this value to any other number and the result will always add up to a number of at least 255 and you can't get much whiter than that! This mode tends to produce an image which is clipped toward the positive (lightest) values.

You can imagine how cumbersome it would be to do all this math on values ranging between 0 and 255 so the numbers are converted to values between 0 and 1 to make the calculations easier to understand. So if we imagine a value of 1 = 255, a value of 0 = 0, and a value of 128 = 0.5.

Fig. 5.92

Fig. 5.93

15 Switch off visibility for the **Background** layer and **RAM Preview** the comp to see the result of the text layers (using **Add** mode) composited with the **LA138.mov** (Fig. 5.92).

16 Switch visibility back on for the **Background** layer and then change the **Blending modes** of the top three text layers to **Multiply**.

Multiply

With Multiply mode, the values are multiplied together to come up with the results. White areas of the layer on top have no effect on the underlying layers as 1 multiplied with any number will leave it unchanged. Black areas will produce pure black. Because, basically, if you multiply any number by 0 you will always get 0 that is pure black! Any 50% gray areas will have a similar effect to reducing the luminance of the underlying layers by 0.5. This mode tends to produce an image which is clipped toward the negative (darkest) values (Fig. 5.93).

17 Change the three text layers to **Screen** Mode.

Screen

Screen is like the opposite of Multiply mode and is visually a more washed out version of the Add mode. In Screen mode, black areas in the top layer have no effect on the underlying pixels. Any white areas in either layer will remain white; 50% gray areas will have an opposite effect to the Multiply mode, increasing the luminance of the underlying values by 50%. This is one of the most

useful modes in my opinion and has a similar effect to placing two photographic negatives together and projecting the result (Fig. 5.94).

The last three modes have worked the same regardless of which layer is on top. The following three modes work a little differently and have a similar effect to projecting the layer over the underlying layers.

18 Switch the top three text layers to **Overlay** mode.

Overlay

This is a combination of the Multiply and Screen modes. Areas in the top layer which are darker than 50% gray will affect the underlying layer by darkening (multiplying) those pixels. Any areas which are lighter than 50% gray will lighten (add) the underlying pixels. Where both layers are 100% black, the pixels will remain 100% black. Where both layers are 100% white, they will remain 100% white. Any areas of the top layer which are exactly 50% gray will not affect the layer underneath at all.

19 Toggle visibility off for the **Background** layer and then **RAM Preview** the comp with the **Artbeats** footage in the background (Fig. 5.95).

20 Change the top three text layers' **Blending modes** to **Soft Light** and **RAM Preview** the comp again.

Soft light

The effect of this mode is similar to that of Overlay mode, but is a little more subtle, 50% gray on the top layer will not change underlying pixels at all. Pixels lighter than 50% will lighten pixels underneath but never to pure white. Pixels darker than 50% on the top layer will darken underlying pixels but never to pure black. All pure black or pure white pixels on the underlying layer will remain unchanged, only areas in-between will be affected (Fig. 5.96).

21 Change the top three text layer's modes to **Hard Light**.

Hard light

This is another of my favorite modes and works very nicely with brightly colored layers. It works similarly to soft light but has a much more dramatic effect. Black pixels on top will always push the image to black regardless of the underlying color. White pixels will always push the image to pure white, regardless of the underlying color, 50% gray areas will not affect the underlying image at all. Here the whole range from

Fig. 5.94

Fig. 5.95

Fig. 5.96

229

Fig. 5.97

pure black to pure white in the underlying image will be affected. This example does not really show it off to its best but I recommend (Fig. 5.97) experimenting with this one. You can use some of the footage donated by Artbeats in the Free-Stuff folder!

There are four other Blending modes in this section.

Linear light

Linear light burns or dodges the colors by increasing or reducing the brightness, depending on the color in the selected layer. If the top layer color is brighter than 50%, the color of the underlying layer is lightened by increasing its brightness. If the top layer color is darker than 50%, the color of the underlying layer is darkened by reducing the brightness.

Vivid light

Vivid light burns or dodges the colors by increasing or reducing the contrast on the color in the selected layer. If the top layer color is brighter than 50%, the color of the underlying layer is lightened by increasing its contrast. If the top layer color is darker than 50%, the color of the underlying layer is darkened by reducing the contrast.

Pin light

Pin light completely replaces colors, depending on the color in the selected layer. If the top layer color is brighter than 50%, pixels darker than this color are replaced. Pixels lighter than this color remain unchanged. If the top layer color is darker than 50%, pixels lighter than this color are replaced. Pixels darker than this color remain unchanged.

Fig. 5.98

Hard mix

Hard mix enhances the contrast of the underlying layer using a mask on the source layer to determine the effect.

22 Change the three text layer's modes to **Color Dodge** and **RAM Preview** the comp again (Fig. 5.98).

Color dodge

Color dodge brightens the underlying pixels, based on the top layer's color values. The brighter the colors in the top layer, the more pronounced the effect is. Areas of pure black in the top layer will have no effect on the underlying pixels.

23 Change the three text layers' modes to **Color Burn** and **RAM Preview** again.

Color burn

This works in the opposite way to the Color dodge tool by darkening underlying pixels based on the color values of the top layer. In this case the darker the colors in the top layer, the more effect they will have on the underlying pixels. Areas of pure white will have no effect whatsoever (Fig. 5.99).

Fig. 5.99

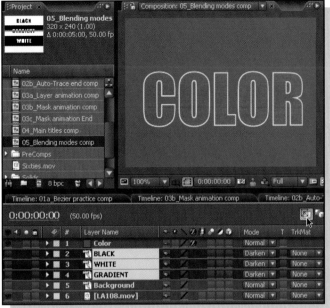

Fig. 5.100

Darken

This mode compares the color values of the individual channels of the top layer with the values of the underlying layer channels and chooses to display the areas with the lowest numeric color value (i.e. the darkest). This can produce some very strange results because each color channel is compared separately.

24 Switch off visibility for the three text layers.

25 Hit the **Enable Shy button** at the top of the **Timeline** to turn it off. This will reveal a new layer named **Color** which has colored text on a blue background (Fig. 5.100).

26 Switch the **Video** switch on for the **Color** layer and change its mode to **Darken**. See the results by **RAM Previewing** (Fig. 5.101).

27 Change the **Color** layer's mode to **Lighten** and then **RAM Preview** again, compare the two modes by toggling between them.

Lighten

This does the opposite of darken mode and shows the lighter of the compared color channels. Notice that now only the lighter areas of the compared images are showing (Fig. 5.102).

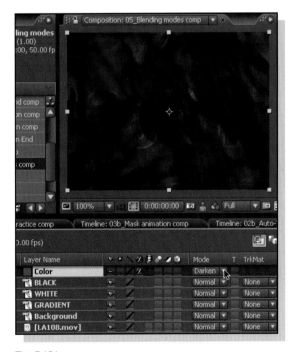

Fig. 5.101

28 Switch on the **Background** layer to see what effect the color layer has when composited over a black and white image.

Fig. 5.102

29 Change the color layer's mode to **Difference**. This is another of my personal favorites and can be used to achieve some very interesting results (Fig. 5.103).

Difference

This is quite a strange one to explain. Basically it will subtract the value of the top layer's channel pixels from the bottom layer's channel pixels or vice versa depending on which layer has the brightest value. If by doing this it pushes the values above 255 or below 0, instead of being left with pure white or pure black, it will use absolute values and behave as if the color values are continuously looping. For example, if I subtracted 200 from 0, I would expect to be left with −200, which you would normally expect to be black. But Difference mode reads −200 as a color value of 55 (i.e. 255 − 200 = 55).

OK, enough of the math, what visual effect does it have? Well, pure white areas in the underlying layers will have the effect of changing the top layers pixels to their opposite color on the color wheel. Notice that the red areas of the text have turned to a cyan color (the opposite color on the color wheel where they are sitting over white pixels). Pure white will completely invert the color values; black will not affect it at all. This mode is great for producing a similar effect to a photographic negative.

You may have noticed, as we have been looking through the Blending modes, that there are modes with the prefix 'Classic' (e.g. Classic Difference, Classic Color Burn). These modes are basically just old versions of the new modes. You can use these modes if you are worried about compatibility with old projects.

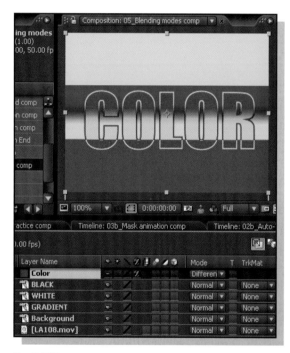

Fig. 5.103

30 Change the **Color** layer's mode to **Exclusion** and notice that there is a subtle change in the gray areas of the top image (Fig. 5.104).

Exclusion

This mode seems to work in almost exactly the same way as Difference mode but excludes 50% gray from the equation. If the top pixels and

Fig. 5.104

underlying pixels are both 50% gray, they are not affected by this mode, everything else behaves as it does in Difference mode.

31 Turn off the **Background** layer and then **RAM Preview** the comp so that you can see the effect this mode has on the moving footage.

32 Change the **Color** layer's mode to **Hue**, and notice that the underlying pixels have now taken on the hue values of the top layer (Fig. 5.105).

Hue

Takes the Hue values from the layer and combines them with the saturation and luminance values of the underlying layers.

33 Change the **Color** layer's mode to **Saturation** and **RAM Preview** again (Fig. 5.106).

Fig. 5.105

Fig. 5.106

Fig. 5.107

Saturation

Takes the Saturation values of this layer and combines them with the Hue and Luminance values of the underlying layers. All of the colors in the Color layer have similar saturation values so the effect here is pretty even.

34 Change the **Color** layers mode to **Color** and **RAM Preview** again (Fig. 5.107).

Color

Takes the Hue and Saturation of this layer and combines it with the Luminance values of the underlying layers. This has the effect of colorizing the underlying pixels with the color values of the

Fig. 5.108

top layer. This is another of my favorites, by combining live footage with a simple colored layer in Color mode you can quickly and easily create a simple, but effective color treatment to your footage.

35 Change the **Color** layer's mode to **Luminosity** and **RAM Preview** again (Fig. 5.108).

Luminosity

Takes the Luminance of this layer and combine it with the Hue and saturation of the underlying layers. This can also provide some nice, more subtle color treatments for TV graphics.

36 Select the **Color** layer and then hit ⌘ *Shift* *T* *ctrl* *Shift* *T* to bring up the **Effect Controls** panel. This layer was created by using the **Basic Text** plug-in.

37 In the **Effect Controls** panel, uncheck the **Composite on Original** checkbox so that the background of the layer disappears. This creates quite a nice effect with the Luminosity mode (Fig. 5.109).

Fig. 5.109

38 Switch the **Color** layer's mode back to **Normal** and **RAM Preview** the comp so that you can understand what we now have on our layer. The background has been made transparent so that the layer only consists of the actual text. You can clearly see the Artbeats LA138.mov behind the text (Fig.5.110).

39 Change the **Color** layer's mode to **Stencil alpha** and then **RAM Preview** the comp (Fig. 5.111).

Fig. 5.110

Fig. 5.111

Stencil alpha

Stencil alpha will use any existing Alpha information, contained in the layer to mask any layers below it. This allows you to cut one shape through several layers in one easy action.

40 Switch the **Transparency Grid** button on to see the transparency created.

41 Change the **Color** layer's mode to **Stencil Luma**, now the **Luminance** information is being used as a stencil to cut through the underlying layers (Fig. 5.112).

Stencil Luma

Stencil Luma will use the luminance values of a layer to create areas of transparency in layers underneath, this is the quickest way of implementing an external matte.

Fig. 5.112

Simply place the matte on top of the footage and apply the Stencil Luma mode. Notice that areas underlying the yellow border of the color text layer are much brighter than the red fill areas.

Silhouette alpha and silhouette Luma

This has the same effect as the stencil modes but invert the mattes so that transparent areas become opaque and vice versa. Try changing the Color layer's mode to these to compare the differences.

Alpha add

Alpha add is very useful, it will combine any Alpha channels from the current layer and any layers below, getting rid of any visible crossovers which can often result when Alpha channels overlap each other, particularly in situations when any of the alphas have been inverted.

Luminescent premultiply

This is something that comes in handy if your imported premultiplied Alpha channel looks a bit dodgy! Sometimes when rendering 3D animations with light glows or lens flares, the color values of the layer can exceed the value of the alpha channel, this can cause clipped edges on your premultiplied alpha channel.

If this ever happens to you, interpret the footage as having a straight alpha and apply this little beauty, it should clean up the edges nicely for you. You can also use this mode as a quick and dirty glow effect on any existing Alpha channel. It takes less time to render than the production bundle glow effect and is available in the Standard version too. You may need to combine the results with a blur to get the effect you are looking for.

You can cycle through Blending modes by selecting the layer and hitting **Shift**+ to move down the list and **Shift**- to move up the list.

OK, I now want you to experiment with what you have learned here. There is plenty of footage on the CD for you to get going with, just make a comp with a few layers and try chopping and changing the modes to see what results you can come up with. If you like anything you see, take a note of what mode was used and what colors the layers consisted of, this way you'll start to recognize what works and what doesn't with each of the modes. Have fun!

Basic keying

Keying, also referred to as 'blue-screening' is the process creating a matte, based usually on color or luminance values. This matte is then used to define which areas of the shot are to be transparent and

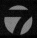

which remain opaque. Using keying techniques the subject or subjects can then be isolated from the rest of the shot so that they can then be composited with a different background.

Keying is used extensively in news programs to place the newsreader in front of the program graphics. Keying is also used in weather reports to place the presenter in front of a weather map. In a typical example, the person is filmed against a blue or green screen, the software will then make the blue/green colored parts of the shot transparent, allowing it to be replaced with a new background. Keying is usually based on color, but occasionally on luminance, hue, chroma, or by shot comparison.

Blue and green are usually the best colors to use as they offer the most contrast with the majority of flesh tones (unless your subject is a frog of course!). Green is usually the best choice when keying compressed footage, such as DV as it tend to produce less noise, which can make the keying process more difficult.

Preparation

Probably the most important aspect of good keying is preparation, lighting in particular is very important and can be very tricky to set up. The background should be lit evenly with a cold light and the foreground lit with a warm light to accentuate the differences. In most cases the subject must be lit in such a way that they will cast no shadows onto the background, therefore the background needs to be placed far enough behind the subject to allow for the correct lighting angles without a shadow being cast.

It is very important to plan your shots well if you are intending to key out areas of the shot. Always use as little compression as possible on footage intended for keying. Although it is possible to key compressed footage, it is much easier and you will achieve better looking results if you use uncompressed ITUR-601 footage.

Third-party solutions

There are very good products around now that make the blue-screen process much easier. Reflecmedia produce several products that make setting up blue or green screens relatively hassle free. http://www.reflecmedia.com

Chromatte fabric was developed in conjunction with the BBC, which utilizes 'retro-reflectivity' to produce perfectly even colored backgrounds for chroma keying. The patented material behaves like millions of 'cats eyes' that reflect the blue or green light source from the accompanying Lite Ring, straight back into the camera lens.

To the naked eye the material appears gray, but to the camera it appears as a solid background that can easily be keyed, either live or in post-production. It makes the job of lighting a lot easier and is a portable solution which means no need for hiring expensive blue-screen studios.

Reflecmedia also have their own keying plug-in for After Effects available called 'Mattinee' which works seamlessly with footage shot in this way. To see Keylight in action with examples of footage shot using Reflecmedia products see the Pro Features chapter on the accompanying DVD.

Suitable footage

Generally, the less compression the better with keying, use the best you can afford. Despite rumors to the contrary, it is possible to key DV footage, it is more of a challenge but I've seen it done very successfully. In the following chapters we will even manage to pull a fairly reasonable key from footage that has been compressed once with the DV codec and then again with Cinepak.

Keying is a science unto itself and a whole book could be devoted to it, in fact many are, there are recommendations for some of these books on the web site. For now, I will just concentrate on how After Effects deals with keying.

There are four different keying filters in the Standard version of After Effects and a massive nine in the Production Bundle. All have their own strengths and weaknesses.

Standard version keying

In the Standard version of After Effects there are only four keying tools, the Color key, the Luma key, Color Range, and Linear Color Key. The Color key and the Luma Key are both binary keys. The word binary indicates that these keys can create pixels in a choice of two states, either transparent or opaque. These tools cannot create semi-transparent areas like some of the more advanced keying tools. For this reason I do not recommend the use of these filters. They are fine for images with well-defined edges and areas of solid color but not for any areas which require semi-transparent pixels. The edges of the key will not be anti-aliased, therefore edge feathering is almost always essential to soften the edge of the Matte.

The color range effect

This is another part of the MacDonna video, from the end of the piece. This section consists of three layers, I wanted to make it look like we were sitting in a nightclub. I couldn't get all of the people that I needed in the shot together at the same time, so I had to shoot them separately and then bring them together afterward. The foreground layer is some sped up footage of me and my friend, BJ. This was shot from a fixed camera (with Holoset ring attached) in my living room against a sheet of Chromatte. This layer has the levels filter applied to it; let's add the Color Range Key to reveal what is behind it.

1 Open the project named **Keying.aep** from the **Training > Compositing** folder on your desktop.

2 Make sure that the **01 Color Range Key** comp is open. This comp consists of three layers, two have been shot against a **Chromatte** background.

Now, I'll be the first to admit I am not a professional camera person and I have done very little blue-screening in my time. The lighting equipment I used to shoot consisted of my old anglepoise lamp and an overhead tungsten bulb, but the results are pretty good considering how little effort I had to put in. I'm sure that with a little more knowledge, time, and patience I could have achieved even better results.

Levels

Let's start by correcting the image, it is very dark and muddy, we'll use the Levels filter to lighten it up.

3 Context-click on the **BJandMe.mov** layer and choose **Effect** > **Color Correction** > **Levels** (Fig. 5.113).

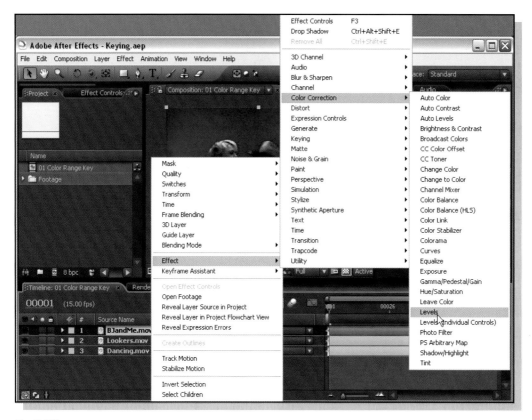

Fig. 5.113

Levels is my favorite filter for brightening dull images. It works in the same way as the Photoshop Levels feature by displaying a histogram (similar to a graph) of the gray levels of your image. This histogram is fairly typical of an image which has been heavily compressed. Notice the staggered appearance of the graph plus the gaps in the white end of the range, the lack of white values is what's causing the image to be so dark. Ideally you want a smooth curve moving from black to white, representing an even range of blacks, whites, and grays throughout your image.

At each end of the Histogram are Input Handles for determining where the black and white levels lie on the Histogram. In the middle is your Gamma slider, this adjusts where the mid gray lies on the Histogram. Pulling in the white handle will increase the highlights, pulling in the black handle will increase the shadows.

Underneath the Histogram are the Output Levels sliders, these control the output of the tonal range of the image. These sliders can be used to soften the contrast in your images. We need to get rid of the gap in the Histogram in order to re-distribute the values over a more even range.

4 To make the lightest values in your image pure white, pull the White Input handle toward the center of the Histogram. Drag the slider in till the Input White reading is about **210**. Notice that you now have a lighter, more evenly lit image (Fig. 5.114).

Now you can adjust the Gamma without affecting the lightest and darkest areas of the image.

5 Drag the **Gamma** slider to the left till you have a reading of approximately **1.5** (Fig. 5.115).

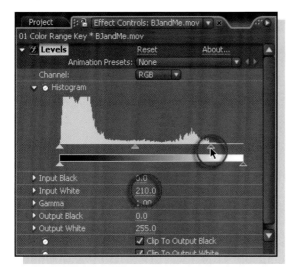

Fig. 5.114 Fig. 5.115

Color range settings

The Color Range Keying tool is always a good place to start because it is so versatile. It creates transparency by keying out a user-defined range of colors, so is ideal when keying out a multi-colored background or a background that is not evenly lit. As well as working in the RGB color space, it can also work in the Lab or YUV color spaces.

6 Context-click on the **BJandMe.mov** layer and go to **Effect > Keying > Color Range**.

7 In the **Effect Controls** panel you will see the Color Range effect which includes three eyedropper tools, click on the top-most Eyedropper tool and then click within the **Comp panel**, on the blue background of the image in the Comp viewer. Try to pick the most abundant blue, notice that a few pixels have become transparent (Fig. 5.116).

Fig. 5.116

Fig. 5.117

As the name suggests, the Color Range tool is ideal for selecting ranges of colors. You are provided with three eyedropper tools which can be used both in the Comp viewer or on the matte display in the Effect Controls panel. The first eyedropper tool allows you to select the main color, the Add eyedropper tool allows you to add to the selected colors. The minus eyedropper allows you to remove colors from the key.

8 Now click the second **Plus** eyedropper tool and then click and drag over the matte in the **Effect Controls panel** to select all the other shades of blue. You should now see the background layers showing through (Fig. 5.117).

9 Try adjusting the **Fuzziness** slider to soften the edges of the key.

You can use the other sliders below to fine tune the key till you have a nice clean key. All areas that you want to be transparent should be a nice even black, the areas you want to keep should be an even white with no gray areas. Don't worry if there's a slight blue edge on the subject, we can get rid of that.

10 Click on the **Show** Channel menu at the bottom of the Composition panel and compare the information in each channel by selecting each sequentially.

You'll see that most of the blue spill and edge is in the Blue Channel. Notice also that, apart from this, the blue and green channels are quite similar. Switch the Show Channels buttons off when you have finished comparing them.

Shift channels

There is no spill suppressor in the Standard version of After Effects but here's a tip for 'cheating' to get rid of some of the blue spill from the footage.

11 Context-click the layer again and go to **Effect > Channel > Shift Channels**. The Shift Channels filter allows you to take information for a specified channel from another channel in the same image.

12 Change the **Take Blue From** drop down menu from Blue to **Green** to take the blue channel information from the green channel (Fig. 5.118).

Now, the same grayscale channel information is being used for both the blue and green channels, getting rid of most of the blue spill. This has the added advantage of removing a lot of the noise from an image because most noise information tends to be held in the blue channel.

13 If you need to you can also add the **Channel Blur** effect to soften the edge of the matte. Set the **Alpha Blurriness** value to **1** and then **RAM Preview** your comp.

Professional version keying

These are some techniques for doing basic keying with the Standard version Keying tools. If you need more powerful keying tools, then the Professional version is what you need, it provides industry-standard keying tools that give you a huge amount of extra control and allow you to key difficult subjects such as semi-transparent materials and shadows. On the DVD > Extras > Angie Talor tutorials folder you will find a tutorial using the Professional version keying effects.

Fig. 5.118

Recap

In this chapter you've learnt all about the processes involved in compositing images together in After Effects. We've learnt about using and understanding channels, creating mattes, interpreting Alpha channels correctly, using masks, nesting, collapsing transformations, editing precomps, rulers and guides, Bezier tools, Auto-Trace, Blending modes, and basic keying.

Inspiration

Here are some gems from filmmaker Robert Hranitzky, as a graduate from the University of Applied Sciences in Mannheim, he finished his design studies with his diploma short film 'Diona Con Carne'.

He currently works as a freelance designer for several design studios and clients, covering the fields of motion-graphics, animation, web, and print design. For the last couple of years, he has also been freelance presenter and trainer for Adobe, Wacom, and Apple providing compelling and high-quality demonstrations on most of their products at many major European trade shows and events.

You can visit Robert's web site at: http://www.hranitzky.com

Q How did your life lead you to the career/job you are now doing?
A I started to draw when I was about 6-year old, then started to build everything I could imagine with Lego. While still at school, I started to play around with Photoshop and discovered the endless possibilities when combining creative energy and amazing tools.

Q What drives you to be creative?

A Hard to say – probably something from the inside? No matter where I am, I always strive for something new, either looking for some nice angles when I have my Camera with me, or sketching in my sketch book. Sometimes, it feels like a demon that just hunts you and you don't know when the next idea will pop up.

Q What would you be doing if not your current job?

A Don't know – struggle? Or maybe just be a surfer on a nice and sunny island.

Q Do you have any hobbies/interests and if so, how do you find time for them?

A I love playing Basketball. Sketching and drawing as well. If there is time, I also enjoy a couple of nice rounds playing the latest computer games. Last but not least, I LOVE movies, especially those from Pixar.

Q Can you draw?

A Yep.

Q If so, do you still draw regularly?

A Yes, but not as much as I would like to.

Q What inspires you?

A Basically everything. Traveling, nature, friends, and family. If I struggle to come up with something, design books, movies, and the Internet offers good inspiration as well.

Q Is your creative pursuit a struggle? If so, in what way?

A Usually it is not. But sometimes if a client is difficult, you have to try harder to hit the sweet spot.

Q Please can you share with us some things that have inspired you. For example film, song, web site, book, musician, writer, actor, quote, place, etc.

A My last trip to East-Europe was inspiring, things are a bit different there and it reminds me not to take everything for granted. Also the nature over there is so beautiful, which I found to be quite inspiring.

Other than that, artists and their constant pursuit for good output (no matter if sketches, animations, or designs) is also very inspiring and motivating.

Q What is your most over-used AE feature/filter?

A Probably motion blur and Trapcode's Shine.

Q What would you like to learn more about?

A Learn more about every aspect that matters for my job.

Q Please include screen shots of the work that you are most proud of and give a brief description of it and explain your feelings about it.

Definitely my diploma short film 'Diona Con Carne'. It was the longest and yet most fulfilling project I worked on so far. It was my first real 3D Animation project, so I had to learn 3D from scratch, but I thought if I don't start learning it now, with my last school project ahead, I might never start doing so. It was such a wonderful experience to see the characters come alive, after creating and designing them on the drawing board first.

I was almost obsessed by this project – on the one hand the pressure to create a good diploma on the other hand my own ambition in creating something cool and telling a story. And of course always with an uncertain feeling on how it will turn out, since I had no experience in creating 3D Animation.

Chapter 06 **Grouping**

Fig. 6.1

There are times when working in After Effects that you may find the need to group layers together. You may need to apply an effect to several layers at a time. You may need to simplify a complicated composition by breaking it into more manageable chunks. You may need to have layers mimic each other's transformations.

There are several ways of doing these things by grouping layers together or linking them so that they can be treated as one group, these include: Nesting, Pre-composing, Parenting and Expressions.

Synopsis

Expressions can be pretty complex so have a chapter all of their own, here we will look at what can be done with Nesting, Pre-composing, and Parenting. In this chapter you'll also learn about the comp flowchart panel and be introduced to Animation Presets, working with null objects and learn to use all these techniques to create character animation.

Nesting

We took a basic look at how nested comps behave in the Import chapter (Chapter 03). Here we will look at how they can be created from scratch.

1 Open the **Grouping.aep** project from **Training > Projects > Grouping** folder.

2 If it is not already open, double-click the **01_Car comp** in the **Project** panel. Here you see an image of a car that has been imported into After Effects as a composition with cropped layers (Fig. 6.1).

I photographed this car at one of the London to Brighton car rallies. The image was opened in Photoshop and roughly split it into layers. It has a Body layer, Front Wheel and Back Wheel layers, and a Levels adjustment layer. Our task is to make a simple animation of the car traveling along a road with its wheels turning.

3 Select the **Front Wheel** and **Back Wheel** layers, and then hit `Shift` `⌥` `R` `Shift` `alt` `R` to display their **Rotation** values and simultaneously set a keyframe for the property.

4 Make sure that both of the **Wheel** layers are still selected, then move to the end of the comp (**End** key) and change the **Rotation** value of both layers to **15 revolutions**. If multiple layers are selected they will all update and new keyframes will be created when the value is changed for either of them (Fig. 6.2).

Fig. 6.2

5 **RAM preview** the animation and see both wheels turning. The rotation looks a bit weird at the moment but we'll add motion blur to them later to fix this problem.

6 Open up the **02_Car Background comp** from the **Project** panel by double-clicking it. This is an Illustrator file that has been imported into After Effects as a comp. We'll use this as our background and have the car drive along the road.

Fig. 6.3

7 You should now have two tabs open in the **Timeline**, try clicking on each of them to toggle between the two open comps. The comp viewer will update to show you a preview of the comp at the current time. Make sure that you have the **02_Car Background comp** showing when you've finished looking at them both.

Now we need to bring the car into the background comp and treat it as one single layer.

8 Drag the **01_Car comp** icon from the **Project** panel, down to the **02_Car Background comp** Timeline and drop it above the **Background** layer (Fig. 6.3).

You have successfully created your first nested comp. Notice that the nested comp appears as a single layer in the Car Background comp.

9 Display the Layer's properties by clicking on the disclosure triangle to the left of the layer name, **01_Car comp,** this will open up the **Transform** property group.

10 Click on the Twirly Triangle to open up the **Transform** group to reveal the properties inside. It has one single set of Transform properties, just like any other layer.

11 Scale the **01_Car comp** layer down to about **60%** and reposition it so that it sits on the Left side of the road (I'm British remember!) and to the Left side of the composition.

12 Click on the **Position** property stopwatch to set an initial keyframe for the **Position** property at the beginning of the comp.

13 Move the Timemarker to the end of the Timeline and then move the car off the screen to the right to create a new position keyframe (Fig. 6.4).

Fig. 6.4

14 **RAM preview** your animation.

As we've seen in previous chapters, double-clicking a layer opens up its Layer panel, but holding down the *alt* modifier will when double-clicking a layer which is a nested comp will open the original composition.

15 Hold down the *alt* key as you double-click the **01_Car comp layer** to open the original comp. This will give you access to the original layers in the nested comp.

16 In the **Effects and Presets** panel, type in **HLS** and then drag and drop the **Color Balance (HLS)** effect from the **Effects and Presets** panel onto the **Levels** adjustment layer at the top of the **Timeline** (Fig. 6.5).

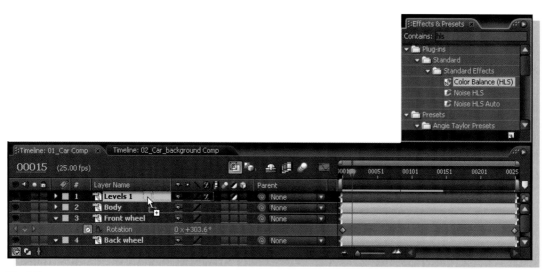

Fig. 6.5

17 Adjust the **Hue** wheel in the **Effects Control panel** to −50 to change the car color from yellow to red (Fig. 6.6).

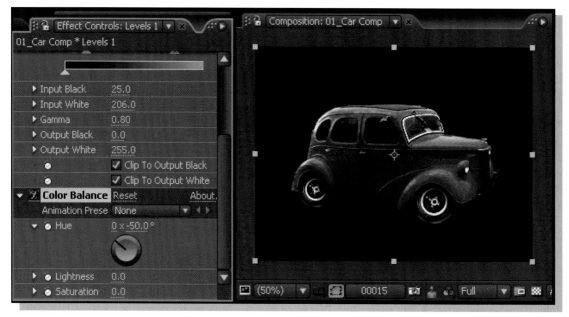

Fig. 6.6

18 Turn on the **Motion Blur** switches in the **Switches** column for each of the animated wheel layers.

19 Hit ⌘K ctrlK to open the **Composition Settings** dialog.

20 Click on the **Advanced** tab and change the **Shutter Angle** setting to **720** to increase the amount of motion blur (Fig. 6.7).

21 Click on the **02_Car Background** comp tab in the Timeline to view the changes in the main comp.

22 Select the **Motion Blur** switch for the **01_Car comp** layer and then hit the **Enable Motion Blur** button to activate it (Fig. 6.8).

23 **RAM preview** the animation.

Pre-composing

After Effects also allows you to nest comps backward, this process is known as pre-composing or *PRECOMP*'ing. Pre-comp'ing is kind of like nesting but

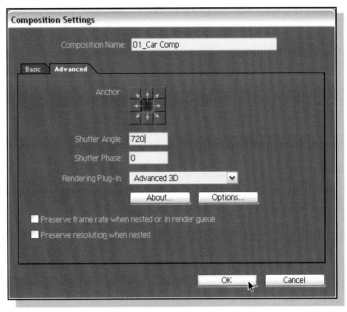

Fig. 6.7

Fig. 6.8

backward. Basically, you can select layers in your comp and decide to place them into a separate comp by pre-comp'ing them. This is a particularly useful trick as it means that you do not have to plan your nesting structure before you begin the work, it can be changed at any time. I use it also to break down complicated comps into smaller, more manageable chunks.

1 Open the **Grouping.aep** project from **Training > Projects > Grouping** folder if it's not already open.

2 In the **Project** panel, double-click the **03_Madogga comp to open it**. This is a multi-layered Photoshop file which I have imported into After Effects as a composition (Fig. 6.9).

Fig. 6.9

The original drawings of the cartoon characters were done by Illustrator Mark Dimeo, you can find out more about Mark's work at: http://www.scottishillustrators.com/

I took Mark's drawings into Photoshop and split each character into layers, ready for animating in After Effects. There are also two background layers within the same composition. Mark contacted me to ask if I could put together an animatic for a TV show proposal.

3 Look in the Timeline panel and notice that each body part is on a separate layer; ⟪⟫-click *alt*-click the **Solo** button to see each layer in isolation (Fig. 6.10).

Notice that the composition is very confusing because there are multiple examples of certain body parts, not only that, there are just too many layers. It simply makes much more sense to break it down into individual comps for each character and the background. Working in comps with loads of layers is not economical as each layer has to be rendered at each frame, plus it's awkward and

Fig. 6.10

confusing to manage due to the sheer size of the Timeline. The solution is to break down your composition into lots of smaller nested compositions.

That's all well and good but there will be times where you cannot plan your nesting in advance. Good examples of this would be if you are importing work that somebody else has begun or if you are importing sequences from editing applications such as Premiere Pro, Avid, or Final Cut Pro (via Automatic Duck). In examples like this, where the layers are already included in one main composition, you may find yourself thinking, 'Blast! I should have put them in separate compositions.' Well, you can, by nest them backward or pre-composing. Let's start by looking at the background.

4 In the Timeline, click on the Expand/Collapse **Transfer controls pane button** to see the Blending modes used on the layers.

5 Scroll down the list of layers till you see the **Color** and **Circles** layers (layer numbers 36 and 37, respectively).

The **Color** layer is a simple colored gradient which has been composited over the **Circles** layer using the Linear burn blending mode. This blending mode has the effect of applying the colors to the white areas of the Circles layer, an easy way to create multicolored circles without having to color them individually.

6 **Solo** both of these two layers to see the **Gradient** and how it affects the underlying layer (Fig. 6.11).

Fig. 6.11

Fig. 6.12

I'd like to animate the colors changing to make it look like disco lights being projected onto a wall in the background. To make life easier, to prevent having to scroll up and down the Timeline, let's pre-compose the layers into their own nested composition.

7 Select the **Colors** layer and the **Circles** layer and then go to **Layer > Pre-compose**. This will open up the **Pre-compose** dialog (Fig. 6.12).

8 Change the **New Composition Name** to **Background comp**.

Notice the only option we can select here is to **Move All Attributes into New Composition**. We'll talk a little more about the options later.

9 Click the **OK** button and look at your Timeline. Notice that the two original layers have been replaced by a nested comp named **Background comp**, this is your *PRECOMP*. Notice that the Solo button is on for this layer and that the appearance of the composition in the comp viewer has not changed.

10 Switch on the **Solo** button to see that both layers are now nested into one single layer.

11 To make changes to the layers within the nested comp hold down the 🔽 *alt* key while you double-click on the **Background comp**. Alternatively, you can double-click on the **Background comp** icon that is in the Project panel.

12 Now you should have two or three tabs open in the Timeline, try clicking on each tab to see each of the comps displayed in the comp panel. Finish with the **Background** comp visible (Fig. 6.13).

Fig. 6.13

13 With the **Background** comp open, notice that the **Linear Burn** blending mode is still applied to the **Colors** layer.

I want to animate the colors changing randomly. To do this we will load one of the free **Animation Presets** that I have provided for you in the **Training** folder on the **DVD**.

14 Select the **Color** layer in the Timeline and then go to **Animation > Apply Animation Preset**.

15 Go to **Training > Animation Presets**, and choose the preset named, **4_Col_Grad_Wiggle.ffx** (Fig. 6.14).

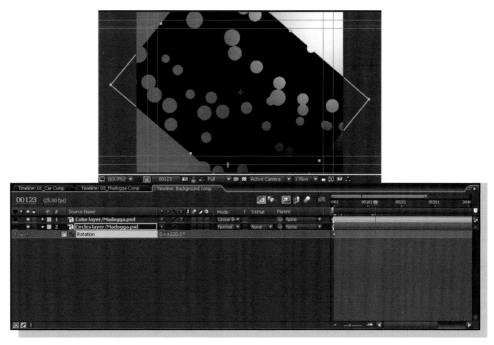

Fig. 6.14

16 **RAM Preview** to see the gradient colors randomly changing over time. This animation preset has Expressions applied to the colors in the **4**-Color Gradient effect to make them animate over time.

17 Select the **Circles** layer and hit the **R** key to display the **Rotation** property.

18 Click on the **Rotation** stopwatch to set a keyframe at **frame 1.**

19 Hit the **End** key on the keyboard to move to the end of the comp and change the **Rotation Revolutions** value to **3**.

20 **RAM Preview** the comp to see the circles rotating around the screen. The only problem with this is that the circles layer is too small, we can see the edges of the layer. To fix this we will replace this layer with a bigger layer (Fig. 6.15).

Fig. 6.15

Fig. 6.16

21 Context-click on the circles Layer/ MacDogga.psd file in the **Timeline** and choose **Reveal Layer Source in Project** (Fig. 6.16).

22 Context-click on the circles Layer/ MacDogga.psd file in the **Project** panel and choose **Replace Footage > File**. In the **Replace Footage File** dialog, go to **Training > Source Images > Angie Taylor Images** and select the file named **Circle.gif**.

Replacing the footage file in the **Project** panel will replace every instance of it in your project, however many times it is used.

23 RAM Preview to see the animation.

24 Click on the **03_Madogga comp** tab in the Timeline. Switch off the Solo buttons for the bottom **Background comp** layer and **RAM preview** the comp to see that all changes are updated in the main composition.

We will come back to this composition later in the Expressions chapter (Chapter 11). But for now, let's pre-compose the other layers to make a separate comp for each of the cartoon characters.

25 In the **Timeline** select the layers from number **3** to **19** and then hit ⌘ *Shift* **C** *ctrl* *Shift* **C** to pre-compose them (Fig. 6.17).

26 In the **Pre-compose** dialog change the **New Composition Name** to **Dancer 1**. Select **Open New Composition** at the bottom left of the dialog and then click **OK** to open up the new comp.

Notice that the layers have been moved into a comp containing only those layers, making it easier to animate them. With the **Open New Composition** option checked when clicking OK, the new comp will open giving you immediate access to the layers within it (Fig. 6.18).

Fig. 6.17

Fig. 6.18

27 Click on the **03_Madogga** tab in the Timeline to open it.

28 Repeat step **25**, pre-composing layers **4–19** to make a new comp named **Dancer 2**, this time uncheck the **Open New Composition** checkbox before clicking **OK**.

29 In the **03_Madogga** comp Timeline, click on the **Shift H Y** button at the top of the Timeline to open up the other layers I have included in this comp (Fig. 6.19).

30 Switch on the **Video** switch in the **A/V Features** column to make the layers visible.

Fig. 6.19

 Each of these two new layers were grouped before they were imported into After Effects. This was done in Photoshop using Layer Sets; when you import a Photoshop file into After Effects, any Layer Sets becomes a nested comp.

Now the character animations can be worked on individually, making your life simpler. Breaking your comps down into smaller nested comps will also speed up your workflow considerably.

The flowchart panel

It can be tricky to keep tabs on the nesting structure of your projects, so After Effects provides you with a Flowchart panel for each project to show you a graphical overview of the structure.

31 With the **03_Madogga** comp still active in the Timeline, go to **Composition > Comp Flowchart View**. A new panel will open up with a detailed view of the hierarchy used to link the layers and comps together (Fig. 6.20).

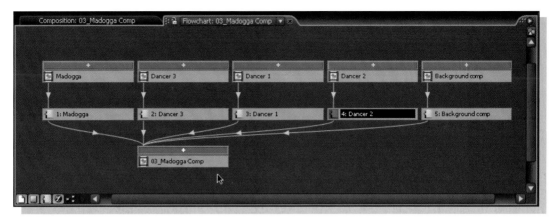

Fig. 6.20

The default flowchart view only displays the selected composition. To see nested compositions you need to expand the composition tile.

32 Click on the little + sign on the **03_Madogga** comp tile to open it up and reveal its contents.

In this view, the individual tiles represent layers, footage, and compositions. Any effects are also listed on these tiles when applied. Directional arrows show the relationships between the elements that make up your compositions.

33 Open up the **wing menu** in the **comp flowchart view** to look at the options within (Fig. 6.21).

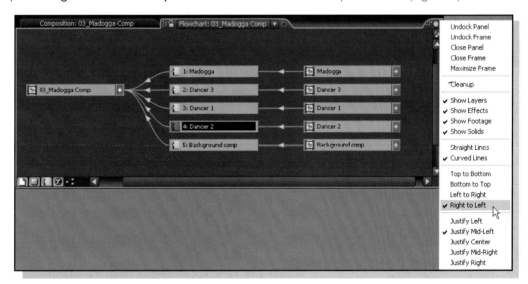

Fig. 6.21

34 Select **Right to Left** to change the layout of the flowchart. You may need to make this panel bigger and/or scroll around it in order to see the whole flowchart.

Making changes in the comp flowchart panel

You can make some minor changes to files in the Flowchart panel but it is fairly limited in its features. I'd like to see it developed further so that Expressions can be applied and effects are edited in this view. Here is a list of what is currently available.

You can delete items. To do this, select the item and then hit the Delete key. If the item is a layer, it is deleted from the composition in which it appears. If it is a footage item or composition, it is deleted from the project.

You can Context-click the icon to the left of the name on each tile to change the properties of the selected item. This will open up the appropriate context-sensitive menu to give you the choice of working with masks, effects, adjust switches, apply transformations, and adjust quality and resolution (Fig. 6.22).

Fig. 6.22

Context-click the name of the element on each tile to open up a different context-sensitive menu which allows you to change label colors and select by label group.

There are other times when pre-composing can be very useful. For example, it can be used as a way of changing the render order of your effects, masks, and transformations. It can also be used to compound an effect with a layer so that it can be accessed by other effects (you can find out more about this in the Effects chapter (Chapter 07)).

Changing render order

After Effects render layers in the order that they appear in the Timeline panel, starting at the bottom and working upward in the list (when working in 2D) (Fig. 6.23).

Fig. 6.23

However, each layer's properties are rendered from the top downward according to how the property groups are listed in the Timeline, Masks, Effects, and then Transformations. Any Blending Modes or track mattes are rendered last.

There are times when you may need to change the Render order. There is no way of changing this order within the comp but nesting and pre-composing allows you to change the order.

1 Open **04_Render order** comp from the **Project** panel. This comp has the same map layer that we animated in the **Pan and Zoom** section of the **Animation** chapter (Chapter 04) (Fig. 6.24).

Fig. 6.24

I've created a short animation of the **Anchor Point** and **Scale** values to pan and zoom around the map. I want to composite this onto moving background and use a mask to highlight the area I wish the viewer to focus on. I've already applied the mask to the layer and have also applied a Drop Shadow effect to the Map layer – you can see these listed in the Timeline.

2 **RAM Preview** the comp and notice two problems:

The first is that the animation takes a very long time to render, this is because the Drop Shadow effect is rendering on the whole layer, and this is a big layer at 3000 pixels square! This is a real waste of processing as we cannot see most of the layers, we should only apply the shadow to the area within the comp.

The other problem is that the mask travels with the layer as it moves and scales, my idea was for the image to move and scale within the mask. First we will remove the mask and effect from the layer, then pre-compose it so that all the Transformations are done in a separate comp, but we want to keep the settings to re-apply them after pre-composing.

3 Delete both the **Mask 1** and the **Drop Shadow** effect by selecting them one at a time and hitting the **Delete** key.

4 Select the **Layer 1/Falmap.ai** layer and then go to **Layer** > **Pre-compose**. Name the new composition **Map animation comp**. Choose to **Move All Attributes into the New Composition**,

259

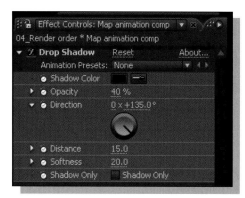

Fig. 6.25

make sure that the **Open New Composition** is *not* selected and then click **OK**. This will move the layer, along with the Anchor Point and Scale animation, into a new nested composition.

5 Select the **Map animation comp** layer in the Timeline and go to **Effect > Perspective > Drop Shadow**. In the effect Controls panel, change the **Opacity** to **40%, Distance** to **15%,** and **Softness** to **20%** (Fig. 6.25).

6 Select the **Elliptical Mask tool** and draw an oval mask on the **Layer ❶/Falmap.ai** layer. Change the **Mask Feather** value to **100** pixels (Fig. 6.26).

Fig. 6.26

7 **RAM preview** and notice that the comp renders faster and that the mask remains in place as the layer scales and moves.

This is possible because we changed the render order so that the **Transformations** were rendered in the **Map animation comp**; this comp was nested into the main 04_Render Order comp (as a single layer), where masks and effects were applied to it.

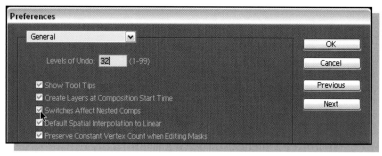

Fig. 6.27

8 Click on the **Enable Motion Blur** button in the **04_Render order** comp and notice that, even though we do not have the Motion Blur switch activated for the layer, it still applies it, why is this? (Fig. 6.27).

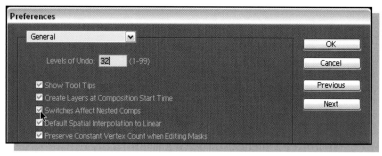

Fig. 6.28

In **Preferences > General** there is an item named **Switches Affect Nested Comps**. With this option turned on the switches in the Timeline behave recursively, in other words, enable a switch in the main comp and it will activate the feature for all checked layers within all nested comps (Fig. 6.28).

Collapsing transformations

We looked at how to collapse transformations in the Nesting section of Chapter 6 – Compositing, but I want to explain a little bit more about how it affects nested comps.

To recap, if you collapse the transform properties of a nested comp, all transformations masks and effects will be applied in a single pass, rather than having a separate operation for each composition. Because of this, collapsing transformations can preserve resolution if a nested composition is scaled down and then scaled back up again as both scale actions will be combined and then calculated as one operation. This is quite hard to explain so let me show you what I mean.

1 Open **05_Collapse Transformations** comp and **RAM preview** it (Fig. 6.29).

Fig. 6.29

Here we have a simple animation of the characters we saw earlier. Notice that the resolution seems to drop at the end of the animation.

2 Select the **Characters and Background** comp and hit s to open the **Scale** property, notice that the layer is scaled to **300%** at the final frame, hence the loss of resolution.

3 Hold down the 🔳 *alt* key as you double-click on the **Characters and Background comp** layer in the **Timeline** to open up the nested comp.

4 Select the three **Dancer** layers and hit s to open their **Scale** properties, notice that they are scaled down to **26%** and **30%** in this comp, this was done in order to compose them correctly (Fig. 6.30).

Fig. 6.30

5 Click on the **05_Collapse Transformations** comp tab again and, in there, click on the **Collapse Transformations** switch for the **Characters and Background** layer (Fig. 6.31a).

Notice that the Dancer layers sharpen up as their resolution improves, this is due to the Scale transformations being combined into a single operation.

Without collapsing transformations the layer is being rendered at 26% in the first comp. This rendered image is then being scaled up to 300% in the second comp so goes through two separate processes.

Fig. 6.31a

When you collapse transformations After Effects combines the two operations, that is it is scaled down to 26%, then up to 300%, and *then* rendered only once. This results in a scale percentage of 78% (26% × 3).

As you can imagine, collapsing transformations can also have the added benefit of speeding up your workflow as less rendering is taking place.

You can find out more about Collapsing Transformations and how it affects working with effects in Chapter 07 – Effects.

Parental hierarchy

To animate these characters we will need to set up what's known as a parental hierarchy to link the body parts together. The Parenting section was written with the help of Fred Lewis whose biography you can read in the Introduction.

Simply put this feature allows you to attach one layer to another; when you make this type of attachment, one of the layers is called the parent and the other layer is, not surprisingly, called the child. When these two layers are attached to each other, we think of the child being attached to the parent, so, wherever the Parent goes, the Child follows, just like in real life! But, as all real-life parents will know, the Child can always move independently from its Parent!

Basic parenting

To see what I mean, and to get a taste of what Parenting is all about (only the animation kind of course!), follow these simple steps:

1 **Open 01_Parent** comp from the **Parenting** folder within the **Grouping.aep** project from **Training > Projects > Grouping** folder. This comp consists of two Text layers, one named **Mother**, the other named **Baby** (Fig. 6.31b).

Fig. 6.31b

2 Look at the **Parent** column in the Timeline, we'll use the menus here to make the **Mother** layer the **Parent** to the **Baby** layer.

If the Parent column is not showing, go to the Timeline's **Wing menu > Columns > Parent**. Alternatively, you can context-click on any of the Columns to bring up the Columns menu.

3 Click on the **Baby** layer's **Parent** pop-up menu in the **Parent** column of the Timeline panel and choose the **Mother** layer from the list. The **Baby** layer is now the **Child** and the **Mother** layer is the **Parent** (Fig. 6.32).

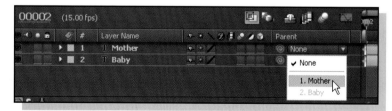

Fig. 6.32

4 Open the Transform property group for the **Mother** layer and scrub the values to see what happens. **Rotate** the **Mother** layer and notice that the **Baby** layer always rotates along with the Parent. **Scale** the **Mother** layer and watch the **Baby** scale simultaneously. **Move** the **Mother** layer and watch the **Baby** follow; the only one that does not follow is the **Opacity** value (Fig. 6.33).

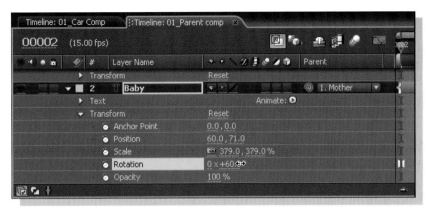

Fig. 6.33

5 Try adjusting the **Rotation, Scale**, and **Position** values on the **Baby** layer as you did on the Mother layer. Notice that you can still rotate, scale, and move the Child layer independently from the Parent layer (Fig. 6.34).

Notice that when you adjust the properties of the Parent layer both the parent and the child are affected. Whatever happens to the parent, happens to the Child. But when you make changes to the child, only the child is affected. Be aware that all of the Transform properties, with the exception of Opacity follow these parenting rules. Any effects applied to your layers will not be affected by parenting; instead, these can be linked together using Expressions.

Fig. 6.34

Resetting properties

 When experimenting with the **Transform** properties you can quickly reset them to the default values by going to **Layer > Transform > Reset**, this will reset all the transform values of the selected layers. To selectively reset individual properties you can context-click on the property name and choose **Reset** from the menu (Fig. 6.35).

Hierarchies

OK, that covers the first word in this section heading, 'Parental' but how about that second word, 'hierarchy'. The notion of hierarchy comes into play with parenting because of the fact that *any* layer can become a parent, including a layer that is

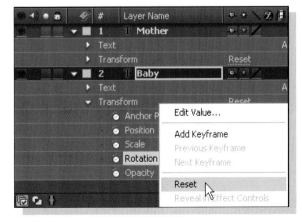

Fig. 6.35

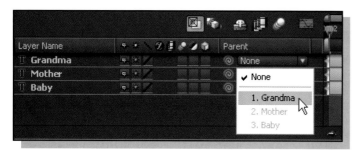

Fig. 6.36

also a child. For example, try the following:

6 Open **02_Hirearchies comp** from the **Parenting** folder within the **Grouping.aep** project from **Training > Projects > Grouping** folder.

7 Choose the **Grandma** layer as the Parent for the **Mother** layer by clicking on the **Mother's** Parent pop-up menu and choosing **Grandma** from the list (Fig. 6.36).

8 Play around with all the three layers some more by moving, rotating, and scaling each of the layers in various ways.

You now have a three-level hierarchy, with the Grandma at the top of the hierarchy, a parent for the Mother. The Mother is in the middle of the hierarchy, this layer is the Child of the Grandma layer but is also the Parent to the Baby layer. The Baby layer is a Child to the Mother and the Grandma layers. Notice that adjusting either the **Mother** or **Grandma** layers will affect **all layers below them** in the **Hierarchy**. Adjusting the **Baby** layer will not have any effect on the other layers as it is not a parent to any of the other layers.

Trouble with relatives

Another thing that happens when you parent one layer to another is that the child's animation becomes *relative* to the Parent's origin (which in After Effects is the upper-left corner, measured at Position 0, 0). When parenting and un-parenting this usually means the child's transform values will adjust in order to keep the child in the same place within the composition. This can lead to a lot of head scratching!

9 Open **03_Un-parenting** comp from the **Parenting** folder within the **Grouping.aep** project (from **Training > Projects > Grouping** folder).

10 Rotate the **Red Parent** layer to any non-zero rotation value (i.e. make sure its rotation value in the Timeline is anything but 0), I have chosen to rotate it by **30 degrees** (Fig. 6.37).

Notice that this immediately rotates the child layer to exactly the same orientation as the parent layer but that the Child layer's **Rotation** value still reads 0, 0.0. This will always be the case because child layer's values are always *relative* to their parent's and a relative value of 0 means 0 difference between the child and the parent.

11 Now try changing the **Blue Child Position** values to **0, 0** (Fig. 6.38).

Notice that this aligns the child's Anchor Point with the parent's upper-left corner. Again, this is because the Child's Position values are relative to the parent's upper-left corner.

Fig. 6.37

Why the parent's upper-left corner, you may ask? Why not make the child relative to the parent's anchor point? Very good question. The answer is when Adobe added parental hierarchy to After Effects, they decided to make child layer be relative to its parent's image rather than its parent's anchor point. And the parent's image, technically speaking, is measured from the upper-left pixel. (It is where the anchor point goes if you zero it.) So, this is where children align to when you zero them.

Divorcing your parents – un-parenting
Because a parented layer's value becomes relative to its Parent's, it can lead to a bit of confusion when you try to un-parent a layer.

12 Make sure that you can see the **Child** layer's **Rotation** r and **Position** P values.

13 Click on the **Child**'s **Parent** pop-up menu in the **Timeline**, and choose **None** from the list to 'Un-parent' the Child from the Parent, watching the values as you do so (Fig. 6.39).

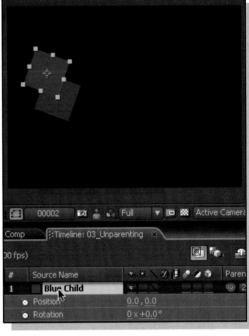

Fig. 6.38

Notice that the child's Position and Rotation values in the Timeline change. If you did not notice this happening undo the last step and redo it, keeping an eye on the Position and Rotation values as you do. The values change because the child's Transform property values are once again relative to the composition, not the parent (Fig. 6.40).

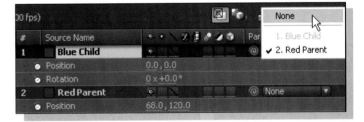

Fig. 6.39

14 Undo ⌘ Z ctrl Z the last step so that the **Blue Child's Parent** menu has **Red Parent** selected. Notice that the **Child's Position** and **Rotation** values in the **Timeline** are now once again at **zero**.

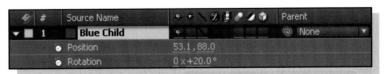

Fig. 6.40

By default, this is what happens both when you parent an object and then you un-parent an object. When you **parent** the object, it stays in the same place in the composition and its **Transform** values become **relative** to the **parent**. When you **un-parent** the object, it stays in the same place in the composition, and its **transform** values **revert** back to how they behaved before the object was parented.

You can, however, force the child's values to remain the same when you parent and un-parent, by holding down the ⌥ alt key. This causes the child to jump to a new position in the composition when it gets parented or un-parented. This is useful for preserving the child's absolute keyframe

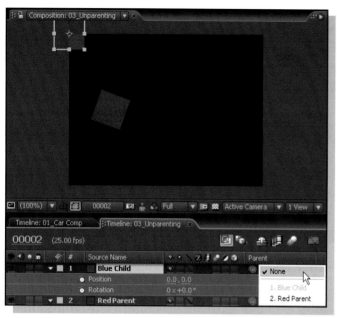

Fig. 6.41

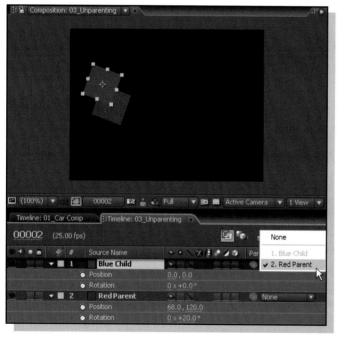

Fig. 6.42

values, while changing its parent. To see how this works, try the following.

15 While holding down the ⌥ *alt* key, **un-parent** the **Blue Child** by choosing **None** from its **Parent** menu (Fig. 6.41).

Because the Blue Child's position values are 0, and you have held the ⌥ *alt* key down to keep them that way, the Blue Child now moves to the upper-left corner of the comp (position 0, 0, within the comp).

16 Again while holding down the ⌥ *alt* key, re-parent the **Blue Child** to the **Red Parent**. The Blue Child's value is still 0, and it pops back into alignment with the parent's upper-left corner (Fig. 6.42).

A parallax trick

Here's a little trick you can do using Parenting to create the illusion of depth in a 2D animation. When you have more than two objects moving parallel to the camera the foreground object will look as if it's moving faster than the background object (Fig. 6.43).

This illustration clearly illustrates the reason for this phenomenon; the hare has more of an *apparent* distance to travel across the screen because of the perspective, even though in reality they are both going to be traveling the same *physical* distance.

17 Open the **04_Parallax** comp from the Parenting folder within the **Grouping.aep** project from **Training > Projects > Grouping** folder.

18 Notice that all the three layers have the same **X** Position value (**160**).

19 From the **Nearer** layer's **Parent** menu select the **Middle** layer (Fig. 6.44).

Notice that its **X Position** value changes to **0.0**. When you set a Parent for a layer, its value changes to be relative to its **Parent** layer's **Origin**, which in this case is in the middle of this center-aligned text layer.

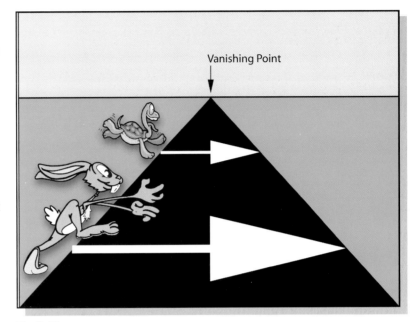

Fig. 6.43

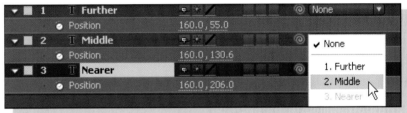

Fig. 6.44

20 Choose the **Further** layer from the **Middle** layer's **Parent** menu to make **Further** the Grandparent (Fig. 6.45).

21 Select **all** the layers and then click on the stopwatch of either of the selected layers to set keyframes for them all, then hit $$ to **Deselect All**.

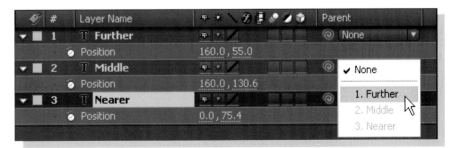

Fig. 6.45

267

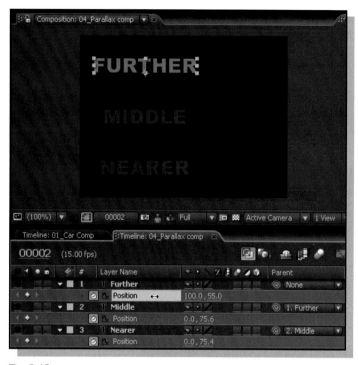

Fig. 6.46

22 Scrub the **X Position** value for the **Further** layer to the left. You'll see that all the three layers are moving at the same speed (Fig. 6.46).

23 Undo the **Position** change by hitting ⌘Z ctrlZ.

24 **Select all** of the layers ⌘A ctrlA again and then, with all selected **scrub** the **X Position** value for the **Further** layer again. This time they all move off to the left again but at different speeds; keep scrubbing the value to the left till the **Further** layer disappears off screen (Fig. 6.47).

Don't change the value by typing in a new value, this will not give you the same result as scrubbing the value. As all layers are selected, this will make all the three layer's Position values identical.

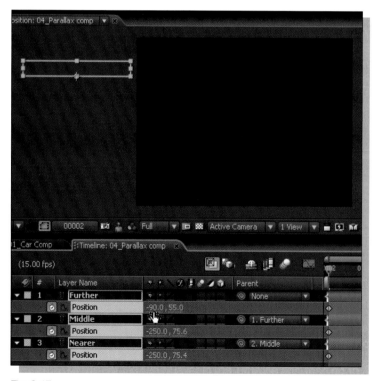

Fig. 6.47

25 With all three layers still selected, move to the end of the **Timeline** by hitting the **End** key on your keyboard and then scrub the **X Position** value till the **Further** layer has completely moved off-screen to the right (Fig. 6.48).

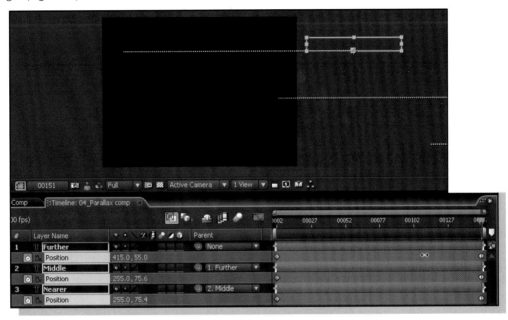

Fig. 6.48

26 **RAM Preview** the animation and you'll see that the layers all move at different speeds, giving the impression of depth. This is because the layers are having their own values adjusted as well as the values taken from their parent layers.

27 Open **04b_Parallax end** comp, this is my finished animation. Make sure the **Timemarker** is at the **End** of the Timeline and pay particular attention to the **Position** values of the layers.

To work out the current value of a parented layer you need to take the Child layer's value and add any associated Parent layer's values to it. In this case we take the **Nearer** layer's **X** position value which is 240, add 240 from the **Middle** layer, plus 400 from the **Further** layer, giving a total of 880 (Fig. 6.49).

28 Un-parent the **Nearer** layer and you'll see its value jump to **880, 206** (Fig. 6.50).

29 **Undo** the last step so that your layers are parented again ⌘ Z ctrl Z.

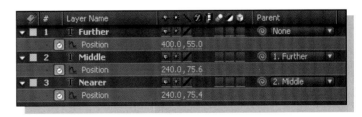

Fig. 6.49

Incidentally, in After Effects, unlike many other programs that have parental hierarchy, the order that the layers are listed in the Timeline panel has nothing to do with parental hierarchy.

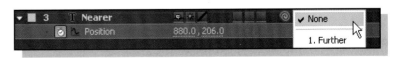

Fig. 6.50

Uses for parental hierarchy

Parental hierarchy is useful in computer animation in a variety of different ways. The next two sections will each demonstrate one of those ways with a different hands-on example. Then, in the following sections, I'll discuss some of the other uses, as well as more advanced parenting issues and some potential pitfalls to watch out for.

Fig. 6.51

Grouping layers

One use for Parenting is grouping layers together. Up till version 5, where parenting was introduced, we had to use nesting to group layers. Now you can set up a simple parenting structure to negate the need for nesting. We can use this technique on the same file that we used in the Nesting section earlier in this chapter. However, nesting can still be useful for changing the render order in After Effects.

1 Open **05_Car comp** from the Parenting folder within the **Grouping.aep** project from **Training > Projects >Grouping** folder (Fig. 6.51).

Here we see the image of the car that we used in the Nesting tutorial. This time the car has been placed into a comp with the background layer. Let's take a look at how we can use parenting as an alternative to the nesting techniques we used earlier.

The pickwhip

You may have noticed right next to the Parenting menu is a little spiral icon. This is the Pickwhip button, it can be used just like the parent pop-up menu to assign a parent to a layer. You can set up parenting by using the Parenting Pickwhip to link from one layer to another, it is also used in Expressions. When using the Pickwhip in parenting you drag from the layer you wish to be the child and choose the Parent layer with it.

2 Click and drag the **Pickwhip** icon for the **Front Wheel** layer over to the **Body** layer. Release the pickwhip when you see the **Body** layer highlighted in a Blue/Green color (Fig. 6.52).

You'll notice that, as you drag a black line extends from the button indicating the direction you are pulling. When you drag the cursor onto the Front Wheel layer you'll see a blue highlight around the

Fig. 6.52

target layer name, as soon as you see this you can let go of the Pickwhip. As you do this the menu will change and you'll see that the body layer is now the Parent for the Front Wheel layer.

3 Repeat this process to choose the **Body** as the parent for the **Back Wheel** layer.

Incidentally, if you accidentally select nothing with the Pickwhip you get a funny thing going on where the Pickwhip recoils back to the button! Try clicking and dragging the Pickwhip from the body layer to some empty space in the Timeline to see this happen.

4 Select the **Body** layer and hit the **S** key to display its **Scale** property.

5 **Scale** the **Body** layer down to **75%**. Now that the Wheels are parented to the body, any changes you make to the body will also affect the wheels, they all scale down as if they were all on the same layer.

6 Select the two **Wheel** layers and then hit **⌥ Shift R** **alt Shift R** to display their **Rotation** values and set keyframes.

7 Move to the end of the comp and change the **Rotation** value to **15 revolutions** for both layers. If you change the value of either of them while both of them are selected then both will update and new keyframes will be created (Fig. 6.53).

Fig. 6.53

8 RAM Preview the animation and see both wheels rotating.

They appear to be rotating backward but that is an optical illusion. Just like in the old Western movies, if a wheel is rotating faster than the frame rate of the medium, it may appear to move backward. For a detailed explanation of this phenomenon go to; http:// en.wikipedia.org/ wiki/ Stagecoach-wheel_effect

Fig. 6.54

Later we will apply motion blur to fix this problem.

9 Select the **Car** layer and then hit Sp to add **Position** to the displayed properties.

10 Set a keyframe at the beginning of the Timeline for **Position** by clicking on the **Position** stopwatch and then move the car off screen to the left. Notice that the wheels move along with the car (Fig. 6.54).

11 Move to the end of the **Timeline** and then drag the car off screen to the right and down a little, so that the path follows the edge of the road (Fig. 6.55).

Fig. 6.55

12 **RAM Preview** and watch as the car drives past the screen with both its wheels turning! Feel free to apply motion blur by clicking on the **Enable Motion blur** button at the top of the Timeline, I've taken the liberty of switching motion blur on for the body and both the wheel layers.

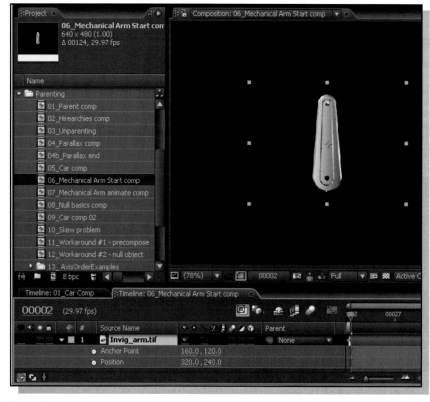

Fig. 6.56

Hierarchal motion

Perhaps the most obvious use for parental hierarchy in animation is to create hierarchical motion. As an example of this kind of use, we'll create and animate a mechanical arm.

1 Open the **06_Mechanical Arm start** comp from the **Parenting** folder within the **Grouping.aep** project from **Training > Projects > Grouping** folder (Fig. 6.56).

The composition contains a single layer, a metal component. This was made with **Zaxwerks Invigorator**, rendered, and then imported into After Effects as a bitmap layer.

Invigorator gives your layers depth and can create true 3D models and layers in After Effects. To find out about this amazing third-party plug-in for After Effects visit: http://www.zaxwerks.com

The pan behind tool

In Chapter 04, Animation we looked at how to adjust the Anchor Point of a layer in the Layer panel, doing this adjusted the relative position in the Composition panel, keeping the Anchor Point in the center of the comp.

The Pan Behind tool can also be used to move a layer's anchor point without moving the layer's relative position in the comp

Fig. 6.57

panel. This technique is useful if you are happy with the relative position of your layers in the comp panel but wish to change the anchor point's position on the layer in order to change it's pivot point.

This shape has a small pivot at each end. We want the anchor point of the layer to be on the pivot at the larger end of the layer, so that the layer will rotate around that point.

2 Select the **Pan Behind** tool from the Tool Panel y and drag the layer's anchor point to the middle of the circle at the larger end of the layer (the end closest to the bottom of the screen). You may need to zoom in a bit to do this (Fig. 6.57).

The Pan Behind tool adjusts the Position value of the layer to compensate for any adjustments you make to the anchor point. This means that the anchor point can be moved without affecting the Composition of your layers in the comp panel (Fig. 6.58).

3 **Rename** the layer, by selecting the layer and then hitting the *Return* key on the keyboard. Change the name to **Forearm**. Hit *Return* again to accept the changes.

4 Select the layer and then hit ⌘ D *ctrl* D to duplicate it.

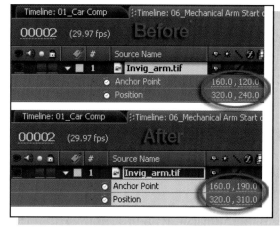

Fig. 6.58

5 Rename the duplicate layer, by hitting the *Return* key on the keyboard and typing in the word, **Hand**.

6 Change the **Hand** layer's **Scale** value to **66%**.

7 Choose the **Selection** tool from the Tool panel v and then click and drag the Hand layer, so that its larger pivot (its anchor point) lines up with the forearm's smaller circle (Fig. 6.59).

Fig. 6.59

If you have difficulty in lining these up try temporarily switching the top-most layer to Difference mode. This will help you see where the two layers differ thus making it easier to line them up.

8 Choose the **Forearm** layer as the **Parent** for the **Hand** by clicking on the **Hand** layer's **Parent** Pickwhip and dragging it onto the **Forearm** layer (Fig. 6.60).

9 **Duplicate** the **Forearm** layer again ⌘ D *ctrl* D, this time rename the duplicate layer to **Upper arm**.

10 In the **Timeline** panel, select the **Upper arm** layer and then drag it down in the layer list so it sits below the Forearm layer in the Timeline panel (this will make it show *behind* the forearm layer in the Composition viewer) (Fig. 6.61).

You can also reorder layers by selecting the layer that you want to move, holding down ⌘ ⌥ *ctrl* *alt* while hitting the **Up** and **Down** arrow keys.

11 Set the **Forearm** layer's **Scale** to **65%**. Notice that the **Hand** layer scales down with it in the Comp viewer as it is the child of the **Forearm**.

12 In the **Comp** viewer drag the **Forearm** layer up so that its larger circle lines up with the **Upper arm's** smaller circle,

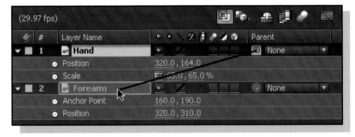

Fig. 6.60

notice that the **Hand** moves with it wherever it goes (Fig. 6.62).

13 **Parent** the **Forearm** to the **Upper arm** by clicking on the Forearm's Pickwhip and dragging it onto the Upper arm layer, the Upper Arm is now the Forearm's parent.

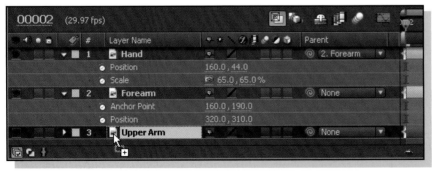

Fig. 6.61

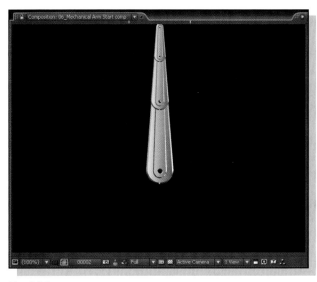

Fig. 6.62

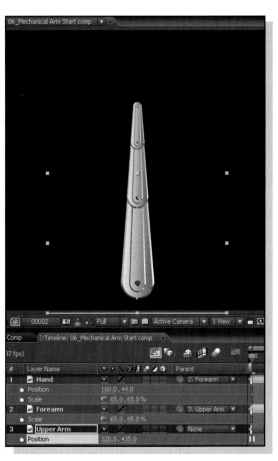

14 Drag the **Upper arm** down the screen, so that its **Y Position** value reads **435**. Notice the **Forearm** and the **Hand** move
with it because it is now the Parent to the Forearm and the grandparent to the Hand (Fig. 6.63).

15 Now we'll make the fingers. **Duplicate** the **Hand** layer ⌘ **D** *ctrl* **D** and rename the duplicate layer, **Finger1a**.

16 Change the **Finger1a Scale** value to **43%**.

17 Rotate **Finger1a** by **50 degrees**.

18 Drag **Finger1a** so that its larger circle lines up with the hand's smaller circle.

Fig. 6.63

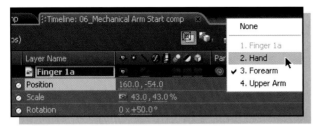

Fig. 6.64

19 Choose the **Hand** layer as the **Parent** for **Finger1a** (Fig. 6.64).

20 Duplicate **Finger1a** ⌘ D ctrl D and rename it, **Finger1b**.

21 Change **Finger1b Scale** to **30%**.

22 Drag **Finger1b** so its larger circle lines up with **Finger1a**'s smaller circle.

23 Rotate **Finger1b** to −50 degrees

24 Choose **Finger1a** as the **Parent** for **Finger1b** (Fig. 6.65).

25 Duplicate **Finger1a** ⌘ D ctrl D and rename the duplicate to **Finger2a**. There is no need to change the Parenting for this layer as both fingers should be parented to the Hand layer.

26 Duplicate **Finger1b** and rename the duplicate to **Finger2b**.

27 Choose **Finger2a** as the **Parent** for **Finger2b** (Fig. 6.66).

28 Rotate **Finger2a** to −50 degrees.

29 Rotate **Finger2b** to 50 degrees (Fig. 6.67).

Many popular 3D animation programs also have a parental hierarchy feature. In those programs, the objects are usually listed

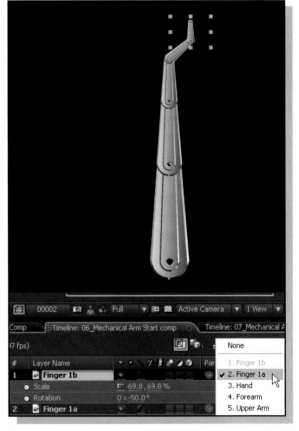

Fig. 6.65

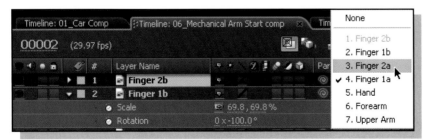

Fig. 6.66

according to their hierarchy. In
After Effects, there is currently
no way to list the objects this
way. If you create a project in
After Effects that has a
complex parental hierarchy, it
may help to make a flowchart
of the hierarchy on paper. An
example of such a flowchart is
shown here (Fig. 6.68).

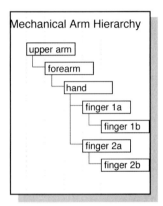

Fig. 6.68

This is a chart of the parental
hierarchy of the mechanical
arm animation and you will
create it in the next section. In
this chart, notice that **Finger1a**
and **Finger2a** are siblings.
Carrying the analogy even
further, **Finger1b** and **Finger2b**
can be thought of as cousins.

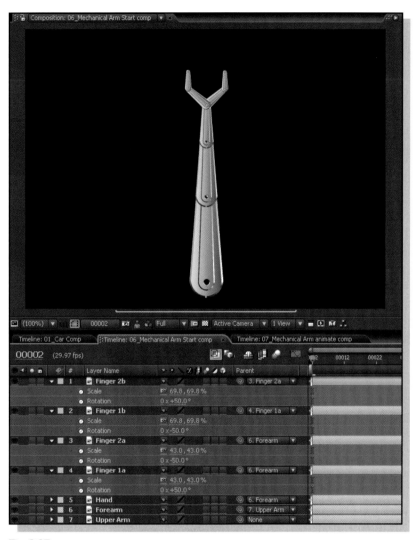

Fig. 6.67

Note that each parent can have an unlimited number of children, but each child can only have one
parent. When more than one layer is parented to the same parent, the children are, naturally, called
siblings.

Animation

The next eight steps will show you how to create the animation of the arm that we just built. I
recommend that you follow all of these steps to create this animation before experimenting on your
own. Afterward, if you wish, you can create your own version of the animation by creating your
own rotation keyframes.

30 Open the pre-built **07_Mechanical Arm animate** comp from the **Parenting** folder within the
Grouping.aep project from **Training > Projects > Grouping** folder.

31 Select all of the layers by hitting ⌘ A ctrl A.

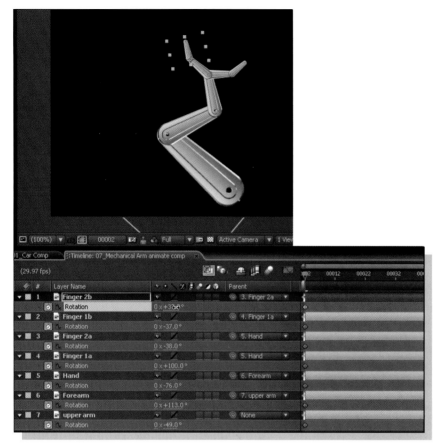

Fig. 6.69

Fig. 6.70

33 Move the Timemarker to the beginning of the **Timeline** and then hit `⌥` `Shift` `R` `alt` `Shift` `R` key to display the Rotation properties and set Rotation keyframes for all selected layers.

34 De-select the layers and then, one at a time, scrub the **Rotation** values in the **Timeline** for each of the layers to pose the arm so that it looks like the one in the diagram (Fig. 6.69).

My advice here is to start at the Bottom of the arm and work your way up to the fingers because any changes made to the Upper arm will affect all the other layers.

35 Go to **Frame 7** and pose the arm like the one in position **1** in the screen shot (Fig. 6.70).

36 Go to **Frame 26** and pose the arm like the one in position **2**.

37 Go to **Frame 32** and pose the arm like the one in position **3**.

38 Go to the **last frame** in the **Timeline** by hitting the **End** key on the keyboard and then advance the Current Timemarker one frame beyond the last frame by pressing the **Page Down** key.

By creating the final keyframes one frame after the end frame, we will be sure to create a perfect looping animation; it will not repeat the first frame.

39 It's important that you do the following steps one layer at a time.

€ Starting at the bottom layer and working your way up the layer stack select the **Rotation** keyframe at **Frame 1**.

€ Hit `⌘` `C` `ctrl` `C` followed by `⌘` `V` `ctrl` `V` to copy and paste the keyframes to the position of the Timemarker (Fig. 6.71).

Fig. 6.71

This must be done one layer at a time, you cannot copy and paste keyframes from all the layers simultaneously; attempt this and you'll end up copying the layers instead.

40 **RAM Preview** the comp to see your animation.

Working with null objects

There are times that you will want to control one layer with another layer as parent, but you won't want the parent layer to be visible. In these situations you can use Null Objects (also sometimes referred to as a dummy object or just plain null for short). A Null Object is a layer that has no visible properties, in other words, it's an invisible layer. Apart from that its like any other layer, it has the same properties; it has a visible wireframe, so you can select and manipulate it in the Composition viewer but the layer will never show in a final render.

There are several situations where it is useful to use Null Objects, particularly when working with 3D and Expressions. They can be used as guides or position markers, to help the animator during complex animations. They can also be used as extra channel holders for use with Expressions, which we'll take a look at in the Expressions chapter (Chapter 11). But for now, let's take a look at some of the basic uses in 2D.

Using nulls as control layers

1 Open the **08_Null basics comp** from the **Parenting** folder within the **Grouping.aep** project from **Training > Projects > Grouping** folder (Fig. 6.72).

Fig. 6.72

2 **RAM Preview** the animation; I've set up a fairly complicated animation of some text layers.

I've made the **Round 1** layer animate around a circle by copying and pasting a circular path shape into the Position property; I've also animated its Scale property. Layers named **Round 2** both have **Round 1** as their Parent layer; so they also have animating Position and Scale properties taken from there. All the three layers have their Opacity values animated to make them fade on over time.

I want to adjust the Positioning and Scale of the whole animation; I could do this by adjusting the Position or Scale properties of my Parent layer. This can be done but is complicated by the fact that I have keyframes on the properties – I would have to adjust all of the keyframes. It's much easier to simply create a Null layer to control the whole animation.

3 Hit the **Home** key on the keyboard to make sure that the Timemarker is at the beginning of your comp.

4 Go to **Layer > New > Null Object** ⌘ *Shift* ⌥ Y *ctrl* *Shift* *alt* Y.

A new Null Object appears in the comp. Notice that the Null has a bounding box but is otherwise invisible. The bounding box is just there for your control, just like with any other layer, it will not render. You'll also notice that the Null layer has an anchor point but that it is not in the center of the layer but is at its Top Left corner at value of 0, 0; this makes it easier to calculate what effect its having on your Child layers. The Anchor Pint still defaults to being placed in the center of the comp.

5 Click on the **Comp** panel to make it active and then go to **View > Show Guides** (if they are not already showing) to check this out for yourself.

6 In the **Parent** column of the **Round 1** layer, choose **Null 1** (Fig. 6.73).

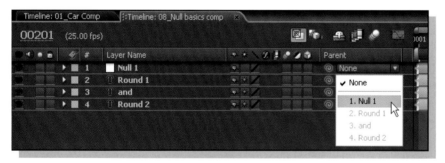

Fig. 6.73

7 Move to **Frame 188** and you'll see that the **Text** layer is too big, it doesn't fit inside the frame of the comp (Fig. 6.74).

8 Click on the **Choose Grid and Guide** button at the bottom of the Comp viewer and select **Title/Action Safe** from the list.

9 Select the **Null 1** layer and hit the **S** key to display its **Scale** value.

10 Scrub the **Scale** value down to about **60%**, so that the title sits within the title-safe area; this will Scale down the whole animation.

Fig. 6.74

You can do a similar thing with the Position and Rotation values. Try animating the Position value of the Null layer so that the whole animation moves from one side of the screen to the other.

Give the parents some time off

You can also use nulls to replace your parent layers; it's just like getting a babysitter! Let's look at our Car comp again. The way we animated the car originally made it impossible for us to add any changes to the Parent without it affecting all of the children. By replacing the Parent layer with a Null layer, we can free up the Parent so that it can go off and do its own thing!

1 Open **09_Car Comp 02** from the **Parenting** folder within the **Grouping.aep** project from **Training** > **Projects** > **Grouping** folder.

2 ⌘ Shift ⌥ Y ctrl Shift alt Y to create a new **Null Object**.

3 Move the Null layer so that the **Anchor Point** sits at the bottom edge of the car just between the two doors. We'll now use the Null layer to group all layers for the car together (Fig. 6.75).

4 Select the **Body** layer and then choose the **Null 1** layer from the **Parent** menu. The **Front Wheel** and **Back Wheel** layers are already parented to the **Body** layer.

Fig. 6.75

5 Lock the **Body, Left**, and **Right Wheel** layers to prevent accidentally selecting them.

6 Set a keyframe at the beginning of the comp for the **Null 1** layer **Position.**

7 **Drag** the **Null** so that all the other layers follow off screen to the **left**. Notice that the layers parented to the null move despite being locked.

8 Move to the end of the Timeline by hitting the **End** key and **drag** the **Null** layer off screen to the **right** (Fig. 6.76).

9 **RAM Preview** to see you have the same result as before without the need to pre-compose, the car, along with its rotating wheels, moves across the screen.

Fig. 6.76

10 Unlock the **Body** layer, select it and then double-hit the **E** key to open up an Expression I have attached to the layer to make it randomly animate its **Rotation** value. Alternatively, you can open the Twirly to open the Expression.

11 You will learn how to use this Expression in the Expressions chapter (Chapter 11) but for now, simply switch on the Expression by clicking on the little **Enable Expression** button. This is the one that looks like a **Does not Equal** sign. When clicked on it changes to an Equal sign (Fig. 6.77).

Fig. 6.77

12 **RAM Preview** and watch as the car body bumps up and down independently of the wheels.

13 To add more realism switch on the **Enable Motion Blur** switch at the top of the Timeline and RAM Preview again (Fig. 6.78).

Fig. 6.78

Advanced parenting

Besides creating hierarchical motion (which we covered when we did the Arm animation) and using parenting as a method of grouping layers together, there are at least a couple of other uses for parental hierarchy. Another use for parental hierarchy is controlling axis order, which is covered in the next section.

The following sections that follow are on fairly advanced topics, including 3D. If you feel comfortable with what you've learned so far and are eager for more, please read on. If on the other hand, you feel the need to absorb what you've learned for a while, get used to using parenting in your animations, or perhaps brush up a bit on 3D before proceeding, feel free to hold off on reading the following sections and come back to them later.

Fig. 6.79

Fig. 6.80

Non-uniform scale problem

As you saw earlier in this chapter, Child layers always animate relative to their Parents. When you parent one layer to another, its values become relative to the parent instead of relative to the composition. By default, when you parent one object to another, it stays in the same place in the composition and does not appear to change at the time of parenting. There is one special case, however, where the child will be *forced* to change when it is parented. To see an example of this, do the following:

1 Open the **10_Skew problem** comp from the Parenting folder within the **Grouping.aep** project from **Training > Projects > Grouping** folder.

2 In the **Project** panel open the **Solids** folder and then drag the **Green** and **Red** solids into your comp (Fig. 6.79).

NB: Solids appear in their own folder in the Project panel so there's no need to create a new solid each time you need one, simply re-use the same solid as many times as you wish.

3 Reposition the solids so that they are sitting side by side with a little bit of space between them (Fig. 6.80).

4 Select the **Green** layer and then hit the **S** key to display the **Scale** property.

5 Unlock the **Lock Aspect Ratio** button for the Scale value (Picture) and then scale the **Green** solid to **50%** in the X-axis but leave it 100% in the Y-axis (non-uniformly scaled) (Fig. 6.81).

6 Rotate the **Green** solid to **45** degrees.

7 In the **Red** solid's **Parent** menu, choose the **Green** solid (Fig. 6.82).

The Red solid will suddenly appear skewed. This is because the Green solid (parent layer) is non-uniformly scaling at a 45-degree angle compared with the Red solid (child) and there is no direct transform that can be applied to the Red solid to compensate for non-uniform scaling in this direction (no way to un-scale it at the 45-degree angle it's being scaled by the parent).

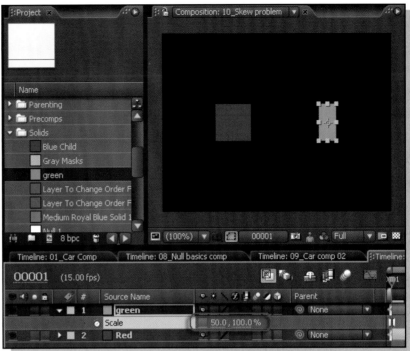

Fig. 6.81

There are two different workarounds for this problem. Each is dealt with in a separate composition demonstrating the problem and each of the two workarounds; 11_Workaround #1 – pre-compose and 12_Workaround #2 – null object. For now, I'll show you how these two comps were developed. The first workaround is to use Nulls to control the rotation.

Solution 1

8 **Undo** the last two operations, leaving you with the **Green** solid still non-uniformly scaled but not yet rotated, and the **Red** solid not yet parented to the Green solid.

9 Create a **New Null** object ⌘ Shift ⌥ Y ctrl Shift alt Y .

10 Choose the **Green** solid as the **Parent** for the **Null** (Fig. 6.83).

11 Rotate the **Green** solid 45 degrees.

12 Choose the **Null** as the **Parent** for the **Red** solid (Fig. 6.84).

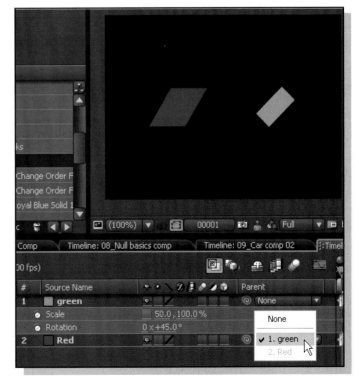

Fig. 6.82

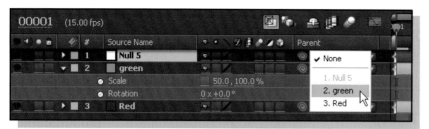

Fig. 6.83

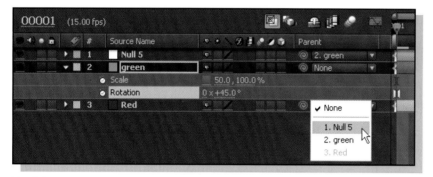

Fig. 6.84

This time, no skewing occurs. That's because the null object was parented to the Green solid *before* it was rotated, thus allowing the null to automatically compensate for the non-uniform scaling of the parent with its own equal and opposite non-uniform scaling. To see this, look at the scale values in the Timeline panel for both the Null and the Green solid. The Green solid is of course 50% in X and 100% in Y, as you last left it. But the null is now 200% in X and 100% in Y, thus undoing the effects of the non-uniform scaling (because 200% of 50% is 100%). Thus the non-uniform scale has no effect on the Red solid.

Solution 2

The second workaround is to pre-compose the scaled parent to a nested composition, moving all attributes to the new composition, before parenting the child to it. This puts the non-uniform scale in the sub-composition, where it cannot affect the child.

13 **Undo** the last operation so that the **Red** solid is not yet parented but the **Green** Solid is non-uniformly scaled and rotated by 45 degrees.

14 **Delete** the **Null** layer.

15 Select the **Green** solid layer and go to **Layer > Pre-compose** to open up the **Pre-compose** dialog box.

16 Type in **Green Pre-comp** as the new comp's name, choose to **Move All Attributes into New Composition** and click **OK** to leave the dialog (Fig. 6.85).

17 Back in the **10_Skew problem** Timeline, **Parent** the **Red** solid to the **Green Pre-comp**. Once again, no skewing occurs because the non-uniform scale happened in the Pre-comp so has no bearing on the child (Fig. 6.86).

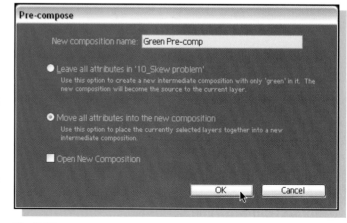

Fig. 6.85

Controlling 3D rotation

If you have no experience with any 3D applications, or have absolutely no understanding about how 3D works in general, then you can come back to this section later, when it is referred to in the 3D chapter

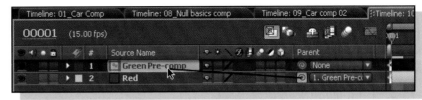

Fig. 6.86

(Chapter 09). If this is the case, skip the next three sections and come back to them once you've mastered the basics of 3D.

If you have a basic understanding of 3D, then it is useful to continue with this section as it will give you a clear insight into how After Effects operates rotation in 3D.

The first section covers a very important method for controlling how layers rotate in 3D space. The second will show you how you can use parenting to create extra pivot points for your 3D cameras.

Now, I am aware of the fact that we haven't yet covered the basic 3D features of After Effects, but I felt that this section really belonged in the Grouping chapter.

Rotational axis order

Another use for Parental Hierarchy is controlling the rotational axis order of 3D layers.

1 For a basic demonstration of what 3D axis order is, open and play the QuickTime movie file, **AxisOrderDemo.mov** which is in the **13_Axis Order examples** folder in the Project panel of the **Grouping.aep** (in **Training > Project > Grouping**).

Once you have viewed this movie, keep it open so that you can refer to it now and then throughout this section. To help you understand more, you can also try the following:

2 Pick up a book and hold it in your hand with the front of the book facing toward you. (Not this book as you will need to keep reading!)

3 Imagine three axes of rotation for the book (Fig. 6.87).

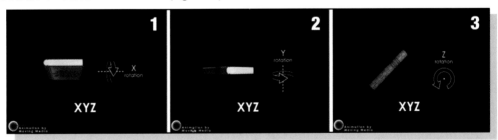

Fig. 6.87

- Rotating on the book on its **X**-axis would mean tipping the book in your hand so that either the top or the bottom edge of the book comes toward you.
- Rotating on the book on its **Y**-axis would mean twisting the book in your hand so that either the left side or the right edge of the book comes toward you.
- And rotating on the book on its **Z**-axis would mean turning the book in your hand like a steering wheel, so that the face of the book continues to point toward you but the book is sideways, with either its left or right edge toward the floor.

4 Now, to demonstrate what axis order is, try rotating the book in your hand **90** degrees in each of the three axes one at a time in the following order: first **X**, then **Y**, then **Z**.

5 Notice the orientation that the book has ended up in (Fig. 6.88).

6 Now, reset the book to its original orientation with the front of the book facing toward you again.

7 This time, rotate the book **90** degrees in each of the three axes again but in a different order: first **Y**, then **X**, then **Z** (Fig. 6.88).

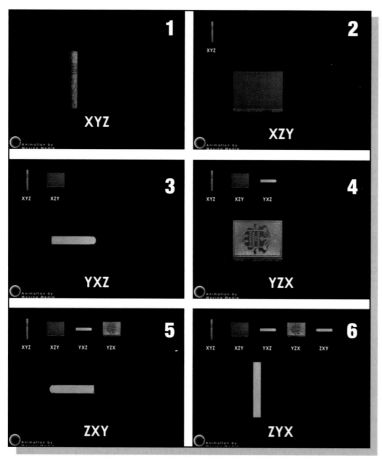

Fig. 6.88

Note that the book is now in a different orientation, even though you have rotated it by exactly the same amount in each axis as you did before. The reason for this is that the order you rotate the book in each axis makes a huge amount of difference and therefore matters a lot – there are six different possible permutations!

In After Effects, when you specify an orientation for 3D layer using X, Y, and Z values, the same issue exists. Depending on what order the rotations are applied, the same set of X, Y, and Z rotation values mean a completely different thing. (This is true for both; the Orientation channel and After Effects' separate X, Y, and Z rotation channels. Either way, After Effects must interpret the three values in a particular order.)

The rotational axis order for 3D layers in After Effects is always ZYX. This means that when you enter rotation or orientation values, the Z value is applied to the layer first, then the Y value, then the X value. There are situations where you may need a different axis order for a particular animation. By using extra Null objects as parents, you can control the axis order of any 3D layer.

As an example, here is how to set the axis order of a 3D layer to XYZ.

8 Open the comp named **14_Force Axis Order** comp from the **Parenting** folder within the **Grouping.aep** project from **Training > Projects > Grouping** folder.

This contains a single comp with a single solid in it called **Layer To Change Order For** and a camera. We will change the axis order of this layer to YXZ. This must be done before applying any rotation values to the solid.

9 Create two **Null** objects, and rename them **Y control** and **Z control**, respectively.

> To rename a layer, click on the layer in the Timeline panel to select it, and then hit the _Return_ key, you can now type a new layer name and then hit the _Return_ key again to accept the change.

10 Make both null objects **3D** layers by clicking their **3D Layer switches** in the Timeline panel (Fig. 6.89).

11 To place the null objects in the exact same position (in x, y, and z) as the solid, first copy the **Position** value from the **Layer to Change Order For** layer by clicking on the **Position** property name (in this case, **Position**) in the Timeline panel and hit ⌘ V _ctrl_ V to copy it.

12 Select the two null layers and then select both of the **Null** layers and hit ⌘ V _ctrl_ V to paste the **Position** property into the selected layers (Fig. 6.90).

13 Parent the **Y** Null to the **Z** Null, and parent the **Solid** layer to the **Y** null.

14 When animating, rotate only the **Z**-axis of the **Z** null, rotate only the **Y**-axis of the **Y** Null, and rotate only the **X**-axis of the **Solid**. Experiment by animating the solid's rotation in this way. Be very careful not to change any other axes besides the Z-axis of the Z null, Y-axis of the Y null, and X-axis of the solid (Fig. 6.91).

Because X is being rotated at the bottom of the parental hierarchy in this case, the effect will be as if X were being applied first. Y being rotated in the middle of the hierarchy will have the same effect as if Y were being applied second, and Z being rotated at the top of the hierarchy will have the same effect as if Z were being applied last. So your effective axis order will be XYZ.

The folder named 13_Axis Order Examples contains examples of this technique already set up for each of the possible axis orders (excluding ZYX since After Effects layers already use ZYX by default).

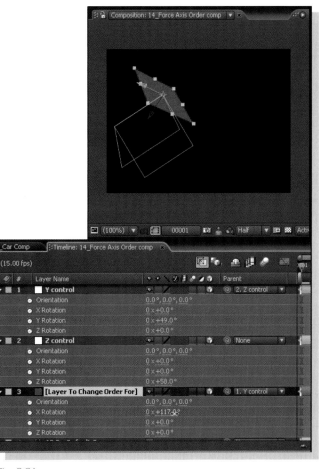

Fig. 6.89

Fig. 6.90

Fig. 6.91

Fig. 6.92

OK, let's take what we've learnt so far and apply some of it to the character animation we started setting up in the Pre-composing section earlier in this chapter. We'll use Parenting to link the body parts together of our main characters.

Character animation

OK, let's go back to our character animation, it's been a while since we've done some work on it. We'll use the same technique as we've just used for the robot arm.

I've done a fair bit of character animation using After Effects, mainly cut-out animation, similar to the style Terry Gilliam used in the Monty Python animations and not too dissimilar to South Park's style of animation.

Till Parenting was introduced, I always used complex nesting procedures to link the individual parts of my characters together. I would draw them in Illustrator with each part on a separate layer, bring it in as a Comp, and then Pre-comp the body parts together as needed.

Parenting gets rid of the need for complex nesting hierarchies, I can now link the body parts together in one composition. Needless to say I spend far less money on headache pills now! I know that it may seem intimidating to those who have never used it before, but Parenting really makes life so much simpler.

1 Open the Project named **Character animation.aep** from **Training > Projects > Grouping** folder (Fig. 6.92 – does not have to be readable).

OK, the first thing that we have to do is to set up our Pivot Points (i. e. the point around which we want our layers to rotate). After Effects uses the Anchor Point of a layer as its pivot point. When you import an image or movie, the anchor point is positioned in the center of each layer.

2 Hold down the 🔲 *alt* key while double-clicking the **Dancer 2** layer to open up the nested composition.

3 Select the **Rotation Tool** from the Tool Panel w (Just think of Elmer Fudd from the old Bugs Bunny cartoons saying the word Rotation to help you remember this shortcut!)

Fig. 6.93

Fig. 6.94

Fig. 6.95

4 Click on the **Head** layer in the comp panel and drag up or down to rotate it, notice it rotates around the center of the layer. You may also notice that the features of the face do not follow the Head as it rotates (Fig. 6.93).

5 **Undo** the Rotation of the layer till you are back to where you started ⌘Z ctrl Z.

6 Select the **Pan Behind** Tool y from the **Tools** panel. As you learned earlier, the Pan Behind Tool will adjust the Anchor Point without altering the layout you already have in the Composition viewer.

7 With the **Pan Behind** Tool, click and drag the **Anchor Point** of the **Head** Layer till it sits on the chin, where you would expect the Head to rotate from (Fig. 6.94).

8 With the **Head** layer still selected, hit the r key to bring up **Rotation** value and scrub the value. Now it rotates around the correct point but the features of the face still do not follow (Fig. 6.95).

291

9 Undo the rotation ⌘ Z ctrl Z and re-select the Selection tool v when you have finished.

10 Use the **Pan Behind** tool to adjust the Anchor point for each of the other layers. Make sure that you move the Anchor point to the position you would expect the body parts to rotate from. For example, the arms would rotate around the elbows and shoulders.

OK, so what we need to do now is to link the body parts together. Let's start with the arms.

11 Make sure that the **Parenting** column is visible. If not, click on the **Timeline wing menu** and then go to **Column > Parent**.

12 Drag the **Pickwhip** from the **Glasses** layer over to the **Head** layer. Let go of the mouse button when the **Head** layer is highlighted in blue and the Parenting menu changes to display the name of the **Head** layer (Fig. 6.96).

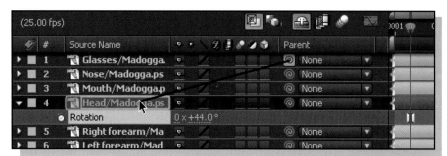

Fig. 6.96

44 Rotate the **Head** layer again and notice that the **Glasses** now move along with the Head.

45 Set up the other layers as follows (Fig. 97):

Nose > Head;
Mouth > Head
Head > Body
Right forearm > Right arm
Left forearm > Left arm
Basque > Body
Left arm > Body
Left shin > Left thigh
Right shin > Right thigh
Left thigh > Hips
Right thigh > hips
Hips > Body
Body > None
Right arm > Body
Tail > Hips

46 Once you have finished setting up the parenting, select all of the layers and then hit the r key to display the **Rotation** values for all selected layers.

Fig. 6.97

13 Deselect the layers and then try rotating the various body parts to see how the parenting structure works.

14 **Undo** the rotations so that your character is back in its original pose ⌘ Z ctrl Z.

OK we are going to leave this tutorial for now but will return to it in the Expressions chapter (Chapter 11), where we will animate the linked body parts using Expressions and Keyframe Assistants.

Recap

In this chapter you have learnt various techniques including Nesting, Pre-composing, and Parenting. These are all useful to animators, motion graphic, and visual effects artists in several important ways. They will help you in the following areas:
- Grouping objects together.
- Adjusting the render order of effects, masks, and transformations.
- Creating hierarchical motion.
- Creating extra pivot points.
- Changing axis order.
- Creating realistic and natural looking movements.

In combination with Null Objects, Parental Hierarchy can also be useful any time you just need to isolate different components of a complex motion. By using a different Null Object for each aspect of the same motion, you can easily create and work with much more complex animations than you would otherwise be able to. In short, Parental Hierarchy is a very important tool for animators! I hope this chapter has helped you become familiar with this aspect of After Effects, and its great possibilities. Now take some time to experiment and make your own animations with Parental Hierarchy, and have fun!

Inspiration – Kate Isles

As a designer specialising in magazine and publication design, Kate has over 20 years of experience in this field working with companies such as the Bank of Scotland, The Royal Bank of Scotland, Scottish Power, Scottish and Newcastle, and Sterling Furniture Group.

Having worked for Insider Publications Ltd for 16 years, heading up the design department, she joined The Union Advertising Agency and has recently become a freelance designer, continuing to design for magazines and publications as well as Corporate Identities and Web sites.

Along with designing concepts and taking projects right up to print, she also art directs photography for publications, styling the photography, and enhancing them to create the right feel for the publication. Kate designed the cover and page layout for this book and be contacted at: kate.isles@mac.com

Q How did your life lead you to the career/job you are now doing?

A Decided to go to Art College when I was eight thinking I'd do painting but when I got there decided to do Graphic design because it would earn me a living – painting doesn't pay! Already interested in Publication/Magazine design, I won a commission to design the Official Edinburgh International Festival Guide and got started in the magazine industry. After leaving college I worked in publications for a year before starting with Aldus Europe working with PageMaker and Freehand 1.0. I then got a job with Insider Publications designing business and contract magazines where I stayed or 16 years. Its all pretty straightforward and a little boring really with no great breaks – just a lot of very hard work and long hours.

Q What drives you to be creative?

A A total love of how people react to visual stimulus and how you can communicate to people by using 'pictures'! Its fascinating how letters and words can be put together with pictures and I never get tired of the shapes you can create. I love the printed form and what you can do with different printing techniques. Design isn't just about how something looks – its more about how people react to it and how easy you can make it for people to 'get the message' you want them to get. I just love everything visual, color, type, shapes, atmosphere, etc.

Q What would you be doing if not your current job?
 Probably painting or craft things but that isn't really a job so I probably wouldn't be doing anything else!

A Do you have any hobbies/interests and if so, how do you find time for them?
 Hobbies: Painting, metalwork, stained glass, DIY, woodwork, traveling. Since going freelance I don't really find the time for them!

Q Can you draw?
A Yes, and love it! Life-drawing classes are a must to keep your hand and eye in – but also as a stress buster. Better than the gym in every way!

Q If so, do you still draw regularly?
A Oh Yes! I do most of my designing in sketchbooks rather than straight onto the Mac. The process of drawing allows my mind to think things through in a deeper way than doing it straight onto computer. The slowness of it allows my imagination to take over.

Q What inspires you?
A Nature, people. All the things you see around you from frosty mornings to summer sunsets. Different lights and colors. Other peoples designs are also inspiring cos you can see how someone else came to a solution and its always good to take a step back and soak up.

Q Is your creative pursuit a struggle? If so, in what way?
A Sometimes. Especially if a brief isn't clear. Its always a lot easier when you know what the clients expectations are and what constraints you are. If a brief isn't clear then it's quite hard to guess what they want and usually it doesn't work. Once you go down a route that isn't right for them it can be hard to clear all that thought out of your head and start again.

 However if all the info is there its usually fairly instant getting an idea that works and then it's just about working through that to get the finished idea. Everyone always want several design options, but the first one usually seems to be the one that works best.

Q Please can you share with us some things that have inspired you. For example, film, song, web site, book, musician, writer, actor, quote, place, etc.
A Music is great to work too but so many different types depending on what the job is – classical, drum and bass, melodic songs. The window that I look out of when I'm working. Standing under a hot shower with the water hitting the top of my head! Other Designers like Ian McIlroy.

Q What would you like to learn more about?
A Video and editing, filming, and the moving image. More print related stuff. Industries move so quick you can't afford to stay put – learning and keeping up to date is essential and brilliant fun too!

Chapter 07 Effects

Fig. 7.1

It's taken some time to get to the chapter that I'm sure a lot of you have been itching to get to, the Effects chapter! When I teach my two-day 'basics' course on After Effects I always concentrate on leaving the effects till last because you need to have a good, solid understanding about how the keyframing and software functions before you can make the most of the effects available to you. The other reason is that the Effects menu is naturally what most people head straight for when they open up After Effects so I find that most users tend to get to know this menu pretty well without a lot of persuasion.

Synopsis

Obviously, I am limited to what I can cover in the pages of this book and there is no way on earth that I could hope to cover every effect available in the Standard and Professional versions of After Effects. So, rather than cover all of the effects sketchily, I decided to cover just a selection of them in a bit more detail. The Adobe After Effects user manual and Online Help system cover what I haven't been able to do here. We'll look at how to break down and understand the way that effects work in this chapter and will then continue to use effects throughout the remaining of the book.

We'll also take a look at Animation Presets and how they can be used to save frequently used effect settings.

Color effects

Without filters
1 Open **01_ColorFX_start.aep** from **Training > Projects > 07_Effects** (Fig. 7.1).

This was created using the Professional version of After Effects but can be opened with either of the versions because no Professional version effects have been used on it.

2 **RAM Preview** the Composition to remind yourself what you have already done in this project. So far, all we have here is a fast-moving background consisting of various graffiti images.

This is going to be a movie that can be used as an interesting background for an opening titles piece. The imagery and movement are exciting and lively, just as we want, but it is currently too multi-colored and distracting to use for a background.

The images change from one frame to another, there is no common thread such as a color theme to pull them together. We need to introduce an element of design which remains constant throughout, the most obvious and effective element is color. By putting a color treatment over the footage we can bring it all together, making it less visually jarring yet still retaining the same excitement.

Sometimes the best way to achieve an effect such as a color treatment is not by using the effects in the Effects menu, but by using other layers to colorize your footage. Remember that the more filters you use, the slower your comp will become to work with. I always like to encourage my students to first think of ways of achieving certain results without the use of effects; it's good exercise for the brain and it encourages them to find new ways of working.

The easiest way to bring some structure into the composition and to colorize the image underneath is to superimpose a single layer with some simple, colored, and geometric shapes over the animation, this will pull the whole thing together.

3 Import the file named **Thick-stripes.psd** from the **Training > Source Images > Angie Images** folder.

4 Drag the file into the Timeline of the **Background Sequence** Comp as the top layer (Fig. 7.2).

5 Click on **Expand/Collapse Transfer Controls** button at the bottom of the Timeline to bring up the **Modes** column (Fig. 7.3).

6 Choose **Hard Light** from the **Thick-stripes.psd** layer's **Mode** menu.

The images will now be composited together, the colors and shapes help to make the background less obtrusive. Dividing the screen into three parts like this will make it appear bigger and take away some of the emphasis from the animated imagery. Using the layer and Layer Modes to colorize the background saves us from having to apply effects to the layer to get a similar result.

Fig. 7.2

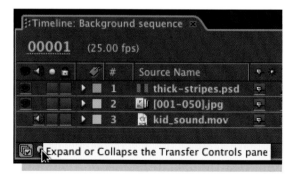

Fig. 7.3

Speeding up workflow

Before moving ahead to the effects I want to show you a couple of ways of speeding up your workflow, very important things to know if you are planning to use a lot of effects in your compositions.

RAM Preview Options

1 **RAM Preview** your composition. If you find that you don't have enough RAM to preview the whole project, there are a few things you can do to help.

2 Open up the **Time Controls panel** if it is not already open by hitting ⌘3 ctrl3 (Fig. 7.4).

3 If it is not already showing open up the **Info panel** ⌘2 ctrl2.

4 **RAM Preview** your composition again and watch the display in the **Info** panel.

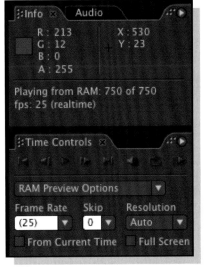

Fig. 7.4

You'll notice that After Effects is attempting to render all 750 frames of your composition. When it plays the frames back to you, it will try it's best to play them back at the same rate as your composition, that is in real time.

In the **Time Controls** panel the **Frame Rate** box tells you how many frames the RAM Preview will attempt to play for every second of your composition.

5 In the **Time Controls** panel change the **RAM Preview Frame Rate** to **15** (Fig. 7.5).

6 RAM Preview the comp again, you'll notice that After Effects still renders the same amount of frames but will play those frames back at half the speed, taking twice as long to render all of the frames. The images and the audio will play back to you in slow motion.

Fig. 7.5

7 Click on the **Frame Rate** drop-down menu and change the **Frame Rate** back to **Auto**. This setting will use the current composition's frame rate.

We will leave our **RAM Preview** at the default setting but will change our **Shift + RAM Preview** settings. The Shift RAM Preview Options allow you to create a new set of preferences for previewing the footage with the **Shift** key held down. At the default setting, holding down the **Shift** key while activating a RAM Preview will render every second frame of your composition.

By being able to customize these options individually, you have two choices for the type of RAM Preview you want to use in a given situation. I prefer to leave the RAM Preview settings at default (rendering every frame in real time) but it's also very handy to use my Shift + RAM Preview for quicker, dirtier previews!

8 In the **Time Controls panel**, click on the **RAM Preview Options** menu and select **Show Shift + RAM Preview** Options (Fig. 7.6).

Fig. 7.6

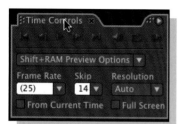

Fig. 7.7

As you can see, we have the same options available as with the RAM Preview Options.

9 Hold down the **Shift** key while simultaneously hitting the **0** key on your number pad to activate a **Shift + RAM Preview**. In the Time Controls panel, notice that After Effects is loading 375 frames into RAM.

With the **Skip Frame** setting at the default value of 1, After Effects will render the first frame and then skip one frame in between all the others, that is it will render every second frame.

10 Change this setting to **14** and then hit **Shift 0** to do another **Shift + RAM Preview** (Fig. 7.7).

11 Look in the **Time Controls** panel while the preview plays back you'll notice that After Effects is now playing a total of **50** frames, that is one frame for every second of the composition. It plays the footage at the correct speed, it is simply missing out 14 frames out of every 15 frames of your comp.

12 Change the **Skip Frames** setting back to 1.

Fig. 7.8

13 Change the **Resolution** menu to **Half**, this will drop the pixel resolution making it quicker to process the frames, and After Effects will be able to load twice as many frames into RAM at half resolution. To see the difference how this works, hold the S key and hit 0 on the number pad to do a **Shift + RAM Preview**.

14 Click on the **Shift + RAM Preview Options** again and select **RAM Preview Options** from the menu.

15 Change the **Skip Frames** value to **14** so that we only preview 1 frame per second of our comp.

16 Click on the **Full Screen** checkbox and then hit **0** on your number pad **RAM Preview** your composition against a plain gray background (Fig. 7.8).

For now, we have finished working on our background. We don't need After Effects to re-render it every time we make a change. At this point in a project, it's a good idea to render the elements that you know are unlikely to change. There are several options for doing this, each can be useful depending on the given situation.

Pre-rendering

One solution is to Pre-render your comp as a finished movie. This can be done by making the comp active in the Timeline and going to **Composition > Pre-render**. This will automatically add the comp to the Render Queue, with **Best Settings** selected for the render settings and **Lossless with Alpha** for the output module. The rendered movie will be automatically imported into your Project panel ready to use in your comps.

This technique is perfect if you know that the movie will not have to be altered again but if you are likely to change anything in the original composition it is quicker to use low-resolution proxies.

Using proxies

Proxies are temporary files that can be used to substitute any layer or composition in your project. These can be smaller, have lower frame rates, or have lower resolution than your original footage; you can even use still images to temporarily replacing complicated compositions. The purpose of using a proxy is to reduce the amount of processing time needed to preview or render your image.

We will use the RAM Preview that we have already built as a proxy for the composition. Later I will show you easy ways to automate the process of proxy creation, for now we will do it manually.

17 Go to **Composition > Save RAM Preview** (Fig. 7.9).

18 The **Output Movie To** dialog box will appear, save the file to the **Desktop** folder as **Background Sequence RAM.mov** (or .avi for Windows users) and then click **Save** (Fig. 7.10).

The Render Queue panel will now appear in the same frame as the Timeline panel. After Effects will automatically render the RAM Preview directly onto your hard disk. Remember that this movie will be rendered using the same settings as you have in your RAM Preview Options. Once the RAM movie has rendered it is imported into the Project window.

19 In the Project panel, select the **Background Sequence** Composition.

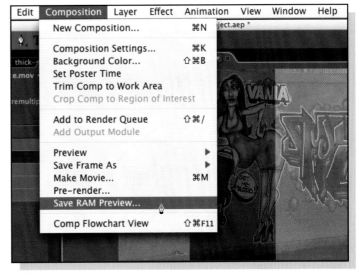

Fig. 7.9

Fig. 7.10

20 Go to **File > Set Proxy > File** or hit ⌘⌥P ctrl AP.

21 Choose the **Background Sequence RAM.mov/.avi** from the **Desktop** and double-click it to select it as the proxy file for your composition. Notice the red highlight at the bottom of the Comp

Fig. 7.11

Fig. 7.12

window indicating a proxy file is enabled (Fig. 7.11).

22 Close the **Render Queue** so that you can see your Timeline again by hitting ⌘⌥0 ctrl alt 0.

23 Move to frame **210** in the Timeline.

You may have also noticed a little square button appears next to the composition icon in the Project panel, this is the **Toggle Proxy** button. This button indicates that a proxy is attached to the original file, when the button is black the proxy is being used to substitute the original file.

24 Move over to the **Project** panel and toggle the **Proxy Toggle** button on and off to see any changes that may occur. You should see the frame displayed in the Comp viewer change, notice that the red highlight appears only when the proxy is enabled (Fig. 7.12).

25 Switch the proxy **on** when you have finished comparing.

26 In the **Time Controls** panel, change the **Skip Frames** setting back to 0 and then RAM Preview the composition again.

Notice that it is now much faster to load a full RAM Preview of your composition. When it plays back, you'll see that it is showing only one frame for every second of your composition.

Using effects on proxies

Once you have chosen a proxy file for your layer or composition, you can still make changes to the original, but beware – the proxy will remain unchanged – only the original layer will update to reflect the changes.

27 Context-click the **Thick-stripes.psd** layer in the Timeline and go to **Effect > Color Correction > Hue Saturation**.

28 In the **Effect Controls** panel, change the **Master Hue** angle to **−90 degrees** (Fig. 7.13).

Nothing appears to change in the Composition panel; this is because we are looking at a frame from the proxy file, not from the original layers.

Fig. 7.13

29 In the **Project** panel, click on the **Toggle Proxy** button, next to the **Background Sequence** composition to switch off the proxy and see the changes to your original layer.

30 **RAM Preview** the movie with the new effect applied.

31 When you have finished looking at the changes you have made, click on the **Hue/ Saturation** name in the **Effect Controls** panel and hit **Backspace** on your keyboard to delete the effect.

32 In the **Project** panel Switch the proxy **on** and then save the project into your **Desktop > Work in Progress > 07_Effects chapter** folder as **01_ColorFX_02.aep**.

In this case the benefits that we get from using a proxy are minimal but just imagine how much time they can save you when working on more complex, multilayered, and effects-laden comps. The fact that they can be turned on and off so easily makes them extremely versatile. The only thing that you must look out for is that you don't forget that your proxy is being used. Many of us have been confused after applying an effect to a layer and not seeing any change, only to realize that a proxy was being used!

Color treatment effects with filters

OK, we'll now return to the project we worked on in the Compositing chapter (Chapter 05). Last time we worked on this we created a new composition to place over our main edit, let's remind ourselves where we left it.

1 Open **SeattleNews04.aep** from the **Training > Projects > 09_Effects** folder (Fig. 7.14).

2 **RAM Preview** the **Edit.ppj** Composition to remind yourself of the contents of this comp.

We have the same problem here as we did with the Graffiti Club project. The edits are in the right place, we have created some nice, animated, and geometric shapes composited over the edit. We now need to use a color

Fig. 7.14

treatment on this to bring it all together. This time we will use another After Effects filter to colorize the footage.

Colorama

We need to give the sequence a uniform color treatment to bring it all together. The easiest way to do this is by using Adjustment Layers. Remember, effects applied to Adjustment layers will affect every layer beneath the Adjustment Layer so not only will our Masks comp layer be affected by the effect but also all the layers underneath it.

3 With the Timemarker at the beginning of the Timeline, go to **Layer > New > Adjustment Layer**.

4 **Context-click** on the new **Adjustment Layer** and go to **Effect > Color Correction > Colorama** (Fig. 7.15).

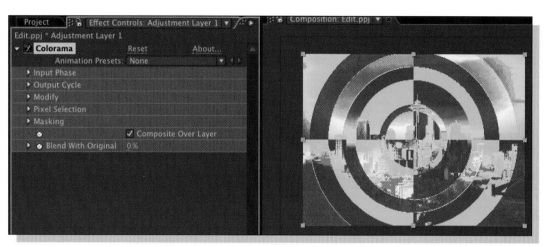

Fig. 7.15

Colorama is a great tool. However, like many other filters, I think it is let down by its default presets. Just look at the following diagram to see what I mean – ouch!

Anyone looking at this for the first time would recoil in horror at the nasty, bright, and gaudy colors that greet you when applying the default setting. Don't let this fool you, it is an extremely powerful and useful image control filter.

Colorama works by mapping the selected colors that you choose for the effect's Output Cycle properties onto a grayscale version of the layer you choose to affect. The default setting will apply the colors to the whole layer but you can also choose to apply the changes to single channels or other image elements such as Hue, Lightness, etc. You can even take these elements from another layer in your comp by using the Input Phase settings.

Brian Maffit and the Atomic Power Corporation designed and developed Colorama as a third-party plug-in for After Effects by. One of its many uses is creating color-cycling animations; you may have seen this type of animation featured heavily in television during the 1970s; for example, episodes of Top of The Pops (UK) or in music videos.

You will also be familiar with color cycling if you were a user of Electronic Arts' 'Deluxe Paint' on Amiga (Ah! Memories!) http://www.amigahistory.co.uk/

With Colorama you start by choosing a range of colors to map onto a cycle. You can then animate the cycle so that the colors loop over and over, building as they go. It can be used as a quick and easy way to make animated fire effects.

5 Open up the **Output Cycle** settings and you will see a rainbow-colored wheel, this is your Output Cycle, where you can choose the colors you want to make up your image (Fig. 7.16).

The Output Cycle works similarly to other color wheels, the colors are positioned around the wheel and they interpolate gradually from one to another. Colorama converts your image to a grayscale image and then remaps the Dark areas in your image with the top color selected on the Output Cycle. It then maps all the other shades of gray evenly around the rest of the color wheel, in a clockwise direction, till it reaches pure white, which is back at the top again.

6 Click on the effect's **Use Preset Palette** drop-down menu to display its list of ready-made presets for you to choose from. These will help you to understand how this plug-in works.

7 Choose **Ramp Green** from the Preset panel drop-down menu (Fig. 7.17).

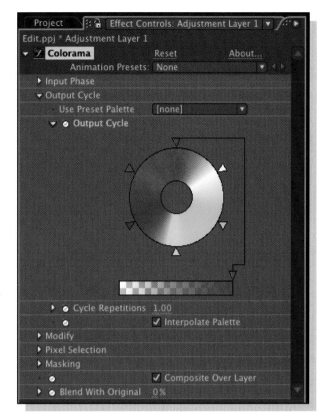

Fig. 7.16

Fig. 7.17

This Colorama Cycle has only two selected colors: black and green. The two Color Triangles are positioned practically in the same place at the top of the wheel so it appears that there is only one. But the black Color Triangle is actually hiding behind the green one.

40 Click to the left of the **green** Color Triangle to bring up the **Color Picker**. The color you choose here will be the color that all the lightest values in your image will be mapped to (Fig. 7.18).

Fig. 7.18

The black triangle is directly under the green one, this makes it easy to accidentally click on it. To make sure that you double-click the green triangle, click slightly to the left of it. To be absolutely sure you have got the right Color Picker open, make sure that the **Color Swatch** in the **Color** dialog is **green** when you first open the dialog; if it's black, then you've opened the wrong one, cancel and try again till you get the green one.

8 Choose a bright, orange color (e.g. **R = 100%**, **G = 60%**, **B = 5%**) and then click **OK**.

9 Double-click on the right-hand side of the Color Triangle to bring up the Color Picker for the black Color Triangle. This is where you will choose the color you wish to map the dark areas of your image to. This is currently set to pure black. Try changing it to a deep, dark brown, almost black but not quite (e.g. R = 16%, G = 0%, B = 0%).

Fig. 7.19

You should be able to see what is happening to your image now. All of the dark areas are now dark brown, all the light areas are bright orange, and all the areas in between are interpolated to various shades in between the two colors.

10 Click the **Effect on/off** switch (little filter icon that looks like a letter **F**) to the left of the effect's name in the **Effect Controls** panel to switch off the effect to see the original colors and then switch on again to compare (Fig. 7.19).

11 Give your image a more posterized look by **de-selecting** the **Interpolate Palette** checkbox underneath the **Output Cycle** (Fig. 7.20).

Fig. 7.20

With this option unchecked Colorama jumps from one color to the other rather than changing gradually. This will make it clearer to see what is happening as we go through the next few steps. This posterized effect works really well with bold close-ups of faces. You can experiment with this a bit more at the end of this chapter.

You can add up to 64 new Color Triangles simply by clicking anywhere around the Cycle and choosing a new color.

12 Position the cursor at the edge of the cycle at about the 3 o'clock position and click once, doing this will bring up the **Color Picker**. Choose a deep but bright red and then hit **Enter** to leave the Color Picker box (Fig. 7.21).

You can also move the Color Triangles easily by dragging them. As with most of the controls in After Effects, holding down the Shift key while dragging will constrain the movement to pre-defined increments. In this case it will constrain the movements to increments of 45 degrees.

13 Click and drag the orange Color Triangle from the 12 o'clock position to the 6 o'clock

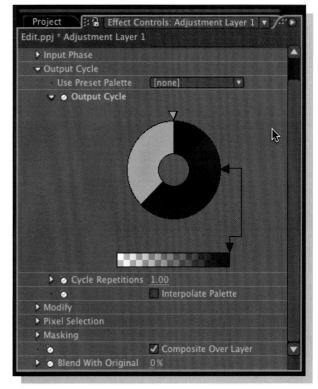

Fig. 7.21

Fig. 7.22

Fig. 7.23

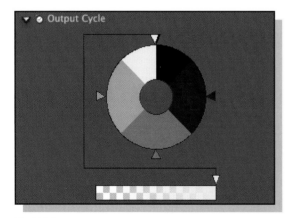

Fig. 7.24

position. Hold down **Shift** as you drag to constrain the movement, allowing it to snap into place at the 180-degree mark (Fig. 7.22).

14 Double-click the **orange Color Triangle** to open up the **Color Picker** again. Change the color to a slightly deeper orange. Click OK to leave the **Color Picker** box.

You will notice underneath the Output Cycle is a strip. This is the Opacity slider for your colors. Notice that this also has a Color Triangle which is connected to the active Output Cycle Color Triangle by a black line.

15 Try dragging the **Opacity** triangle all the way to the left to see how it affects the selected color (Fig. 7.23).

Notice that the color decreases in opacity as it is dragged to the left. This will allow the original pixels to show through. By placing the triangle half-way along the slider you will be blending the original pixels with the new color by 50%. It's nice to be able to adjust the opacity of the colors individually, this feature can even be used for pulling successful keys on footage but we'll leave that for another time!

16 Once you have finished experimenting with this, drag the slider all the way back to the right again to put the **opacity** back to **100%**.

17 Click on the 9 o'clock position of the **Output Cycle** and this time choose a paler orange from the **Color Picker.**

18 Click to the left of the top, **black Color Triangle** (at about 5–12). This time, choose a pale cream color. Click **OK** to leave the **Color Picker** (Fig. 7.24).

19 Hold down the S key and drag the new Color Triangle to the right till it snaps against the Black one.

It is clear to see what is happening now. Each color has an equal slice of the pie. Because the lightest and darkest colors are overlapping, they share a segment of pie. This means that there will be half the amount of these colors in the final image, compared to the other three colors which will have an equal distribution in the final image.

I find that it helps to set up the color cycle with interpolation switched off so that you can see the distribution of the colors more clearly.

20 Select the **Interpolate** checkbox again to blend the colors together gradually (Fig. 7.25).

Fig. 7.25

Saving effect settings

After Effects gives you the ability to save your own custom Animation Presets. When you've set up an effect or series of effects that you like, and may want to use in a future project, you can save all of the effect settings, including any keyframes and/or expressions as an Animation Preset. This is a great way to work because Animation Presets are very small files which can be easily e-mailed to other AE workstations and can be applied across platforms.

Later in this chapter we'll take a closer look at Animation Presets but for now we'll use one to save the Colorama settings that we customized. Using this technique you can quickly build up a library of custom settings for your favorite plug-ins.

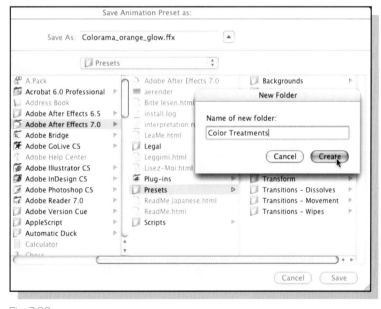

Fig. 7.26

21 Select the **Colorama** effect by clicking on its name in the **Effect Controls** panel and then go to **Animation > Save Animation Preset**.

22 In the **Save Animation Preset** as dialog box, After Effects should navigate automatically to your **Adobe After Effects 7 > Support files > Presets** folder. Within there, create a new folder and name it **Color Treatments** (Fig. 7.26).

Fig. 7.27

On the **Mac** this should be in **OSX > Applications > Adobe After Effects 7 > Presets**. On **Windows** this should be in **(C:) > Program files > Adobe > Adobe After Effects 7 > Support Files > Presets** (Fig. 7.27).

23 Save the file into the new folder as **Colorama_Orange_Glow.ffx**

24 Once you are back inside your After Effects project, go to **File > Save As** and save your project to your **Work in Progress > 07_Effects chapter** folder as **SeattleNews04b.aep**.

Your new preset now appears in the **Effect Controls** panel's **Animation Presets** drop-down menu at the top of the panel. This appears in the menu alongside other presets that also use the **Colorama** effect. Different preset settings for an effect can be accessed either from this menu or from the **Effects & Presets** panel, we'll look at these options in a little more detail later in this chapter.

There are various other ways of adjusting the effect's Output Cycle:

- Move the Color Triangles around the Cycle to change the balance of color.
- **⌘** **ctrl** – drag any of the Color Triangles to duplicate them, allowing you to create bigger blocks of color.
- Delete Color Triangles by simply dragging them off the sides of the panel.
- Create more triangles using the techniques we used in this lesson.
- Use the Input Phase settings to convert only to a selected channel of your image into grayscale before applying the effect such as Hue, Lightness, etc.
- Use the Modify settings to choose only to affect one channel of the final output.

There are also several animatable properties in the Colorama filter. Once you feel comfortable with the parameters, then you can start to experiment by animating their properties.

25 If you need more information on how this filter works, go to **Help > Effects Help** and then click on the hyperlink to the **Color Correction effects gallery**. Click on the hyperlink under the gallery example for more information.

Time effects

Cast your mind back to the animation chapter, remember we played around with the timing of our clips to make me dance in time with the music? Well, we're going to work some more on those sections with some more of After Effects built-in effects.

1 Open **MacDonna03.aep** from the **Training > Projects > 09_Effects** folder (Fig. 7.28).

2 **RAM Preview** 0 the **Finished Time Remap** composition.

We need to work on the background and the foreground of this movie to make it more visually appealing. At the moment the colors are a bit dull and the keyed footage of me dancing looks a little 'cut out' from the rest of the shot. Let's start with the foreground layer.

Echo

The Echo filter is another one of my favorites, it is one of the filters from the **Time** category and is available in both Standard and Professional versions of After Effects. It creates a visual echo effect by taking information from other frames at either side of the current frame to

Fig. 7.28

create a similar effect to shooting moving footage with slow shutter speed on your camera – anything that is moving in your footage will create motion trails as it moves. You can adjust the settings to control how much of this effect you want. It's an effect that is often seen in music videos creating a dream-like effect.

3 Move the Timemarker to the beginning of the **Timeline** by hitting the **Home** key on the keyboard and then select the **MeDanceAlpha.mov** layer and go to **Effect > Time > Echo**.

Nothing appears to have changed in the Comp panel. This is because the Echo filters default setting takes information from the previous frame to create the echo. Because there are no previous frames before the first frame, it has nothing to sample from.

4 In the **Effect Controls** panel # change the **Echo Time** setting to **1** and notice that an echo has now appeared (Fig. 7.29).

Because we have entered a setting of 1, After Effects is taking the echo from the frame 1 second ahead from the current frame.

Fig. 7.29

5 Change the **Number of Echoes** value to 3, we now have three Echoes on our layer, each one will be one second in advance from the last.

6 RAM Preview 0 the comp to see how this looks. It's a bit too much, we can hardly see what is happening. We also run out of frames at frame 36 meaning that I am frozen in time from this point onwards!

Fig. 7.30

7 Change the **Echo Time** value to **0.03** to take the Echoes from frames nearer the current frame and **RAM Preview** 0 the comp again (Fig. 7.30).

We now have a quite nice effect, our movie is creating an echo of itself ahead of the current time. You'll also notice that the image appears to be much brighter, that is because the Echo filter is using an **Add** echo operator (the same as the **Add** blending mode) to blend the echoes together.

Using a positive value for the Echo Time is great when you are working out the effect but it is usually preferable to use a negative value for the Echo filter so that the filter uses previous frames that have already been cached. Doing this will speed up the effect as well as looking more convincing.

8 Change the **Echo Time** value to **−0.027**, the **Number of Echoes** to **6**.

You may have noticed that increasing the **Number of Echoes** has brightened up the image, this is because each subsequent echo is using the add operator, and therefore is adding to the brightness of the image. We can reduce the brightness by adjusting the Decay setting.

9 Change the **Decay** value to **0.7**. With this setting each new echo will have 0.7 intensity of the previous one (Fig. 7.31).

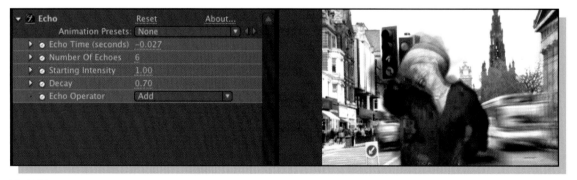

Fig. 7.31

10 RAM Preview 0 the comp again.

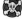 The Echo filter overrides all other filters and mattes, so if you have effects applied to your layer before applying Echo you must pre-compose your layer to compound the existing effects.

Combining filters

I like the effect but I am not happy with the edges of the echoes. We will use another effect to remedy this problem. It is very rare that you will achieve exactly the effect that you want with one single filter, often you will require a combination of filters that will do the job.

Channel blur

11 Context-click on the **MeDanceAlpha.mov** layer and go to **Effect > Blur & Sharpen > Channel Blur**.

This filter is designed to blur a single channel of your image, any of the color channels or the alpha channel can be blurred individually using this filter.

12 In the **Effect Controls** panel, change the **Alpha Blurriness** value to **10**, this will blur the edge of the layers alpha channel, in turn, softening the edges of the echoes (Fig. 7.32).

Fig. 7.32

13 Finally, notice that the bottom edge of the layer is also blurred, which is an undesired effect. Check the **Repeat Edge Pixels** Checkbox to get rid of the blurred edge.

14 RAM Preview **0** the movie to see the finished result.

15 Select the **PrincesSt.mov** layer and hit **⌘ D** **ctrl D** to duplicate the layer, for the effects we are about to use we will need two copies of the same layer.

Just before this book went to press it was decided that the Glow effect would be included in the new Standard version of After Effects 7. Up until this version, it was only available in the Professional version. I designed this tutorial to demonstrate how a similar effect can be achieved with either version of After Effects and included two tutorials to demonstrate this: one using the Standard version and another using the Production Bundle filters.

As the announcement happened just before going to press, I decided to keep these tutorials as they are. The good news is that everybody can follow both tutorials! Plus, they do teach you that, with a little bit of imagination and experience you can achieve virtually anything with the software.

In many situations it is possible to achieve the same results with the Standard version as with the Professional version, it just takes a little bit more time and imagination. We'll start by using the Glow filter which is designed specifically for adding glows. I'll then show you how to achieve similar results by combining several effects together.

Glow effects

1 If you do not have the project open from the previous step, open **MacDonna04.aep** from the Training > Projects > 09_Effects folder.

2 In the **Effects & Presets** panel type the word **Glow**.

 Your Effects & Presets panel may look different from mine. There may be multiple instances of the **Glow** effect in here now as it has been used in several of the free Animation Presets that I have provided for you. To find the correct one, scroll down to the list, past all the other effect categories, till you reach the **Stylize** category. In there you will find the Glow effect. Drag the **Glow** effect from the **Stylize** section onto the top **PrincesSt.mov** layer in the **Timeline** (Fig. 7.33).

Fig. 7.33

This filter will add a diffuse glow to certain parts of your image. These areas can be defined by first selecting the channel that you wish to apply the glow to (colors or alpha) and then adjusting the threshold to determine what percentage of area you wish to apply it to.

Notice that the glow is applied to the brightest parts of your image, it is accentuating the highlights. This effect is a bit too much when applied directly to a layer in this way but you can use a matte to determine the areas you wish to apply it to.

Set Matte

3 **Context-click** on the layer and go to **Effect > Channel > Set Matte**.

The Set Matte effect allows you to make a matte for your layer from a wide choice of layer properties, you can even take the matte from a different layer altogether.

Effects are applied in the order which they appear in the Effect Controls panel (and, simultaneously in the Timeline). We want to create the matte first and then apply the glow only to the areas defined by the matte. For this reason, the Set Matte filter needs to be applied before the Glow filter.

4 Close the Glow effect by clicking on the twirly next to the effect name in the Effect Controls panel (Fig. 7.34).

5 To change the order in which the effects are applied, simply select the **Set Matte** effect in the Effect Controls panel by clicking on its name and then drag it up, so that it becomes the first effect listed in the Panel (Fig. 7.35).

Fig. 7.34

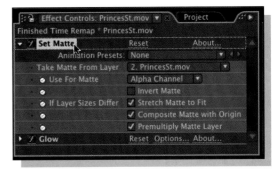

Fig. 7.35

6 Click on the **Use For Matte menu** and choose **Lightness** from the list of possible choices. Notice the choice of other properties available (Fig. 7.36).

7 To clearly see what effect this is having on your layer, switch off the **Video** switch for the layer beneath it (layer number 3) and then turn on the **Transparency Grid** button in the Comp panel. You'll notice that the image has been made partially transparent (Fig. 7.37).

8 In the **Effect Controls** panel, click on the Invert **Matte** checkbox to reverse the matte so that the lightest areas of the image become transparent (Fig. 7.38).

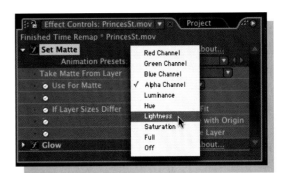

Fig. 7.36

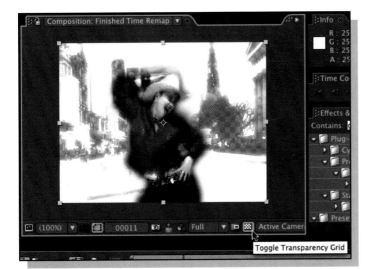

Fig. 7.37

We are essentially removing the very lightest parts of the image and, as a result, applying the Glow filter to the darker areas of the image.

9 Switch the **layer number 3 Video** switch back on so that you can see the layers composited together. Now we can adjust the glow values to get the effect we want.

10 Show the **Glow** effect's properties by clicking on the twirly in the **Effect Controls** panel.

11 Scrub the **Glow Intensity** slider up to about **7** (remember

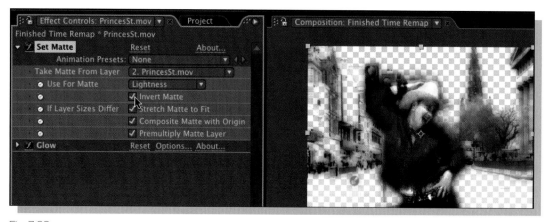

Fig. 7.38

that you can hold the **Shift** key while scrubbing to increase the increments). Notice what effect this is having on your layer; it will do exactly as it says, it will increase the intensity of the glow (Fig. 7.39).

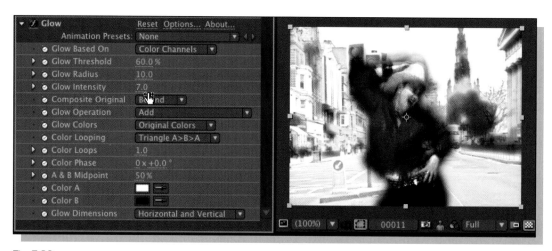

Fig. 7.39

12 Scrub the threshold value to determine how much of the area will have the glow applied to it. I find a setting of about **75%** works quite well in this instance.

Fig. 7.40

Blending mode

13 Finally, change the **layer number 2** blending mode to **Hard Light**. This will produce a much stronger image. The Hard Light mode tends to increase the contrast in your images, darkening shadows, and lightening highlights; it's like shining a bright light on your image to improve its clarity (Fig. 7.40).

Often in After Effects there is more than one approach to the same job. To illustrate this I have provided a second option for getting a really nice Glow effect.

Animation Presets

The following section on Animation Presets is co-written by my good friend and colleague, Mark Coleran. Mark has also kindly donated one of his fabulous Layerlab projects for the readers of this book, you can find it, and instructions on how to use it on the DVD in the **Extras** folder.

Presets are a relatively new addition to After Effects, appearing just a few years ago. Like many features in creative programs they are something that can be easily overlooked and undervalued. Using them however can make your life far easier and be a great timesaver.

Many professionals, be they engineers, architects or designers, develop techniques, build-up resources, and refine procedures that enable them to be more efficient and start each new project with a foundation they have acquired from previous experience. Presets within After Effects allow visual effects artists, motion designers, and animators to do this as well.

In essence, a preset allows you to save information from one or more parameters or functions in a form that be stored and re-applied later. Presets allow you to store a variety of different kinds of information. The functions that you can save as presets are:

- Keyframes
- Transform values such as rotation, position, opacity, etc.
- Expressions
- Effects and Filters
- Masks
- Text

or any combination of the above.

Overall these fall into one of two categories. You'll start to really understand the differences between them as we start working with presets but just to summarize the differences:

- The first is *Animation Presets*, which is any kind of preset that applies to a layers transform parameters, keyframes, expressions, masks, or text. These presets affect parameters already on the layer.
- The second is *Referring Presets* which is any preset that refers to and applies an effect or filter to your layer. These presets add new parameters to the layer in the form of After Effects or third-party effects filters. We have already witnessed referring presets in step **26** of the *Saving Effect Settings* section of this chapter where we saved the Colorama effect setting as an Animation Preset that we then accessed in the **Effect Controls** panel's *Animation Presets* drop-down menu.

Over a short period of time it is possible to create an extensive library of presets from your day-to-day settings through to cool settings you have discovered for a particular filter or combination of filters by stumbling across them while trying to achieve something else. Storing these allows you come back later and nothing is lost. Presets can save you a great deal of time on current and future projects.

We will go through each of the parameters in turn and explore what we can do with them, while also taking a look at the Effects & Presets panel and how to make best use of it. To begin with, let's take a look at what can be done in the most basic sense with a preset, how to save it, and how to re-apply it.

Preset basics

First, we need to have something to work with.

1 Open the project **Preset A.aep** from **Training > Projects > 09_Effects**. Here we have a simple After Effects composition with two layers. We will be creating a preset on one layer and then applying that saved preset to the second layer (Fig. 7.41).

Fig. 7.41

Fig. 7.42

The project should open up with the standard workspace layout. If you do not see the Effects & Presets panel open then go to the **Window > Effects & Presets** or hit **⌘ 5** **ctrl 5**.

The **Effects & Presets** panel is the hub for saved presets. Here you can organize find and apply the presets. It can be tricky to find what you are looking for as it also contains all the effects and filters available in After Effects. Thankfully, there are settings within the pull-down menu on the Effects & Presets panel that allow you to customize the view.

2 Open up the **Options** menu for the **Effects & Presets** panel by clicking on the little triangle at the top left of the panel and select **Show Effects** (Fig. 7.42). This will turn off the visibility of the effects and display only the **Animation Presets**.

You will notice there is a folder in the **Effects & Presets** panel called **Animation Presets** (Fig. 7.43a, b). If you twirl down the folder you will see that After Effects supplies you with a host of free presets for a wide variety of uses. Just for now though we will ignore them and concentrate on creating our own presets. Once you have completed this tutorial, you will better understand how the supplied presets work and will be able to look through these supplied presets.

Fig. 7.43a

Fig. 7.43b

3 In the Timeline select the **Artwork Left** layer and hit the *Return* on the keyboard to show the **Rotation** properties.

4 Click on the **Rotation** stopwatch to create a keyframe at the start of the Timeline (Fig. 7.44).

5 Move your Timeline to the one-second mark and rotate the layer by 176 degrees to create a second keyframe (Fig. 7.45).

6 Click on the name of the property (**Rotation**) to select all the keyframes for the property.

Fig. 7.44

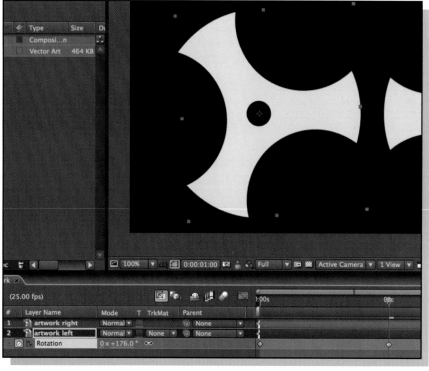

Fig. 7.45

7 Go to **Animation > Save Animation Preset** or alternatively you can hit the **Save Animation Preset** icon on the **Effects & Presets** panel (Fig. 7.46).

Either way, After Effects will automatically take you to the application **Presets** folder (or the last folder used to save a preset). You will be able to see the free presets included with After Effects within this folder. What we need to do is create our own presets folder to contain all the presets for the book tutorials.

8 Create a **New Folder** within the Presets folder and name it **CAE Presets** (Fig. 7.47).

Fig. 7.46

Fig. 7.47

9 Save the preset using the name **Artwork Rotate.ffx**.

It is very important to use logical naming conventions when saving presets. As you can imagine it can be very difficult to find what you are looking for if they are named Preset 1, Preset 2, etc.

In the Effects & Presets panel you may have noticed that After Effects has closed the **Animation Presets** folder after you have saved the preset. After Effects does this when it refreshes the folder to include the file you just saved.

10 In the Effects & Presets folder open the Animation Presets folder and you will now see a new folder called **CAE Presets** in the list. Opening this will reveal our preset **Artwork Rotate** (Fig. 7.48).

11 To apply the new preset, first go to the Timeline and select the **Artwork Right** layer.

12 Hit the R key to reveal the **Rotation** property so we can see what happens as we apply the preset.

13 There are several ways to apply presets to layers; we can choose **one** of the following options.

14 Select the **Artwork Right** layer and then **double-click** on the **Artwork Rotate** preset in the **Effects & Presets panel** to apply it. Or drag the **Artwork Rotate** preset into our **Composition panel** and drop it onto the artwork (Fig. 7.49). **Or** we can drag the **Artwork Rotate** preset into the **Timeline** and drop it onto our layer.

Fig. 7.48

Fig. 7.49

You will notice that the preset has applied our keyframes to the new layer. However, the preset will does not apply the keyframes at the same time as the layer from which it was made. The preset will apply the keyframes to where ever the Timemarker is currently parked. In our case, the Rotation keyframes are applied from the one-second mark (Fig. 7.50).

319

Fig. 7.50

15 **RAM Preview** the animation to see the artwork rotating at different times.

Not so simple

You might be thinking that there isn't much point in saving a couple of keyframes as a preset and you would probably be right. What you can do however is save much more complicated arrangements of keyframes and settings – this is where presets really come into their own.

1 Open the project file **Presets B.aep** from **Training > Projects > 08_Text**. Do not save the previous project. You will see a much more complicated piece of artwork than the previous project (Fig. 7.51).

Fig. 7.51

To break this down, we have applied several filters to the layer, changed the opacity and added a simple expression to the rotation. Do not worry if you don't understand expressions, this is for demonstration purposes only. The nice thing about presets is that it is not always necessary to have an in-depth understanding of the preset contents to be able to take advantage of them.

We will do the same thing here that we did with the previous project. First, we need to select the parameters we wish to save as a preset.

2 Select the Artwork Base layer and then double-hit the **U**-**U** key in very quick succession to open up any values that have changed from their default value (Fig. 7.52).

Fig. 7.52

3 To select the parameters we wish to save hold down the ⌘ *ctrl* key when clicking on the following properties in the **Timeline, Fill, Compound Blur, Fractal Noise, Opacity,** and **Rotation** (Fig. 7.53).

Fig. 7.53

4 Save these into the **CAE Presets** folder by clicking and dragging the selected items onto the CAE Presets folder in the **Effects & Presets** panel.

5 Name the saved preset **Artwork Effect**. When saved go back to the **Effects & Presets** panel and open up the **CAE Presets** folder. We now have a preset that contains far more than just a set of keyframes.

6 With the Timemarker at the beginning of the Timeline drag this preset onto each of the additional Artwork Side layers in the Timeline. Notice that the effects and transformations are applied to the other layers as the preset is dropped onto them (Fig. 7.54).

Fig. 7.54

You have now applied all the effects and parameters to all the layers. It would be possible to do this by copy each parameter and each effect and pasting them to each layer, but this is far faster and preserves your work.

 If you decided to change any of these settings then it is just as fast to create a new preset and drop it on your layers, but be aware. A preset will add any effects again to your layer on top of those already applied. If you want to replace the preset you previously applied to a layer, it is first necessary to remove the effects applied to each of those layers.

Looking further

What we have looked at above pretty much covers how to save and apply presets. There is however some additional functionality to presets than can be very handy. For this we will look at some of the presets that come with After Effects.

1 Open the project file **Presets C.aep** from **Training > Projects > 08_Text**. Do not save the previous project.

It is possible to save a mask shape from a layer as a preset. This can be a great timesaver if there are particular shapes you use regularly. The nice thing about mask presets however is that they do more than the presets we previously looked at.

2 Look in Animation Presets folder within the Effects & Presets panel and, in there, open the folder called **shapes** (Fig. 7.55).

Previously, we need to have a layer to apply a preset too. If you double-click on a shape preset however, After Effects will create a new solid and apply the shape to that solid. It will also apply the shape to a layer if you have one currently selected. The ability to create a new layer also extends to text layers.

3 **Double-click** on the **5-Sided Star** preset to create – you guessed it – a 5-sided star (Fig. 7.56)!

One of the great thing to do with presets is create libraries of settings for Effects either the included ones or from third parties. Some third-party developers even supply effects presets for use with their effects. You might think it could get tricky to find the presets that you have made for an effect such as Fractal Noise within all the available presets. After Effects does however make it easy for you.

Fig. 7.55

Fig. 7.56

4 Open the project file **Presets D.aep** from **Training > Projects > 08_Text**. Do not save the previous project. In this project you will find a single-solid layer with the effect **Fractal Noise** applied (Fig. 7.57).

5 Select the **Fractal Noise** layer in the **Timeline** and then hit # to open up the **Effect Controls panel**, you will notice at the top there is a pull-down menu called **Animation Presets**. The presets displayed here are only the presets from the library that use the Fractal Noise effect.

6 Take a look through the **Animation Presets** list to see how many different looks you can achieve using Fractal Noise (Fig. 7.58).

7 Choose the **Curtain** preset from the list and then do a **RAM Preview** to see the effect parameters animate.

Fig. 7.57

Fig. 7.58

 You will achieve very different results depending on whether you apply presets from the **Effect Controls** panel's **Animation Presets** menu or from the **Effects & Presets** panel.

If you select a preset from the **Effect Controls** panel it will simply change the values of the existing effect to match the effect property settings within the saved preset. Each preset listed in the **Effect Controls** panel's Animation Presets menu doesn't represent the entire preset, only the settings for the particular effect which forms part of that preset.

If you apply the same preset from the **Effects & Presets panel** it will apply a complete new copy of the effect to the layer. Plus it will add any other saved properties contained within the preset, such as masks, transformations, keyframes, expressions, and other effect settings. An Animation Preset may contain several different effects as well as other properties listed above.

Applying individual properties from presets

So, the list of presets in the Effect Controls panel contains all presets that use the same effect, including those saved with multiple parameters and effects. However, applying the preset from the Effect Controls panel will only change the values you saved for that specific effect, it will not apply any other elements from the preset. For example, the Curtain preset, when applied from the Effects & Presets panel, also includes the CC Toner effect.

When applying a preset using the **Effect Controls Animation Presets menu**, you may get an error if the effect contains an expression connected to part of a bigger and more complex preset. To overcome this potential problem, and to provide you with more control, After Effects provides you with a way of selectively applying individual properties from a preset.

1 Open the project file **Presets E.aep** from **Training > Projects > 08_Text**. Do not save the previous project.

2 Go to the **Effects & Presets Panel** and open the **Animation Presets** folder (Fig. 7.59).

3 Open up the **Backgrounds** folder within the **Animation Presets** folder and twirl down the arrow next to the **Curtain** preset you will see each individual parameter as a separate item. This preset contains the **CC Toner** effect as well as the **Fractal Noise** effect.

4 Drag the **CC Toner** effect from the **Curtain** preset in the **Effects & Presets** panel, onto the **Fractal Noise** layer in the **Timeline** to apply the customized effect onto the layer (Fig. 7.60).

Fig. 7.59

Fig. 7.60

Effects as well as presets ...

When we started this tutorial, we used the drop-down menu in the Effects & Presets panel to turn off visible effects. This was to make our view a little less cluttered.

5 Go to the **Effects & Presets** panel and choose Show **Effects** from the **Options** menu, you will see the complete effects filters library available to you in After Effects.

Although these look very much like presets they are not. They work in a similar way. They can be dragged and dropped into your composition or Timeline or double clicked to apply to the currently selected layer. This list however is built from the installed effects available to your installation of After Effects and will always apply the default filter in the same way as if you applied it from the Effects menu or context clicked on the layer.

Sort it out

Over a period of time, you will build a large range of presets. These combined with all your filters can make for a library that is massive, and potentially difficult to navigate – it is possible to be a victim of your own success!

Fig. 7.61

After Effects however can make life very easy for you. At the top of the Effects & Presets panel is a text box. You can type in the name of a preset that you have previously saved or filter that you want to apply and After Effects will filter all the available sets to show only the ones that contain that text string.

6 Try typing in the word **Artwork** into the text field to display all Effects & Presets containing the word (Fig. 7.61).

Conclusion

From this I hope you can see how presets can be a valuable part of your workflow. Personally, I have invested a great deal of time into creating presets and the payoff has been substantial. Each time I approach a project I have a foundation to build on, freeing up more time for design and refinement. Everything from storing commonly used expressions, shapes, effects, and combination thereof. I have had specific instances where using presets have turned a half-day of work into a ten-minute job. Hopefully, you can leverage this great feature to get the same benefits.

Recap

I want you to take some time to experiment with what you have learned in this chapter. Either start a new project or open the project that you have been working on from the start and experiment with some of the plug-ins in the Effect menu. Remember what you have learned here:

- You can customize effects to get new looks, try not to always use them at their default settings.
- Don't use plug-ins solely for their original intended purpose, bend them a bit to see what else they'll do for you, it's possible to happen upon some interesting combinations.
- Sometimes you need to use a combination of different plug-ins to achieve a look.
- By mixing new combinations of effects together you can come up with so many more creative possibilities, they're endless.
- The order in which you apply effects is very important but the order of effects can be changed at any time.
- There are times when you need to apply effects to nested comps, this compounds any changes made to the original layer and treats it as a new movie.
- Use RAM Previews for Proxies, or drop Resolution when things become slow.

Inspiration – Joost van der Hoeven

Joost van der Hoeven is the owner of Animotion.nl, a motion graphic design company working mainly in the television and video education industries. He also provides demos and training in software applications including After Effects and Final Cut Pro.

Submerged: 'Title animation for Submerged History, Documentary, © Frenken Films'

KidDocs: 'Title animation for KidDocs, Documentary Film Festival for Youths, © Het Pakhuys'

Q How did your life lead you to the career/job you are now doing?

A My favorite subjects in high school were math and art; I always had this dualistic interest in computer technology and design/photography/music. When I was orientating to choose a University to go to, my mentor pointed out that I could as well go to Art School. I was surprised, because I did not know that there actually existed a study that covered both grounds.

Q What drives you to be creative?

A I risk to sound arrogant, but: My own curiosity. I always want to know why things work the way they do. 'Why?' is much more interesting than 'How?' Building a collage form all the answers that I find – 'is what I think' – is my creativity.

Cultmix: 'Title animation for CultMix, Lifestyle TV program for youths, © BOOZ'

Q What would you be doing if not your current job?
A If I had failed to enter Art School I would have studied Music Technology. Guess I'd be working with Audition or ProTools instead of After Effects. Ha ha!

Q Do you have any hobbies/interests and if so, how do you find time for them?
A I just became father so that is a new hobby, being a dad. But I also like to sail and scuba dive. I try to keep Friday and the weekend free – 'which is no always possible' – to spend time with my son. In Spring and Summer I participate in sail races every Wednesday evening, and Scuba Diving is only for holidays.

Createurs: 'Title animation for Créateurs, Advertorial for Renault, © Palazzina'

Q Can you draw?
A I used to doodle a lot. In Art School I've had proper drawing lessons. But I find it very hard to like my own drawings.

Q If so, do you still draw regularly?
A Unfortunately I stopped drawing and doodling because of Art School; I saw that other people drew much better then I did, and I had a very bitch teacher who told me that my drawing was no good. I still find it a pity. But for some reason I can't find the joy anymore in doodling the way I did in High School.

Q What inspires you?
A People, because they point in directions that I on my own cannot imagine. Their work (books, films, history, interviews, etc.) is my big source.

Q Is your creative pursuit a struggle? If so, in what way?

A Sometimes when a project is just not that what you hoped for, and I cannot find a way to make it work, it can be a struggle. But in general it is almost a way of life or a working method to me. I don't mind rotoscoping 2000 frames if I feel comfortable that the end result is just what I want. But if a text or logo just doesn't look right I can really pull my hair to get it the way I think it should be.

Q Please can you share with us some things that have inspired you. For example film, song, web site, book, musician, writer, actor, quote, place, etc.

A One film that 'got' me was Delicatessen. When I saw that movie for the first time I was astonished that a movie could have its own reality and be surrealistic and very funny at the same time. Also, I love salsa music. It is very happy and tropical, makes me want to dance.

Q What is your most over-used AE feature/filter?

A That must be the 'Add' transfer mode on text objects. Together with motion blur, again on text.

Q What would you like to learn more about?

A There are so many things, like, I still need to dig into scripting in After Effects! On the creative side; I'm always looking into how effects or styles from commercials or film titles are done. I like to read and do those 'case studies.'

Chapter 08 **Text**

Animators

After Effects 6 introduced two huge new features which stood out from the others, one was paint, which we'll take a look at in the next chapter but before that, let's take a look at the text!

The way that text works in After Effects is unique. You no longer have to import text from other applications (although this is still possible of course!). Just like all other Adobe apps, you can type text directly into your composition and After Effects automatically creates a new text layer for you. And just like all other Adobe apps, you have a Character and Paragraph panels to format your type. You can transform and animate a text layer and its properties just like any other layer in After Effects. But there are a few things that make text layers a little bit different from other layers (**Animators 01.tif**).

Text layers have their own built-in Animators that allow you to animate multiple instances of a property, these can be used to animate individual characters within your text so you can have each character in a word performing it's own little animation while the whole word is controlled by another animation. Sound confusing? Well it is a little, it takes a bit of getting used to as it is a whole new way of working for everybody, but the creative possibilities are endless so let's dive in and get learning! (See **Mind Warp.tif**).

Mind Warp

Synopsis

In this chapter we'll look at a whole heap of things you can do with text. We'll start by discussing some rules of typography and how those rules apply to designing for the screen. We'll move on from there to look at the basic text controls available in the Character and Paragraph panels. Once you are comfortable with that we'll move on and look at some of the amazing things you can do with text animators, you'll learn how to make seemingly complex text animations with a few clicks of the mouse. Then we'll look at how effects can be applied to text to make it less uniform as some tips and tricks for making your text look hand drawn. Finally, we'll look at how you can use text as a track matte (or stencil) to punch holes in video layers for interesting reveal effects (**Graffiti.tif**).

Graffiti

Fonts

I'm a great fan of the old school fonts; Helvetica and Gill Sans are two of my favorites, they are well designed and will work flexibly in lots of different situations. It pays to get acquainted with these fonts before you start using some of the more unusual, modern fonts. If you can accumulate a good understanding of the old faithfuls then you won't go wrong; most of the decent new fonts are based on the same basic shapes as these old classics anyway. Once again that old adage raises its head 'you have to learn the rules first in order to have fun

breaking them.' It's important to have a good understanding of typography rules and how fonts work. There are two main types of fonts, **serif** and **sans serif** (also referred to as simply 'sans').

Sabon (Type1)

abcdefghijklmnopqrstuvwxyz
ABCDEFGHIJKLMNOPQRSTUVWXYZ
123456789.:,;(:*!?')

12 The quick brown fox jumps over the lazy dog. 1234567890

18 The quick brown fox jumps over the lazy d

24 The quick brown fox jumps ove

36 The quick brown fox

48 The quick brow

60 The quick br

72 The quick

Serif

generally simpler in shape. They tend to be used a lot for headings, headlines, posters, and of course TV graphics. They are generally cleaner to use than serif fonts for TV design. Sometimes serif fonts tails can create interlacing problems if the letterforms are too small on screen. The headings in this book are all Helvetica Neue which is a sans serif font (**Sans serif.tif**).

Basic text

1 Open **Text_01.aep**. You should see the **01_Text Overview** comp (Fig. 8.1).

2 **RAM Preview** the comp. This comp has a single layer in it, a Quicktime movie from **Artbeats Mad Scientist** collection named, **MAD131B.mov**. We will make the opening title sequence for a spoof horror movie called **Mind Warp**.

Serif

Fonts have little tails (serifs) on the letterforms to maximize the readability. These fonts are generally easier to read and are used in magazines and books, for the body text. The font used in the body text of this book is a Serif font called Cheltenham. Times is the most commonly used Serif font (**Serif.tif**).

Sans serif

These fonts (meaning 'without serif') don't have the tails that Serif fonts have and are

Arial (OpenType)

OpenType Font, Digitally Signed, TrueType Outlines
Typeface name: Arial
File size: 359 KB
Version: Version 3.00
Typeface © The Monotype Corporation plc. Data © The Monotype Corporation plc/Type Solutions Inc. 1990-1992. All Rights Reserved

abcdefghijklmnopqrstuvwxyz
ABCDEFGHIJKLMNOPQRSTUVWXYZ
123456789.:,;(:*!?')

12 The quick brown fox jumps over the lazy dog. 1234567890

18 The quick brown fox jumps over the lazy

24 The quick brown fox jumps ove

36 The quick brown fox

48 The quick brow

60 The quick br

72 The quick

Sans serif

Fig. 8.1

3 From the **Toolbar**, select the **Horizontal Type tool** ⌘ T
ctrl T. Notice that the **Toggle Character and Paragraph
panels** button automatically pops up in the **Tools panel**. Click
on this to open up the Character and Paragraph panels (Fig.
8.2a, b).

Fig. 8.2a

4 With the **Horizontal Type tool** selected, position the cursor
in the center of the globe in the Comp viewer and then click
once. You will see a insertion point indicating where your text
will start when you begin typing (Fig. 8.3).

> You can also create a new text layer in the center of the
> comp by going to **Layer > New > Text** ⌘ ⌥ Shift T
> ctrl alt Shift T.

5 Type **Mind Warp** and then hit the Enter key on the number
pad of your keyboard to accept the changes you have made

Fig. 8.2b

and come out of text-editing mode. Select the Selection tool from the toolbar before moving ahead with the next step.

 Please make sure that you don't hit the big _Return_ key on the main keyboard (also known as the _Enter_ key) by accident as this will add a carriage return to your text! If you do not have a number pad you can accept the text by deselecting the layer in the Timeline by clicking away from it (Fig. 8.4).

You will now see a bounding box and handles around your text layer, showing that the layer is selected (but is not in text-editing mode as it is when selected with the **Type** tool). When the text layer is selected with the selection tool, you can still make changes to it's attributes using the Character and Paragraph panels.

If nothing is selected, making changes in these panels will sets the properties for the next text layer that you create.

The Character panel

6 In the **Character** panel you will see the **Set the Font Family** menu. Choose the first font in

Fig. 8.5

Fig. 8.3

Fig. 8.4

the list of available fonts. Notice that all the letters change to the new font because the whole layer is selected (Fig. 8.5).

7 Click once in the **Set the Font Family** text field, doing this selects the current font.

 You can type in the name of your favorite font here to select it. You can even just type in the first letter of a font to locate it more easily.

8 Type the letter **G**. The first font listed, beginning with the letter **G**, should now be the active font in the **Character** panel and in the selected **text** layer.

9 Click once again in the **Set the Font Family** text field to make it active, and then hit the **Up** and **Down** arrow keys to cycle through all the available fonts on your system. This is a really quick way of previewing all available fonts.

 You can also use the arrow keys to move up and down the font list while the menu is fully expanded.

10 Using either of these techniques, change the Font to **Creeper**.

If you can't see the **Creeper** font in your list then you need to exit After Effects and install the fonts that came on the DVD. See the **Before you Start** section in the **Introduction** for instructions on how to do this.

Fig. 8.6

11 Click on the **Paragraph** tab and in there, click on the **Center Text** button (Fig. 8.6).

12 Go back to the **Character** panel and click once in the **Size** text field to select the value and make the property active.

13 Hold down the **Shift** key while hitting the **Up** arrow key to make the text scale up in increments of 10 points till it gets to a size of **50**.

Hitting the **Up** and **Down** arrow keys on their own will scale up and down by increments of one point.

We'll give the text a little more tracking than we would if we were using mixed case, this will make it more legible.

When working with text on screen it is always important to give text a little more tracking than you would normally do for, say, printed graphics. The reason for this is because screens emit light and the light tends to bleed at the edges of the letterforms making the text appear slightly bolder and more tightly tracked. This is most noticeable when using light colored text on a dark colored background or when foreground and background colors clash but is worth considering in all typographical situations.

14 Move the cursor over the **Tracking** value. Notice that, when you hold your cursor over any of the values, the cursor changes to a scrub icon, allowing you to click and drag to scrub the value interactively. Use this method to scrub the **Tracking** value till it reads **80** (Fig. 8.7).

15 Click on the **Fill** color swatch to change the Fill color of the text with the Color Picker. Choose a Bright, vivid Green color.

16 Click on the **Stroke** Color swatch and choose a Bright, vivid Orange color.

17 Change the **Stroke** value to 3 pixels, and make sure that **Stroke over Fill** is selected from the **Stroke Type** menu (Fig. 8.8).

Fig. 8.7

Fig. 8.8

As I mentioned in the section regarding interlacing issues when designing for television, you should always design your strokes to be nice and chunky, so that you reduce the chance of interlace flicker that can occur when working with very thin horizontal lines.

18 In the **Timeline**, open up the **Mind Warp** text layer and you'll see that, as well as having a **Transform** property group (as you would have on any other layer in After Effects) there is also a **Text** property group.

19 Open up the **Text** property group to reveal what's inside and you'll see a keyframe-able property names **Source Text**, and two other property groups named **Path Options** and **More Options**. In addition, there's a button labeled **Animate** next to the **Text** property group (Fig. 8.9).

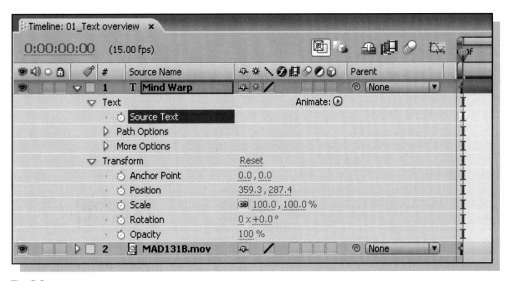

Fig. 8.9

20 Open up the **Transform** property group and you'll see the usual list of properties that you will recognize: **Anchor Point, Position, Scale, Rotation,** and **Opacity**. You can adjust and animate all of these properties just as you can see in any other layer.

21 Select the **Horizontal Type** tool from the **Tools** panel and select only the word **Mind**. This can be done by either dragging a selection across the text (as you would do in any text-editing application) or by double-clicking the word **Mind**.

22 In the **Transform** section of the layer in the **Timeline**, scrub the **Scale** property to approximately **500%** and you'll see that the letters become deselected and that whole layer of text is scaled up, even though only a few characters are selected.

I want you to pay particular attention to the way that the Scale is changing before we move ahead. The first thing to notice is that the text is scaled up as one solid line of text. In other words, the line of text is being scaled as a layer. This will become easier to understand as we go through the next few steps.

The second thing to take note of it is that the text remains at crystal-clear quality whatever size it is scaled to. This is because the text is vector based and is continuously rasterized to give you 100% quality at all times.

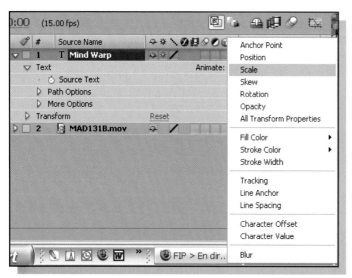

Fig. 8.10

23 Select the **Selection** tool from the **Tools** panel again and then take a minute to scrub the **Scale** value up and down, and notice the effect this has on the text. When you have finished set the **Scale** value back to **100%** and close the **Transform** property group.

Text animators

24 Alongside the **Text** property group name, in the **Switches** column, you'll see a pop-up menu button with the word **Animate** beside it. This menu contains **Animator groups** that you can apply to your Text layer (Fig. 8.10).

25 Click on the **Animate** pop-up menu and look at the **Animator groups** available. Choose **Scale** from the menu. As you do a new Animator group, named **Animator 1** appears in the Timeline (Fig. 8.11).

Range Selectors

Animator groups contain two things, first you'll see a **Range Selector**. This is used to isolate individual characters or groups of characters to apply your animation to. We'll take a look at that shortly, but before we do let's take a look below the Range Selector at our **Scale** animator property.

Fig. 8.11

You may think it odd to add a **Scale** animator when we already have a **Scale** property in our Transform property group. But this Scale animator property which has many more options, as you'll see.

26 To see one of the differences between the way this works as opposed to the regular **Scale** property, **scrub** the **Scale** value in the Animator group backward and forward to see how the text scales up and down.

Notice that the characters of the text are being scaled individually. In fact they even overlap each other at large sizes. (This is the default behavior but can be overridden by use of the More Options section where you can change the way that the characters are grouped together.)

27 Change the **Scale** animator value to **200%**, so that the characters are overlapping each other (Fig. 8.12).

The property animators have the ability to work on the characters as individuals. This makes animating text in After Effects very creatively flexible, it's now easy to create complex animations with very little keyframing. This is achieved by the use of **Range Selectors**. A Range Selector is used to specify a Range of text that you want to apply changes to.

28 Open up the **Range Selector** group. You'll see three properties listed: **Start, End,** and **Offset** (underneath these sits the **Advanced** property group which we'll look at a bit later) (Fig. 8.13a).

29 Hold down the ⌘ *ctrl* key as you slowly scrub the **Start** value to the right till it reaches **20%** and watching the result in the Composition viewer.

 Holding down the ⌘ *ctrl* key as you drag will make the scrubbing happen in smaller increments, giving you a higher level of control over your adjustments.

Notice that, as you scrub the selector values that you can see two **Range Selector Bars** in the main composition viewer. The **Start Selector Bar** is at the left edge has a right pointing arrow on it and the **End Selector Bar** has a left pointing arrow. Notice that characters to the left of the **Start Selector Bar** are no longer affected by the **Scale** animator (Fig. 8.13b).

Fig. 8.12

Fig. 8.13a

Fig. 8.13b

30 Hold down the ⌘ *ctrl* key as you slowly scrub the **End** value to the right till it reaches **30%** and watching the result in the Composition viewer.

Notice that characters to the right of the **End Selector Bar** are no longer affected by the **Scale** animator, these Range Selector Bars determine which characters are affected by the animator.

You can also drag these Selector Bars interactively in the Comp viewer.

31 With the **Selection** tool selected **V**, in the **Comp viewer**, click and drag the **Start Selector Bar** (on the left) so that it snaps to the left edge of the letter **W**. A double-sided arrow appears next to the mouse pointer when the pointer is over either the **Start** or **End** Selector Bar (Fig. 8.14).

Fig. 8.14

32 Drag the **End Selector Bar** in from the right so that it snaps to the right edge of the letter **W**. You'll notice that the scale change that we made is now only applied to the letter **W** as it is the only letter within the active range.

33 In the Timeline, scrub the **Start** and **End** Selector values, so that they are selecting only the letter **M** (Fig. 8.15).

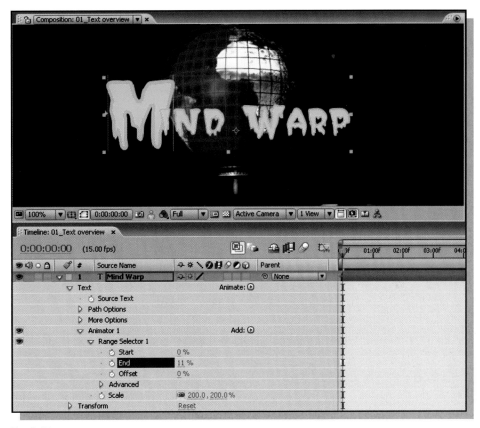

Fig. 8.15

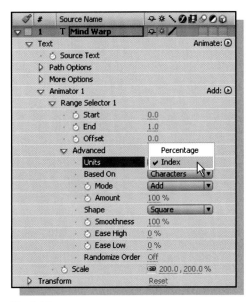

Fig. 8.16

Notice that it is difficult to get this exactly right because the current unit of measurement is **Percentage**. It's not easy to work out that the letter **M** is **11%** of our complete title. It's much easier to work out what's going on in the animation by using an **Index** value which gives you the number of characters you have in your sentence.

34 Open up the **Advanced** group and change the **Units** menu so that it reads **Index**. Close up the Advanced group when you have finished, we'll delve back in here later! See Fig. 8.16.

 The Start, End, and Offset values are represented by a percentage value when you add an animator to a complete line of text with the selection tool active. You can default to an Index measurement by adding animators to the text when the Type tool is active and the text is in an editable state.

341

35 In the **Comp viewer**, drag the **End** Selector Bar to the right side of the letter **Delete**. Notice the Timeline gives you a value that represents individual characters in your words or sentences. With four letters selected, the value is **4** (Fig. 8.17).

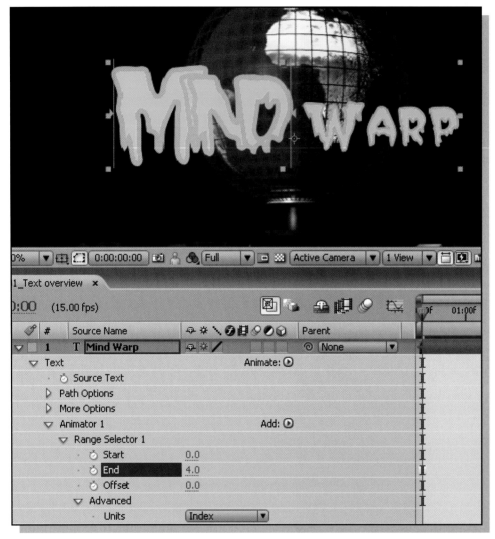

Fig. 8.17

Animating Range Selectors

You can animate an Animator's Scale property as you would animate any other property, by setting keyframes or by applying Expressions. But as well as being able to do all that, you can easily create a whole array of interesting animations by animating the Range Selector itself.

1 Open **Text_02.aep** and then double-click the **Text Overview** comp icon in the Project window to open it if it is not already open.

2 Select **Animator 1** in the Timeline so you can see the **Range Selector Bars** on the text layer and then drag the **End Selector Bar** to the left edge of the letter **M**, so that the **End** value is **0.0** (so that

none of the characters have the Scale applied to it). The **End Selector Bar** has an arrow pointing **left** while the **Start Selector Bar** arrow points **right**.

3 With the Timemarker at the beginning of the **Timeline**, click on the **End** stopwatch to set an initial keyframe at a value of **0.0** (Fig. 8.18).

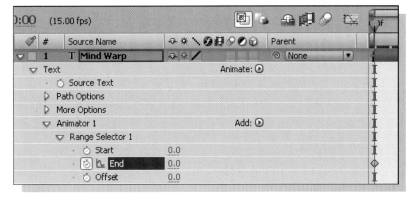

4 Move the Timemarker to the **two**-second mark and change the **End** value to **9.0**. Remember that the Index value will count the space as a character so we have a total of nine characters.

Fig. 8.18

 This default behavior can be changed by choosing **Characters Excluding Spaces** from the **Based On** menu in the animator's **Advanced** menu.

5 Hit the **N** key on the keyboard to trim the **End Work Area** to the current time (Fig. 8.19).

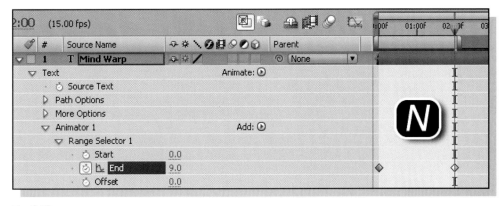

Fig. 8.19

6 **RAM Preview** the animation. See the letter scale up one-at-a-time. By animating the Range Selector you are controlling how, and when the Scale is applied to the characters.

Adding multiple properties

The only problem here is when the letters overlap each other they become unreadable at the larger size. To overcome this problem we can add some tracking to the existing animation to introduce space between the characters. You'll notice that an **Add** pop-up menu appears in the **Switches** column, next to **Animator 1**.

7 Click on the **Add** menu and choose **Property > Tracking** from the list. Two new Tracking properties appear underneath the **Scale** property in **Animator 1**, one is named **Tracking Type**, the other **Tracking Amount**. At first nothing will happen because the **Tracking Amount** value remains set at **0** (Fig. 8.20).

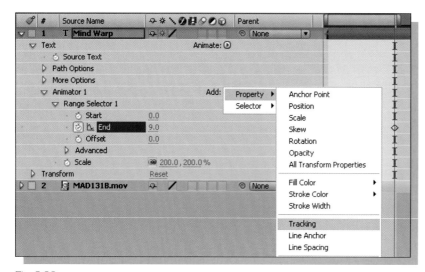

Fig. 8.20

8 Move the Timemarker to **Frame 14** where only the word **Mind** is affected by the **Scale** change.

9 Scrub the **Tracking Amount** value to **35**, notice that the tracking value applied by the animator is only applied within the Range Selector's Start and End points, just like the Scale property (Fig. 8.21).

10 **RAM Preview** the animation again to see the letters scale up and increase tracking sequentially.

To recap what we've learnt, the tracking is added to the same Range selection that we applied the Scale to. Adjusting properties using Animators affects characters selected by the Range Selector.

It makes sense to name your animators carefully, so that you can easily see what they are doing without having to open them up in the Timeline.

11 Select **Animator 1** and then hit the ⟮Return⟯ key on the keyboard to make it's name active. Type in **Scale & Tracking 01** and then hit ⟮Return⟯ again to accept the new name (Fig. 8.22).

So, we have one animator animating the Scale & Tracking of our characters individually by using only two keyframes, fantastic! This makes it very easy to make adjustments to the animation.

12 To speed up the animation, drag the second keyframe to the **one-second** mark and then **RAM Preview** to see the text animate more quickly. Notice that both Scale & Tracking speed up since the Range Selector controls them as one.

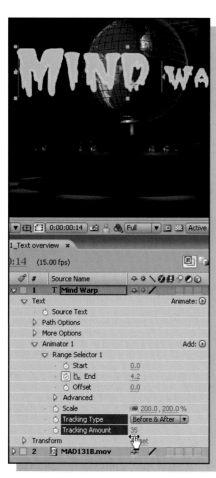

Fig. 8.21

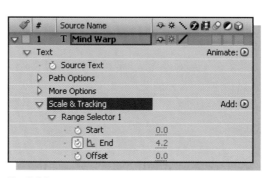

Fig. 8.22

13 Close the **Scale & Tracking** animator group by clicking on its Twirly (Fig. 8.23).

Working with multiple animators

After Effects allows you to create multiple animators, layering them on top of each other. This makes it possible to animate multiple instances of the same property. This may sound confusing to begin with, but it opens up a whole new way of animating.

Fig. 8.23

I'm sure we've all been in situations where we have had to precompose in order to Scale down a complex Scale animation, with text animators you can have many different Scale animations on a single layer without the need for precomposing.

Fig. 8.24

1 Open **Text_03.aep** and then double-click the **01_Text Overview** comp icon in the Project window to open it if it is not already open.

2 Select the **Horizontal Type tool** ⌘T ctrl T from the toolbar and use it to select the letter **M** in the Comp viewer (Fig. 8.24).

3 In the **Mind Warp** layer, click on the **Animate** menu again and choose **Scale** from the list of properties. This will add a completely new animator, named **Animator 1** to the layer.

Because we renamed the first animator, any new animators will be named using the default naming convention (i.e. Animator 1, Animator 2, etc.).

4 Open the new **Animator 1** to reveal its **Range Selector** and **Scale** property.

5 Open the **Range Selector** to see the **Start, End,** and **Offset** values inside (Fig. 8.25).

Notice that the Selector Bars are automatically placed around the letter that was selected when applying the animator, the letter **M**. You may also have noticed, in the Timeline, that the Start and End values are automatically measured as an Index value as opposed to a percentage value.

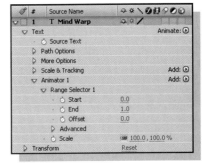

Fig. 8.25

6 Change the **Scale** value in **Animator 1** to **150%**, only the selected letter **M** is scaled since it's the only letter within the Range Selector (Fig. 8.26).

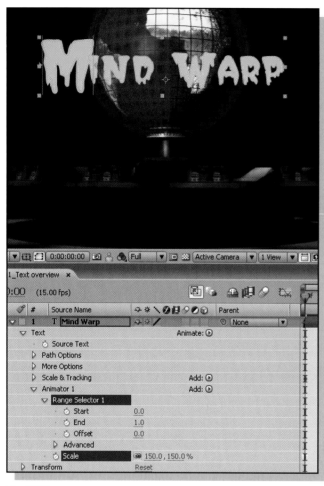

Fig. 8.26

If you can't see the Selector Bars, it is likely that your layer is not selected. The animator or one of its properties must be selected in order to see Selector Bars and other layer controls in the Comp window.

It is perfectly possible to animate the Start and End points individually again, so that the letters scale up in sequence and remain at the new scale value. But in this situation I want the scale to run along the title so that the letters scale up and then down again to their original size.

To get this effect I need the whole range (including both the Start and End Selector Bars) to move across the letters. Rather than animate both Start and End values individually, I can achieve the effect of animating both simultaneously by animating the Offset value. Doing this has the effect of animating the Start and End points together as a group.

7 With the Timemarker at the **one-second** mark, click on the **Offset** stopwatch to set an initial keyframe and then change the **Offset** value to −**1** to move the range off to the left of the text (Fig. 8.27).

8 Move the Timemarker to the **two**-second mark and then hold down the ⌘ *ctrl* key as you slowly scrub the **Offset** value to see both

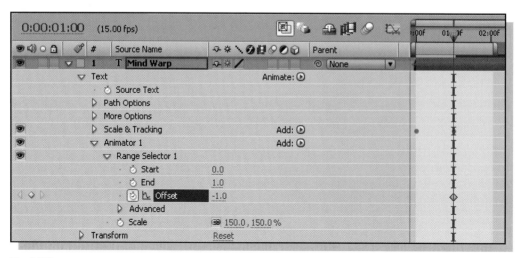

Fig. 8.27

the **Start** and **End** Selector Bars move across your text. Notice that the letter within the Selector Bars is scaled up. Finish with an Offset value of 9, this will move the offset of the other end of the sentence.

9 **RAM Preview** the animation. By animating the Offset value we get the effect of the characters scaling up as the range passes over them, then scaling down as the range moves past them.

To recap, we set the Start and End points of our range so that they selected one single character. We then animated the Offset value to move the one-character selection across out titles.

The text is now a little large for the comp but remember we still have our trusty Scale transform property which can be used to make slight adjustments to the whole layer.

10 Use the **Choose Grid and Guide Options** menu in the **Comp** panel to switch on your **Title/Action Safe** Guides (Fig. 8.28).

11 With the layer selected hit the **S** key to open the **Scale** transform property.

12 Adjust the **Scale** value till the text lies within the **Title-Safe** zone (about 75% should do it) (Fig. 8.29).

Fig. 8.28

13 Close and then open up the **Mind Warp** layer again and open up the **Text** property group to reveal the **Animator 1** again.

14 Select **Animator 1** and then hit the *Return* key on the keyboard to make it's name active. Type in **Scale 02** and then hit *Return* again to accept the new name.

Remember that we can add other properties to this animator, we'll return to do this later.

Other types of selector

OK, so we have our text scaling from one side to the other to emphasize it's presence. I also want the text to shiver as if it's

Fig. 8.29

quaking in it's boots! Remember, this is a comedy horror so we can get away with using loads of lovely cliches!

1 Open **Text_04.aep** and then double-click the **01_Text Overview** comp icon in the **Project** window to open it if it is not already open.

2 Open up the **Mind Warp** layer again in the Timeline and open up the **Text** property group to reveal the **Scale 02 animator**.

3 Click on the **Animate** pop-up menu again and this time, choose **Skew** from the list. This will add a completely new animator (with it's own new Range Selector) to your text layer (Fig. 8.30).

Fig. 8.30

With a text layer selected you can also add a new animator by going to Animation > Animate Text > < Property name >

4 Select the new **Animator 1** and then hit the *Return* key, rename this animator **Skew Shiver** and then hit *Return* again to accept the name (Fig. 8.31).

5 Change the **Skew** value to **20** and notice that it affects all the characters in our title. That's because it has a completely new Range Selector which defaults to encompassing all of the characters in our title (Fig. 8.32).

Fig. 8.31

This time we are going to use a different technique to animate the letters. Range Selectors are great for isolating specific letters that you want to animate but there are other types of selectors that you can use to animate your text in different ways.

Wiggly Selector
One of these selectors is the Wiggly Selector. If you've ever used the Wiggler panel or the Wiggle Expression you might be familiar with the term 'wiggle' in After Effects. It basically does what it describes, it wiggles a value around to achieve a more random look to your animations and is very useful wherever you want a repetitive but non-uniform look to your animation.

6 Look in the **Switches** column and you'll see that there are now three **Add** menus. One is for the **Scale & Tracking 01** animator, the second is for the **Scale 02** animator, and the third is for our **Skew Shiver** animator that we are currently working on.

7 Click on the third **Add** pop-up menu and choose **Selector > Wiggly** (Fig. 8.33).

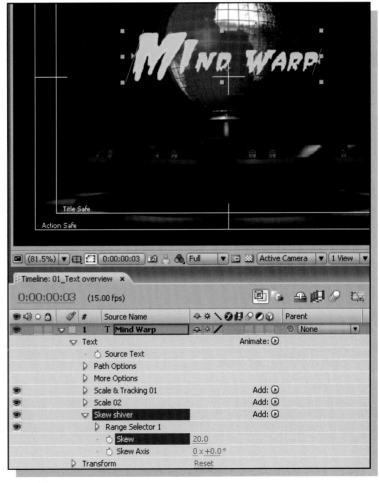

Fig. 8.32

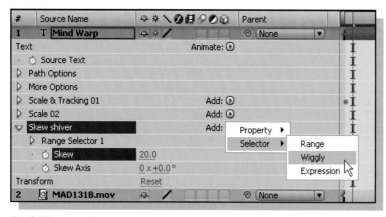

Fig. 8.33

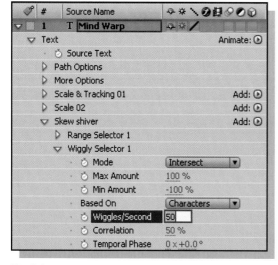

Fig. 8.34

8 **RAM Preview** the animation to see the **Skew** value randomly animating over time.

Notice that the complete line of text now has a wiggly Skew value throughout the animation. This is animating of it's own accord. That's because the Wiggly Selector is a procedural animation system. In other words it carries out a procedure (wiggling!). There's no need to set keyframes, it will automatically wiggle the values for you. You can customize the effect by making adjustments to various properties in the Wiggly Selector controls.

9 Open up the **Wiggly Selector** and change the **Wiggles/Second** value to **50** and then **RAM Preview** the animation. Notice that the wiggling is now much faster (Fig. 8.34).

You can add multiple properties to this animator group just as you could with the other groups.

10 Click on the third **Add** menu again, choose **Property > Scale** to add the **Scale** property to this animator group (Fig. 8.35).

11 Change the **Scale** value to **150%**.

12 **RAM Preview** the animation and notice that the Scale is wiggling about with the same timing as the Skew. The only problem is that the Scale is wiggling on

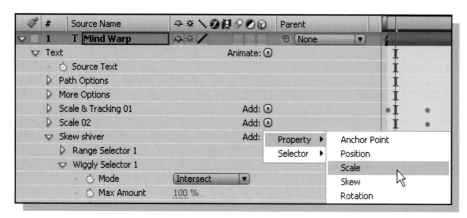

Fig. 8.35

the **X**- and the **Y**-axes independently, making it look a bit odd.

13 In the **Wiggly Selector** group, switch the **Lock Dimensions setting** On and then close the **Wiggly Selector 1** (Fig. 8.36).

14 RAM Preview the animation again to see the results. The Scale now wiggles the same amount on both the **X**- and the **Y**-axis.

The nice thing about using animators is that they are really easy to animate using very few keyframes. This means that making changes to the animation after the fact is much easier. For example, if I want to bring down the amount that the Skew value wiggles by I don't need to adjust any keyframes, I just make adjustments to the original skew value. To make it look like the characters are shivering it's best to make the value change rapidly, but to use small adjustments.

15 Adjust the **Skew** value till it reads **5**. While you're there also adjust the **Scale** value to **110%**.

16 RAM Preview the animation and notice that the wiggled values have changed throughout the whole animation.

It's also easy to add more properties to the animation after you have adjusted the Wiggly properties.

17 Add a **Position** property to the **Skew shiver** animator.

18 Change the **Y Position** value to **20** (Fig. 8.37).

19 RAM Preview the animation and see that the Position is now also wiggling on the **Y**-axis.

At any time I can go back and make adjustments to any of the animators. For example, lets add a little bit of extra tracking and position to the **Scale 02** animator which is currently Scaling the letters up one-at-a-time, from left to right, over the space of one second.

20 Close up the **Skew shiver** animator to keep things tidy and to avoid confusion.

21 Move to Frame **1:06**, so you can see the result this animator is having on your text.

22 Click on the second **Add** menu, next to the **Scale 02** animator and choose **Property > Tracking** from the menu (Fig. 8.38).

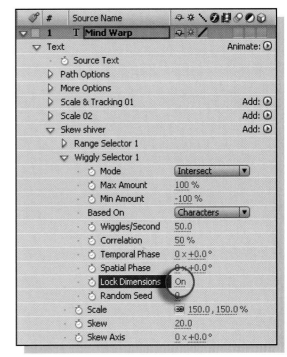

Fig. 8.36

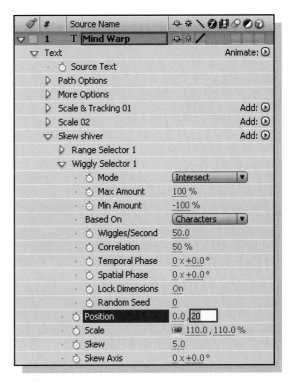

Fig. 8.37

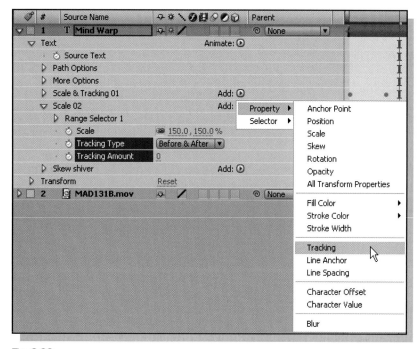

Fig. 8.38

23 Adjust the **Tracking Amount** value to **40**.

24 Click on the second **Add** menu again, this time choose **Property > Position** from the menu.

25 Change the **Y Position** value to −**40**.

26 **RAM Preview** again to see the changes this has made. The characters now jump up as they Scale.

 When you have multiple animators using the same property you need to be careful not to get them mixed up. Naming your Animators sensibly helps to avoid confusion

You can also apply these techniques on text originated in Photoshop. As long as the layer was a Text layer in Photoshop (and wasn't merged with any other layer while in Photoshop), it can be converted to editable text by going to **Layer > Convert to Editable text.**

Applying effects to text

Effects can be added to text in the same way as any other layer, the nice thing is that the text remains vector based throughout as the effects are non-destructive.

1 Open **Text_05.aep** and then double-click the **01_Text Overview** comp icon in the **Project** window to open it if it is not already open.

2 Close up the **Mind Warp** layer and select it in the **Timeline**.

Fig. 8.39

3 Go to **Effect > Distort > Warp** to apply the **Warp** effect to your layer. This is similar to the Illustrator Warp effect, it allows you to apply different methods of reshaping your layer.

4 In the **Effect Controls panel** change the settings as follows: **Warp Style = Bulge, Bend = 75, and Horizontal Distortion = 4** (Fig. 8.39).

5 Make sure that the layer is selected and then go to **Effect > Perspective > Bevel Alpha**.

6 In the **Effect Controls** panel, change the **Edge Thickness** to 3 (Fig. 8.40).

Fig. 8.40

7 Make sure that the layer is still selected, and this time go to **Effect > Distort > Liquify**. This is an animatable version of the Photoshop Liquify filter and is great fun to play with. You can use it on text to make it look less font-like, giving it a more hand-drawn quality (Fig. 8.41).

8 To use the **Liquify** effect you must first choose a **Warp Tool** to select the kind of distortion that you wish to use on your layer. We'll start by using the default **Warp** tool, this works by allowing you to push the pixels of your image around using a brush. The only way to get used to this tool is to play with it!

9 Place the cursor over the text and you will see a circle representing the brush size. Click and drag on the Text to push the pixels around to create distortion.

10 Click on the **Bloat** tool and open up the **Bloat Tool Options** under the **Tool** buttons in the **Liquify** effect controls.

11 Change the **Brush Size** to **100** pixels either by adjusting the **Brush Size** setting in the **Effect Controls** panel or by holding down the ⌘ *ctrl* key as you drag the brush in the composition window (Fig. 8.42).

Fig. 8.41

12 Position the brush over the letters in the Comp window and click and hold to make the area within the brush bloat.

13 Switch to the **Pucker** tool and do the same as before to shrink the area inside the brush.

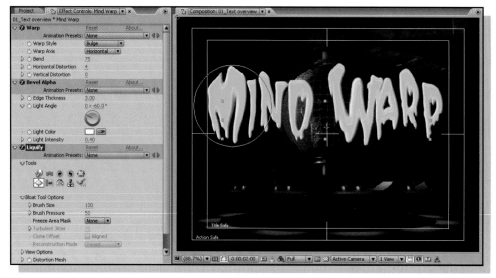

Fig. 8.42

14 Try out some of the other tools till you have something you like on the screen (Fig. 8.43).

Fig. 8.43

15 **RAM Preview** the animation again. You will notice that the animation has slowed down considerably because of all the distortion effects applied to the layer.

Animating effects

1 Open **Text_06.aep** and then double-click the **01_Text Overview** comp icon in the Project window to open it if it is not already open.

2 Move the Timemarker to the **two-second** mark in the **Timeline** and select the **Mind Warp** layer.

3 Hit the **E** key on your keyboard to open up the effects in the Timeline.

19 Open the **Liquify** effect in the Timeline and click on the **Distortion Mesh** stopwatch to set a keyframe (Fig. 8.44a).

Fig. 8.44a

4 Move to the **three-second** mark and then click **Reset** next to the **Liquify** effect's name in the **Timeline** to reset the filter to its default settings (Fig. 8.44b).

5 RAM Preview the animation to see that the text moves across the distortion mesh.

6 Move back to the **two-second** mark, so that you can see the distortion and then open up the **Liquify** effect's **View Options** in the Timeline.

7 Switch the **View Mesh** option to and then hit **Spacebar** to preview the animation with the mesh showing. This will give you a better idea of how the effect works.

Fig. 8.44b

8 Switch the **View Mesh** option to **Off** and then close the **Liquify** effect and then open up the **Warp** effect.

9 Animate the **Bend** value from **75** at the **two-second** mark to a value of **0** at the **three-second** mark (Fig. 8.44c).

10 Hit the **N** key on your keyboard to extend the **Work Area End** to the current frame.

11 RAM Preview the animation to see the effects decrease over time.

Fig. 8.44c

Animating animator properties

As well as being able to animate properties by keyframing the Range Selector values, you can also animate the basic properties used within the animator.

1 Open **Text_07.aep** and then double-click the **01_Text Overview** comp icon in the Project window to open it if it is not already open.

2 Close the **Effect** property group in the Timeline and open the **Text** property group.

3 Open the **Skew Shiver** property group and then select the four properties within: **Position, Scale, Skew,** and **Skew Axis**.

4 With the Timemarker at three seconds, click on the **Stopwatch** for one of the properties to set a keyframe for all of the active properties (Fig. 8.45).

Fig. 8.45

5 Move to the **four-second** mark and context-click on one of the property names and choose **Reset** from the list, doing this will reset all selected properties (Fig. 8.46).

Fig. 8.46

6 Select the layer and then hit the **U** key on your keyboard to display only keyframed properties.

7 **Select all** of the **keyframes** by dragging a marquee around them (Fig. 8.47).

Fig. 8.47

8 Extend the **Work Area End** to **five seconds**.

9 Go to **Animation > Keyframe Assistant > Easy Ease**.

10 Close up the layer and then, in the **Switches** column, Select the **Motion Blur** switch for the **Mind Warp** layer.

11 Click on the big **Enable Motion Blur** switch at the top of the Timeline to activate it for the comp (Fig. 8.48).

Fig. 8.48

12 **RAM Preview** the animation.

The amazing thing about this is that despite all the effects and animations we've applied to the layer, the text remains editable as we will discover in the following steps.

Text presets

That was a lot of work! Often when designing titles I go off into my own little world and I begin experimenting, not really concentrating on what I'm doing. When I get to a stage where the design looks good, I stop. But quite often I can't remember all the steps that I used to get the final result so I end up either using the idea once only, or spending too long trying to re-create the effect again. This is where animation presets can come in very useful.

If I want to use this design again for other jobs, or if I am working on a series of pieces that need a common 'look.' Well I can save everything I've done as an animation preset. These files are so small that they can even be e-mailed to colleagues working in different locations, there's no need to send projects.

After Effects comes bundled with lots of animation presets that we will take a look at later but for now lets take a look at how we can save and reuse these presets.

Saving text presets

1 Open **Text_08.aep** and then double-click the **01_Text Overview** comp icon in the Project window to open it.

2 Select the **Mind Warp** layer and double-hit the 🔘 key to open up anything that has changed from the default settings. There are so many things that have been changed on this layer that we do not have the space to see them so we need to open up our Timeline.

3 Click on the Timeline's **wing menu** to access the options and choose **Maximize Frame** from the list. Doing this will make the Timeline fill the screen (Fig. 8.49).

Fig. 8.49

Fig. 8.50

4 Go to **Window > Workspace > Save Workspace** and save the new workspace as **Maxed Timeline** (Fig. 8.50).

5 In the Timeline, click and drag a selection around all the properties listed. Notice that the keyframes, as well as the property i-beams are selected when you select the properties in this way (Fig. 8.51).

6 Click on the Timeline's wing menu again to access the options and choose **Restore Frame** from the list.

Fig. 8.51

7 With the **Mind Warp** layer active, click on the **wing menu** of the **Effects & Presets** panel and choose **Save Animation Preset** from the list (Fig. 8.52).

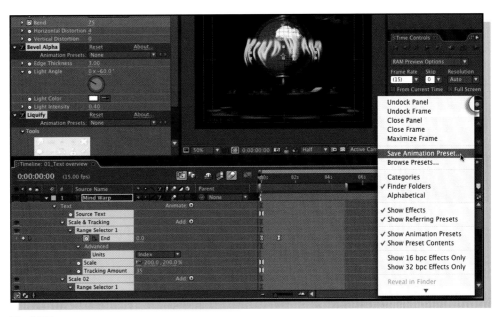

Fig. 8.52

8 Navigate your way to the **Adobe After Effects 7 > Presets > Text** folder and create a new folder in there with your name on it. Save the new preset in there as **MindWarpText.ffx**.

Applying text presets

Once a text preset has been saved it can then be applied to any other layer in the same way as regular animation presets.

9 In the **Project** panel double-click the **02_Basic Text comp to open it**.

10 Type **Mind Warp** in to the **Effects & Presets** panel, and then drag the preset onto the Basic Text layer in the Comp window (Fig. 8.53).

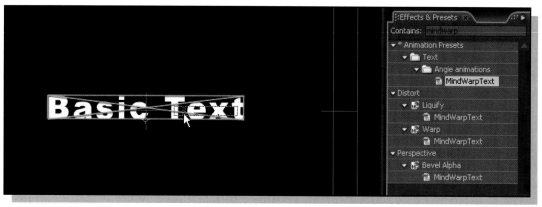

Fig. 8.53

11 **RAM Preview** to see exactly the same animation applied to the new text. All you need to do now is edit the text.

12 Go to **Window > Workspace > Text** to open up the **Character** and **Paragraph** panels.

13 Click on the **Mind Warp** layer to select it and then use the **Character** panel to change the **Font** to **Arial Black, Fill Color** to **White,** and **Stroke** to **No Stroke.**

14 **Double-click** the text layer in the **Timeline** to make it editable and type in **Animation**. This will replace the Mind Warp text with the new word (Fig. 8.54).

15 **RAM Preview** to see the same animation applied to the new text.

This works well because the word, **Animation** has the same number of characters as the phrase **Mind Warp**. Remember that the space is counted as one character so both have a total of nine characters. If you intended to apply a preset to a word, or group of words with more, or less characters than the original you may have to make adjustments to the Range Selector settings in order for them to work as expected.

Bonus trick

While writing this tutorial I stumbled on a little trick that you might like so I thought I would share it with you.

1 Open **Text_08.aep** and then double-click the **03_After Effects** comp icon in the **Project** window to open it.

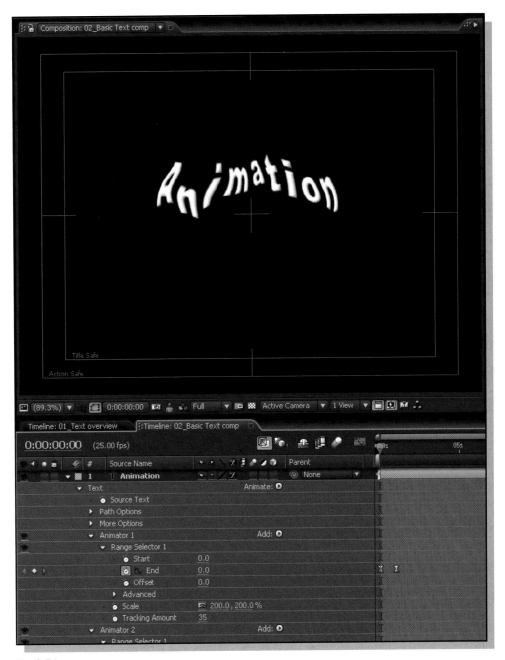

Fig. 8.54

If you get a warning that the ⌘⌘ **Radial Blur** effect is missing then you need to install your free Cycore effects from the After Effects installer disk. These effects are included free with your copy of After Effects but are run as a separate installer from the main application installer. So what are you waiting for? You have between 60 and 70 free effects on your After Effects 7 install disk! Go install them now and then restart this tutorial.

2 Select the **Horizontal Type tool** from the Tools panel ⌘𝑇 𝑐𝑡𝑟𝑙𝑇 (Fig. 8.55).

Fig. 8.55

3 In the **Comp** window select the word **Effects**.

4 With the word still selected, open the layer in the Timeline so that you can see the **Text** property group and click on the **Animate** button and choose **Position** from the list. The Range Selector will automatically be placed around the selection when you add an animator to selected text (Fig. 8.56).

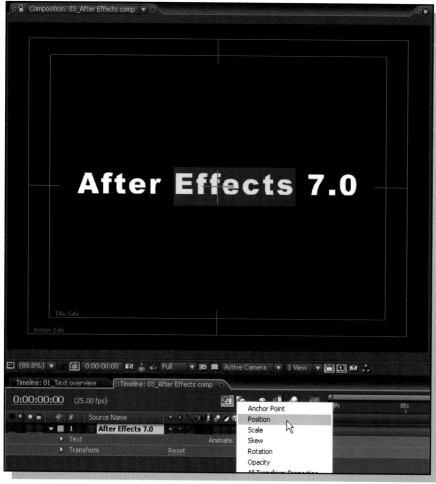

Fig. 8.56

5 Select the **Selection** tool **V** from the Tools panel and then click and drag the selected text around the screen. You must make sure that you click on the text, it's easy to accidentally deselect the text by clicking away from it.

Notice that the position value of the animator is changing as you drag. This is a nice, interactive way of adjusting the position value when adding animators.

Browsing presets with Adobe Bridge

After Effects 7 comes bundled with lots of goodies for your delectation! These include project templates and hundreds of free animation presets. It's often a good idea to browse through these to see if an easy solution to your design ideas exists before you start trying to create it from scratch. Sometimes you can find exactly what you need, other times you may stumble across a good starting point that you can customize to suit your needs more precisely.

1 Open **Text_08.aep** and then double-click the **03_After Effects** comp icon in the **Project** window to open it.

2 Open the **04_Text Presets** comp. This comp contains 10 identical text layers for you to experiment on, select the top layer.

3 Click on the **wing menu** of the **Effects & Presets** panel and choose **Browse Presets** (Fig. 8.57).

Adobe Bridge will now open up at the **Presets** folder. The first thing to do is change the view, I find that **Detail** view is a lot more easy to navigate than the default **thumbnail** view.

4 In **Bridge**, go to **View > As Details**, or click on the **Details View** button in the bottom right corner of the Application window (Fig. 8.58).

Fig. 8.57

Fig. 8.58

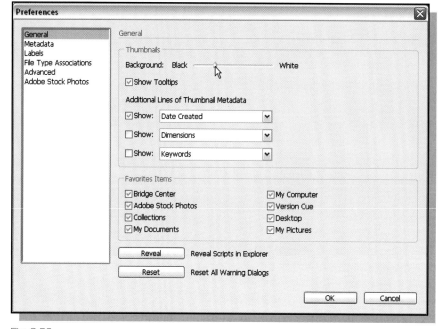

Fig. 8.59

5 Still in **Bridge**, go to **Edit > Preferences** and then change the background color to a dark gray, this will be a lot easier on your eyes (Fig. 8.59).

6 Open the **Text** folder and then scroll down the list to look at all the different categories then open the **Animate In** folder.

7 One-by-one click on the thumbnails, as you do a little preview movie of the selected preset will begin to play in the **Preview** panel. Look through the presets and decide on one that you would like to apply (Fig. 8.60).

Fig. 8.60

8 To apply the preset, double-click it in Adobe Bridge. If you are using a Mac After Effects will automatically reopen; if you are on a Windows system, After Effects will flash in the Task bar to remind you to go back to After Effects.

9 Go back to **After Effects** and **RAM Preview** the animation to see the results.

You may notice that your animation looks different from the one in the preview. This is because **Motion Blur** is switched on in the previews. To activate **Motion Blur,** select the **Motion Blur** switch for the layer and also activate the **Enable Motion** Blur switch at the top of the Timeline (Fig. 8.61).

Fig. 8.61

10 Once you have finished previewing the animation, switch off the layer's visibility, switch on the next layer's visibility, and try out a new preset.

Remember that Animation presets are applied from the current time where the timemarker is parked so make sure to hit the **Home** key before applying a new preset.

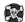

Some animation presets may produce unexpected results, this can be due to several variables being different in your own text layer. For example, you may be working in a PAL comp when most of the Presets are designed with NTSC (National Television Standards Committee) aspect ratios in mind, or your text layer may have more or less characters in it than the example text animation. In these cases it's possible to customize the settings. We'll look at ways of doing this in the following section but for now just enjoy some care-free experimentation.

This comp is here for your experimentation. If you run out of text layers, just create some new ones or go to **File > Revert** to refresh the project.

11 Close **Adobe Bridge** once you have finished previewing presets.

Customizing presets

1 Open **Text_08.aep** and then double-click the **05_Seattle Evening News** comp icon in the **Project** window to open it.

2 **RAM Preview** the comp and you will notice that it takes a fair bit of time to build a preview. There are several nested comps and lots of effects applied to the nested comps. We'll pre-render the comp to speed up our workflow.

Fig. 8.62

Creating proxies

Once you have finished working on elements in your comps they can be rendered as proxy files to speed up your workflow. The item that is rendered will be temporarily replaced by a draft-rendered version as a guide, so that you can continue working on other elements within the comp. This means that effects, transformations, and other operations are not continually processing while you make further changes to your comp.

It's important to know which item is suitable for rendering as a proxy file, in this situation we don't want to make a proxy for the entire comp because we are still working on it. Creating a proxy file for the open comp will replace the whole comp with the proxy file, meaning that we can't make any new changes to it when the Proxy is switched on. We will make a proxy file for the Edit.ppj comp.

3 In the **Project panel**, open the **Precomps** folder and context-click on the **Edit.ppj** comp icon to open up its context-sensitive menu, choose **Create Proxy > Movie** (Fig. 8.62).

4 The **Render Queue** panel will open, in here, click on the movie name in the **Output to** section of the **Render Queue** (Fig. 8.63a).

Fig. 8.63a

This gives you the opportunity to choose a location to save your file. Keep the default name for the file that After Effects has chosen, based on the name of your comp, and save your proxy file to your **Work in Progress** folder in your **Desktop** folder.

5 Click on the **Render** button in the **Render Queue** to begin the proxy rendering process. After Effects will render a version of your movie that will automatically become a low-resolution proxy, temporarily replacing the comp wherever it's used in your project.

6 Click the **05_Seattle Evening News** Timeline tab to make it active again.

7 **RAM Preview** again and notice how much faster the preview is.

8 In the **Project panel**, notice that there is a little square next to the **Edit.ppj Comp** name, this is the **Enable Proxy** switch, you can use this to toggle the proxy file on and off as required. Try switching it on and off to see the differences in the Comp panel between the low-resolution proxy and the actual comp (Fig. 8.63b).

Proxies are great because they don't replace the file in the Timeline permanently and they are very quick to render.

Fig. 8.63b

9 Move to the beginning of the Timeline by hitting the **Home** key on your keyboard and then select the **Horizontal Type** tool from the **Tools** panel.

10 Click once in the middle of the **Comp** panel and then type in **Seattle R Evening R News R**. Each of the three words should be on a separate line.

11 When you have finished typing re-select the **Selection** tool ⓥ. You can now use the **Character** and **Paragraph** panels to make changes to your text till you can see all three words on

Fig. 8.64

screen. You may have to choose a different font than I have chosen but use the panels to adjust the text till it is roughly in the same position as mine (Fig. 8.64).

12 Move the Timemarker to **0:00:25:01**. When you apply a preset, any keyframes in the preset are inserted relative to the current point in time, in other words the animation will start from the location of the Timemarker when the preset was applied.

13 In the **Effects & Presets** panel, open the **Animation Presets > Text > Multiline folder** and, from there, drag the **Data Stream.ffx** onto your layer in the Comp panel (Fig. 8.65).

Fig. 8.65

14 **RAM Preview** to see the animation preset applied to your text layer. I like the movement of the letters but the timing is not quite right when the letters come to rest, I want them to be timed with the beats of the music so we will adjust the timing of the animation to suit our needs.

Fig. 8.66

15 Select the **Seattle Evening News** text layer and then **double-hit** the 🔘 key to open up all altered properties. You should see four keyframes and an Expression, these are the elements that control this animation.

16 Drag the **Work Area Start** Bar in to approximately **23:00**, so that you will only preview this short section in the following steps (Fig. 8.66).

17 **Select** the two **keyframes** at **27:01** and drag them along the Timeline to **29:00**. You can use the **Info** panel as a guide (Fig. 8.67).

18 **RAM Preview** the animation to see the improvement in timing.

Fig. 8.67

19 Double-click the **Seattle Evening News** text layer to select it and then click on the **Toggle** button for the **Character and Paragraph** panels if they are not already open (Fig. 8.68).

Fig. 8.68

Fig. 8.69

20 In the **Paragraph** panel, click on the **Left Align text** button.

21 Use the **Character** panel to adjust your text **Font** and **Font size**. I'm using Arial Black as it is likely that you will also have this font on your system, but you can choose your own font.

22 At the bottom of the **Character** panel you will see a row of buttons, click on the **All Caps** button (Fig. 8.69).

There aren't many situations where I would advocate the use of upper case throughout a design, words are generally harder to read in upper case and it's usually a bit too 'in your face' for my liking. However, this is a news program so this is one of the few occasions where upper case letters will work. Headlines and notices are often written in upper case so people are used to seeing this bolshy, attention-grabbing typography in these contexts. It will also serve to reinforce the 'Newsy' feel of the titles.

23 In the **Comp** window, **click and hold** the **Choose Grid and Guides** button and choose **Title/Action Safe** from the menu (Fig. 8.70).

Fig. 8.70

24 **Select** the **Selection** tool **V** and then click and drag the text into a more central position so that the **Shift** in the word **Seattle** lines up with the left side of the title-safe guide.

25 Select the **Horizontal Type tool** **⌘T** **ctrl T** and click once before the first letter **Enter** in the word Evening. Hit **Tab** once to move the word across. Do the same with the word **News**, repeatedly hitting **Tab** till it looks similar to the screen shot (Fig. 8.71).

26 Hit **⌘A** **ctrl A** to select all of the characters and, in the **Character** panel, change the **Leading** to 55 (Fig. 8.72).

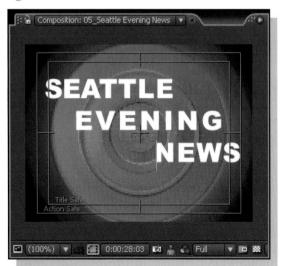

Fig. 8.71

Fig. 8.72

27 Select the Selection tool **V** again and click on the **Faux Italic** button at the bottom of the **Character** panel.

28 **RAM Preview** and notice that the animation adapts with the new settings you have made.

29 **Context-click** on the text layer and, in the menu go to **Blending Mode > Overlay**.

Fig. 8.73a

30 If the **Effects & Presets** panel is not already open, go to **Window > Workspace > Effects** to open it, and then type the word Drop into the Contains field of the panel.

31 Drag the **Dimension-Bevel + shadow** animation preset onto your text layer in the **Comp** window (Fig. 8.73a).

Fig. 8.73b

32 In the **Effect Controls** panel, change the **Drop Shadow** effect's **Distance** value to **1.0** and the **Bevel Alpha Edge** effect's **Thickness** value to **0.5** (Fig. 8.73b).

While in the **Effect Controls** panel, you may notice two other effect controls, one named **Frequency,** and the other named **Period**. These are sliders to control the Expression applied to your text layer. These enable you to easily control elements of the Expression without having to get your hands dirty editing code! In the Expressions chapter (Chapter 11) I'll show you how to do this but for now we'll simply adjust the Frequency of the random movement.

33 In the **Effect Controls** panel, set the **Frequency** effect's **Slider** value to **20** (Fig. 8.73c).

34 Move the Timemarker to frame **29:00** and then, in the **Effect Controls** panel click on the **Frequency** stopwatch to set a keyframe (Fig. 8.74).

Fig. 8.73c

Fig. 8.74

35 Move to frame **30:00** and change the **Frequency** value to **0**.

36 Finally, let's add Motion Blur to the text layer by first clicking on the text layer's **Motion Blur switch** and then activating the **Enable Motion Blur** button at the top of the Timeline (Fig. 8.75).

Fig. 8.75

37 In **Project** panel, open the **Precomps** folder and click on the **Toggle Proxy** switch to switch off the proxy file (Fig. 8.76).

38 If you have adjusted the Work Area, double-click the **Work Area Bar** to extend it to the duration of the comp and then **RAM Preview** the finished piece.

Fig. 8.76

Messing around with fonts

I used to draw my own fonts by hand before computer-generated fonts were existed around. I would usually draw them by hand from scratch, but when I began studying at art college I found tracing letterforms by hand an extremely useful exercise.

We used what's known as a **Grant projector** to enlarge letters from magazines, we then traced the letters and created individual designs around each of the letters of the alphabet. This is a great way of getting to know the shapes, why not try it, using a photocopier to enlarge the text. Hand-drawn text has a lovely raw quality that's hard to achieve using a computer, it's also very therapeutic.

Although I love the easiness of using Computer fonts, I find they tend to look a little bit too perfect and impersonal. So, I like to play around with them in the same way as I did with the old Grant projector and Rotring pens! Here are some tips for doing just that.

1 If you haven't already done so, make sure to install the **fonts** on the book's DVD, and the free **third-party plug-ins** from the After Effects installer disk for this tutorial. You can find instructions on how to do this in the **Before you Start** section of the **Introduction** at the beginning of the book. You will need to restart After Effects after installing these.

2 Open **Text_08.aep** from **Training > Projects > 10_Text** folder and then double-click the **07_Graffiti** comp icon in the **Project** window to open it (Fig. 8.77).

3 The first thing I do is to make the font look a little less uniform. I do this by selecting individual letters and adjusting the settings in the **Character** panel. **Baseline shift, Font Size,** and **Kerning** are usually my first ports of call.

The idea is not to follow my exact steps but to experiment a little, just to give you a few tips though. Kerning is a little tricky if you've never used it before, it's used to increase or decrease the space between letter pairs.

4 To use Kerning, move the i-beam between the two letters you wish to work on, then adjust the **Kerning** value. You'll have to use large numbers before you'll see a result so if you are using the arrow keys, hold down *Shift* as you do (Fig. 8.78).

Fig. 8.77

Fig. 8.78

Normally, I would go through all screen text, checking that all the Kerning pairs had the correct amount of spacing between them. It can be tricky for a beginner to know exactly how much spacing to use between the letters but it helps if you can be aware of what's known as the 'typographic color' of your text. This term refers to the density of your text as a unit.

To become an accomplished typographer you need to start thinking of letterforms as shapes rather than text, each letter is an individual shape, when these letters are combined into words, they create new shapes, the words are combined to make sentences and then sentences become paragraphs. The combination of the type and the space around it will form a pattern, the key to good typography is to make sure that the amount of space compared to the amount of solid text is pretty even.

As a test, pick up a good magazine and have a look at some text blocks through half-closed eyes. If the typography is good, you should see an even spread of gray throughout the text. If, however, you do the same with a cheap newspaper, you'll probably see big chunks of white space amongst the paragraphs, making the text look uneven and causing it to be more difficult to read.

The most common cause of bad typography is the use of Justified Alignment, this is when the text is forced to extend to the edges of columns, the computer makes a guess at the best way to space the letters to fit the space. As you should know by now, computers are great tools but are not very good at making design decisions, that's your job, it takes a trained eye to know what's needed.

You can learn a lot about typography by observing text very carefully in everyday life, it's all around you. Notice the fonts used for different purposes (e.g. billboards, magazines, shop signs, graffiti, TV, film, web, etc.). Pay attention to the spacing and colors, try to start seeing letters, words, and phrases as shapes.

Creating outlines

Once you have the text as close as you can get to what you want you can convert it to outlines which are made from editable paths. This allows you to adjust the shapes of the letters to personalize them

Fig. 8.79

and make them less recognizable as standard fonts. You can also animate the shapes and apply effects to the outlines to make it look as though the text is being written on the screen.

5 Select the **Graffiti text** layer with the **Selection tool** **V**.

6 Go to **Layer > Create Outlines**. A new layer will be created with masks for each of your letter shapes.

7 Switch off the original **Graffiti** layer's visibility and then select the **Graffiti Outlines** layer in the **Timeline**. Hit the **M** key on the keyboard to open up the masks in the Timeline (Fig. 8.79).

8 Use some of the techniques you used in **Chapter 05 – Compositing** for editing mask shapes to play with the shapes till you find something you like. You can start with Free Transforming whole paths, then progress onto editing individual points on the masks (Fig. 8.80).

Fig. 8.80

Don't think too much about what you're doing to begin with, treat it like doodling – go mad! I did, and check the results. This example is not the best typography in the world but I had fun doing it, and that's when you learn the most, while practising and having fun!

Fun effects for text

There are several effects that are perfect for creating quick but impressive text animations. Here are a few quick tips on using a couple of my favorites.

1 Open **Text_08.aep** from **Training > Projects > 10_Text** folder and then double-click the **08_Graffiti End** comp icon in the **Project** window to open it.

Scribble

2 Context-click on the **Graffiti Outlines** layer and go to **Effect > Generate > Scribble** (Fig. 8.81).

3 In the **Effect Controls** panel, click on the **Scribble** menu and choose **All Masks Using Modes** (Fig. 8.82).

4 **RAM Preview** the animation to see the text filled with animated scribbles.

5 Change the **Fill Type** menu to **Outside Edge**.

Fig. 8.81

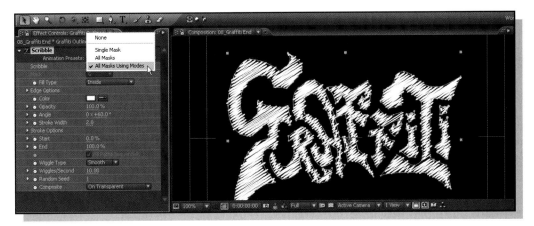

Fig. 8.82

6 Open the **Stroke Options** and change the **Path Overlap variation** to **0**. This will stop strokes overlapping the edges of the text.

7 Change the **Spacing** to **0.1** and the **Spacing Variation** value to **0**. OK, lets animate the effect so that it paints on over time.

8 In the Timeline move to **5:00** and then click on the **End** stopwatch in the **Effect Controls** panel (Fig. 8.83).

9 Drag the timemarker back to the beginning of the Timeline and then scrub the **End** value back to **0**.

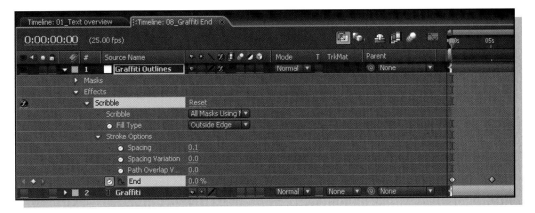

Fig. 8.83

10 **RAM Preview** to see the results (Fig. 8.84).

11 Change the **Fill Type** menu to **Inside Edge** to see the difference.

There are loads more settings for this filter, please feel free to experiment with them. I've also saved a few presets for you in the **Angie Taylor Presets** folder on the DVD. If you haven't already done so, drop the **Angie Taylor Presets** folder into the **Adobe After Effects 7 > Support Files > Presets** folder and restart After Effects to see them appear in your effects and presets folder. If they are not there initially, go to the panel's wing menu and choose **Refresh List**.

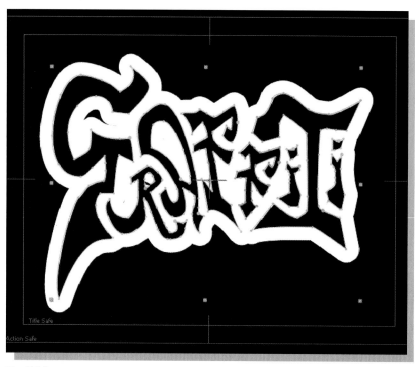

Fig. 8.84

Stroke

12 Go to **File > Revert** to revert the **Text_08.aep** project back to the last saved version and then double-click the **08_Graffiti** End comp icon in the **Project** window to open it.

13 Context-click on the **Graffiti Outlines** layer and go to **Effect > Generate > Stroke** (Fig. 8.85).

14 In the **Effect Controls** panel change the **Color** to **Orange** and click on the **All Masks** checkbox to apply the stroke to all of the masks.

15 Change the **Paint Style** menu to On **Transparent**.

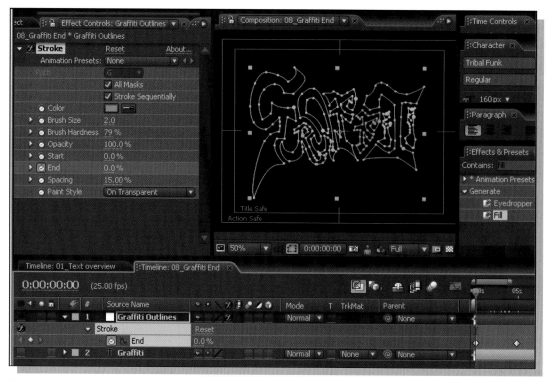

Fig. 8.85

16 Set keyframe for the **End** value from **0%** at the beginning of the Timeline, to **100%** at **5:00**.

17 **RAM Preview** the animation.

Track Mattes

We are going to create what is commonly referred to as a Track Matte. This involves punching a hole in one layer, using a grayscale image from another layer as a kind of stencil. Using this technique, the grayscale image can be taken form another layers Alpha channel or from its luminance value.

18 In the **Project** panel, open the **09_Track Matte** comp.

19 Switch on visibility for the **Space.ai** layer in the Timeline.

Here we have a simple Illustrator file containing some text. Under this is a Quicktime movie from Artbeats (http://www.artbeats.com). We will use the text layer as a stencil for the movie layer.

20 In the **LF130 NTSC Watermark.mov** layer **Track Matte** menu in the Timeline's **Modes** column choose **Alpha Matte 'Space.ai'** (Fig. 8.86).

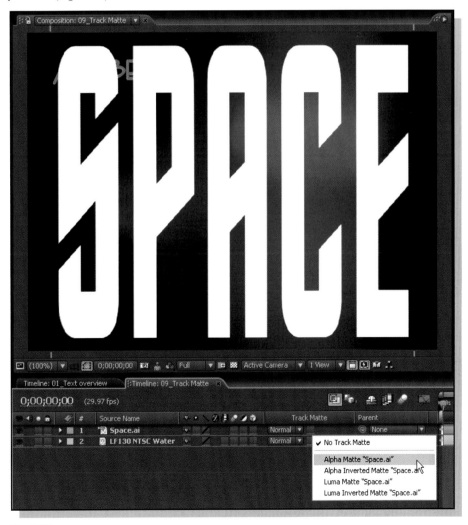

Fig. 8.86

21 **RAM Preview** the comp to see the movie play through the text layer.

22 Switch on the **Transparency Grid** in the **Comp** panel to see the transparent areas (Fig. 8.87).

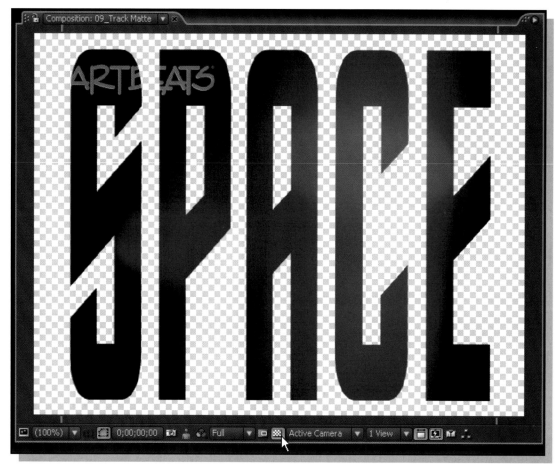

Fig. 8.87

23 Animate the **Space.ai** layer's **Scale** property starting from **2000% at 0:00** to **100%** at 5:00.

24 **RAM Preview** notice two problems, one is that the text looks rough and bitmapped at the edges, to correct this, click on the Continuously Rasterize button for the **LF130 NTSC Watermark.mov** layer (Fig. 8.88).

25 Click on the **Scale** property name, this will select both keyframes, **context-click** on either one of them to open up the context-sensitive and then go to **Keyframe Assistant > Exponential Scale**.

26 In the **Effects & Presets** panel, type in the word **Shadow**. Drag the **Radial Shadow** effect onto the **LF130 NTSC Watermark.mov** layer in the Timeline.

Radial shadow uses a point source to cast a shadow from your layer allowing you to create more realistic shadows than with the regular Drop Shadow effect. It uses the alpha channel to cast the shadow, so it will transmit color from the semi-transparent areas of your image.

27 In the **Effect Controls** panel, change the **Projection Distance** to **3**.

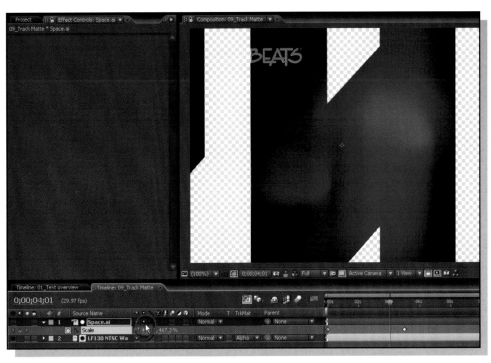

Fig. 8.88

28 If you look in the Comp window you will see the Light Source control point. This can be clicked and dragged around the screen to change the angle of the shadow (Fig. 8.89). If you have difficulty in

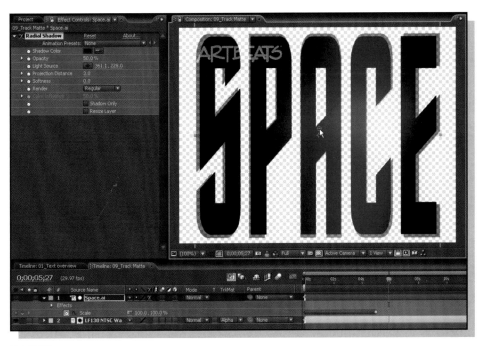

Fig. 8.89

finding it you can click once on the Light Source button in the effect Controls panel to place a crosshair over it, this can be moved and then clicked once when happy with the placement (Fig. 8.90).

Fig. 8.90

Recap

Well, we've covered a fair amount in this chapter regarding text but you can never learn enough about text and typography, it's one of those things, the more you learn – the more you want to know!

If you have followed all the tutorials in this chapter you should feel comfortable about creating text from scratch within After Effects as well as importing it from Photoshop or Illustrator. You've learnt how to animate the text using animators, how to save your text animations as presets, and how to customize the hundreds of presets that come free with After Effects. We also took a look at using Adobe Bridge to browse animation presets and effects before applying them to text layers. Finally, we looked at some of the effects that are great to use with text.

Inspiration – Birigitta Hosea

Birigitta Hosea is a digital artist, freelance animator, and part-time Course Director of the Character Animation postgraduate at Central Saint Martins. Her work has been shown in festivals and exhibitions internationally. As well as having trained corporate clients in most of the major broadcasting companies in the UK, she works as a presenter and consultant for Adobe, a curator of digital moving image events and is the author of the *Focal Easy Guide to Flash 8* (Focal Press). She is currently conducting Ph.D. research into animation for virtual performance at University of the Arts London (Fig. 8.91).

Studio venus

www.studiovenus.co.uk (motion
graphics/animation/london (Fig. 8.92))

Q How did your life lead you to the
 career/job you are now doing?

A Ten years ago, I was working in design for
 performance and initially started learning
 about computers so that I could find new
 techniques for design presentation
 drawings. I quickly fell in love with
 computers and haven't looked back since
 then.

Q What drives you to be creative?

A It's an addiction, a subconscious urge.

Q What would you be doing if not your
 current job?

A Not sure, but hope it wouldn't be selling
 burgers!

Q Do you have any hobbies/interests and if
 so, how do you find time for them?

A Gardening/walking/cinema. I am trying to
 make a big effort to not work at the
 weekends, which can be difficult to do if
 you do freelance work.

Q Can you draw?

A Well, I could once.

Q If so, do you still draw regularly?

A Not really, but it's right up there on my list of
 things I must get around to … soon.

Q Is your creative pursuit a struggle? If so, in
 what way?

A Yes, it's always hard to juggle being freely
 creative and making money as well as
 listening to your inspiration instead of
 negative thoughts.

Q Please can you share with us some things
 that have inspired you. For example film,
 song, web site, book, musician, writer,
 actor, quote, place, etc.

A At the moment I'm really into early – mid-
 1960s graphic design.

Fig. 8.91

Fig. 8.92

Fig. 8.93

Fig. 8.94

Q What is your most overused AE
 feature/filter?
A Probably just 'jitter' in various guises.

Q What would you like to learn more
 about?
A I would like to learn more about
 scripting and what it could do.

Q Please include screen shots of the work
 that you are most proud of and give a
 brief description of it and explain your
 feelings about it.
A Two stills enclosed of very different
 projects, although they are both video
 installations.

London Angel was a part of an installation called Visitation that I did in the crypt of an old church in London. It involved using animated photo collage and video compositing to visualize the guardian angels of London.

PhotoSonic is something that I am working on at the moment about digital color and audio. I am using abstract animation to create a soundtrack. The images are quite simple – inspired by abstract painting. The actual colors in the piece are generating tones. It's quite painful to listen to, but I have been having hours of fun creating it!

Chapter 09 **3D**

The way After Effects 3D works is unique in that it will allow you to mix 2D and 3D in the same composition. As far as I'm aware, at the time of writing this book, there is no other application that will allow you to do that. There are other compositing applications which will allow you to work in either 2D or 3D but After Effects allows you to mix them together in the same environment. This has loads of creative benefits and time-saving benefits which we'll see as we explore all the features.

Synopsis

Throughout this chapter, you will develop a good understanding of the basic capabilities of 3D in After Effects. Of course, there are a million creative ways to use these tools, and I can't possibly attempt to cover all of them, it's your job to experiment, have fun, and find out more tricks after you have completed this chapter! I will explain how to understand the 3D workspace; how you can mix 3D and 2D in the same environment, and lots of tricks and techniques using the After Effects lights and cameras.

I want to thank Maia Sanders and Paul Tuersley who both contributed to this chapter, you can read their biographies on the accompanying DVD > Biographies.

3D in After Effects

3D in After Effects works in a unique way, unlike any other software application. It can be initially confusing if you've never used any 3D applications as you'll be dealing with a new 3D. As you'll discover as you progress through this chapter, After Effects measures 3D space in a different way from traditional 3D applications like CINEMA 4D, Maya, Softimage, Lightwave, 3ds Max.

Most 3D applications measure their coordinates from the center origin of the space which is the 0.0 point. They measure the X, Y, and Z coordinates in the direction of the arrows in the diagram (**3D coordinates.tif**).

As with 2D coordinates, After Effects measures the X and Y coordinates form the top-left corner of the Comp panel in the direction of the arrows. The Z coordinates are a measurement for the depth. As you can see from this diagram, both the Y and Z coordinates are measured in the opposite

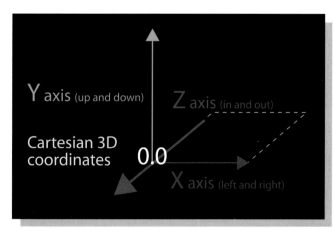

3D coordinates

AE coordinates

3D Layer

direction from the regular 3D system (**AE coordinates.tif**).

This can be confusing if you regularly use 3D applications but once you get used to it, it's a nice, intuitive way of working. There are essentially two aspects to the 3D in After Effects, 3D layers and 3D filters.

3D layers

After Effects is not a full 3D application with modelling capabilities, it remains, at heart a 2D image processor with a firm grasp of 3D principles. It has been referred to as '2.5D', or 'postcards in space'; you'll soon see that these are quite accurate descriptions of its functionality. After Effects works by allowing you to animate layers as objects in 3D space, where they can move freely within 3D, allowing for some amazing effects. This will be explained in the sections that cover using 3D layers (**3DLayer.tif**).

3D effects – Pro only

After Effects does not generate the same type of data as a traditional 3D application, such as CINEMA 4D, 3ds Max, Softimage or Maya, although it can work with the file's output by these programs in a 3D fashion. It can utilize the Z-depth channel (the 3D) to enhance the appearance of depth of field in rendered 3D scenes; import camera data to match up new elements with the camera moves created in these 3D applications; or simply adjust the shadows or lighting in a multipass-rendered 3D scene.

There are also several effects in After Effects professional version that can also interact with the 3D cameras and lights, there's even a third-party plug-in called Invigorator that allows you to build and import real 3D models into After Effects. All of the 3D Channel effects will be discussed in the **3D_Pro.pdf** document on the accompanying **DVD > Extras**.

3D workspace

The 3D workspace may sound and look a wee bit intimidating, but it really nothing more than you see every day in the real world around you. In a regular After Effects composition, you deal with

the X-axis (left to right) and the Y-axis (up and down). In the After Effects 3D workspace, there is the additional Z-axis, which represents in-and-out, back-to-front, near-to-far, or, put more simply, depth.

Layer quality and resolution

You may notice a real slow down in render times when you start to work in 3D so remember to make use of the different Layer Quality modes available.

As with any other layer in After Effects, select the layer and go to **Layers > Quality** to find **Draft** and **Wireframe** settings for your layers. You can also use the **Quality** switches in the Timeline to do the same job. You can also choose to decrease the resolution used for previewing by using the Resolution menu in the comp window. Experiment with these if you are finding that things are beginning to slow down (**Wireframes.tif**).

Wireframes

Making a layer 3D

1 Open **3D.aep** from the **Training > Projects > 11_3D** folder.

2 Double-click the **01_3D Space** comp in the **Project** panel to open it. You will see a Composition that contains six **2D** layers (Fig. 9.1).

3 Hold down the ⬚ *alt* key and then, one by one hit the **Solo** button for each of the layers to view them one at a time.

Fig. 9.1

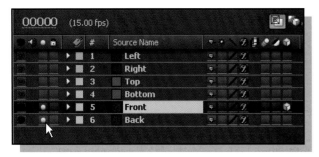

Fig. 9.2

Fig. 9.3

Holding down the ⌥ alt key will have the effect of switching off the last layer Solo'ed when you click on a new layer.

4 When you have finished looking at the layers, switch on the **Solo** buttons for the **Front** and **Back** layer's **Solo** buttons so that only the **Front** and **Back** layers are visible (Fig. 9.2).

3D-ness (as I like to call it!) is applied on a layer by layer basis. Layers can be toggled between 2D and 3D in by clicking on the layer's 3D button in the Timeline or by going to **Layer > 3D** layer. All of the layers in this composition are currently 2D layers.

As you should understand by now, when working with 2D in After Effects, the layer stacking order in the Timeline determines how they are composited together in the Composition panel. The top-most layer in the Timeline is always the front-most layer in the Composition panel.

When you make your layer 3D, it no longer follows the rules of the usual After Effects layer hierarchy. When you make a layer 3D, it will override the normal After Effects layer order, the 3D layer nearest the camera will be the front-most in the Comp panel, no matter what position it is in the Timeline.

5 In the **Timeline**, clicking the **Front** layer's Twirly triangle to expose the **Transform** Properties then click on the **Transform** Twirly to expose the five transform properties within.

6 Click on the **3D** switch for the **Front** layer (Fig. 9.3).

The first change we notice is that the number of properties has expanded. Anchor Point, Position, and Scale still have the same **X** and **Y** values they had as 2D layers but now they also have a third **Z** value. And instead of a single rotation property, we now have individual **X**, **Y**, and **Z Rotation** properties. We even have a brand new property called Orientation. You'll also notice that a whole new

Property group named **Material Options** has been added to the layer.

Adjusting 3D position

7 With the **Front** layer selected in the **Timeline**, toggle the **Front** layer's **3D** switch on and off and pay particular attention to the **Comp** panel. When the layer is switched to 3D it is given axis to help you to move or rotate the layer in 3D space (Fig. 9.4).

These axes are very easy to understand; you can see clearly, from the direction of the arrows, which dimension they each will control. You can also make a connection between the axis and the corresponding colors – **X**, **Y**, and **Z** is represented by the colors **Red**, **Green**, and **Blue**, respectively.

When teaching some students who were having trouble remembering their axes, I asked them to tape a stickies to there monitors, they had stickies with the letter X at the left and right side of the monitor, and the letter Y at the top and bottom of the monitor. The only axis left is X which moves into and out of the monitor. Any method that will help you to become familiar with each of the axes is great.

Fig. 9.4

8 Move the **cursor** over the **red axis** and notice that, as you do, the cursor changes to show a little **X** beside it. This tells you if you click and drag now your layer will move only on the X-axis (Fig. 9.5).

9 With the **Selection** tool click and drag this handle left and right to move it on the **X**-axis. Notice in the **Timeline** the **X** value is changing.

10 When you have finished experimenting, context-click on the **Position** property name in the Timeline and choose **Reset** from the menu (Fig. 9.6).

11 Repeat these steps on the green **Y-axis**, notice that adjusting the Y value will move the layer up and down, just as before; these axes give you a new method for moving the layer and constraining the movement to a single axis.

Fig. 9.5

Fig. 9.6

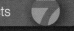

12 **Reset** the **Position** property when you've finished experimenting.

13 Click on the blue **Z-axis** and drag in the same way as you did with the X- and Y-axes.

This is where things start to look really different! The Z value will change in the Timeline and the layer will move nearer to you, or further away from you, depending on which way you drag it. Drag it either down or to the left to move it away from you. Drag it up, or to the right to move it closer. You can also scrub the Z value, like you would scrub any other value.

14 Scrub the **Z Position** value (the third value after the **X** and **Y** values **160, 120,** respectively) in the Timeline till it reads **100**. Doing this will move it away from the Camera (Fig. 9.7).

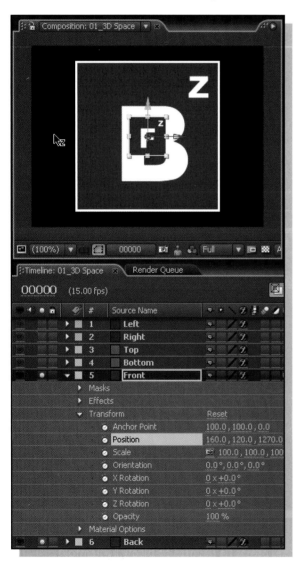

Fig. 9.7

Have you noticed that, no matter how far away you move it, the Front layer never jumps behind the Back layer? This is because the other layer is 2D, so cannot be positioned in 3D space or interact with other 3D layers. In order to make it understand the same 3D rules we also have to turn on its 3D switch.

15 Select the **Back** layer and hit the **P** key so that you can see its **Position** value.

16 Click on the **3D** switch for the **Back** layer and watch as it appears to jump in front of the Front layer!

That's exactly what it has done. The Front layer was moved forward on the Z-axis, further away from the camera. The Back layer is still in its default position at 0 along the Z-axis so it now sits in front of the Front layer, which is at 100 on the Z-axis. When a layer is made 3D it can move freely through 3D space, regardless of its placement in the Timeline's layer stack. Even though the Back layer is at the bottom of the Timeline, it is still the front-most layer in the Comp panel due to the layer's Z-axis Position value. Its easier to see what is happening if we take a look at our scene from a different angle.

3D views

Another unique aspect of working with 3D layers is that you can view your 3D layers from different perspectives using the Comp panel's **3D Views** Popup menu.

Look in the bottom-right corner of the Comp panel and you'll see a box that says **Active Camera**; this is your 3D View menu, it's where you can choose to

look at your 3D world from different angles; this will help you with precision placement when animating your scene elements (Fig. 9.8).

Fig. 9.8

2 Select the **Back** layer and then click and drag its blue **Z**-axis to move it through **Z** space. You'll find you can drag it in front of, or behind the Front layer (Fig. 9.10).

3 When you've finished experimenting, change the **Back** layer **Z Position** value to −**100**; and make sure that the **Front** layer's **Z Position** value is **100**. This will place the layers exactly **200** pixels apart.

4 In the **3D View** menu, choose **Custom View 2** and then **Custom View 3** to see your scene from different angles (Fig. 9.11).

These three custom views are user-definable, in other words, you can set them up however you like. To do this you use the Camera tools.

Custom views

1 Click on the **3D View** menu and choose **Custom View 1**. Now it's clear to see what is happening, there is space between the layers. Notice that the **Back** layer is positioned in front of the **Front** layer (Fig. 9.9).

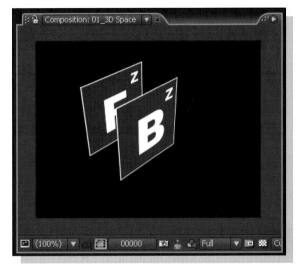

Fig. 9.9

Fig. 9.10

Fig. 9.11

Fig. 9.13

Camera tools

5 From the **Tools** panel select the **Orbit Camera** tool (C). Click and drag this around in the Comp panel to change the angle of your view (Fig. 9.12).

Fig. 9.12

6 There are two other camera tools available under the Orbit tool. **Click** and **hold** on the **Orbit Camera** tool in the **Tools** panel to see the other two camera tools (Fig. 9.13).

7 Select the **Track XY** Camera tool. This does exactly what it suggests, allows you to adjust your view on the X- and Y-axes, keeping the view parallel to the camera.

8 Click and drag around the **Comp** panel with it and get used to the way it works.

9 Finally, select the **Track Z** camera tool and then click and drag inside the **Comp** panel. This tool adjusts your view on the Z-axis, with it you can get closer to, or further from your scene.

You can cycle through the Camera tools by repeatedly hitting the **C** key on the keyboard. Each time you hit the key it will cycle through the camera tools. Play with this till you feel comfortable maneuvering the views around. Using this shortcut is the quickest way to utilize these tools to adjust your scene:
- **Orbit Camera tool** is used to rotate your view of the scene.
- **Track XY Camera tool** moves your view along the X- and Y-axes.
- **Track Z Camera tool** is used to move closer to, or further from your scene.

It is not essential to undo any of these steps as the changes you are making will have no effect on your final output. The Custom Views are different from the Active Camera view, they will not render, they are only there to help you to look around your scene from different perspectives.

However you can rest your Custom Views at any time. The Active Camera view is the view that will be rendered when you Export or Make Movie.

Resetting custom views

10 In the **Comp panel** make sure the **3D View** popup menu is set to one of your **Custom Views** and then go to **View** > **Reset 3D View**.

Orthogonal views

You can use the Camera tools to adjust your views when in any of the Custom Views. You can also use them in what are known as the Orthogonal Views.

11 Click on the **View menu** and choose **Switch 3D View** > **Top** from the menu. This will show you how your layers look from the top view. Notice that the layers have no depth but are represented by a gray line (Fig. 9.14).

There are six Orthogonal Views in this section of the **View** menu and also the 3D View Popup menu in the Comp panel – **Front, Left, Top, Back, Right,** and **Bottom**. These views are always perpendicular to the plane of projection. Allow me to explain what that means.

12 Try using the **Orbit Camera** tool on the **Top** view. You'll discover that you cannot adjust the angle of this view, it will always be fixed at this angle, so that you are seeing your view from directly above.

13 Select the **Track Z Camera** tool and, inside the Comp panel click and drag to the Left. Notice that you can use the Track Z camera tool to get closer to, or further from your scene.

Fig. 9.14

14 Hit the **C** key till you have the **Track XY Camera** tool selected and then drag inside the Comp panel again. You are able to move the scene on the X- and Y-axes (parallel to the After Effects camera).

15 Choose **Front** from the **View** > **Switch 3D View** menu. This view always shows you the view from the Front of your scene; again, this is a parallel view to the camera. This view is different from looking through the Active camera view as it allows you to view your scene without any perspective angles applied.

16 Switch off the **Solo** button for the **Back** layer and you'll notice that the **Front** layer is behind it, but without any perspective distortion. Let's compare the **Front** view and the **Active Camera** view to see the differences.

Multiple views

You can work with multiple viewers in the Comp panel to help you compare views or position things precisely.

17 In the **Comp** panel, click on the **Select View Layout** button and choose **2 Views – Horizontal** from the menu (Fig. 9.15).

Fig. 9.15

The view you were looking at is now on the right half of the panel. It's the active panel, you can see this represented by the little orange triangles in each corner of the active view. The 3D View Popup menu also identifies which view is active, Front in this case.

18 Click anywhere in the **Left** hand viewer of the panel to make it active, you should see the corners of the viewer highlighted in orange when it is active. Choose **Active Camera View** from the **3D View** menu. The view will change to show you the view through the active camera (Fig. 9.16).

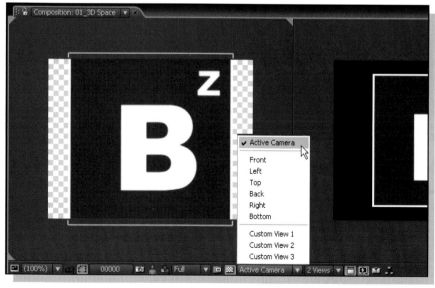

Fig. 9.16

19 Click on the **Right** hand viewer of the panel to select it. If its not already selected choose **Front** View from the **3D View** menu so that you can see different views through each of the viewers.

20 Switch on the **Back** layer's **Solo** button and then choose **Back** from the **3D View** menu. Now you can see your layers from the back, notice that the layer appears reversed.

21 One-by-one, look through all of the **Orthogonal Views**. In each view, try using the **Camera** tools; notice that you can use the Track XY and Track Z camera tools, but cannot use the Orbit Camera tool to adjust the angles of these views, their angles are fixed.

By using these tools in any of the Orthogonal or Custom views, you will not affect the position of your layers or the rendered Active Camera view, only your perspective of the scene will change. You cannot use these tools in Active Camera view until you create a new camera layer, when you do, using these tools will affect the active camera (which defaults to the camera layer's view once you create a camera). We'll look at that later when we start creating new camera layers.

F10 **F11** and **F12** are the keyboard shortcuts for toggling between 3D views. These default to being **Front, Custom View 1,** and **Active Camera** but can be customized.

22 In the **comp** viewer change the **3D view** menu to **Custom View 3** (Fig. 9.17).

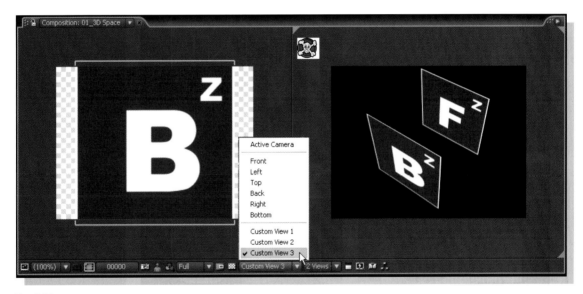

Fig. 9.17

23 Go to **View > Assign Shortcut to 'Custom View 3' > F10 (Replace 'Front')**

24 Use **F10** **F11** and **F12** to toggle through the three assigned views.

This will only work if no other applications have commandeered these shortcuts. Expose on Mac OSX uses these keys, as do some screen capture software applications. I advise customizing the shortcuts used in these applications so that the F keys are available for After Effects as these are very useful shortcuts that you don't want to be without.

25 You can also change the 3D view displayed in the active viewer by **context-clicking** on the **Comp panel** and going to **Switch 3D view** (Fig. 9.18).

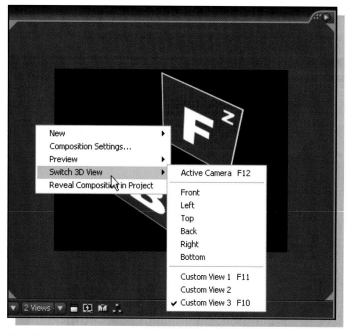

Fig. 9.18

2D and 3D layer order

A strange thing happens when you mix 2D and 3D layers in After Effects. The 2D layer's position in the Timeline is still important and determines where it will sit in relation to the 3D layers. After Effects treats the 3D part of the comp as a rendered layer which has its own place in the 2D stacking order.

1 If you do not already have the project open from the previous step, open **3D_02.aep** from the **Training > Projects > 11_3D** folder and close up the **Front** layer's Twirly in the Timeline.

2 Switch on the **Solo** button for the **Left** layer to add it to the **Front** and **Back** layers which are currently visible. You'll notice that it obscures the **Front** and **Back** layers and jumps to the front of the Composition (Fig. 9.19).

Fig. 9.19

3 Drag the **Left** layer down to the bottom of the **Timeline** and see how it jumps behind the 3D layers (Fig. 9.20).

Fig. 9.20

Because this layer is 2D it does not interact in the same 3D environment as the two 3D layers, it's position in the comp window is determined by the stacking order in the Timeline.

You can even drag a 2D layer between two 3D layers. When you do this you can break the render of the 3D layers. This can cause some unexpected problems, but it can also be used to our benefit as we'll see later in this chapter.

4 Drag the **Left** layer between the **Front** and **Back** layers (Fig. 9.21).

Fig. 9.21

The 2D layer now sits between the 3D layers, causing a break in the 3D render. Notice how the Back layer has disappeared behind the Left layer, even though it was nearest the camera.

5 Click on the **Left** layer's **3D switch**. See how it now jumps into the 3D space, no longer causing a break in the render, but instead becoming part of the 3D render (Fig. 9.22).

Fig. 9.22

6 Switch **off** all of the **Solo** buttons so that all the layers are visible.

7 **Select** all of the **layers** and then hit the ⓟ key to bring up their **Position** values. Notice that all the other layers have Position values of 160.120, the default Position value for a layer.

The default 2D Position value for a layer is half the dimensions of the layer. For example, if a layer has the dimensions; 320 × 240, its default 2D Position value will be X = 160, Y = 120.

3D layers have exactly the same default X and Y Position values but they also have a Z Position value which defaults to 0.

8 **Select** only the **Right, Top**, and **Bottom** layers, click on the **3D switch** for one of the selected layers to make them all 3D.

9 **Switch** off the **Video** switch for the **Back** layer (the bottom-most layer in the Timeline) so that you can clearly see all of the layers behind it.

Notice that the Right layer is foremost in the comp Window. When 3D layers have exactly the same position values as each other, they revert to using the Timeline stacking order to determine how they are placed in the Comp panel. As you switch the eyeballs on and off you'll see that they are placed in the same order that they appear in the Timeline panel.

10 Starting from the top of the Timeline, switch **off** the **Video** switches of your layers one-by-one so that you can see how they are positioned in the Comp panel.

11 Click and drag the **Left** layer up so that it becomes the top layer in the Timeline. See how it jumps to being the front-most layer in the Comp panel (Fig. 9.23).

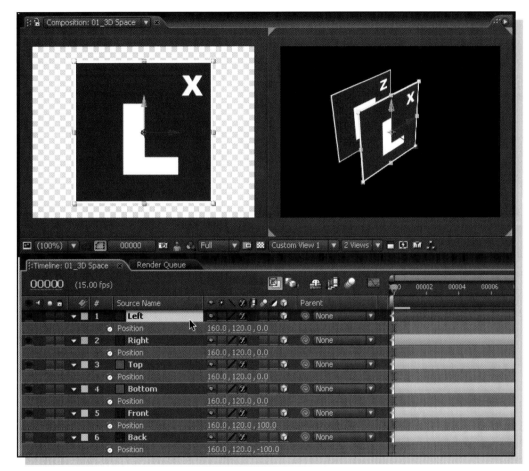

Fig. 9.23

Adjusting 3D rotation

OK, lets make a box with these layers. This is a good exercise to get you used to manipulating layers in 3D space as we will have to adjust the position and the Rotation of the layers.

12 Select the **Left** layer and then hit the **R** key to bring up the **Rotation** property. Notice that, when you do this you now have four properties to deal with – **Orientation, X Rotation, Y Rotation,** and **Z Rotation**.

13 Select the **Rotation** tool **W** from the **Tools** panel. When you do you'll see that a little menu appears on the right side of the docked **Tools** panel allowing you to choose whether you want to adjust Orientation or Rotation (Fig. 9.24).

Fig. 9.24

Orientation

The default behavior is to use **Orientation** as it produces the smoothest and most natural-looking animations; I have issues with this. Although the animations produced by animating Orientation are smooth, the Orientation property behaves in a completely different way to 2D Rotation and I think it leads to confusion for a lot of newcomers to 3D in After Effects. I'll show you what I mean by adding some animation to the Orientation property.

14 Click on the **Orientation** Stopwatch to set a keyframe at the beginning of the comp. Notice that Orientation requires only one keyframe for all of it's values – **X**, **Y**, and **Z**.

15 Move to the end of the Comp by hitting the **End** key on the keyboard.

16 Place the cursor over the blue **Z-axis** in the **Comp** panel and then drag to the left till the **Orientation** value reads **270** degrees on the Z-axis. Hold down *Shift* to constrain the rotation to increments of 45 degrees (Fig. 9.25).

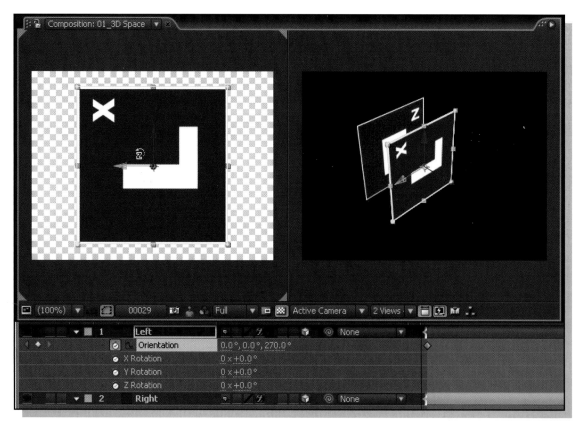

Fig. 9.25

> You can also use the Rotation tool on the layer handles to Rotate a layer in 3D space. Place the cursor over any of the corner handles to move on the Z-axis; over the Left or Right handles to move on the Y-axis; over the Top or Bottom handles to move on the X-axis (Fig. 9.26).

You can also click anywhere else on the layer to Rotate the layer freely. I don't advise doing this till you feel more confident working in 3D, so please resist for now!

17 **RAM Preview** the Comp and notice that the layer is actually moving counter-clockwise (or anti-clockwise to us Brits!), not what you would expect!

Orientation always looks for the shortest route between one angle and another, and it travels in that direction. This is the first big difference to be aware of between Orientation and Rotation.

Fig. 9.26

18 On the last keyframe scrub the **Z Orientation** value till it reaches **360** degrees. You'll see that it counts up to **359** and then snaps back to **0** (Fig. 9.27). Allow it to snap to **0** and then release the mouse.

Orientation does not count in revolutions, only in degrees. This means that you cannot spin layers round multiple times using Orientation.

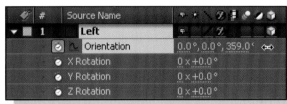

19 **Preview** the animation again and you'll see that the layer does not rotate at all between these two keyframes, even though we physically rotated it in the Comp panel.

Fig. 9.27

So, beware when rotating a layer using the Orientation value as you may end up with unexpected results. It's fine to use if you are simply adjusting the value but if you are animating between values just be aware of these possible pitfalls.

20 Hit the **Home** key to move back to the beginning of the Timeline and then click on the **Orientation** stopwatch to remove the keyframes.

Rotation

21 In the **Tools** panel, change the menu so that it says **Set Rotation for 3D layers** (Fig. 9.28).

22 At the beginning of the Timeline **click** on the **Z Rotation stopwatch** to set a keyframe.

The first thing to draw your attention to is the fact that **X, Y,** and **Z Rotation** are all individually keyframable properties. You must set keyframes for each axis you wish to animate.

Fig. 9.28

23 Move to the end of the comp and **rotate** the layer along its **Z**-axis in the **Comp** panel till the value reads **270** degrees (Fig. 9.29).

24 Preview the animation and see that the Rotation now moves in a clockwise direction, just as you would expect it to.

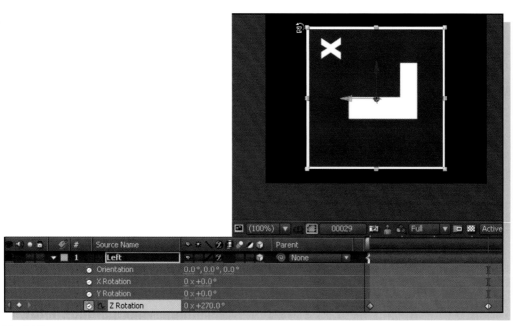

Fig. 9.29

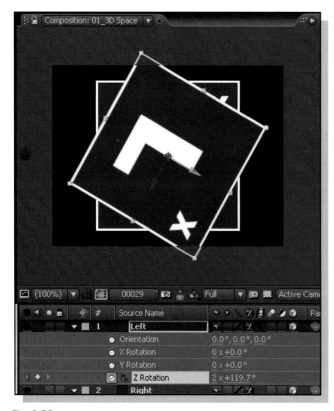

Fig. 9.30

25 With the Timemarker on the last keyframe, scrub the **Z Rotation** value beyond 360 degrees and you'll see that the layer will now count revolutions just like the rotation value does when working in 2D (Fig. 9.30).

26 Preview the results if necessary and then click on the **Z Rotation** property name to select both keyframes and hit *Delete* to return the value to the default value.

So, by all means, use **Orientation** if you simply want to re-position something or if you want to create a really smooth move from one angle to another. But I usually advise newcomers to use **Rotation** rather than **Orientation** to animate the layers as it tends to be a bit more intuitive. I also prefer to use the scrubbable values in the Timeline for adjusting values, rather than the Rotation tool from the Tools panel, this way you know exactly what's going on as you can see the values changing as you scrub. As we will not be animating our cube so we can adjust the Orientation value to get the angles we need.

27 Type **90** into the **Y Orientation** value (the second value of the three) (Fig. 9.31).

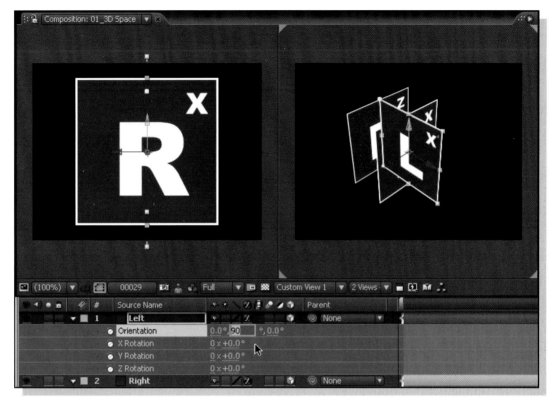

Fig. 9.31

3D render plug-ins

Depending on your Comp settings you may notice that the layers are not intersecting correctly in the Custom View, if this is the case it's because After Effects is using the Standard 3D Render plug-in which doesn't support intersections. I recommend using Advanced 3D or OpenGL for most situations. Standard 3D may speed up rendering for some comps but the trade off is not worth it. We'll talk more about OpenGL later in this chapter.

28 Hit ⌘ K ctrl K to open the **Composition Settings** dialog. Click on the **Advanced** Tab and choose **Advanced 3D** from the **Rendering Plug-in** menu if it's not already selected (Fig. 9.32).

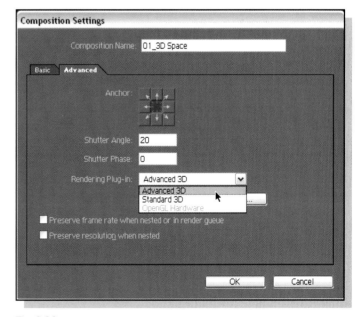

Fig. 9.32

Fig. 9.33

After Effects provides three options for the rendering of 3D elements: Advanced 3D, Standard 3D, and OpenGL. The 3D Rendering plug-in you select here will become the default for future comps.

29 Click **OK** to leave the dialog box. You should now see your layers intersecting correctly in the **Custom View** (Fig. 9.33).

30 Click on the right side of the **Comp** panel to make the **right view** active and then change the **3D View** menu to **Top** view. Use the **Camera tools** to adjust your view if necessary. Now we need to move our layer to form the left side of our cube (Fig. 9.34).

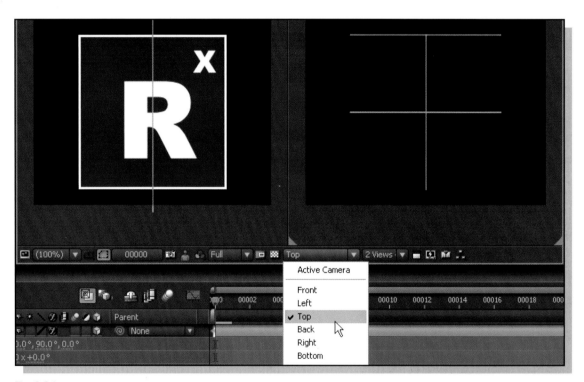

Fig. 9.34

31 In the Timeline select the **Left** layer and then hit **Shift** **P** so that you can see the **Position** property alongside the **Orientation** and **Rotation** properties.

32 Click on the **X position** value and then place the text insertion point after the current value of 160 and type in −**100**, then hit **Enter** on the number pad to change the value to **60**.

After Effects will subtract 100 pixels from the current value, making it 60. Because our box is exactly 200 pixels square it is easy to work out position values that are multiples of 100.

33 Select the **Right** layer in the Timeline and hit **R** followed by **Shift P** to open the **Position** and **Rotation** properties, change the **Y Orientation** value to −90.

34 For the **X Position** property, place the text insertion point after the current value of **160** and type **+100** and hit **Enter** on the number pad to move the layer 100 pixels to the right (Fig. 9.35).

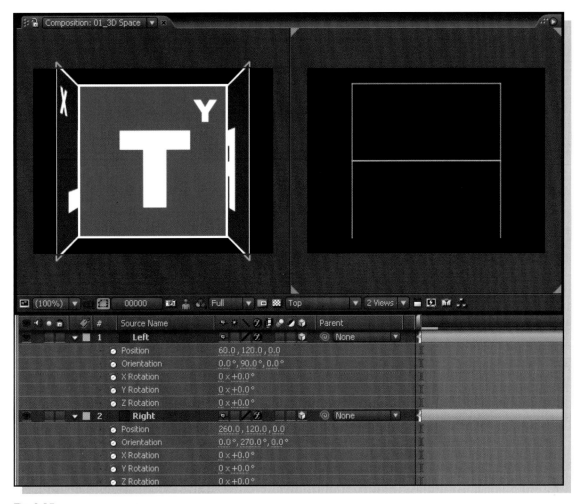

Fig. 9.35

35 Close all the layers and then select only the **Top** and **Bottom** layers and then hit **R** to bring up their **Orientation** and **Rotation** properties.

36 With both selected, type **−90** into either of the layers **X Orientation** value to change both values simultaneously. Notice that After Effects converts −90 to 270 degrees, another quirk of using Orientation! Orientation does not animate in negative values, it only has values between 0 and 360 degrees (Fig. 9.36).

Fig. 9.36

Axis modes

Just to confuse you a little bit more, there are different axis modes available when working in 3D! Seriously though, this is a big help in disguise! These three Axis Modes allow for very fine tuning in your animation when working in the different views.

37 Select the **Top** layer and hit **P** to open its Position value, and close any other layers.

Look at the **Top** layer's axes in the **Active Camera** view. Notice that the axes have rotated along with the layer. If it helps, you can temporarily toggle the **Front** Layer off and then on again to see this more clearly.

The blue **Z-axis** is now pointing up and down instead of going into and out from the screen.

The green **Y-axis** is pointing in and out as if it's controlling the Z-axis, instead of up and down.

In fact the only one that hasn't changed is the red **X-axis,** that's because we have rotated the layer on the X-axis so it remains true.

38 Select the Selection tool **V** from the tools panel and place the cursor over the blue **Z-axis** till you see the little **Z** and then drag the layer upward a little, as you do this, watch the Position values in the Timeline (Fig. 9.37a).

Fig. 9.37a

You are pulling on the **Z-axis** handle in the Comp panel, so why is it that the Y value is changing in the Timeline? It's to do with the orientation of these axes and how they behave when layers are manipulated.

Local axis mode

We are currently working in **Local Axis Mode,** which is the default Axis Mode for After Effects. This mode will fix the axes to the layer. So, wherever the layer moves, the axes will follow. Since we rotated the Top layer's Orientation, its 3D axes rotated with it. Local Axis Mode allows you to rotate around the central axes of your object (Fig. 9.37b).

Fig. 9.37b

There are two other axes modes, you can change the axis mode by clicking on the **Axis Mode** buttons in the Comp panel.

World axis mode

39 In the **Tools panel**, select the World Axis **Mode** button to make it active (Fig. 9.38).

Notice what happens to the axes on your layer when you do so, it changes so that the axes is fixed to the coordinates of the Composition or world. No matter how much you rotate your layer the axes will always be aligned to the edges of the Comp. World Axis Mode will allow you to rotate around the geometric center of your 3D scene.

Fig. 9.38

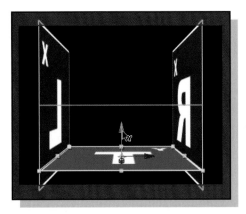

Fig. 9.39

40 **Click and drag** the green **Y-axis** and notice that the **Y Position** value is now changing in the Comp panel as you'd expect (Fig. 9.39).

View axis mode

This is the final axis mode, it can be a bit tricky to get your head round so beware! **View Axis mode** will align the axes to whatever view you are in. It allows you to rotate around the geometric center of your scene as it is currently being viewed.

41 Set up the **right** viewer in the **Comp** panel to **Custom View 1** and then use the **Camera** tools to set it up so that it looks like the one in (Fig. 9.40).

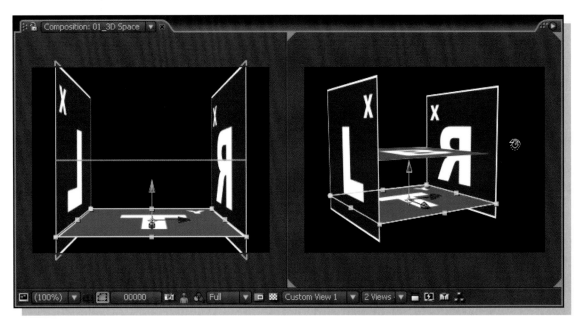

Fig. 9.40

42 Click on the **View Axis Mode** button and watch the axes change in **Custom View 1** viewer so that the green **Y-axis** is aligned to the **Y** coordinates of the Custom View.

43 Select the **Orbit Camera** tool and drag in the **Custom View 1** to change the angle of view. Watch in amazement as the axes remain true as the view is rotated (Fig. 9.41).

44 Choose the **Selection** tool from the **Tools panel** **V** and then drag up and down on the **Y**-axis.

In the Timeline notice that all three **X, Y,** and **Z** Position values change simultaneously. Because the Custom view is at a non-standard angle, the axes are not aligned along any one single axis but crosses all three.

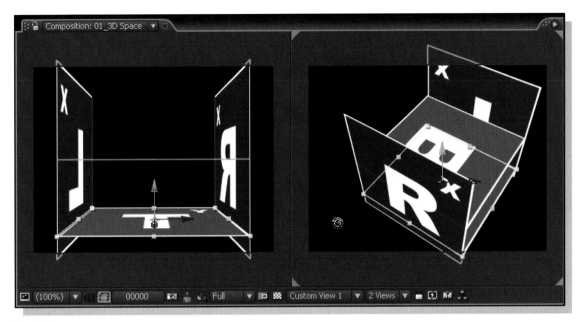

Fig. 9.41

The result is that all three change when it is manipulated in this view.

Although it is useful to use View Axis Mode in certain situations where a layer is required to be moved parallel to a particular view, I do not advise using it until you are comfortable with the other two.

I find that World Axis mode is the most logical because adjusting the X-axis always affects the X value, the Y-axis always affects the Y value, and the Z-axis always affects the Z value.

45 Reset the **Position** property of the **Top** layer by context-clicking the property's name and choosing **Reset** from the menu (Fig. 9.42).

46 Click on the **Y Position** value and then place the text insertion point after the current value. Type in **−100** and hit **Enter** on the number pad to move the layer up on the **Y-axis** by **100** pixels, giving it a **Y Position** value of **20**.

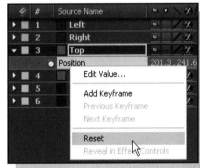

Fig. 9.42

47 Select the **Bottom** layer and hit p to bring up the **Position** value. Enter **+100** after the current **Y**-axis value and hit **Enter** to move it down the Y-axis by 100 pixels, giving you a final Y Position value of 220.

48 Switch all the other layers on again so that you can see the complete box. Use the **Camera Orbit** tool to look at the box from different angles in **Custom View 1** (Fig. 9.43).

Fig. 9.43

49 Save the project into your Work in Progress folder as **3D_02b.aep.** We'll come back to this comp later.

Camera basics

Although you can easily animate layers in 3D space it's often more practical to keep the layers stationary and, instead animate your view with an animated camera layer. Up till now we have been using the default After Effects Active camera which is fixed. In order to animate or change the properties of a camera you must first create a new custom camera layer.

1 If you do not already have the project open from the previous step, open **3D_03.aep** from the **Training > Projects > 11_3D** folder (Fig. 9.44).

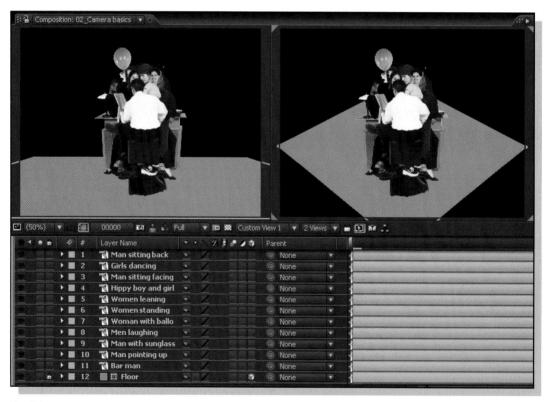

Fig. 9.44

2 In the **Project** panel, double-click the **02_Camera Basics** comp. You should have two views open, the **left** view displaying the **Active Camera View**, the **right** view showing **Custom View 1**.

In this composition we have eleven 2D layers and a single 3D guide layer representing the floor of the room we are about to create. We are going to create a nightclub scene with a camera moving through it to make it appear as if the viewer is walking into the nightclub. The floor layer will act as a guide for us to position our layers against in 3D space.

Guide layers

You can make guide layers from any layer in your comp to use as a guide for positioning elements in the Comp panel. They can also be used as guides for syncing audio, for referencing timecode, or for any other reason that you may need a non-rendering layer in your comp.

Guide layers are not rendered by default, but can be rendered by removing the guide layer status from the layer, or by changing the composition's (Guide Layers) render settings to **All On**.

The other layers in the comp are kindly donated by Able Stock, my favorite place for finding images for my projects. Go to the web site at http://www.ablestock.com to find out how you can subscribe. Basically, you either pay per image or you can pay a subscription for a specified period, during that time you download as many images as you can! It's a really great way to work.

3 **Click and drag** across the **3D** switches for all of the people layers (layers 1–11) to make them jump into 3D space. Notice in the **Custom** view that the layers all jump into the same 3D space as the Floor layer.

Depending on your computer specifications, you may notice a slow down in performance when these layers are made 3D. There are several options for previewing in After Effects, including OpenGL.

OpenGL

OpenGL is the preferred method of previewing for most situations, particularly when working in 3D. However not all features are supported by OpenGL. When a feature is not supported OpenGL will create a preview without the feature.

4 To enable OpenGL previewing go to Edit > Preferences > Previews (Windows) or After Effects > Preferences > **Previews (Mac OS)**.

5 Select **Enable OpenGL**, and then click **OK** (Fig. 9.45).

Clicking the **OpenGL Info** button here will open up a box that gives you information on your graphics card, specifying which features in After Effects are supported by the card. You can also increase the amount of memory assigned to After Effects in this dialog box if you have an OpenGL card with more than 128 MB of VRAM.

6 In the **Comp** panel, make sure that **OpenGL** is being used for previewing by clicking the **Fast Previews** button and then choose **OpenGL — Always On** (Fig. 9.46).

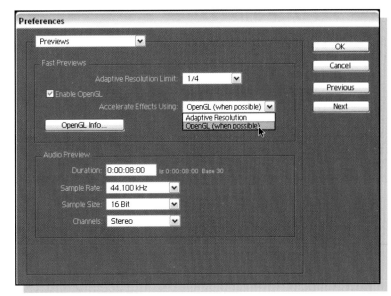

Fig. 9.45

Fig. 9.46

This will use OpenGL for all previews. In this mode **OpenGL** will be displayed in the top-left corner of the Comp panel as a reminder that OpenGL previewing is enabled. The little lightning bolt in the **Fast Previews** button will be permanently yellow showing that it is **Always On.**

The second option in this menu is **OpenGL – Interactive.** This will use OpenGL only for interactions, such as scrubbing in the Timeline or dragging layers in the Comp panel. With this selected, the little lightning bolt on the **Fast Previews** button will only be yellow during interactions where OpenGL is in use.

There is also a menu item named **Fast Previews Preferences** here that will take you directly to the **Previews Preferences.**

7 **RAM Preview** your comp and notice that the **Fast Previews** icon is lit yellow.

8 Go to **Layer > New > Camera** ⌘ ⌥ Shift C ctrl alt Shift C.

Camera settings

After Effects provides you with this rather daunting, but extremely useful dialog box which not only provides you with settings but an excellent graphical representation of the 3D camera and how the settings relate to each other. You can use this to learn a bit more about how the cameras actually work. You can even set up the cameras to match up with real world cameras by using the presets, or creating your own custom settings. This way you can match up your animations with footage shot on video or film.

Don't be afraid of the Camera Setting dialog box, understanding cameras can be a lifelong career for some people. Some knowledge of basic camera functions will definitely be useful if you are lucky enough to have it, but the basics are fairly simple to get to grips with. After Effects provides presets for all standard lenses from telephoto to wide angle.

Fig. 9.47

9 Choose the **50 mm** default camera from the list of **Presets** (Fig. 9.47).

10 Click **OK** to leave the **Camera Settings** box for now; we'll come back to it later.

A new camera will appear in the Composition panel. Cameras appear as layers in the Comp panel and can be adjusted and animated just like any other layer in After Effects. They also have some other properties that are unique to cameras. The default Active Camera (that the comp uses when you don't have a camera layer setup) uses the same camera settings as the 50 mm Preset. This is why nothing appears to have changed in the Comp panel.

11 Expand the Camera layer in the Timeline so that you can see its properties. Notice that as well as the **Transform** property group, there is also an **Options** property group. Expand them both so that you can see all of the properties inside the groups.

12 Select the **Camera** layer and notice, in **Custom View 1**, you can see a little box which represents your camera. This has three axes just like other 3D layers. You cannot see this in the Active camera view because it is showing you the view from the camera which does not include the camera itself (Fig. 9.48)!

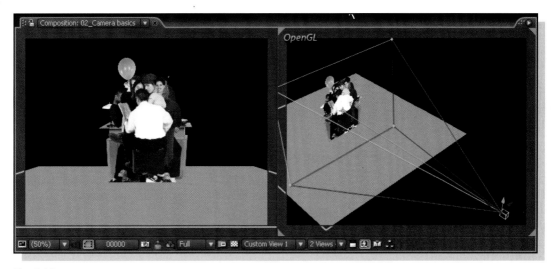

Fig. 9.48

You'll also notice a pyramid-shaped frame around the camera and the layer; this represents the camera's **Field of View**. If you create a camera using the Camera Presets and do not adjust the settings, this Field of View will extend exactly to the edges of the comp.

In the Timeline notice that the Transform properties for the camera are slightly different from those of a regular 3D layer. Instead of having an anchor point property we have a new property called Point of Interest (POI). You can think of this as a target that the camera always faces (Fig. 9.49).

The POI

The POI is represented by a little circle intersected by cross hairs which looks just like the Anchor Point of a

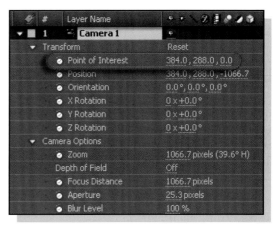

Fig. 9.49

regular layer; there is also a line extending from the camera to the POI. You can adjust the POI in the Comp panel or in the Timeline.

13 Click and drag the **POI** around in **Custom View 1**; notice what effect it is having on the image in the Active Camera view (Fig. 9.50).

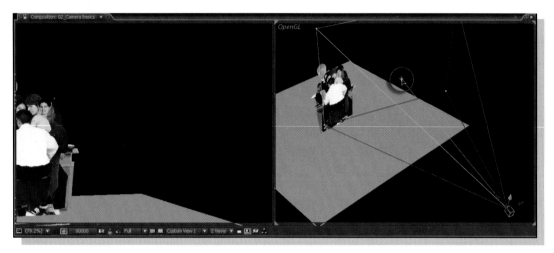

Fig. 9.50

The camera's default setting is to always pointing at the POI, therefore the POI will always be in the centre of the Comp when you create a new camera. You may have also noticed that it was quite hard to control the way that the POI moved.

Notice what's happening to the POI values in the Timeline. You'll probably see that all three values are being adjusted as you move it around the scene. If this proves difficult for you then you can scrub the values in the Timeline.

14 Experiment by **scrub**bing the **POI** values in the Timeline till you feel comfortable with what it's doing.

15 When you have finished experimenting **reset** the **POI** property by context-clicking on the property name and choosing **Reset** (Fig. 9.51).

Fig. 9.51

One of the easiest ways of animating a camera is to simply animate the POI value. If you want to create a simple pan around a 3D scene then this is a very easy way to do it.

There are a couple of 'gotchas' associated with using cameras and understanding how the POI works. The POI behaves differently depending on which method you choose to move the camera.

16 Make sure you are in **Local Axis mode** and then click and drag the blue **Z-axis** in **Custom View 1** toward the **POI**. Pay attention to the **Position** and **POI** values in the **Timeline** as you drag (Fig. 9.52).

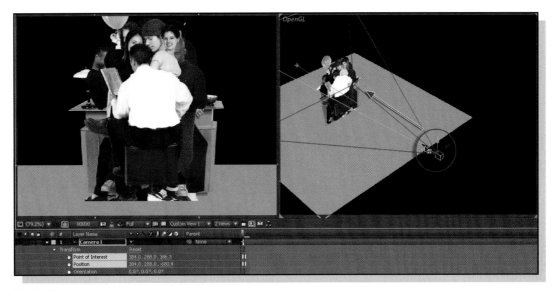

Fig. 9.52

You'll notice that the POI moves along with the camera. Now, I don't know about you, but I dislike this automatic behavior, I don't like to see values adjusting unless I ask them to. This behavior was introduced in After Effects version 6. The reason this was introduced was that some users found the POI difficult to work with, allow me to show you why.

17 Go to **Layer > Transform > Reset** to reset the Transform properties of the camera so that it is back in its default position.

18 Repeat the step 15 but, this time, hold down the ⌘ *ctrl* key as you click and drag the blue **Z-axis** toward the **POI** in **Custom View 1**, make sure not to drag the camera beyond the POI at this point.

 Scrubbing the Position value in the Timeline is another way of adjusting the Position property without affecting the POI property value. This is by far my preferred method as it is easy to see the values change as you scrub, plus there can be no confusion about exactly what property is being adjusted.

Notice this time that the **POI** values in the **Timeline** do not move and that the POI remains in place in the Comp window.

19 ⌘ *ctrl* – click and drag the blue **Z-axis** beyond the **POI** in **Custom View 1**. You will notice as you drag the camera past its own POI, that it flips around to face it. This is because camera layers default to **Auto-Orient toward the POI** (Fig. 9.53).

In the animation chapter we looked at how layers can Auto-Orient along their own motion path. Cameras can also Auto-Orient along motion paths, but the default behavior is for a camera to Auto-Orient toward its POI.

Fig. 9.53

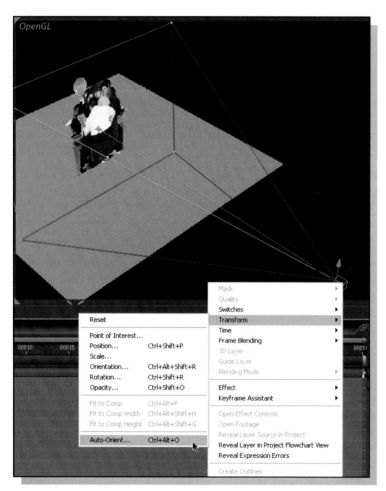

Although I sympathize with those who find the POI concept difficult, but I don't think automatically animating it was the right solution, but we have to work with it I'm afraid. But don't worry, there are alternatives!

20 Go to **Layer > Transform > Reset** again to reset the Transform properties of the camera so that it is back in its default position.

21 **Context-click** on the **camera** in **Custom View 1** and go to **Transform > Auto-Orient** ⌘⌥O ctrl alt O (Fig. 9.54).

22 In the **Auto-Orientation** dialog choose **Off**, doing this will turn off the POI completely. Notice in the Timeline that the POI property has disappeared and, in the Comp panel, the POI indicator has gone too (Fig. 9.55).

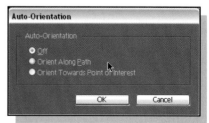

Fig. 9.54

Fig. 9.55

This is not my preferred way of working, but it will make it easier for you to understand the choices you have for animating cameras in After Effects.

3D Assistants

Before we animate our camera let's make this a bit more interesting by re-distributing our layers in 3D space. If you haven't already done so, please install the software in the **Free-Software** folder on the DVD as you will need the Digital Anarchy *3D Assistants* for the following exercise.

3D Assistants Pro are a set of keyframe assistants that take care of this problem. Digital Anarchy have kindly donated a lite version of two of their keyframe assistants free for the readers of this book. Find out about their other After Effects plug-ins at http://www.digitalanarchy.com

With *3D Assistants*, you can arrange, re-arrange, re-position, and re-arrange your layers in 3D space. If you don't like one configuration, change a few parameters and re-adjust the layers. Or hit undo to go back to your original layout. The *3D Assistants* work directly within the After Effects 3D environment, so there are no import issues or additional render time.

23 Close the **Camera** layer and then select the **Bar Man** layer and scrub his **Z Position value** till the value reaches approximately **485**. He should be positioned at the back on the view (Fig. 9.56).

24 Select all of the other **people** layers (except for the Bar Man).

25 Go to **Window > Cubic Distribution Lite.** This plug-in allows you to easily distribute your layers in 3D space (Fig. 9.57).

26 In the **Cubic Distribution** dialog change the **X** value to **768**, which is the width of our comp. Change the **Y** value to **1**, we don't want our layers distributed on the Y-axis. Leave the **Z** value at **1000**.

27 Click the **Apply** button to redistribute your layers within the constraints you have set. You can continue to click the Apply

Fig. 9.56

Fig. 9.57

417

Fig. 9.58

button to achieve different random results. You can also undo to get back to a previous state. Close the dialog when you have finished.

Fig. 9.59

28 Change the **Comp** panel's **Custom view** to **Front** view to check that your layers are not floating in mid-air. Adjust the **Y Position** value of any stray layers (Fig. 9.58).

29 Use the other views to check that your layers are distributed nicely. Fine tune them if necessary.

30 Close the comp by clicking on the **Close** button on the **02_Camera Basics** tab in the Timeline (Fig. 9.59).

Animating cameras

1 If you do not already have the project open from the previous step, open **3D_03.aep** from the **Training > Projects > 11_3D** folder.

2 In the **Project** panel, double-click the **03_Camera Animation** comp. You should have two views open, the **left** view displaying the **Active Camera View**, the **right** view showing **Custom View 1**.

3 In the **Timeline**, make sure that the Timemarker is a **0 and then** select the **Camera** layer and hit **P** to open up the **Position** property.

4 Click on the **Position** stopwatch to set an initial keyframe.

5 Move to the end of the **Timeline** and then, in **Custom View 1** drag the blue **Z-axis** so that the camera moves beyond all the 'people' and sits just in front of the bar man. A new keyframe will be created at the end (Fig. 9.60).

Fig. 9.60

6 RAM Preview the **Active Camera view** to see the camera travel through the people, always facing forward.

OK so we have a few problems, first of all the camera moves through people, that just doesn't happen in real life – it would move around the people. Plus, the camera is moving into the room at waist height which makes it seem as if it is a small child walking into the room. This is a nightclub so the viewer must be an adult!

Adjusting multiple keyframes
7 Move the **Timemarker** to the beginning of the **Timeline** so that it is parked on the first keyframe.

8 Change the custom view to **Left** view and use the **Camera** tools to adjust the view so that you can see your layers and the camera. Notice the Camera's motion path running between the two keyframes.

9 In the **Timeline**, click on the **Camera's Position** property name to select all its position keyframes.

With both keyframes selected, and the Timemarker parked on one of them, the property can be adjusted for the complete animation.

10 In the **Left** view use the **Selection** tool to click and drag the **Y-axis** up till the keyframes and the motion path are sitting at head height (the **Y** value should be at about **168**) (Fig. 9.61).

11 RAM Preview again to see the camera moving in at a higher level, it now look like an adult is walking into the bar rather than a small child!

12 Change the **Left** view to **Top** view and use the **Camera** tools to adjust the view so that you can see your layers and the camera.

Fig. 9.61

13 Adjust the motion path using the Bezier handles so that the camera moves around the people in the comp. If you can't find the Bezier handles, simply hold down ⌘ *ctrl* as you click and drag on the keyframes to pull out a new handle (Fig. 9.62).

Fig. 9.62

14 **RAM Preview** to see the results previewed in the Active Camera view.

You'll notice that the animation looks very strange because the camera is always facing forward, this would be a very unnatural way to walk into a room, normally your head would turn with your body.

15 Click on the view to the right of the **Comp** panel (currently **Top view**) to make it active and then click on the **Always Preview This View** button in the bottom-left of the Comp panel (Fig. 9.63).

16 Select the **camera** and then hit the **Spacebar** to preview the **Top** view, complete with the layer handles showing.

Auto-Orienting cameras

17 Context-click on the **Camera** layer in the **Timeline** and go to **Layer** > **Transform** > **Auto-Orient**.

18 In the **Auto-Orientation** dialog, choose Orient **Along Path** (Fig. 9.64).

19 Scrub through the Timeline to see both views update simultaneously. See how the camera now automatically turns to face the direction it is traveling along the path.

20 Click on the **Active Camera** on the left to make it active and then click on the **Always Preview This View** button in the bottom-left of the Comp panel.

Fig. 9.63

21 **RAM Preview** again and notice that this does not look much better.

Although your head will usually move along with your body, it can also move independently from your body. Imagine you are walking into a busy nightclub; you would either look around the club, from side to side, to check out the 'talent'; or you would focus on one thing as you walked in – the bar man holding your nice cold pint of beer! Well, those are the things I would tend to do anyway!

Fig. 9.64

Both of these things are possible if we use the POI to animate our camera, and this is why I think it is my favorite way of animating a camera. It can be tricky, but wait till you experience the level of control it provides you with.

22 In the **Timeline** select the **Camera** layer again and hit ⌘⎇O `ctrl` `alt` `O` to open up the **Auto-Orientation** dialog, **choose Orient Toward POI** and click **OK**.

23 In the **Comp panel**, adjust the custom view to display the **Top** view and click and drag the **POI** icon so that it is positioned on the **Bar Man** layer at the back (Fig. 9.65).

Fig. 9.65

24 Change the view to **Front** View and adjust the **POI** so that it is positioned on the pint of beer. You may need to switch off the other layers to see this more clearly. You may also prefer to adjust the POI by scrubbing the **POI** values in the Timeline (Fig. 9.66).

Fig. 9.66

25 **RAM Preview** and notice that there is an improvement to the movement.

There are two more problems, one is that the speed is not correct, it moves too fast. When I'm setting up 3D animation I often create the basic moves over a very short period of time, then I stretch out the duration afterward, it's simply a way of speeding up my workflow, the less frames to render, the quicker I can get my work finished.

Also, as the camera moves toward the layers at an angle it makes it very obvious that the layers are 2D. We need to adjust this so that the layers are always facing the camera straight on. Luckily 3D layers have an extra Auto-Orientation option which is to Auto-Orient toward the camera.

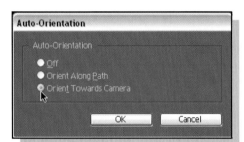

Fig. 9.67

26 Select the **Bar Man** layer in the Timeline and hit **⌘⌥O** **ctrl alt O** to open up the **Auto-Orientation** dialog, choose **Orient Toward Camera** and click **OK** (Fig. 9.67).

27 Change the custom view to Top view and then scrub the Timemarker along the Timeline to see how the **Bar Man** layer moves to always face the camera.

28 **RAM Preview** to see a much more convincing animation of the viewer moving in to the bar area, keeping an eye on that refreshing pint of beer as they progress! Later we'll light the scene but meanwhile let's take a look at some other camera techniques.

Orbital camera move

Creating an orbital camera move, where the camera always focuses on the object that it is orbiting is not the easiest thing to achieve if you attempt it by animating the position and/or orientation of the camera. In many situations it is easier to control the movement of cameras and lights with null layers.

1 Open **3D_04.aep** from the **Training > Projects > 11_3D** folder.

2 In the **Project** panel, double-click the **01_3D Space** comp. You should have two views open, the **left** view displaying the **Active Camera View**, the **right** view showing **Custom View 1**.

Pre-comping 3D layers

3D layers can be pre-composed in just the same way as they can be in 2D. There are a couple of gotchas to be beware of and there are a couple of neat tricks that you can use when pre-composing 3D layers.

3 Select all Ca La of the layers in the Timeline and then go to **Layer** > **Pre-compose** (Fig. 9.68).

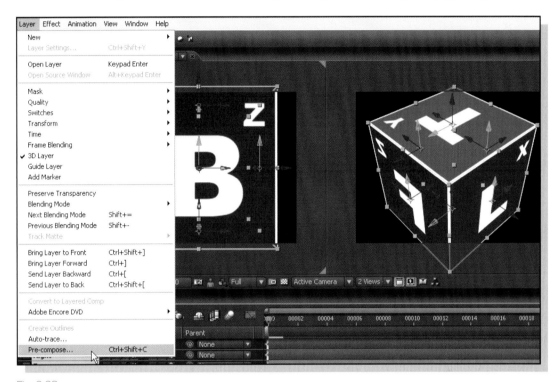

Fig. 9.68

4 In the **Pre-compose Options** dialog **name** the new composition **Box Comp** and choose **Move All Attributes into the New Composition** (Fig. 9.69).

5 In the Timeline switch on the Box Comp layer's 3D **switch** and watch as it jumps into 3D space as a flat 2D layer! In order to retain the 3D geometry from the original layers we must Collapse Transformations.

6 In the Timeline click the **Collapse Transformations** switch for the **Box Comp** layer. The 3D-ness comes back so that we have the geometry from the nested comp within the current comp (Fig. 9.70).

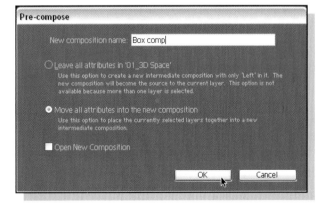

Fig. 9.69

One of the nicest things about After Effect's 3D environment is the way that collapsing a nested composition works. When you collapse a nested composition that contains 3D elements, those

Fig. 9.70

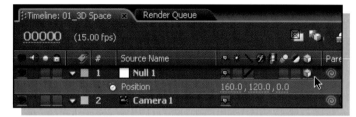

Fig. 9.71

Fig. 9.72

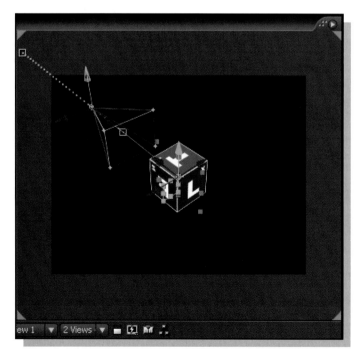

Fig. 9.73

elements will retain their 3D geometry in the new composition. This means that you can set up complex 3D scenes in one composition before combining them together in another and flying a camera through them, all still in glorious 3D.

7 Hit **⌘ ⌥ Shift C** **ctrl alt Shift C** to create a **new camera** layer. Choose the default **50 mm** camera again.

8 Hit **⌘ ⌥ Shift Y** **ctrl alt Shift Y** to create a **new null**.

9 Make the **Null** 3D by clicking on its **3D switch** in the Timeline.

10 Notice that the **Position** values of the **Null** and the Box comp layers are identical. The **Camera's POI** also has the same value (Fig. 9.71).

11 Drag the **Parent** pickwhip from the **Camera** layer to the **Null** layer to make the null the parent for the Camera (Fig. 9.72).

12 Open the **Y Rotation** value for the **Null** layer and set a keyframe at the beginning of the Timeline.

13 While you're there, set a keyframe at the beginning for the **Camera** layers **Position** value and change it to −2000 on the **Z-axis**.

14 Move to the end of the Timeline, change the **null** layer's **Y Rotation** value to **1** revolution and change the **Camera Z Position** value to −500.

15 Make sure you can see **Custom view 1** and adjust your view so that you can see the camera and null layers clearly.

16 With the **Custom view 1** still active, click on the **Always Preview this View** button in the Comp panel.

17 **Select all** layers and hit the **Spacebar** to preview your camera orbiting around the box (Fig. 9.73).

Lighting basics

One of the coolest things that After Effects 3D can do is 3D lighting. The rules for 3D lighting are similar across all areas of 3D, so a brief explanation of these rules will help you understand the principles involved.

Light types

Ambient

Ambient light is a soft, even, overall scene lighting with little or no shadow-casting power of its own. It is also sometimes known as scene lighting, diffuse lighting, or default lighting. This light type is useful for brightening a scene without adding shadows or hotspots, but is not very atmospheric. Ambient lighting has no real equivalent in the natural world, unlike the other three types of light commonly used in 3D space.

Parallel

Parallel light is a shadow-casting light, emerging from one direction only. Imagine an infinitely tall and wide plane, emitting light at a 90-degree angle to its surface. Parallel light is also commonly referred to as directional light. This light type is useful for broad illumination from a single angle with shadows cast, for a gentle or strong wash of light across a scene with no spread, and for a soft fill of light for a dark corner. Parallel light can be found in the real world, during what photographers and cinematographers call 'the magic hour', the half-hour after sunrise and before sunset, when the sun is close to the horizon and its rays are nearly parallel to the earth. It can be found in the movie and photographer's studio, and in cities and stadiums, as a giant wall of light bulbs. The photographer's flashbulb also has the effect of a parallel light if sufficiently powerful.

Parallel

Point

Point light is a light evenly emitted from a single point of origin. It is a soft, shadow-casting light that illuminates only what is in its path. It is easy to use, as the light casts shadows, but has no hard edges itself. It is useful for all lighting setups, providing an even illumination in an area whose size is determined by the distance the point light is from its subject. The sun is the ultimate point light, casting evenly in all directions unless something blocks its way. Our human adaptation of the point light is the incandescent light bulb.

Point

Spot

A spotlight is, well, a spotlight. A light focused by a cone, the closer it is to the surface it is illuminating, the smaller and more intense the light becomes. This is the most dramatic, and possibly the most versatile of the light types, as the parameters are so varied for its use. The spotlight cone can be adjusted for

Spot

angle and softness as well as brightness, shadow, and color attributes. Spotlights are a dramatic and often over-used light type, so be sure you need the spotlight instead of automatically reaching for it every time.

Lighting a scene

When lighting a scene, the use of multiple lights allows for greater flexibility and control in the look of the scene. Individual light attributes can be keyframed, just by opening the light layer as you would any other layer and adjusting the attributes. We will explore three different lighting setups, just to get you started.

Light options panel

We'll start off with a neutral, classic three-point setup, useful in lots of situations. Next on our list will be a dark, mysterious film-noir type setup, great for arty shots and for creating suspense. Finally we'll go for a camp, and exciting, party atmosphere in our nightclub scene, complete with disco lights!

Lighting scheme one – basic

First, you will set the key light, the brightest and usually warmest light in the scene. This light also indicates the light direction or source, this is vitally important to remember when continuity between scenes is a consideration.

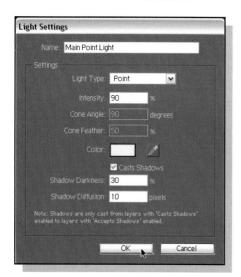

Fig. 9.74

1 If you do not already have the project open from the previous step, **open 3D_04.aep** from the **Training > Projects > 11_3D** folder.

2 In the Project panel **double-click** the **04_Basic Lighting** comp to open it.

3 Go to **Layer > New > Light**. In the **Light Options panel** choose the following settings:
- **name:** main point light;
- **light type:** point light;
- **intensity:** 90%;
- **Color:** pale, buttery yellow (Fig. 9.74).

4 Turn on the **Cast Shadows** option, set **Shadow Darkness** to **30%**, and set **Shadow Diffusion** to **10** pixels. Click **OK** to create your light. The layers now have a nice depth to them, coming from the shadows cast by the light.

5 In the **Timeline**, switch off the **Live Update** button, doing this will speed up your previews while changes are being made (Fig. 9.75).

Fig. 9.75

With this button enabled After Effects will use a wireframe to represent your layer when you are making changes to it, only refreshing the display with the fully rendered layer once your interactions are complete.

6 In the **Comp** panel, select the **Point Light** icon and then use the **axis** arrows to move it to the upper left of the **Active Camera** scene, exactly the same as moving a 3D layer. Remember you can use the multiple views to help you (Fig. 9.76).

Fig. 9.76

Next, we'll set the fill light, the subordinate light that softens harsh shadows and fills out the chromatic range of the lighting scheme. This light is usually cooler than the key light, and often is used to give a clue as to the color of the general environment of the scene being lit.

7 Create another new light by hitting ⌘ ⌥ *Shift* **L** *ctrl* *alt* *Shift* **L**. In the **Light Options** panel set:
- **name:** subordinate point light;
- **light type:** point light;
- **intensity:** 30%;
- **color:** cool, pale violet;
- **shadow darkness** to 20%;
- **shadow diffusion** to 5 pixels;
- CLick **OK** to create the new light.

8 In the **Comp** panel, using the axes, pull the new Point Light icon to the lower right of the scene in the Left view. Notice how the addition of this light really improves the scene, making it look more natural and balancing the color (Fig. 9.77).

Fig. 9.77

Finally, you will make a bounce light, to simulate the reflection from the photographer's scrim. A scrim is a reflective sheet used to add a general wash of light to the scene, providing that little bit of extra sparkle and illumination. In this case, you will use a neutral, cool tone to mimic the look of daylight lighting.

9 Make a new light and in the light settings dialog set:
- **light name:** bounce light;
- **light type:** parallel;
- **color:** cool pale blue-gray;
- **intensity:** 30%;
- **cast shadows: off.**

It's a good idea to get into the habit of naming your lights so that you can easily see what job they're doing by looking at them in the Timeline.

In the Comp panel you will notice that this light has a slightly different icon to the others, it has a POI attached to it just like the camera layer had in the camera setup. This is because it is a directional light. The POI is like the target for the light, wherever it lies is the place that the light will point toward.

10 ⌘ *ctrl* – click on the X- and the Y-axes to move the light to the bottom-left of the Active Camera View (Fig. 9.78).

If we had moved the light without simultaneously holding down the ⌘ *ctrl* modifier key, the POI would have moved along with the light. Holding the modifier key while dragging allows you to move the light while maintaining the current position of the POI.

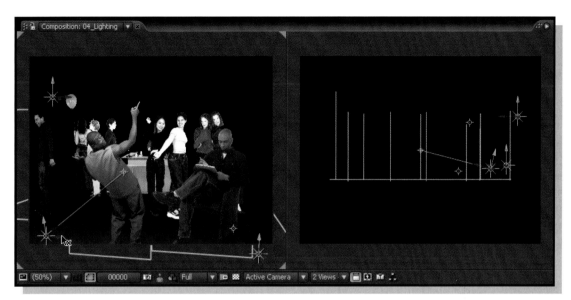

Fig. 9.78

Draft 3D mode

You may find that things start to slow down when adding lots of additional lights. If this is the case you can switch to Draft 3D mode while positioning elements. Be aware although that Draft 3D mode will disable all lights and shadows as well as the camera's depth-of-field blur (Fig. 9.79).

Fig. 9.79

Casting shadows

You may have noticed that, despite the fact that we set the layers to cast shadows there are no shadows being cast from the characters. As well as choosing the lights that will cast shadows, you also need to select which layers will cast shadows.

Material attributes

There is an additional property group in the Timeline for 3D layers called Material options. These can be used to change the way 3D layers and lights interact with each other.

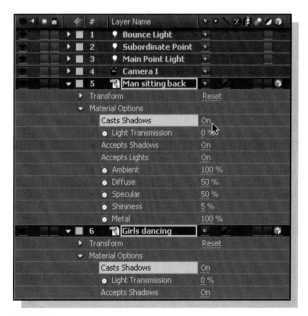

11 Select all of character layers except for the Bar Man layer and then double-hit the a key on the keyboard in a very quick succession to open the **Material Attributes** for all selected layers.

12 In the Materials Options property group you will see a **Casts Shadows** option which is currently set to Off. Click once on this to switch the option to **On** (Fig. 9.80).

Fig. 9.80

You should now see some shadows being cast from the characters onto the floor.

Lighting scheme two – stained glass

In this exercise, we'll make a screen for our light to shine through, casting mysterious 'venetian blind'-type shadows on your scene. This technique is adapted from theatre and film lighting, where the lighting technician will use a cut-out of a shadow-casting object off-stage to cast shadow onto the stage set. It's very common to use silhouettes of tree branches, for example, to give the set an outdoors feeling.

1 If you do not already have the project open from the previous step, open **3D_04.aep** from the **Training > Projects > 11_3D** folder.

2 In the **Project** panel **double-click** the **05_Shadow Lighting** comp to open it.

This is exactly the same as the comp we started with in the first lighting setup, with the addition of a stained glass layer at the back of the scene and a light positioned behind it which we will switch on shortly. The stained glass image is courtesy of AbleStock at http://www.ablestock.com

3 Switch on the **Spotlight** layer at the top of the Timeline. Notice that we have very harsh shadows being cast from the characters onto the floor (Fig. 9.81).

Fig. 9.81

Let's start by adding an Ambient Light to soften our scene. It's a common mistake for people who are new to 3D to simply start adding loads of spotlights as these are the lights that are probably the easiest for us to relate to because they are directional and they cast shadows.

There is nearly always some Ambient Light in a scene, even in a darkened room. So it makes sense to give the scene an overall natural light before adding spots.

4 Hit `⌘` `⌥` `Shift` `L` `ctrl` `alt` `Shift` `L` to add a new light to the scene. In the Light Options dialog set the following:

- **light type:** ambient;
- **name:** ambience;
- **intensity: 20%;**
- **color:** very pale orange.

Ambient Lights cannot cast shadows so this option will not be available to you.

5 Click **OK** to create the new light.

6 Select the **Stained Glass** layer and then **double-hit** the **a** key to open up its **Material Options**. Switch **on** the **Cast Shadows** option and notice that the shadow is obliterating the other layers.

7 Under the **Cast Shadows** option you will see a **light Transmission** value.

This allows the light to pass through your layer picking up color as it travels. You can use this feature to create the effect of using lighting Gels.

8 Change the **light Transmission** value to **100%** to allow color from the stained glass layer to influence the shadow color (Fig. 9.82).

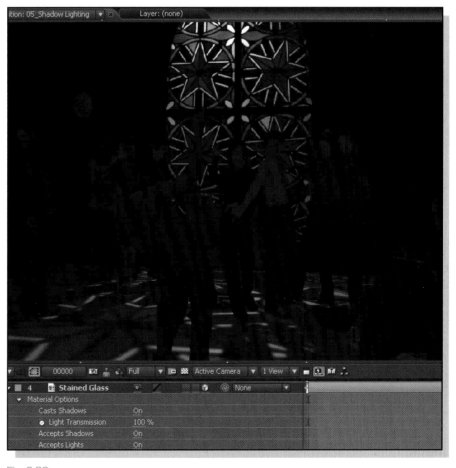

Fig. 9.82

Remember we looked at Animation Presets in the previous two chapters? Well I like using Animation Presets to save my custom camera and lighting setups, let me show you how. First of all please check that you have copied the **Angie Taylor presets** folder to your hard drive, if you haven't done so, please follow the instructions in the Before you Start section of the Introduction.

9 In the **Effect & Presets** panel, open the **Animation Presets > Angie Taylor presets** folder and from there, drag the **NightclubLight** preset into the **Comp** panel, making sure to drop it onto an empty space, not onto an existing layer. Alternatively, you can drop the preset into the Timeline to avoid accidentally selecting a layer in the Comp panel. A new Parallel light will be added to your scene (Fig. 9.83).

Fig. 9.83

There may be times when you want to use a layer as a Gel but do not want the layer to be visible in the Comp panel. In cases like these you can switch the Cast Shadows option to only cast the shadow, making the source layer invisible.

More material options
10 Select the **Stained Glass** layer and **double-hit** the **a** key to open the **Material Options**. **Switch** the **Cast Shadows** switch **only** to see the **Stained Glass** window disappear from the scene but its shadow remaining. Switch the shadow back on by toggling the switch till the **on** option returns.

You can also make adjustments to the material options of the layers that the lights and shadows are being cast onto.

11 Go to **Help > After Effects Help** and in the contents tab, go to **3D Layers > Cameras, Lights and Points of Interest > Material Options properties** to look at the options available before

proceeding with the next step. The Help file shows you very clear examples showing how these properties can affect your layers (Fig. 9.84).

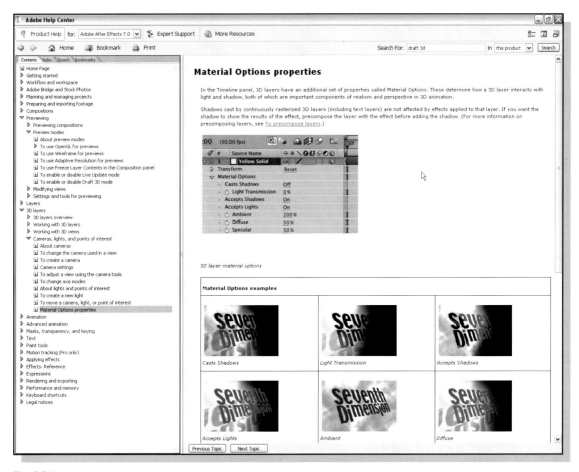

Fig. 9.84

12 In the Timeline select the **Floor** layer and **double-hit** the a key to open the layer's **Material Options**.

13 Reduce the **Ambient** amount to **50%**, this will have the effects of reducing the amount of Ambient Light the layer reflects. Change the **Diffuse** amount to **30%** (Fig. 9.85).

Lighting scheme three – disco lights

1 If you do not already have the project open from the previous step, **open 3D_04.aep** from the **Training > Projects > 11_3D** folder.

2 In the **Project** panel **double-click** the **06_Disco Lighting** comp to open it.

Fig. 9.85

First of all we will make a room for our characters to exist in. We'll use the replace layer modifier key to replace the floor layer in the Timeline.

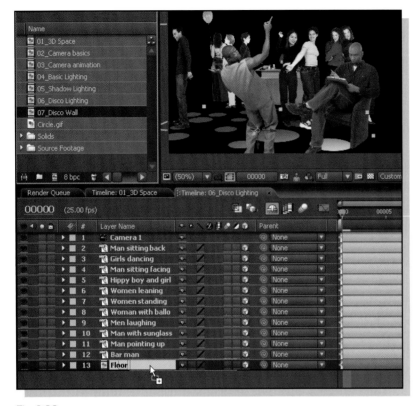

Fig. 9.86

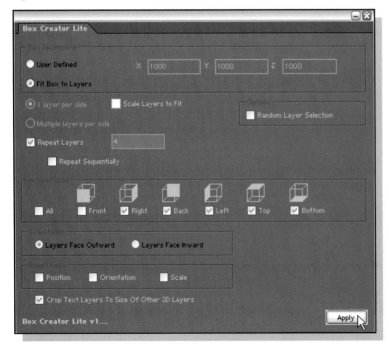

Fig. 9.87

3 Select the **Floor** layer in the **Timeline** and then ⬚ **alt** – click and drag the **Disco Wall** composition from the **Project** panel onto the **Floor** layer in Timeline (Fig. 9.86).

4 **RAM Preview** and you'll see that this layer is animating, giving us a nice moving floor for our disco. Now we'll build a box from this layer.

5 Go to **Window > Box Creator Lite** (Fig. 9.87).

6 In the **Box Creator Lite** dialog, select **Fit Box to Layers**. Change the **Repeat Layers** setting to **4** (this will give us a total of five layers, enough to create an open box). In the **Active Faces** section, de-select **All** and then select **Right, Back, Left, Top, Bottom**. Click **Apply** and then close the dialog box.

When working in 3D it's usually easier to work with square pixel comps and layers. The reason is that everything will then be truly square as you would expect it. For example, if you make a layer that is 100 × 100 pixels in a square comp it will be truly square; if you make the same layer with non-square pixels it will not be perfectly square. Therefore if you try to make a cube out of non-square pixel layers of 100 × 100 pixels, you'll find the edges don't quite meet as they are not true squares but are in fact rectangles!

7 Select all of the Floor layers in the Timeline and then go to **Layer > Pre-compose**. We

will pre-compose the layers together in the same way as we did earlier to create a room for our characters.

8 In the **Pre-compose Options** dialog choose **Move All Attributes into New Composition** (Fig. 9.88).

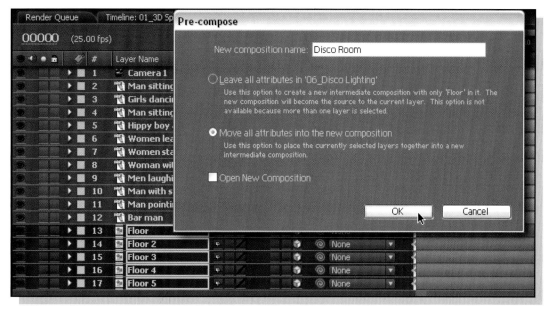

Fig. 9.88

The layers are nested into a single comp just as they are when working 2D, but you may have noticed that the lighting of the comp has changed. This is because of two things: the new composition that has taken the place of the layers is a 2D layer, therefore it will not react to the lights within this comp. And the lights were not nested into the same comp as the layers, therefore they have no effect on the layers in the comp.

Fig. 9.89

9 Switch on the **Disco Room** layer's **3D switch** and watch as it jumps into the same 3D space as the other layers but as a flat 2D layer! In order to retain the 3D geometry from the original layers we must Collapse Transformations (Fig. 9.89).

10 In the Timeline click the **Collapse Transformations** switch for the **Disco Room** layer. The 3D-ness comes back so that we have the geometry from the nested comp within the current comp (Fig. 9.90).

Something to bear in mind is the fact that when you collapse a layer

Fig. 9.90

435

7

in this way, any cameras or lights contained in the nested composition are ignored, instead the cameras and lights that are contained in the current composition are used to move through and illuminate the 3D scene.

11 Adjust the **Disco Room** layer Y Position value till the Floor meets the feet of the characters (Fig. 9.91).

Fig. 9.91

I want to create spinning multi-colored disco lights in this comp but we are already experiencing slow render times due to the complexity of the scene. Instead of adding several spotlights to our scene, I'll show you a way of achieving a disco light effect without the rendering time!

12 **Switch on** the two lights that I have already added to the comp. The first light is an Ambient Light named **Ambience**, this gives us an overall warm Ambient Light and does not casts shadows onto the scene (so therefore does not take too long to render).

The second light is named **Shadow Light,** it is a parallel light. I chose this light type because it is the quickest-rendering of all the shadow-casting lights as shadows have no diffusion. This light is here purely for creating the shadows needed to give the comp depth.

Rather than set up a complicated lighting setup in this comp, where we will have to wait for all of the 3D layers to update, we can create a separate comp for the sole purpose of setting up our lighting rig!

13 Create a **New Composition** ⌘C ctrl C. Make it the same size as the current one; name it **Disco Lights comp**.

14 Hit ⌘Y ctrl Y to create a **New Solid** layer. Click on the **Make Comp Size** button; choose a mid-gray color and then click OK (Fig. 9.92).

15 Make the layer 3D by clicking on its **3D** switch in the Timeline.

16 Hit ⌘ ⌥ *Shift* **L** *ctrl* *alt* *Shift* **L** to create a **New Light**. Use the settings illustrated in (Fig. 9.93).

Fig. 9.92

Fig. 9.93

17 **Duplicate** the **Pink Light** layer by selecting it in the Timeline and hitting ⌘ **D** *ctrl* **D**.

18 **Double-click** the **Pink Light 2** layer to open up the **Light Options**. Change the **Color** to **bright green** and change the **Name** to **Green Light**.

19 **Select both light layers** and hit ⌘ **D** *ctrl* **D** to duplicate them.

20 With the **two** new light **layers selected, double-hit** the **a** key to open up their **Material Options**. Change the **colors** to **Orange** and **Blue,** respectively and **rename** them appropriately (Fig. 9.94).

21 **Select** all **four light layers** and hit the **R** key to open up their **rotation** properties.

22 Change the **Y Orientation** of each of them so that they are set at **0, 180, −90,** and **90,** respectively (Fig. 9.95).

Fig. 9.94

Fig. 9.95

23 **Select three** of the **lights** and then **drag** the **Parenting pickwhip** over to the remaining light, this will make it the parent to all the other lights, meaning that all the other lights will follow this one (Fig. 9.96).

Fig. 9.96

24 **Select** the **parent** light and set a **keyframe** at the beginning of the Timeline for the **Y rotation** value.

25 Jump to the **End** of the **Timeline** and change the **Y rotation** value to **3 revolutions.**

26 **RAM Preview** to see the spinning disco lights.

Now, we could copy and paste these lights into the Disco lighting comp but

it would take a very long time to render. Instead we will drag the whole comp into the Disco Lighting comp as a 2D layer.

27 In the **Timeline** click on the **06_Disco Lighting** tab to make it the active comp, then, from the **Project** panel **drag** the new **Disco Lights comp** that you have just created into the **Timeline** (Fig. 9.97).

28 Change the **Blending mode** of the **Disco Lights comp** layer to **Hard Light** and change the **Opacity** to **70%** to composite the 2D **Disco Lights comp** layer onto the 3D layers.

Fig. 9.97

Depth of field

Finally, let's take a look at how we can use depth of field to give our comp the finishing touches, it is used to create realistic camera-focus. Depth of field is basically the range of focus of the camera. This range can be adjusted manually by you, it can even be animated over time. Anything within the range of focus will be in focus, anything outside the range will be blurry. It will become increasingly blurred the further it is from the focus range.

The default setting for cameras is to have depth of field switched off.

1 In the **Timeline**, switch off all three light layers so that you can see the characters in your comp more clearly.

2 Select the **Camera** layer and **double-hit** the a key to open up its **Camera Options**.

3 Switch **Depth of Field** to **On**.

4 Change the **Aperture** value to **70**. The aperture determines the size of opening of the lens. With a higher setting things are in focus across a deeper distance.

5 Notice in the **Active Camera View** that the dancing girls are the most in-focus of all the layers, if you look at the **Top** view you can see that this is the layer at the end of the field of view (Fig. 9.98).

Fig. 9.98

6 Change the **Focus Distance** to **750**. Notice in the **Active Camera** view that the girls go out of focus and, in the **Top** view, that the **Focus Distance** is represented by another plane within the field of view (Fig. 9.99).

Fig. 9.99

7 Click on the **Focus Distance** stopwatch to set a keyframe at the beginning of the Timeline.

8 Move to the end of the **Timeline** and change the **Focus Distance** value to **220** so that the focus tightens on the **Bar man** with the pint! (Fig. 9.100).

Fig. 9.100

9 Once you've seen the results of the depth of field, change the Aperture value to 30, switch on the light layers and then **RAM Preview** the comp in all its glory!

So, this is a fairly simple little comp, designed to demonstrate the principles of working in 3D. You can now take these principals and apply them to your own work.

There are a couple of other tutorials on the DVD including one showing you how to create a 3D city landscape in After Effects. You can find these in the Extras folder.

Recap

In this chapter you've learnt all about how to control and work with all aspects of 3D in After Effects. Hopefully now you will feel comfortable working in the 3D workspace and navigating using the 3D views, Camera tool, and Axis modes.

You've also learnt how important 2D and 3D layer order is, and how this odd mix of dimensions can be used creatively.

We looked at OpenGL and the different 3D render plug-ins available as well as *3D Assistants* from Digital Anarchy, a third-party plug-in. There are more tutorials using third-party plug-ins in the Extras folder on the DVD.

You've had experience doing various different types of lighting and camera setups including classic push in and rack focus camera setups, plus you learned how to create gels and stencils for your lights. If you want to learn more there are some bonus 3D tutorials on the DVD in the Extras folder.

Inspiration – Rachel Max

Rachel Max is a freelance broadcast designer and animator in NYC. She also writes and directs short-animated films, which she has been screening in film festivals since 1999. Her clients include MTVN, MTV Animation, Sesame Workshop, PBS, GEICO, Bright Eyes, BAM, and Pfizer. Max is originally Irish, born and raised in Dublin, but has considered herself fully assimilated to American culture since watching 'Pee-Wee's Big Adventure' on video in 1997.

RachelMax

Q How did your life lead you to the career/job you are now doing?

A I went to film school, and even that was sort of an accident as I had chosen the college originally for its Physical Therapy Program. I didn't realize I could study film and it sounded great – it was great – hard but great.

I took a computer animation class right before I graduated and oddly that class had more of an effect on my life than any other class in college. We learned to animate using early frame-by-frame software but after all I went through in film school with actors and securing locations, and getting insurance it was so refreshing to just be able to sit down at a computer and make something myself.

When I graduated I bought a G3 and all the software I could afford and made short-animated films in my parent's basement. I figured that was better than running around getting coffee for people on set in LA. It took a while but I managed to get a job doing animation and some light broadcast design for a well-known corporation. Once I was in the post-production environment I was able to learn more and finally was able to move to New York and become a freelance Animator and Broadcast Designer.

Q What drives you to be creative?

A I like making things, feeling productive, and speaking with my own voice when possible.

Q What would you be doing if not your current job?

A Physical Therapy or Producing of some kind I suppose or programming. I don't know.

Q Do you have any hobbies/interests and if so, how do you find time for them?

A I have always loved to watch comedy and this year I decided to get more into it. I did my first stand-up show this year and have been taking Improv classes. Going to class gets me away from my computer and interacting with people. Also, hopefully Improv is making me think faster on my feet. I also like the idea of being anyone anywhere and getting out of my head. I make class a priority – like some people make exercise a priority …

I'd like to learn to play the guitar and I'd love to sing in a band. A girl band. I have no idea how to go about doing that though.

Angie I'd like to do that too Rachel, let's start a band!

Rachel I love to travel. Getting away is hard but I've been to many film festivals because that's a 'business trip'.

Q Can you draw?

A Not so much. What I set out to draw is usually very different from what I end up with – but animation was always means to an end for me – so I mostly OK with that fact that I can't draw. Low-fi is popular now anyway right?

Q If so, do you still draw regularly?

A I haven't done much drawing this year but look forward to getting back to it next year.

Q What inspires you?

A Guilt. Ahahahah. Short Films, watching other people's work – or museums, illustrated books, friends, music videos …. I don't know what inspires me really.

Q Is your creative pursuit a struggle? If so, in what way?

A Yes, when I do my own personal work, it always becomes a burden in the sense that it is always on my mind and I feel that I have to finish it. I've been aware of it for a while and it's something I'd like to change.

Q Please can you share with us some things that have inspired you. For example, film, song, web site, book, musician, writer, actor, quote, place, etc.

A Here are some great short films: Herd by Mike Mitchell; Magda by Chel White; Anything by Don Hertzfeld; Gay Boyfriend by Ryan Mc Faul; Lunch by Matthew Ehlers; Anything by Jason Reitman.

Feature films: American Astronaut; Dropping Out; Delicateensen; Rasing Arizona; A Fish Called Wanda; Anything Monty Python.

Musicans: Le Tigre; Beck; Black Rebel Motorcycle Club; Devotchka; The Magnetic Fields.

Magazines: RES; Boards; Creativity.

Q What is your most over-used AE feature/filter?
A Drop Shadow, Fractal Noise, Trapcode Particular whenever I can use it.

Q What would you like to learn more about?
A There's so much I'd like to learn – in AE I'd like to learn to become an expert matte cutter and motion tracker. I'd also like to beef up my pitiful knowledge of Expressions.

Q Please include examples of the work that you are most proud of and give a brief description of it and explain your feelings about it.

1 – Sesame Workshop – Sprout Promo Fall 2005 – Words

2 – Sesame Workshop – Sprout Promo Fall 2005 – Sharing

I just finished 7 promos for a new channel called Sprout for children aged 3–5. These are two screen shots of 2 of the promos. I love Sesame Street and I'm very happy to able to put this on my reel. I worked for them directly and did all the compositing and most of the design and illustration. I had 5 days to produce 7 promos and got sick in the middle of it but it was so worth it.

3 – MTV Networks – Nick Source – Spring 2005

4 – MTV Networks – Nick Source – Spring 2005

5 – MTV Networks – NCTA conference loop – Spring 2005

These were the first jobs I did for MTV Networks. I am happy with them because I was able to incorporate some of my animation style and personality into the pieces. MTV was another dream client and was a pleasure to work for as well.

6 – Video for the band Bright Eyes – for the 2005 Tour

Bright Eyes is an independent band from Omaha Nebraska who are quite popular in the States. I had been mulling over the idea of using old 18th- and 19th-century drawings in an animation and this seemed like a good project for it. I was mostly happy with the way this turned out. I ran out of time and energy toward the end. It was an incredibly hard project to organize and prepare for animation. I went to the NY Public Library once a week to get the images which I would scan and then prepare in Photoshop. It took ages to do. It was nice to get away from drawing things and using scans instead.

You can see all of these files at www.rachelmax.com

Chapter 10 **Paint**

Wacom Intous 3 Wide

Paint has opened up a whole new way of working for many After Effects users. The paint in After Effects is vector based and non-destructive which means that any changes you make do not alter your original files. This allows you to be very experimental with it.

Synopsis

Paint can be used for many varied tasks, you can keyframe your brush strokes to create animated cartoons or make handwriting appear as if it's being drawn on screen. I'll be showing you how to do all of these things plus; how to use the Clone Stamp tool to remove wires and mike booms from shots or to touch up old, damaged film.

You also have access to the eraser tool, which can be used to remove pixels edit your paint strokes or create interesting reveals. The possibilities are endless, we'll examine a few of them in the following pages, hopefully this will inspire you to come up with a few unique paint techniques of your own.

Paint basics

We'll start by looking at the Brush tool and how it works. For this first tutorial you can use either a pen or a mouse but painting will be infinitely easier if you use a graphic tablet and pen, in fact there are some features of paint which will only work if you are using a pen as your input device.

Input devices

I recommend Wacom's excellent 'Intous' range of tablets. Wacom have an 'Intous 3 Wide' tablet which is perfect for working with widescreen footage and widescreen monitors (**Wacom01.tif**). The

Wacom Cintiq 21 UX

'Cintique' is also lovely if you are lucky enough to be able to afford one (**Wacom02.tif**)! You can find out more about these tablets by going to the Wacom web site at: http://www.wacom.com

The other input device that I couldn't live without is my Contour ShuttlePro (**Contour.tif**). The ShuttlePro is designed for allowing one-hand access to fully programmable buttons and a jog/shuttle knob. The 'jog' rotates through 360 degrees and provides frame-by-frame control of your footage and comps. The outer 'shuttle' ring is rubberized and spring loaded. It facilitates fast forward, rewind, scrolling, volume control, and sequencing. There's information about the ShuttlePro on the DVD and also at the contour web site at: http://www.contourdesign.com/shuttlepro/

The Brush tool

1 Open **Paint01.aep** from **Training > Projects > 12_Paint**. Open the Project panel if it is not visible.

2 Open the **01_Brushes** comp. This comp contains one single layer named **Black solid 2**, we'll use this to practice painting.

3 In the **Tools** panel, choose **Paint** from the **Workspace** menu. The workspace will change and the **Paint** and **Brush tips** panels appear. Here you can choose from preset brushes and have various options for changing the attributes of the brush you are currently using (Fig. 10.1).

Contour Shuttle Pro

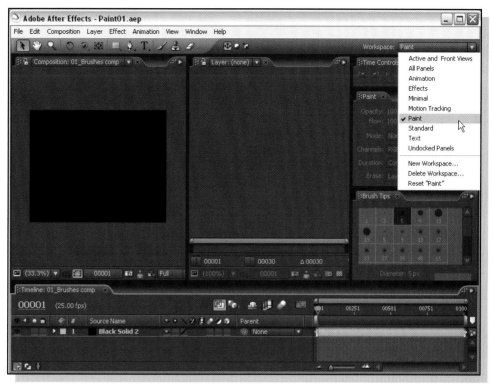

Fig. 10.1

4 In the **Tools** panel select the **Brush** tool ⌘ **B** *ctrl* **B** (Fig. 10.2).

Fig. 10.2

5 The **Layer** panel becomes the predominant panel in the workspace instead of the Comp panel, this is because Paint cannot be applied in the Composition panel; it must be applied to your layer in the Layer panel.

6 In the **Paint** panel, click on the **Foreground/Background Colors** switch by the color swatches to swap the **foreground** and background colors till **White** is the foreground color (Fig. 10.3).

7 **Double-click** the **Black Solid 2** layer to open it up in the **Layer** panel.

Maximizing frames

When painting you ideally want to work at **100%** magnification as it is easier to paint all full size. When you have the magnification set to **Fit up to 100%** the Layer panel may not necessarily be displaying the layer at 100%. A quick way of extending the frame so that it's big enough to accommodate the layer displayed at 100% is to maximizing the frame so that it fills the available workspace. This is also useful when animating in

Fig. 10.3

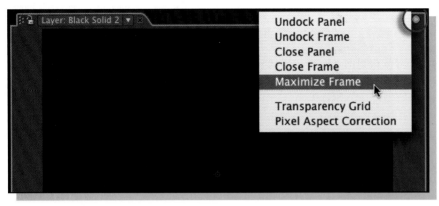

the Comp panel as it will extend the panel to reveal the gray pasteboard surrounding the composition.

8 To maximize the **Layer** panel so that it fills the workspace you can either go to the **Layer** panel's **Wing Menu** and choose **Maximize Frame** or hit the **Tilde** key **9** (Fig. 10.4).

Fig. 10.4

The **9** key is in different places depending on whether you are on Mac or Windows. On the Mac keyboard it's located to the left of the **Z** key. On a **Windows** it's to the left of the **1** key on the main keyboard.

9 Draw a **squiggle** in the **Layer** panel like the one in the screen shot (Fig. 10.5).

10 Choose **Restore Frame Size** from the panel's wing menu (or hit the **9** key again) and then open up your layer to reveal the property groups in the **Timeline**, and then double-hit the **P** key to reveal the **Paint** effect.

As you can see, Paint is applied as an effect, this means that it is separate from your layer and can be removed easily without affecting the pixels of your original footage. It also means that you can use other effects in combination with paint to achieve some very interesting results.

You'll also notice that the Paint stroke is represented in the Timeline by a gray duration bar that looks similar to a layer; it's kind of like a sub-layer of the layer you're working on. This makes it possible to trim and retime your brush strokes independently from the actual layer.

Fig. 10.5

11 Move the **Timemarker** to frame 50 and then click and drag the **In Point** of the **Paint** stroke sub-layer to trim it into **frame 50**. Hold down **Shift** as you drag so that it snaps to the Timemarker (Fig. 10.6).

12 Move the **Timemarker** back to the **beginning** of the **Timeline** and then hit **Spacebar** to preview and see that the paint appears at frame 50, this preview will take place in the **Comp** panel.

Fig. 10.6

13 Drag the **In Point** back to the **beginning** of the **comp**. Hold down **Shift** as you do so that it snaps to the beginning of the Timeline.

> At the time of writing there are no keyboard shortcuts for trimming or moving a brush stroke independently from a layer, they have to be manually moved or trimmed.

14 Open up the **Brush 1** Twirly to reveal the property groups of the brush stroke.

Notice the brush properties are divided into two groups: **Stroke Options** and **Transform**. As well as having Transform properties for the layer, you also have Transform properties for each individual brush stroke you apply! This is extremely useful as it means you can scale, rotate, move individual brush strokes independently from the layer itself (Fig. 10.7).

Fig. 10.7

15 Go back to the **Paint** panel and switch the color swatches so that red is the foreground color.

16 In the **Brush Tips** panel, choose a **Hard Edged 13 point** brush (Fig. 10.8).

17 Make sure that the layer is selected but that **Brush 1** is de-selected in the Timeline before you paint the next stroke.

> If you draw a new brush stroke with another brush selected you will simply replace that brush instead of drawing a new one. This comes in very handy when animating brush strokes but can sometimes lead to annoying accidents – so beware!

Fig. 10.8

18 Move the Timemarker to **frame 100** and draw a rough circle with your new paintbrush. Notice that **Brush 2** now appears in the Timeline above **Brush 1**. The new brush begins at the position of the Timemarker (Fig. 10.9).

19 **Open** up **Brush 2** Twirly to see its property groups.

20 Open the **Transform** property group for **Brush 2** and scrub the **Scale** value to about **200%**.

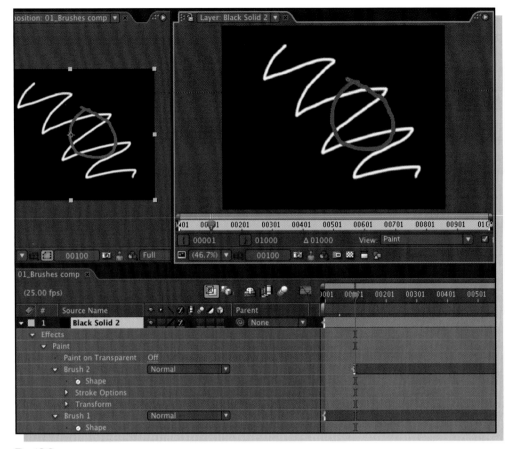

Fig. 10.9

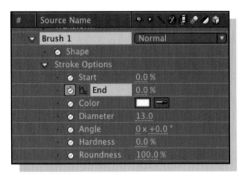

Fig. 10.10

The quality may drop as you change the value but that it returns to crisp, clear vector brilliance as soon as you've finished scaling it. You can resize a brush stroke indefinitely without losing quality, it's just like using continuously rasterized Illustrator files. You may have also noticed that the Scale change you made only affected Brush 2, it did not affect Brush 1.

21 Change the **Scale** value of **Brush 2** back to **100%**.

It goes without saying that all the Transform properties for brushes are animatable over time in the same way that other properties are.

As well as Transform properties, each brush has its own Stroke options which are also animatable over time.

22 Close the **Transform** property group on **Brush 2**.

23 Open up the **Stroke Options** for **Brush 1** (Fig. 10.10).

The great thing about vector paint strokes is that the attributes of them can be altered after you have painted them, this leads to a very creatively flexible way of working.

But be warned, if you want to change a property of a brush after it has been drawn, you can't change it by adjusting the values of the Paint panel, doing so will only affect the Brush tool.

To alter a stroke after it has been drawn you can use the Stroke Options in the Timeline. Let's take a look at some of the properties that can be changed over time.

24 Move to **frame 50** and set a **keyframe** for the **End** value of **Brush 1** by clicking on the **End** value stopwatch in the **Timeline**.

25 Hit the **Home** key to go to the beginning of the comp and then change the **End** value to **0%**.

26 **RAM Preview** to see your brush stroke draw on screen over time in the **Comp** panel.

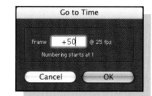

Fig. 10.11

27 Jump to the second keyframe by using the **J** and **K** keys on your keyboard, and set keyframes for **Color** and **Diameter**.

28 Hit ⌘ **G** ctrl **G** to open the **Go To Time box**. Type in **+50** and hit *Enter* to move ahead by 50 frames (Fig. 10.11).

29 In the **Timeline** change the **Brush 1 Color** to **Green** and the **Diameter** to **50**.

30 Set keyframes here at **frame 100** for **Hardness** and **Roundness**.

31 Move ahead to **frame 150** and change the **Hardness** value to **100%** and the **Roundness** value to **0%**. This gives you a brush that looks more like a marker pen. You can adjust the angle of the pen using the Angle setting (Fig. 10.12).

32 **RAM Preview** the animated brush strokes.

There are also animatable properties for Spacing, Opacity, and Flow. All of these attributes can be changed and/or animated

Fig. 10.12

after the brush stroke has been painted. You can even animate the shape of the brush stroke. What we've done so far is pretty basic but we'll take it further as we progress throughout this chapter.

33 Select **Brush 1** and then hit the `Delete` key on the keyboard to delete it.

34 Choose a **Soft Round 17 pixels** brush from the **Brush Tips** panel.

Fig. 10.13

35 Open **Brush 2** so that you can see its property groups, **open** the **Stroke Options** property group.

36 Move to frame **150** and then create keyframes for **Shape** and **Color** (Fig. 10.13).

37 Make sure that the **Paintbrush** tool is selected `⌘` `B` `ctrl` `B`.

You can still make changes to your brush before you start to paint. Remember you use the Paint panel to make changes to the current brush, not to the brush strokes in the Timeline.

38 In the **Paint** panel, make the **Brush Color blue** and choose a Soft Round 45 **pixels** from the **Brush Tips** panel. Any changes you make to your brush will be saved as the new default until you change them again.

As I mentioned earlier, if you draw a new brush stroke with the current brush stroke selected, the new stroke will replace the old one.

Fig. 10.14

39 Move to **frame 100** and then select **Brush 2** by clicking on its name.

40 Draw a new shape in the **Layer** panel with your new brush. The old shape is replaced by the new one at the current point in time and new **Shape** and **Color** keyframes are added to the stroke (Fig. 10.14).

41 **RAM Preview** to see the brush stroke animate both **Shape** and **Color** over time.

42 Still at **frame 100**, in the **Paint** panel, change the brush **Color** swatch to **white**.

43 Move the brush over to the Layer panel. As you do, you'll see a small circle where the cursor is, this represents the size of the current brush stroke. You can change the size of the brush stroke interactively.

44 Hold down the `⌘` `ctrl` key while you click and drag to change the size of the brush. Dragging to the right or upward will make it larger, dragging to the left or downward will make it smaller.

45 Hit **F2** to make sure **Brush 2** is de-selected before continuing with the next step. Or you can click anywhere on the gray empty space away from the Brush 2 name in the Timeline.

46 Paint roughly over the shape you have already painted so that some of the existing shape is overlapped by the new brush stroke (Fig. 10.15).

Fig. 10.15

Notice that the In point of the brush stroke starts from the point you are at when you start painting, this can also be adjusted after it has been drawn by dragging the trim handles as we did earlier.

The Eraser tool

As well as having a brush, you are also provided with an Eraser tool to selectively soften or remove parts of your brush strokes. The eraser has some of the same options as the Paintbrush tool but also has some distinct differences.

47 Select the **Eraser** tool from the **Tools panel**. Hitting ⌘ B ctrl B repeatedly will cycle through the three Paint tools – the **Brush** tool, **Clone Stamp** tool, and **Eraser** tool.

48 Adjust the size of your **Eraser** tool brush using the same method as we used for adjusting the **Brush** tool ⌘ ctrl – drag.

49 Make sure that the **Transparency Grid** is switched on in the **Layer** panel and then paint with the **Eraser** tool over part of the drawing (Fig. 10.16).

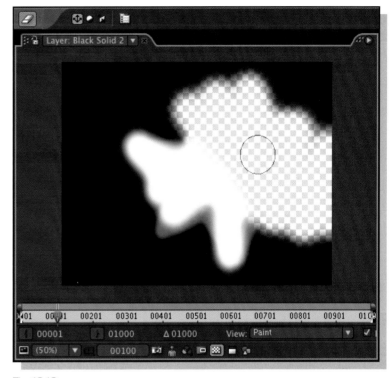

Fig. 10.16

You should be able to see the checkerboard behind the part that you have just erased. The default behavior is for the Eraser to erase everything, including all paint strokes and the background layer, making a big hole in your layer.

50 Notice also that a new brush appears in the **Timeline** named **Eraser 1**.

51 In the Timeline, select **Eraser 1** and then hit the *Delete* key to get rid of it.

52 With the **Eraser** tool still selected, go back to the **Paint** panel and look at the Erase menu, which currently reads **Layer Source and Paint**.

53 Change this menu to read **Paint only** (Fig. 10.17).

Fig. 10.17

54 **Paint** with the **Eraser** tool over part of the drawing where the lines overlap again. This time you'll notice that only the Paint strokes disappear and the background layer is unaffected.

55 Click on the **Eraser 1** Twirly to open up the property groups and then open up the **Stroke Options**. With the first two eraser modes you have all the same options for adjusting and animating the Eraser stroke after it's been painted.

Fig. 10.18

Fig. 10.19

56 Scrub the **Diameter** value of **Eraser 1** to around **200%** and see the erased area grow (Fig. 10.18).

57 Delete the **Eraser 1** again by selecting it in the Timeline and hitting the *Delete* key.

58 In the Paint panel, change the **Eraser** menu to **Last Stroke Only** (Fig. 10.19).

59 Paint with the Eraser tool over the part of the drawing where the lines overlap. This time you'll see that only the last stroke painted will be erased (Fig. 10.20).

This is useful if you make a mistake and quickly want to remove it when painting. Notice that this mode does not create a new brush stroke in the Timeline; therefore, the attributes cannot be changed after you have painted with it. You can, however, undo this Eraser stroke by using the regular undo *⌘ Z* *ctrl Z*.

Animating paint

The following tutorials involve a fair amount of drawing. Although you can continue with the tutorials by drawing on screen with your mouse, you will find it much easier if you use a graphic tablet. We will also be taking a look at brush dynamics, these are only supported on tablets with pressure sensitivity, you cannot use the brush dynamics if you are using a mouse.

If you don't have already a graphic tablet, then it is really worthwhile considering the purchase of one, it will really add a new dimension to your work processes.

Fig. 10.20

I have used a Wacom Intous A4 graphic tablet for this exercise and the instructions given are particular to this tablet. Wacom tablets are pressure sensitive and are fully supported, if you have any other supported tablets, you will still be able to follow the exercise but you may have to experiment with settings to achieve the same results. I have endeavored to explain the steps in as much general detail as I can. Although I cannot guarantee that it will work using any unsupported tablets, you are welcome to try it out.

1 Before moving on, use the graphic tablet's control panel to make sure that, in the **Mapping** section your tablet is set to **Pen mode** (or equivalent), this exercise will not work in mouse mode. While in the control panel, please make sure that the **Screen Area** is set to **Full** (or equivalent) and its **Aspect** is set **to Fit** (or equivalent).

If you have problems accessing your control panel, please see its user manual for details.

The screen resolution I have used for this exercise is 1024×576. If you have a lower screen resolution you may need to adjust the size and/or magnification of the Composition panel.

As we will be doing a lot of drawing over the next few pages, we'll start with something fairly basic to give you a bit of practice and build up your confidence, we'll animate a little stick figure.

Stop-frame look

The first thing I wanted to do when I saw Paint in After Effects was to use it for animations. I tried doing a little stop-frame animation but found that it was a bit tricky as there is no onion skinning to help you visualize movement between frames (I'm still keeping my fingers crossed for that one)!

But, after playing around with the other features of paint I managed to come up with something that simulates stop-frame animation and is actually much faster to produce.

Fig. 10.21

2 Open **Paint01.aep** from **Training > Projects > 12_Paint**. Open the **Project** panel if it is not visible.

3 Open the **03_Character animation start** comp. This contains a solid black layer named **Stick Person** which we will paint our character on.

4 In the **Tools** panel select the **Brush tool** ⌘ B ctrl B (Fig. 10.2).

5 Go to **Panel > Workspace > Paint**. The workspace will change and the **Paint** and **Brush Tips** panels appear.

6 In the Timeline double-click the **Stick Person** layer to open up the Layer panel.

7 In the **Paint** panel make sure you have **White** selected as the **Foreground color** swatch.

8 In the **Brush Tips** panel, change the **Diameter** to **11** and the **Hardness 80%** (Fig. 10.21).

The Brush tips panel also lets you choose preset brushes but also allows you to create custom brushes and set up your brush dynamics for your pen.

9 Expand the **Brush Tips** panel so you can see the **Brush Dynamics** section at the bottom of the panel. You'll see that the **size** is automatically set to respond to the **Pen Pressure** but that the other Brush Dynamics are switched off.

10 Change the **minimum size** setting to **70%**, this will now be the smallest size the brush will draw on screen when you use a very light pressure.

11 Change the **Flow** menu to **Pen Pressure**.

12 Click on the **Brush Tips** panel **wing menu** and choose **New Brush** from the list (Fig. 10.22).

Fig. 10.22

Fig. 10.24

13　**Name** the new brush **Chalk Brush** and then click **OK**. All of the settings that we've already set will now be stored in your new brush (Fig. 10.23).

It's a good idea to create a set of brushes that you regularly use, remember that the preset brushes do not have customized dynamics to work with the graphics tablet. So take a minute or two after this chapter is completed to customize your brushes and rename them. You can also rename and delete brushes by context-clicking on the thumbnails in the **Brush Tips** panel.

Fig. 10.23

14　Click on the **Brush Tips wing menu** again and choose **Small List** from the menu to see your new brush listed with its name and size displayed (Fig. 10.24).

15　Maximize the Layer panel by opening its **Wing Menu** and choosing **Maximize Frame** from the list (or hit the **Tilde** key **9**).

16　Move over to the **Layer** panel and draw a circle for the head of our stick person at the top center of the screen.

17　Lift the pen and then draw a new line for the body. We want to do a walking cycle animation so we will position the arms and legs as if they are taking a step.

18　Lift the pen again and draw new lines for the Right leg, Left leg, Right arm, and Left arm. Each limb should be one individual brush stroke (Fig. 10.25).

Don't worry if you don't get it right first time, even drawing a stick figure can be tricky on a graphics tablet if you're not used to it. If you

Fig. 10.25

are not happy with any of the body parts, simply select the associated brush strokes and then redraw them till you are happy.

I often find the surface of the tablet too slippery, I'm used to the resistance of real paper when drawing. If you do too, then try putting a piece of cartridge paper over the tablet and draw on top of that. I also use the gray felt nib that comes free with the Intous pen, it offers a little more resistance than the standard nib.

Fig. 10.26

Fig. 10.27

20 Select **Brush 1**. Notice in the **Comp** panel, that the brush has a gray line to show that it is selected. You can also see the anchor point which is positioned where the line was first drawn from – its start point (Fig. 10.26).

21 Hit the *Return* key on the keyboard, this makes the **Brush Name** active so that you rename it.

22 Type in the word **Head** and then hit *Return* again to accept the new name.

23 Using the same technique, rename all the other body parts – **body, Right arm, Left arm, Right leg, Left leg** (Fig. 10.27).

24 **Select all** of the **brush strokes** and then click on the Twirly next to the any brush stroke name. As you do, all of the selected brushes should open to reveal their property groups.

25 Click on the **Shape** property stopwatch for any one of the brush strokes to set a keyframe, this will create keyframes for all of the selected brushes (Fig. 10.28).

19 Hit the **9** key again to restore the Layer panel to its original size, select the **Stick Person** layer and then **double-hit** the P key to open up the brushes; there should be **6** brushes in total.

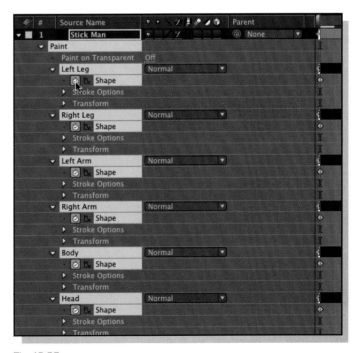

Fig. 10.28

26 Close up the **Left Leg** brush and all the selected brushes will close too.

27 Move ahead to **frame 11**.

28 De-select **all** of the selected **brushes** by hitting **F2** and then **select** the **Head** layer only. You should see its selection line and anchor point in the Layer panel.

Fig. 10.29

29 Redraw the **head** so that it's in slightly different position, as soon as you do this a new keyframe will be created for the **Shape** property.

30 Do the same with the **Body** brush stroke, select it then redraw it so that it's leaning the opposite way.

31 Use the same technique to redraw the **Right arm** shape to be similar to the **Left arm** current shape and position. Then redraw the **Left arm** to approximate the original shape of the **Right arm**.

32 Redraw the **Right leg** to swap with the **Left leg** and visa versa (Fig. 10.29).

Notice that the brush strokes duration bar have little markers on them now at the current point in time, showing us where the keyframes are. This is an extremely useful feature as it indicates where you have keyframes without the need to display all the brush properties.

33 Hit the **N** key on the keyboard to set the **Work Area End** to frame **11**.

If you have zoomed into the Timeline it may look like the Work Area End is located at frame 12, this is not the case it's because After Effects places the Work Area at the end of **frame 11** (Fig. 10.30a).

Fig. 10.30a

34 Context-click on the **Work Area Bar** and choose **Trim comp to Work Area** (Fig. 10.30b).

35 Open the **Time Controls** panel and change the Loop button to **Ping Pong** mode (Fig. 10.31).

36 In the Comp panel, click on the **Always Preview this View** button so that your RAM Preview will happen in the main Comp panel (Fig. 10.32).

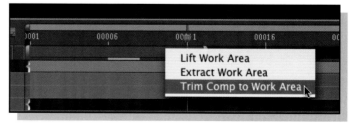

Fig. 10.30b

Fig. 10.31

Fig. 10.32

37 **RAM Preview** to see the animation play backward and forward repeatedly.

The shapes animate between the two extremes but, as we would expect, the shapes in between are not that great! Remember in the Animation chapter (Chapter 04) I told you that usually the best way to animate in After Effects is to first set the extremes, then go in between to perfect the intermediate keyframes? Well that's what we're going to do here.

38 Move half way between the keyframes (frame **6**).

39 Select the **Right leg** brush and then redraw it so that it's straight; see Fig. 10.33 for guidance.

40 Repeat this process with the remaining **arms** and **legs** so that they are straight at frame 6.

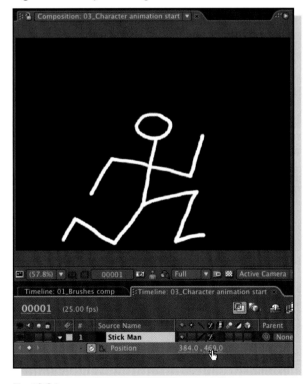

Fig. 10.34

Fig. 10.33

41 Switch off the **Transparency Grid** in the **Comp** panel and then **RAM Preview** to see the looping animation.

At the moment the animation looks too linear, and it looks as if the whole animation is being driven from the neck area. Let's add some bounce to the walk, this will make the animation look more convincing.

42 With the layer selected, at frame **6** hit *Shift* ⌥ *P* *Shift* *alt* *P* to set a keyframe and simultaneously display the **Position** property.

43 Move to **frame 1** and change the **Position** value so that the character moves down the screen so that he is almost touching the bottom edge of the comp (Fig. 10.34).

Notice that adjusting the **Transform Position** value of the layer affects the whole layer (including all of the brushes). If we adjusted the **Brushes Position** values of that we would have to adjust the values of all the brushes individually.

44 Move to **frame 6** and scrub the **Y Position Axis** value till he is standing on the bottom edge of the comp (Fig. 10.35).

Fig. 10.35

45 Move to **frame 11**, click on the first **keyframe** to select it and then hit ⌘ C ctrl C followed by ⌘ V ctrl V to copy and paste it to the current frame.

46 **RAM Preview** to see your character bounce up and down as it walks. At the moment the movement is very linear, we'll ease the keyframes so that there is a very slight pause between the steps.

47 Make sure that you can see all of the keyframes for the layer. To do this hit the **U** key on the keyboard to reveal all keyframed properties.

The **U** key is also referred to as the **Uber** key, possibly due to the fact that it is arguably the most useful shortcut in After Effects. Single-hitting **U** brings up the keyframed properties for the selected layer (or layers); double-hitting **U** shows all modified properties for the selected layer (or layers).

48 **Select all** of the **keyframes** (by either dragging a marquee around them or by **Shift**-clicking all the keyframed property names) and then go to **Animation > Keyframe Assistant > Easy Ease**[a] to Easy Ease them.

49 Hit the key once to close all the properties and then **RAM Preview** the animation. Now we need to create a complete loop of this animation. There are several ways of doing this as follows.

The simplest way would be to render out the movie and then import it. Then, in the Interpret Footage dialog box, set it to loop as many times as you like. There is a movie in the Project window named Walk_Cycle.mov that has been rendered and has been looped in this way. The trouble with this method is that the movie has to be rendered, if you want to make changes to the original animation it all has to be re-rendered.

Alternatively, you could copy and paste keyframes over and over again till the duration of your comp is filled. The trouble with this method is that if you want to make changes to the original animation you would have to either edit a lot of keyframes or go through the whole copying and pasting process again.

The third option is to use an Expression to loop the keyframes which we will do in the Expressions chapter (Chapter 11). For now let's just take a look at some more drawing techniques and we'll rejoin this tutorial later.

> OSX 10.3 or later has Expose set up to use the **F9** key to Expose all panels, this will override the After Effects shortcut for Easy Ease. I recommend going into the OSX system preferences and disabling this.

Drawing straight lines

Let's take a look at some of the other things you can do with your brush strokes. Up till now we have painted free hand. This worked for our little stick figure as it is intended to look like a primitive drawing. But what if you want to draw very straight, angular lines? Well you've already discovered that it is not that easy to do when drawing free hand. I'll show you how as we make a background for our character to walk across.

Drawing straight lines is easier to do with the mouse so put your Wacom pen down for this tutorial.

1 Open **Paint01.aep** from **Training** > **Projects** > **12_Paint**. Go to **Window** > **Workspace** > **Standard** (*Shift* *F10*) to open the **Project** panel if it is not visible.

2 Open the **05_Character Walking End** comp. Here we have our little character walking across the screen. This is my pre-saved version of the comp that you were just working on. You'll find out how to do the looping in the Expressions chapter (Chapter 11) but for now, let's concentrate on the background.

3 Double-click the **Black Solid 2** layer to open up its **Layer** panel. Change the workspace to the Paint workspace to open up all the Paint panels and close other panels.

Fig. 10.36

4 Select the **Brush** tool from the **Tools** panel and then, in the **Brush Tips** panel, choose the **Hard, Round, 5 pixel** brush from the **Preset Brushes** menu (Fig. 10.36).

Rulers and grids

5 With the Layer panel active, go to **View** > **Show Rulers** (*⌘* *R* / *ctrl* *R*) so that you can see the Rulers displayed along the top and left edges of the **Layer** panel.

6 Go to **View** > **Show Grid** (*⌘* *'* / *ctrl* *'*) and then **View** > **Snap to Grid** (*⌘* *Shift* *'* / *ctrl* *Shift* *'*).

7 Make sure that the **Timemarker** is at **0** and then move the cursor over to the **Layer** panel, positioning the brush at about the **400** pixel mark on the **vertical** ruler, the cursor should also be

Fig. 10.37

positioned outside the left edge of the comp. You should see a red line on the ruler showing you exactly where the cursor is.

8 Hold down **Shift** as you click once with the mouse and then release the mouse button, keeping the **Shift** key pressed down for the next step. This will have drawn a small dot that will not be visible due to the fact it was drawn outside the edge of the comp (Fig. 10.37).

9 Keep the **Shift** key held down as you move the cursor to the opposite side of the Comp panel. Click again to draw a perfectly straight line between the two dots. Holding down **Shift** while clicking will draw straight lines between the points where you click. The layer will automatically snap to the grid so that the line is absolutely horizontal (Fig. 10.38).

10 In the **Timeline**, make sure that the **Black Solid 2** layer is selected and then **double-hit** the **P** key to open up the brush stroke you have just created. This line will be

Fig. 10.38

one side of a road that we will make the character walk along. Now let's make the other side of the road.

11 Select **Brush 1** and go to **Edit > Duplicate** to make an exact copy of the Brush named **Brush 2**.

12 Open up **Brush 2** and then open up its **Transform** properties.

Fig. 10.39

Fig. 10.40

13 Adjust the **Y** position value till it has a value of about **530** pixels (Fig. 10.39).

14 Repeat steps **11, 12,** and **13** again on **Brush 2**, this time place the new line at **460** pixels. This will become a dotted line for the middle of the road.

15 Open up the **Stroke Options** for **Brush 3** and change the **Diameter** to **13** pixels, **Spacing** value to **670%,** the **Roundness** to **25%,** and the **Hardness** to **50%** (Fig. 10.40).

16 Close the **Layer** panel and look at the new strokes in the Comp panel.

17 **RAM Preview** the comp to see the character running along the road (Fig. 10.41).

Fig. 10.41

Practice with the brushes by drawing a nice background for the character, try drawing some trees, hills, the sun, and perhaps even a little animated dog to run beside him. In the Output chapter (Chapter 12), I'll tell you how you can output your finished movie as a Flash file and to post it up on the Creative After Effects web site for us all to see!

 Remember that, as well as using the guides and rulers in After Effects, you can use real rulers and other tools on your Wacom tablet to aid the drawing process. I have a tin full of protractors, F-curves, rulers, and other items that I regularly use with my Wacom tablet. I even have an old spirograph set that I use with my Wacom tablet to create interesting patterns.

Scribble and Auto-Trace

There are other effects that give you a painted look, these can be used in combination with paint to great effect. There are three main effects that do this: Stroke, Fill, and Scribble. You used the Scribble effect and Auto-Trace in the Text chapter (Chapter 08) but we'll use them again to create an animated fill for our text. The Scribble effect uses masks so we'll also use After Effects 6.5 Auto-Trace feature to create masks from our Artwork.

Fig. 10.42

1 Open **Paint01.aep** from **Training > Projects > 12_Paint**. Go to **Window > Workspace > Standard** *Shift* *F10* to open the **Project** panel if it is not visible.

2 Open the **09_Handwriting end** comp.

3 From the **Project panel > Footage folder**, drag in another copy of the **GraffitiClub.jpg** and place it directly underneath the existing **GraffitiClub.jpg** layer.

4 With the layer selected, hit *Return* on the keyboard and rename the layer **Scribble Fill** (Fig. 10.42).

5 Switch on the **Scribble Fill** layer's Solo button.

6 Go to **After Effects > Preferences > User Interface Colors (Mac)** or **Edit > Preferences > User Interface Colors (windows)** and check the **Cycle Mask Colors** box. With this selected, each new mask will have a different color from the previous one, making it easier to differentiate between them.

7 With the **Scribble Fill** layer still selected, go to **Layer > Auto-Trace**.

Auto-Trace will trace an image and produce vector shapes (or masks) based upon the channel information in the image; Auto-Trace is even more special as it can also trace moving images. In this tutorial we will trace a single frame but you can set it up to trace a whole animation or movie, this can produce some very interesting effects.

8 In the **Time Span** section select **Current Frame**; in the **Options** section, choose **Luminance** from the list of options in the **Channel** menu; set the **Minimum Area** to **50** pixels and check the **Invert** box.

9 Check the **Preview** box to see a preview of the masks that will be created by Auto-Trace. Leave all other settings on default (Fig. 10.43).

10 Select the **Apply to New Layer** check box and then click **OK** to create your masks. A new layer appears in the Timeline with the masks applied to it.

11 Hide the **Scribble Fill** layer by toggling off its **Video** switch.

12 Select the **Auto-Trace Scribble Fill** layer and hit the **M** key to open up its masks. You should have **34** masks on your layer.

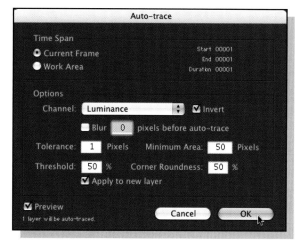

Fig. 10.43

13 Select all Masks and then click the Twirly next to the **Mask 1** name to close all selected masks.

14 Switch on the **Transparency Grid** button in the Comp panel so that you can see the transparency outside the masks (Fig. 10.44).

You'll see that all of the letters and spaces have now been traced. Because we are working with a line drawing, Auto-Trace has given us two masks for each shape, one to mark each edge of line. First, we will get rid of any unnecessary masks.

15 Select **Mask 1**, this is the outline mask that

Fig. 10.44

Fig. 10.45

goes around the whole block of text. We don't need this for the effect we are trying to achieve so hit **Delete** to get rid of it.

The remaining masks are for the letter shapes and spaces. We want to keep the spaces for the letter holes but can get rid of the spaces between letters, we will not be using them.

16 Delete masks – **13, 15, 16, 17, 19, 20, 23, 26, 28, 30, 32, 34** by **⌘** **ctrl** – **clicking** on the mask names in the Timeline to select them, then hitting **Delete** on the keyboard (Fig. 10.45).

17 Change masks **27, 29, 31, 33 Mask Mode** to **Subtract**. These masks will punch holes into the letter shapes (Fig. 10.46).

18 Go to the **Effects & Presets** panel and type in the word, **Scribble** then **drag** the **Scribble** effect from the Generate category onto the **Auto-Traced Scribble Fill** layer in the **Timeline**. The **Effect Control** panel should automatically open.

19 In the **Effect Control** panel, change the **Scribble** menu, which currently reads **Single Mask**, to **All Masks Using Modes**.

20 Click on the **Color** swatch and choose a mid turquoise blue color (Fig. 10.47).

21 Change the **Stroke Width** to **4**.

22 Hit the **Enter** ND key to move the Timemarker to the end of your comp and set a keyframe for the **End** value of the **Scribble** effect at **100%**.

Fig. 10.47

Fig. 10.46

23 Select the **Scribble Fill** layer and hit the **U** key to open up its keyframes.

24 Jump to the last keyframe on this layer (which should be at **frame 1184**).

25 Close the GraffitiClub.jpg layer and go back to the **Auto-Traced Scribble Fill** layer. Change the **End** value of the **Scribble** effect to **0%**.

26 Change the **Wiggles per second** value to **0**.

27 Switch off the **Solo** button on the **Auto-Traced Scribble Fill** layer so that you can see all three layers.

28 **RAM Preview** to see the outlines of the letters being filled with scribbles over time.

29 Open **11_Scribble End** comp and **RAM Preview** this. In this comp I've added a brick wall texture as a background layer and applied displacement maps and blending modes to the graffiti layers.

Matte painting

There are occasions, when pulling a key from a blue or green screen, when the foreground elements may contain a small amount of the key color. When you use a keying tool to remove the color, it can create holes in your matte. You can use paint to manually add or remove pixels to an existing matte.

1 Open **Paint01.aep** from **Training** > **Projects** > **12_Paint**. Go to **Window** > **Workspace** > **Standard S°** to open the **Project** panel if it is not visible.

2 Open the **12_Matte painting start** comp (Fig. 10.48).

Fig. 10.48

3 **Double-click** the **Lookers.mov** layer to open it up in the Layer panel and then go to **Window** > **Workspace** > **Paint**.

Notice that the can of beer being held by the man on the left of the picture is blue, the same color as the bluescreen.

One of the uses for paint is to add or remove areas of an existing matte. As well as being able to paint in the RGB channels, you can also use paint to add or remove pixels from an alpha channel.

4 Select the **Brush tool** ⌘B *ctrl*B from the **Tools panel** and then go to **Window** > **Workspace** > **Paint** to open the Paint workspace if it is not already open.

5 This will open the **Paint** panel. Change the **Channel** menu to **Alpha** (Fig. 10.49).

6 Select **White** as the foreground in the **Paint** panel. Change the **Duration** to **Constant**.

Fig. 10.49

Fig. 10.50

Fig. 10.51

In matte painting white represents 100% opacity, black represents 100% transparency, and gray values represent varying degrees of transparency depending on their gray values.

7 In the **Layer** panel, click on the **View** menu and choose **Color Range**, this will display the result of the **Color Range** effect in the **Layer** panel. Switch on the **Transparency Grid** if necessary (Fig. 10.50).

8 Adjust the size of the brush if necessary, using the techniques you have learnt in this chapter, and then paint over the hole with your brush (Fig. 10.51).

9 Switch the other two layers back on and **RAM Preview** the finished movie.

The Clone Stamp tool

As well as having a Brush tool you have access to the Clone Stamp tool. This can work just like the Clone Stamp tool in Photoshop but is slightly different in that it can clone moving footage and you can save the tool's settings to five presets. To begin we'll look at some simple tasks made easy by the Clone Stamp tool.

Scratch removal

When working with old footage, originated on film, you will quite often get scratches and blemishes on the frames. Even with video, there can be occasions where you have a hair or a bit of dust on your lens. In these situations, you can use the Clone Stamp tool to remove the blemish and replace it with pixels from elsewhere in the frame.

As I've mentioned, the Clone Stamp tool works very similar way to the Clone Stamp tool in Photoshop but as well as allowing you to sample pixels from other places, it also allows you to sample pixels from other points in time.

1 Open **Paint01.aep** from **Training** > **Projects** > **12_Paint**. Go to **Window** > **Workspace** > **Standard** *Shift**F10** to open the **Project** panel if it is not visible.

2 Open the comp named **14_Scratch removal start** from the **Project** panel (Fig. 10.52).

Fig. 10.52

3 **RAM Preview** the footage, notice that I have added a fake scratch to the footage on **frame 27**.

This footage is from Artbeats Retro Transportation collection. This footage did not have a scratch on it when I got it from Artbeats, I added the fake scratch only for the purpose of this tutorial!

4 If you have moved the Timemarker use the **J** and **K** keys to jump to **frame 27**, where the scratch is.

5 Use the **Page Up** and **Page Down** arrow keys to move backward and forward one frame at a time and notice that the scratch only exists on a single frame of the clip.

Because the footage has been shot from a fixed camera we can simply paint the scratch out with pixels from exactly the same position in the previous frame. Be aware that this would not be such an easy job if the footage was shot from a moving camera or if the background was moving.

6 Select the **Clone Stamp tool** ⌘ **B** *ctrl* **B** from the **Tools panel** (Fig. 10.53).

7 Go to **Window** > **Workspace** > **Paint** to open up the **Paint** and **Brush Tips** panels.

469

Fig. 10.53

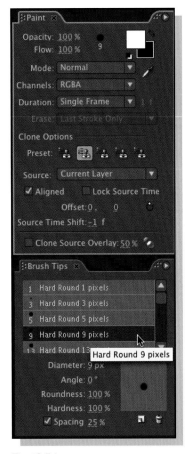

Fig. 10.54

8 In the **Paint** panel, make sure that the **Mode** menu is set to **Normal** and the **Channel** menu is set to **RGBA**.

9 Change the **Duration** menu to **Single Frame**. This will ensure that the brush stroke is painted only on the problem frame.

10 If you don't see the **Clone Options** section in the **Paint** panel, enlarge the panel until you see the **Clone Options** section and click on the second **Clone Preset** button. We will create a custom brush specifically for painting out single-frame blemishes (Fig. 10.54).

Clone Presets only save the settings in the **Clone Options** section of the **Paint** panel. They do not save the settings for **Mode, Channels,** and **Duration** menus.

11 Make sure that the **Aligned** box is checked and the **Lock Source Time** box is unchecked.

12 Make sure that the Offset value is 0, 0 by clicking on the Reset button.

This is the Positional offset that determines where the pixels are sampled from. We want to take the pixels from exactly the same place (just a different time) so we set the value to have no offset.

13 Change the **Source Time Shift** setting to −1.

This will offset the brush in time so that we are painting from one frame before the current frame.

14 Open the **Brush Tips** panel and choose the **Soft Round 9 Pixel** brush tip.

15 Make sure that all of the **Brush Dynamics** are switched **Off** in the lower half of the **Brush Tips** panel.

16 **Double-click** the TR101_small.mov layer in the **Timeline** to open up its **Layer** panel.

I would recommend using your mouse for the following steps as it is easy to keep the mouse steady and click on precise points.

17 Click once on the bottom of the scratch, make sure that the brush is over the center of the scratch.

18 Hold down **Shift** as you click on the top of the scratch (Fig. 10.55).

Fig. 10.55

Holding down the **Shift** key will draw a straight line between the two points. The scratch should disappear!

19 With the **TR101_small.mov** layer selected in the **Timeline, double-hit P** to open up the **Clone 1** brush stroke and notice that it only appears for one frame of the comp.

20 **RAM Preview** and notice that the scratch has completely vanished without a trace!

Extending existing footage

As I'm sure you can imagine, so much more can be done with the Clone Stamp tool than paint out scratches from old or damaged film. You can use the Clone Stamp tool to remove wires and mike booms from shots; you can even use it to create crowd shots from a few actors. You also have access to the eraser tool, which can be used to remove pixels or create interesting reveals. The possibilities are endless. Let's take a look at how we can use the Clone Stamp tool to increase the resolution of a movie file.

1 Open **Paint01.aep** from **Training** >**Projects** >**12_Paint**. Go to **Window** > **Workspace** > **Standard Shift F10** to open the **Project** panel if it is not visible.

2 Open the comp named **16_Widescreen start** comp from the **Project** panel (Fig. 10.56).

This comp is NTSC widescreen resolution, the footage inside the comp is NTSC D1 footage with an aspect ratio of 720 × 486.

3 Hit **0** on the number pad of your keyboard to RAM Preview the footage.

The original footage of two lions drinking from a watering hole is from the Artbeats Wild Cats collection (Ref: VWC119). This shot has been stabilized using the Professional version of Adobe After Effects.

Fig. 10.56

Imagine a scenario where I need to use this footage for a widescreen broadcast, the footage would not be big enough to fill a widescreen frame. This is a problem that I often come across when trying to source stock footage. Although Artbeats have an excellent selection of HD and widescreen footage, sometimes the footage you want to use is only available with a 4:3 aspect ratio.

Notice how the image appears to be distorted, this is because this comp has an NTSC widescreen pixel aspect ratio.

Fig. 10.57

4 Click on the **Aspect Ratio Correction button** in the Comp panel to see how this comp will look when it is broadcast (Fig. 10.57).

Notice the empty areas at either side of the footage. We need to fill these transparent areas with footage using the Clone Stamp tool.

5 Move the **Stabilized Lions.mov** layer across the screen so that it touches the left edge of the screen (Position value **270, 240**). To make our job a bit easier we will extend the footage on one side only (Fig. 10.58).

6 Double-click the **Stabilized Lions.mov** layer to open up its **Layer** panel.

Fig. 10.58

The first problem we come across is that the layer does not currently extend to the edges of the comp. We cannot paint in the gray pasteboard area. In order to paint new footage we need to create some empty space to paint into. We can do this by pre-composing a layer within a bigger comp.

7 **Close** the **Layer** panel once you have finished looking at it and pay particular notice to where the handles on the corners of the layer appear in the Comp panel.

Pre-composing

8 Select the **Stabilized Lions.mov** layer and hit ⌘ *Shift* **C** *ctrl* *Shift* **C** (or go to **Layer >** **Pre-compose**).

9 In the **Pre-compose** dialog, change the **New Composition Name** to **Paint** comp and check the **Move all attributes into the new composition** radio button. Leave the **Open new Composition** box unchecked (Fig. 10.59).

10 Click **OK** and as you do, notice that the layer handles (on each corner and edge of the layer) jump to the edges of the comp.

11 **Double-click** the **Paint comp** layer in the Timeline to open up its **Layer** panel.

12 Click on the **Pixel Aspect Ratio Correction** button and the **Transparency Grid** button at the bottom of the **Layer** panel to see the transparent pixels displayed as a checkerboard (Fig. 10.60).

Fig. 10.59

Notice that our layer is now the same size as the comp, now we have plenty of empty space to paint into!

13 Select the **Clone Stamp tool** from the tools panel ⌘ **B** *ctrl* **B**.

Clone Presets

Clone Presets allow you to save your settings for the Clone Stamp tool, this makes it easy to switch backward and forward between different settings.

14 In the **Paint** panel, select the third **Preset** button and make sure that it is on the default setting by clicking on the **Reset Clone Source Offset** button. While you are there, take a minute or two to check that your other settings are the same as the ones in the diagram opposite (Fig. 10.61).

Fig. 10.60

15 Click on the **Brush Tips** panel and change the brush to **Soft Round 45 pixels**. Check that your settings match mine in the diagram of the **Brush Tips** panel opposite.

Fig. 10.61

16 Make sure that you are at the beginning of the **Timeline** and then hold down ⌥ *alt* as you click on the big rock above the lion on the right to sample it as your **Clone Source point**. This is exactly the same technique as you use in Photoshop to set the Clone Source (Fig. 10.62).

Fig. 10.62

17 Move the cursor over to the empty area to the right of the source point and start to paint a line across the top of the empty space. Stop when you reach the right edge of the Layer panel (Fig. 10.63).

Fig. 10.63

18 Paint again from the edge in toward the lions. Stop when you have reached the edge of the lion's back (Fig. 10.64).

Fig. 10.64

Notice that the Clone Stamp tool continues to paint from a point relative to your original source point. This is because we have the default **Aligned** option selected in the Paint panel. With this option checked you can start and stop painting as many times as you wish and After Effects will

continue to keep your brush strokes aligned to the original Clone Source point.

This behavior works well in most situations but in a case like this where we have a very limited amount of material available for painting it makes sense to use the non-aligned option. Doing so will help us to avoid obviously repeating areas.

39 In the **Brushes** panel, select the fourth **Preset. De-select** the **Aligned** checkbox (Fig. 10.65).

40 Hold down [⌥] [alt] and click on a new Clone Source **point**. Choose a fairly characterless area like the one I have chosen in the screen shot (Fig. 10.66).

Fig. 10.65

Fig. 10.66

Fig. 10.67

41 Move the cursor over the transparent area and start to paint from left to right again. If the paint starts to pick up pixels from the lions back again, let go of the mouse button or lift your pen and then restart a new stroke (Fig. 10.67).

Notice that each stroke you paint now starts with the original sample point you selected. Each time you let go of the mouse and start painting again the Clone source goes back to the original source point, no matter where you paint.

42 With a non-aligned brush you do need to be careful not to make a very obvious repeating pattern. To avoid this happening you can re-sample a new Clone Source point at any time by [⌥] [alt]-clicking.

43 When you have finished painting hit the [0] on the number pad to **RAM Preview** the comp.

In this example, I want to paint a new lion into the scene, it makes sense to use an aligned brush for this but I may, at some point, want to go back to touch up my background. Presets allow me to set up new Clone settings without losing my old settings.

44 Click on the fifth **Preset** button in the **Paint** panel. Make sure that all of the settings in the **Paint** panel are as in the screen shot (Fig. 10.68).

45 In the **Brush Tips** panel, choose the **65 pixel round brush**. In the **Brush Dynamics** section change the Size menu to Off.

46 Move the cursor onto the nose of the Left-most lion, ⬛ *alt*-click to sample a new **Clone Source point** (Fig. 10.69).

Fig. 10.68 Fig. 10.69

47 Make sure you are at the beginning of the **Timeline** by hitting the **Home** key on your keyboard. Then move the cursor over to the empty space on the bottom right of the screen and then start to paint, stop when you have painted one brush stroke.

48 **Undo** the last step and then click on the **Reset** button in the **Paint** panel to reset the **Clone Offset** value.

Clone source overlay

You may notice that it is very hard to position the lion exactly correctly so that it lines up perfectly with the river bank. After Effects provides you with a clone Source Overlay to make this job easier.

49 Click on the **Clone Source overlay** checkbox in the **Paint** panel.

50 Move the cursor onto the nose of the Left-most lion again, hold down ⌥ *alt* and click to sample a new **Clone Source point**.

51 Make sure you are at the beginning of the **Timeline** by hitting the **Home** key on your keyboard, and then move the cursor over to the empty space on the bottom right of the screen. You should see a 50% opacity overlay of the lion as you drag the cursor across the screen. This overlay is provided to assist you to line up the position of your brush stroke before you begin to paint (Fig. 10.70).

Fig. 10.70

52 Line the lion up so that it is in exactly the correct position, with the bottom edge of the paint lined up against the bottom of the Comp panel. Once you have it in place, click and drag to paint your lion in with one single stroke (Fig. 10.71).

You should end up with something similar to what I have here. Don't worry about the edges too much as we will see them in the next step. You may need a little practice to do this but just keep undoing and re-painting till you have the lion painted in nicely. It's important to use a single stroke

Fig. 10.71

as it makes editing easier. However, the Clone Stamp stroke is not destructive and we can erase elements of the Clone Stamp stroke wherever needed.

More erasing

As well as regular brushes and Clone Stamp tool, After Effects provides you with an eraser tool. We can use this to tidy up our nasty edges!

1 Open **Paint02.aep** from **Training** > **Projects** > **12_Paint.** Go to **Window** > **Workspace** > **Standard** *Shift* *F10* to open the **Project** panel if it is not visible.

2 Open the comp named **17_Widescreen middle** comp from the **Project** panel.

Fig. 10.72

3 In the **Tools panel**, choose the **Eraser** tool and then go to **Window** > **Workspace** > **Paint**.

4 In the **Paint** panel, choose **Last Stroke Only** from the **Erase** menu (Fig. 10.72).

5 In the **Brush Tips** panel choose any **soft** brush.

6 Double-click the **Paint** comp to open up the **Layer** panel and then move the cursor over the **Layer** panel and then hold down the *⌘* *ctrl* key while dragging to resize your brush interactively.

7 Use the **Eraser** to neaten up the edges. Feel free to make adjustments to your brush to get the edge you like (Fig. 10.73).

8 Once you have finished, if you need to, go back to the **Clone Stamp tool** and change the **Opacity** to **30%**.

Use it to blend some of the edge pixels in with the background.

9 Close the **Layer** panel and then **RAM Preview** your comp to see the footage play back in real time.

The lion looks pretty good but there is one thing that really gives it away – the fact that both lions are moving with exactly the same timing. This makes it blatantly obvious that it is a copy of the other lion. To make this less obvious we will adjust the time offset of the Paint stroke.

Fig. 10.73

Time offset

As you've seen, painting and cloning in After Effects work in a very similar way similar to Photoshop but there is one important difference – here we are painting on moving footage that is time based – as well as being able to clone pixels from other places, we can also clone pixels from other times. And because the paint in After Effects is vector based, we can adjust the properties of the brushes either before or after we paint, it's incredibly flexible.

10 Select the **Paint comp** layer in the Timeline and then double-hit **P** in quick succession to open up the **Paint** for that layer.

You should see several paintbrushes listed in the Timeline. Every time you paint a new stroke in After Effects, a new brush is created so you probably have up to about 19 brushes in here.

11 Click on the **brushes** one by one and see that, as they are selected, you can also see the brush highlighted in the **Layer** panel.

12 Stop when you have selected the brush for the main lion and then click the Twirly next to the brush name. In my case this is **Clone 18**.

13 In the **Clone Source** section, select the **Clone Time Shift** value and type in **−15**. This will change the Clone so that it uses pixels from 29 frames before the current time (Fig. 10.74).

14 Close the **Layer** panel.

15 In the Timeline, drag the **End Work Area** to **frame 29** and then **RAM Preview** your comp to see the lions now offset in time, making the replicated lion less obvious.

Fig. 10.74

This piece of footage is quite short so we have only offset it by one second. With a longer piece of footage you could offset the timing by a few seconds to improve the effect even more.

So, there we have it, a new piece of footage that can be used in a widescreen broadcast. It's not absolutely perfect but if used with a graphic over the top, or composited in with other shots no one would ever know!

Advanced cloning

I was very honored when I was asked to work on the film, 'Hibernation' with John Williams in 2005. I've always been a great admirer of his work, particularly his music videos.

The job was an unusual one. John had shot the movie on 16-mm film, by the time I got involved all the footage had been shot and Up-res'ed to HD 1080 × 1024. This was then formatted with the BlueFish codec and imported into Premiere Pro where a rough edit had been done.

This was one of those jobs that I call a 'No Glory' jobs. A visual effects where the main purpose of the job is for nobody to notice the work that's been done on it. This kind of work is not really my

forte but, being a freelancer, working in the UK, I have to be flexible and be open to all possible jobs. The job also involved doing some animation, which is my favorite kind of work.

John showed me the source footage and I have an example of it here.

1 Open the project named, **Hibernation.aep** from **Training > Projects > 12_Paint** (Fig. 10.75).

Fig. 10.75

2 Make the **Timeline** active and then **RAM Preview** by hitting the **0** key on your number pad.

The scene is a shop building at night. There is a tree with a tree beside the shop and on the tree are some lights. In the foreground is a boy with a walkie-talkie. The camera moves down and shifts focus from the background to the foreground. The boy then moves across the screen, running from foreground to background while crossing past the shop and tree.

As I watched the footage John told me that he wanted the tree to be full of lights, but that they only had enough budget to buy one set. So, they thought they could 'add the rest in post'! This is fairly common for directors to imagine that it will be an easier job to do it after the shoot, in the computer, using the magic 'add lights' button! Of course, any visual effects artist will tell you that this is rarely the case. It's usually much preferable to do it in the camera unless absolutely impossible due to either physics or budget.

If you really must do it 'in post' then it helps you plan the shot with the task in mind. For example, if you want to add or remove something from a shot you'll make it 10 times easier if you shoot it with a fixed camera.

Of course, I had none of these luxuries on this particular job. As you can see, the camera is moving, as is the main character. The main character runs across the relevant arts of the footage that I need to work with. And just to make it really difficult, it was shot on 16 mm so is very grainy – a visual effects nightmare!

This job was the first time I had used the After Effects paint engine in version 6.5. I found a few pleasant surprises while working on it but also some annoyances which I had to find workarounds

for. Here's the technique that I used to track new lights onto the tree using motion tracking and paint.

3 Select the **Hibernation_clip_01.mov** layer and then hit ⌘D *ctrl*D to duplicate it. I will explain later why we are doing this.

4 **Double-click** on the *top* **Hibernation_clip_01.mov** layer to open up its **Layer** panel. You may want to click on the **Pixel Aspect Ratio Correction** button so you can see the footage undistorted.

5 Select the **Clone Stamp tool** from the **Tools panel** ⌘B *ctrl*B.

6 In the **Paint** panel, make sure that you have the settings in (Fig. 10.76a).

Fig. 10.76a

7 In the **Brush Tips** panel choose a brush that is about **30** pixels in **diameter** with a **soft** edge.

8 ⬛ *alt* – click on one of the tree lights to select it as the source position of the **Clone Stamp** tool (Fig. 10.76b).

9 Move to an empty part of the tree and click once to paint a new light into place.

OK, it looks good so far but if you preview the footage you'll see we have a few problems. As soon as the camera starts to move we run into these problems, the first is that the light is not moving while the footage is. We need to make the source of the paint, as well as the paint stroke itself, move along with the tree.

Fig. 10.76b

Sometimes it helps to figure out our problem by isolating the problem area. Let's try viewing the paint on a transparent background to see it more clearly.

10 With the *top* **Hibernation_clip_ 01.mov** layer selected in the **Timeline**, **double-hit** the **P** key to open up the paint.

11 Change the **Paint on Transparent** setting to **ON** and you'll notice that the layer and its paint have disappeared from view (Fig. 10.77).

12 Switch on the **Transparency Grid** in the **Layer** panel if it is not already on to make sure that the paint is really not visible.

This is one of those annoying things about the Paint in After Effects. If you make the layer transparent, it also makes the source transparent so your Paint disappears. The solution is to take the Paint source from another identical layer. This is a bit of a workaround but it works!

Fig. 10.77

13 In the **Timeline**, open up the **Clone 1** brush and then open up its **Stroke Options**. In there you should see a section controlling the source of the paint.

14 In the **Clone Source** menu, choose the *bottom* **Hibernation_clip_01.mov** layer. You should now see your single brush stroke on a transparent background. Now you know why we duplicated the layer to begin with (Fig. 10.78)!

15 **Preview** the **Paint** in the **Layer** panel – notice that the brush stroke remains in place and does not move.

Fig. 10.78

However, the content of brush stroke *does* move while the brush stroke remains in place, meaning that the 'light' leaves the brush stroke. So first we need to get the clone source following the changing position of the light, to do this we'll use Motion Tracking. For those of you with the Standard version, you can skip this section and continue with step **19** where you can open up a pre-prepared project. For those of you with the Pro version, this will be a nice introduction to Motion Tracking for you.

Motion tracking – pro only

16 Context-click the *bottom* **Hibernation_clip_01.mov** layer in the Timeline and go to **Track Motion**. This will open up the **Layer** panel and add a tracker to the footage (Fig. 10.79).

17 Hit the **Home** key to move to the beginning of the clip and in the **Layer** panel position the **Feature Region** (the innermost rectangle in the track point) around the light that you originally sampled as the source light; resize it to fit snugly around the light.

When moving make sure you don't drag the **Feature Center** crosshair in the middle of the **Feature Region,** just drag anywhere else within the inner square to move the **Feature Center.**

18 Make the **Search Area** box (the Track Point's outer rectangle) small enough that it does not include any other lights as this will confuse the tracker software (Fig. 10.80).

Fig. 10.79

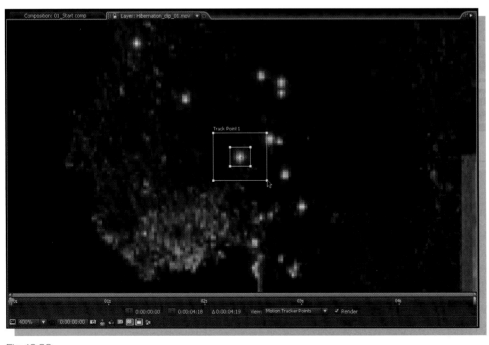

Fig. 10.80

19 In the **Tracker Controls** panel, click on the **Analyze Forward** button to analyze the motion. **Do not apply** the tracker when it is finished (Fig. 10.81).

Once the tracking is done, notice the motion path display created by the motion Tracker. We will use an Expression to apply the keyframe data to the paint (Fig. 10.82a).

Applying tracking data

1 Open the project named, **Hibernation02.aep** from **Training** > **Projects** > 12_Paint, you may save your own project to come back to later.

This project contains an extra layer named **Tracker Keyframes** which has the tracked information stored in the **Position** property.

2 In the **Timeline**, select the bottom-most layer and then hit the **U** key to open up the keyframes created by the Tracker.

3 On the top layer in the Timeline, open up the **Clone 1** brush and then open up its **Stroke Options**. In there you should see the **Clone Source** property.

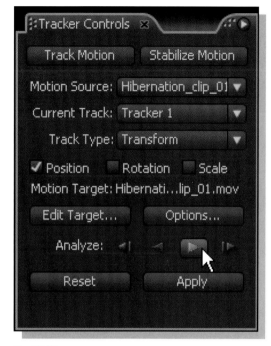

Fig. 10.81

4 Under the **Clone Source** property in the **Stroke Options** add an Expression to the **Clone Position** property by selecting the property name and then going to **Animation** > **Add Expression**.

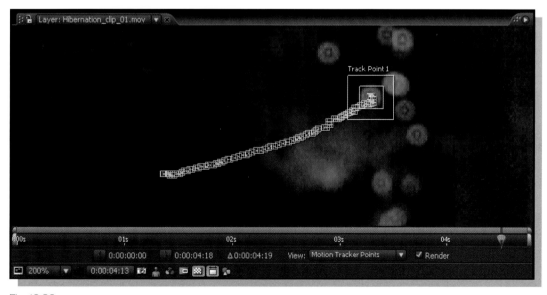

Fig. 10.82a

5 Drag the **Expression Pickwhip** to the **Position** property name on the bottom layer then release when it lights up (Fig. 10.82b).

Fig. 10.82b

6 Preview the footage and notice that the contents of the paint are now correct (the paint displays the sampled light throughout the whole duration of the comp) but the paint stroke is not following the tree. We need to animate the position of the whole layer so that the paint follows the tree's position.

7 Select the **top** layer and hit **P** to open the **Position** property.

8 Add an Expression to the **Position** property by **alt** – clicking the **Position** property stopwatch in the **Timeline**.

9 Drag the Expression Pickwhip onto the **Position** property of the bottom layer (Fig. 10.83).

10 Select the **top** layer again and this time, double-hit the **P** key to open up the **Paint**. Switch **OFF Paint on Transparent** so that you can see the whole layer (Fig. 10.84).

11 **RAM Preview** and notice that the top layer is tracked onto the bottom layer, the anchor point of the top layer follows the lights on the tree.

Fig. 10.83

We need to line the layers up so that they match exactly. A good trick for doing this is to use difference mode on the top layer. When both images are lined up exactly, the image should be completely black except for any differences between the layers.

12 Change the **top** layer to **Difference** mode in the Timeline's modes column, and line up layers by adjusting the Anchor Point value. Using this to adjust the position of the layer will not affect the Position Expression and will keep everything relative (Fig. 10.85a).

13 Change the **Difference** mode to **Normal** and then switch **Paint on Transparent ON** again.

14 Preview the Comp panel to see the light composited on the tree.

15 Double-click the **top** layer to open the Layer panel. You will see the light against a transparent background again. In order to arrange the lights we need to see the original tree.

Fig. 10.84

Fig. 10.85a

Fig. 10.85b

16 Switch **OFF Paint on Transparent** again to see the light composited against the original layer.

17 Select the new light (named **Clone 1**) and change its **blending mode** to **Lighten,** this will work well as it will emphasize the lighter areas and ignore the darker edges of the cloned light (Fig. 10.85b).

18 Hit ⌘ D ctrl D to **duplicate** the selected light to make another light.

19 Select the new light **(Clone 2)** in the **Timeline**. In the **Layer** panel you will see the light represented by a small crosshair icon when it is selected (Fig. 10.86a).

20 **Click and drag** the new **Clone 2** light to a new location on the tree (Fig. 10.86b).

21 Repeat this process till you have filled your tree with new, duplicated lights.

22 Switch **ON Paint on transparent** and open the **Comp** panel to preview the lights on the tree.

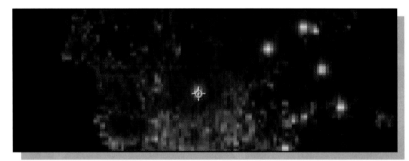

Fig. 10.86a

Fig. 10.86b

23 Change size of some of the clone brushes to make the effect more random (Fig. 10.87).

Fig. 10.87

There you have it, a fairly complicated procedure to get the effect we were after but that's often the way with visual effects work. It is very seldom a case of pressing a single button – more often than not there are hours of pain-staking manual labor involved!

Recap

In this chapter you've learnt all about the wonderful world of After Effects paint. The Brush tool in conjunction with a Wacom tablet can be used to create all sorts of amazing animations and graphics, as well as some impressive visual effects.

We looked at how you can between your paint strokes to create a stop-frame look for your character animations. You also learnt how to draw geometric shapes by utilizing the rulers and grids in After Effects.

You can now animate your own handwriting as well as use the Scribble effect in conjunction with Auto-Trace to animate the drawing of any vector shape over time.

You learnt how to create visual effects by using After Effects paint for matte painting; the Clone Stamp tool for scratch removal; extending the dimensions of existing footage and combining it all with motion tracking to add new items to existing hand-held footage.

If you're not inspired by that then perhaps this will help. Here is a little bit about John Williams who directed the film Hibernation which was featured in this chapter.

Inspiration – John Williams

'Diagnosed dyslexic from the age of 11 years, John turned his brain to various creative activities.'

John started making stuff from a young age and during primary school made a series of comic strips about a chicken detective. At 11 John got his first computer, an Amiga 500 with half a megabyte of

John on set of Hibernation

Robots

memory and started animating on a retro package called 'Deluxe Paint.' After six months of messing about John had a couple of things shown on an early Saturday morning TV show. From that point he was fascinated with bringing characters to life through stories.

Working with pencils, paper, wood, metal, plasticine, sand, high 8, super 8, and oil paint. John spent his teenage years creating all manor of 2D and 3D artwork and often used animation to bring these things to life. At University John worked with a number of other students on their animated films and created five shorts of his own. One of the students who shared a similar passion was David Lea and they have worked on a number of projects together since then. In 2000 John graduated from Wales and moved to London to work as an animator/director on a number of hugely creative videos and commercials.

After an intense few years of short format projects including a handful of short films and animations using an assault of techniques, a fully kinetic shop window display, a mound of music videos, and a couple of underground techno records, John opted to take some time out and has spent 12 months working in school with children with learning difficulties. During this time he has been developing a number of ideas and in-between working at the school has shot his latest film the live action short 'Hibernation' which indicates a progressive step forward into longer format film.

Q How did your life lead you to the career/job you are now doing?

A I started classically by doing stop-frame animations in my parents garage at my home in Devon. I also used an old Commodore Amiga to do 2D animation and sound. I got something on TV when I was 11 and from then on I was hooked.

Throughout school and college I studied art and model making and made little animated films in the holidays. When I got to University (South Wales, Newport) I studied Animation Full Time and continued to make more little films using all the different techniques I could get my hands on. After graduating I got some work animating at the National Film and Television School and following that I started working with Tim Hope for Passion Pictures. From there I got into compositing and then more directing, working with a friend, David Lea, who I had met at University.

Hibernation

Still from Hibernation

Q What drives you to be creative?

A I think at school I quickly learnt I wasn't that quick in academic classes. Although I often tried hard, I usually didn't do that well, I noticed other people who were not bothering much getting A grades. So I decided to turn my attention to the sort of stuff that requires hard work and passion and offers some reward for the effort. This is probably what started driving me. Over time I found often the harder I worked, the better the results. Now I think I have a tendency to push too hard which can strain creativity so I'm trying to find a slightly more balance and hopefully healthier way of working.

Q Can you draw?

A I have always tried to draw and find it is a very useful skill, I think an idea can often be communicated visually much quicker and more accurately in a picture than in many words, and drawings bridge the boundaries of age and culture. However, I don't consider myself as someone who can draw very well as most of my illustrations tend to be 2D, either side on or front on.

Q If so, do you still draw regularly?

A I don't really draw regularly but I do occasionally some scribbles and then remember how simple and creative it can be. With a single pencil and piece of paper you can be as creative as your mind will allow. I think I need to do more drawing!

Hibernation costume designs

Q What inspires you?

A Music, Art, and real life. Recently as I have been doing more writing, I have found music to be a great inspirational tool. Music captures moods and emotions and when I find a piece I feel captures the tone I'm trying to create in a scene, I will listen to it looping for ages while writing stories and scenes to it. Composers such as Thomas Newman, Phillip Glass, Peter

Gabriel are really powerful and groups like GoldFrapp, Coldplay, Lemon Jelly, and Hybrid take you to other cinematic places.

Coldplay – Trouble

I find Art is also very evocative, I really love Joseph Wrights work, the moods and lighting, and his subject matter is often intriguing. I'm currently looking at George Stubbs's work with Horses. Animation always inspires me. There have been so many really amazing animated short films that take the imagination somewhere they haven't been before. (The man who planted trees, The Wolfman, Hillary, Hill Farm, The Wrong trousers, When day breaks, Dog…) As mush as I like all the really wild stuff I do like reality and I'm constantly trying to find new ways of blending interesting ideas with very real and relatable stories and characters. I like news articles and documentaries for this purpose but often there is little better than meeting people and hearing them share their experiences first hand.

Q Please can you share with us some things that have inspired you. For example, film, song, web site, book, musician, writer, actor, quote, place, etc.
A See above + The Bible.

Q What is most over-used AE feature/filter?
A Personally I like the old Cine-Look plug-ins to take us back to those Super eight days.

OffSpring

Q What would you like to learn more about?

A Having spent the time since I was 11 doing short projects I'm interested to learn how longer stories work. I think priorities change a bit, rather than it being about little details like in commercials, or shots and ideas like in music videos, it becomes about a bigger picture, the story and the message and this is what I'd like to learn more about.

GreenPeace3

Chapter 11 **Expressions**

Expressions are one of the most powerful features of After Effects. An Expressions is essentially a small script that can be added to a property to control its value, but please don't let that 'S' word put you off using them. I can sympathize totally with anyone who feels like running a mile right now. The word 'script' can be enough to send any creative person off running for cover. Although you can use After Effects without ever needing to venture into the world of scripting, learning how to use them is fairly easy and is guaranteed to change the way you use After Effects in the future, and all for the better.

Synopsis

During this chapter your confidence will build as you learn the basics regarding Expressions. Processes will be explained clearly and you'll discover that you don't need to be a programmer or a scripting genius to make use of this wonderful feature. For those of you who feel inspired by this and feel brave enough to delve deeper we will progress to the Advanced Expressions section where you'll edit and combine Expressions syntax.

In this chapter you'll discover ways of linking properties together, editing multiple properties simultaneously, looping animated keyframes, randomizing values, and even creating replicas of children's toys! You'll also discover how to apply these techniques to a real-world animation project by making characters dance in time with music and lip synch automatically.

I am not a very technical person, my training was in fine art so the part of my brain that deals with scripting and programming is not particularly well developed! When I first saw Expressions were to be included as part of After Effects I felt very worried! I imagined that I would never be able to master them. But after being shown a few examples of simple Expressions, and seeing how easily After Effects can automate the process of implementing them, I was confident to get stuck in and explore them further. Now I am using them all the time, so much so that I don't know how I could cope without them. So the moral of this story is that if I can master them, anyone can – so no excuses, let's get started!

 Paul Tuersley made valuable contributions to this chapter and was incredibly helpful in getting me up to speed on Expressions when I first started working with them; his biography is included on the DVD and you can find some of his own tutorials and Expressions at: http://www.aenhancers.com

What are Expressions?

They are phrases of Java Script which tell the selected property how to produce a value. So far we have been animating properties by using keyframes. Keyframes are perfectly good for most animation tasks but can become tedious to use in situations where you need to set several hundreds

of them; if you need to apply the same value to several layers; or if you need to make something mathematically precise. In these situations Expressions can make your life a whole lot easier!

Expressions are based upon Java Script but they form only a very small part of Java Script. Put it this way, if you buy a book on Java Script, the Expressions chapter would make up about a 10th of the whole book. I find that it helps my non-techy, creative mind to think of Expressions as commands (or orders) that you give to your properties.

Instead of keyframing every single change in a value, you give the property a command; that command could be a very simple one that says 'make this layer move up and down randomly'; or 'loop these keyframes for the duration of my comp.' Expressions can also be used to control values by linking to and adapting values from other properties. For example, they can make one property follow another, perhaps changing the color of one layer when another layer rotates, or increasing the blur value of a text layer as the tracking value is adjusted. They can also do really useful things like, make perfect geometric patterns or convert one range of values to another range of values. When you consider that After Effects is basically made up of keyframes and values, having a way to link them together opens up lots of possibilities.

When should I use them?

Let's imagine a situation. You want to move a layer repeatedly up and down at short, one-second intervals over the duration of three minutes. To do this with keyframes you would have to set a few initial keyframes at intervals of one second; these would mark the minimum and maximum range of movements. You would then copy and paste these keyframes repeatedly till the duration of your comp was filled. To make matters worse, if you (or your client!) decided to make changes, these would have to be made to all of the keyframes.

The same job can be done by using an Expressions but instead of keyframing the minimum and maximum values individually, we can do it by giving the layer a command. So, in this example we could say to the layer 'move up and down repeatedly,' resulting in the layer moving up and down. We could then say, 'move faster or slower' or 'move higher' and the layer property will obey these commands.

How to learn?

The best way to and feel comfortable with Expressions is to learn just a little at a time, don't try to run before you can walk. In the early part of this chapter, we're going to concentrate on the basic rules of the Expressions language and you may want to go through it a few times. It's important that you understand these rules, as they will form the basis for all of your future Expressions building.

There's quite a bit to learn in this chapter, so find a nice quiet place and plenty of time. Rest assured, after this chapter you'll be well on your way to being an Expressions guru.

Adding Expressions

The first step is to learn how to add an Expressions to a property.

1 Open the **BasicExp.aep** project from the **Training > Projects > 13 Expressions** folder (Fig. 11.1).

2 Open the **Lesson 1 – Clock** comp and **RAM Preview** it. This comp contains four layers that make up a clock.

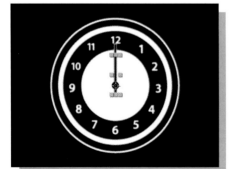

Fig. 11.1

3 Select the **Hours** layer and hit the key to see its keyframed properties. I have used two **Rotation** keyframes to animate the Hour hand so that it rotates one single revolution over the duration of the comp.

4 Select the **Minutes** layer and open the **Rotation** property .

5 Select the **Minutes** layer **Rotation** property by clicking on the word **Rotation** and then go to **Animation > Add Expressions** (Fig. 11.2a).

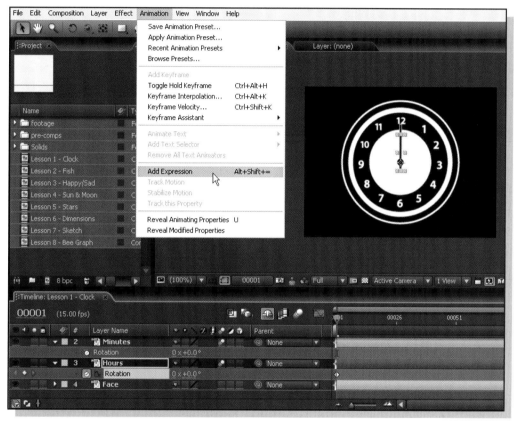

Fig. 11.2a

Congratulations, you have now added your first Expressions to a property, simple wasn't it? Let's activate the Expressions to see if anything has changed. Notice that there is a red overlay on the Comp panel alerting you to the fact that the Expressions must be activated before changes can be seen (Fig. 11.2b).

6 To activate the Expressions either click away from the Expressions text field or hit the *Enter* key on your keyboard's **number pad**.

You must be careful not hit the *Return* (or **Enter**) key on the main keyboard to activate the Expressions as this will add a carriage return to the Expressions, adding a new line of text.

Fig. 11.2b

Expressions switches

You will notice that several things happen when you add an Expressions to a layer (Fig. 11.3):

- The first thing to notice is that a little = icon appears in the Switches column. This is your **Enable Expressions** switch, it is used for switching the Expressions on and off; we'll look at this shortly.
- The **value** for the expressed property turns **pink** or **red** (depending on the darkness of your User Interface Brightness preferences) indicating that the value is being controlled by an Expressions.
- Three other switches are added to either the **Switches** or **Modes** column, depending on which columns are displayed in the Timeline, which we'll look at later.

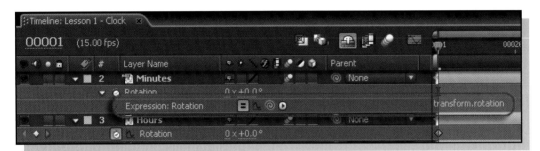

Fig. 11.3

An Expressions text field appears on the right side of the Timeline. This currently contains the words: `transform.rotation`.

Default Expressions

Let's see what this default Expressions does to our Rotation value.

7 **RAM Preview** the animation.

In this situation, the Expressions doesn't do anything, it is simply giving the property an address to get the value from. This command is saying, 'take the **Rotation** value from the **Transform property group > Rotation value**.' Whatever values already exist for the Rotation property will still be maintained, if this layer had any keyframed Rotation values, the animation would be unaffected by this basic Expressions.

Language and syntax

Expressions are based on the Java Script language and syntax. In order for your Expressions to work they must adhere to the rules of that language, in the same way as I need to use correct spelling and grammar in order for you to understand my writing.

Operators

An Expressions text field can contain several items like text, numbers, punctuation marks, and symbols. These are known as **operators**, and they all do different things depending on how they are applied within the Expressions, many of these will already be familiar to you.

Learning Expressions are pretty similar to learning a new spoken language. To start off with you may mispronounce words and the people of that country may not be able to understand you. But, by using guidebooks and learning the proper pronunciation you can quickly build up a vocabulary. The more words you learn, the more things you can communicate. In the same way the more Expressions vocabulary you learn, the more you can communicate to your layers in After Effects.

Words

Java Script is a strange language, a sort of mish mash of different things. You'll be pleased to learn that most of the words used are in English, for example the Expressions we just applied contained the word `Rotation`. Some of the words are relating to specific terms used in After Effects, for example the word `Comp` represents a composition.

Math symbols

Some words are math-related such as `Math.sin` which can be used to calculate a perfect circle or other geometric shapes. You can also use numbers in your Expressions along with simple math symbols such as + to add values and - to subtract values.

1 Click on the text inside the Expressions text field (which currently reads `transform.rotation`) to highlight it.

2 Replace this text with the number `90` and then click outside of the Expressions text field, or hit the (*Enter*) key on your keyboard's number pad, to activate the Expressions (Fig. 11.4).

3 Scrub through the **Timeline** and you'll see that the **Minutes** layer now has a value of **90** degrees throughout the whole duration.

You may be thinking, well I could have done that easily by simply changing the Rotation value. This is true but you can also use this type of Expressions to achieve things you couldn't possibly do by simply adjusting a value. Let's take a look at how we can use this simple Expressions in a real-life situation to do something really useful.

Fig. 11.4

Fig. 11.5

Disabling Expressions

1 Open **Lesson 2 – Fish** and **RAM Preview** the composition (Fig. 11.5).

As you can see, we have a goldfish swimming around inside a bowl. Imagine this is somebody else's project and you are trying to figure out what they've done in this animation.

2 Select the **fish** layer and hit the **U** key to open up all keyframed properties.

The layer is a three-dimensional (3D) layer and has some Rotation keyframes which are animating our fish to make it swim around the bowl. There are also Opacity keyframes that fade him in and out to make it appear as if he is swimming through cloudy water. Because the opacity fades in the middle of the animation, it makes it difficult to see what's going on with the Rotation property. In a situation like this it would be useful to be able to temporarily turn off the Opacity keyframes, to concentrate on the Rotation animation. We can do this by using an Expressions to override the existing keyframes, while still keeping them safe for later.

3 Select the **Opacity** property by clicking on the property name.

4 Go to **Animation > Add Expressions** to apply an Expressions to the **Opacity** property. The Expressions will read `transform.opacity`.

5 Click away from the Expressions text field, or hit the `Enter` key on your keyboard's number pad, to activate the Expressions.

6 **RAM Preview** and you'll see that nothing has changed. As we saw before, when an Expressions is first created, the default Expressions ensures that the current values (including any keyframes) remain the same.

So the Expressions `transform.opacity` is simply saying, 'make my **Opacity** value the same as the current **Opacity** value in the **Transform** property group.' In other words, it is keeping the opacity the same as it was before the Expressions was applied. However, in our case we want the Expressions to ignore the current Opacity values.

7 Highlight the current Expressions text and replace the words `transform.opacity` with `100`, so the Expressions simply reads `100` (Fig. 11.6).

8 Activate the Expressions by clicking outside of the Expressions text field, or hitting `Enter` on the number pad of your keyboard.

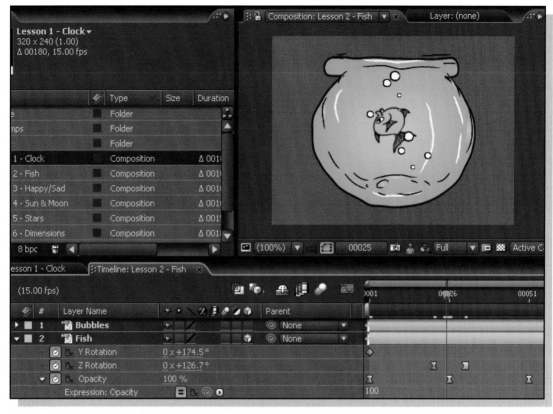

Fig. 11.6

9 **RAM Preview** the animation again. The fish now stays at **100%** opacity throughout, overriding any existing values; the Expressions is now saying, 'make my **Opacity** value equal **100** on every frame.'

Enable Expressions switch

Now that the fish is visible at all times, we get a clearer view of what its doing and can easily make any adjustments. To bring back the original fades, we can simply switch the Expressions off. The 'equals' = icon under the **Opacity** value is the Enable Expressions switch.

10 Move to frame **26** so that you can see what is about to happen, and then click the 'equals' icon underneath the **Opacity** value to temporarily switch off the Expressions (Fig. 11.7).

11 The symbol will change to a 'does not equal' ╪ icon and the Expressions is now disabled. You can turn an Expressions on or off at any time, just by clicking this icon. If you've completely finished with the Expressions, you may decide to delete it altogether.

Fig. 11.7

Deleting an Expressions

12 To delete the Expressions, click on the Opacity property name and choose **Animation >**
Remove Expressions from the pull-down menu (Fig. 11.8).

Fig. 11.8

Linking properties

An Expressions can only control the property (and layer) to which it is applied, but it is able to read the values of almost any property, on any layer in the project. So Expressions can be used to link layers and their properties together. To do this you have to tell the Expressions where to take the value from. Think of this in the same way as giving somebody an address or file path to follow.

1 Open the **BasicExp.**
aep project from the
Training > Projects >
Chapter 11 folder.

2 Open **Lesson 3 – Happy/Sad**. Here we have a background and two main layers, a **Happy**
Face and a **Sad Face**.

3 Toggle the **Video** switch for the **Happy Face** layer on and off to see the layer underneath. Finish
with the layer switched on.

We're going to use an Expressions to make the Happy Face layer's Opacity value follow its Rotation
value, so that as we rotate the Happy Face layer, it will fade out to reveal the Sad Face layer beneath.tR.

4 Make sure you can see **Happy Face** layer's **Rotation** and **Opacity** properties. If not, select the
Happy Face layer, then press the **R** key, followed by **Shift T**.

This time, we'll use a much quicker way to add an Expressions by using a modifier key.

Expressions shortcut

5 Hold down **⌥ alt** while you click on the **Opacity** stopwatch of the **Happy Face** layer to add
an Expressions. You can also delete Expressions using the same modifier (Fig. 11.9).

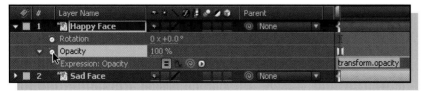

Fig. 11.9

Now, we could just type the word **Rotation** into the **Opacity** property's Expressions text field; that would work perfectly well. But After Effects provides you with a way of

automating the process of Expressions writing so that, if preferred, you never need to enter a single line of text in order to use Expressions.

Using the Pickwhip

To help us build Expressions that read other property values, we have the Pickwhip. The Pickwhip is the third from the left of the new items that appear in the Timeline when an Expressions is applied. It works in a similar way to the one in the Parenting panel in that it allows you to link elements together. If we go back to our analogy of providing the Expressions with an address to get the value from, the Pickwhip allows you to point at the address on a map rather than laboriously typing it out.

6 Click and drag the Pickwhip from the Opacity value, onto the Rotation property name and release the mouse when the Rotation property name is highlighted by a blue rectangle (Fig. 11.10).

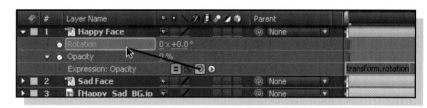

Fig. 11.10

7 Activate the Expressions by clicking away from the text field or hitting *Enter* on the number pad.

When you drag the Expressions Pickwhip onto another property, you are basically telling After Effects to write an Expressions that says 'makes *this* property value the same as *that* property value.'

The Expressions should now read: `transform.rotation`. This translates as 'take my **Opacity** value from my **Rotation** value in the **Transform** property group.'

You may have noticed that our face is no longer happy; Happy Face's Opacity now matches the Rotation value of zero, what we're actually seeing is the Sad Face layer underneath.

8 Select the Rotation tool *W* from the Tools panel and rotate the Face layer in the Composition panel. Make sure that you have Live Update button enabled in order to see the Opacity value dynamically update (Fig. 11.11a).

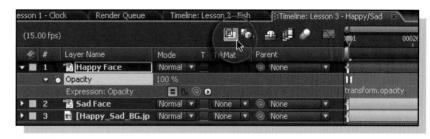

Fig. 11.11a

9 Rotate clockwise for happy, anti-clockwise for sad. Notice that as you rotate between 0 and 100 degrees, Happy Face's Opacity fades between 0% and 100%. If you rotate above 100 degrees then the value gets clipped at 100% opacity as that is the maximum possible value for opacity.

I have already added an Expressions to the **Sad Face** layer's **Rotation** so that it mirrors the **Happy Face's Rotation** value.

10 Finish by rotating Happy Face until its value reads **50 degrees** (or just enter **50** into **Rotation's** value box); you will see that the **Opacity** value has also changed to **50** (Fig. 11.11b).

Fig. 11.11b

Basic arithmetic

It's not as scary as it sounds, don't worry! We're going to stay with the Happy/Sad Face for the moment as we try to solve his mood swings. It isn't taking much to make him happy or sad; only a small change in rotation is having any effect.

Opacity is currently set to equal the Rotation value, but Opacity values only range from 0% to 100%. As a result we are only seeing a change in Happy Face's Opacity when the Rotation value moves between 0 and 100 degrees. We can modify the relationship between these two values by using some basic arithmetic on the end of our Expressions. We can add, subtract, multiply, and divide the values provided by the Expressions. Here are the symbols we can use for doing this:

+ for addition / for division

− for subtraction * for multiplication.

1 **Highlight** the Expressions **text field** by clicking on it, and then place the text cursor at the end of the current Expressions (i.e. after the word `rotation`).

Fig. 11.12a

2 **Type** `/10` on the end (divide by 10). So the Expressions now reads `transform.rotation/10` (Fig.11.12a).

3 **Activate** the **Expressions** by clicking away from the text field or hitting *Enter* on the number pad.

4 Rotate the **Happy Face** layer again to **150 degrees**, you will find it takes 10 times more rotations to fade from the **Happy Face** to the **Sad Face**. The **Happy Face Opacity** value should now read **15**, which is **10%** of **150**.

Our Expressions is now saying, 'take my **Opacity** value from my **Rotation** value, and then **divide** the **result by 10**.' Or, 'make my **Opacity** value **10 times less** than my **Rotation** value.'

5 Adjust the **Happy Face** layer's **Rotation** value so it now reads: **0, 50**. You should now find that the **Happy Face** layer's **Opacity** is just **5%**: the Expressions is taking the **Rotation** value of **50** and **dividing** it by 10 (Fig. 11.12b).

Fig. 11.12b

This seems a good time to review what we've looked at so far. We've seen how to add an Expressions to a property, how to switch it on and off, and how to permanently delete it. More importantly, we can use the Pickwhip to read values from other properties, and then modify those values. This is really what Expressions are all about: although the Expressions will get longer and more complicated as we progress, there will be different ways to read and/or modify values by using commands.

Taking values from other layers

So far, we've only linked an Expressions to a property on the same layer: but as I've already mentioned, Expressions can read the values of properties on any layer.

1 Open the **BasicExp.aep** project from the **Training > Projects > Chapter 11** folder.

2 Open **Lesson 4 – Sun & Moon**. It's a peaceful suburban scene, just before sunset. The comp consists of three visible layers.

3 **Double-click** the **Sun & Moon** layer to open up its layer panel. You'll see that this is a large square layer containing Sun & Moon symbols. The layer's anchor point is positioned in the center of the layer (Fig. 11.13).

4 **Close** the **Layer** panel tab and look at the other layers in the **Lesson 4 – Sun & Moon** comp; these are the **Day sky** and **Night sky** backgrounds, respectively. Both layers were made using the **Stylise > Ramp** effect.

5 Click the **Video** switch for the **Day sky** layer to switch off the layer so that you can see the **Night sky** layer beneath it. Switch it back on when you have seen it.

We're going to use the **Sun & Moon** layer's **Rotation** to control the **Day sky** layer's **Opacity**; as we rotate the sun away, the orange sunset will fade to reveal the blue **Night sky** background.

Fig. 11.13

6 Select the **Sun & Moon** layer and hit **R** to open its **Rotation** value; then select **Day sky** and press **T** to open its Opacity value. For the following step you need to see both the **Sun & Moon** layer's **Rotation** property, and the **Day sky's Opacity** property.

7 ⌥ *alt* – click on **Day sky's Opacity** stopwatch to add an Expressions to the property.

8 Click and drag the Expression's **Pickwhip** over to the **Sun & Moon** layer's **Rotation** property, releasing when Rotation is highlighted. Then, activate the Expressions (Fig. 11.14). The resulting Expressions should be: `thisComp.layer('Sun & Moon').transform.rotation`.

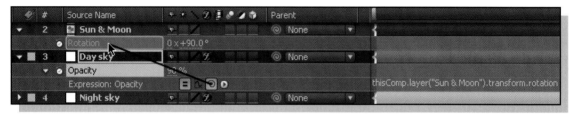

Fig. 11.14

This looks slightly more complicated than the Expressions we've looked at so far but it's really nothing to worry about. As we've seen, the Pickwhip does most of the hard work for us by writing the Expressions. Having said that it's still useful to understand how this is written.

As I said before an Expressions describes the location of a layer and property in a similar way to how you might describe the location of an address, or a file on your computer. You might write down the location of a file on your computer as:

Hard Drive/Documents Folder/The File name

Similarly, think of the location of a property in After Effects as:

Composition/Layer/Property

When written as an Expressions, this would be:

thisComp.layer('layer name').property group.property name

or in our case:

`thisComp.layer('Sun & Moon').transform.rotation`

If we break it down it's easy to understand. This Expressions is saying, 'take my value from: `thisComp` which means the composition that we are currently working in.' (Expressions can take values from any composition in your project so we first need to tell After Effects which comp to use.)

`Layer('Sun & Moon')` which tells us which layer to look for in the comp.

`Transform` which tells us which property group to look for in the layer.

`Rotation` which tells us which property to take the value from.

Notice how each of the three sections are separated by a full stop.

Although the Expressions looks more complicated this time, it's basically saying, 'Take the **Day sky's Opacity** value from the **Sun & Moon layer's Rotation.**'

So to recap, Expressions that read values from their own layer, just need to know which property group and property to read. For example, **Transform property group > Opacity property.** Expressions that read values from other layers also need to know which layer they are linking to, and what composition to look for that layer within.

9 Select the **Rotation tool** ⓦ from the **Tools** panel and then **rotate** the **Sun & Moon** layer it **anti-clockwise** in the **Composition** panel. As the Sun & Moon layer's Rotation value decreases, the **Day sky's Opacity** value will also decrease, fading out until we're looking at a night-time scene (Fig. 11.15).

If you want to you can try keyframing the **Rotation** of the **Sun & Moon** layer so that the sun sets gradually over time.

So, we've seen how to link to properties on other layers. Earlier we learned how to use basic arithmetic on our expressed values. Let's now try combining these two techniques together.

More arithmetic

10 Open **Lesson 5 – Clock comp 2** and **RAM Preview** it to remind yourself what's happening here. The Hour hand does one full revolution over the duration of twelve seconds while the Minute hand stays at the 3 o'clock position.

11 Make sure that you can see the **Rotation** properties for the **Hours** and **Minutes** layers (select both and then hit Ⓡ).

12 Hit the **Home** key to ensure that you are at the beginning of the comp.

13 Drag the **Pickwhip** from the **Minutes** layer's **Rotation** value to the **Hour** layer's **Rotation** value and let go when the Rotation value is highlighted (Fig. 11.16). The Expressions will read:

`thisComp.layer('Hours').transform.rotation.`

14 Click away from the Expressions or hit *Enter* on the number pad to activate the Expressions.

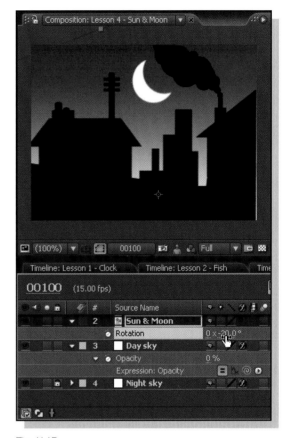

Fig. 11.15

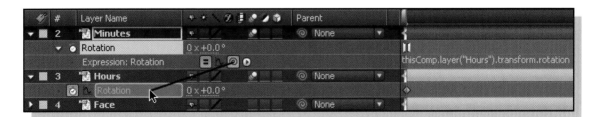

Fig. 11.16

You'll notice that the Minute hand jumps from 90 degrees back to the 12 o'clock position. So, when you are linking one property to another property it will have the effect of overwriting any existing values or keyframes.

15 **RAM Preview** the animation, the **Minutes** hand follows exactly the same Rotation as the Hour hand.

The Minute hand of a clock rotates 12 times for every single rotation of the Hour hand so we must use some simple arithmetic on our Expressions.

16 Make sure the text insertion bar is at the end of the current Expressions and type *12. This will multiply the result of the Expressions by 12 (Fig. 11.17).

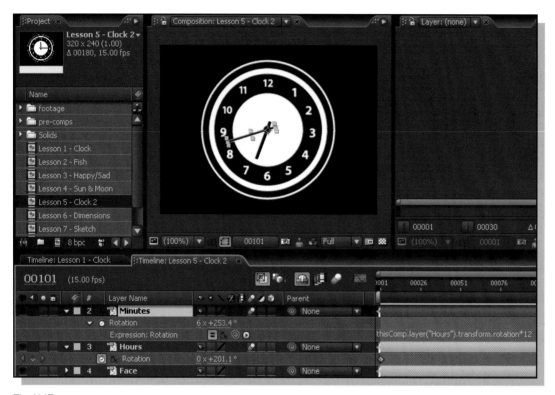

Fig. 11.17

17 **Preview** the animation and notice that the hands now move correctly around the clock.

The duration of this animation is twelve seconds, if we are to stretch it out over twelve hours this would be a prefect working clock!

18 There is a **Seconds** hand which I have hidden with the Shy button. If you're feeling brave switch it back on, unlock it and try to figure out how to apply an Expressions to make it rotate correctly! Just be aware though, that with the current duration and frame rate of the comp you will not be able to see the true rotation of the seconds hand, it will just be too fast to register!

 Expressions refer to other layers by their names, so it's very important to give each layer a unique name to avoid any problems. After Effects helps you avoid this by automatically renaming layers when you duplicate them or create solids. However, it is still possible to run into problems so beware.

In situations where two layers are named the same, After Effects gets confused and doesn't know which layer to look at. As a solution it will always choose the topmost of those layers in the Timeline, which isn't necessarily the one you had planned to use.

Properties and dimensions

You may have noticed that so far, we've only been linking between Opacity and Rotation. Opacity and Rotation are examples of properties in After Effects that contain just one value. Opacity has a value between 0% and 100%.

Rotation has a positive or negative value in degrees. (You can also count the number of degrees in revolutions but really it is just another way of counting degrees.) As these properties consist of just one value, we can call them one-dimensional (or **1D**) properties.

Properties such as Position and Scale, are a bit different; they each contain at least two separate values, one for the X-axis (left/right) and one for the Y-axis (up/down). These are two-dimensional (**2D**) properties.

Position = [X value, Y value]

Scale = [X value, Y value]

When you start using 3D layers, you'll find that previously 2D properties (like Position and Scale) have gained a third Z value.

Position = [X value, Y value, Z value]

Scale = [X value, Y value, Z value]

These are **3D** properties.

It's important that you are aware of how many dimensions a property contains, when you start writing your own Expressions.

Using 2D properties to control 1D properties

1 Open the **BasicExp.aep** project from the **Training > Projects > Chapter 11** folder.

2 Open **Lesson 6 – Stars comp**. Make sure you can see the **Rotation** and **Position** properties for the **Blue star** layer. Notice that I have already added some **Position** keyframes to this layer (Fig. 11.18).

Fig. 11.18

3 **RAM Preview** the animation to see the movement. We will attempt to use the **Position** value to control the **Rotation** value.

4 Add an Expressions to the **Rotation** property by ⌥ *alt* – clicking on the **Stopwatch**.

5 Drag the **Pickwhip** from the **Rotation** property onto the **Position** property name and then click away from the Expressions or hit *Enter* on the number pad to activate the Expressions. You'll notice that the Expressions reads: `transform.position[0]` (Fig. 11.19).

Fig. 11.19

The Position property is **2D** and has two values (an **X** value and a **Y** value). Rotation is a **1D** property, it only has one value and cannot accept both values from the **2D** property.

A **1D** value has to be given a single value; therefore, we need a way of telling After Effects which value to choose from the **2D** property.

Now it would be nice and simple if the **X**- and **Y**-axes values were represented by the letters **X** and **Y** in Expressions, but unfortunately, they are not! They are represented by numbers within square brackets:
- The X-axis value is represented by the number **0** in square brackets – `[0]`.
- The Y-axis value is represented by the number **1** in square brackets – `[1]`.
- The Z-axis value is represented by the number **2** in square brackets – `[2]`.

You can see that this Expressions has the number `0` within square brackets after the property name. When you drag the Pickwhip onto the name of a 2D property After Effects always chooses the first value (the X-axis) unless you tell it otherwise.

6 **RAM Preview** the animation and you'll see that the **Blue star** now rotates along with the **Position** value but only when it moves on the **X**-axis. It does not rotate when moving along the **Y**-axis.

7 **Drag** the **Pickwhip** again but this, instead of dragging it onto the property name, drag it **onto** the **Y value** and then release it when the value is highlighted.

A new Expressions appears that reads:

`transform.position[1]`

 If the Expressions is active and the blinking cursor is somewhere within the Expressions text, the new Expressions parameters are added to the existing one instead of replacing the current Expressions. If you ever need to replace the current Expressions you must select the whole Expressions text before applying the new Expressions.

You can click the property name or click away from the Expressions to get out of Expressions editing mode.

8 Click away from the Expressions or hit *Enter* on the number pad to activate the Expressions.

9 **RAM Preview** the animation to see that the layer now rotates only when it moves on the **Y**-axis.

What about if we want the Star to Rotate when it's moving on both on the X- and Y-axes? As you've seen, when you try to link the Rotation to the Position it automatically chooses one single value. The solution is very straightforward, all we have to do is to place the two values together in the Expressions.

Change the Expressions so that it reads:

```
transform.
position[0] +
position[1]
```

10 Activate the Expressions and watch as the Blue star rotates as it moves both on the **X**- and the **Y**-axes (Fig. 11.20).

To recap, when taking a 1D property value from a 2D property you need to tell After Effects which dimension (or values) to use. So what about when you want to use a 1D property to control a 2D property?

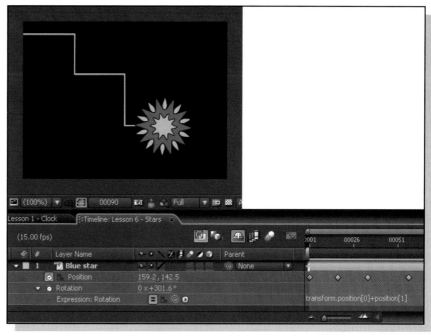

Fig. 11.20

Using 1D properties to control 2D properties

1 Open **Lesson 7 – Dimensions** comp. Here you'll see six layers, the top three are dials. We will use **Rotation** value of the dials to control the scale values of the three text layers.

2 Select the **Scale** text layer and hit **Shift** to bring up its **Scale** value (Fig. 11.21).

Before we look at the Rotation value let's find out what a 2D property requires. We'll try simply typing a value into a Scale Expressions as we did with the Rotation value earlier.

3 Add an **Expressions** to the **Scale** property by **⌥** **alt** – clicking on the **Scale** stopwatch.

4 Highlight the **Expressions** text and type in 50 and then activate the Expressions (Fig. 11.22).

You'll notice that a yellow warning symbol appears in the Switches column next to the Expressions and that the Equals sign (=) changes to a does not equal sign (≠). You will also get an error message which tells you:

Expressions result must be of dimension 2, not 1. Expressions disabled. Error occurred at line 0.

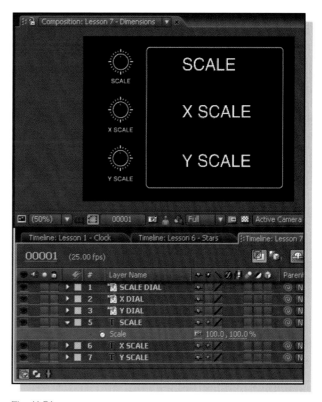

Fig. 11.21

Fig. 11.22

These error messages are nothing to be afraid of; they are actually very useful in helping us work out what's gone wrong. This message is saying that the result of this Expressions must be two values, not one.

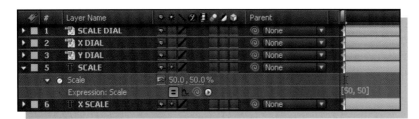

Fig. 11.23

For properties that have more than one value (e.g. Position or Scale), the correct way to write this Expressions is to put both values within square brackets, separated by a comma:

```
[X value, Y value]
```

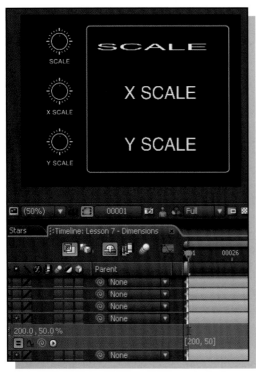

Fig. 11.24

5 Click the Expressions text field to **highlight** the current **Expressions** and **change** it to [50, 50] and then **activate** the Expressions. Now both the **X** and the **Y** values read **50%** (Fig. 11.23).

6 Change the first value inside the brackets to **200** and then **activate** the Expressions.

You'll see that the **X** value is now **200%** and the **Y** value is **50%** (Fig. 11.24).

Now we know that the **2D** property needs **two** values, let's see how we can take the values from a **1D** property. This is quite easy if you use the Pickwhip as After Effects will automatically write the correct Expressions for you.

7 Select the **Scale dial** layer and hit **Return** to bring up the **Rotation** value.

We will link the Scale value of the text layer to the Rotation value of the dial so that, when the dial is turned, the layer will scale up or down depending on which direction it is turned.

8 Drag the **Pickwhip** from the **Scale** property of the **Scale** text layer onto the **Rotation** value of the **Scale dial** layer. Release when you see the property highlighted (Fig. 11.25).

9 Click away from the Expressions or hit *Enter* on the number pad to activate the Expressions. The Scale text layer disappears because the Scale value jumps to 0% to match the default Rotation value of 0 degree.

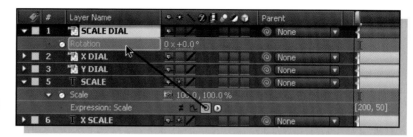

Fig. 11.25

10 Use the **Rotation** tool **W** to rotate the **Scale dial** layer by **50** degrees. Notice that the **Scale layer** scales up to **50%**. That was easy wasn't it? It's important that you understand how this works so let's take a look (Fig. 11.26).

11 Click on the Expressions text field. As you do so it should expand to show you both lines of the new Expressions. If not, then you can resize the Expressions text field by holding the cursor over the bottom edge of the text field and then dragging when the double-headed arrow appears (Fig. 11.27).

Notice that this Expressions is written over two lines, it reads:

```
temp = thisComp.layer('SCALE DIAL').
transform.rotation; [temp, temp]
```

This Expressions looks very different to anything we've previously come across and may look a bit daunting to somebody who is new to Expressions but don't worry, its pretty straightforward.

Variables

In this Expressions After Effects is using what's known as a variable. A variable is a character or series of characters that can represent any value in an Expressions. I'm sure

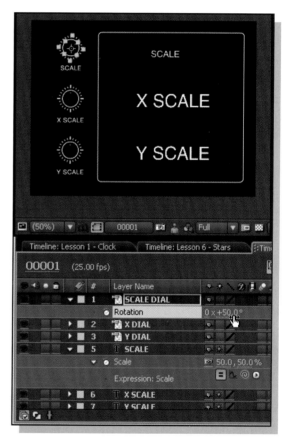

Fig. 11.26

Fig. 11.27

you'll remember your arithmetic classes at school? You would be given equations represented by letters, for example:

x + y = z

You would then work out that:

if **X = 5** and **Y = 10**, then **Z = 15.**

In the same way, we can take a letter or word and assign values to it. Let's break it down to see what's happening. The first line of the Expressions reads:

```
temp = thisComp.layer('SCALE DIAL').transform.rotation;
```

After Effects uses the word `temp` as its default variable. The first line of the Expressions is saying make the word `temp` represent the **Rotation** value from the **Scale dial** layer within **this comp.**

Fig. 11.28

From this point on, each time we type the word `temp` into the Expressions it will return that value.

Each line of an Expressions ends with a semicolon. The next line tells After Effects where to take both the **X** and **Y** values of the **Scale** property from. As we already know, a **2D** property needs **two** values into square brackets, separated by a comma. In our Expressions the second line reads: `[temp, temp].`

Which means take both the **X** and **Y** values from the **Rotation** value from the **Scale dial** layer within **this comp** (which are represented by `Temp`!)

12 Try changing the **Rotation** value of the **Scale dial** layer to **180** degrees, notice that the **Scale** of the **Scale** layer is always the same as the **Rotation** value, it will now be **180%** (Fig. 11.28).

In this case we could also have simply typed in:

```
[thisComp.layer('SCALE DIAL').
transform.rotation, thisComp.layer
('SCALE DIAL').transform.rotation]
```

But using variables to represent values becomes especially useful as the complexity of our Expressions grow, they will save you a lot of typing, copying, and pasting!

Now let's take a look at how we can control the individual axes of the **Scale** text layer. I want the

X dial layer to control only the **X** value of the **X Scale** layer, keeping the **Y value** fixed at **100%**. Here's how it's done.

13 Close up the **Scale** layer and the **Scale dial** layer.

14 Select the **X Scale** layer and open up its **cale** property s.

15 Select the **X dial** layer and open up its **Rotation** property.

16 Add an **Expressions** to the **Scale** property of the **X Scale** layer.

17 Drag the **Pickwhip** from there **onto** the **Rotation** value of the **X dial** layer. The Expressions will read:

```
temp = thisComp.layer('X DIAL').
transform.rotation; [temp, temp].
```

At the moment the **X** value and the **Y** value are both being controlled by the **Rotation** value of the **X dial layer** within **this comp**, which of course is represented by the word `temp`. To keep the **Y** value constant all I need to do is replace the second value in brackets with the value I want to fix it at.

18 Change the Expressions so that it reads:

```
temp = thisComp.layer('X DIAL').
transform.rotation; [temp, temp]
```

19 Click away from the Expressions or hit *Enter* on the number pad to activate the Expressions. You will not notice any difference as the **X Scale** is still at **0**.

Fig. 11.29

20 In the **Timeline**, scrub the **X dial rotation** value to **200**. Notice that the **X** value changes as the **Y** value always stays at **100%** (Fig. 11.29).

Test your knowledge

OK, time to see if you've taken it all in. I want you to add an Expressions to the **Y Scale** layer which will take the **Y scale** value from the **Rotation** value of the **Y dial** layer but keep the **X value fixed** at **100%**. Just think your way through it, using the previous example (and the following diagram!) as a guide if you need help (Fig. 11.30).

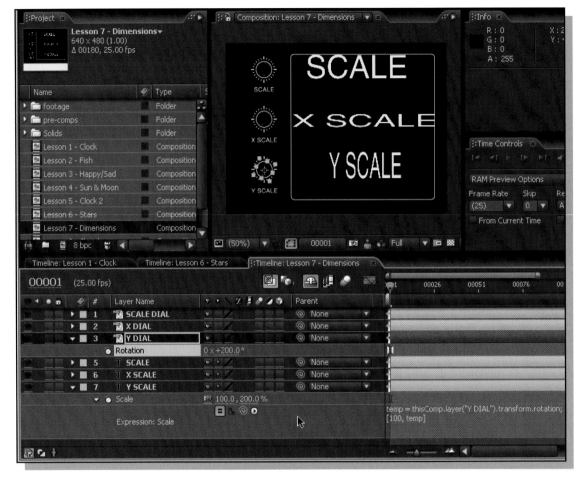

Fig. 11.30

Character animation

The following tutorial is from an animatic I produced for Illustrator Mark di Meo. Mark wanted his illustrations animated and approached me to do an animatic to take to broadcasters to show how his characters would look in motion. I used After Effects to create a quick and easy way to animate the characters dancing in time with music.

1 Open the **RadioWLDJ.aep** project from the **Training > Projects > Chapter 11** folder (Fig. 11.31).

Missing effects

This project contains references to the **Trapcode Sound Keys** effect which I used to create keyframes from the audio frequencies. Don't worry if you do not have this effect installed on your system, the project will still work perfectly well without it as the keyframe created by this effect are already applied to the layers.

When After Effects opens a project containing missing effects it keeps an empty effect placeholder in the Effect Controls panel so that you can continue to work with the project, if you should ever install it, the project will automatically pick it up.

2 In the **Project** panel, double-click the **Dancers.mov** and play the movie to see a section from the animatic. I have removed the music from this movie as we did not have clearance to use it in the book.

I have already set up a parenting structure for the character in the Timeline. If you haven't already read the Grouping chapter, now would be a good time to do so to find out how this was done.

3 Click on the **Layer Name/Source Name** column heading till you can see the **Layer Names** displayed and then select the **Left arm** and **Left Forearm** layers in the Timeline and then hit to open their **Rotation** values.

4 Scrub the **Rotation** values to see how the parenting works. Notice that the **Left arm** and **Left Forearm** can be rotated independently but that the Left Forearm always follows the Left arm.

The other step that I have done is to add some markers to the Audio layer. This was done by selecting the layer and then hitting the asterisk key on the number pad while previewing the audio. I then used these as a guide to create keyframes for the main beats of the music.

5 Select the **Body** layer and the hit r to see the **Rotation** keyframes that have been created. We will use these keyframes to create the main movements for the character.

Fig. 11.31

6 **RAM Preview** the animation to see the whole character rotation from side to side. The first thing we'll do is add a very simple Expressions to make the movement stronger.

7 Add an Expressions to the **Rotation** value of the **Body** layer by ⌥ _alt_ – clicking on the **Rotation** stopwatch in the **Timeline**.

8 Place the text insertion point after the current Expressions and add *2 after transform. rotation. Hit _Enter_ on the number pad to activate the Expressions (Fig. 11.32).

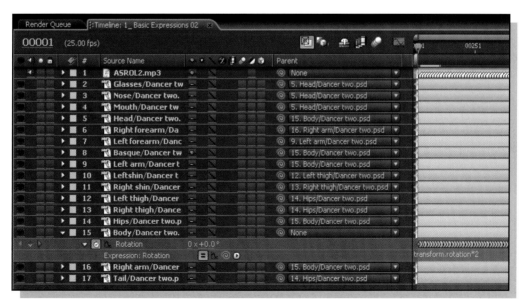

Fig. 11.32

9 Add an Expressions to the **Left Forearm's Rotation** value and then use the **Pickwhip** to link to the **Body** layer's **Rotation** value (Fig. 11.33).

Fig. 11.33

10 Place the text insertion point after the current Expressions and add `*3` after `thisComp.layer`
(`'Body'`)`.transform.rotation`. Hit [Enter] on the number pad to activate the Expressions.

11 RAM Preview the animation.

Reveal Expressions shortcut

12 Select the **Hips** layer and then **double-hit** the [E] key in quick succession to open up any Expressions applied to the layer; this is a really useful shortcut for revealing Expressions.

Fig. 11.34

13 This Expressions is currently disabled. To activate the Expressions click on the **Enable Expressions** switch in the Switches column (Fig. 11.34).

14 **RAM Preview** the animation. By multiplying the result of the Expressions by −1 it has the effect of reversing the hips animation making them appear not to be rotating.

15 **Select all** of the **layers** by hitting ⌘A ctrl A and **switch on** all the other **Expressions** that you discover. All of the Expressions are operating on the transform properties of the layers and have basic arithmetic applied to them to adjust the resulting values (Fig. 11.35).

Although using basic arithmetic is a great way to adjust Expressions it can be hard to figure out what's required to do to get exactly the result you need.

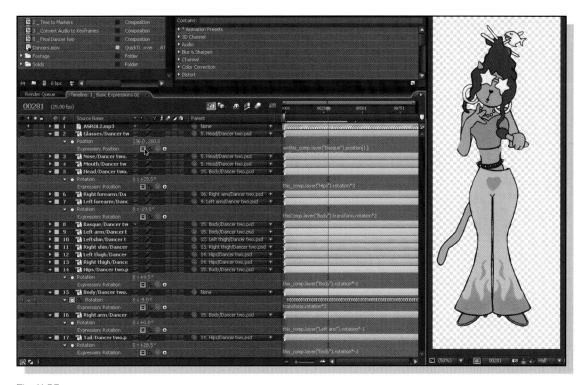

Fig. 11.35

Convert Audio to Keyframes Assistant

In this comp we'll use the built in **Convert Audio to Keyframes** assistant to create some keyframes based upon the audio levels of the **ASROL.MP3 layer.** Wherever the audio levels are louder keyframes with a high value will be produced; wherever the levels are quieter, keyframes with low values will be produced. We'll use Expressions to link properties to these keyframes so that the animation is automatically synchronized with the music. We'll use this technique to control the animation of the characters legs.

16 Open 02_Linear & Ease comp.

17 Context-click on the ASROL.MP3 audio layer and choose Keyframe Assistant > Convert Audio to Keyframes. A new layer will be automatically created for you holding keyframes based upon the audio of the layer.

This Keyframe Assistant works by converting **Audio Level** data into **keyframe** data that can be used to control your animations. The most obvious use is to use it to make layers move in time with music but it can be used for a whole host of useful things when combined with the power of Expressions.

18 A new layer named Audio Amplitude will appear at the top of the Timeline. With the Audio Amplitude layer selected, hit **U** to show the new keyframes.

The Keyframe Assistant creates keyframes for three effects named: **Left Channel, Right Channel,** and **Both Channels,** we'll use Both Channels (which is a mix of the left and right channels) to control the rotation of the legs.

519

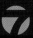

Fig. 11.36

19 Add an Expressions to the **Left Thigh** layer's **Rotation** value and then drag the Pickwhip to the **Slider** property of the **Both Channels** effect (Fig. 11.36).

20 Activate the **Expressions** and then **RAM Preview** to see a very silly leg movement.

The leg is moving in time with the music but the rotation looks all wrong. We need to adjust the leg so that it is moving in a more sensible way. Ideally it should rotate between −10 and 10 degrees but you can imagine how difficult it would be to work out the math involved in making adjustments to the Expressions values till you came up with that exact result.

Linear & Ease Expressions

In situations where you need to have precise control over the movements of your layers it is much easier to use the interpolation Expressions to convert one range of values to another. These Expressions may seem daunting to begin with but they will make your life a whole lot easier and save you from headaches!

We could use arithmetic on the Expressions as we did before, this would work. But the trouble with that method of adjusting values is that you need to do arithmetic in your head to figure out how much you need to adjust the values by. You also need to figure out whether it should be a positive or negative value. This may not be that much of a problem when working with one simple addition or subtraction but when you have to do multiple calculations to get what you want you'll find that this trial and error approach is not very practical.

Instead I'm going to show you the **Linear & Ease** Expressions, I find these invaluable and use them constantly. These Expressions can convert one range of values to another but in order to use them you first need to find out what range of values you are working with.

21 In the Timeline click on the **Graph Editor** button so that you can see the graph and then **double-click** on the **Slider** value for the **Both Channels** effect to activate **Free Transform** for the selected keyframes (Fig. 11.37).

A bounding box will appear around the keyframes and if you look in the **Info** panel you'll see information presented regarding the keyframes selected, this includes the minimum and maximum values displayed on the graph. Notice that the current range is between **0.0** and **42.86**. If we also look at the graph itself we can see that during most of the animation the minimum value is around **5**. We can tell this by looking at the peaks and troughs of the graph.

Fig. 11.37

22 Zoom into the Timeline + (until you can see space between the keyframes) and hold the cursor over a keyframe to display a little yellow box telling you the current value of the keyframe. Notice that the Info palette displays the **minimum** and **maximum** values *displayed* in the graph; when zoomed into the graph it updates automatically (Fig. 11.38).

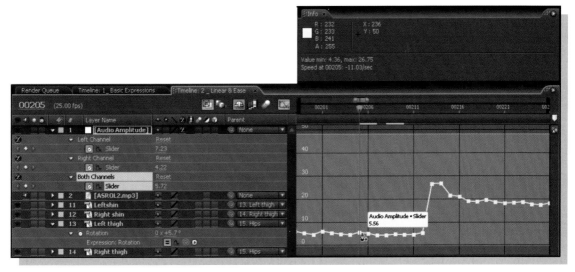

Fig. 11.38

So, we have determined that the range of values that we are working with are between 5 and 43, we need to convert that range of values to a range between −10 and 10.

23 Adjust the Expressions for the **Left Thigh Rotation** so that it reads a = thisComp.layer ('Audio Amplitude').effect('Both Channels')('Slider');

24 Without activating the Expressions, and making sure that the text insertion point is after the semicolon at the end of the Expressions, hit **Return** (or **Enter** on the main keyboard) to add a new line to the Expressions. Do not activate the Expressions yet.

Expressions Language Menu

25 Click on the **Expressions Language Menu** button in the **Timeline** (Fig. 11.39).

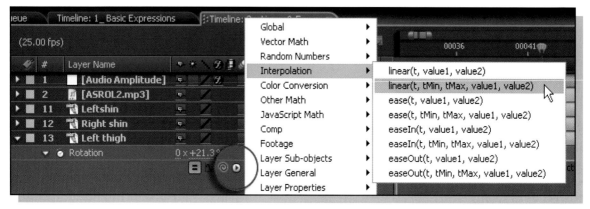

Fig. 11.39

26 Go to the Interpolation section and choose `linear(t, tMin, tMax, value1, value2)`. A new line will be added to your Expressions but don't activate the Expressions yet otherwise you may get a warning; we still need to edit this a little more for it to work.

In order to get the linear Expressions to work we need to alter the text within the parentheses (or 'brackets' as I've always wrongly called them – apparently!)

So, let's break it down to see how this needs to be adjusted.

The letter `t` in between the parentheses needs to be substituted with the value at the current time. We have used the letter `a` as a variable to equal the value at the current time so we can use this as the substitute.

`tMin` needs to be substituted with the current minimum value which we determined is `5`.

`tMax` needs to be substituted with the current maximum value which we determined is `43`.

`Value1` needs to be substituted with what we wish our minimum value to be which is `-10`.

`Value2` needs to be substituted with what we wish our maximum value to be which is `10`.

27 Adjust the Expressions for the **Left Thigh Rotation** so that it reads:

```
a = thisComp.layer('Audio Amplitude').effect('Both Channels')
('Slider'); linear(a, 5, 43, -10, 10)
```

28 RAM Preview to see the leg animate between −10 and 10 degrees.

29 Add an Expressions to **Right Thigh Rotation** and use the **Pickwhip** to link to the **Left Thigh Rotation** (Fig. 11.40).

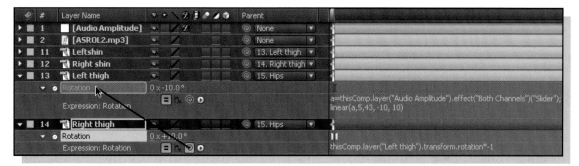

Fig. 11.40

30 Add `*-1` to the end of this Expressions to make the **Left Thigh** animate in the opposite direction from the **Right Thigh**.

31 Finally, add **Expressions** and use the **Pickwhip** to link the **Left Shin Rotation** to the **Right Thigh Rotation** and the **Right Shin Rotation** to the **Left Thigh Rotation** (Fig. 11.41).

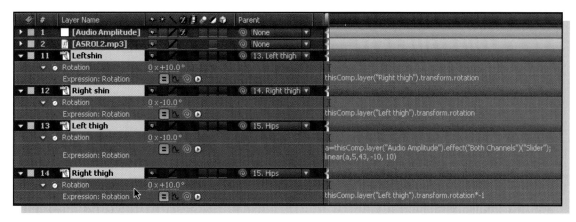

Fig. 11.41

32 **RAM Preview** to see the result. Taking the **Shin's** animation from the opposite thigh gives the effect of inverse kinematics.

Lip synching

Many of the jobs I am contracted to undertake are low-budget, fast-turnaround jobs; these are my bread and butter. To suit this kind of work you need to be flexible, resourceful, and have the ability to stick to both budget and deadline. If you can do all of this your clients will keep coming back for more because they know they can rely on you.

The following tutorial is based upon an example of exactly that kind of job. The client was a major TV network in the UK, they rang me in a desperate state. The requirement was to create one minute

of 3D, lip-synched animation in three days. Everyone else they had rung said the job couldn't be done in the time given for the budget provided. I reckon that clients come to me when everyone else has turned a job down!

Always one to relish a challenge, I eagerly agreed to do the job and then immediately began worrying about how I was going to execute it! I spent a day trying out various options using 3D animation software but every technique I attempted was just too time- consuming in both lip-synch technique and rendering time. I went to bed that night unable to sleep from the worry, I'd accepted this job from a major TV network, if I let them down my whole reputation would be at stake, I had to find a solution!

I tossed and turned till about 4 o'clock in the morning, frantically sweating, when, finally the moment of inspiration hit me. I remembered seeing a technique used on Brian Maffit's wonderful Total AE tapes that used Motion Math scripts to synch masked mouth shapes with audio levels. 'Wait a minute!' I thought, 'Surely I can use the Convert Audio to Keyframes in conjunction with Time Remapping on some 3D animation to achieve similar results?' I eagerly ran downstairs to my studio and switched on the computer to try out the technique that was in my head. To my surprise and delight the technique worked perfectly first time. And the project I am about to show you is exactly the same one that I put together that very night.

My idea was to create a few simple phonemes (phonetic mouth shapes) in my 3D software. For these tests I used Curious Labs Poser to create this simple animation of a dog. I then took this short animation into After Effects and placed it into a new project.

1 Open **Dog Talk.aep** from the **Training > Projects > Chapter 11** folder.

2 From the **Project** panel, open the **01_Talking Dog** start composition and **RAM Preview** it. You'll see a few seconds of some 3D animation accompanied by some music.

This music was made by a good friend of mine, and very talented musician, Jason Levine. The song is called 'Memories Of Your Own' – Words & Music by Jason A. Levine ©1995/2005 Jason A. Levine/Boodah Joo Music (BMI) ℗ 2005 Boodah Joo Music (BMI).

Notice that the animation lasts for about four seconds and consists of a 3D dog opening and closing its mouth. I realized that I could open and close the mouth of the dog by scrubbing the time of the clip backward and forward.

3 In the **Timeline**, scrub the Timemarker backward and forward to open and close the dogs mouth. The next task was to find a way of keyframing the time moving backward and forward like this.

Time Remapping allows you to animate time, you can keyframe the timing of a layer to speed it up, slow it down, move backward, forward, or freeze time completely.

4 Select the **DogTalk.mov** and then go to **Layer > Time > Enable Time Remapping** (Fig. 11.42).

5 **Double-hit** the r key to open up the **Time Remap** property in the **Timeline**.

You'll notice that the Time Remap value has two keyframes, one at the start of the clip and the other at the end. You'll also notice that the layer can now be extended to the end of the comp.

6 Click and drag the **Layer Trim** handle to the **end** of the **Timeline** (Fig. 11.43).

7 **RAM Preview** the comp and notice that the clip remains on a still frame after the final keyframe.

8 Click and drag the last **keyframe** to the **end** of the **Timeline**.

9 **RAM Preview** the comp and notice that the clip now plays in slow motion. This is because we are stretching the original animation out over a longer period of time (Fig. 11.44).

I want the dog's mouth to be open when the audio levels are loud and closed

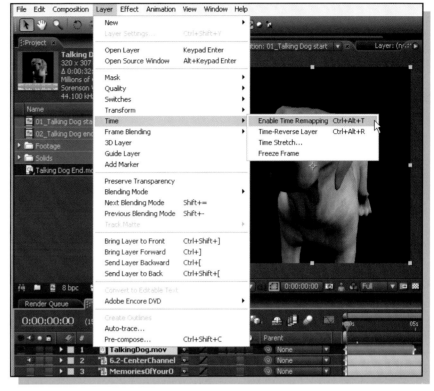

Fig. 11.42

Fig. 11.43

Fig. 11.44

when the audio levels are silent. To automate this process I decided to use the Convert Audio to Keyframes assistant.

10 In the **Timeline,** switch off the **Audio** for the **6.2-CenterChannel-MemoriesOfYou** layer and switch on the **Audio** of the **MemoriesOfYourOwn-SilencedGaps** layer.

I have used the **Edit Original** function on this layer to open it up in Adobe Audition (Windows only). In Audition I used the **Center Channel Extractor** to remove the instrumentation from the track so that I am left with vocals only. We'll use this layer to create the keyframes to control the Time Remap value.

11 Select the **MemoriesOfYourOwn-SilencedGaps** layer and then go to **Animation > Keyframe Assistant > Convert Audio to Keyframes**. It will take a minute or so to create the keyframes for you.

12 Select the new **Audio Amplitude** layer and hit the **U** key on the keyboard to open up the property and its keyframes.

13 **⌥** **alt** – click on the **Time Remap** property stopwatch in the Timeline to add an Expressions to the property.

14 Drag the **Pickwhip** from the **Time Remap** property to the **Both Channel's > Slider** property on the **Audio amplitude** layer (Fig. 11.45).

Fig. 11.45

15 RAM Preview and notice that the animation is not working properly.

16 In the Timeline click on the **Graph Editor** button at the top of the Timeline so that you can see the graph and then **double-click** on the **Slider** value for the **Both Channels** effect to activate **Free Transform** for the selected keyframes (Fig. 11.46).

Fig. 11.46

Notice that the Info panel is displaying a minimum value of 0 and a maximum value of **15.31** (Fig. 11.47). Animating to a maximum value of **15.31** will not work because our original animation was only about **four** seconds long, we need our maximum value to fall between **zero** and **four** seconds in order to work. Because the main bit of movement happened between zero and one second, we'll choose that section of footage to work with.

Fig. 11.47

17 Click on the Graph Editor button again to switch it off so that you can see your Expressions and then edit the Expressions on the Time Remap value so that it reads:

```
a = thisComp.layer
('Audio Amplitude').
effect('Both Channels')
('Slider'); ease
(a,0,15.31,0,1)
```

By doing this we are converting the current range between **0** and **15.31** to a range between **0** and **1** (Fig. 11.48).

18 **RAM Preview** the animation to see the mouth open and close in time with the vocals.

19 Click the **Frame Blending** switch twice to apply **Pixel Motion Frame Blending** to your **Talking Dog** movie (Fig. 11.49).

20 Switch on the **Enable Frame Blending** switch at the top of the Timeline to activate it for the composition (Fig. 11.50).

Pixel motion works by analyzing the pixels in intermediate frames and creating motion vectors from this information, this produces very smooth results.

21 **RAM Preview** the comp with **Frame Blending** applied to see the difference.

22 Open the **02_Talking Dog** end comp from the **Project** panel.

Fig. 11.48

Fig. 11.49

Fig. 11.50

In this comp I have added a couple of extra steps to improve the results. I have converted the keyframes to Auto-Bezier creating a different kind of interpolation. You can also try using the Smoother panel on the Audio Amplitude layer's Both Channels keyframes to soften the results.

This is a good, quick, and dirty technique for lip synching. You'll be pleased to know that I did get the job finished within the deadline!

 I've used this technique in other jobs to create animation from sound effects. For example, in one job that I did for the BBC I used the sound of a hammer tapping to create Rotation keyframes for my character's arm, it's amazing how many situations this comes in useful.

More looping animations

1 Open **loop walk.aep** project from the **Training > Projects > Chapter 11** folder.

2 RAM Preview the **01_Character Animation End** comp to remind yourself of the looping animation that we created back in the **Paint** chapter (Chapter 10) (Fig. 11.51).

Fig. 11.51

What we really need is a method that uses the loop Expressions to loop the brushes' Shape keyframes. The trouble is that (at the time of writing) it is not possible to use Expressions on the Brush Shape property. Never fear though, I've figured out a workaround that you can use! This technique uses Time Remapping.

3 In the **Project** panel, drag the **01_Character Animation End** comp onto the **New Comp** button to nest it into a new comp so that it appears there as a single 2D layer (Fig. 11.52).

4 Hit ⌘ K ctrl K to open up the Composition Settings panel. Change the name of the comp to **Looping comp**. Change the duration to **176 frames** and then click **OK**.

5 In the **Timeline**, drag the **Navigation** slider all the way to the **left** to zoom out the **Timeline** (Fig. 11.53a).

6 In the **Timeline**, select the **01_Character Animation End** layer and then go to **Layer > Time > Enable Time Remapping** ⌘ O T ctrl alt T.

Fig. 11.52

Fig. 11.53a

As soon as you do this the Time Remap property appears with two keyframes at the **In** and **Out** points of the layer. You can tell that there is extra footage available by holding the cursor to the right of the Out point, if extra footage is available you will see the Slide **Edit** tool appear (Fig. 11.53b).

7 Drag the **Out point** of the layer toward the right till the layer fills the whole length of the comp (Fig. 11.53c).

Fig. 11.53b

Fig. 11.53c

8 In the **Time Controls** panel, change the **Loop Mode** button to **Loop** which is a cycle loop, in other words it will continue to cycle but each time the loop reaches the end it will jump suddenly back to the start.

9 **RAM Preview** and notice that the character goes through one cycle and then remains on a black frame held for the remainder of the duration. We need to get rid of the last black frame.

10 Move to **frame 21** and then click on the **Add or Remove Keyframe at Current Time** button to create a **keyframe** for the current value (Fig. 11.54).

11 Select the keyframe at **frame 22** and hit the *Delete* key to delete it.

12 **RAM Preview** again and notice that the animation now holds on the last frame of the animation till it reaches the end of the comp.

We want to use Time Remapping to determine our loop, and then use the loop Expressions to loop our Time Remap value.

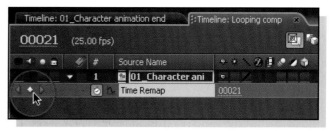

Fig. 11.54

529

13 ⟨⟩ *alt* – click on the **Time Remap** stopwatch to add an Expressions to the property.

14 With the Expression's text selected, click on the **Expressions Language Menu** button and go to **Property** > loopOut(type = 'cycle', numKeyframes = 0) (Fig. 11.55).

Fig. 11.55

15 Edit the **Expressions** so that it reads: loopOut(type 5 'pingpong', numKeyframes 5 0).

16 **RAM Preview** the animation to see the results. The character is now walking for the whole duration of the comp. The nice thing about Expressions is that they update easily, for example, if you want to speed up the walk, simply drag the keyframes closer together, and the whole animation will update. To slow down the walk – just drag the keyframes apart.

Basic motion capture

You can use the Motion Sketch panel in conjunction with Expressions to create all sorts of interesting animations that would otherwise be very tricky to produce.

The Motion Sketch panel is available in both Standard and Professional versions of After Effects. It allows you to capture any motion you make with your input device, this can be a mouse or a graphics tablet and pen. I find it much easier to use Motion Sketch with my trusty Wacom tablet rather than a mouse which can be quite cumbersome to move around. If you have never used a graphics tablet before I thoroughly recommend investing in one, they are much easier and more creatively flexible to use than a mouse. They take a little time to adjust to and once you've started using one, you never want to go back. You can find out about the whole Wacom range of tablets at http://www.wacom.com

To use Motion Sketch the first step is to click once on the Start Capture button in the Motion Sketch panel to let it know that you want to capture some motion. With the button clicked, After Effects will not begin to capture the motion until you click again at the point where you wish to begin your animation. As soon as you click the mouse or pen again, anywhere on the screen, After Effects will start to record the motion, it will stop recording when you release the mouse button or lift the pen from the tablet.

1 Open Motion Sketch.aep project from the **Training** > **Projects** > **Chapter 11** folder.

The first comp we'll look at is a practice comp, it has a single layer inside it which is a bee that I put together in Photoshop, then animated in After Effects.

2 Open the **01_Motion Sketch** comp and then go to **Window** > **Motion Sketch** to open up the **Motion Sketch** panel (Fig. 11.56).

3 Select the **Queen Bee** layer and then move over to the **Motion Sketch** panel.

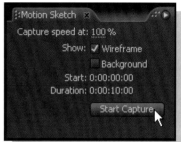

Read through the next couple of paragraphs so that you are aware of what the process is before starting to capture the movement you make with the pen or mouse. You may need a fair bit of practice before getting this absolutely right but don't give up, repetition is the best method for improving your techniques.

Move your pen or mouse over the Comp panel, taking care not to accidentally click the mouse button or touch the graphics tablet as you do. Position the cursor where you would like to start the motion capture from.

Fig. 11.56

4 Click on the **Start Capture** button (Fig. 11.56).

5 When you are ready, click the mouse button or pen and then move it around the screen as you would expect a bee to move – erratically and quickly.

6 When you have finished **RAM Preview** the movie to see the results.

7 To make the bee face in the correct direction as it travels, go to **Layer** > **Transform** > **Auto-Orient** and choose Orient along Path (Fig. 11.57).

Fig. 11.57

8 Click on the **Enable Motion Blur** button for the comp and then **RAM Preview** to see your bee fly around the screen.

9 Click on the **Shy** button at the top of the Timeline to expose the hidden layers that I have included here.

Fig. 11.58

10 Switch on the **Video** switches for the **Cloudy Sky** and **Bee Swarm** layers so that they are visible in the Comp panel (Fig. 11.58).

There are three additional layers. A **Cloudy Sky** background that I made using the **Offset** filter on a flat PSD file that I then adjusted in 3D to get a nice feeling of depth; and a **Bee Swarm** layer which is using the final layer; **WeBee.mov** as a layer map to create a swarm of bees using the **Particle Playground** effect.

11 RAM Preview the animation and notice that the particles are following the bee wherever it goes. Let's take a look at how that is done.

12 Select the **Bee Swarm** layer and double-hit the e key to open up the Expressions applied to this layer. This is a very simple Expressions linking the **Brush Position** property of the **Bee Swarm** layer to the **Position** value of the **Queen Bee** layer: `thisComp.layer ('Queen Bee').transform.position`.

Any effect property that has a positional value can be linked to Position keyframes in this way, these include: Lens Flares, Lightning effects, Bulge, and other Distortion Filters.

Handwriting

Although you can create animated handwriting using Paint, it is fairly inflexible after it has been painted as the vectors cannot be adjusted. Using the following technique it is possible to adjust the shape of your handwriting after it has been drawn.

13 Open the **02_Handwriting comp** and then go to **Window > Motion Sketch** to open up the **Motion Sketch** panel. You will see a single square **White Solid** in the Comp window.

14 Select the **White Solid** and then move over to the **Motion Sketch** panel.

15 Click on the **Start Capture** button and then move over to the Comp window.

16 Write your name with the pen or mouse in joined up writing, do not lift the pen or mouse till you have finished writing your name (Fig. 11.59).

Fig. 11.59

17 Click on the **Shy** button at the top of the Timeline to expose the hidden layer that I have included here.

18 Switch on the **Video** switch for the **Write On layer**.

19 Select both layers and then hit the **U** key on the keyboard, this should open the **Position** property of the **White Solid** and the **Brush Position** value of the **Write On** layer.

20 **∇** **alt** – click on the **Brush Position Stopwatch** to add an Expressions and then drag the **Pickwhip** over to the **Position** value of the **White Solid** layer (Fig. 11.60).

Fig. 11.60

21 **RAM Preview** to see the text being written on screen (Fig. 11.61).

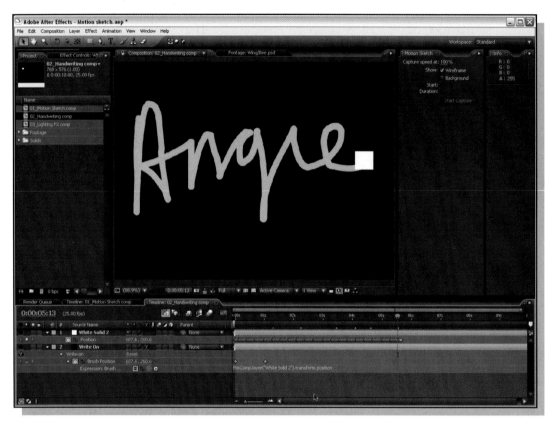

Fig. 11.61

22 If you want to make adjustments to the shape of the path that controls the text, select the **Position** property in the **Timeline** so that you can see it displayed in the Comp window. And then individually select the keyframes that you want to adjust and adjust them in the same way as you would any other positional path (Fig. 11.62).

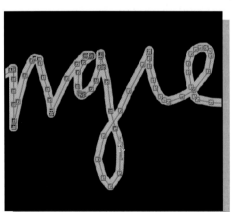

Fig. 11.62

Controlling other properties

23 Open up the **03_Lighting FX** comp and preview it.

This is a fairly boring and basic composition. I've created the neon-lit text with the Vegas effect. I've also use the **Cell Pattern** effect to create the blue neon background effect. It lacks movement and excitement, to make it more realistic I want to make the lights flicker and glow erratically.

24 Hit the **Shy** button to open up the hidden layers.

25 Select the **Las Vegas Outline** and **Background** layers, and then **double-hit** the **E** key to open up the Expressions that I have already created on these layers (Fig. 11.63).

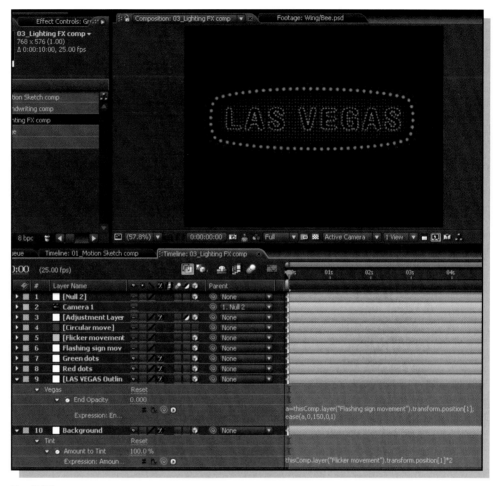

Fig. 11.63

26 Switch on the **Circular Move, Flicker Movement**, and **Flashing Sign Move** layers and hit their **Solo** buttons.

27 **RAM Preview** these layers. Each one makes a different move that I have done using Motion Sketch and my Wacom tablet. I'll use these moves to control the lighting on this sign.

28 Switch off the solo buttons and then switch on the Expressions on the **Las Vegas Outline** and **Background layers**.

29 RAM Preview to see how the movement is controlling the lighting. All I've done is to link the Opacity settings of the effects to the Y Position values of the solid layers, this way I can achieve a very organic looking flicker, as opposed to a computer-generated one.

30 Finally, switch on the **Adjustment layer**, this contains a glow that is controlled by the Position value of the Circular move layer. Switch on the **Camera** layer and switch off the three control layers before **RAM Previewing** the final animation (Fig. 11.64).

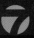

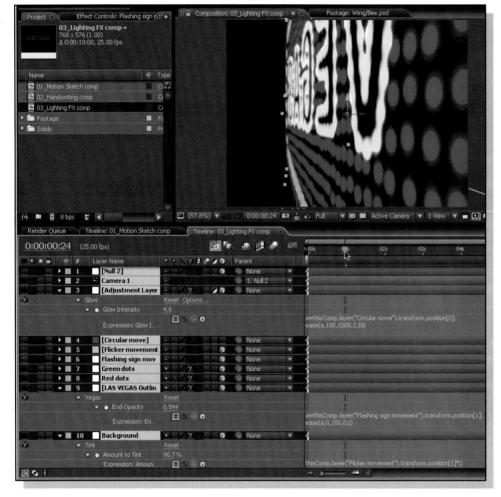

Fig. 11.64

There are loads of other tricks that you can do with your Wacom tablet and the Motion Sketch panel. Try this for an experiment.

31 Tie a piece of string or elastic to your Wacom pen, then position the pen over the Comp window, ready to capture the movement that you are about to make.

32 Click once on the **Start Capture** button in the **Motion Sketch** panel.

33 Dangle your pen over the tablet so the movement is being registered on the screen.

34 With the other hand, click and hold your mouse button till you have captured the movement you want.

As long as the mouse button is held down, Motion Sketch will capture whatever the pen is doing over the tablet. This is a great way of getting great moves. I've even been known to use clockwork toys to create weird and wonderful movements this way.

As I mentioned in the Paint chapter (Chapter 10), remember that you can also use drawing implements with your Wacom tablet, for example, holding a ruler at the bottom of the tablet and

using that as an edge to slam your pen against can be an easy way to get a kind of 'thudding' velocity that is very difficult to achieve with the graph editor.

Finally, the last thing to mention is that, if you would wish to convert your Expressions back to keyframes, you can by selecting the property and then going to **Animation > Keyframe Assistant > Convert Expressions to keyframes** (Fig. 11.65).

Recap

So we've reached the end of the Expressions chapter; you should now have a pretty good

Fig. 11.65

understanding of the basics of the Expressions language, which will serve you well as you move on to creating your own Expressions.

What we've covered in this chapter is really only the tip of the iceberg in terms of what you can do with Expressions. If you're interested in finding out more, there are several resources you can use to further your knowledge. You'll find a selection of additional tutorials on my website at: www.creativeaftereffects.com, showing you some more ways you can use Expressions. These will also help if you want to go back and figure out how we created some of the more advanced Expressions we've been slipping into the projects you've gone through in the chapter.

After Effects' online help is also very useful as a reference tool, providing a complete list of the Expressions commands that are available to you. I'd also encourage you to share your Expressions with other After Effects' users; one of the best ways of learning how Expressions work is to check out as many examples as you can. Taking someone else's Expressions and modifying it to suit your own needs can be a great timesaver. It's a really good thing to be able to share your knowledge with others. Whatever you give out, you'll get back 100-fold, believe me. Don't make the mistake of feeling that you have to keep all of your new-found knowledge to yourself, otherwise you'll end up limiting yourself and cutting yourself out from a potentially very helpful and sharing community of fellow artists and designers.

Working with other designers on projects is much more fun than being stuck at a desk on your own. Plus, it helps to bounce ideas off other people when going through a creative block, sometimes all you need is a bit of encouragement and to see things from another point of view. I have found that the most knowledgable and talented designers I have met seem to be the same people who are prepared to share ideas and co-operate with others. Often, the act of hiding ideas and an unwillingness to share are signs of insecurity and lack of confidence, and that's not the reader I know and love!

OK, see if you can develop some more ideas for your own project. Have a good old play around with what you've learned and see what you can come up with. Good luck!

Inspiration – Treehouse: Lucy Scott and Tom Ellis

Treehouse

Treehouse 24 was founded in 2005 by Lucy Scott and Tom Ellis. Treehouse provide a complete visualizing service – shooting boards, storyboards, illustration, animatics and animation.

Tom Ellis did a BA Hons in Product Design at Central Saint. Martins Art College in London. His business partner, Lucy Scott completed a BA Hons degree in Drawing and Painting, she also gained a Post Graduate Diploma and Master of Fine Art at Edinburgh College of Art.

Together they have eight years experience in the TV/Advertising industry working on campaigns for BBC, Coca Cola, Walls, Cadburys, Sony, Budweiser, Mastercard, Nokia, Vodafone, Argos, Adidas, and many more.

www.treehouse24.co.uk

studio@treehouse24.co.uk

Lucy

Lucy

Q How did your life lead you to the career/job you are now doing?

A I spent six years at Edinburgh College of Art doing a BA Hons in Drawing and Painting then a Master of Fine Arts. I exhibited for a couple of years and worked in various jobs before moving to London in 1999.

With the knowledge that I was fairly unemployable I enrolled in a part-time computer graphics course where I learned Photoshop, Illustrator, and Quark. I started work as a freelance storyboard artist for a young storyboard agency in Soho where my computer skills proved invaluable, I spent the next six years there as Studio Manager during which time the company became one of the largest and most successful agencies in London. I recently left to start my own company Treehouse 24 with a friend and colleague, we produce storyboards, animatics, and animation.

ContactSheet-Whiskas

Q What drives you to be creative?
A I think it's exactly that 'a drive' and as such you don't have much choice in the matter.

Q What would you be doing if not your current job?
A Before computers and storyboards I worked in the art department on short films and music videos, I really enjoyed it so probably something in that field.

Q Do you have any hobbies/interests and if so, how do you find time for them?
A Because I never know when work is going to come in, it's impossible to plan anything. I also work ridiculous hours so it's lucky that my job covers a lot of my interests. When I'm not busy I can draw, animate, make my own stuff.

Q Can you draw?
A I hope so (Yes says the author!)

Q If so, do you still draw regularly?
A Everyday.

ContactSheet-ITC

Q What inspires you?
A I'm inspired everyday when I come into my office, it's a beautiful quiet space in the middle of Soho, everything I need is in one place, I can just sit down and work.

Q Is your creative pursuit a struggle? If so in what way?
A Making work is often a painful process, but I love it.

Q Please can you share with us some things that have inspired you. For example film, song, web site, book, musician, writer, actor, quote, place, etc.
A I'm inspired by people's talent, when I see or hear or read something brilliant it makes me want to keep trying.

Q What is your most over-used AE feature/filter?
A Fractal noise.

Q What would you like to learn more about?
A Honestly everything.

Tom Telephones

Tom

Q How did your life lead you to the career/job you are now doing?

A I moved to London to study a Foundation Course and then a Product Design Degree at Central Saint Martins. After I graduated in 2003 I was unsure as to exactly what to do next until I got a job at the D&AD Awards in 2004. Here I got an excellent overview of some of the best work across a range of mediums and I met some fantastic people. I then got a job at a great storyboard company in Soho where I got the opportunity to learn about animation and really improve my drawing and computer skills. At present I am running my own company, called Treehouse 24, with a friend and colleague. We produce storyboards, animatics, and animation.

Q What drives you to be creative?

A Doing a job I love.

Q What would you be doing if not your current job?

A I don't know. Probably trying to make it as a product designer.

Tom Ipod

Q Do you have any hobbies/interests and if so, how do you find time for them?
A My job covers most of my main interests. Working for myself allows me the time to experiment, learn, and always improve. It's hard to find time for much else away from work but I go to see live music whenever I get the chance and I read as much as I can on the bus.

Q Can you draw?
A Yes, I think so.

Q If so, do you still draw regularly?
A Everyday at work.

Q What inspires you?
A People who make nice things.

Q Is your creative pursuit a struggle? If so, in what way?
A Sometimes the time restrictions on storyboarding can be frustrating but it's not really a struggle at all.

Tom City

Q Please can you share with us some things that have inspired you. For example film, song,
 web site, book, musician, writer, actor, quote, place, etc.
A So many things but if I had to pick out one in particular it would be a short animated film by
 Stuart Hilton called 'Save me' from 1994. I am really interested in how the use of sound and
 music can affect the interpretation of a film and Hilton explores this beau. Abstract shapes
 and scribbled drawings are brought to life through attention to tiny animated detail and
 sound effects. He expertly mixes drawing with photography and film to create something
 that is chaotic and exciting but also funny and sad and thoughtful. It made me want to be an
 animator.

Q What is your most over-used AE feature/filter?
A Masks.

Q What would you like to learn more about?
A Stop motion animation.

Chapter 12 **Output**

Fig. 12.1

Once you have finished creating your masterpieces you will need to output them for their final destination format. We covered the basics of rendering movies and archiving projects in the Basics chapter (Chapter 02) but here we will go into more detail regarding the various different output options in After Effects and a few things to watch out for.

Synopsis

There are no definitive rules for output settings, the settings required for each individual situation will differ depending on a whole multitude of variable factors. Each individual will have different needs and requirements in regard to output formats so I have decided to concentrate on teaching you how all the output options in After Effects work; it'll then be up to you to discover exactly what is required for your own particular situation. Let's start by refreshing our memory of the Render Queue; we'll use the Seattle News project that we finished in the Text chapter (Chapter 08).

Rendering your movie

1 Open **SeattleNewsEnd.aep** from **Training > Projects > Chapter 12_Output**.

2 Select the **Seattle Evening News** comp in the **Project** panel and then go to **Composition > Add to Render Queue** ⌘ *Shift* ⁄ *ctrl* *Shift* ⁄ . Choosing Add to Render Queue has the same result as choosing Make Movie from the same menu. The added benefit of using Add to Render Queue is that you can apply it to multiple selected items in the Project panel (Fig. 12.1).

We'll render out two different versions of the same movie. When a project is finished, I usually render out a copy of the movie or image sequence at the best quality with no compression, this way I have a perfect copy of the work that I can re-format at any time and for any use, simply by running it through batch compression software.

When I deliver my final movies to my clients, I usually provide them with a totally uncompressed version for their archives. Because most of my movies are pretty short, I can usually fit them uncompressed onto a DVD which is a great, cheap, and easy way for me to deliver my material. The client can then re-format the movie for any purpose required.

Third-party codecs

Avid, amongst other companies, have their codecs freely available to download from their web site. By simply installing the required codec onto my system and rendering out from After Effects using the appropriate settings, I can format my work for virtually any editing system I choose. This means that the file sizes are usually smaller, and the editor doesn't have to suffer delays when importing my footage into his/her system.

In the **Render Queue** window, there are two main sections. The top section gives you information regarding your renders, the bottom half of the panel is the queue itself, this is where you can arrange the order of your renders, adjust settings, etc.

Render Settings

3 In the bottom section of the Render Queue, click on the text **Custom** from the **Render Settings** drop down menu. The **Render Settings** panel will open up (Fig. 12.2).

After Effects goes through two separate processes when you output your footage. First of all it renders the footage, then it formats the footage for a specific purpose. The Render Settings determine the settings used to render the frames.

Fig. 12.2

The top **Composition** section of the Render Settings dialog determines the composition settings used for the render. Here you can override settings used in the Composition or Project settings. These include: Quality, Resolution, Proxy Use, Effects, Solo switches, Guide Layers, and Color Depth. Each of these have several options to either keep the **Current Settings** used within the comp, Switch features **All On** or **All Off**. In some cases, such as **Color Depth** you can choose the exact settings you require.

The middle section is the **Time Sampling** section, this is where you can determine the Frame Rate, **Start time**, **End time**, and **Duration** of your final output. On the left of this section you have settings for Frame Blending, Field Render, Motion blur, **3:2 Pulldown**, and **Timespan** of your comp. These work similarly to the settings in the top section in that they allow you to override settings made in the original composition.

4 Make sure that you have the same settings as I have here by changing the **Effects** menu to **All On** and then click **OK** (Fig. 12.3).

Making templates

Once you have changed a setting it makes sense to save it as a template as it is more than likely that you'll have to use those settings again. It always seems like a real hassle to save templates and workspaces, I'm the worst at it, I'm always telling myself that I'm too busy to save templates! I then regret saving them when I have to repeat the same processes over and over again. So, do as I say, not as I do, then you'll go far! By taking a little bit of time to save templates in the beginning, you'll save bucket-loads of time in the end.

5 Click on the **Render Settings** drop down menu in the **Render Queue** panel, here you will see several preset templates that come free with After Effects. Although some of these templates are useful I think it pays to create your own using your own personal settings and naming conventions.

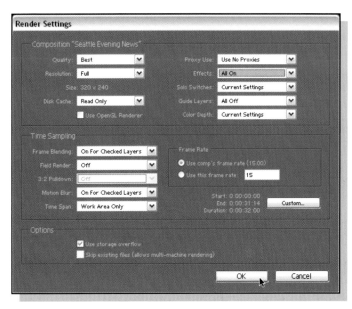

Fig. 12.3

6 Choose **Make Template** from the menu and you'll see the **Render Settings Templates** dialog. After Effects allows you to set up templates for your most commonly used settings (Fig. 12.4).

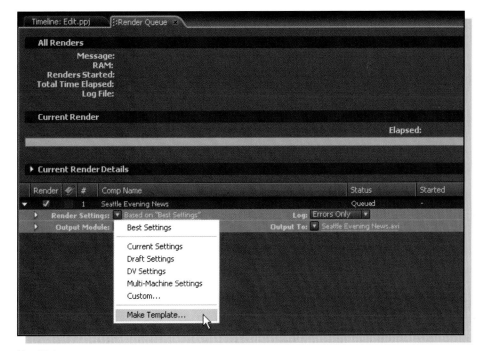

Fig. 12.4

The **Render Settings** and **Output Module** templates do not have a physical location in the application folder like other kinds of After Effects templates and presets do. These templates will automatically appear in the **Render Settings** dialog, in the **Render Queue**, and also in the **Settings** pop up in the **Render Settings Templates** dialog. But you need to take the extra step of saving them to create a file that you can use across different systems, this is extremely useful for freelancers like myself who move from system to system on a daily basis.

7 In the **Render Settings Templates** panel, change the **Settings Name** to **Effects all On** and then click on the **Save All** button (Fig. 12.5).

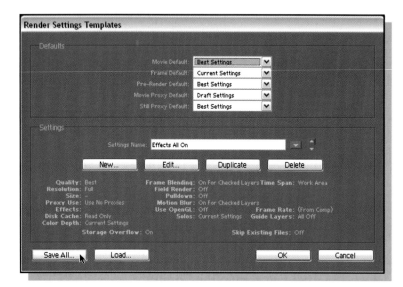

Fig. 12.5

In the **Save Render Settings Template** dialog that appears you will now be given a chance to save all of your templates as one single text file. This file can be moved to other workstations so that you can always be sure to have your own personal settings wherever you work. The file type is an ARS file. (If you are from the UK you can stop laughing now!)

8 Create a new folder named **Render_Output Templates** inside your **Documents** folder. Give the file. a name that means something to you, I have called mine **Angie.ars** (now behave!) (Fig. 12.6).

You may have also noticed at the top of this window, there is a section named **Defaults**. This is where you can choose the default settings for your Render Settings. If you decide that you will be using the Effects All On setting for most of your movies then you can make that happen by selecting it in the movies menu. Included are settings for all the various output needs.

To use the saved templates in After Effects on another computer, you need to use the Load button in the **Render Settings Templates** dialog.

9 Click the **Save** button in the **Save Render Settings Templates** dialog and then click OK in the **Render Settings Templates** dialog to leave.

Fig. 12.6

Output modules

The **Output Module** settings work in a very similar way to the Render settings but they determine how the frames will be formatted once they have been rendered.

10 Click on the **Output Module** drop down menu and look at the list of templates that are already listed. The list that you see here will differ depending on your operating system (Fig. 12.7).

11 Select **Make Template** from the list to open up the **Output Module Template dialog**. There is no need to set up the output modules before entering the Template panel as you are given an option to change your settings before saving. This is also true with Render Settings.

Fig. 12.7

12 In the **Output Module Template dialog** type in **Uncompressed QT** as the **Settings Name**. We'll set up a template for using absolutely no compression on output.

13 Hit the **Edit** button to bring up the **Output Module Settings** dialog box which you will already be familiar with from the Basics chapter (Chapter 02).

14 At the top of the window, choose **QuickTime movie** in the **Format** menu and then, in **Post Render Action** choose **Import**. This will import a reference to the movie into your finished project (Fig. 12.8).

15 In the **Audio Output** section, check the **Audio Output** checkbox to enable the output of audio from your comp. Make sure that the settings are at **48.000 kHz; 16 bit; Stereo**.

16 Click on the **Format Options** button to open up the **Compression Settings** dialog box and change the **Compression Type** to **None**. With this setting, After Effects will use no compression at all on the movies that you render with this template.

Fig. 12.8

549

17 Click OK to leave the **Compression Settings** dialog box and then click **OK** again to go back to your **Output Module Templates** dialog box.

18 In the **Defaults** section at the top, click on the **Movie Default** drop down menu and choose the new **Uncompressed QT** from the list, this will ensure that the settings that you have just determined will be the default settings used when rendering out a movie from After Effects. Notice that there are separate settings for Frames, RAM Previews, Pre-Renders, and Proxies (Fig. 12.9).

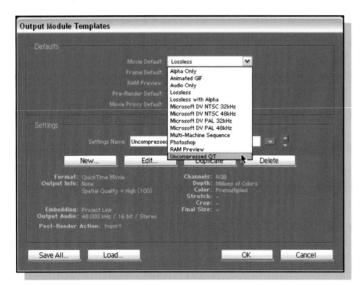

If all you need to do now is save this Output Module setting, all you need to do is click OK. However if you want to save a template as a separate file you must follow this extra step.

19 Finally, to save the settings as a file which can be kept as a backup, hit the **Save All** button at the bottom of the **Output Module Templates** box.

20 Save the **Output Module Template** as **YourName.aom** into your **Render_ Output Templates** folder.

21 Click **OK** to leave the **Output Module Templates** dialog box and then look in the **Output Module** drop down menu again, notice that the **Uncompressed QT** option is now at the top of the list.

Fig. 12.9

We've chosen our movie settings, now we need to name our movie and determine where on our hard disk we want to save it.

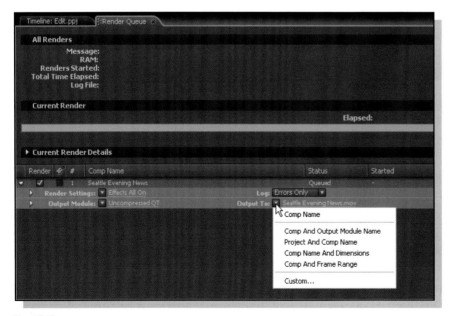

Naming files

22 Click on the **Output To** pop-up menu in the Render Queue panel and look at the list of naming convention options. Here you can choose a template that will automatically name your file using properties from the project and/or composition (Fig. 12.10).

The default template uses the Comp Name to create a name but you can choose a new default template by

Fig. 12.10

holding down ⌘ *ctrl* while choosing a template from the list. Alternatively you can rename the file manually.

23 Click on the current movie name (which should currently appear as 'Not yet specified') to open up the **Save** dialog.

24 Name the movie, **Uncomp_News.mov** and save it into your **Work in Progress** folder (Fig. 12.11).

Fig. 12.11

It will help you enormously if you stick to the same naming convention for all movies of the same type. I always prefix my uncompressed movies with **Uncomp**, this way, it's easy to group them together when performing searches.

Rendering multiple items

In the Render Queue you can set up several items to render in sequence, hence the name **Render Queue.** You can select multiple comps in the Project window and send them to the Render Queue as we did before or you can duplicate the items directly in the Render Queue. But what many people don't seem to realize is that you can set up multiple output modules for the same rendered item. This saves you time as it means that you only need to render the frames once and then use different output modules to re-format the movies as you need them.

25 Select the **Seattle Evening News** item in the **Render Queue** by clicking on its name and then go to **Composition > Add Output module** (Fig. 12.12).

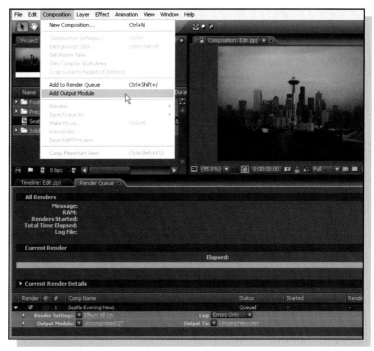

Fig. 12.12

A new output Module will appear under the one we just created. We will use this to output a low-res movie to e-mail to our client for approval.

26 In the **Output Module** section, click on the second instance of the words; **Uncompressed QT** to open up the **Output Module Settings** box.

Compression and codecs

The word *codec* is an abbreviation of compressor/decompressor. Why do we need to compress and then decompress video? Well, uncompressed video consists of multiple frames played back in sequence to give the impression of continuous movement. Each frame is a self-contained image of approximately 1–2 MB in size (depending on whether you are working in NTSC, PAL, widescreen, etc.). So, if we then multiply the file size of one frame by the number of frames per second (25 for PAL, 29.97 for NTSC) we can work out that uncompressed video needs to playback from disk at a speed of approximately 27–30 MB per second. This is also known as the data rate (i.e. the rate at which data is written to disk).

Most desktop systems cannot cope with such high data rates. You can see evidence of this if you try to playback uncompressed, full screen video on your desktop computer. The video will stutter or even grind to a halt. This is (in basic terms) because the hard drive cannot run fast enough to playback that amount of material from the hard disk every second. Compression is also required when capturing video, or printing your video back to tape. Most people working with desktop video will have accelerated hard drives on their systems, these allow them to achieve faster data rates and therefore use less compression on their footage. These systems will process the video fast enough to write one frame on to tape 25 times every second (for PAL; 29.97 times every second for NTSC).

There are uncompressed video solutions available for After Effects which allow you to capture footage directly into After Effects without having to use a NLE. SDI stands for Serial Digital Interface, this has a transfer rate of 270 MB per second so very fast hard drives are essential before you consider investing in a SDI Option. SDI-enabled video cards provide you with an interface within After Effects which allows you to capture and playback uncompressed footage directly from a Digibeta or Beta SP deck. The quality of the footage captured via SDI is fantastic, particularly footage captured from the analog Beta SP format.

Codecs work by compressing the footage when it is written to the hard disk or to videotape and then decompressing it again when it is played back. There are two basic types of compression: Temporal and Spatial.

Spatial compression works by comparing the frames within your movie and reducing the amount of colors used by creating averages of colors which are very similar to each other. The results from Spatial compression can sometimes appear blocky. This type of compression is best used on animations containing large areas of flat color, for example 2D animation.

Temporal compression algorithms also compare frames, if the codec finds identical areas in sequential frames it will just repeat those areas rather than re-draw them, this will reduce the file size and improve playback speed and performance. This sort of compression works well with footage shot from a fixed camera where the background remains static and therefore repeated does not alter much from frame to frame.

There are lots of different codecs available, each codec has its own area of excellence and excels at compressing a particular type of footage. Some codecs are specifically designed for use with TV and video. Other codecs are designed for use with footage used for CD-ROM and DVD-ROM output.

Some codecs are designed for use with footage designed for the web, others are specifically for DVD playback. There are also audio codecs, specifically designed for reducing data rates of audio files.

If you have a video capture card installed on your system, the codecs for using with the card will have been installed when you installed the card's driver. Once installed, this codec will be available from the list of codecs in the After Effects Output Module Settings window. If you are outputting the movie back to tape via your video card, you would choose to render with the card's own codec.

As video cards and codecs are being constantly developed and improved upon it doesn't make sense to include specific information and recommendations in the pages of this book as the information may become out of date. Instead I recommend that you use the URL links on my web site to find out more about what is currently available: http://www.creativeaftereffects.com

For more information about using codecs in After Effects, see the **Supported file formats for output** and **Adobe Media Encoder Video options** document in the online help system.

For a list of other available codecs visit the Adobe web site customer support section, also stop here for technical documents, tips, advice, etc:
> http://www.adobe.com/support/main.html
> http://www.adobe.com/studio/main.html

. . . or search the Adobe Knowledgebase for documents relating to codec or compression in After Effects:
http://www.adobe.com/support/products/aftereffects.html

We're going to use the Sorenson Video codec which is commonly used for Quicktime movies for the web. It's quite a lossy codec but it usually maintains an acceptable level of compression considering the reduction in data rate achieved.

27 Click on the **Format Options** button and, in the **Compression Settings** dialog, change the **Compression type** to **Sorenson**. Change the **Quality** slider to **Medium** and then click **OK** to leave (Fig. 12.13).

28 Back in the **Output Module Settings** dialog, check the **Stretch**

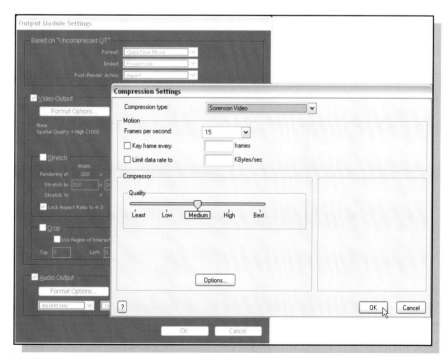

Fig. 12.13

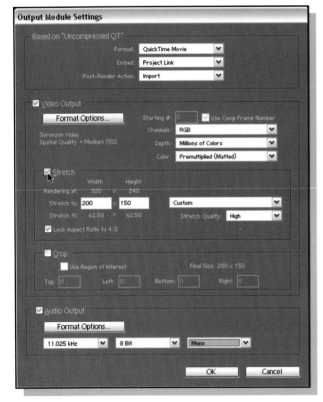

Fig. 12.14

checkbox and change the **Stretch To** values to **200 × 150** (Fig. 12.14).

29 Click on the **Audio Output** checkbox, then change the drop down menus to **11.025 KHz; 8 Bit; Mono**. Dropping the quality of the audio and video settings will greatly reduce the file sizes.

30 Click **OK** to leave the dialog and then in the **Render Queue**, click on the **Output To** option, save your movie into your **Work in Progress** folder as **LowResNews.mov**.

31 Now that you have set up your **Render Queue**, simply press down the **Caps Lock** key to lock the display in the **Comp** window and then hit the **Render** button to begin rendering your finished movies. Locking the comp window will speed up rendering slightly as the window does not have to continuously refresh during the process.

32 Open up the **Current Render Details** while the second queue item is rendering, you will see that After Effects is rendering two movies simultaneously. Well, to be precise, it's rendering the movie once and then compressing and writing it to disk twice! This method is extremely useful for comparing the results of the different codecs on a piece of footage (Fig. 12.15).

Fig. 12.15

33 Once rendered compare the movies for file size versus quality and then save your finished project as **SeattleNewsRendered.aep** into your **Work in Progress** folder. Do not close the project as we will use it in the following steps.

Exporting alpha channels

Often you will find that you need to output footage with an embedded alpha channel. The alpha channel of an image or movie holds information transparency and enables you to read that transparency information in other compositing and editing applications that also support alpha channels. Using this information you can easily composite transparent or semi-transparent elements together without the need for further masking, keying, or effects.

Only certain file formats support Alpha channels so it is imperative that you choose one of these if you want to retain the transparency in your movies. The file types that support alpha channels include: PSD, ElectricImage, Targa, Pict, Tiff, EPS, PDF, and QuickTime. When you want to retain

the alpha channel of your file you must make sure that you select a bit depth of Millions Of Colors+, and choose to output RGB and Alpha channels when you render the movie, this can be done in the Video Output section of the Output Module settings (Fig. 12.16).

When you choose to output movie files then be aware that only certain codecs support this bit depth (including the alpha channel) so you need to check before using them. The most popular codec to use with QuickTime that supports Alpha channels is the Animation Codec, preferred as it is a lossless codec.

Other output options

After Effects is capable of outputting virtually any type of image, audio, or movie file format, it would take reams of pages to be able to cover all of them in detail here. The wonderful Adobe After Effects Help supplies you with details regarding all the output formats, it doesn't make any sense to repeat that information here so I have decided to focus on some of the output formats that I have found to be the most useful.

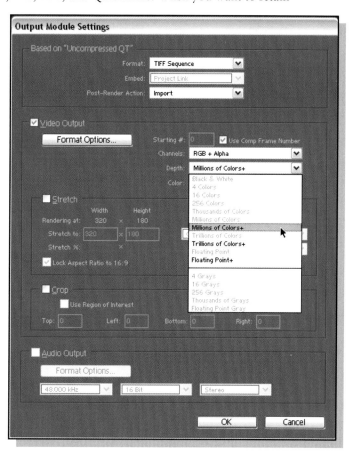
Fig. 12.16

34 To find out all you need to know about these go to **Help** > **After Effects Help** > **Contents** > **Rendering and Exporting**, you'll find more information here (Fig. 12.17).

Fig. 12.17

Image sequences

We've just output movie files from our project but in real-world work situations I am more likely to render out my finished work as image sequences. Occasionally renders fail and movie files can become corrupted when this happens, resulting in wasted render time. Outputting image sequences means that any rendered frames are safe and do not need to be re-rendered. Image sequences are also more universally acceptable than movie files when importing into editing systems, in fact some editing systems can only accept sequences. The most common image sequence formats I use are Tiff sequences, Targa sequences, and Pict sequences.

Filmstrip files

I love filmstrip files as they are pretty much unheard of (Fig. 12.18), and, you know me, I always like to support the underdog!

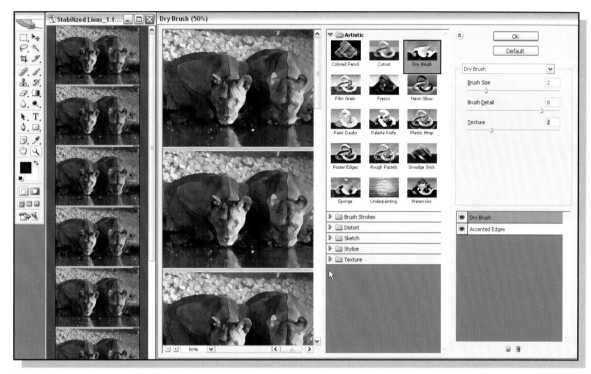

Fig. 12.18

Filmstrip files facilitate painting (or rotoscoping) your images directly in Photoshop but is also useful for applying Photoshop-native filters to your videos. This format comes in extremely handy when you need to use a feature in Photoshop that is not available in After Effects. I used Filmstrip files when working with Chris Cunningham on the 'Aphex Twin' 'Rubber Johnny' video. This was the only way I could find to use the healing brush on video frames, and it worked like a dream!

It allows you to render multiple frames as a single, uncompressed filmstrip file. This opens in Photoshop as a strip of film with the individual frames on it. Filters, selections and tools can then be used on the file before re-saving and importing back into After Effects.

Adobe media encoder

The Adobe Media Encoder is common amongst all of the Adobe Video Collection products. It provides high-end export settings for certain formats including; MPEG2, MPEG2-DVD, Windows Media, and Real Media. The settings for these can be accessed via the Render Queue. To find out more about these options and how to use the settings please go to **After Effects Help > Contents > Rendering and Exporting > Rendering to Windows Media, Real Media, or MPEG** (Fig. 12.19).

The export menu

In the file menu there is an export option. I rarely use this menu item as the Render Queue often offers much more control over my renders, however there are some options in here that are unavailable in the Render Queue.

557

MPEG2-DVD

Use this option to export your edited movie in the MPEG2-DVD format. You may use any of the system presets provided or customize the settings for your use.

Export Settings

Format: MPEG2-DVD

Preset: PAL Progressive 4x3 High Quality 7... ▼

Comments: High quality, CBR transcoding of Progress

☑ Export Video ☑ Export Audio

▽ Summary

PAL, 25 [fps], Progressive, Quality 5.0

48 kHz, 16 bit, Stereo, PCM

CBR, 7.00 [Mbps]

Filters **Video** Audio Multiplexer Others

▼ **Video Codec**

Video Codec: MainConcept MPEG Video

▼ **Basic Video Settings**

Quality: 5.0

TV Standard: ○ NTSC ● PAL

Frame Rate [fps]: 25

Field Order: None (Progressive) ▼

Pixel Aspect Ratio: ● Standard 4:3 (1.067) ○ Widescreen 16:9 (1.4...

▼ **Bitrate Settings**

Bitrate Encoding: ● CBR ○ VBR, 1 Pass

Bitrate [Mbps]: 7.0000

▼ **GOP Settings**

M Frames: 3 ▼

N Frames: 12 ▼

Estimated File Size: OK Cancel
1.02 MB/Sec

Fig. 12.19

Export to Premiere Pro – Windows only

You can now export an After Effects project as an Adobe Premiere Pro project. Keyframes, effects, and other supported properties are converted into the Adobe Premiere Pro sequence.

Export to flash video

Flash video is probably the most promising format around for streaming web video. Flash is the industry standard for creating interactive web sites, presentations, and content for mobile devices.

After Effects now includes the Flash Video Exporter, which encodes video and audio into the FLV file format using QuickTime to export movie files with the FLV file extension.

FLV video supports alpha channels, this means that you can overlay video with transparent or semi-transparent pixels over other Flash content, for example keyed blue-screen footage or semi-transparent footage of smoke, water, or fire.

35 Open SeattleNewsEnd.aep from Training > Projects > Chapter 12_Output if it is not already open.

36 Select the Seattle Evening News comp in the Project panel and then go to File > Export > Flash video FLV (Fig. 12.20).

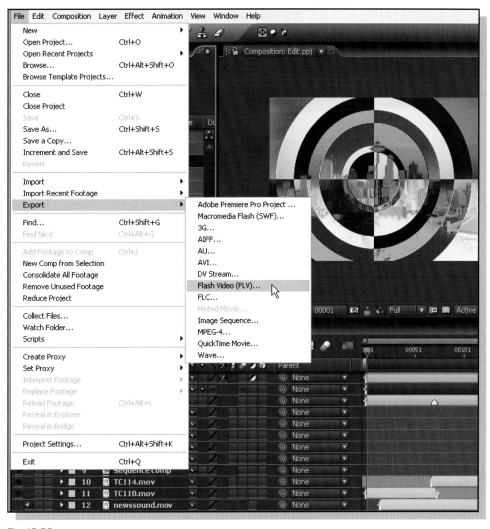

Fig. 12.20

37 Click **OK** in the dialog that appears about the output capabilities of the Render Queue, and then click the **Show Advanced Settings** button to expose the **Encoding Settings**, this is where you can choose your video and audio codec settings and encode an alpha Channel (Fig. 12.21).

38 Select **Flash 8 – High Quality (700 kbps)** as the **Flash Video Encoding Profile** and then click **OK** to render out a FLV file.

Note! You will need to have **Macromedia Flash 8** player installed on your system to be able to open the resulting file.

Fig. 12.21

Export to SWF

The Flash SWF format is one of the most common file formats on the web. Not all features in After Effects are supported by the SWF export, basically anything vector based will be supported but anything that has to be rasterized (e.g. a blur) can either be ignored or exported as JPEG compressed frames.

39 To discover which features are supported by SWF go to **After Effects Help > Contents > Rendering and Exporting > Exporting to Macromedia Flash Format (SWF) > Supported Features for SWF Export** (Fig. 12.22).

40 Open **PopArtEnd.aep** from **Training > Projects > Chapter 12_Output**.

Fig. 12.22

Many of the movies and effects we used in this composition are not supported by SWF so have to be rendered out as JPEG compressed frames. Let's try it out on the Pop Art titles we worked on earlier in the Text chapter (Chapter 08).

41 Open the **Finished Pop Art titles** comp from the **Project** panel.

42 Go to **File > Export > Macromedia Flash (SWF)** to open up the **Save File As** dialog. Choose to save the file into your **Work in Progress** folder as **PopArt.swf** and then click **Save** to open the **SWF Settings** dialog (Fig. 12.23).

43 Set up the settings to match the ones illustrated in Fig. 12.23 and then click **OK** to render your **SWF** file.

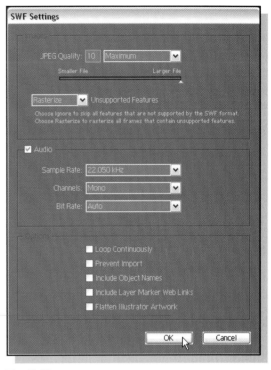

Fig. 12.23

44 Go to your **Work in Progress** folder and you will see two new files, one is named **PopArt.swf**, the other is named **PopArtR.htm**.

45 Double-click the **PopArtR.htm** file to open it in your default web browser. Here you will see details about the file that you have rendered including details about the render of each individual frame (Fig. 12.24).

Network rendering

If you are doing any network rendering using the network rendering built into After Effects Pro then you will almost certainly have to use image sequences as your output as the frames need to be distributed amongst several machines. However if you use the wonderful GridIron X-Factor to take care of your network rendering and previewing then you can also output QuickTime movies and Video for Windows. I'd thoroughly recommend the

Fig. 12.24

GridIron products, they can speed up your workflow enormously, check them out at http://www.gridironxfactor.com

I will be posting a Network rendering tips and tricks document on my web site in the near future. This will be freely downloadable so please keep checking the web site for details.

Open GL rendering

You can render in OpenGL if you have a video card that supports OpenGL 1.5 or later. OpenGL rendering will only render features supported by your OpenGL graphics card so I don't really recommend this with the exception of rendering out proxies or guide layers.

46 To find out more about Open GL rendering go to **After Effects Help > Contents > Rendering and Exporting > Rendering a movie > To Render with Open GL**.

Recap

OK, so you should now have completed all of the tutorials in this book, it's now time for you to take what you've learned and develop your own project to a finished state. By this time you should have built up a fair amount of work. In your **Work in Progress** folder there should be a whole host of projects and movies that you can use in your finished project, some of you may have even started developing these into a finished piece already, if so, keep up the good work.

There are also loads of more bits and pieces for you to look at on the DVD. The **Extras** folder contains more tutorials and projects for you to experiment with. This folder contains lots of free plug-ins, kindly donated by the plug-in companies. Have a play around with them to see what you can come up with. It also contains demo versions of some great applications and plug-ins that I simply couldn't live without, see what you think of them.

You should also check on the web site regularly at **http//www.creativeaftereffects.com**

I will be updating this web site with new tutorials, information, and revisions on a regular basis. There are also links in here to other useful sites and mailing lists, where you can post questions and opinions to some of the most experienced After Effects users on the planet. You can also contact me here with any feedback you have regarding the book, or just to say hello!

I'd like to finish by thanking you for buying this book and following these tutorials, I hope you've found them useful and informative and hope that you get as much pleasure from using After Effects as I have done over the years. To finish here are a few words of inspiration from filmmaker and animator Madeleine Duba.

Madeleine Duba is a Czech-Swiss award-winning filmmaker based in London. A graduate of Royal College of Art, she collaborates with film production companies in the UK and Prague, Czech Republic as a director, animator, and art director. Madeleine has worked with Liberation Productions, Magician Pictures, Rotor Productions, and other companies on various projects. Her work is represented in London, New York, and Prague. For more information about Madeleine's work you can visit her web site at http://dubanimation.com

But from me all that's left to say is, 'Happy keyframing!'

Inspiration – Madeleine Duba

Madeleine Duba is an Animation Film Director/Writer working on Illustration, Animation, and Live Action. She was born in Winterthur, Switzerland; did a BA Visual Communication (Animation, Graphics, Illustration, and Video) at the University of Applied Art of Lucerne, Switzerland followed by an MA Communication Art and Design (Animation, Illustration, and Film) at the Royal College of Art in London

www.dubanimation.com

Q How did your life lead you to the career/job you are now doing?
A As my father has been an experienced director for many years, he has influenced me since childhood.

Madeleine Duba

When I was 6-year old, we sometimes used to visit a sound studio together. I vaguely remember that I tended to observe the environment with a certain curiosity while my father was working on a film synchronization. I found the atmosphere very interesting and cozy, partly because the light was slightly dimmed and the acoustics were somehow different.

When I was 10-year old, my father was animating for an industrial film. I used to help him to click the stop frame button on a 16-mm camera and I remember that I felt very proud to do that.

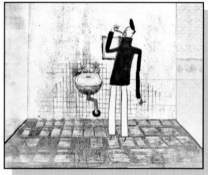

My favorite subject at school was always visual art and music. There I could reflect my feelings. In my free time, I used to draw and play on the piano. This lead me naturally to make the Art College; first BA in Switzerland, then Master at the Royal College of Art in London. There I had space to explore.

Touching the field of moving image, I experienced first time by clicking the stop frame button on a super 16 camera while helping my father. At the Art College in Lucerne, Switzerland, I re-discovered animation. First focusing on Illustration, it was a great joy when I discovered on how to make images move, feeling a certain magic in the process. Until this day, I feel moving image is an endless field to explore and I hope to continue.

Q What drives you to be creative?
A The Natural world as a backdrop inspires my imagination.

Q What would you be doing if not your current job?
A Work creatively in any possible way.

Q Do you have any hobbies/ interests and if so, how do you find time for them?

A My hobby is music. It is a nice balance to my work. It is great to use different senses than my eyes. I enjoy playing piano, if I have time I love to go to live concerts, listen to music, etc. It inspires me and lets my thoughts flow.

Q Can you draw?

A Yes, although there is always something more to explore.

Q If so, do you still draw regularly?

A Yes, I have my sketchbook always around. However, it is filled with lots of written ideas as well as drawings. I always develop content/ideas for my films as much as visuals. I believe without a subtle storyline (this can be as much experimental as literal), visuals are pointless.

Q What inspires you?

A My background, my surroundings … what I see … what I hear.

Q Is your creative pursuit a struggle? If so, in what way?

A Sometimes it can be a struggle. The journey from the first idea to an inventive story structure needs a lot of patience and research. The way through those thoughts can take sometimes as long as the actual visual production time.

Q Please can you share with us some things that have inspired you. For example film, song, web site, book, musician, writer, actor, quote, place, etc.

A Studying Illustration beforehand, I've been influenced by surreal and experimental work with lots of humor. Later I started to use this style in films.

Eadweard Muybridge's experiments of movement helped me a lot to understand animation. Jirí Trnka, head of the 'Trick Brothers Puppet Animation' in Prague (Czech Rep.), amazed me through his work.

I was inspired by Vera Chytilová (Czech Rep. 1960s) to choose collage, different illustration styles, colors, and decor to concoct a surrealistic reverie on social critical issues ('Water?', Animation 2001).

Jan Svankmajr's surrealistic view of story telling also slipped into my work ('Living in a box', Puppet Animation 1998).

'Direct-Cinema' and 'Cinema Verité'. By watching films of Jean Luc Godard, François Truffaut and even Milos Forman's early work, where he shot episodic stories on locations with non-professional performers and improvised scripts. I developed the idea of a cinema-verité documentary (Man United/ Ladies Choice, Documentary 2001).

Later I developed a short fiction called 'Mirror' (2003) with a very raw script. It is a surreal suspense story with a philosophical content of the 'Psychoanalysis of the Real'. Buñuel, Hitchcock, and even David Lynch have certainly left an impression, that can be seen in my work.

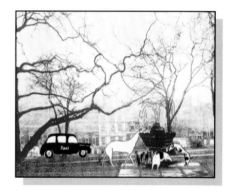

I was always amazed by slapstick humor that I learned definitely in the Czech Republic with Jirí Slíva and Slitr's stage comedies, in Switzerland Emil Steinberger in 'Schweizermacher', in England with Fawlty Towers, Monty Python and Only Fools and Horses, not to mention the French Tati films and many many more. I like those stories because they are all brilliant observations of our society.

Q What is your most over-used AE feature/filter?

A I can't tell you, it depends of what the visual concept needs. This varies from project to project.

Q What would you like to learn more about?

A I would always like to learn more about technical issues to be able to combine it with my creative ideas. Seeing new films containing more and more super professional animation special effects, I find this very impressive. However, this to combine with my creative vision is my ambition.

Q Please include screen shots of the work that you are most proud of and give a brief description of it and explain your feelings about it.

A Synopsis for 'Water?'

Taking the saying: 'London tap water has been drunk seven times before you drink it, how come it tastes so good?'

London drinking water as an example, it is recycled up to seven times before it reaches the general public. This film is a short and critical reflection on ecological sustainability. It's aim is to raise the public awareness of natural resources and their possible exhaustion.

'Water colored, collaged, and quite busy 3D backgrounds combined with very simplified effective characters, work as a contrast together.

The content is a simple saying and is told in a very simple storyline. However the theme contains a complex social environmental issue. With the simple way of exposing such a theme, I hope to achieve awareness for sustainability.

Index

Also available from Focal Press

Animation: The Mechanics of Motion

Chris Webster

'Makes a complicated subject understandable and … fun to do.'

Animation World Magazine

- Improve your timing, performance and animation production skills with this practical guide to animation skills suitable for all disciplines
- Benefit from the skill and experience of a leading professional and educator with more than 20 years' industry experience
- Understand and master action analysis, movement and timing with this beautifully illustrated guide

Learn the key skills you need with this practical and inspirational guide to all the fundamental principles of animation. With extended pieces on timing, acting and technical aspects, Chris Webster has created the vital learning tool to help you get the most out of your animation and develop the practical skills needed by both professionals and serious students alike.

The free CD-ROM includes more than 30 animations illustrating the techniques described throughout the book as well as examples of a professional Production Schedule, Budget and Production Chart – everything you need to get started!

July 2005: 189 × 246 mm: Paperback:

0-240-51666-4

To order your copy call +44 (0)1865 474010 (UK) or +1 800 545 2522 (USA) or visit the Focal Press website: www.focalpress.com

Also available from Focal Press

Digital Compositing for Film and Video,

2nd Edition

Steve Wright

- Written by an author with 15 years' experience, including major films such as Vanilla Sky, X-Men 2, Swept Away, and Solaris
- This edition contains an entire section on working with HiDef video
- Now includes information on Adobe Photoshop

A good compositor must be both an artist and a technician. This heavily illustrated book (now in full color!) presents you with techniques, tricks, and solutions for dealing with the badly shot elements, colorations artifacts, and mismatched lighting that bedevil compositors. Included in this book is in-depth, practical methods for matte extraction, despill procedures, composting operations, and color corrections – the 'meat and potatoes' of all digital effects.

May 2006: 191 × 235 mm: Paperback:

0-240-80760-X

To order your copy call +44 (0)1865 474010 (UK) or +1 800 545 2522 (USA) or visit the Focal Press website: www.focalpress.com

Also available from Focal Press

How to Cheat in Photoshop, 3rd Edition

The art of creating photorealistic montages

Steve Caplin

'Well-written, insightful and beautifully illustrated.'

Digital Creative Arts

- Extensive new material to show you how to take your Photoshop skills even further
- CD includes all the images from the book and 100 new, free, high resolution AbleStock images
- Benefit from a professional illustrator's timesaving tips and tricks!

With this book you can work from the problem to the solution with expert guidance from a professional illustrator. Each section is divided into color double page spreads on illustrative techniques; giving bite size chunks with all that you need to know in a highly visual, approachable format.

Most of the original Photoshop files are provided on the free CD, along with hundreds of dollars' worth of free, sample plugins and images, so you can try out each technique for yourselves as you read.

August 2005: 189 × 246 mm: Paperback:

0-240-51985-X

To order your copy call +44 (0)1865 474010 (UK) or +1 800 545 2522 (USA) or visit the Focal Press website: www.focalpress.com

Also available from Focal Press

Timing for Animation

Harold Whitaker and John Halas

'The best book for students of the art of animation. I can't recommend it highly enough.'

Bob Godfrey, Oscar winning leading animated filmmaker and author

- New foreword by John Lasseter of Pixar and 'Toy Story' fame
- Benefit from the expertise of two internationally acclaimed animators
- All you need to breathe life into your animation at your fingertips

This classic text teaches you all you need to know about the art of timing and its importance in the animated film. This reissue includes a new foreword by John Lasseter, executive vice president of Pixar Animation Studios and director of 'Toy Story', 'Toy Story 2', 'A Bug's Life' and 'Monsters Inc.' He sets the wealth of information in this classic text in context with today's world of computer animation, showing how this is a must-have text if you want to succeed as a traditional drawn, or computer animator.

Feb 2002: 189 × 246 mm: Paperback:

0-240-51714-8

To order your copy call +44 (0)1865 474010 (UK) or +1 800 545 2522 (USA) or visit the Focal Press website: www.focalpress.com